Diagramming Devotion

THE LOUISE SMITH BROSS LECTURE SERIES

Diagramming Devotion

Berthold of Nuremberg's Transformation of Hrabanus Maurus's
Poems in Praise of the Cross

JEFFREY F. HAMBURGER

The University of Chicago Press : : Chicago and London

The University of Chicago Press, Chicago 60637
The University of Chicago Press, Ltd., London
© 2020 by The University of Chicago
Published 2020
Printed in China

29 28 27 26 25 24 23 22 21 20 1 2 3 4 5

ISBN-13: 978-0-226-64281-9 (cloth)
ISBN-13: 978-0-226-64295-6 (e-book)
DOI: https://doi.org/10.7208/chicago/9780226642956.001.0001

Publication of this book has been made possible in part by a generous grant from the Louise Smith Bross Lecture Fund, Department of Art History, The University of Chicago.

Library of Congress Cataloging-in-Publication Data

Names: Hamburger, Jeffrey F., 1957– author. | Rabanus Maurus, Archbishop of Mainz, 784?–856. In honorem Sanctae Crucis.
Title: Diagramming devotion : Berthold of Nuremberg's transformation of Hrabanus Maurus's poems in praise of the Cross / Jeffrey F. Hamburger.
Other titles: Louise Smith Bross lecture series.
Description: Chicago ; London : The University of Chicago Press, 2020. | Series: The Louise Smith Bross lecture series | Includes bibliographical references and index.
Identifiers: LCCN 2019013313 | ISBN 9780226642819 (cloth : alk. paper) | ISBN 9780226642956 (e-book)
Subjects: LCSH: Berthold, of Nuremberg, active 1292. De misteriis et laudibus Sancte Crucis. | Berthold, of Nuremberg, active 1292. De mysteriis et laudibus intemerate Virginis genitricis Dei et Domini nostri Ihesu. | Illumination of books and manuscripts, Medieval. | Forschungsbibliothek Gotha. Manuscript. Memb. I 80. | Rabanus Maurus, Archbishop of Mainz, 784?–856—Influence | Visual poetry, Latin (Medieval and modern)—History and criticism. | Art and literature.
Classification: LCC ND2980 .H36 2019 | DDC 741.6/70943—dc23
LC record available at https://lccn.loc.gov/2019013313

For Esther and Miriam

Contents

Preface & Acknowledgments

Few works are so complex that their authors feel compelled from the start to supply them with an commentary of their own. That work is usually left to others. In the Middle Ages, beginning with the Bible, most commentaries postdated the authoritative works on which they were written. In addition to serving an explanatory function, such supplementary texts cemented the reputation of the work to which they directed the reader's attention as a source of authority, in some cases even of revelation. Today such commentaries might be described as packaging. To endow a work with an interpretive framework entailed either confidence or concern regarding the urgency of its claims. Although in some instances it constituted a rote exercise, in others it provided a vehicle for piggybacking on another author's fame. The boundary between an *explication du texte* and a rewrite masquerading as commentary proved very thin. Commentaries served a double didactic purpose, unraveling the work's secrets for the uninitiated while at the same time identifying the base text as a thesaurus of wisdom. Commentaries not only enlightened but also stratified their audiences.

In honorem sanctae crucis, the most celebrated collection of Latin *carmina figurata*, represents something of an exception in that the core text and the accompanying commentary were written by one and the same person: Hrabanus Maurus (ca. 780–856), abbot of Fulda and, late in life, archbishop of Mainz. Hrabanus's magnum opus included not one but two prose commentaries. Each picture poem in Hrabanus's work is accompanied by an explanation in prose, which together with the facing poem fills an opening and hence presents a single visual unit, to which Hrabanus ap-

pended an additional prose commentary in book 2. Having received his training with Alcuin at the great center of Carolingian learning in Tours, Hrabanus, who had risen through the monastic ranks to become abbot of what was to become a comparable center of scholarship, the monastery of Fulda in central Germany, justified his activity by appealing to the authority of the ancients:

> The ancients had the custom of writing their works in a double style [by which he means in verse and prose, a genre known as *opus geminatum*, paired/doubled work] so that their gifts would be more agreeable and more useful to their readers. Among the profane and ecclesiastical authors, there are a very large number who have written about one and the same subject in meter and in prose. To say nothing of all the others, can one not observe this concerning the blessed Prosper of Aquitaine and the venerable Sedulius? Did they not publish a double work in a double style, so that the variety itself would spare readers fatigue and so that, if someone understood something less well in one text, he could recognize it in the other more amply explained?[1]

Although Hrabanus invokes conventional humility topoi, in referring to poetic predecessors he also vaunts the breadth of his own learning and literary culture.

Some four and a half centuries later, in the late thirteenth century, Hrabanus's *carmina* generated yet another commentary, this one by the Dominican Berthold of Nuremberg, the work that stands at the heart of this study. In light of his Carolingian predecessor's own exegetical activity, it might seem perverse or at least superfluous for Berthold to have doubled Hrabanus's endeavor yet again: first by paraphrasing. excerpting, combining, and commenting on Hrabanus's prose commentaries in books 1 and 2 of *In honorem sancti crucis*; then, as if that were not enough, by adding his own set of diagrams, which condense the content of the Carolingian *carmina*. In a process of prolix compounding, Berthold further redoubled his own efforts by

adding an entirely new book of complementary Marian figures, sixty in number, amplified by his own commentary and excerpts from authorities borrowed from or prompted in part by the Dominican lectionary.

As I will attempt to show in my commentary—in effect, a commentary on a commentary on a commentary—Berthold's ambitious undertaking represents anything but a bowdlerization of his Carolingian predecessor.[2] Rather, Berthold reshapes Hrabanus according to the theological, exegetical, liturgical, devotional, and, not least, artistic imperatives of his own day. Given the reverence in which Hrabanus's work was held, Berthold's decision to rewrite it was, if anything, not humble but daring. It certainly remained unmatched in the extent of its author's willingness to depart from his model.

In writing this book I have not, any more than Berthold, heeded the advice of Solomon in Ecclesiastes 12:12: "More than these, my son, require not. Of making many books there is no end: and much study is an affliction of the flesh." Far from an affliction, however, the writing of this book has been a pleasure—and a consolation, as my work on it coincided with the final phase of my wife Dietlinde's fatal illness. She is very much present in these pages. The initial pleasure consisted of the surprise prompted by my first encounter with the manuscript in the library in Gotha, where I was kindly permitted to examine it by Cornelia Hopf. Having traveled to Gotha to look at another codex, I filled an idle hour at day's end by calling up not one but two manuscripts described in a simple checklist as containing an ample number of illustrations.[3] Not a word about diagrams. One manuscript turned out to be the presentation copy of Lothar of Segni's *De missarum mysteriis*, a Parisian manuscript made circa 1200 which spawned all later illustrated examples of this widely disseminated text on the mysteries of the Mass. Having first published that manuscript in the *Wiener Jarbuch für Kunstgeschichte*, I was, thanks to the generosity of Prof. Eckart Conrad Lutz of the University of Freiburg, Switzerland, able to publish a revised version in translation as part of a series of publications stemming from the Wolf-

gang Stammler Gastprofesseur.[4] I subsequently presented Berthold's book at a conference on medieval diagrams also organized by Prof. Lutz.[5] Ensuing discussions led to the idea of a fuller publication of Berthold's diagrams; this book is the result.

The National Endowment for the Humanities provided me with the fellowship that permitted me to pursue this project during a sabbatical spent at Dumbarton Oaks, a scholar's paradise sans pareil. In light of the heightened threat to the endowment, it gives me special pleasure to acknowledge its indispensable assistance. For his help in making my year of sabbatical possible, I am also grateful to its director, Jan Ziolkowski, as well as to the librarians who fulfilled my every wish. At the Bibliothèque nationale de France, Marie Pierre Lafitte generously shared an unpublished description of a manuscript. David Ungvary (Harvard) and Tristan Sharp (Toronto) provided assistance with the transcription and translation of ms. 418 in Toulouse. Early on, my former student Beatrice Kitzinger asked some probing questions, as did many colleagues and students, among them Chris Waggoner at Indiana University, on the various occasions on which I presented this material, whether in Washington, Bloomington, Oslo, Tel Aviv, or Jerusalem. John Kim graciously permitted me to consult his excellent Harvard dissertation on diagrams in twentieth-century literature; Christoph Mackert offered paleographical advice. Daniel Heller-Roazen kindly read the text of a lecture based on my first chapter and offered stimulating suggestions. To those colleagues and friends who served as sounding boards throughout, above all, Hildegard Elisabeth Keller, and the authors of the two perceptive readers reports I received, I also extend my thanks. I am especially grateful to the twenty-five graduate students representing a wide variety of humanistic disciplines who in the spring of 2017 and fall of 2018 took my seminar "The Diagram as Paradigm in the Middle Ages—and Beyond." I have described the experience of this class in a short article, "A Seminar on Diagrams as Conversation and Consolation," which appeared in a collection of essays edited by Caroline Walker Bynum and published in *Common Knowledge* 24 (2018), 356–65 (Symposium: In the Humanities Classroom, part 2). At the University of Chicago Press, Susan Bielstein, Ruth Goring, Elizabeth Ellingboe, and James Toftness expertly guided my manuscript through the editorial process. With no less care, Marta Steele compiled the complex indices.

My deepest gratitude goes to John and Judy Bross, the sponsors of the Bross Lectures at the University of Chicago, where in the fall of 2015 I presented much of the material that has gone into this book, as well as to my colleagues there, especially Aden Kumler, who extended the initial invitation to present my ideas in such a stimulating and hospitable setting. The Brosses' generosity has further enabled the publication of the book in its current form, including the ample number of color plates that are essential to understanding Berthold of Nuremberg's color symbolism as well as the aesthetic merit of diagrams that too rarely are appreciated as works of art in their own right. Additional support was also provided by the Anne and Jim Rothenberg Fund for Humanities Research at Harvard University and the Rose Marrow Fund.

It is my hope that this book will in turn inspire more commentaries. Of books and of the critical reception of the past that they represent, there should never be an end.

Note to Reader

All translations of the Latin Vulgate Bible are taken from the Douay-Rheims Bible. In order to distinguish between the figures illustrating this book and those illustrating Berthold's, the latter are designated in Latin as *figura* (singular) and *figurae* (plural).

Introduction

Medieval Art as Diagram

Central and reciprocal propositions of this book are that diagrams were central to the making of medieval art and that much, although hardly all, of medieval art is diagrammatic to its core. Neither of these suggestions as such is new to this study, which doubles as a monograph on one of the most ambitious diagrammatic works of the Middle Ages, Berthold of Nuremberg's pair of treatises devoted, in turn, to the Holy Cross and the Virgin Mary, composed and illustrated in Germany in the last decade of the thirteenth century (figs. 1–2). What is new, however, is the degree to which this book places medieval and modern materials in dialogue with one another in ways that I hope are mutually illuminating. In considering medieval diagrams in light of modern thinking about the truth claims made by diagrams in multiple areas of human inquiry, from the philosophical to the mathematical, I am not seeking to engage in the kind of creative and often instructive anachronism that has informed, usually by way of analogy, a good deal of recent scholarship on medieval or, for that matter, modern art, much of which focuses on representations of the body.[1] Rather, in keeping with some of the objective claims to which diagrams aspire, I am interested in the ways in which their analysis in a variety of fields, ranging from semiotics, anthropology, and the history of mathematics and logic to what in Germany is called *Bildwissenschaft*, can inform our understanding of the workings of medieval diagrams, in particular those from the religious realm.

Bildwissenschaft is usually translated as "image science," but that rendition fails to capture the ambiguity according to which *Wissenschaft* can

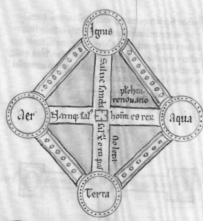

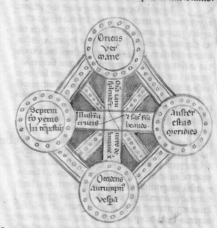

...turas ad laudem creatoris exhortando conciuebant
atq; dicebant. Gaudiete omnia opera diuini domino.

De quatuor elementis. septa figura.
O varen anim numerum perfectione satutut
pene nullus ignorat. iudo bn̄ illum in
forma titulis transfigurantur. totus orbis ueniatur.
Siquide mund. quatuor elementis constat
manifestum e̅. igne. aere. aqua. ⁊ tra. Si ergo
crectam trucem uolumus aspicere ignem qd̅ sup-
mum e̅ elementoꝝ. in ʒte illius collocemus. Ae-
rem quoq; ⁊ aquam que media sunt ut elementis
in transfuso truris ligno qꝫ p mediu stipitis erecti du-
titur consignemus. Terram uo que grauissima est
rimum in terminis tenet locum. inferiori pti tru-
tis deputemus. Hec quippe omnia elementa fiant
quadam nature ꝓpinquitate sibi met ꝍiscentur.
ut mundi integritatem psiant. ita etiam q̅tuor
ptibz trutis sibi met cohamtur ut ꝑfectam esse tro-
tem demonstrent. Cur uo inuitis quatuor elementa
ꝓta sint hec ratio e̅ quia omnis mundi machina
temptalis e̅ quadā ꝓmixtione elementoꝝ uaria-
bilis siu mutabilis. Nunc .n. ignis aerin siccat
aqua humidiore fuit. Nunc tetra aquaꝝ alluuio-
nibz afficitur. nitc solis ardore siccatur. Aqua quippe
naturali mobilis e̅ quendam circulum cursu con-
ficit. Omnia flumina inquit ecclesies intrant in
mare ⁊ mare non redundat. Ad locum un̄ exeunt
flumina reuertuntur. ut iterum fluant. Ignis q̅
similit naturalem motum h̅t. in adalt ora se sp-
tigte accensus. ⁊ locum sibi sup acta querit. Disiru-
runt fulgura ⁊ nebris micant ignibz. ether.

¶ Ignis
dum omnia penitem ostedit esse recuperata ⁊ p ꝑ passi-
onem renata ac melorata atte ad eius laude uere-
ri conueniunt. quia ipe e̅ cum patre ⁊ spu̅ santo
unus deus au soli bn̄ dictiois ille competunt h̅-
trus pueri in camino ignis ardentis omnes tras-

De quatuor plagis mundi. ⁊ iiij. uicissi-
T omnium oram ꝗuor. trudinibz tempeꝝ
firman ptibz siue angulis no septima fi-
rum est. oriente. ⁊ occidente. aquilone ⁊ meris gua-
die. Quatuor etiam sunt uicissitudines tempeꝝ .i.
uer. estas. autumpnus. hyemps. Quatuor quoq; q̅
dyantes sunt naturalis diei .i. quater sene hore que
tamen huis initus dinoscuntur. mane uidelicet ⁊ me
ridie. uespere ⁊ intemꝑesto. Sz quomodo sante truti
possint hec conuenient coaptari uidend est. Si q̅tuor
plagis orbis cum uolumus assignare. iacentem meti-
mur necesse est. ita ut prima partem eius orienti
ꝓximam occidenti. dexteram aquilon. sinistri austro
deputemus. Similit quoq; quatuor uicissitudines te-
poꝝ seu quatuor ptes naturalis diei eadem disposi-
tione intuere possint adiuuart. ut una spties anni. siue
diei congrue nihus queat ostendi. Ver .n. atq; auro-
ra oertim luas ⁊ coalescentia in fra gemina ordinec-
sio ꝓferunt. roblꝫ bn̄ orienti deputantur. Estas au
atq; meridies qꝫ feruentem austro coaptantur. quia
diui in eisdem celi ptibz sol erigitur. flagrantiore
mundum torret caloes. Autumpnus quoq; ⁊ uespera
iure occidenti mancupant. eo qꝫ tunc omnis finituri
ue messis finitur. ⁊ tota diei spatia immin aut̅. hyemp
uo ⁊ intempestum septentrioni assimilantur. eo qꝫ te
siu figore torpeat. ⁊ magis quieti quam alicui opeti
tempus expetuum sit. Hec figura etiam informis
spties ꝓsita est. quia tempora circulis transeunt ⁊ ui-
cissitudines quatuor tnoꝝ mensiu orbibus eunt.

Unde

Sol luna dm hic xpm en benedicite ihm.
Crux est noster honor stabilis lux pacifer ordo.
Laus probitas scdes primitia et secula lumen.

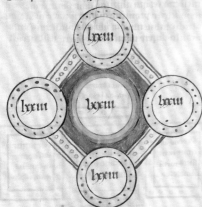

De diebz anni solaris. Octaua figura.
Annus si consideretur secdm. xii. menses. quos
[medieval Latin text, left column]

dinibz angelorum incelesti brtudine xpriua fulgeant
claritate. Hec figura similie informis obrialarib; qm
est qp anni inse reuisionem. et solis reuolutionem. annus
[medieval Latin text, right column]

Cuncta qua do'reno
uaiut secula prisca.

En crucis hec spenes
qbe bn mostrat honore.

Quonior De numero annox a principio mu
[medieval Latin text, lower right column]

1. Berthold of Nuremberg, Liber de misteriis et laudibus sancte crucis, Lake Constance region (?), 1292–94.
Forschungsbibliothek Gotha der Universität Erfurt, Memb. 8, ff. 42v–43r. Photo: FBG.



pfecta laus esse pbat. cum ī dño vital. ⁊ ī saluatore
nīa ⁊ mendium. ℂ Hec figura ptinet ad annam sa-
muelis. q̄ ratione accepte fecunditatis figuralr cum
virgine beata in dño exultauit. De ipsa namq̄ ī li-
bro regum scriptū est. Exultauit cor meu in dño. ⁊
exaltatū e cornu meū in deo meo. Dilatatū ē os meū
sup inimicos meos.q̄ letata sum in salutari tuo. Con-
met ⁊ sponsam que dicat ī canticis. Introduxit me
rex in cellaria sua. Exultabimus et letabimur in te
memores uber tuor sup uinum.

De beatificatōne ipsius ab omnibus mulieribus. xx̄
figura. Hugo de scō victore super magnificat.
Igitur uirginis matris humilitas apud deum facta
est acceptabilis ⁊ grā sic ⁊ er humilitas apud hō-
nes ī gliam est ⁊ mutata. Vn̄ postq̄m humilitate
sua adño respecta asseritur. ex hoc iam se beatam ī omī
generatōnes pdicanda subiunxit. Nam usq̄ ad illud
tempul. apud homines obpbriū stilitatis potuerat
a q̄ uirginitatis integritate thoro maritali pfere-
br. Sed nūc respexit deus humilitate eius. ⁊ abstulit
humiliatōne er. Ideo inquit beatā me dicent omēs ge-
neratōnes. ut ī pax iam sit ī generatōne pr̄ita ste-
rilitatis obpbriū sustinuisse. que ab omī futura genī-
one beata vocabitur pstructu fecunditatis mee ℂ
In hac figura ponit lȳa de eius beatitudine ac beati-
ficatōne in Genesi ita scriptum ē. Pepit quoq̄
zelpha altum. Dixitq̄ lȳa hoc p̄ beatitudine mea. Be-
atam quippe me dicent omnes generatōnes p̄ptea ap-
pellauit eū aser. Aser significat xp̄m. qui e refectio
animar. De busdione eni aser in Genesi scriptum ē.
Aser pinguis panis er. et p̄bebit delicias regibus. Po-
nitur ⁊ hic elizabeth zacharie. q̄ uirginis matris
beatitudine extulit. ut pstatur lucas cū dixit. Beata
q̄ credidisti qm̄ pficient ea que dicta sunt tibi adño.



De p̄cessu xp̄i ad modū sponsi ex utero uirginalx. xx-
xi. figura. Glosa sup psalmum decimū octauū.
Dōns belligerare uolens ad suis regna tempaluī
error posuit tabnaculū suum quasi militare hī-
taculū. idest dispensatōne incarnatōnis siue inqua ue-
nit expugnare errores mundi insole. Sol tria facit. lu-
cet uir. ⁊ uarietatem tempaluī tempu facit. Posuit
ergo tabnaculū insole. idest in tempe q̄ carnem assūp-
sit tempalibz uicissitudinibz subiectam. vel insole ide-
ī manifestatōne scilt ī manifesto mundi. Unde aur. so-
uenit lucerna ut ponat̄ sub modio. ⁊ sup candelabrū.
vel insole idest in labore. q̄ estium labor gratis sustinū-
vel tabnaculū suū idest ecclesiam posuit insole. idest in
manifesto non ī occulto. ut lateat scām illd. Non pot
abscondi ciuitas sup monte posita. Et ipse tamēn spo-
sui pcedens. q̄ a p̄hinc tociens pmissus pcedit de thala-
mo suo idest de uirginali uto. ubi deus humane natū-
ur sponsus sponse copulatus est. Et est hic magna
⁊ conueniens similitudo sacramti. idest signi ⁊ signati
⁊ deo eui de uirgine natus ē. ut significaret qd ecclā
sibi uirgine copularet. ℂ Hec figura ptinet ecclā
uelut xp̄i sponsam incui amore. carne de uirgi-
ne assumpsit. ⁊ in hunc mundū pcessit. et morte
sustinuit. Ad ephesios namq̄ scriptum ē. Viri diligi-
te uxores uras sicut ⁊ xp̄e dilexit ecclesiam. et semetip-
tradidit p̄ ea. ut illam scificaret mundas lauacro aq̄
ī uibo uite. ut exhiberet ipse sibi gliosam ecclesiam. nō
hūc maculam aur rugam. aut aliquid huiusmodi s̄; ut
sit sancta et immaculata.

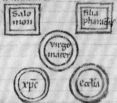

De gaudio xp̄i siue sponsi ⁊ ei coronatōne auir-
gine marie. xx̄ij. figa. Gregorius sup cantica.
Egredimini filie syon et uidete regem salomoē;
in diademate. quo coronauit eum mat sua in
die desponsatōnis eius. ⁊ in die leticie cordis eius. ma-
ter xp̄i beata maria esse creditur. que coronauit eū
diademate. qn̄do humanitate n̄rm et ex ipse assūp-
sit. sicut ī euangelio recitatur. Et hoc ī die despon-
satōnis eius. et in die leticie cordis eius. trm esse d̄r
q̄ qn̄do unigenit̄ filius dei diuinitate suā huma-
nitati n̄re copulare uoluit. qn̄do pbona uoluntate
suā tempe optimo ecclesiam suā sibi assume placuit.
nūc caritatis exultatōne carne n̄ram ex matre
uirgine suscipe uoluit. inqua cum doloribz p̄ temps
uiuens. de redemptōne n̄ra uehemēt exultauit.

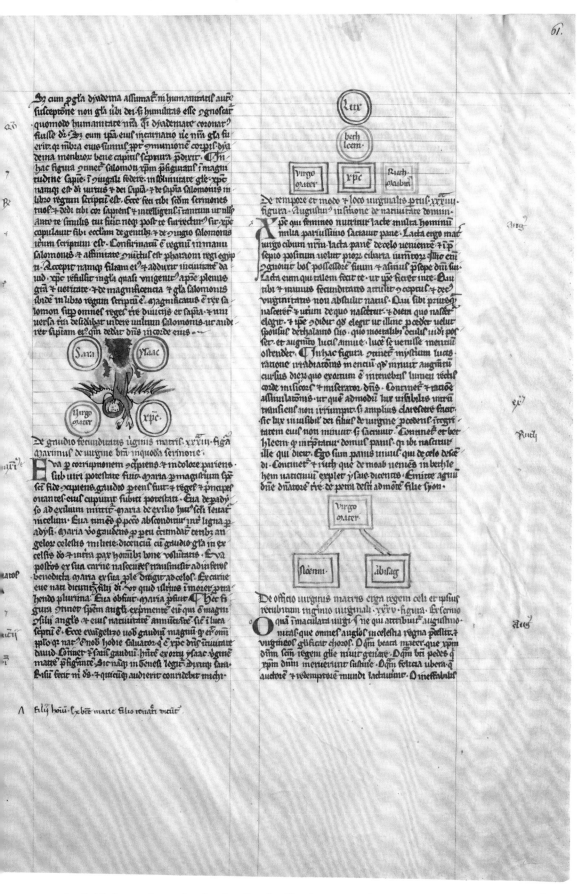

2. Berthold of Nuremberg, Liber de misteriis et laudibus intemerate Virginis genitricis Dei et Domini nostri Ihesu, Lake Constance region (?), 1292–94. FBG, Memb. I 80, ff. 60v–61r. Photo: FBG.

mean not simply science but also the pursuit of knowledge or simply scholarship. As a subject, the history of diagrams neatly captures this ambiguity. In mathematics, philosophy, and logic, the discussion of diagrams has focused largely on the legitimacy of their use as instruments in the pursuit of true propositions. In contrast, in the humanities the claims made by diagrams have been seen as more contingent, conditioned, if not determined, like all representation, by the historical contexts in which they were used. Medieval religious diagrams require a confrontation of these two very different understandings of diagrams. To the modern observer, a medieval diagram dealing with theological truths, such as the nature of the Trinity, presents something of an oxymoron: how can one demonstrate something that by definition remains a matter of faith? To a medieval viewer, however, the application of diagrammatic schema derived from science and logic to theological propositions made perfect sense, not only because those propositions were believed to be true but also because, as this book will explore, certain qualities of diagrams were thought to be especially suitable to such subject matter.

A single object can serve to demonstrate, very much in the manner of a diagram, the intersection of faith and the visual rhetoric, sometimes referred to as visual exegesis, of diagrammatic demonstration. The object, the Alton Towers Tripych (named after the stately home of the Earls of Shrewsbury who owned it prior to its having entered the collection of the Victoria & Albert Museum in 1858), does so in terms of typology, a topic central to Berthold of Nuremberg and hence to this book (fig. 3).[2] Although its style associates it with enamels produced in Cologne around the middle of the twelfth century, its complex typological program, which systematically relates Old Testament types (prophecies) to the episodes marking their fulfillment

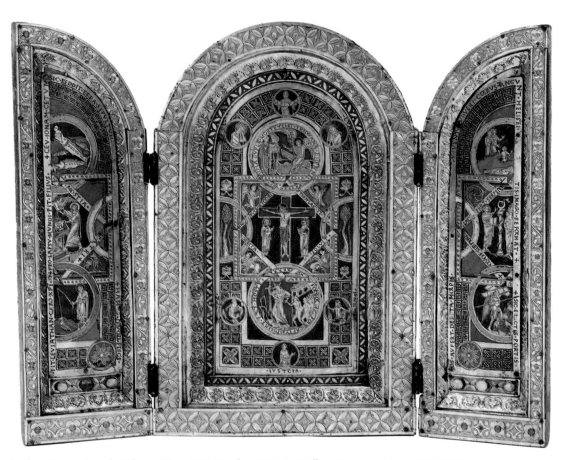

3. Alton Towers Tripych, Cologne (?), ca. 1150. London, Victoria & Albert Museum, inv. no. 4757-1858.
Photo: © Victoria & Albert Museum.

in the New Testament, more closely connects it to winged reliquaries of a type associated with the Mosan region, that is, the territory flanking the River Meuse, which winds its way through modern-day Belgium before flowing through the Netherlands to the North Sea.[3] The outermost frame is most likely a nineteenth-century concoction; the original may well have contained relics, including, given the triptych's iconography, perhaps a relic of the True Cross.

As a process of thought, typology is as old as Christianity itself. Words attributed to Christ in the Gospels make use of the method. In Mosan and Rhenish enamel work of the twelfth century, however, the typological method as a system of visual representation reaches its apogee.[4] The systematization in question does not simply take the form of pressing conventional pairings of type and antitype into a complex geometrical framework. As in a stained-glass window, the diagrammatic framing elements themselves are constitutive of meaning.[5] Not only do they bear the inscriptions that identify, clarify, and, through the use of verse, amplify the images, they also impose a series of logical relationships among them. Thus the crucifix set within the trapezoid at the center, surrounded in the corners by the symbols of the four Evangelists, directs the viewer along its vertical axis towards two additional New Testament scenes: above, the Three Marys at the Tomb, and below, less conventionally, Christ's Descent into Hell. Although in the abstract, the Resurrection might have made more sense in this spot, by virtue of its being placed below the Cross, as if underground, the Descent obeys a certain visual logic (perhaps suggested by Byzantine models), all the more so in that it is flanked by personifications of Mare and Terra, Earth and Sea.

Nested between two supplementary trees, the cross-arm of the Cross defines the other direction in which this diagrammatic constellation of images must be read. It points to the subsidiary scenes on the wings, all drawn from the Old Testament: to the left, the Sacrifice of Isaac (Gn 22:9), and to the right, Moses and the Brazen Serpent (Nm 21:9), both conventional types.

Like the scenes that they supplement, those on the wings also occupy two circles framing a central trapezoid, none of which, however, in keeping with their status as prophecies, is complete.

At the upper left, Jonah emerges from the mouth of the whale (Jon 1:17), and at the upper right, the bones of Elisha bring a dead man back to life (2 Kgs 12:21). Both scenes anticipate the Resurrection signified by the absence of Christ's body from the tomb at the center. At the lower left, God (not Christ, as indicated by the absence of a cross-halo) fishes for Leviathan (Job 41:1), a soteriological allegory. As explained by the accompanying inscription ("HAMVS QVOD PISCI FIT LEVIATHAN CARO XP[IST]I," Bait for the fish, the flesh of Christ becomes a hook for Leviathan), it serves as a type of salvation, represented by the Descent into Hell. No less unusual is the coupling of the Descent with the scene at the lower right: Samson carrying away the doors of Gaza (Jdg 16:3).

Just as the supplementary trees which spring up to either side of the Cross elaborate the vivifying power of Christ's sacrifice, thereby lending all of the triptych's vegetal ornament a quickening charge, so too the verse inscriptions broadcast a strong soteriological message.[6] For example, the verse accompanying the Crucifixion itself reads "IN CRVCE XPC [sic XP(IST)O] OBIT PTHO [sic P(RO)THO] PLASTI DEBITA SOLVIT" (Christ dies on the cross and repays the debts of the first created man); that adjacent to the scene of the Brazen Serpent, "QVOS SERPENS LACERAT SERPENTIS IMAGO REFORMAT" (Those whom the serpent bites, the image of the serpent restores).[7] In combination with the relics presumably once contained within the triptych, such proclamations lend the images an operative, apotropaic power. The resemblance of the triptych's central configuration to representations of Christ in Majesty underscores the triptych's underlying message. Within historical time the Crucifixion looks back to its historical Old Testament types, but it also points to Christ in eternity, outside of time. The six medallions, divided into two groups of three (Charity, Sun, and Moon at the top; Sea, Earth, and Justice at the bottom), root the overall scheme, based on cosmological diagrams, in

an ordered whole in which theology and cosmology are grafted together.[8] Whereas the first trio forms an extension of the Crucifixion, in which images of sun and and moon refer to the eclipse that according to the Gospels took place at the moment of Christ's death, the placement of Justice opposite Charity, at the bottom of the image, effectively summarizes the triptych's opposition of the Old and the New Law.

Like typology, diagrams are fundamentally relational in character. In lieu of linear or continuous narrative of a kind brought to perfection in antiquity, typological art lent itself to demonstrative, didactic, and diagrammatic modes of image making. The triptych's geometry speaks through the relationships it establishes in conjunction with its narrative imagery. In a manner typical of medieval religious diagrams, indeed of much medieval art, the triptych conjoins two modes of image making, one abstract, the other figural. In keeping with the rhetoric of typology, further explored in chapter 5, the two modes do not simply stand in opposition: the one completes the other according to an incarnational logic endlessly elaborated by theologians and exegetes. Just as the Word became flesh, so too Old Testament prophecies (pre)figured their New Testament realizations. This fleshing out, in all senses of the word, constitutes the foundation of figuration in Western art.

Within this framework, to read the geometry of the Alton Towers Triptych simply as a means of laying out previously established pairings would be to underestimate its formative role, not only in clarifying relationships but also in generating meaning. Far from an underlying element, the geometry manifests itself on the surface and controls the way in which the parts are read. The interlocking forms, which, like insular interlace, pass above and below one another in regular alternation, rearrange episodes of linear narrative into repetitive patterns that lend themselves to being read in typological terms.[9] In the instances of departures from more common iconographic pairings, the geometry, far from the final element, may even have suggested deviations from traditional schemes as well as the ways certain subjects were placed and depicted.

Moreover, the overall gestalt of the triptych proves constitutive of its meaning. Although differentiated by color, the circles and squares spread across its surface, linked like the parts of a chain, knit the disparate scenes from salvation history into a single matrix. By definition, the (highly selective) narrative is forward looking. Typology, however, also requires a form of looking back, a teleological retrospective in which everything makes sense from the eschatological endpoint. In this context, it hardly seems by accident that all the protagonists in the scenes to the sides turn their back on Christ at the center. Like Leviathan, they cannot see the truth the Crucifixion represents. That truth is left to the viewer to see for himself, aided by the way in which typology shapes (or distorts) the representation of history. For example, the fish that disgorges Jonah is set at much the same angle as the lid of the tomb in the scene of the Three Marys; the doors carried by Samson (only accidentally arranged in a cross pattern?) echo, even though they chronologically precede, the two halves of the doors of Hell broken down by Christ. Rather than merely allowing for duplication, however, this repetition creates an accretion of meaning. When open, the two wings of the triptych, were they joined together, would match the geometry of the center; when closed, however, the object would have looked like nothing so much as the form traditionally given to the tablets received by Moses on Mt. Sinai, the literal embodiment of the Old Law.[10] Only when opened is the Old Law broken, revealing the truth of the Christian dispensation at the center. The structure of the triptych and the imagery that it frames invites a process of putting together, the recognition of a pattern that, in a manner analogous to the Law itself, imposes itself on the accidental.

In effect, Berthold's complementary treatises, the first, on the Cross, finished in 1292, the second, on the Virgin Mary, completed in 1294, when added to Hrabanus Maurus's series of *carmina figurata*, produce a threefold work that in structure, method, and program echoes the Alton Towers Triptych. Both of Berthold's works balance and integrate narrative and geometrical elements combining abstract and figural imagery

in a diagrammatic "demonstration" of the truth of Christian doctrine. Each of the numerous subsections of Berthold's treatises finds its match in an image, the vast majority of which take the form of seemingly simple diagrams composed of a limited repertory of geometric motifs connected by lines (see figs. 1–2). Whereas Berthold's first commentary, like the central portion of the Alton Towers Triptych, elaborates the cosmic significance of the Cross, his second, like the triptych's wings, adduces types in service of salvation history in a manner comparable to that of other typological treatises of the thirteenth century such as the *Biblia pauperum*.

The three central chapters of this book (chaps. 2–4) echo the structure of Berthold's work by providing a triptych of their own. Whereas chapter 2 focuses on Berthold's source, Hrabanus's series of picture poems dedicated to the Cross, which have their own strong diagrammatic component rooted in cosmology, chapters 3 and 4 turn, respectively, to Berthold's commentaries dedicated to the Cross and the Virgin Mary. In addition to general discussions of Berthold's exegetical and diagrammatic technique, including his elaborate use of color symbolism, chapters 3 and 4 mimic Berthold's expository structure by discussing each of his diagrams separately, providing, in effect, my own commentary on Berthold's commentary.

Like any triptych, however, mine also requires a frame, which takes the form of two additional chapters, one at the beginning, the other at the end of this book. Of these, the first establishes a historical and methodological framework for the ensuing analysis of Berthold's diagrammatic method by considering his diagrams against the forward-looking foil of diagrams and the discourse about diagrams in our own day and age. Throughout this first chapter, which is designed to lay the groundwork for what follows, the emphasis is as much, if not more, on modern rather than on medieval diagrammatic paradigms, not to underestimate differences but rather to provide both analytical and historiographical frameworks within which to approach the medieval examples, specifically those of Berthold. Whereas in the past diagrams were often seen

as of being little interest, extraneous even to the texts they illustrated, to the point that they were often omitted from editions, today they are recognized as marking a critical and highly creative chapter in the development of techniques of visualization across diverse disciplines.[11] Critical to laying out complex content, then as now, they imposed order on structures of knowledge right across the curriculum. More than convenient vehicles of memory or even means of generating knowledge in the first place, however, diagrams, I argue, whether medieval or modern, express the deeply held desires of those who make them. These desires are often paradoxical in nature, addressing urges as basic as a craving to see order in a world whose appearances seem to escape it.

One of the most important arenas for the application of diagrams was logic. The relationship between logic and typology, in particular as developed by Berthold, stands at the heart of my fifth chapter. The current literature on medieval diagrams does not exclude logic from its purview, but it also hardly grants it the importance it deserves.[12] Logic diagrams linked disparate realms of inquiry and played a generative role for various forms of diagrammatic imagery, including in the religious realm. These tools of thought, rather than being simply one further application of a generalized set of working procedures, provided Berthold and some of his contemporaries with something of a master method when it came to construing the world and history in diagrammatic terms. Diagrams such as the square of opposition formed part of every student's mental tool kit; they constituted a way of both framing and generating knowledge—and, as I hope to demonstrate, of images, including Berthold's.

Some readers may perceive a potential contradiction in my bringing together logic and theology. Whereas one deals in rational propositions, the other deals with matters that lie beyond proof. Yet as any reader of the medieval theologian Nicholas of Cusa (1401–64) will know, the cardinal saw no such contradiction. In fact, within his theory of *docta ignorantia*, learned ignorance, diagrams provided a point of conjunction between the two realms.[13] In modern discussions of diagrams, that conjunction has proved more

elusive. The writings of Charles Sanders Peirce as well as their illustrations, some of which are discussed in this book, testify to the two sides of this coin. Diagrams, although but one of many signifying forms in his triadic system of signs, were of particular importance to Peirce in that they enabled what he called "diagrammatic reasoning."[14] The margins of Peirce's manuscripts, however, contain doodlelike drawings that, if anything, manifest unreason: their often manic, compulsive forms, reminiscent of medieval marginalia, seem to speak to Peirce's fear that his entire system might unravel.[15] From Peirce to Eco, diagrams have fascinated semioticians, whose understanding of the making of meaning is no less relational and hence diagrammatic than that of medieval theologians like Berthold. Yet diagrams also form the focus of intensive research in scientifically oriented fields in which issues of cultural construction are for the most part considered incidental or even irrelevant. Among these are information visualization and computer graphics, artificial intelligence, cognitive psychology, and physics; witness the use of Feynman diagrams, not simply to represent processes within quantum electrodynamics (QED) but indeed as tools for analyzing those processes in precise mathematical terms. Whether in regard to game theory, algorithms, networks, cloud computing, or computer graphics, diagrams now constitute an essential component of all aspects of computer science, and hence of almost all aspects of human existence.[16]

Many of these areas are beyond my ken, not that I have eschewed efforts to acquire some rudimentary understanding of their complexities. This much is clear: to gauge the full measure of the depth of interest in diagrams, one must step outside the confines of cultural history. The study of diagrams itself maps out relationships between widely disparate areas of inquiry that usually remain tangential to one another. In effect, one has to imagine a Venn diagram mapping the areas of intersection among cultural history, philosophy (especially logic), mathematics, and both computer and cognitive science. In this book a number of research fields—the history of art, the history of science and cosmology, the his-

tory of logic and philosophy, and, not least, the history of theology and monastic meditation, as well as what now, at least in Germany, is called *Diagrammatik* (itself an interdisciplinary area of research)—all come together to various degrees.[17]

In the Middle Ages, as today, diagrams mapped the intersection between the technical and the cultural. To begin with the present: we live in an age in which the internet and the World Wide Web have displaced traditional centers and hierarchies in favor of rhizomatic, distributed networks—systems best understood in terms of diagrams. In an age of social networks, human actors have themselves in a sense become diagrams, defined less in terms of a stable, autonomous self (if anything such thing ever existed) than of a system of relationships tied, but unanchored, to a shifting constellation of myriad nodes. It is no less the case that the algorithm, which, even if not a diagram in itself, is best understood in diagrammatic terms, has become, in a manner of speaking, the Platonic form of everyday existence, both underlying and informing the "reality" of contemporary life, although it must be admitted that as a rule for endless computation, the algorithm, while lending form, also could be construed as dissolving it. As more and more forms of social interaction become networked, and as all human activity comes to be defined in terms of links within a larger web, our world and our selves increasingly come to resemble the mechanics of a diagram. The converse question might also be raised: to what extent can medieval diagrams be thought of as algorithms, not merely representations of knowledge, but means of processing a particular class of problems? Logic diagrams fit such a definition particularly well, but other diagrams might be thought of in the same or similar terms.

Diagrams, if not as pervasive in the Middle Ages as they are today, were central to the making of medieval art. The complex armatures of stained-glass windows provide only the most obvious example; Gothic cathedral facades are another. Medieval authors and artists seized upon traditions of scientific illustration rooted in antiquity to create complex representations of Christian cosmology.[18] Medieval art is not sim-

ply symbolic, abstract, and antinaturalistic, it is structured and systematic in its approach to representing a world that its makers perceived as being highly structured in itself. History, far from being open ended, had a structure, one that could be investigated and manifested in the language of geometry. There was, however, no single medieval *Weltanschauung*; multiple theologies and cosmologies competed to claim the mantle of the just interpretation.

It is within this contested field, modern as well as medieval, that the subject of diagrams and the diagrammatic in medieval art becomes particularly compelling and within which this book seeks to set Berthold of Nuremberg's unsually ambitious set of diagrammatic images.

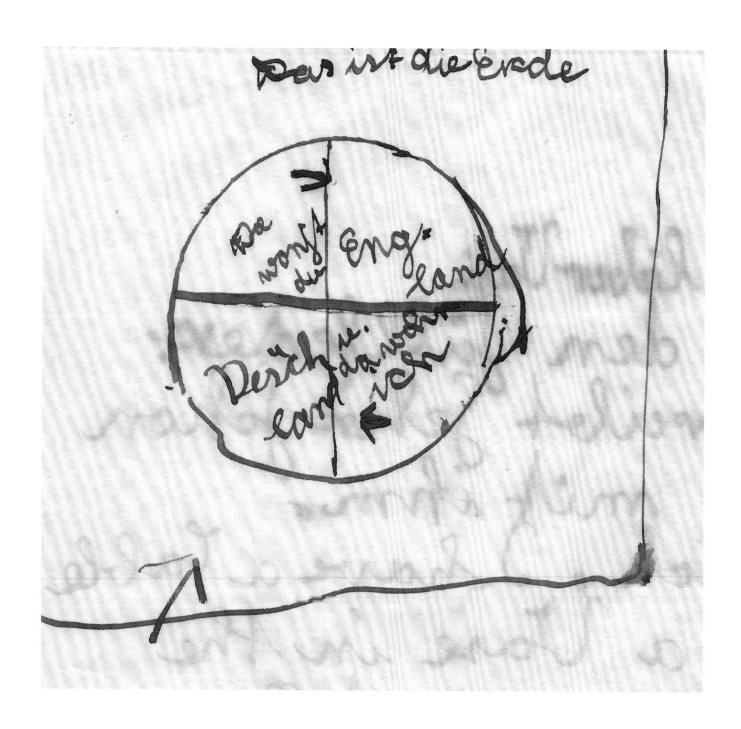

4. Lotte E. Hamburger, letter (recto), Leipzig, 1934 (detail). Photo: Jeffrey F. Hamburger.

1

The Diagram as Paradigm
in Medieval Art—and Beyond

Diagrams and Desire

I begin with a diagram (fig. 4). A caption at the top, written in a child's
hand, identifies the circle as the earth ("Das ist die Erde"). The four quad-
rants are arranged in a chiastic fashion, along the opposing diagonals. The
diagonal running from lower left to upper right marks the distance be-
tween Germany (Deutschland) and England. The opposing diagonal con-
tains vectors, in the form of arrows. In addition to attaching text to image,
these pointers set the orb spinning. The arrow at the lower right, which
points to Germany, lends motion and meaning to the deitic declaration, "Da
wohne ich" (I live there); that at the upper left, which points to England, to
the equally emphatic statement "Da wohnst du" (You live there).

In its elementary abstraction, this simple drawing resembles a medieval
T-O map, in which the simplest of geometrical schemata exemplifies the
basic structure of God's creation.[1] A typical map of this kind is far from
being Eurocentric in orientation. The upper semicircle represents Asia, the
lower two quadrants Europe and Africa. The continents converge on the
world's true center, the Holy Land, with Jerusalem sometimes, although
not always, at the middle point (fig. 5). Such maps indicate that medieval
cartography was diagrammatic to its core.[2] To what extent, however, are
diagrams cartographic in the sense of modeling reality in spatial terms?[3]
No less than a medieval map, a medieval diagram embodies a *Weltan-
schauung*, a worldview, if not as literally, then in its structuring of a reality
thought to govern the world and humankind's place within it.

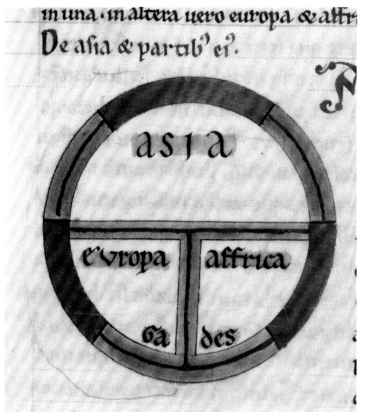

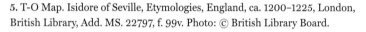

5. T-O Map. Isidore of Seville, *Etymologies*, England, ca. 1200–1225, London, British Library, Add. MS. 22797, f. 99v. Photo: © British Library Board.

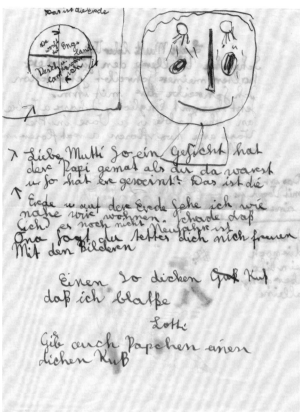

6. Lotte E. Hamburger, letter (recto), Leipzig, 1934 (detail). Photo: Jeffrey F. Hamburger.

The letter from which this child's diagram is taken explains the circumstances of its making (fig. 6). It begins, in translation, with several deitic gestures: "Dear Mummy, Papa made a face like this when you were here and cried like this," then continues, "This is the earth, and on the earth I see how close we are living." All these points are underscored by indexical arrows. A trio of additional pointers draw the reader's attention from the text to the diagram in the upper left-hand corner, lending added force to its plaintive affirmation of proximity, as if its declaration of inconsequential distance could in fact effect a reunion. Adjacent to the diagram stands a crudely drawn face, if not quite round, then in most respects no less schematic than the cartographic schema to which it is juxtaposed. The tears to which the letter refers stream not from the large black eyes but rather from a second pair above them, perhaps doubling as eyebrows. As if one pair of eyes could not weep enough, their duplication adds weight to the letter's words. Be-

low the face, a trapezoid representing both neck and torso extends to embrace the word *Gesicht* (face). The overlap assures the linking of text and image, as does the long loop representing a tie, which knots the two types of graphic traces together. The other side of the letter includes a simple exercise in English, conducted, it seems, in anticipation of the longed-for reunion.

The letter in question was written by my mother in 1934, when she was ten. She had been left behind in Leipzig by her parents, who had already fled Nazi Germany for London, where they were seeking to establish themselves before bringing over the rest of the family. The arrows that punctuate the letter lend it a hoped-for instrumentality. The paintings of Paul Klee, whose notebooks are crammed with diagrams, deliberately (and deceptively) ape the naiveté of children's drawings and incorporate arrows and pointers to similar ends, transforming his playful yet haunting images into diagrams of desire.[4] Like a medieval diagram of the micro- and the

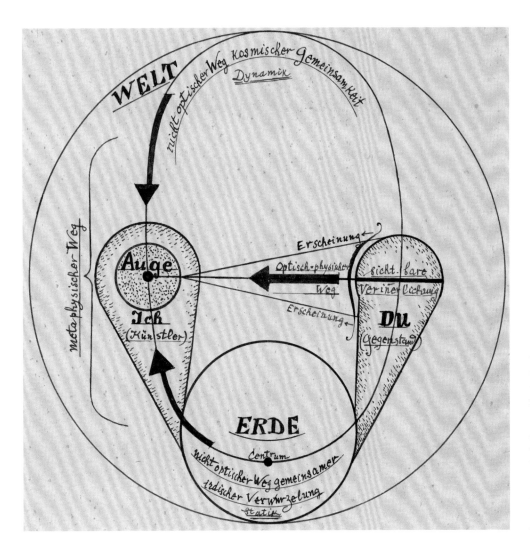

<figure>
WELT

nicht optischer Weg kosmischer Gemeinsamkeit
Dynamik

metaphysischer Weg

Auge

Ich
(Künstler)

Erscheinung

Optisch-physischer
Weg

Erscheinung

sicht. bare
Verinerlichung

Du
(Gegenstand)

ERDE

Centrum

nicht optischer Weg gemeinsamer
irdischer Verwurzelung

Statik
</figure>

7. Paul Klee, Bildnerische
Gestaltungslehre: Anhang
(Illustration zu "Wege des
Naturstudiums") / Theory of
Pictorial Configuration:
Appendix (Illustration
to "Paths in the Study of
Nature"), pen on paper on
cardboard, 33 × 21 cm.
Zentrum Paul Klee, Bern,
Inv.Nr. BG A/030. Photo:
Zentrum Paul Klee.

macrocosm, Klee's schematic drawing *Ich Du Erde Welt* (I You Earth World) also mixes iconic and indexical elements to diagram the relationship between the self and the world, in this case his eye and his I (fig. 7).[5] The horizontal arrow at the center pointing from the tear-drop shaped "Du" on the right (labeled "Sichtbare Verinerlichung [Gegenstand]," You: visible interiorization/object) to the reciprocal "Ich" on the left (labeled "Auge/Ich [Künstler]," Eye/I [artist]) traces the path of optical appearances ("Optisch-physischer Weg/Erscheinung," Optical-physical path/appearance). The orb of the earth, placed, as in a medieval diagram of the Four Elements, at the bottom, marks one half of an elliptical pathway that converges from above and below on the eyeball at the left, the focal point of all the arrows. The lower half of the path represents the "nicht optischer Weg gemeinsamer ird-

ischer Verwurzelung/Statik," "Earth: nonoptical path of terrestrial (or material) rootedness/stasis." In contrast, that at the top, which traverses the upper region of the all-embracing circle, labeled "Welt", represents the "nicht optischer Weg kosmischer Gemeinsamkeit/Dynamik" (World: nonoptical path of cosmic communality/dynamism).

Klee's drawing encapsulates the argument presented in his essay "Wege des Naturstudiums" (1923; Paths for the study of nature). By the standards of common parlance, Klee's poetic diagram could not be further from a naturalistic representation of the world. Rather than reflecting reality, however, Klee's poetic diagrams participate in his credo of "making visible."[6] In his essay Klee describes the diagram in the following terms: "On the lower path, which gravitates toward the center of the earth, lie the problems

of static balance, which can be defined with the words 'Stand despite all the possibilities of falling.' The upper path leads desire to break away from earthly attachment through swimming and flying to free impetus, to free movement."[7] Klee explicitly identifies his diagram, which provides a pattern for his paintings, as a means of charting desire.

The arrows in my mother's less ambitious cosmic diagram are no less indexical; not only do they convey information or express an affective state—in this case a severe case of separation anxiety—they also represent an attempt to impose order on the world, in this case a world in which order was quickly slipping away and in which nothing would soon make sense. More an expression of distraught desire than crude cartography, the diagram, despite its simplicity, raises fundamental questions. In the words of Nelson Goodman: "What role do symbols play in the making? And how is worldmaking related to knowing?" To paraphrase Goodman's response to his rhetorical questions, diagrams do not map the world, they make a world.[8] Medieval authors would not have accepted Goodman's account of multiple actual worlds (although in the context of discussions of divine omnipotence, possible worlds represented a different matter).[9] His questions would nonetheless have made sense to them. This book argues that, no less than my mother's diagram, those made in the Middle Ages should be viewed not simply as tools for thinking or representations of knowledge but also as vehicles of deeply held desires.[10] They make and model worlds rather than simply representing them. Diagrams do not simply convey information; they disclose the intentions and passions that moved their makers.

Defining Diagrams

Diagrams and desire might seem far removed from one another. No less a logician than Charles Sanders Peirce, however, saw fit to connect them, and in more than a casual fashion. As part of his definition of logic, Peirce in his essay "Logic as Semiotic," written circa 1897, spoke of the habit of "abstractive observation" that forms the foundation of learning from experience. Peirce defines the process in terms of desire:[11]

> The faculty which I call abstractive observation is one which ordinary people perfectly recognize, but for which the theories of philosophers sometimes hardly leave room. It is a familiar experience to every human being to wish for something quite beyond his present means, and to follow that wish by the question, "Should I wish for that thing just the same, if I had ample means to gratify it?" To answer that question, he searches his heart, and in doing so makes what I term an abstractive observation. He makes in his imagination a sort of skeleton diagram, or outline sketch, of himself, considers what modifications the hypothetical state of things would require to be made in that picture, and then examines it, that is, *observes* what he has imagined, to see whether the same ardent desire is there to be discerned. By such a process, which is at bottom very much like mathematical reasoning, we can reach conclusions as to what *would* be true of signs in all cases, so long as the intelligence using them was scientific.

On Peirce's account, which remains indebted to Kant's notion of the *schema* (form, shape, figure) of imagination—namely, the rule or procedure by which a pure, nonempirical concept or category is associated with a sense impression—the process of perception itself involves a form of diagrammatic projection. In this model, diagrams are not simply something seen but are also an inherent part of constituitive cognitive patterns that viewers and thinkers bring to their experience of the world. While cast in very different terms, this active back-and-forth between viewer and the world is of a kind that medieval observers, familiar with theories of intro- and extromission, would readily have recognized.

In coming to terms with diagrams, whether medieval and modern, it might seem easiest to begin with a definition. After all, readers of this book no doubt have an intuitive sense of what

is meant by a diagram. Diagrams, which especially in the German philosophical tradition are thought of as appealing to intuition (*Anschauung*), constitute a staple of our textbooks.[12] A tradition going all the way back to Plato associates diagrams with transcendental truth (although in ways that Greek mathematicians would not necessarily have recognized as true to their intentions and technique).[13] Diagrams, however, at least as materially produced and transmitted, are very much a product of their time and place. Despite their association with laws, logic, and truth, diagrams have contingent dimensions.[14]

A diagram, some might say, is a two-dimensional schematic representation, usually linear or geometric, of relationships between, in the case of a technical drawing designed to show how something works, various parts or objects or, in the case of an aid to thought, interrelated concepts.[15] If only it were that simple. Even this rudimentary definition is riddled with equivocation and makes all kinds of assumptions, for starters, with what one might call the representational regime of the diagram. Does a diagram in some way reflect or embody reality, or does it possess its own reality, whether ideational or material? Are diagrams Platonic or pragmatic? Moreover, if one is to speak of the diagrammatic as well as the diagram per se, why need one limit oneself to two dimensions? In a day and age of virtual reality, diagrams readily assume three-dimensional form (also in logic, in which tautologies have given way to topologies).[16] With the rise of computer-generated design, which encourages less the representation of preexisting forms than the playful generation of novel, perception-bending spaces, architectural historians and even some architects refer to their solid structures as diagrammatic, not simply in character but also in conception.[17]

Modern design practice serves as a reminder that a diagram, whether made of lines, squares, triangles, circles, or other shapes, is more than the contours inscribing its perimeters; it is also always spatial and relational in character. Some diagrams, such as the Feynman, Penrose, and Minkowski diagrams employed by physicists to graph space-time and the interactions among particles, explicitly integrate the component of time. As in the *Compendium historiae in genealogia Christi* of Peter of Poitiers (ca. 1130–ca. 1215) and historical works such as the *Fasciculus temporum* of Werner Rolevinck (1425–1502), the shift from the third into the fourth dimension can unfold or unfurl on paper or parchment, not to mention on a computer screen.[18] Diagrams chart, they map, they interrelate, but they also unfold, sometimes literally.[19] Diagrams deal with process, both in the world and, no less importantly, in the mind: they plot rationality in spatial terms and map out cognitive as well as mechanical practices and procedures.[20]

Cognitive psychologists ask: "Are spatial schemas a metaphor for cognitive process, or a mechanism for cognitive processes?"[21] Medieval diagrams suggest that the answer is both. A single diagram found in a fourteenth-century compendium from the diocese of Constance consisting of Petrus Comestor's *Historia scholastica*, Alexander de Villa Dei's *Summarium biblicum metricum cum commentario*, and Peter of Poitier's *Compendium historiae in genealogia Christi*, all three of which stand in lieu of the text of the Bible proper, can serve as a demonstration (fig. 8).[22] The diagram, perhaps more aptly described as a figure, to use one of the most common medieval terms for a diagram, takes the form of a seven-armed candelabrum and in this particular copy can be considered either the last part of Peter of Poitier's work, with which it often circulated, or the first in a series of nine diagrams at the end of the manuscript, the remainder of which belong to the set known as the *Speculum theologiae*.[23] Its placement alone permits it to serve a mediating role between the historical works that constitute the bulk of the book and the moralizing diagrams at the end, whose emphasis is tropological rather than typological. Whereas in an early thirteenth-century English example (one of the earliest surviving copies) the candelabrum, accompanied by a Tree of Consanguity, stands at the very beginning of Peter's time line of scriptural history, in the fourteenth-century version (in which, moreover,

the work has been adapted from roll to codex), the candelabrum instead comes at the end of Peter's work, thereby endowing the image with an eschatological as well as prophetic aura (fig. 9).[24] Embedded within the text that ostensibly explains it, the diagram represents the Church by means of a seven-branched menorah from the temple. Transplanted to a Christian context, the seven-armed candelabrum, similar to monumental bronze examples found in churches throughout the empire, such as that in the collegiate church of St. Blaise in Braunschweig (now the cathedral), indicates, as does the genealogy that precedes it, that Judaism (*Synagoga*) has been superseded by Christianity (*Ecclesia;* see fig. 10).[25] The candelabrum represents part of the symbolic as well as literal booty of the Church Triumphant. The upright central arm represents Christ; the three on one side (the left) represent the three orders or grades of the faithful during the period before, the three on the other side (the right) after, the incarnation. The text in turn defines these three orders within the Church in terms of the prophecy in Ezekiel 14:13–14: "Son of man, when a land shall sin against me, so as to transgress grievously, I will stretch forth my hand upon it. [. . .] And if these three men, Noe, Daniel, and Job, shall be in it: they shall deliver their own souls by their justice, saith the Lord of hosts." Here Noah represents the prelates, Daniel represents the continent or virgins, and Job those who are married. Prelates, the reader is informed, pursue a life of contemplative rest, whereas the continent toil in the fields—that is, pursue preaching—and the married toil at the grindstone. All await the Day of Judgment, when they will discover who will be saved and who shall be condemned. Above each of the seven arms, an upturned chalicelike cup (*infusorium*) pours out oil into one of the bowls (*ciphus*) held aloft by the arms. The arms, in turn, consist of pieces that are linked together by small spheres or globes (*sperule*) from which spring decorative lilies (*lilia*), terms which are repeated obsessively across the surface of the page, as if to match the number of parts in real examples (the candelabrum in Braunschweig, for example, has seventy-four). The redundant denomination

of the depicted object's parts provides a plethora of places (*loci*), not unlike the segments of the Guidonian hand, which the reader remains free to populate of his own accord.[26]

How does such a diagram work? The text that accompanies the diagram by no means provides an adequate explanation. In fact, it barely makes any reference to it at all.[27] Some terms are allegorized. The majority, however, in particular the components of the candelabrum, are not, in contrast to what one finds in an authentic work by Peter, the *Allegoriae super Tabernaculum Moysi.*[28] It is left to the viewer to make sense of the figure. More than a line diagram but less than a free-standing image, the image hovers between two modes of representation. The object-diagram figures both time (sacred history) and space (heaven and hell, as well as the ranks within the ecclesiastical hierarchy). Like the diagram, all of history and all people are divided in two by the coming of Christ. The image's meaning, moreover, is conditioned by its context. The preceding schematic rendering of salvation history in Peter's chronology identifies the diagram as an image that connects past and future, even as it distinguishes between the blessed and the damned and, by implication, Christians and Jews. The subsequent image, a Tree of Life based on Bonaventure's *Lignum vitae,* provides a visionary vehicle for spiritual ascent by way of the imitation of Christ, in the words of the inscription at the bottom, a paraphrase of the book of Revelation 22:2: "I saw the tree of life, bearing twelve fruits, yielding its fruits every month, and the leaves of the tree were for the healing of the nations" (fig. 11).[29] Just as the viewer of the candelabrum is instructed that the gifts which Christ confers on mankind surpass human understanding, so too the viewer of the tree is invited to ascend with Christ and aspire to those heights. Both diagrams serve a mnemonic function, permitting the reader, like the artist. to hang various concepts on the branches of both candelabrum and tree. The metaphors, however, merge, a complementarity encouraged and enhanced by the fact that the two images face one another across an opening. Simply by virtue of the two images' juxtaposition and not

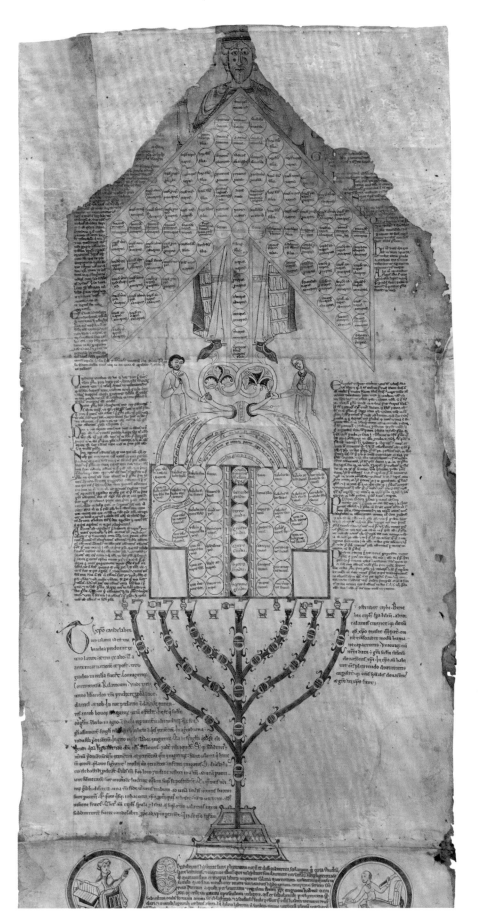

8. Peter of Poitiers, Compendium historiae genealogia Christi, northern France, ca. 1200. Cambridge, MA, Houghton Library, Harvard University, MS Typ 216, membrane 1. Photo: Harvard University Library.

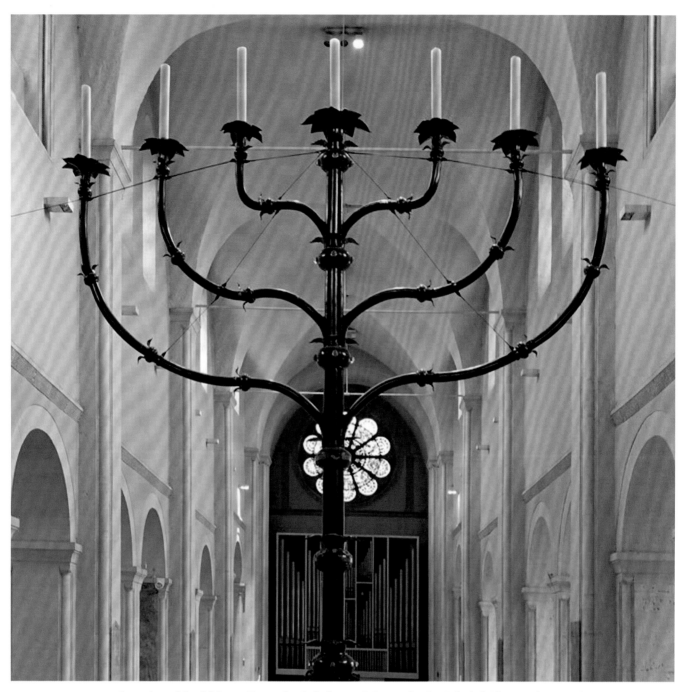

9. Seven-Armed Candelabrum, Braunschweig, before 1196. Braunschweig, Cathedral. Photo: Helmut Kuzina.

on account of any such claim in the text, the candelabrum becomes a type of Christ on the cross; the branches of the menorah and the tree become intertwined, generating new associations. Metaphor becomes a mechanism, whose parts the viewer is expected to manipulate; the images both represent a Christian conception of truth and provide the viewer with vehicles for striving toward it.[30]

Diagrams as Demonstrations

The use of diagrams as demonstrations of truth, whether mathematical or philosophical, or as vehicles with which to attain it, is as old as Plato, Euclid, and Archimedes.[31] As William Blake observed (in the course of disparaging reason as opposed to the imagination), "The Gods of Greece & Egypt were Mathematical Dia-

grams."[32] Each of the forty-two diagrams developed by Lothar of Segni (1160/61–1216), later Pope Innocent III, to accompany his treatise on the mass, is paired with an explanation beginning "Haec figura demonstrat" (This figure demonstrates; see figs. 64 and 70)[33] The repeated rubric was hardly necessary; the diagram itself served to make the point. Throughout the Middle Ages, diagrams made particular types of claims on their viewers and demanded specific forms of cognitive response. Philosophical tracts regularly contained diagrams, whether to represent their contents or to provide the reader with tools for conceptualizing problems.[34] The diagrammatic tradition's roots in science, in particular astronomy and cosmology, make it natural to associate medieval diagrams with reason rather than with feeling.[35] Their abstraction, in turn, makes it easier to perceive them as instruments of the intellect rather than as vehicles for experience. For medieval readers, however, particularly in the context of religious subject matter, the two realms were not that distinct.

Of course the truth claims of diagrams do not need to be accepted at face value. One of the principal claims of this book is that diagrams, in particular religious, devotional, and theological diagrams, which deal with such topics as life and death, prophecy and salvation, and even the underlying order of creation in the form of cosmology, necessarily grapple with powerful emotions that, no matter how hard they try to impose it, escape the establishment of order. Not without reason, postmodern philosophers have subjected diagrams to scathing suspicion, if for different reasons than did mathematicians such as Frege, Pasch, and Hilbert in the late nineteenth century.[36] Writing on figures such as Gilles Deleuze, François Laruelle, and Alain Badiou (a Neoplatonist who elevates set theory to the role of geometry in Plato's corpus), John Mullarkey has declared, "There is no Truth in diagrams, nothing sacred in geometry. . . . The flexuous line is not an intimation of the divine . . . ; its immanence, its materiality, keeps it at some distance from the infinite lines, pure circles and perfect triangles of Nicholas of Cusa. . . . Such

infinities, purities and perfections smack of the virtual, the transcendental, 'the vision of God.' "[37] This iconoclastic critique of the diagram, which casts it not as a tool of reason but rather as a rhetorical device, opens its seemingly cogent demonstrations of irrefutable logic to accusations, if not necessarily of mystical irrationality, then at least of fiction, which in turn, it could be argued, makes them instruments of ideological persuasion.[38]

Art historians now regularly speak of the "power of images."[39] Within anthropological perspectives, less often is it asked to what end such power, whatever form it might take, is being put. To do so would require reinserting the anthropological, with its claims of transcultural validity, into history, and with it both culture and politics. Against the backdrop represented by the tension between these different approaches, one can ask: what is the power, if any, of the diagram? The power that derives from persuasion is very different from a demonstration of irrefutable truth. To what extent do diagrams lend one the appearance of the other? Part of diagrams' persuasive power lies in their uncanny ability both to mimic and to structure the process of ratiocination itself. To these functions the diagrammatic methods underlying some forms of artificial intelligence bear witness.[40] Charles Sanders Peirce invented a complicated diagrammatic language, called by him "Existential Graphs," with which he thought he could address any philosophical problem, in particular those in logic.[41] In Peirce's definition, the term *existential* referred to existential statements (represented by the rotated E (\exists) of the kind that could not be represented in the system coined by the English logician John Venn.[42] In a celebrated passage written in 1913, shortly before his death the following year, and included in a variant draft of his essay known under its editorial title as "An Essay toward Improving Our Reasoning in Security and in Uberty," Peirce declared that "reasoning is dependent on Graphical Signs."[43] Peirce, who said of Aristotle, "Have read and thought more about Aristotle than about any other man," echoes the philosopher's treatise on memory, in which Aristotle observes that "it is not possible to think

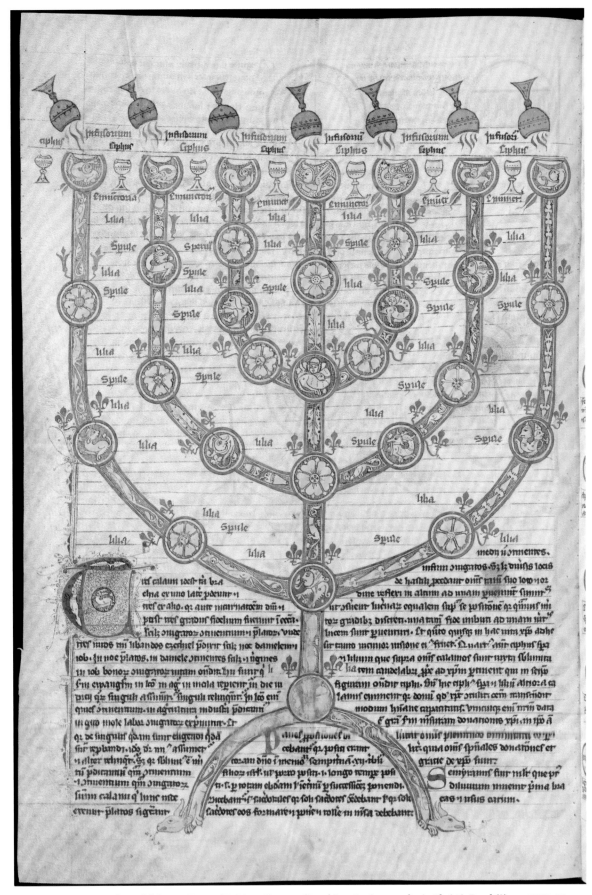

10. Seven-Armed Candelabrum. Peter of Poitiers, Compendium historiae in genealogia Christi, Basel (?), ca. 1325–50. Aarau, Aargauer Kantonsbibliothek /MsWettF 9, f. 244v. Photo: www.e-codices.unifr.ch.

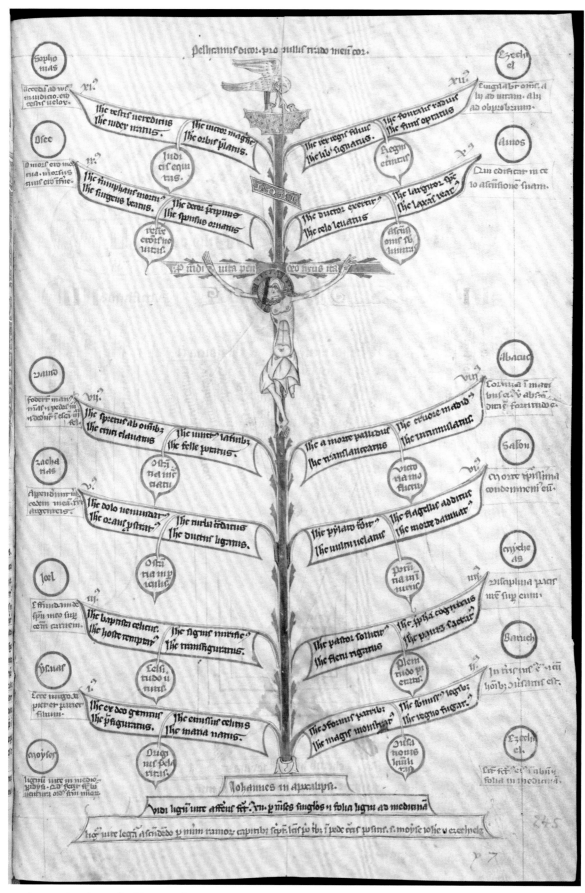

11. Lignum Vitae (Tree of Life). Peter of Poitiers, Compendium historiae in genealogia Christi, Basel (?), ca. 1325–50. Aarau, Aargauer Kantonsbibliothek /MsWettF 9, f. 245r. Photo: www.e-codices.unifr.ch.

without an image" (*De memoria et reminiscentia* 449b31–450a1)."[44]

Neither Peirce nor Aristotle, however, refers to representational images, whether actual or mental. In fact, Peirce insists that neither on paper nor in his dreams do his diagrams engage with the imagination:[45]

> There is nothing fanciful about my diagrams. I do not, for example, see numbers with colors attached to them and placed upon some curve, and it perfectly astounds me to find how useful some persons are able to make such strange constructions. When I am in health I am not aware of having any dreams, unless perhaps of a problem in algebra where no real significations are attached to the letters, or something equally abstract. My "Existential Graphs" have a remarkable likeness to my thoughts about any topic of philosophy.

Although he was dismissive of dreams, Peirce's insistence on not simply the utility but also the necessity of diagrams stands in sharp contrast to the method of his approximate contemporary, the philosopher, logician, and mathematician Gottlob Frege (1848–1925), whose *Begriffsschrift, eine der arithmetischen nachgebildete Formelsprache des reinen Denkens* (Concept-script: A formal language for pure thought modeled on that of arithmetic) represented a revolution in logic but also had the effect of banishing pictures, even diagrams.[46]

The stakes here are high. Moreover, they can be framed in terms that, admittedly in a radically different context, a medieval theologian would have understood—namely, what purchase does the imaginative faculty, which operates with images, have on truth?[47] This was a debate that exercised medieval authors, in particular authors of mythographic texts whose *integumentum* or *involucrum*, to use their terms, veiled the naked truth that hid behind its fictions.[48] Just as medieval thinkers disagreed when it came to this issue, with iconoclasts representing the radical skeptics, modern philosophers and students of psychology have swung from one pole to another.[49]

In the words of James Franklin: "We live at the end of a period which, perhaps more than any other, has hidden the pictorial life of the mind from intellectual view. Philosophy in the mid-century regarded 'sense data' as fictions, arrived at by (bad) inference and suitable for disposal as an undergraduate exercise. It was seriously maintained that all inner representation was propositional."[50]

Peirce's view could not have been more different. In his essay on improving reasoning, Peirce explains:

> By "graphical" I mean capable of being written or drawn, so as to be spatially arranged. It is true that one can argue viva voce; but I do not believe one can go very deeply into any important and considerably large subject of discussion without calling up in the minds of one's hearers mental images of objects arranged in ways in which time, without space, is incapable of serving as the field of representation, since in time of two quite distinct objects one must be antecedent and the other subsequent.[51]

In insisting on the spatial dimension of thought, Peirce again echoes Aristotle, who, like the American pragmatist, speaks not of mental pictures but rather of diagrams. Having affirmed that "it is not possible to think without an image," Aristotle (*De memoria et reminiscentia* 449b31–450a1) observes: "For the same effect occurs in thinking as in drawing a diagram."[52] In comparing cogitation to the process of drawing, Aristotle goes beyond asserting that a diagram represents the content of thought. Rather, it is the procedure of producing the diagram which resembles and even enables the process of thought. Both, in his view, involve a step-by-step method of defining and drawing relationships that point toward particular conclusions. If drawing a diagram and the process of thinking represent two sides of the same equation, then it is not simply a matter of thought generating diagrams but also of diagrams generating thought.[53] Rather than a representation, the diagram structures the patterns according to which one thinks.[54] The dia-

gram is more than a mere representation; it is active or operative.[55] This understanding of the diagram, not as an illustration but as a tool for thinking and, in religious contexts, a vehicle for carrying the soul to God, was to assume major importance in the Middle Ages.

When thinking about medieval diagrams, Peirce provides a useful point of entry, and not only because he assigns them such importance in his semiotic system. Peirce employed diagrams not simply to map out a precogitated philosophy of signs but to generate it in the first place. Peirce famously discusses the diagram in the context of his complex differentiation of signs into three overarching categories: icons, indices, and symbols. An icon or likeness is predicated on shared qualities; an index, in turn, on some form of contact or factual correspondence; a symbol on convention or shared qualities that are merely imputed to the symbol and its referent.[56] In discussing specific instantiations of icons, Peirce defines the diagram in scholastic terms that betray an obsession with triads worthy of a medieval theologian struggling to understand the Trinity. Just as theologians spoke of "hypostases" to refer to the persons of the Trinity as individuated instantiations of the Godhead, so Peirce (who tellingly converted from unitarianism to trinitarianism) called his three classes of individuated icons "hypoicons":

> Hypoicons may be roughly divided according to the mode of Firstness [that is, the pre-reflexive immediacy] of which they partake. Those which partake of simple qualities, or First Firstnesses, are images; those which represent the relations, mainly dyadic, or so regarded, of the parts of one thing by analogous relations in their own parts, are diagrams; those which represent the representative character of a representamen by representing a parallelism in something else, are metaphors.[57]

Peirce outlines a hierarchy of connectivity. Whereas images involve, in his view, one-to-one relationships predicated on shared qualities (a kind of phenomenology), and metaphors in-

volve a higher-order set of parallel relationships that are mediated without any actual correspondence among their component parts (a kind of metaphysics), a diagram, which in his view belongs to the realm of science, charts forces that, like vectors, require that a given object and its sign possess an analogous structure of internal relationships.

Peirce sought to make his system, which ultimately grew to embrace a sixty-six-fold classification of signs, all-encompassing. Yet as betrayed by the personification of "Epistêmy" sketched on a page in one of his manuscripts, his system was as much a product of compulsive obsession as of distanced speculation (fig. 12).[58] In laying bare the contradictions and cracks, even the breaking points, of his system, Peirce's marginalia ape the function of the often unruly, ribald images teeming in the borders of medieval manuscripts.[59] Whether or not one regards them as revelatory of the philosopher's unconscious concerns about the stability of his system, they are symptomatic of tremendous emotional as well as philosophical struggle. Peirce's diagram of "IT"—part of the triad "I, IT, and THOU," an early attempt (1859–61) to reduce Kant's twelve categories of understanding to a more manageable three—which he drew as he was working on his treatise "The Natural History of Words," provides a compelling example of diagrammatic contingencies (fig. 13).[60] Less a table or an octagon (both words that have been used to describe it), the diagram suggests a whirling St. Catherine's wheel of words and vectors whose centrifugal forms fly out from the center. Rather than charting the "Infinite Qualities of Quantity" indicated to the right, the spinning forms suggest a centrifuge spiraling out of control. In fact, the drawing's vortexlike structure reflects the circular blades of the turbine, a new technology whose construction fascinated Peirce, as it did his contemporary Henry Adams.[61] In "The Virgin and the Dynamo," perhaps the most famous chapter of his autobiography *The Education of Henry Adams*, Adams describes the great machines at the Great Exhibition of 1900 in Paris as "a symbol of infinity." Adams continues: "As he grew accustomed to the great gallery of machines, he began

12. Charles S. Peirce, "Epistêmy." Houghton
Library, Harvard University, Cambridge, MA,
Charles Sanders Peirce Papers, MS Am 1632
(1538). Photo: Houghton Library.

13. Charles S. Peirce, "IT." Houghton Library,
Harvard University, Cambridge, MA, Charles
Sanders Peirce Papers, MS Am 1632 (931).
Photo: Houghton Library.

to feel the forty-foot dynamos as a moral force, much as the early Christians felt the Cross."[62] In its linking of categories of perception to vectors of motion, Peirce's drawing is uncannily reminiscent of Klee's diagram "Ich Du Erde Welt" (see fig. 7); both embody precisely the kind of metaphorical ambiguity that Peirce's so-called existential graphs sought to eliminate.[63]

On the one hand, Peirce's diagrams reveal a determination to discover order in the unruly world of signs. On the other hand, they suggest a deep-seated fear of disorder.[64] This double-faced character, both rational and irrational, finds its match not only in medieval diagrams but also, it is worth noting, in *Mnemosyne*, the unfinished project of Peirce's contemporary Aby Warburg, which both included medieval diagrams and was itself diagrammatic in its open-ended, composite construction.[65] In the Middle Ages, diagrams acted not only as instruments of pedagogy but also as means of recording, if inadequately, prophetic and visionary experience.[66] In other cases, in keeping with their generative as well as their representational capacities, they further provided an matrix for such experiences.[67] Diagrams supplied an armature within which authors and artists could, to use the medieval term, "figure" those things that could not be captured by words and images alone.[68]

To view diagrams as instruments of mystification might seem like a contradiction in terms. Like their modern counterparts, medieval diagrams demonstrate. As soon as one speaks of demonstration, however, a contradiction arises. The purpose of a demonstration is to make something clear. Yet an image requiring deciphering can also be used to veil the truth. Diagrams' potential to clarify often, if not always, comes at the expense of metaphorical misrepresentation. Of this liability, the drawings that accompany Peirce's papers, some of which have overtly sexual overtones, offer tacit acknowledgment. In one particular drawing, part of a manuscript combining caricature and compulsive calculations, forms resembling Peirce's existential graphs morph into involuted, interlocking anatomical appendages (fig. 14): at the left, a woman with feet that balloon into bulbous, breastlike protuberances; at the right, a man with a Pinnochio-like proboscis, an unlikely male member pointed directly at her abdomen. Above them, another male and female pair extrude each other in boxes resembling speech bubbles, except that they emerge not from their mouths but rather from their noses, an emphasis underscored by the man in profile at the right, whose nose serves as a spigot pouring liquid (mucus?) into a raised wineglass. In response to seemingly uncontrol-

14. Charles S. Peirce, Cariacatures. MS Am 1632 (1538). Photo: Houghton.

lable urges, the metaphorical dimensions of the diagram seem to grow under our very eyes.

If Peirce's method and drawings suggest an effort to suppress the irrational at all costs, then medieval religious diagrams embrace their metaphorical dimensions, often deliberately cultivating an oxymoronic combination of the rational and suprarational. Does history or do concepts really unfold like the ramifications of a tree?[69] (See fig. 192.) In such cases the metaphor lends has the virtue of lending the disposition and dependencies of concepts a logic that, were they simply laid out in expository prose, they otherwise would not possess. Nicholas of Cusa made the case that a triangle is analogous to the Trinity.[70] But is it? (See fig. 193.) In his treatise *Contra Faustum*, Augustine had strictly forbidden such comparisons.[71] The paradoxical triangle to which the cardinal referred had three right angles.[72] Even if one could draw such a figure—and that is precisely the point—how, to name another such construction, is God like a circle whose center is nowhere and whose circumference is everywhere?[73] In this double character of the diagram lay a large part of its appeal to medieval theologians and exegetes, among them the English Franciscan John of Howden (fl. 1268/9–75), who deployed the imagery of paradoxical geometry in a hymn in honor of the Virgin Mary so as to express the counterintuitive nature of the incarnation: "The straight line becomes a circle, figure of perfection, when opposites meet in your verdant bosom. You know the art of squaring the circle; you squared the quadrangle of the flesh with the sphere of God, miraculously curing the wounded world with salvation."[74] Metaphor, as Umberto Eco points out in reference to Aristotle's theory of the trope, has the capacity to establish new ontologies.[75] Whether overtly figurative or merely suggestive of figuration, the medieval diagram participated in a dynamic dialectic of revelation and concealment, one in which the viewer was invited to participate.[76] To look at a theological diagram was to be instructed, but also to be initiated.

Not only do diagrams make visible; their abstract, etiolated forms also hint at what re- mains invisible, beyond representation.[77] With this turn, one could object or observe that at a fundamental level a diagram is not a representation at all. One could even go so far as to say that diagrams ultimately have no object or referent in the world: rather than reflect the world as it is, they first identify, then rearrange its parts into coherent configurations that both reflect and enable, shape and structure our patterns of thought. There is therefore a poetic dimension to the diagram. Like a metaphor, if less open ended, a diagram posits a correlation among disparate elements or figures of those elements in order not simply to reveal but rather to create a *tertium comparationis.*

Hrabanus's Reception

It is impossible to press all diagrams or even all medieval diagrams into a single mold. As in the case of other images, there exists no necessary relationship between a diagram and its object. Moreover, diagrams remain part of the culture and historical horizon that produced them. In part for these reasons, this study will be devoted to a single set of diagrams, composed of two parts, written in short succession in the early 1290s by the Dominican friar Berthold of Nuremberg. According to a pair of authorial subscriptions, one at the end of each part, the work was written between circa 1292 and 1294. In its complete form, it survives only in a single manuscript (Forschungsbibliothek Gotha der Universitäts Erfurt, Memb. I 80), most likely the presentation copy. Although Berthold's name suggests an origin in Franconia, the competent if not outstanding execution of the illumination renders its localization difficult.[78] "Of Nuremberg" does not necessarily indicate "in Nuremberg," just as, to name one instance, Honorius Augustodunensis or Honorius of Autun does not mean that this famous twelfth-century theologian worked in the Burgundian town (indeed it most likely was not even his place of origin).[79] The manuscript's manufacture in Nuremberg cannot be ruled out, but the evidence of style suggests rather its production in the Upper

Rhenish region, somewhere between Strasbourg and Zurich.[80] One of the most ambitious diagrammatic works from the entire Middle Ages, it ostensibly serves as no more than a guide and supplement to *In honorem sanctae crucis* (In honor of the Holy Cross), otherwise known as *De laudibus sanctae crucis*, the celebrated collection of *carmina figurata* or figured poems composed shortly before the year 810 by the monk, abbot, and scholar Hrabanus Maurus (ca. 780–856).[81] Taking Hrabanus's magnum opus as their point of departure, Berthold's paired treatises, the first on the cross (*De mysteriis sanctae crucis*, completed in 1292), the second on the Virgin Mary (*De mysteriis et laudibus intemerate virginis genitricis Dei*, completed in 1294), depart from the original to such an extent as to represent an independent work in their own right.[82]

Even in the context of medieval art, which is schematic and very often text-based, both Hrabanus and Berthold represent radical shifts in what we are accustomed to thinking of as an image. Whereas the one shifts image in the direction of text, the other shifts image in the direction of diagram. Despite its difficulty, Hrabanus's commentary on the cross was copied and admired throughout the Middle Ages.[83] Written in the early ninth century, at a time when forms such as the figured and historiated initial, which combined word and image in ways that were to become integral to the formal and expressive repertory of medieval art, remained of recent vintage, Hrabanus's work provided a benchmark of unrivaled complexity for their integration.[84] Its reception thus provides a measure of difference in medieval aesthetics, theology, and piety.[85] Berthold's religious commitments as a Dominican friar and his attitude toward images differed dramatically from those of his Carolingian predecessor. These differences chart an epoch-making shift from cross to crucifix, from a simple, stark, all-embracing sign to a compelling, heart-rending, and ultimately abject depiction of the human body hanging not from a sign but from a green, living cross. The differences between Hrabanus's original and Berthold's reinterpretation chart the origins and development

of figuration in medieval art: a passage from disembodied sign to embodied image that in itself and in keeping with Christian justifications of anthropomorphic representations of the Godhead fulfills and demonstrates the doctrine of the incarnation.[86]

Development introduces the danger of teleology, a progress from abstraction to anthropomorphism. Medieval art, however, relied on mixing multiple systems of representation, the figural and the abstract, the narrative and the hieratic. Similar cross-contamination persists in modern scientific diagrams.[87] Peter Galison's distinction between the homologous ("retaining logical relations within that which is represented") and the homomorphic ("retaining the form of that which is represented") in scientific imaging points to the emergence of a diagrammatic mode in scientific investigation as a means not only of representing results but also of generating them in the first place.[88] The reemergence of the diagrammatic in the modern avant-garde, in which figural modes of representation were largely abandoned in favor of various forms of abstraction, provides further insight into the forces at work in medieval diagrams. For example, in diagnosing the diagrammatic aspects of Dada, David Joselit has spoken of "a historical rupture between the textual codes of the book and the visual codes exemplified by cinema" constituting "the ground against which Dada's spectacular heteroglossia [the combination of two distinct discourses in a single work] emerges."[89] According to Deleuze and Guattari, whose concept of the rhizome is fundamentally diagrammatic (albeit, by definition, in the manner of a distributed nodal network, not a tree), the diagram "does not function to represent even something real but rather constructs a real that is yet to come, a new type of reality."[90] In this definition the diagram acquires a particular form of agency. One might thus ask: is *abstraction* an appropriate term applied to medieval diagrams? To apply the classic formula of E. H. Gombrich, "making comes before matching."[91] Medieval diagrams make and model the world, the only difference being that their ideations refer not to a world to

come (except perhaps in an eschatological context) but rather to its protypical existence in the mind of God.

Given that Hrabanus's picture poems all are structured by the exemplary Christian diagram, the cross, they also exhibit a "spectacular heteroglossia": they function simultaneously as poems, pictures, and diagrams.[92] Their origins can be traced not only to the antique traditions of picture poems and *opus geminata* (prose and poetry combined) but also to the earliest Christian representation of the crucifixion, the staurogram, forged from parts of the Greek words for "cross" and "crucify."[93] In some cases Hrabanus imposes diagrammatic elements on the poems in the form of geometric or figural shapes, in other cases the shapes themselves take the form of letters pregnant with meaning (sometimes defined by abstruse numerology). In translating Hrabanus's treatise into the diagrammatic mode and in drawing it out at such length, Berthold disturbed its delicate balance between word and image, separating the two and employing independent images in the form of colored diagrams, many accompanied by figural elements. The differences in formal and theological presentation between the two authors, one famous, the other forgotten, define two ages: the first operating in the aftermath of Byzantine iconoclasm, the second in a moment of unchecked enthusiasm for images.[94] Both works are serial in structure—Hrabanus's with 28 (not including the two introductory poems that make up part of the prefatory material), Berthold's with an astonishing 120 parts—but each is organized according to different principles. Speaking of serial art from the postwar period, Briony Fer observes that "it is not at all bound by the definition of a mechanical, technical, or scientific drawing. Rather, the whole idea of 'diagramming' sets in play a series of temporal and spatial relations."[95] In Berthold's case, the temporal relations in question are twofold: first, that which transpires in working through each diagram in turn, page by page, and moving from one to the next; and second, more importantly, that which these processes simulate, namely, the progress of sacred history. Within

and among the diagrams, the spatial relations are those of typology, which maps oppositions and complementarities created by juxtaposition onto the before and after of linear narrative. Spatial relations reveal the patterns underlying temporal links. Sacred history, however, is not simply represented; it is effectively reenacted using a medium, the diagram, which itself incorporates a temporal and corporeal dimension, not only as a result of diagrams being placed in sequence but because each diagram implicitly involves a series of connections being drawn in both the material and ideational sense of the word.[96] In this sense Berthold's diagrams could be said to evolve in the manner of a mathematical proof, each one not only in and of itself but also in combination with one another as a series that both retraces and maps out the course of salvation history from past to present to future. Each diagram represents an event or personage within sacred history—the Tree of Jesse, the cross, the four Evangelists, etc.—but it also represents "a piece of reasoning based on the representation of that object."[97] Words used to describe the diagrammatics of computer graphics apply just as well to Berthold's medieval method: "Here syntactic possibilities extend into time and space as they define transposition operations that facilitate the dynamic exploration of information. Information is entered or played against time. The analyst enters the diagrammatic space, and what was formerly a snapshot, now becomes . . . a flow of information."[98]

Diagrams thus represent not simply knowledge in the form of facts, or what in a medieval context were accepted as facts, but also the very process by which that knowledge is attained. Diagrams not only are signs: they also embody technique.[99] The very process of drawing a diagram (or of recapitulating in the mind the steps by which it was made) permitted the draftsman and the reader to draw conclusions. Medieval authors were themselves aware of the processual nature of diagrams as a medium. In *De septem liberalibus artibus*, a picture poem (or at least one intended to evoke such a picture), Theodulf of Orléans, known for his profound skepticism

regarding religious imagery, describes a tree within a disk that doubles as a *mappa mundi*. The tree's branches support the seven liberal arts. The poem concludes with a series of images that describe not only the tree but also the process by which its imagery is to be understood:[100] "This tree bore both these things: leaves and pendant fruits, / And so furnished both loveliness and many mysteries. / Understand words in the leaves, the sense in the fruits, / The former repeatedly grow in abundance, the latter nourish when they are well used." There follows the perhaps predictable injunction to ascend from lower to higher things. The real lesson is about the nature of diagrammatic imagery itself: just as a tree repeatedly bears fruit, so too prolonged study of the diagram allows the reader to move from the words (leaves) to their sense (fruits).

In light of the processual nature of diagrams—the way in which they do not simply represent knowledge but, still more important, inculcate and recapitulate ways of knowing—any adjustment to Hrabanus's complex text-image amalgam testifies to shifting epistemologies, not to mention shifting attitudes toward images in particular and visual experience in general. Whereas Hrabanus's work revolves around and is in part generated by intricate numerology, having no center other than the cross itself (witness his doubling of the Seven Gifts of the Holy Spirit so as to be able to rearrange them as a symmetrical cross), Berthold's is thoroughly historical and hence paratactic in structure, tracing the history of salvation in terms of typology from beginning to end. Whereas the disciplined construction of Hrabanus's work presents itself as a revelation of atemporal truth whose validity is underscored by an abundance of number symbolism, Berthold's sprawling structure, as devotional as it is theological, accommodates a gradual unfolding of human events in historical time. For Hrabanus, locking his figurations within diagrammatic arrays of words disfigures the image, stripping it of its materiality. For Berthold, fleshing out his diagrams with figuration enhances their ability to effect the truth of the incarnation.

As a historical form predicated on dyadic relationships, typology is fundamentally diagrammatic in form.[101] *Figura*, one of the terms most commonly employed in medieval sources to designate diagrams, carries within it the connotations of a typological figure that merely foreshadows the truth to be fully fleshed out in the fullness of time.[102] Berthold effectively fuses the two connotations of the term, the one a geometrical figure, the other a prophetic image.[103] In keeping with the discourse that identified Old Testament prophecy as a mere foreshadowing of Christian truth and the incarnation as the ultimate authorization of images, the diagram prefigures and points toward the visible and necessary reality of Christ's coming into the world.

Diagrams, at least in the majority of their high medieval instances, take the form of complex combinations of words and images. They occupy a hybrid middle ground between the two media. As imagetexts, they sit squarely in the contested cultural field described by W. J. T. Mitchell.[104] One should, however, not speak too blithely of text and image in medieval art without first questioning just what each of these key terms might have meant for a monastic reader.[105] *Imago*, image, was a term freighted with multiple meanings: man was made in the image and likeness of God; Christ was the perfect image of the Father.[106] *Image* was not a term to be taken lightly. Medieval images, moreover, rarely came without text, whether in the form of *tituli* (titles) or inscriptions.[107] Medieval images bear identifying inscriptions even in instances when by any measure they would not have been necessary; their inclusion, which anchored images in discourse, indicates an ontological, not simply didactic, necessity to authorize images by linking them to language, in particular that of the Bible.[108] At the same time, however, at least within monastic meditational practice, words were viewed as invitations to visualization. After all, the root sense of *contemplation* is "to see." Lest this all seem too far removed from modern discourse on diagrams, consider the following characterization of mathematics by Brian Rotman, a semiotician of mathematics: "One does mathematics by propelling an *imago*—an idealized

version of oneself that Peirce called the 'skeleton self'—around an imagined landscape of signs."[109] For a medievalist, Rotman's characterization of mathematical thinking cannot help but bring to mind a medieval dream vision.[110]

To get the full measure of Berthold's paired treatises, one must analyze all ninety-three of their illustrations, the majority of them diagrams. The chapters that follow do just that. To begin with, however, we can anticipate some conclusions. And in what better form than in an imagined diagram? It would take the form not of a line, leading either forward from the Middle Ages to modernity or backwards from the present to the past, but rather of a parallelogram in which analogous relationships undergo similar shifts, if to different ends. Whether medieval or modern, diagrams mix modes of expression, visual and verbal. Diagrams are not only conceptual; they are also material. Process is part not only of their making but also of their meaning. Diagrams do not simply reflect or embody ideas:

they shape them. And beyond ideas, they move, like machines, to encourage action.[111] Diagrams are relational. And very often, as in the case of Hrabanus and Berthold, they are serial. As for Berthold, his way of thinking about the history of salvation—typology, which pairs Christian event to Old Testament prophecy and uses geometry to lend those pairings the character of a demonstrative proof—is fundamentally diagrammatic. Whether looking at modern or medieval art, one can ask the same question: why resort to diagrammatic modes of representation in the first place? The answers—whether to demonstrate cosmic harmony, provoke visions, understand the prophetic course of salvation history, or, in the case of more modern examples, to disrupt established social codes—will differ dramatically. But to come full circle, one thing remains constant: the diagram, on its face a cold abstraction, permits one to delve deep into the desires that informed its makers.

2

Configured Commentaries

Hrabanus Maurus: A Maze of Meaning

In honorem sanctae crucis by the Carolingian polymath Hrabanus Maurus requires little introduction.[1] Celebrated as the consummate example of the *carmen figuratum*, the work incorporates its praise of the cross as the governing structure of the cosmos within twenty-eight figural Latin poems (thirty if one includes the prefatory material) that, from a modern perspective, might be described as the most complex crossword puzzles ever invented, to which, on account of their dense number symbolism, has been added an element of sudoku.[2] From a medieval perspective, however, the dense web of signification expressed by all means possible—verbal, visual, and numerical—the measure and harmony of the cosmos.[3] After all, God had "ordered all things in measure, and number, and weight" (Wis 11:21). It also ensured that the poems could serve as an inexhaustible source of religious instruction and contemplative wonder. Delight, however, had to be kept in check if it led to indulging the senses: images unattached to words presented a clear and present danger. As Michel Perrin has pointed out, esoteric though Hrabanus's procedures might seem, he went out of his way to explain his methods and meanings, first in the prose paraphrases (*declarationes figurae*, or "explanations of the figures") that face the poems across the openings in the first part of the work, and again in the additional commentaries that constitute book 2.[4]

Each of the poems in book 1 consists of a carpet of letters, filling the entire page, that can be read continuously from left to right, within which smaller sections outlined by imposed figural forms, known as "intexts"

(*intextus, literally, interwoven*), similarly make discrete sense. The fact that shuffling word order in Latin, a declined language, is easier than in English hardly diminishes the mind-boggling complexity of the task that Hrabanus set himself, all the more since his adherence to a variety of meters, each with its own demands, posed yet another obstacle.[5] Hrabanus's poems vary in their approach. Ulrich Ernst has identified five different ways in which the poet embeds figures of the cross in his compositions: (1) linear figures of the cross, (2) crosses composed of geometric forms, (3) crosses consisting of letters, (4) crosses in which the letters double as numbers in the manner of gematria, and (5) crosses consisting of images or pictorial elements.[6]

One example serves to give some sense of the work's intricacy. In the twenty-sixth *carmen*, dedicated to the prophets' foretelling of the Passion, an unadorned cross divides the square of thirty-seven letters into quadrants (fig. 15). Each arm of the cross is made up of the following hexameter: *Es placita superis, crux, huic es navita mundo* (You are pleasing to the beings on high, O cross, you are the pilot of the world). Each letter in the vertical cross-arm forms part of the horizontally aligned verse that intersects it. Vision becomes as crucial as hearing to comprehension of the poem; the crux must literally be seen to be understood. This emphasis on visibility had already been an explicit feature of Optatian's poems; the Constantinian poet speaks of his verses being "suitable for the holy looks of the lord" (Carmen 1.6: "dominus visibus apta sacris").[7] Visual wordplay of this sort became a staple of medieval manuscript illumination and epigraphy. A Gospel lectionary from Moissac, dated to the second half of the twelfth century, provides a simple, stark, yet striking example that hovers between abstraction and concretization (fig. 16).[8] The words PAX, LUX, REX, and LEX (peace, light, king, and law), written in blue, converge on the *X* at the center of the red cross, which with its pronounced terminals refers not to the historical but rather to a processional cross. The two colors red and blue possibly refer respectively to Christ's human and divine natures. The *X* performs double duty as both a letter and a concrete

instance of the object that the image represents, emphasizing that the object in question is most emphatically not the body of Christ but rather a liturgical object.[9] Hrabanus also exploits the "crux" of his complex imbrication of text and image. The internal rhyme between "placita" and "navita" balances the two parts of the verse around the "crux" at the center, with the two occurrences of the word themselves forming a cross at the point of intersection. As if this were not enough, the verse also functions as a word (as opposed to a letter) palindrome. Read in reverse as *Mundo navita es huic, crux, superis placita es*, the sense does not change, but the meter does. The hexameter becomes a pentameter.[10] The consistency with which Hrabanus satisfies the requirements of his self-imposed metric structure matches the systematic fulfillment of the promises of Old Testament prophecies cataloged in the poem's verses.

Complicating each picture poem are elements of number symbolism, many of them with cosmological significance. Number determines many aspects of each poem's layout, as well as of the set as a whole.[11] Of the twenty-eight poems, one has 41 lines, two have 36, four have 39, seven have 35, and fourteen have 37. These numbers might seem arbitrary until one considers that the division according to poems of different length (and meter) depends on the sum of the factors of 28: 1, 2, 4, 7, and 14.[12] The totality of the work therefore is knit together by an underlying order marked by the measured pace of the poetry itself. Boethius's *De institutione arithmetica*, which dealt with such topics as quantity, odd and even numbers, multiplication, so-called perfect numbers, geometry and angles, and proportion, provided the indispensable introduction to the subject throughout most of the Middle Ages, certainly prior to the scholastic period, and Hrabanus incorporates its lessons in a thoroughgoing manner.[13] In the proemium to book 1 of his treatise, Boethius gives three reasons for the priority of mathematics within the quadrivium (literally, the four ways: number or arithmetic, geometry, music, and astronomy): first, the concord expressed by the assigned, logical order of the world; second (and perhaps most important

15. Carmen XXVI. Hrabanus Maurus, In honorem sanctae crucis, Fulda, ca. 840. Città del Vaticano, Biblioteca Apostolica Vaticana, Cod. Reg. lat. 124, f. 33v. Photo: BAV.

16. CRUX, PAX, LUX, REX, and LEX, Gospel Lectionary, Moissac, 1150–1200. MS. Harley 2893, f. 268v. Photo: © British Library Board.

within the author's Platonic argument), the elemental, a priori nature of those things defined by number; and third, "because God the creator of the massive structure of the world considered this first discipline as the exemplar of his own thought and established all things in accordance with it."[14] Of this way of thinking, albeit it in an entirely different framework, one finds an echo in Galileo's famous statement of 1623 that "philosophy is written in this all-encompassing book that is constantly open before our eyes, that is the universe; but it cannot be understood unless one first learns to understand the language and knows the characters in which it is written. It is written in mathematical language, and its characters are triangles, circles, and other geometrical figures; without these it is humanly impossible to understand a word of it, and one wanders around pointlessly in a dark labyrinth."[15] Like a medieval theologian, Galileo still speaks of the book of nature, but translates it into a different language.

Boethian number theory informs not only the underlying structure but even the shape of Hrabanus's work, which draws on the definitions and diagrams of the late antique master not only for the forms of various polygons constituting the crosses in his *carmina* but also for their numerical values, expressed by the number of letters they enclose.[16] In adopting these figures, visual as well as numerical, Hrabanus was influenced by not only the text of Boethius's treatise but also, no less importantly, its illustrations in the form of diagrams, of which there were well over one hundred and which constituted a cornerstone of the medieval diagrammatic tradition.[17] Depending on the intended recipient of a given copy, the diagrams ranged in quality from crude aids to complex works of art, as in the luxury codex made in Tours, circa 845, most likely for Charles the Bald. Having been inherited by Henry II from Otto III (983–1002), this sumptuous schoolbook became part of the library that the Salian emperor donated to the cathedral in Bamberg (fig. 17).[18] Even less extravagant copies, however, possess an austere beauty that is closer to the sober elegance of Hrabanus's creations.

Difficult to decipher, Hrabanus's poems pose a deliberately formidable challenge to the reader. In keeping with their subject matter, the poems present a plenitude of meaning combined with an element of mystery and magic akin to that associated since antiquity with word and number squares, of which the so-called Sator Square containing a (coincidental?) anagram of the Pater noster (but subject to countless other interpretations) remains the most famous and also the most enigmatic.[19] Writing in praise of the work in the eleventh century, Odilo of Cluny declared that "no work more precious to see, more pleasing to read, sweeter to remember, or more laborious to write can or could ever be found."[20] And in the thirteenth century, only half a century before the time when Berthold was at work on his adaptation of the Carolingian *carmina*, Vincent of Beauvais (ca. 1190–1264), found the work worthy of mention in his *Speculum historiale*, where it is mentioned under the title *Metrica de lauda crucis.*[21]

Although unmatched in their complexity and

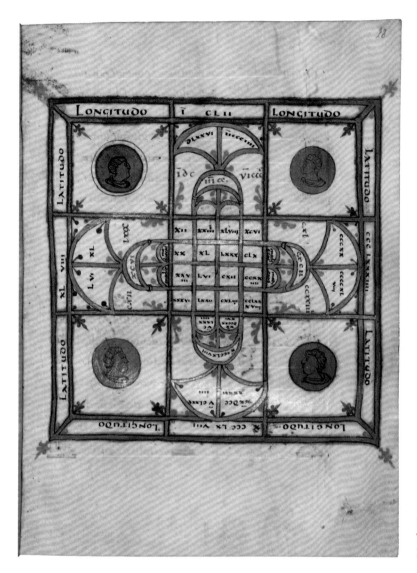

17. Boethius, De institutione arithmetica,
Tours, St. Martin, ca. 845. Staatsbibliothek
Bamberg, Msc. Class. 5, f. 28r. Photo: SB.

ambition, Hrabanus's poems stand in a tradition of antique origin, whose most important representative is Publilius Optatianus Porfyrius (ca. 260/270–before 335).[22] Optatian served as court poet to Constantine, but not without a period of exile during which he complained that he could no longer count on his poems' being recorded in gold and silver in purple codices, an indication not simply of luxury but also of the extent to which such works depended on extravagant materiality in order to be fully legible.[23] During this time he had to make do with regular ink and, for the *versus intexti*, the ruddy orange color known as minium derived from red lead and from which the word *illumination* takes its name, both on plain rather than purple parchment, which is in fact the form in which, in the earliest extant

codex, his poems are preserved (fig. 18). His twenty-five panegyric poems in praise of the emperor (within a corpus of thirty-one extant works) take the form of *carmina cancellata*, that is, gridded poems in which portions within the field of letters constituted by the verses (whose visual consistency was reinforced by the lack of spacing and punctuation common in Latin codices of late antiquity) are "canceled out" or distinguished by being written in another color. One poem (XIX, in which the canceled portion portrays a ship whose mast takes the form of a Chi-Rho initial) opens by pointing the reader to its presence: "The red cinnabar will reveal the heavenly signs [*caelestia signa*] to the reader."[24] The poet himself speaks of his poems as paintings.[25] The reserved intexts are woven into the fabric of

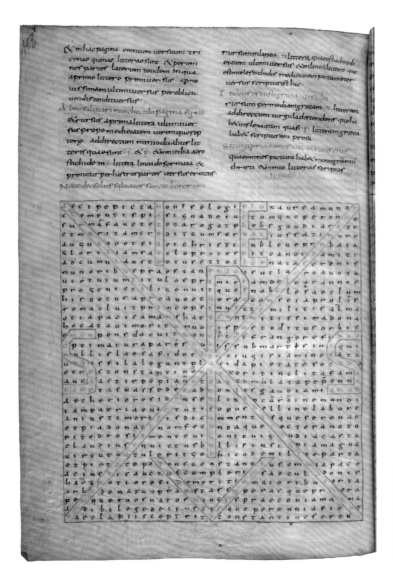

18. Publilius Optantianus Porphyrius, Carmen VIII (Chi Rho and IESUS), ca. 315–325, in Miscellany, Mainz, Cathedral School, first third of ninth century. Burgerbibliothek Bern, Cod. 212, f. 113v. Photo: Burgerbibliothek.

the letter grid of which they form a part. As observed by Michael Squire, the poem requires that readers "navigate between different representational registers."[26]

No less a figure than Cicero, disputing the notion that "no one can be a great poet without being in a state of frenzy," testifies to the taste for such calculated poetic pyrotechnics in antiquity. In *De divinatione* (2.54.111–12), the orator offers a defense of highly wrought poetic artifice:

> Moreover, that this poem is not the work of frenzy is quite evident from the quality of its composition (for it exhibits artistic care rather than emotional excitement), and is especially evident from the fact that it is written in what is termed "acrostics," wherein

the initial letters of each verse taken in order convey a meaning; as, for example, in some of Ennius's verses, the initial letters form the words, Quintus Ennius Fecit, that is, "Quintus Ennius wrote it." That surely is the work of concentrated thought and not of a frenzied brain. And in the Sibylline books, throughout the entire work, each prophecy is embellished with an acrostic, so that the initial letters of each of the lines give the subject of that particular prophecy. Such a work comes from a writer who is not frenzied, who is painstaking, not crazy.[27]

Hrabanus himself includes in his work a comparable device (fig. 19). Placed between the dedication to Louis the Pious—an addition to the work

MVSAGITASTVDIOGAVDENSNVNCDICERENVMEN
NOSTRAGVPETPARITERCARMINEGETALLOQVIIS
DONAPATRISSVMMIQAELARGVSREDDIDITORBI
REGISGFALTITHRONISANCTATROPHAEASTMVL
QVAGGROXOSTSACRACRVCEPIXINOMINEPLENA
OMNIBVSAPTABONISSTIRPSVGNERANDASATIS
HANGEGOPAVPEREGENVSINOPSENORELOQELLA
TEMPTAVIPIEPAMVLGSSONSDARETHOCORIAR
NECMEFACTAPIANTQVODDIGNVMMVNCROTANTO
MEFORGADHOGRODAMSEQVODFOMENTOPVERVM
SEDMIHIEARGADEIBONITASSPESMAXIMADEI
ESTQVAGNOPRVMPTVMLAGSDABATOVHILARANS
PAVPERISETVIDVAGNONSPRGVITRARAMINVTA
SEDTVLITIPSAPROBANSARBITERONNITONANS
ATQVECORDEDOMINAESEISANCTSOLVSETONIS
CVNCTAVGNGSTABONAHANGLAVDEGOAVITAMOR
MANDATOMVGTERINEMPGSTETLEGEQVIBVSGE
MONERAVTAPTADARENTTEMPLAADHONESTADEI
PARSDEDITARGENTVMPARSAVRIMVNERACLARA
PARSTRIBVITGEMMASPARSQOGETINCTADEDIT
LIGNAOLGANIDAMPIGMENTAQVGCARADEHORE
MVLTAGMAGNADOMVSMONSTRATVBIQVGMICANS
ASTALIISGLASTVLERANTPILOSQVGCAPRARVM
NECVGRANTSPIGETIBIDONAPGRGNIODGOHAGG
QVAPROPTERROGITONEMMATVMDIVGSVFFIGTIC
VILLACVMPORTEMHVNGSPERNGRGNOLLITONOS
IPSELIGETGAZASINMENSASCONFERATAMPLIS
AGMINIBVSPLLTVSTEMPLAOREGRANDOLVIBINC
HISEGONONMOTVSCONTVRBORNAMIMPLEGALTV
SEDGRATVLANSSPEGVLORCRESCEREDONASIBI
ILLEQVOQVEXOSAVTHABEATMEAMVNGRANOLO
SEDMAGISESSESCIARQVALIACVMQVEDETHAGC
EXPROBRATIPSEDEOGIDISPIGTTACEROGENVM
CVIVSAGENVSHICESTCVIVSETOMNISHOMOEST
OMTANTVMMIHIDGOTRIBVITMIHIEGOSVSAMATOR
SINTSVAFACTAPIEHICCVNCCTAQVEHICRVPGAT

19. MAGNENTIVS HRABANVS MAVRVS HOC OPVS FECIT. Hrabanus Maurus, In honorem sanctae crucis, Fulda, ca. 840. Città del Vaticano, Biblioteca Apostolica Vaticana, Cod. Reg. lat. 124, f. 7r. Photo: BAV.

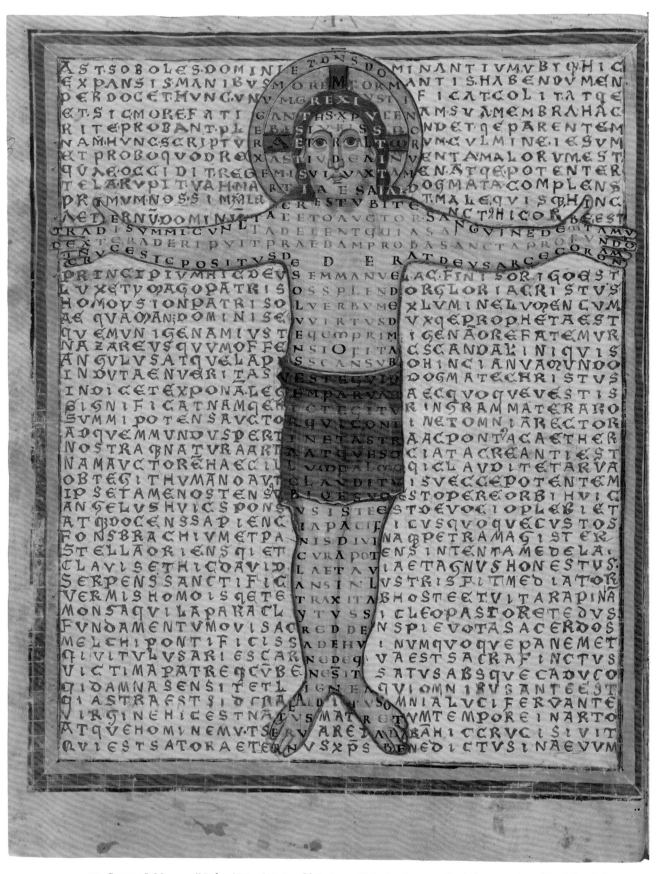

20. Carmen I, Magnencij Rabani Mauri De Laudib[us] sanct[a]e Crucis opus, Pforzheim, 1503, in aedibus Thom[a]e Anshelmi, f. 1r. Munich, Bayerische Staatsbibliothek, VD16 H 5271. urn:nbn:de:bvb:12-bsb00019912-1. Photo: BSB.

that must postdate 831—and the first of the *carmina* dedicated to Christ, the poet embeds his signature—*Magnentius Hrabanus Maurus hoc opus fecit* (Hrabanus Maurus of Mainz made this work)—in six rows of six letters each, numbers reflected in the overall dimensions of the picture poem, which forms a perfect square, thirty-six letters in length on each side.

In contrast to the antique tradition of the *carmen cancellatum*, in which the intexts are singled out from the surrounding text by ink or pigment of a different color, the *carmen figuratum* in Hrabanus's treatment lends these insertions the form of pictures or figures painted on the page (fig. 20). A seemingly small change, it is of profound significance. Whereas in the *carmen cancellatum* the geometric cancellations most often trace sequences of letters and only occasionally suggest schematic symbolic objects, such a ship or a palm tree, in Hrabanus's poems the intexts assert themselves more forcefully as images in their own right. By modern standards, Hrabanus's departure represents but a small step in the direction, if not of the pictorial per se, then of the figurative. By medieval standards, however, particularly given the sensitivities around images in Hrabanus's time, the shift is far more significant. In Hrabanus's work, text and image are integrated in so thoroughgoing a fashion as to be inseparable. As Hrabanus himself observed in the prologue to his magnum opus, any alteration to his *carmina figurata* would necessarily have a profound impact on how the work would be perceived and understood. Hrabanus specifically admonishes his readers (the Latin verb is *moneo*) that they adhere to the order of his composition (*ordo conscriptionis*) and that they not overlook his figures (*figurae non negligere*).[28]

Rewriting Hrabanus

Berthold willfully ignored Hrabanus's directive, disentangling text and image to the point of separating them almost entirely (see figs. 1–2). His reduction of Hrabanus's *carmina* to colored configurations prefacing explanatory texts effectively tears asunder what Hrabanus so painstakingly put together. In this systematic separation

of text from image, Berthold's book conforms to what has been called the aesthetics of the Gothic manuscript (which also reflects changing conditions of production, chief among them a greater division of labor): on the one hand, when it came to the text, a *horror vacui* (to which the fusion of letters and line-fillers testify) which insists on the unity of the text block and, on the other hand, an increasingly strict segregation of text from image. Symptomatic of this segregation is the virtual disappearance of display scripts as well as of figured initials, both of which imbricated text and image one within the other.[29] As in Berthold's book, moreover, the images for the most part tend to be of the same size and shape.[30]

Berthold could be dismissed as an intellectual bowdlerizer, removing from Hrabanus's original anything that was too difficult for his readers to understand. Closer consideration of his reworking, however, suggests that other motivations were at work. As the most dramatic (one could say invasive) rewrite of Hrabanus's original, Berthold's illustrated compendium represents a critical chapter within the longer history of the work's reception, which has yet to be written.[31] Manuscript copies of Hrabanus's work survive from every century right up to early modern times. To trace the transformations wrought by these adaptations speaks volumes about the Carolingian originals (among which there are themselves telling variations). The later works, Berthold's included, serve as foils from the future, highlighting many of the features that make each generation of copies distinctive.[32]

It comes as no surprise that early modern renditions of Hrabanus's *In honorem sanctae crucis* depart most dramatically from their ostensible model, even when they present themselves as faithful reproductions, some of them carried out in the name of antiquarian recovery. The first edition, produced at the initiative of the theologian Jacob Wimpfeling (1450–1528) and edited by a team that included Johannes Reuchlin (1455–1522) and Sebastian Brandt (1457–1521), was printed in Pforzheim in 1503.[33] The product of Christian humanist interest in Latin classics, not only those of antiquity but also of the early Christian and early medieval periods, it repre-

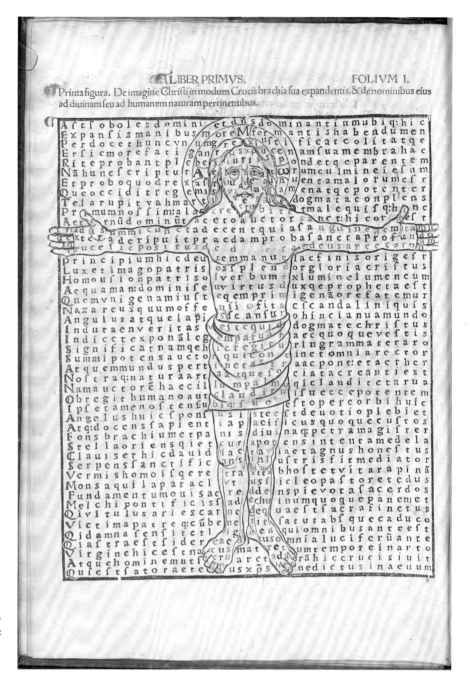

21. Carmen I. Hrabanus Maurus, In honorem sanctae crucis, Fulda, ca. 840. Città del Vaticano, Biblioteca Apostolica Vaticana, Cod. Reg. lat. 124, f. 8v. Photo: BAV.

sented a considerable technical accomplishment, given the need on the part of the woodcutter, Thomas of Baden, to combine text and image in such intricate ways (fig. 21).[34] Whereas the texts were printed using movable type, the *carmina figurata* were reproduced xylographically—that is, images and letters alike were carved in relief, requiring all the surrounding space to be cut away, a most exacting exercise. The revival, however, also represented a revision. The figures were drained of all color except for the red of the

intexts, normally reserved for headings, major initials, and rubrics.[35] Although the reduction of color may not seem significant with regard to any single image, across the series as a whole it produces a monotonous uniformity. The proverbial blackening of the page that came with printing affected even images as reticent as those created by Hrabanus. One might think, moreover, that the regularity of printing was ideally suited to the need to align the letters of each *carmen* within a strict lattice of regular rows and columns. In

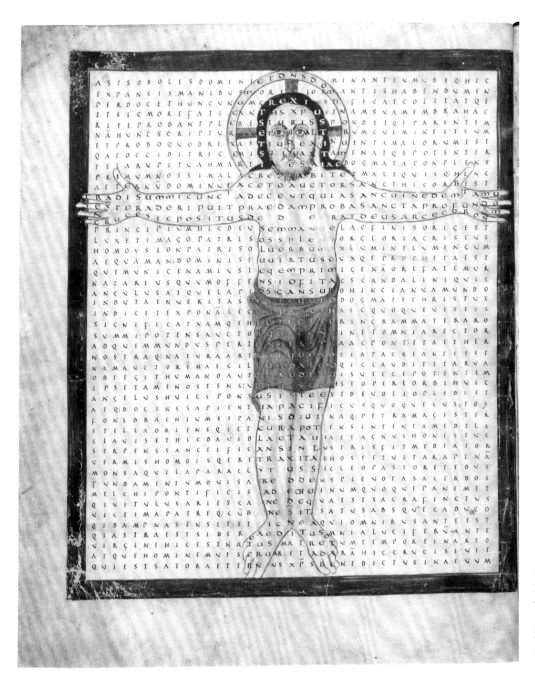

22. Carmen I. Hrabanus Maurus, In honorem sanctae crucis, Fulda, 825–50. Bibliothèques d'Amiens Métropole, Ms 223 F, fol. 6v. Photo: CNRS-IRHT.

this, however, the Carolingian scribes were more successful than the woodcutters of the early sixteenth century. In the printed edition, small shifts in the positions of individual letters lend the frontal figure of Christ constituting *carmen* I, the only anthropomorphic representation of God in the entire set, a restless effect at odds with its otherwise hieratic rigidity.

The printer appears to have had before him either the sumptuous codex now in the Vatican Library, which, unlike other copies that had been given away as gifts in Hrabanus's lifetime, had been retained at his home monastery of Fulda, or another one very much like it (see fig. 21). As in this copy, which was written circa 840, Christ is presented with uncompromising frontality. Neither the Carolingian *carmen* nor its copy in print bears any trace of the distinction between the left and right legs found, for example, in the copy in Amiens, which, in the differentiation of folds in the loincloth, retains the slightest trace of a classical contrapposto (fig. 22).[36] If anything,

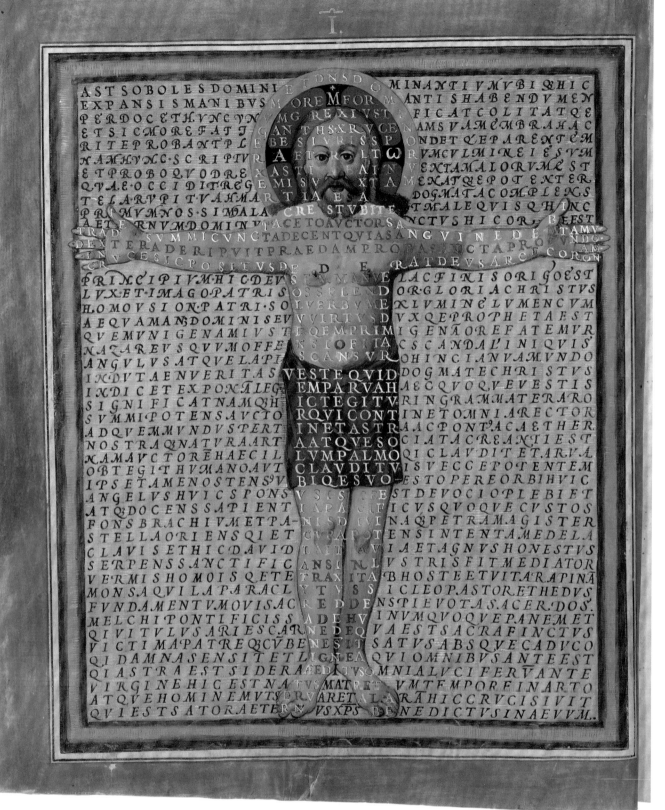

23. Carmen I. Hrabanus Maurus, In honorem sanctae crucis, Prague, 1600. Paris, Bibliothèque de l'Arsenal, ms. 472, f. 9v. Photo: BnF.

in the printed image Christ's body has become stiffer still. Gone too is the slight but subtle tilt of the head, most easily detected in the angle of Christ's mustache, a subtlety that the printer simply eliminated. Some of these simplifications were due no doubt to the challenges presented by the printing process. As in its model, the printed figure distinguishes the five verses that outline Christ's body (but not, it should be noted, in his loincloth, which forms a separate semantic unit). The first ("DEXTRA DEI SVMMI CVUNTA CREAVIT IESVS," Jesus created all things with the right hand of the Highest) extends from the tip of the longest finger of his right hand to the summit of his head, followed by the second, which proceeds from the crown of the head to the tip of his left hand, then from the ring finger of the right hand along his right flank, skipping the loincloth, down his right leg before completing the circuit by returning up the left leg to the hem of Christ's garment. Whereas in the Vatican manuscript these verses are picked out in black, in the printed edition they are set in red.

When at the turn of the seventeenth century Holy Roman Emperor Rudolf II (1583–1612) commissioned the last in this line of copies (Paris, Bibliothèque de l'Arsenal, Cod. 472), his craftsmen effected a no less dramatic and in many respects disorienting transformation, but of an entirely different kind (fig. 23).[37] For the purpose, Rudolf borrowed the codex that had remained at Fulda, recognizing what scholars since have argued, that the manuscript's opulence implies that it had originally been intended as a gift to the emperor, Louis the Pious (see fig. 21).[38] In addition to its splendor, it was distinguished by virtue of its containing corrections in the author's hand, which only added to its authority. If the printed edition adopted an austerity that exceeded even that of Hrabanus, the overweening luxury of Rudolf's copy might well have left Hrabanus reeling. Given, however, the range in quality among the Carolingian copies, which were tailored to their recipients, what would have surprised the Carolingian abbot most about the Rudolfine revival is its overtly pictorial character.

In making such a comparison, it is critical to bear in mind that had the Carolingian craftsman wanted to create the impression of an illusionistic body standing in space, he would have had no trouble in doing so. Carolingian manuscript illumination is full of such figures. In the copy from Fulda, however, everything is reduced to surface pattern in keeping with the figure's character as imagetext. In the Rudolfine copy, as in the original, the use of purple grants the codex an immediate imperial aura. In the copy, however, the various shades of purple further lend the frame the appearance of a beveled wood molding, thereby likening the image to an easel painting. The letters on Christ's body, including the halo, employ both burnished gold and various other pigments, notably white in the halo's outermost circle as well as other hues conforming to the underlying flesh tones. Whereas in the original, whatever variation exists—black, red, white—serves to enhance legibility of discrete syntactical units within the otherwise uniform blanket of letters, in the copy the lettering also aims to conform with a consistent set of pictorial effects, of which the most important is the light that appears to illuminate the image from the space occupied by the reader. In the case of the light reflecting off the burnished gold, such effects, of course, are real. Similar distinctions extend to the different types of lettering employed to distinguish body and ground. The Carolingian manuscript employs Roman epigraphic capitals on the body and more ornate uncial capitals on the ground in order to distinguish one from the other. In the copy the latter are transformed into italic capitals, and the ground itself is streaked with highlights so as to create the effect of shimmering reflection. Perhaps the most pronounced difference between model and copy is the strong black silhouette in the original, which in the copy gives way to delicate hatching accentuating the contours of the body. Each change is subtle in itself, but in sum they transform the overall effect: despite the lattice of letters covering his body, in the copy Christ pops off the page. Whereas in the original, figure and ground form part of a continuous field of text, in the copy Christ and

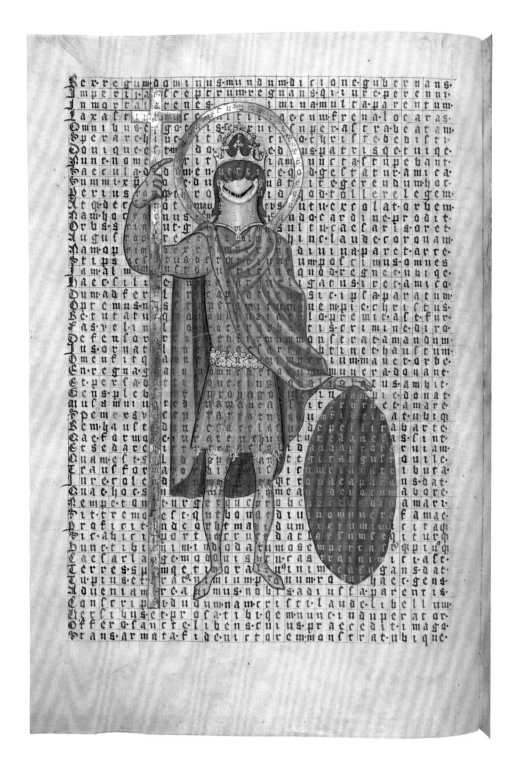

24. Dedication. Hrabanus Maurus, In honorem sanctae crucis, Metten, 1414–15. Munich, Bayerische Staatsbibliothek, Clm 8201, f. 38v. urn:nbn:de:bvb:12-bsb00040329-3. Photo: BSB.

the Word have been split. The introduction of spatial depth detracts from the figure's character as a calligram. The treatment of Christ's eyes proves particularly telling. In both versions they are, exceptionally, kept clear of letters so as not to diminish the image's iconic impact, in itself an affirmation of the importance of vision and the visual. In the copy, however, Christ's eyes stand out much more clearly, enhancing the overall impression that the Christ-Logos somehow occupies a space behind the lettering rather than himself being made of words. No less indicative, whereas in the model Christ's nipples and navel are represented by the three letters of the word "DEO," in the Rudolfine copy, although the *O* is allowed to stand for Christ's navel, the omphalos

25. Reliquary Bust of Charlemagne (side view), Aachen and Prague (crown), ca. 1350. Aachen, Domschatzkammer. Photo: Pit Siebigs, © Domkapitel Aachen.

of creation, the other two letters are shifted so as to stand alongside painted nipples. Rather than standing before the viewer as the Logos incarnate, Christ's body simply appears to have been overwritten.

Medieval copies of Hrabanus's masterwork effected less dramatic but no less telling changes, not all of them intentional. The luxurious compendium of spiritual texts, many of them with diagrams, illuminated in the early fifteenth century for Abbot Peter I of the Bavarian Benedictine abbey of Metten, transforms the (eventual) imperial dedicatee, Louis the Pious, from a staunch *miles Christi*, dressed for battle in a chlamys as if he were a Roman footsoldier, into a foppish paragon of chivalry equipped less for combat than for a courtly tournament (fig. 24).[39] In lieu of a lance, Louis carries a golden cross, a helmet with visor on his head. The imperial "Bügelkrone" (hoop crown), which resembles that worn by the mid fourteenth-century reliquary bust of Charlemagne in the Aachen ca-

thedral treasury, has been modernized (fig. 25). For good measure, as a final flourish, it sits atop a decorative red cloth. The reliquary is a composite: whereas the bust, according to tradition, represented a gift presented by Charles IV following his coronation as holy Roman emperor in Aachen on July 25, 1349, the crown itself—the very crown the emperor had placed on his head on the occasion—had been brought by Charles from Prague.[40] Despite appearances, the abbot's decision to incorporate Hrabanus's work into his library between two covers reflected both an interest in earlier medieval art and a broader reform impulse among Bavarian Benedictines.[41]

Mistakes were made. At the Praemonstratensian abbey of Arnstein in the Rhineland, which in the latter part of the twelfth century greatly increased the size of its library through a combination of in-house production and acquisitions (including of important Carolingian manuscripts), an illuminator's initial attempt circa 1175 to copy the first of Hrabanus's christological *carmina*

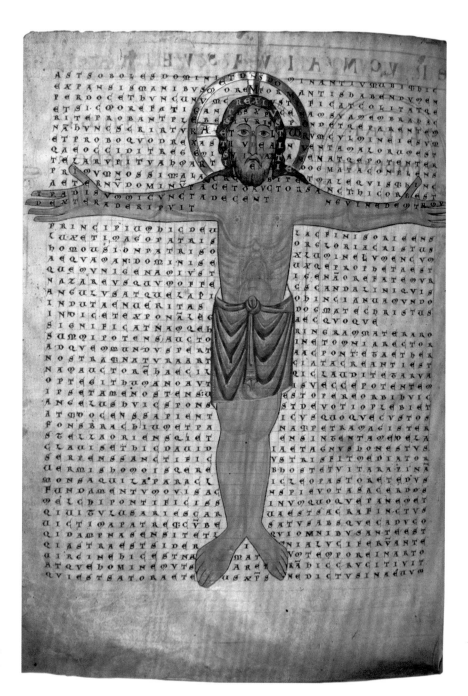

26. Carmen I. Hrabanus Maurus, In honorem sanctae crucis, St. Mary and St. Nicholas, Arnstein, ca. 1175. London, British Library, Harley MS. 3405, f. 49v. Photo: © British Library Board.

proved sufficiently malapropos that the scribe with whom he was collaborating eventually gave up, leaving much of the space reserved for lettering blank (fig. 26).[42] If one looks closely, the cause of the illuminator's frustration becomes apparent. By tapering the torso of Christ, leaving at most seven and as few as five empty spaces for the scribe to fill in, when in fact regular rows of eight squares each were required, the artist distorted the carefully calculated proportions of the model. A second attempt proved more suc-

cessful (fig. 27). The first botched folio, however, was not discarded; rather, it was bound into the back of the manuscript, perhaps because, in the manner of storing discarded Jewish texts in a genizah, the thought of discarding an image of Christ somehow seemed sacrilegious.

In a late twelfth-century copy from the monastery of Anchin in northern France, the scribe Rainaldus created such difficulties for the illuminator Oliverus that he inscribed an apology in the manuscript: "Rainaldus, the scribe of this work,"

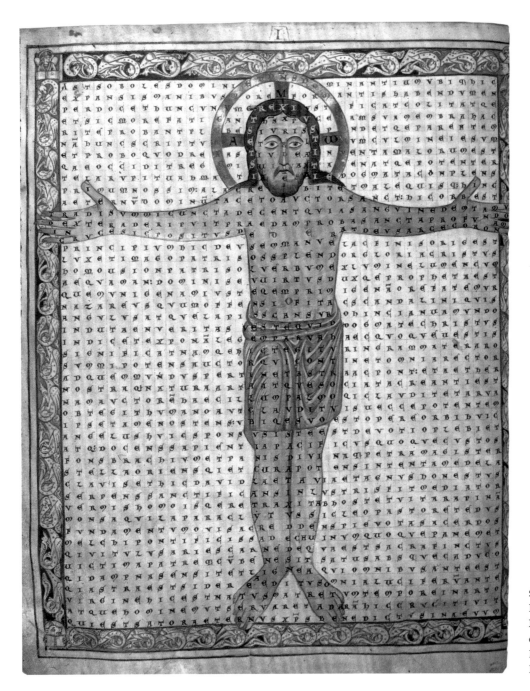

27. Carmen I. Hrabanus Maurus, In honorem sanctae crucis, St. Mary and St. Nicholas, Arnstein, ca. 1175. London, British Library, Harley MS. 3405, f. 6v. Photo: © British Library Board.

begs the reader's pardon "for the aberration of [his] error for I wrote this book less carefully than I ought, and I extended in length more than was right the squares of the pages [to be] laid out for figures—which I ought to have made square with the correct line. Wherefore, the painter was forced to make the circles which ought to have been round, more oblong than round" (fig. 28).[43] As Richard Gameson has pointed out, the figure to which Rainaldus refers in particular is the seventh in the series, in which four circles rep-

resent the quaternities—the elements, seasons, and parts of the day—whose concord with one another and the four arms of the cross constitute the subject of the poem. The manuscript's most significant departure from the original, however, consists of a deliberate alteration: the addition of a full-page frontispiece prefacing the first figure depicting the diagrammatic Tree of Jesse (fig. 29). Flanked on the right by four prophets and on the left by three prophets and a sibyl, all of whom gesture dramatically toward the center,

28. Carmen VII. Hrabanus Maurus,
In honorem sanctae crucis, Anchin,
late twelfth century. Douai, Biblio-
thèque municipale, ms. 340, f. 17v.
Photo: Bmun.

the axial tree shows in succession David, Mary, and Christ rising above the recumbent Jesse. Although Hrabanus touches on the incarnation in his *carmina*, it is far from a prominent theme. The focus remains resolutely on Christ, and above all, Christ's divinity. It is in this spirit that the first *carmen* in the series, in which Christ stands, eyes wide open and with arms extended in a common gesture of prayer, but with no sign of any wounds, while reminiscent of the crucifixion, shows not the suffering Christ but rather Christ triumphant, reaching out as if to encompass the entire cosmos, in keeping with the alpha and omega that occupy the horizontal cross-bar within his halo (the *M* in the vertical bar stands for *medius*, middle or center). The newly introduced frontispiece to the Anchin Hrabanus registers a seismic shift in focus toward Christ's humanity, and with it the Virgin Mary. Within the reception of this particular work, Berthold's Marian supplement to his commentary on Hrabanus represents the high-water mark of what by

29. Tree of Jesse. Hrabanus Maurus, In honorem sanctae crucis, Anchin, late twelfth century. Douai, Bibliothèque municipale, ms. 340, f. 11r. Photo: Bmun.

the late Middle Ages would build to a phenomenon comparable in its impact to a tidal wave.[44]

"Wonderful Inventions": The Manuscript in Gotha and Its Progeny

When it comes to ascertaining the facts of Berthold's life, little if anything can be gleaned from the manuscript copies, of which the earliest, dated to 1294 or very shortly thereafter, survives in Gotha (Forschungsbibliothek Gotha der Universitäts Erfurt, Memb. I 80).[45] In addition to a truncated copy of Hrabanus's *De laudibus*, added at the front in the fifteenth century (ff. 1–40v) to replace what, on codicological grounds, must have been a thirteenth-century original, the manuscript contained, second, Berthold's reworking of Hrabanus's *carmina* and commentaries thereon, titled *De misteriis et laudibus sancte crucis* (ff. 41r–54r), and, third, the Marian supplement, *De misteriis et laudibus intemerate Virginis genitricis dei et Domini nostri Ihesu* (ff.

54r–67r), in effect, a semi-independent work that takes Hrabanus as its model. Just as Hrabanus, on the model of the ancients, doubled his poems in prose, Berthold in turn doubles Hrabanus.

Codicological evidence in the form of signatures (numeration of the gatherings to assist in the assemblage of the completed manuscript) indicates that at least three such units—sufficient to contain both books of Hrabanus's work—have been lost at the front of the manuscript and that they were present from the beginning.[46] The unusually prominent signatures, which are contemporaneous with the making of the manuscript and which were written, apparently by the rubricator, in large Roman numerals in red ink, occur on folios 47v (IIII) and 55v (V). The next and final gathering of the original manuscript, the sixth, from which the twelfth, blank folio has been excised, would not have required a signature. From those signatures that remain, it can be deduced that in the original thirteenth-century manuscript, three gatherings preceded what is now the first folio of a fragment (f. 41) and that the latter part of the third gathering held the majority of the table of contents for Berthold's commentary on Hrabanus, of which the tail end survives (f. 41r).

That three gatherings are missing is further confirmed by a notation in the upper right-hand corner of the very last folio (f. 67r), where a modern foliator, perhaps a nineteenth-century cataloger of the collection in Gotha, has corrected a note reading *90 folia*, so that it reads *91*. The same hand that made this correction was responsible for the modern foliation, which concludes on folio 67. Ninety-one minus 67 equals 24, the equivalent of three gatherings of eight leaves, precisely what the evidence of the original signatures indicates. The earlier foliation indicates that at one point the manuscript had ninety-one folios. Given that this was apparent to whoever added the modern foliation, it could be concluded that the substitution of the fifteenth-century copy of Hrabanus for the thirteenth-century original took place only in modern times, not in the late Middle Ages. That this cannot have been the case, however, is demonstrated by the earliest extant reference to the manuscript, published in 1689, which offers a precise description of the fifteenth-century copy of the dedication image (f. 1v), which depicts Hrabanus, together with Alcuin, presenting his book to the archbishop of Tours (cf. fig. 44). As noted by Wilhelm Ernst Tentzel, who praised the manuscript as being full of "wonderful inventions," Alcuin wears a triple tiara of a kind usually associated in the late Middle Ages with the pope.[47] The fifteenth-century copy of Hrabanus testifies to the reawakening of interest in the abbot of Fulda at the end of the late Middle Ages that would ultimately lead in 1503 to the production of the first printed edition of the work in Pforzheim organized by the humanist and religious reformer Jacobus Wimpfeling.[48]

Berthold's Marian supplement to Hrabanus met with limited success. Beyond the manuscript in Gotha, five copies survive. Only one of these (Basel, UB, B IX 11, ff. 1r–50r) is illustrated (fig. 30).[49] In addition to Berthold's *Liber de mysteriis et laudibus intemerate virginis genitricis dei et domini nostri Ihesu*, the composite manuscript, which comes from the library of the Dominicans in Basel, contains among other texts the earliest surviving copy of a far more famous text, the Latin version of the *Das fließende Licht der Gottheit* by Mechthild of Magdeburg (ca. 1207–ca. 1282/94).[50] The various parts of the manuscript date to between the very beginning of the fourteenth century and about 1400; the paleography of the section containing Berthold's work suggests a date circa 1300 or in the very early fourteenth century—in any case, somewhat later in date than the manuscript in Gotha. Although not quite as adeptly drawn, the sixty diagrammatic illustrations reproduce those in Gotha with extraordinary fidelity, not only their shapes but also their colors, the latter being important in light of Berthold's emphasis on color symbolism. Although the portion of the manuscript consisting of Berthold's work bears no indication of its place of origin or provenance, the fact that the composite book of which it became a part belonged to the Dominican in Basel could be taken to support an origin in the region consistent with the localization of the manuscript in Gotha on the basis of style.[51]

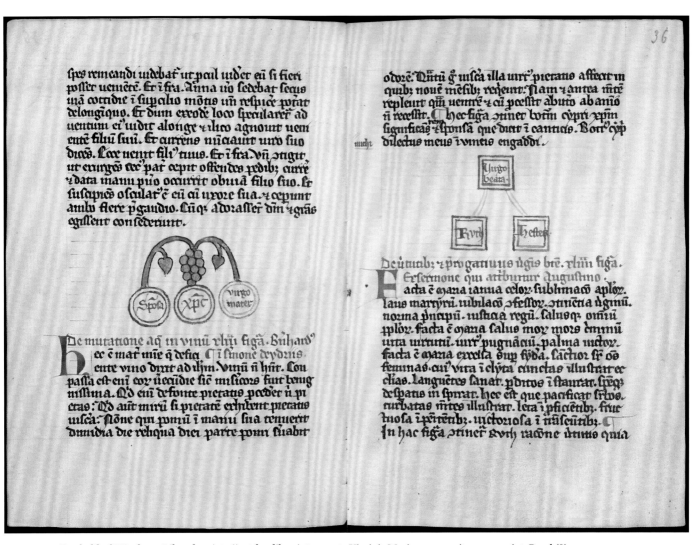

30. Berthold of Nürnberg, *Liber de misteriis et laudibus intemerate Virginis Mariae*, composite manuscript, Basel (?), Dominicans, early fourteenth century. Basel, Universitätsbibliothek, Cod. B IX 11, ff. 35v–36r. Photo: UB.

The remaining four copies of Berthold's Marian work, all of them in Munich (BSB, Clm 3050, 8826, 18188, 21624) and all of them written on paper between 1428 and 1446, remain without illustrations.[52] The concentration of copies in Bavaria points to the intense reception of Hrabanus's work in this region, as indicated by the luxury copy from Metten. Unillustrated copies of diagrammatic works represent an interesting topic in their own right insofar as the presence or absence of diagrams speaks directly to the inherent nature of the diagram as a medium. To argue, as some have done, that a diagram requires textual accompaniment, even if it takes as simple a form as individual letters distinguishing its various parts, is not only to affirm that diagrams rep-

resent a mixed genre, occupying a middle ground between text and image—what James Elkins calls "notations"—but to imply that within this heterogenous compound, image remains subservient to text. Elkins's definition is useful but also perhaps inadequate, for whereas diagrams may rely on notation defined in these terms, not all notation is diagrammatic.[53] Moreover, for a text-image compound to function as a notation, its component parts have to obey a certain set of rules; the symbols have to have been submitted to a certain set of syntactic constraints. This is what Peirce had in mind when he stated that all reasoning is dependent on graphical signs. Ignoring the myriad fusions of word and image so typical of early medieval art, Elkins asserts,

"That-which-is-neither-picture-nor-writing did not become prominent in the West until the late Middle Ages."[54] Yet what Elkins calls notations need not be linked so closely to the emergence of modern science. The medieval diagrammatic tradition had its roots in the cosmology of antiquity.[55] Already in the early Christian period, diagrams were employed as instruments of religious initiation and devotion.[56] By the Carolingian period, diagramming had established itself as one of the principal forms of making meaning in medieval art.[57]

Just as some diagrams exist without lengthy didactic texts accompanying them, suggesting that they could operate independently as images, so too many didactic texts ostensibly requiring diagrammatic illustrations, of which Berthold's is merely one example, nonetheless remain devoid (or were stripped) of diagrams, suggesting

31. Daniel de Geertruidenberg (scribe), Hrabanus Maurus, In honorem sanctae crucis; Berthold of Nuremberg, Liber de misteriis et laudibus sanctae crucis; Publilius Optantianus Porphyrius, Pangeguricus Constantino missus, Cologne, 1468. Paris, Bibliothèque nationale de France, ms. lat. 8916, f. 58r (detail). Photo: BnF.

that in some instances these were not needed to understand whatever it was that the text sought to demonstrate. It is also possible that in some cases scribes simply found diagrams too cumbersome to copy or that the specialist to whom the task was left for whatever reason never got around to it. A scribe's apparent discomfort with diagrams would appear to explain their partial absence in a previously unrecorded and only partially illustrated copy of part I of Berthold's work, his Treatise on the Cross (Paris, BnF, ms. lat. 8916), copied in Cologne in 1468 by Daniel de Geertruidenberg (Mons sanctae Gertrudi in Brabant and the diocese of Liege; fig. 31). Daniel was a canon from the house of the Kreuzherren in Cologne whose work can be documented in other books from the same monastery.[58] A Daniel, cleric of the diocese of Liège, possibly identifiable as the same man, is recorded as having matriculated at the University of Cologne in 1445.[59] It only makes sense that the order of the Kreuzherren, dedicated to the cross, took an interest in Hrabanus's In honorem sanctae crucis. In addition to Hrabanus's famous treatise and Berthold's elaboration of it, the manuscript in Paris contains Optantianus Porfyrius's Panegyricus, the inclusion of which indicates a remarkable, almost antiquarian awareness of the tradition of carmina cancellata in which Hrabanus was working.[60]

Comparison of the manuscript in Gotha with that in Paris reveals that the fifteenth-century copy was left unfinished, not due to lack of time but rather because the illustrator felt unable to execute the five illustrations that included figural imagery, whether angels or Christ on the cross (the sequence of diagrams was altered in Paris). The most obvious omission is Berthold's second figure, derived from the Speculum virginum.[61] Further comparison of the two manuscripts underscores the extent to which supposedly identical diagrams remained subject to variation. Far from fixing knowledge or serving as reliable explanatory tools, diagrams varied in their execution, a variation that introduced an element of interpretation already before the books were taken up by readers.[62] If one sets the diagrams for the same sections side by side, the variability

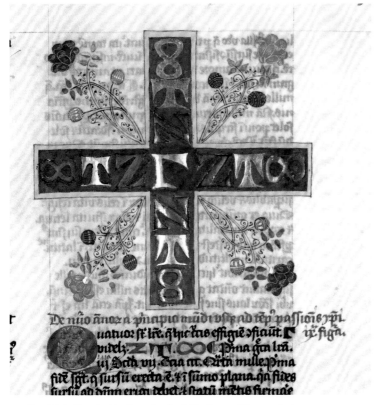

32. Daniel de Geertruidenberg (scribe), Hrabanus Maurus, In honorem sanctae crucis; Berthold of Nuremberg, Liber de mysteriis et laudibus sanctae crucis; Publilius Optantianus Porphyrius, Pangeguricus Constantino missus, Cologne, 1468. Paris, Bibliothèque nationale de France, ms. lat. 8916, f. 58r (detail). Photo: BnF.

33. Berthold of Nuremberg, Liber de misteriis et laudibus sancte crucis, Lake Constance region (?), 1292–94. FBG, Memb. I 80, f. 43r (detail). Photo: FBG.

introduced by changes in frames and decoration stares one in the face (figs. 32 and 33). In comparison to the spare geometry of the thirteenth-century manuscript, the florid ornament characteristic of late fifteenth-century manuscript illumination in Cologne lends the later manuscript an altogether different character and complexion.

Given that the corrected authorial subscription at the end of the second part of the compendium identifies Berthold as a *lector* of (or from) the convent of Nuremberg, the works cannot predate 1275, the date when the friars' convent in the Franconian city was founded, assuming that Nuremberg was indeed where Berthold worked.[63] The information provided by the pair of authorial subscriptions, one at the end of each part, allows for much greater precision. The one that concludes Berthold's reworking of Hrabanus, accompanied by an image similar in structure to a Coronation of the Virgin, provides the

date 1292 (figs. 34, 37, 40); that which concludes the Marian commentary, 1294 (fig. 35). Each of the two works was written by a different scribe, the second of whom picked up where the first one left off, only about one third of the way down the first column of text on folio 53v, following the elaborate explicit, written in a display script consisting of lines that alternate between dark brown and red, written in widely spaced letters.[64] One could argue that the second part simply represents an afterthought. Militating against such a conclusion, however, is the fact that the final sections of the commentary on the cross and the first sections of the commentary on the Virgin Mary occupy the same gathering (VIII). Had the first part been concluded in 1292 with no intention of extending it, either the gathering would have been reduced to a sexternion, consisting of three bifolia instead of four, or the unused folia would simply have been excised, as was common practice. Instead it appears that the ruled but

34. Authorial subscription. Berthold of Nuremberg, Liber de misteriis et laudibus sancte crucis, Lake Constance region (?), 1292–94. FBG, Memb. I 80, f. 54r (detail). Photo: FBG.

35. Authorial subscription. Berthold of Nuremberg, Liber de misteriis et laudibus intemerate Virginis genitricis Dei et Domini nostri Ihesu, Lake Constance region (?), 1292–1294. FBG, Memb. I 80, f. 67r (detail). Photo: FBG.

otherwise blank folios were left as they were in anticipation of the second part, which was completed by another scribe only two years later. Although the two parts are somewhat distinctive in appearance, script, and, to a degree, decoration, both have more or less the same dimensions (53 lines within a written space that varies by no more than 3 millimeters), thereby producing the impression of a single, seamless whole that in all essential respects had been planned as such from the beginning.

Regardless of the manuscript's localization, a date of circa 1292–94 accords with the style of the illustrations. Toward the end of the thirteenth century, the agitated angularity and prismatic forms associated with the *Zackenstil* (the jagged style) that dominated much of German painting throughout the thirteenth century slowly give way to a more elongated, pliant, supple, and often sweeter, more sentimental mode of expression.[65] Although the diagrams themselves are impossible to date, let alone localize, the handling of the scant figural elements is consistent with that found in a late thirteenth-century gradual made circa 1290 for a house of Dominican nuns, almost certainly St. Katharinenthal, given that the manuscript served as the model for the famous gradual from that convent, dated circa 1312 (figs. 36 and 37).[66] Another manuscript to which the figural decoration in Berthold's compendium can be compared is a Benedictine martyrology from Strasbourg, dating to the latter part of the thirteenth century, which survives only in the form of fragments (fig. 38).[67] Given that Berthold's name might mean only that he came from Nuremberg, not that he necessarily resided in the city, it could well be that his two-part opus was composed, and the manuscript made, elsewhere, possibly at a Dominican house along the Upper Rhine.

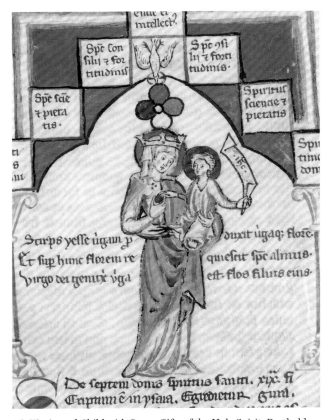

36. Virgin and Child with Seven Gifts of the Holy Spirit. Berthold of Nuremberg, Liber de misteriis et laudibus intemerate Virginis genitricis Dei et Domini nostri Ihesu, Lake Constance region (?), 1292–94. FBG, Memb. I 80, f. 47r (detail). Photo: FBG.

37. Coronation of the Virgin, for feast of Assumption of the Virgin (Gaudeamus omnes), gradual for St. Katharinenthal (Thurgau), Zürich (?), ca. 1290, with additions from first quarter of the fourteenth century. Nuremberg, Germanisches Nationalmuseum, Hs. 21897, f. 168v (detail). Photo: GNM.

38. Crucifixion with Mary, John the Evangelist, and St. Benedict, cutting from a Strasbourg martyrology, Upper Rhine, last quarter of thirteenth century. Mettingen, Draiflessen Collection (Liberna) M. 2. Hilversum. Photo: © Draiflessen Collection (Liberna).

The style, date, and character of the manuscript in Gotha all suggest that it is the presentation copy of the work, prepared under Berthold's supervision. To whom, however, the book would have been presented remains unclear. Any dedication, pictorial or otherwise, at the book's beginning was lost when in the fifteenth century Hrabanus's work was bound in at the front to replace an earlier copy. It may well be that Berthold had the book made for his own convent's library. The presence of small guide letters alongside the decorative initials by either the rubricator or the illustrator (perhaps one and the same person) could be read in several ways. In light of the presence of at least three different scribes, two in the commentary on Hrabanus, the other in the Marian supplement, as well as the principal corrector (one of several, perhaps identifiable with

Berthold himself), Berthold does not appear to have played any significant part in the production of the manuscript per se.[68] The manuscript is a professional production based on Berthold's draft and preliminary sketches for the diagrams, presumably accompanied by color notes, given the importance of color in Berthold's didactic apparatus. In this context it is worth noting that the Basel copy of Berthold's Marian compendium, the second part of the manuscript in Gotha, adheres almost without exception to the colors in the original.

The pair of dedicatory images that frame Berthold's two-part opus, the first falling between the commentary on the cross and that on the Virgin, the second at the very end of the combined works, make manifest the theme of presentation (and self-representation; see figs. 34–35).[69] The first of the two extant presentation images functions as a visual segue between the two commentaries in that it places the kneeling Berthold between Christ on the left (but on the heraldic right), his back to the commentary on the cross, and the Virgin on the right, her back to the opening of the book dedicated to her. In its general outlines, the dedication image resembles a Coronation of the Virgin, except that in this case it is Berthold who kneels between the two holy figures rather than the Virgin Mary (see fig. 34). A similar adaptation of the iconography occurs in the early fourteenth-century Dominican Gradual of Katharinenthal, in which the kneeling soul, standing in for the *Sponsa Christi*, is crowned by Christ and the Virgin, his mother and bride (fig. 39).[70] Dressed in his distinctive Dominican habit, a white tunic, scapular, and capuce, together with a black cappa and capuce, Berthold holds up his book, its open pages echoing those of the opening within which it appears. As if to signal their acceptance of the work, Christ and Mary hold open the verso and recto respectively; with their other hands they present each other a rose and a lily, presaging the prominent place of flower symbolism in the pages that follow. The flowering blossoms that spring from the terminals of the long bench on which they are seated, whose fenestration permits it to double as an image of *Ecclesia*, the Church, amplify the motif as if to

evoke the vivifying power of prayer. The accompanying passage from John of Damascus's *De fide orthodoxa* in the translation by Burgundio of Pisa (d. 1193), better known as the translator of Galen, both underwrites the image and allows certain elements within it to acquire additional meaning.[71] To exegetical elaboration, however, must also be added liturgical; the immediate source for Berthold's borrowing was the fifth lesson for the Feast of the Nativity of the Virgin in the Dominican lectionary.[72] John speaks of the various figures (*diversis imaginibus*) and words (*sermones*) of the prophets and Holy Spirit that in images and speech (*per imaginata et prepredicata*) prefigured Mary's flowering from the root of Jesse (*ex Davitica radice germinata est*). In opening with this passage, Berthold identifies his procedure as biblical, exegetical, and liturgical in inspiration. His images function as the visual equivalents of biblical figures of speech as reinterpreted in exegesis and the liturgy.

Mirroring the first presentation image, the series concludes with a second, nestled between the commentary on the last of the sixty Marian diagrams and the authorial subscription. Christ and the Virgin again are present, this time in the form of a Virgin and Child (see fig. 35). Identified in the subscription as Berthold of Nuremburg, the Dominican kneels in prayer before a deliberately ambiguous image that could represent either the Virgin and Child enthroned or a statue of the enthroned Madonna. The ambiguity, which is by no means unique to this image, lends it the quality of an image that comes to life in response to the petitioner's prayers.[73] Willibald Sauerländer, criticizing much modern writing about the donor figures in Naumburg, memorably dismissed the projection of modern traits into medieval sculpture as "Pygmalionismus," a bringing to life of the statue in the image of the beholder (a view conditioned by the abuse of such images in National Socialist propaganda).[74] Some medieval sculpture, however, was designed both to shape and to elicit similar sorts of projection from its medieval viewers. It is not simply that in keeping with anthropological theories of the image that stress its identification as a body, figural representation automatically invites pro-

39. Coronation of the Soul, gradual of St. Katharinental, Lake Constance region, ca. 1312. Zürich, Schweizerisches Landesmuseum, inv. no. LM 26117, f. 188r (detail). Photo: www.ecodices.unifr.ch.

jection and animation on the part of the viewer.[75] In anticipation of such responses, medieval images self-consciously fashioned and channeled viewer experience in ways specific to their original time and place, practices that can traced to the early Middle Ages.

Paintings such as Berthold's dedication image permitted deliberate play with such expectations. A magnificent missal, most likely from the Benedictine monastery of Prüm and illuminated in Trier circa 1320–30, of which only the summer section survives, complements the initial that opens the canon of the mass, the prayers of consecration. The initial shows a monk as deacon accompanying the priest, who bends over the host and chalice on the altar. A second, no less striking image occupies the right-hand margin; it depicts a second monk holding aloft a

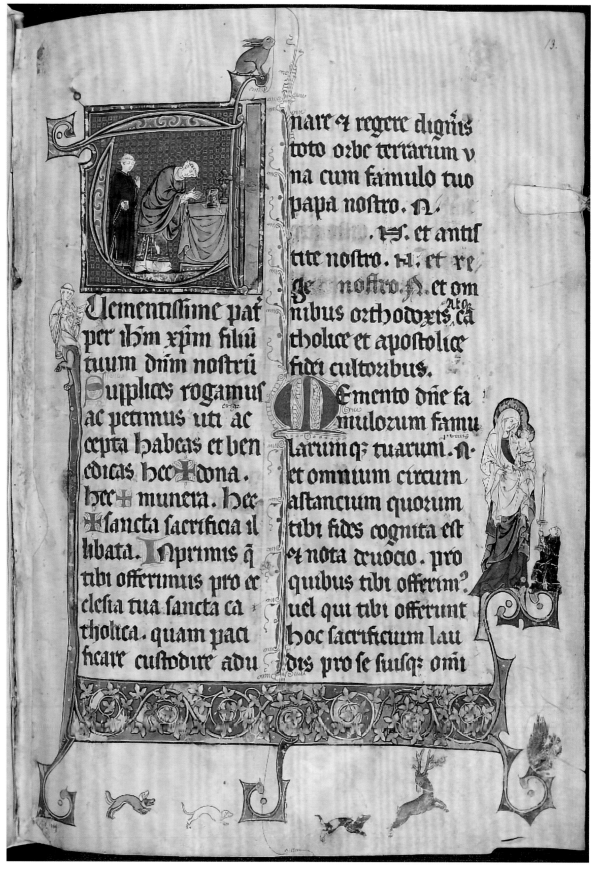

nare 7 regere dignis
toto orbe tertarium v
na cum famulo tuo
papa nostro. N.
. N. et antis
tite nostro. N. et re
ge nostro. N. et om
nibus orthodoxis ca
tholice et apostolice
fidei cultoribus.
Emento dne fa
mulorum famu
larumq; tuarum. N.
et omnium circum
astancium quorum
tibi fides cognita est
et nota deuocio. pro
quibus tibi offerim?
uel qui tibi offerunt
hoc sacrificium lau
dis pro se suisq; omi

Clementissime pa
ter ihm xpm filiu
tuum dnm nostru
Supplicas rogamus
ac petimus uti ac
cepta habeas et ben
edicas hec dona.
hec munera. hec
sancta sacrificia il
libata. Inprimis q
tibi offerimus pro ec
clesia tua sancta ca
tholica. quam paci
ficare custodire adu

40. Canon of the mass, Prüm Missal, Trier, ca. 1320–30. Berlin, Staatsbibliothek zu Berlin—Preußischer Kulturbesitz, Ms. theol. lat. fol. 271, f. 13r. Photo: bpk Bildagentur; Art Resource NY.

41. Sacristan Lighting Oil Lamp before an Altar of the Virgin, southern Germany, ca. 1420–30. Kupferstichkabinett, Staatliche Museen, Berlin, inv. no. 36-1928; Min 12834. Photo: Jörg P. Anders; Art Resource NY.

burning taper in honor of a monumental Virgin and Child (fig. 40).[76] The hint of incarnational vivification suggested in the margin informs the action across the page, in which the bodily presence inherent in the consecrated eucharistic elements cannot be seen, only believed. Although the kneeling monk's action suggests that the Madonna is indeed a statue, her size, reminiscent of the oversize Virgin and Child in van Eyck's *Madonna in a Church* (which the painter also likens to a statue come to life), suggests that she is seen in a vision. The importance of scale can be seen if one compares the marginal image to that in a south German cutting, dated circa 1420–30, in which a nun designated as the "Küsterin" (i.e., sacristan) lights an oil lamp suspended from a rope and hung from the vault canopy that shelters a more realistically scaled Madonna atop an altar (fig. 41).[77]

Berthold's second dedication image immediately follows his final benediction at the end

of the series of Marian diagrams. As usual, he chooses to speak not in his own words but, in this case, those of Bede, as mediated by a lesson from the Dominican lectionary for the Vigil of the Assumption.[78] Wearing the black-and-white habit of his order, the author raises his hands toward Mary, who wears a crown. The Christ Child, identified by a cross-halo, responds by turning toward him. Mary holds a red apple in her hand, a common attribute that identifies her as the new Eve. The Christ Child blesses Berthold with his outstretched right hand; what he holds in his left hand remains unclear, in part due to abrasion at the image's outer edge. The Christ Child's active standing pose represents a fairly recent departure from the largely immobile frontality of the traditional *Sedes sapientiae*. Together, the stances of the two holy figures form a pronounced V-shape inverted by the garments covering the Virgin's lap and legs, so that the overall pattern suggested by the composition is chiastic.

As in the first presentation image, the architectural elements are rich in allusions. The architectural throne on which the couple are seated shows them against a celestial blue ground punctuated by triplets of red dots. The canopy takes the form of an elongated trefoil arch with a small oculus to either side of the central cavity. The ensemble is framed by slender colonnettes which, given the small paired red bands that divide them into segments, should probably be perceived as *en delit* columns held together by reinforcing rings, just as in contemporary Gothic architecture. The pinnacles that extend the columns stand on floral capitals with red abaci whose green leaf foliage is so pronounced as to enhance the effect of living architecture. Capping the structure is a red-and-white roof that lends the whole the character not simply of a tabernacle, to which the previous commentary often compares the Virgin Mary, but of an entire cathedral, suggesting yet another comparison evoked in the preceding texts—namely, of Mary to Ecclesia.

In most respects Berthold's second dedication image conforms to a familiar type. A grandiose representative of the genre prefaces the picture cycle at the front of the so-called *Goldenes Buch* or Golden Book of Hohenwert, a Benedictine convent in the diocese of Augsburg (in fact, a combined Gospel book and lectionary, of which the lectionary dates to the eleventh century and of which the later section with Gospel excerpts was illuminated in Regensburg ca. 1260–65; fig. 42).[79] As in Berthold's image, the dedicator, in

42. Dedication Image, Golden Book of Hohenwert, Regensburg, ca. 1260–65. Munich, Bayerische Staatsbibliothek, Clm 7384, f. 3v. urn:nbn:de:bvb:12-bsb00094632-5. Photo: BSB.

this case a Benedictine nun, probably identifiable as the founder of the convent, Duchess Wiltrudis, kneels before the enthroned Virgin and Child. Across the opening, the miniature faces a second image of the convent's other patrons, Peter and George. Whereas Berthold is of approximately the same size as the seated Virgin to whom he offers his devotion, in the Golden Book (another term for Codex Aureus) the nun is dwarfed by the Virgin's majesty. Both Berthold's Virgin and the mobile Christ Child standing on her left thigh respond to him by looking in his direction; in contrast, in the Golden Book the Virgin and Child, depicted as the lovers of the Song of Songs, remain utterly absorbed in their mutual glances and gestures. What both images share, however, is the doubling of the throne as Church, complete with fenestration above and below, that reinforces the identification of Mary with Ecclesia.

In effect, Berthold's concluding image does double duty, serving not only as a second dedication image but also as the visual equivalent of the authorial subscription that follows. In contrast to dedication images, illustrated explicits or authorial subscriptions are exceptionally rare. In the few cases that exist, the illustration accompanying the explicit, while not incidental to the authorial information that follows, often serves another purpose. This holds true of another Dominican manuscript, the Collectar of Margareta Widmann from the convent of St. Agnes in Strasbourg (fig. 43).[80] On the verso of the penultimate folio (248v), which faces the colophon (f. 249r) in which Margareta records that she completed the writing (and most likely also the illumination) of the manuscript on the Feast of the Annunciation in 1495, the outer and lower margins present a scene of profession in which a Dominican nun—in effect a kind of self-portrait—kneels in prayer before a Virgin and Child. Like the priest in an actual profession ceremony, the rosy-cheeked Christ Child reaches with one hand to bless the new nun while with his other hand he offers her the ring symbolizing her marriage to Christ.[81] The preceding text, a copy of the note (*Professzettel*), a slip of parchment that she would have been obliged to sign at her profes-

sion, represents a document in which Margareta "speaks" in her own voice.[82] Even if what she "says" is formulaic, her words convey a good deal of information. Margareta was born on February 9, 1449, and although she entered the convent on her seventeenth birthday in 1466, she took her oath of profession until death on February 8, 1467, when she was eighteen, in the presence of God, the Virgin Mary, and St. Dominic (virtually present like the saints in the lower margin, who occupy a cloud); the prioress, Margareta de Blumeneck (formerly subprioress of the convent of Unterlinden in Colmar); and Martial Auribelli of Avignon, the general vicar of the order (r. 1453–62 and again 1462–73). Margareta's profession is attended by three saints: Dominic, patron of the order, plus two crowned female saints; one

43. Profession, Collectar of Margareta Widmann, St. Agnes, Strasbourg, ca. 1485. Bonn, Universitätsbibliothek, Hs. S. 1943, 248v. Photo: UB.

of these, the third from the left, is Agnes, patron saint of her convent, who also holds a ring (which in her case refers to her mystical marriage with Christ); the other is almost certainly Margaret, the nun's name saint and after 1475 copatron of the monastery), who assists at the ceremony by holding a processional cross. As in Berthold's book, the image sits between a kind of personal envoi—in Margarete's case, her life-changing profession of fidelity to Christ for all eternity; in Berthold's, a plea for eternal life that closes his commentary on the sixteenth Marian diagram— and the explicit, which in Margareta's case doubles as a colophon.[83]

In providing his Marian commentary with a very personal frame in the form of not one but two dedicatory images, Berthold's ultimate source of inspiration may have been Hrabanus Maurus himself. Most manuscripts of *In honorem sanctae crucis* open with a series of presentation images of which the first portrays Alcuin of York (under the alternate name Albin) taking the author under his protective arm and recommending him to St. Martin, patron saint of the abbey in Tours of the same name, of which Alcuin served as abbot from 796 to 804 (fig. 44).[84] As an image of an author offering his work to a saint, Hrabanus's image has to be distinguished from far more common images, similar in structure, that portray donors in similar fashion. In still other images it is the scribe who offers up the work. The subsequent miniatures in the opening series depict Hrabanus offering his book to Pope Gregory IV and the eventual (not original) dedicatee, Louis the Pious. Both miniatures precede a preface within which an authorial subscription,

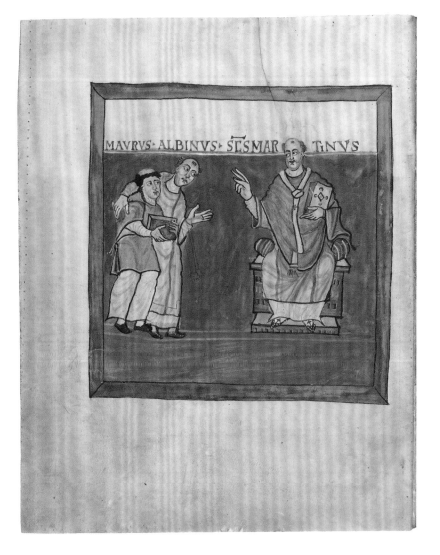

44. Alcuin of York Recommending Hrabanus Maurus to St. Martin. Hrabanus Maurus, In honorem sanctae crucis, Fulda, ca. 840. Città del Vaticano, Biblioteca Apostolica Vaticana, Cod. Reg. lat. 124, f. 2v. Photo: BAV.

"Magentius Hrabanus Maurus hoc opus fecit," is inscribed, followed by a list of chapter headings corresponding to the twenty-eight *carmina figurata*.[85] Like the Holy of Holies, the work proper can only be approached step by step, through a series of intermediary texts and images. Closing the frame of self-referential images at the front and back of the book, the twenty-eighth *carmen* depicts—if *depiction* is the right term for so austere an image—Hrabanus prostrating himself in adoration, not of Christ but simply of the cross (fig. 45). The intext defined by his body reads: "O Christ, in your mercy, I beseech thee, protect me, Hrabanus, on the day of judgment."[86] The Carolingian monk faces back toward his text. Of this page, Hrabanus writes: "Truly, my image, which I have painted beneath the cross bending the knee and praying, is written in Asclepiad me-

ter."[87] Hrabanus's reference to a specific form of choriambic meter, which he most likely learned from Horace, hints at a pride seemingly at odds with the humility expressed by the accompanying image. More important, however, is his insistence that his "self-representation" ("self-portrait" would be entirely wide of the mark) is both painted and written. Hrabanus depicts himself in profile; frontality is reserved for the full-page image of Christ in the first *carmen* (see fig. 20).[88]

Alcuin had been Hrabanus's teacher; he was, moreover, the author of at least a pair of *carmina cancellata* in the manner of Optantianus Porfyrius, one on the cross, the other a panegyric in praise of Charlemagne.[89] Alcuin in turn could look back to the example of Venantius Fortunatus (ca. 530–600/30), bishop of Poitiers, whose

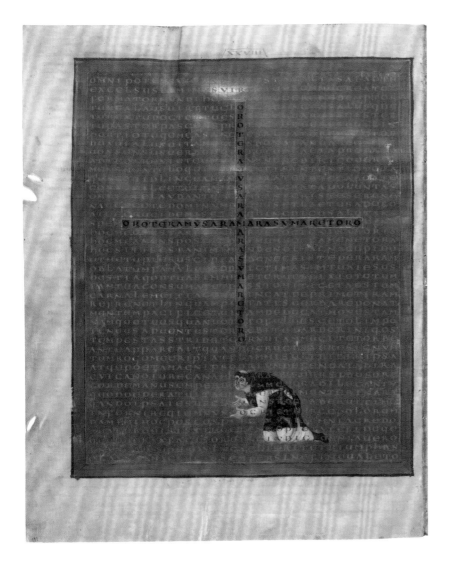

45. Carmen XXVIII. Hrabanus Maurus, In honorem sanctae crucis, Fulda, ca. 840. Città del Vaticano, Biblioteca Apostolica Vaticana, Cod. Reg. lat. 124, f. 35v. Photo: BAV.

large corpus includes three *carmina figurata* (2.4–5 and 5.6) on the theme of the cross, the salvific sign that the poems, by virtue of their presentation on the page, make visible, in keeping with the theology of the incarnation.[90] A letter by Fortunatus (6.7), addressed to Syagrius, the bishop of Autun, in which he characterizes the accompanying picture poem (5.6) as a gift proffered in exchange for a prisoner held captive by the bishop, describes in great detail the process by which such a poem was composed and conveys the intersection of artifice and devotion that informed both their writing and their reading. Fortunatus begins by invoking Horace's *Ars poetica* to justify his combination of a poem and a picture: "What then what should my modesty offer as a gift? As I was hesitating to decide, in my inertia the words of Pindaric Horace came to mind: 'Painters and poets have always enjoyed equal sanction to dare anything.' In pondering the verse, I wondered, if each artist intermingles whatever he wants, why should not their two practices be intermingled, even if not by an artist, so that a single web be set up, simultaneously a poem and a painting?"[91] Comparing the prisoner whose freedom he seeks with humankind freed by Christ's sacrifice, the poet makes, as it were, a prisoner of himself by imposing on himself a constraint in the form of a grid of thirty-three letters, corresponding to the thirty-three years of Christ's life: "I wove a poem of just that number of verses and letters. Consequently what was I to do or where was I to go, deterred, as I was, immediately by the difficulty of the task or rather in difficulties because inhibited by the constraints of meter and the restraint on the number of letters?" He adds, "I began to be bound by a task undertaken for a man to be freed and, with a reversal of roles, I enchained myself as I sought to remove the captive's ties." The letter further characterizes both the pictorial form of the poem (a cross made up of two intersecting diagonals set within a square) and the color red in which the intexts are written, the whole constituting, in the poet's words, a "loom of letters," a metaphor that puns on the double meaning of *textus* as both text and textile and which the poet allegorizes by comparing its texture to that of the priestly garments described in the Old Testament.

Both of Alcuin's poems are preserved in a composite manuscript in Bern (Burgerbibliothek, Cod. 212, ff. 111r–122r), most likely produced in its entirety at the cathedral school of Mainz in the first third of the ninth century.[92] In addition to a rich assortment of such works, the codex includes a copy of the *Institutiones* of Cassiodorus, a work that stands at the origin of diagrammatic imagery in the medieval West (figs. 46–47). The poem dedicated to the cross provides a clear precedent for Hrabanus's practice. Picked out in letters penned in ruddy minium (a pigment derived from red lead), the intext forms a Greek cross within a rhombus. The poem falls into two parts, one above, one below the cross-arm of the cross. The first half outlines Christ's role in the salvation of humankind; the second sings the praises of the cross. The intext itself, beginning "Crux, decus es mundi" (Cross, you are the glory [also the ornament] of the world), speaks of the salvific power of the cross reaching all four corners of the world ("Crux pia vera salus partes in quattuor orbis"). In other words, the content of the poem itself is diagrammatic and cosmological in character. Hrabanus himself described the world as being quadrangular in his encyclopedic work of natural history, *De universo*.[93] The allusion to the cross's fourfold nature points to the geometry of the page: if one subtracts the row and column of letters forming the cross itself, there remains a quadrangle thirty-six letters in length on each side, a number that medieval exegetes considered to be perfect in that it is the product of 6 times 6.[94] The diagrammatic poem doubles as a figure of the *mundus tetragonus*, a geometrical figure of perfection derived from antique scientific and mathematical treatises and mediated to the early Middle Ages by Boethius's *De arithmetica*. In addition to representing the perfect order and harmony of creation, it provided the underpinning for images of Christ in Majesty (fig. 48).[95] Images of the *Majestas Domini*, which at the time Hrabanus wrote were not yet ubiquitous, built on such schema, inherited from antiquity, by overlaying them with other sets of four: the Evangelists and the rivers of paradise.[96]

Berthold may have drawn from Hrabanus the idea of framing his Marian commentary with a pair of dedicatory and devotional images. He must, however, also have been familiar with more modern examples. Images of donors presenting their gifts (whether a manuscript or an entire monastery) to Christ, Mary, and the saints, placed at the front of manuscripts, are plentiful, as are comparable images of book owners offering up their devotions.[97] One such image, prefacing a manuscript of sermons and the treatise *De virtutibus* by Richard de Saint-Laurent (Saint-Omer, BM, ms. 174, f. 2v), depicts a male figure kneeling and offering a book to the Virgin and Child.[98] The hand of God appears above, conferring his blessing on the donation. As in Berthold's second dedicatory image, the Christ Child offers Mary an apple. In contrast, however, the

46. Alcuin, Versus de sancta cruce ad Carolum, Mainz, Cathedral School, first third of ninth century. Burgerbibliothek Bern, Cod. 212, f. 123r. Photo: Burgerbibliothek.

47. Third Division of All Numbers. Cassiodorus, *Institutiones*, Mainz, first third of ninth century. Bern, Burgerbibliothek, Cod. 212, f. 65r. Photo: Burgerbibliothek.

man kneeling at the Virgin's feet is not the author. Rather, as indicated by the compartmentalized inscriptions written beneath the two figures in burnished gold—a surprising display of luxury in a Cistercian manuscript, even at this late date—he is the donor, Robert de Béthune, abbot of the Cistercian monastery of Clairmarais in the diocese of Arras from 1257 to 1266 ("Robertus abbas de Claro Marisco").[99] One thing the im-

age does have in common with Berthold's: the standing Madonna resembles nothing so much as a statue of the Virgin Mary yet remains deliberately ambiguous. The burnished gold ground, which breaks the otherwise heraldic chiasmus of blue and pink panels, lends the image a visionary air.

Far less common than such images are dedicatory miniatures that, as in Berthold's book,

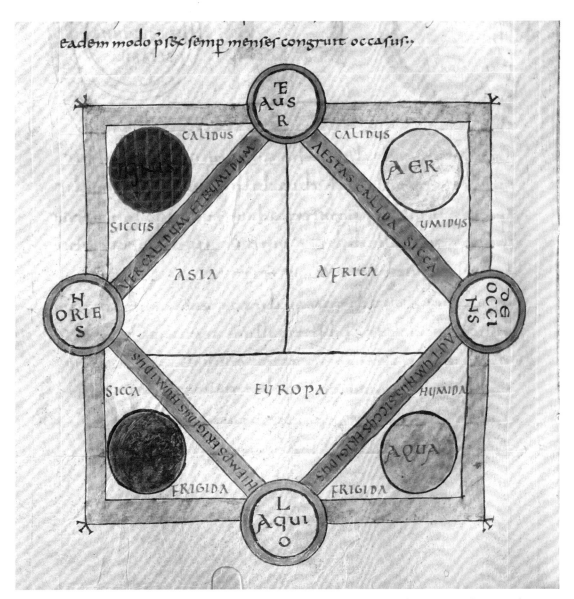

CALIDUS CALIDUS

SICCUS UMIDUS

ASIA AFRICA

EUROPA

SICCA HUMIDA

FRIGIDA FRIGIDA

48. Mundus tetragonus, astronomical-computistical miscellany, St. Peter's, Salzburg, after 818. Munich, Bayerische Staatsbibliothek, Clm 210, f. 132v. Photo: BSB.

come in pairs, one at the beginning, another at the end of a given work. Among the most striking examples occurs in not a German but a French manuscript that is more or less contemporary with that in Gotha, a deluxe copy of the *Coutumes de Beauvaisis* by Philippe de Beaumanoir, datable to the last decade of the thirteenth century.[100] At the front of the codex, prefacing the prologue, a male figure kneeling with clasped hands offers up his prayers to the enthroned Virgin and Child (fig. 49). As in Berthold's second dedicatory image, Mary holds an apple, signifying her status as the New Eve. Christ also holds a small disc (also an apple, less likely a host) in his

left hand, identifying him as the New Adam. Although the Christ Child sits rather than stands, he too extends his right hand in blessing. Also analogous to Berthold's image is the architectural canopy that, in addition to placing the otherwise schematic scene in an implied interior, reinforces an identification of Mary with Ecclesia. Augmenting the image at the front of the book, a second (f. 223v) at the end again shows a male figure, presumably the author, offering his book to Christ and the Virgin (fig. 50).[101] In the miniature the *Coutumes*, which in their modern edition occupy three volumes, appear to fill two, of which one already rests in the hands of the Vir-

49. Dedication image. Philippe de Beaumanoir, Coutumes de Beauvaisis, Beauvais (?), ca. 1290–1300. Berlin, Staatsbibliothek zu Berlin—Preußischer Kulturbesitz, Ms. Hamilton 193, f. 1r (detail). Photo: bpk Bildagentur; Art Resource NY.

50. Dedication image. Philippe de Beaumanoir, Coutumes de Beauvaisis, Beauvais (?), ca. 1290–1300. Berlin, Staatsbibliothek zu Berlin-Preußischer Kulturbesitz, Ms. Hamilton 193, f. 223v (detail). Photo: bpk Bildagentur; Art Resource NY.

gin, seated to the left, while the second is blessed by Christ, who is in the process of receiving it from the author's hands.[102] If in the first image the author prays for Mary's assistance (contrary to the letter of the prologue that the image introduces, in which the author beseeches the Trinity), in the second, having successfully completed his magnum opus, he presents it to Christ, who passes it on to Mary, its ultimate recipient. Overleaf from the first miniature (f. 1v) there comes yet a third for which there is no equivalent in Berthold's book, a scene of dictation that serves to authenticate the ensuing text by attaching it to the author's oral delivery.[103]

Diagrammatic Didacticism

As a *lector*, that is, literally, a reader, Berthold also no doubt engaged in the oral performance of texts. Yet everything about the manuscript in Gotha identifies it as a book that was made to be seen, not simply heard. By identifying Berthold

as a *praedicator* and *lector* of (not necessarily at) Nuremberg, the second explicit provides a precious, if imprecise, indication of the work's possible function. The distinction between *praedicator* and *lector* is significant. All Dominicans were trained to be preachers; a *lector*, in contrast, was the person within the convent who was charged with training them.[104] In short, a lector was a highly respected member of the order. In his *Instructiones de officiis ordinis*, Humbert of Romans, who served as the fifth master general of the order from 1254 to 1260, opens his chapter on the office of the lector by declaring that "the duty of a good lector is to conform himself to the capacity of his listeners; to lecture clearly and understandably upon things both useful and profitable to them; to shun new opinions and to hold to the older and more secure opinions; and never to talk about things he does not fully understand himself."[105] Although Berthold does not make use of the core teaching texts recommended by Humbert—beyond the Bible, the *Historia*

scholastica of Petrus Comestor and the *Sentences* of Peter Lombard—in compiling his work almost exclusively from the Bible, Church Fathers, and monastic authorities, many in excerpts taken from the Dominican liturgy, he certainly champions older authors, whose writing, it must be emphasized, continued to be read throughout the Middle Ages.[106] In no way does his diagrammatic discourse adhere to the guidelines laid out by the *artes praedicandi*, manuals on the art of preaching.[107] Moreover, such manuals, most of which date to after the mid-fourteenth century, by which time the form of the modern Dominican sermon had long since been established, "summarized the current rhetorical practice of the pulpit more than they charted its course; they followed the trends but did not set them."[108] The Dominican art of preaching had to be lived as well as learned; in the words of Humbert of Romans, the arts, including that of preaching, "consist in doing and are better learned by the showing of examples than through the teaching of the Word."[109] It was in part to this opposition that Meister Eckhart, himself a lector who twice had lectured in Paris, in 1293–94 and again in 1302–3, referred in a saying attributed to him that distinguished between masters of the page ("Lesemeister") and masters of life ("Lebemeister"): "A Lebemeister is more necessary than a thousand Lesemeister, but to read and to live without God, no one can come to that. If I wanted to find a master of scripture, I would seek him in Paris and in the schools of higher learning. But if I wanted to inquire after the perfect life, he wouldn't be able to tell me anything about it."[110] In contrast to a lector, whose activities as such were very much an in-house affair and conducted in Latin, a praedicator's activities were addressed to a lay public outside the walls. Berthold's meditative work is more inner directed.

In addition to implying something of his work's function and hence its intended reception, the wording of Berthold's second explicit also provides some indication of its manner of composition. Rather than simply stating that Berthold wrote the work ("scripsit," here to be understood in the sense of "composuit"), the explicit speaks of his having collaborated ("con-

scripsit," written with). The explicit further notes that Berthold "arranged" the work ("ordinavit," literally, put it in order) and edited it ("edidit").[111] The formula "conscripsit et ordinavit" can be traced back at least as far as the Roman breviary, which speaks of Pope Boniface (r. 418–22), inspired by the Holy Spirit, having coauthored ("conscripsit") and ordered ("ordinavit") it according to the old songs or chants ("cantilena") of the liturgical year.[112] The liturgist Sicardus of Cremona (1155–1215) employs the same formula to characterize the writing activity of Pope Gregory the Great.[113] In the *Didascalion*, Hugh of St. Victor (1096?–1141) speaks of Plato in his capacity as the disciple of Socrates having cowritten ("conscriptsit") many books, among them *The Republic*, which Cicero then set forth and reorganized ("ordinavit") in his own *De republica*.[114] In 1374 Bishop Albert of Halberstadt (ca. 1320–90), better known as the philosopher Albertus de Saxonia, being, according to the document, of sound mind and body, witnessed the will of the canon Ludolph of Neindorp by signing with his own hand ("ac sua manu propria conscripsit") the testament that he, Albert, had set out ("ordinavit").[115] Copyists of Berthold's work found his formula for describing his manner of composition striking enough that they made a point of reproducing it. All four of the unillustrated manuscripts of Berthold's commentary on Hrabanus now in Munich include subscriptions with wording along the lines of that in the copy from Tegernsee (Munich, BSB, Clm 18188, f. 20v): "Explicit liber de misteriis et laudibus sancte crucis ordinatum et conscriptum ex libro Rabani de sancta cruce ad honorem et laudem ipsius sancte crucis salutis et finitum." It is as if the formula had become part of the work's title.

None of this evidence compels one to conclude that Berthold himself had a hand in the making of the manuscript in Gotha, which is a highly polished, professional product. To the contrary: "conscripsit" provides a perfect description of Berthold's manner of proceeding by "writing with," that is, adding to, the church fathers and monastic authorities whose excerpted works constitute the bulk of his compilation. "Edidit" likely refers to his having selected the

texts, much as the editor of a modern anthology might do, or to his having corrected the definitive exemplar. All the evidence points to the manuscript in Gotha, the sole extant copy of Berthold's complete opus, as being this presentation copy, made with his participation and under his direct supervision.

Attitudes toward compilation as a form of authorship have fluctuated wildly over time. Whereas postmodernism acclaimed bricolage, pastiche, and appropriation, modernism's cult of originality gave compilation a bad name. Not that compilation was always frowned on, even within modernism itself. Of his *Arcades* project, Walter Benjamin famously said (N1a,8): "Method of this project: literary montage. I needn't say anything. Merely show. I shall purloin no valuables, appropriate no ingenious formulations. But the rags, the refuse—these I will not inventory but allow, in the only way possible, to come into their own: by making use of them."[116] Berthold hardly regarded his sources as "refuse" recovered from the ash heap of history, but in offering next to no commentary on his sources, he did allow them to speak largely for themselves.

In the Middle Ages compilation constituted a form of authorship.[117] An author might compile a *florilegium*, literally a bouquet of flowers, according to an organizing principle, not simply to save reader time or even to direct their attention to a particular assortment of authorities, but rather to prompt them to undertake the work of arranging them. In keeping with the practices of the medieval art of memory, compilations aimed to be productive, not simply reproductive.[118] By the early thirteenth century, however, let alone the turn of the fourteenth century, when, taking Hrabanus as his point of departure, Berthold compiled his commentaries on Christ and the Virgin, attitudes toward compilation were shifting. In his own order, collections of *distinctiones*, arranged alphabetically by subject matter, brought together multiple *auctoritates*, usually from the Bible but sometimes from other sources, all of which revolved around the same term. The various figurative meanings assigned a given word served as fodder for sermons, defining its different divisions.[119]

In the first book of his Sentence commentary, Bonaventure (1221–74), the great Franciscan theologian, philosopher, and preacher, defines the role of the compiler in comparison to those of the scribe, commentator, and author in keeping with the standards of his day. Whereas the scribe merely copies what he has before him, neither adding nor changing anything ("nihil addendo vel mutando"), the compiler rearranges texts that he himself did not compose ("Aliquis scribit aliena addendo, sed non de suo"). The commentator, in turn, adds to what he has before him ("Aliquis scribit et aliena et sua, sed aliena tamquam principalia et sua tamquam annexa ad evidentiam"), whereas the author's work is principally his own ("Aliquis scribit et sua et aliena, sed sua tamquam principalia, aliena tamquam annexa ad confirmationem").[120] Berthold's method combines perfectly Bonaventure's characterizations of the compiler and commentator and could be said to stand somewhere between the two. In its reliance on authorities, primarily patristic and monastic, Berthold is, for his day, rather old-fashioned. Yet in its rigorous subdivision into numbered sections, ordered according to principles of numerology, and its use of a variety of marginal source signs and paraph marks, his book, despite its essentially monastic and liturgical content, displays all the telltale signs of scholastic *ordinatio*. Its Janus-faced character, forward looking in terms of its organization, backward looking in terms of its devotional and liturgical underpinnings, goes a long way toward helping us understand its likely function. Berthold's book is both didactic and devotional, geared both to the requirements of teaching and preaching and to prolonged meditation on the mysteries of the cross and the Virgin Mary within the larger plan of salvation.

Reading reflects material as well as mental habits. From a modern perspective, the ways in which Berthold's book organizes and presents his materials seem unobtrusive, even unremarkable. Each and every aspect, however, has a history that speaks to the author's purpose and to the reader's experience. Among these elements is something as seemingly simple as the layout of the page. In an article published in 1981,

sometimes credited with marking the origins of modern "diagrammatology," W. J. T. Mitchell asked: "If we cannot get at form except through the mediation of things like diagrams, do we not then need something like a diagrammatology, a systematic study of the way that relationships among elements are represented and interpreted by graphic constructions?"[121] Mitchell's question anticipated current interest in the materiality of texts and other forms of communication, although in terms of today's paradigms it might have been just as well to ask for a systematic study of the ways in which, as in the Alton Towers Triptych, graphic constructions themselves construct rather than simply represent such relationships. In medieval manuscripts, however, even those without diagrammatic illustrations, a diagrammatic element is built in from the start insofar as all the elements—mise-en-page, justification, margins, miniatures, even the internal structure of illustrations—are to a large extent determined or at least conditioned by the system of ruling within which they all have to be accommodated.[122] Medieval texts, whether illustrated or not, are effectively laid down on a kind of graph paper. The ruling serves as a set of guidelines in the sense the term is used by Tim Ingold: lines that are "intrinsic to the plane, as its constitutive element" as opposed to "plotlines," which are "extrinsic"—that is, their "erasure would leave the plane intact."[123] Drawing on the metaphorics and etymology of the term *textus*, Ingold makes the ruling in medieval manuscripts his principal example of the "guideline," a concept and practice that he traces, very much in the manner of Gottfried Semper, back to the process of weaving.[124] The medieval method of inscription, one could say, was predisposed to the diagram simply by virtue of its materiality.

Both parts of Berthold's work, the commentary on Hrabanus and the Marian supplement, open with a list of sections, in effect a table of contents, characterized in scholastic terms as a "division" of the book.[125] Although Pliny's *Natural History* was perhaps the first book to employ such a table, Berthold's immediate source of inspiration lay in scholastic texts, of which the most influential was Peter Lombard's *Sen-*

tences, written in Paris between 1156 and 1158, which employs both chapter headings and, at the front of the book, a list of such headings, both of which can be attributed to the master himself.[126] The Lombard himself refers to this practice in his text, informing his readers "that it will not be necessary for the seeker to turn through numerous books, for the brevity [of the *Sentences*] offers him, without effort, what he seeks. . . . So that what one is looking for can more easily be found, we have placed in advance [literally, sent ahead] the titles by which each of the single books is distinguished."[127] By Berthold's day, this practice, which represented a real innovation in the mid-twelfth century, when the Lombard wrote his commentary, had become standard practice.[128]

Berthold's reworking of Hrabanus falls into thirty-three parts (corresponding, perhaps, as in the case of Fortunatus's picture poem, to the thirty-three years of Christ's life): a preface (missing in Gotha but present in other copies) and a concluding *benedictio*, between which thirty-one diagrams elaborate Hrabanus's twenty-eight poems.[129] Already here one can observe a certain independence on Berthold's part. Whereas Hrabanus provided each of his figure poems with an explanation, in most manuscripts placed on the facing recto, as well as a recapitulation in prose contained in a second book, Berthold translates the picture poems into diagrams accompanied by appropriate passages largely lifted from Hrabanus's book 2, to which he then adds a few words of his own, introduced by a red pilcrow or paraph (¶, in Latin *alinea*, literally, off the line).[130]

In distinguishing between his own words and those of his authorities, and in employing an unmistakable visual device in order to do so, Berthold subscribes (in the sense of writing at the bottom) to a practice that was developed in the schools, beginning in the twelfth century, to ensure that readers would not confuse commentary with the *sententia*, that is, the opinions, but more literally the sentences of the authorities gathered on the page. The extent to which seemingly minor markings attach Berthold's practice—and with it, the mise-en-page of his manuscript—to established scholastic tradition may seem a

minor point, but it is worth insisting on, as it governs the structure, visual as well as intellectual, of the work as it is presented on the page. Berthold's pilcrow marks distinguish his *magistralia* from the *authentica* of his authorities.[131] The clear differentiation between levels within the text supports an equally distinctive practice of reading (*lectio*) cultivated in the schools, one that insists on regular divisions in the form of classroom exercises linked in turn to habits of memorization. Claire Angotti has characterized the imposition of such regular divisions onto texts and their consistent reproduction across multiple copies a part of the "normalization" of new habits of reading that were developed in the schools.[132] The great pedagogue Hugh of St. Victor lays down the foundations for this linking of memory and mise-en-page in his short treatise *De tribus maximis circumstanciis gestorum*. Moving on from the value of number as an aide-memoire to that of location, specifically, location on the page, Hugh observes:

> Have you ever noticed how a boy has greater difficulty impressing on his memory what he has read if he often changes his copy [of a text] between readings? . . . Therefore it is a great value for fixing a memory-image that when we read books, we strive to impress on our memory through the power of forming mental images not only the number and order of verses or ideas, but at the same time the color, shape, position, and placement of the letters, where we have seen this or that written, in what part, in what location (at the top, the middle, or the bottom) we saw it positioned, in what color we observed the trace of the letter or the ornamented surface of the parchment.[133]

Hugh compares the reader's confrontation with the painted page to an encounter with a person with distinctive facial traits.[134] His little work concludes with an explanation of the diagram—essentially a chronological table of biblical history modeled on the format of the canon tables found at the beginning of Gospel books—that exemplifies the method he recommends to his pupils.

The margins of a manuscript represent the principal place in which habits of reading, primarily in the form of glosses and marginalia, play out. In this Berthold's book is no exception. A separate hand, not identical to that of any of the three scribes responsible for the body of the text, used the outer margins to provide cues both to biblical books referenced in the text and to the names of authors whose works supposedly provide the sources for Berthold's compilation (see figs. 1–2).[135] The use of source marks as a scholarly tool and aid to readers appears to have been invented by Bede and could stand as the origin of the footnote.[136] Hrabanus Maurus also made use of them, especially in his commentary on Kings. In a letter written in 829 to Abbot Hilduin of Saint-Denis, he writes:

> And I noted in the margins of the pages their various names, where they are their proper words; where their true sense was expressed in my words or where their sense was nearly similar, in proportion to the divine grace worthy of being granted to me; from the beginning I wrote the letter *M* indicating the name Maurus, because my teacher of blessed memory, Alcuin, instilled in me that I take care to make notes in this manner so that the diligent reader would know what anyone made known of himself and discern which one was to be noted in each.[137]

In this case also it is just conceivable that Berthold once again took the abbot of Fulda as his source of inspiration. A more immediate source, however, could have been found in glossed schoolbooks of the twelfth century, for example, in copies of Peter Lombard's *Sentences*, in which passages quoted in the main body of the text were marked in the margins by brackets, usually drawn in red ink, which often trail from the name of the cited authority.[138]

Berthold's scribes employed variants of both devices. Authors' names, noted in the margins, occur predominantly in the rubrics to the various sections. It should come as no surprise that not all the attributions are accurate.[139] The majority of marginal callouts referring to biblical passages

occur in Berthold's additions to the authorities appended to the diagrams in the Marian supplement. The way in which Berthold strings passages together suggests that he may have relied on biblical *distinctiones* with a strong typological bent.[140] As a Dominican friar, among whose duties were preaching, Berthold must have been familiar with such tools as sets of *distinctiones*, which served both as practical aids and a form of exegesis. Additional marks, resembling inverted check marks, take the form of *positura* (defined by Alcuin as "punctuation marks . . . to distinguish meanings"; see fig. 2).[141] This form of punctuation was created in part to meet the demands of liturgical readings, of which many of the texts excerpted by Berthold are examples.[142] Although developed as a form of punctuation, they here reside in the margins, where they function as a shorthand equivalent of brackets and indicate, in keeping with Isidore of Seville's definition, the end of one passage and the beginning of another. Although not applied systematically, these signs were, to judge from the color of the ink, provided by the original scribes.

Berthold would also have been familiar with the latest innovations in marginal apparatus from copies of the exemplar of the Dominican liturgy, disseminated from the Dominican house of Saint-Jacques in Paris following the reform of the order's liturgy in 1256.[143] The exemplar (Rome, Sta. Sabina, Ms. XIV.L.I) is remarkable not only in containing an elaborate marginal apparatus but also in explaining how it works. The letter *A* for "abbreviatus" placed at the opening of a given lesson (or reading for the office) indicated that the passage in question had been abbreviated, whereas the letter *T* ("translatio") indicated that the lesson paraphrased its source, which, as the text notes, was rarely the case.[144] No letter at all indicated that no notable change in wording had occurred.[145]

One of Berthold's scribes marked some, if hardly all, of the questions within the text with the marginal sign *Qo* for "Questio." These marks, with the *Q* written above the *o*, represent the origin of the question mark (another theory would trace it to the punctuation mark known as the *punctus interrogativus*).[146] The majority of these

occur in the Marian supplement. Given how frequently Bernard of Clairvaux, one of Berthold's principal sources in this section, employed rhetorical questions in his prose, the *Questio* signs occur with some frequency.[147] These markings provide a clue to how the manuscript was to be used. The *questio* or question played an essential role in scholastic discourse; treatises, like classroom disputations, were structured around such questions, both sides of which were argued.[148] So prominent was the letter *Q* in medieval texts structured around rhetorical questions that it even became the subject of visionary experience. "While sitting on his bed after Compline, a certain brother [the early thirteenth-century Cistercian Richalm of Schöntal] keeping watch saw in front of him the letter *Q* written many times each separated in turn from the others and written as if in pure cinnabar [vermillion] in that form in which capital letters ought to be written, and much though he tried, he could not figure out what it meant."[149] In due course it dawns on Richalm that he is being instructed to read Gregory's *Moralia in Iob*, a monastic classic of which manuscript copies are peppered with prominent letter *Q*s.[150] Berthold's students would presumably have had less difficulty; the questions thus highlighted are not scholastic propositions. Nonetheless, they are clearly regarded as cruxes and intended to provoke the reader to ponder his own answer along the lines that the text sketches out. The images, in not illustrating the commentary per se but rather in diagramming it, serve much the same purpose.

It remains unclear whether it is possible to know anything about Berthold beyond what evidence the manuscript in Gotha provides. An explicit at the end of one part of a composite manuscript (Uppsala, University Library, Hs. C.78, ff. 91r–120r), dated to the first half of the fourteenth century, identifies its compiler as the Dominican Berthold of Wimpfen, using a formula strikingly similar to that employed in the second explicit in the manuscript in Gotha: "Hoc opus conscripsit et ordinavit frater Bertoldus de ordine fratrum praedicatorum quondam lector Wimpinensis anno domini M°CCC°I° anima eius requiescat in pace. Amen."[151] All that differs from the equiv-

alent passage in the manuscript in Gotha is the place with which the Berthold in question is associated: Wimpfen. The three works gathered in this portion of the codex, which at one point entered the library of the Birgittine monastery at Vadstena, carry generic titles: *Hortus spiritalis*, *Speculum virtutum*, and *Collationes sanctorum doctorum*. Each florilegium consists of a collection of *sententiae* or moral sayings attributed to church fathers and monastic authorities such as Bernard of Clairvaux and Hugh of St. Victor. All three offer classic examples of the genre. Like Berthold of Nuremberg's works, those in Uppsala would have served primarily as instructional aids employed within the convent, although as handy lists of wise sayings grouped by topic, the florilegia would also have been useful in the preparation of sermons.[152] In effect, they offer shortcuts, not unlike *Bartlett's Familiar Quotations*.

According to its prologue, the *Hortus spiritalis*, which culls passages on a variety of topics from writings by or attributed to Bernard of Clairvaux, offers its readers "the spiritual sweetness of smell" and "the flowers and fruits of honor and honesty."[153] The second work (ff. 106r–111r), intended to serve as a "mirror of virtue," in turn extracts fifty passages from the writings of the ever-popular Gregory the Great.[154] The third (ff. 111r–120r) mirrors the second in consisting of fifty quotations, in this case, however, ten apiece attributed to five different church fathers: Ambrose, Augustine, John Chrysostom, Jerome, and Bede. Alessandro Palazzo, who has edited the florilegia, states, "As one would expect from the titles of these collections and the authorities quoted, the sentences collected in the three texts concern theological issues; recurring topics are God, the Virgin Mary, Christ, the Holy Cross, sacraments, sin, virtues and vices, religious life and its various states, eternal beatitude, etc."[155] The clear organization of these compilations, with lists of headings in the manner of a table of contents corresponding to the numbered parts, mirrors that found in both works in the manuscript in Gotha, each of which opens with just such a list, that for the commentary on the cross on folio 41r (incomplete due to the loss of the preceding folio) and that for the commentary on the Virgin Mary on folio 54r (fig. 51).[156] Indeed, other than the fact that the authorities assembled are shorter and lacking illustrations, the contents of the two manuscripts are organized in very much the same manner. Just as the manuscript in Gotha presents its two parts as components of what is effectively a seamless whole, that in Uppsala treats the three florilegia as if they were essentially all parts of a single work. All three are written out by the same scribe and employ the same codicological conventions to parcel out the material.

It is tempting to identify both Bertholds with one and the same person.[157] To do so, one simply has to assume that the Berthold in question moved from Nuremberg, where according to the manuscript in Gotha he was located in 1292 (at least if one assumes his full name to register not

51. Berthold of Wimpfen, Hortus spiritalis, Speculum virtutem, and Collationes sanctorum doctorum, southern Germany (?), first half of the fourteenth century. Uppsala, University Library, Hs. C.78, f. 107r. Photo: University Library.

his place of origin but the locus of his activity), to Wimpfen im Tal (the valley in question being that of the Neckar in Baden-Württemberg) no later than 1301, the date given by the explicit in Uppsala. On today's roads from Nuremberg to Bad Wimpfen, the site of a dramatically situated Pfalz of the Staufer dynasty high above the river, is only 172 kilometers. More important, given the mobility of Dominicans in the Middle Ages (witness Meister Eckhart), Wimpfen was home to an important convent of Dominican friars, a large part of whose library, albeit almost exclusively from the fifteenth century, survives.[158] One can only speculate, but Berthold's transfer from Nuremberg in Franconia to Wimpfen in modern-day Baden-Württemberg, which in turn lies closer to the Upper Rhenish region to which, on the basis of style, the manuscript can best be localized, might explain the apparent disjunction between the author's place of origin and that of the artist who illustrated it on his behalf.

Such speculation aside, the identity of the two Bertholds with one another seems likely but can hardly be considered certain. Already in the Middle Ages, confusion as to his identity and origins appears to have reigned. As corrected, the authorial subscription at the end of Berthold's Marian commentary in Basel (f. 50r) locates Berthold in yet another place: Würzburg ("Herbipolis") in Franconia, no more than seventy miles from Nuremberg (fig. 52). As originally written out, presumably after the equivalent passage in the manuscript in Gotha, the wording, like that in the model, associates Berthold with Nuremberg ("Hunc librum de mysteriis et laudibus intemerate virginis Marie conscripsit ordinavit et edidit frater Bertoldus de ordine fratrum predicatorum quondam lector Nurembergensis anno dei M°CC°XCIIII°"). But in this instance, portions of the subscription have again been corrected. The dedication miniature above the subscription has unfortunately been excised. In Basel the subscription's wording reproduces precisely its corrected form in Gotha. In this case, however, the correction serves not to ensure that Berthold is designated a lector of the Dominican order; rather it is his association with Nuremberg that is challenged: "Nurembergensis," originally writ-

ten in the same red ink as the rest of the rubric, is struck through and replaced in brown ink by "Herbipolensis."

Loris Sturlese has posed the question whether a *lector* with Berthold's intellectual profile, which he characterizes as quite modest, was typical or exceptional in the years around 1300.[159] He himself reserves judgment. Some preliminary observations, however, can be made. The disparity between Berthold's apparent intellectual horizons, at least as reflected in his extant works, and the loftier philosophical and mystical speculations of other German Dominicans of the period, among them not only Eckhart but also lesser known figures such as Dietrich of Freiburg (1250–1310) and Berthold of Moosburg (d. after 1361), has more to do with the partitions segregating modern academic specializations than

52. Authorial subscription. Berthold of Nürnberg, Liber de mysteriis et laudibus intemerate Virginis Mariae, composite manuscript, Basel (?), Dominicans, early fourteenth century. Basel, Universitätsbibliothek, Cod. B IX 11, f. 50r. Photo: UB.

it does with life among the Dominican intelligentsia. To be judged, such works need to be restored to their *Sitz im Leben*. Berthold's working procedure in his commentaries on Hrabanus and the Virgin Mary, to be discussed in greater detail in the following chapters, makes this clear. In the first commentary he excerpts Hrabanus; in the second he draws liberally, if not exclusively, on a wide range of authorities most of which are culled from readings that formed part of the Dominican liturgy. The liturgy itself can be regarded as a florilegium of sorts: not only does it quote and paraphrase the Bible but it appropriates and distributes, in the form of lessons or readings, portions of a great variety of patristic and monastic texts in a manner identical to that employed by Berthold in his extant works.[160] Berthold's florilegia and commentaries composed of quotations seem at odds with Dominicans' scholarly pursuits only if one forgets that it was their duty to celebrate the liturgy each and every day. Liturgy required them, at least to some extent, to be *Lebemeister* as well as *Lesemeister*. Regardless of the question of authorial identity, which cannot be solved definitively on the basis of extant evidence, the kinship between the manuscripts in Gotha and Uppsala anchors the practices of compilation that they share in Dominican authorial and pedagogical practice circa 1300. They bear witness, if not to the most advanced level of Dominican education, then to its propaedeutic stages that remained rooted in monastic precedent and practice. The most original part of Berthold's contribution, which has been overlooked by scholars focused on his texts, lay in adding a diagrammatic dimension. In so doing, Berthold rooted his spiritual instruction in the classroom procedures of his day.

<div style="text-align: right; font-size: 3em;">*3*</div>

From Cross to Crucifix

"Renewed Reading and Careful Looking":
Text and Image in Hrabanus

Medieval terminology for various types of image remains infuriatingly imprecise. The imprecision, however, is itself instructive. *Imago* could mean anything from a sculpture or a painting as listed in an inventory to the image in whose likeness God had fashioned mankind (Gn 1:27).[1] Medieval theories of the image as well as pastoral and devotional works exploited such ambiguities in order to navigate the boundaries between the visible and invisible.[2] Only by allowing visual representations to participate in less concrete forms of likeness could the charge of idolatry be avoided or deflected.

Hrabanus lived through the second great period of iconoclasm in Byzantium (814–43). Carolingian responses to this crisis were complex and sometimes based on erroneous information rooted in remoteness and inaccurate translations.[3] Writing in an environment of hypersensitivity to the implications of images as well as words about images, Hrabanus chose his discourse carefully, and not only because, at least in his collection of picture poems, he had to accommodate whatever he said to the tortuously difficult requirements of the *carmen figuratum*. Hrabanus had at his disposal a nuanced vocabulary. He consistently urges his readers to seek in the *dispositio, distributio,* or *expositio* of his text the *forma, figura,* or *species* of the divinely sanctioned sign of the cross.[4] Whether in a medieval

<div style="text-align: right;">79</div>

version of both *ut pictura poesis* (as is painting, so is poetry) or the *paragone* (comparison, in this case, of the arts), the revealed Word of God and words about scripture were bound to come out on top. In a poem addressed to Abbot Hatto of Fulda (r. 842–56), Hrabanus wrote: "The sign of writing is worth more than the form of an image and offers more beauty to the soul than the false picture with colors, which does not show the figures of things correctly. For script is the perfect and blessed norm of salvation and it is more perfect in its meaning, and is more easily grasped by human senses. It serves ears, lips and eyes, while painting only offers some consolation to the eyes. It shows the truth by its form, its utterance, its meaning, and it is pleasant for a long time. Painting delights the gaze when it is new, but when it is old it is a burden, it vanishes fast and it is not a faithful transmitter of truth."[5] Elsewhere, in his encyclopedia *De universo* (21.9), completed in 847, Hrabanus defines painting as "an image expressing the species of some thing, which when it is seen creates a memory of it."[6] If one consult's Hrabanus's source Isidore of Seville, from whom he quotes verbatim, one finds an indictment of paintings as material falsehoods: "A picture is an image representing the appearance of some object, which, when viewed, leads the mind to remember. It is called 'picture' [*pictura*] as if the word were *fictura*, for it is a made-up [*fictus*] image, and not the truth. Hence also the term 'painted' [*fucatus*], that is, daubed with some artificial color and possessing no credibility or truth."[7] In keeping with a tradition that can be traced as far back as Plato, painting, like poetry, has no purchase on the intelligible forms. *Pictura* is *fictura*, having no part of faith or truth ("nihil fidei et veritatis habentia"). A commonplace in classical literature, the pairing of *fingere* and *pingere*, further resonated in medieval hymns, in which it was used to contrast the reality and reliability of divine creation to the illusoriness of that which is merely imagined or painted.[8]

Hrabanus's insistence on images as aids to memory is significant, as it would seem to offer a positive role for painting, but so too is the context. The same passage was cited in the proceedings of the Synod of Paris, convened in 825

for the express purpose of responding to a letter sent to Louis the Pious by the Byzantine emperor Michael II and his son Theophilus in which they asked for assistance in their struggle against the veneration of icons.[9] The emperor and his son evince a certain ambivalence regarding images. Whereas those images in churches that had been placed low enough to encourage adoration had by their time been raised, at higher levels, and in keeping with the canonical Western view most famously articulated by Pope Gregory the Great, they continued to be tolerated as instruments of instruction for the faithful. Just as the Byzantine emperors' missive represented only a moderate form of iconoclasm, so too the Carolingian response articulated a moderate form of iconodulism.[10] Parsing correct and incorrect forms of worship involving images, the participating bishops concluded that no images besides the cross and signs of the cross, which enjoyed a special status, were worthy of veneration. The honor owed to God should not be accorded to any created material thing. Nonetheless, images performed a useful, if not necessary, function (not unlike the heuristic role assigned to diagrams in many philosophical accounts). In addition to having been authorized by the incarnation, images served to raise the mind to God and to direct worship to its proper, invisible object.

The records of the Synod of Paris point to a climate in which attitudes toward images were slowly shifting. Moreover, Hrabanus's own attitude toward the visual could not have been entirely negative.[11] This much can be surmised both from the form and content of *In honorem sanctae crucis* as well as his own patronage. Hrabanus's choice of medium, in which text and image can hardly be distinguished, allowed him to have his cake and eat it too.[12] Moreover, as so often, there appears to have been a difference between theory and practice. To begin with, had Hrabanus been utterly opposed to images, he hardly would have departed from the model provided by Optantianus by introducing a greater measure of figurative imagery, even if those figures were composed of words.[13] In general Hrabanus insists on the priority of words, and his work has usually been read as overwriting images to the

detriment of the visual.[14] Not without reason, however, did Hrabanus admonish copyists of his work to ensure that in reproducing his text they take no less care with the images.[15] His primary concern was that the work not be corrupted. But the entire gestalt of his work is predicated on every opening of the book as a seen, visible space, as opposed to the text as something to which one listens.[16] The forms of the figures were no less important to the author and to the work's comprehension than was the ordering of the words.[17] In some cases, without the superimposed images any direct reference to the cross would be hard to find. In a key phrase, Hrabanus asks of his readers "saepius legentes ac sedulo conspicientes," "renewed reading" and, no less important, "careful looking."[18]

Additional evidence for Hrabanus's attitude toward images comes from the small basilica, dedicated to St. Leoba on September 28, 838, that he had built on the Ugesberg (today Petersberg), only a short distance from the mother house at Fulda.[19] Erected almost three decades after the composition of *In honorem sanctae crucis* in 810, the church's extensive program of paintings suggests that Hrabanus's view of images evolved in keeping with the shifts in attitude that marked the reign of Louis the Pious (r. 814–40), during which the divisiveness exemplified by the writings of Theodulf of Orléans (ca. 750/760–821) and Claudius of Turin (fl. 810–27) gave way to greater tolerance.[20] The church contained an elaborate decorative program, fragments of which have survived in the crypt. These include in the central apse vault a painting of Mary with female saints along with an Annunciation to the Shepherds and the Adoration of the Magi above and around the altar dedicated to the Virgin. In the chapel that capped the left aisle, dedicated to the last prophet, John the Baptist, the Lamb of God in the vault presided above a Baptism of Christ, flanked by patriarchs and prophets of the Old Testament. The altar in the right chapel was dedicated to St. Michael and the angels. In combination, the three altars provided a précis of salvation history: the time prior to the First Coming, the First Coming itself in the form of the incarnation, and the Second

Coming.[21] As in other churches at Fulda, not only the vast basilica erected between 802 and 817 by Ratger, the third abbot, on the model of Old St. Peter's, but also the cemetery church of St. Michael's and the Church of St. Mary on the Bischofsberg, interior paintings were accompanied by *tituli*, of which no material trace remains but which are recorded as poems.[22] A chronicle of the monastery at Fulda attributes to Hrabanus the verses composed to accompany or adorn each of the altars in the church on the Petersberg.[23] If the presence of such paintings indicates a reasonably tolerant attitude toward images, the *tituli* in turn could be read as representing a desire to channel the responses of viewers, at least those who were literate in Latin.[24] In addition to identifying the subject matter of paintings now lost, the verses shed light on the function attributed to the images by the patron. The paintings identified their viewers as witnesses to sacred history.[25]

Berthold's Refiguring of Hrabanus

Were one to take Berthold at his word, his purpose was simply to make his Carolingian predecessor easier to comprehend. He states: "This book orders and rewrites Hrabanus's book on the Holy Cross, which is written in honor and praise of that most glorious and salvific cross in a manner which is diffuse and difficult to understand."[26] Berthold certainly succeeded in making Hrabanus's work less intimidating. Gone are the poems with figurated intexts; they are replaced by inscribed diagrams made up of simple geometric building blocks, articulated by number, color, and inscriptions, most of which are reduced to the form of labels. In the way of words Berthold has little to add to Hrabanus. In addition to small emendations, he occasionally adds a few sentences of his own. On closer inspection, however, these turn out for the most part to consist of another form of compilation, in the form of biblical passages. Berthold provides his readers with the pieces of a mosaic. It is left to them to put together the picture.

In other ways Berthold is more assertive. Of these, the first is his separation of Hrabanus's imagetexts into their two component parts. Each

cento of texts from *In honorem sanctae crucis* is prefaced by an unframed vignette of eight to ten lines containing neither a diagram nor an illustration in the conventional sense of the word, but rather what Berthold, using terminology that Hrabanus himself had employed, calls *figurae*, figures. *Figura* is but one term used for diagrams in the Middle Ages; others are *descriptio*, *formula*, *forma*, *pictura*, *imago*, and, in the case of circular diagrams, *rota* and *sphera*.[27] Such terms embraced an extraordinary variety of forms, and it is pointless to try to define them too precisely.

Figuration provides the key to the most thoroughgoing of Berthold's revisions. Given how rarely, other than Parisian copies of Aristotle, scholastic manuscripts receive figural illumination, Berthold's decision to illustrate his work so profusely is unsurprising only insofar as Hrabanus himself had recourse to images, though of a very special kind.[28] *Imago* was a word that Hrabanus used very sparingly; it appears only twice in the titles of his twenty-eight christological *carmina*: in that for the first picture poem, which portrays Christ in anthropomorphic form, arms outstretched, and in the last, which represents the author in supplication at the foot of the cross.[29] Elsewhere Hrabanus restricts himself to other terms, of which *figura* is one. A loaded word in Christian discourse, *figura*, as charted by Erich Auerbach, carried a complex and changing constellation of connotations.[30] Auerbach's seminal essay has been both contextualized in terms of the historical moment in which he wrote it and criticized for his confusing distinction between figure and allegory, which in the Middle Ages was in fact the principal term used for typological interpretation.[31] In this context, however, Auerbach's emphasis on figuration within a Christian framework as a validation of history remains of undiminished importance (although here too complications ensue given that the reality to which figural speech ultimately refers is not reality in the everyday sense, but rather one that is consummated only in the fullness of time, lending typology a triadic rather than a dyadic structure). Nonetheless, with all appropriate qualifications, Auerbach's reading of *figura* fits

Berthold's well. For Berthold figuration was so fundamentally historical in character that he felt driven to rewrite Hrabanus in accord with the demands of salvation history.[32]

According to Quintilian (*Institutiones* 9.1.10–11), "the term [*figura*] is used in two senses. In the first it is applied to any form in which thought is expressed, just as it is to bodies which, whatever their composition, must have some shape." The Roman rhetor continues: "In the second and special sense, in which it is called a *schema*, it means a rational change in meaning or language from the ordinary and simple form."[33] *Figura* as shape closely approximates Hrabanus's use of the term. Hrabanus refers to the forms that constitute the cross, whether letters or geometrical configurations, as *figurae*. Schema and shape: the two definitions together would also seem to define very nicely Berthold's apparent understanding of *figura* as he applies it in both word and image. One must, however, be wary; Quintilian defines *schema* not as anything approaching a diagram but rather as what we would call figural language. *Figura* had yet to acquire the meanings that Berthold takes for granted.

In early medieval schoolbooks, in addition to figural language, *figura* could mean form, shape, diagram, outline, shape, arrangement. To speak *figuraliter* meant to speak schematically or according to a plan. In a foreshadowing of its later application in exegesis, it could also mean speaking with the appearance of truth.[34] In his treatise on grammar, the Carolingian scholar Aluin used the term *figura* in a relatively prosaic sense to denote the graphic signs (*nota*) with which he edited scripture: "Critical signs [*notae*] are certain marks [*figurae*], either to abbreviate words, or to express meanings; or they are used for a variety of reasons, such as the obelus ÷ in Holy Scripture, or the * asterisk."[35]

Like Quintilian's, Berthold's understanding of *figura* is twofold, but in a different manner. For him, *figura* means a figure in the sense of an demonstrative illustration (much in the same sense as the illustrations in this book are referred to as figures). The fact that his *figurae* precede

any exposition or explanation suggests not only their primacy but also, to a degree, their independence: in each section it is the *figura* that the viewer first encounters and can try to tease out without yet having had the benefit of the following text, which, moreover, hardly offers a direct explanation of its components or working. For Berthold the term *figura* has another, more poetic set of meanings. A *figura* is a prefiguration in the specifically Christian sense, rooted in the mode of exegesis known as typology. For the first of these senses, Berthold could have had recourse to his fellow Dominican Thomas Aquinas. In his commentary on Aristotle's *Metaphysics*, as part of his discussion of Aristotle's distinction between actuality and potency, Aquinas, in recapitulating the philosopher's argument, himself resorts to the example of diagrams, stating: "He [Aristotle] accordingly says, first, that 'geometrical constructions,' i.e., geometrical descriptions, 'are discovered,' i.e., made known by discovery in the actual drawing of the figure [*figura*]."[36] Berthold's *figurae* meet these definitions in serving not simply as visual aids but as demonstrations through the drawing of which (real or imagined) discoveries can be made.

More importantly, however, Berthold's *figurae* also provide insight into the structure of salvation. His *figurae* do not simply illustrate. In another understanding of discovery through process, they point beyond themselves toward a universal truth to be realized over the course of time. In this sense of the term, the *figura* could be seen or imagined, but it never represented the full truth. In a sermon for the Feast of the Purification of the Virgin, Aelred of Rievaulx (ca. 1110–67) provides an encapsulation of the figural method all the more pointed for its focus on an elaborate allegorization of Jewish ritual:

> The Jewish people had their feasts and sacraments, and we have our own similar feasts and sacraments. But theirs were the shadows and images of the things that were to come. In ours is the truth, that is, that which the previous ones signified. Therefore the apostle says (1 Cor 10:11): "All things were contained

there figuratively; they were written nevertheless for us." There they were prophesied; here they are fulfilled.[37]

Figuration allowed not only for levels of meaning but also for their essential interconnection. It was a quintessentially diagrammatic mode.

Breaking Down Berthold's Book

Berthold's approach is manifest from the very beginning. Appropriating words from Burgundio's Latin translation of John of Damascus, Berthold prefaces the entire work by declaring: "For that is what is foreseen in perpetuity and predetermined in the counsel of the Son of God and signified in the various images and prophetic words by the Holy Spirit."[38] What we today would call the figural elements in Berthold's diagrams lend embodiment to the concept of figuration as defined in typological terms; they flesh out the diagrams with anthropomorphic elements that make their typological content concrete. In the language of prophecy, they give corporeal form to what previously had been no more than a shadow. In the influential formulation of John Chrysostom, who glosses Hebrews 10:1 ("For the law having a shadow of the good things to come, not the very image of the things"): "For as in painting, so long as one [only] draws the outline-marks, it is a sort of shadow, but when one has added the bright painting and laid in the colors, then it becomes an image. Something of this kind also was the Law."[39] Less familiar than the way in which Berthold casts the history of the incarnation in terms of figural "enfleshment" captured in pigments is the way in which he uses geometric, diagrammatic elements to map out the process by which this process of fulfillment occurs.

Given the thoroughgoing character of Berthold's restructuring, a table correlating Berthold's figures with Hrabanus's *carmina* provides the best means of comprehending the extent of the reordering he imposes. More than any other copy of Hrabanus's complex concatenation of poems, Berthold's emerges as a quasi-independent

work. Berthold's images provide a more reliable indicator of the reordering than the inscriptions, as in some cases, he distributed inscriptions extracted from a single *carmen* and distributed them across several of his own diagrams. The titles of Hrabanus's *carmina* or chapters provide orientation, although, taken out of context, the inscriptions from those chapters no longer necessarily designate the same subject matter.

Berthold of Nuremberg	Hrabanus Maurus
1: De nomine Adam significet et eius passionem demonstret	12: De nomine Adam protoplasti quomodo secundum Adam
2: De spiritu et carne, ratione et sapientia	[*Speculum virginum*]
3: De quatuor affectionibus anime	21: De numero quadragenario et misterio eius
4: De quatuor virtutibus cardinalibus	6: De quattuor figuris tetragonicis circa crucem et significatione eorum
5: De esse, vivere, sentire, et intelligere	2: De quattuor figuris tetragonicis circa crucem scriptis et significatione eorum
6: De quatuor elementis	7: De quattuor elementis et quattuor vicissitudinibus temporum vicissitudinibus temporum et de quattuor plagis mundu et de quattuor quandrantibus naturalis diei quomodo omnia in cruce ordinentur et in ipsa sanctifecentur
7: De quattuor plagis mundi, et quatuor vicissitudinibus temporum	7: De quattuor elementis et quattuor vicissitudinibus temporum et de quattuor plagis mundu et de quattuor quandrantibus naturalis diei quomodo omnia in cruce ordinentur et in ipsa sanctifecentur
8: De diebus anni solaris	9: De diebus anni in quattuor hexagonis et monade conprehenis et de bissextili incremento quomodo in specie sanctae crucis adornentur et consecrentur
9: De numero annorum a principio mundi usque ad tempus passionis Cristi.	14: De annis ab exordio mundi usque in annum passionis Christi in notis graecarum litterarum secundum formam sanctae crucis dispositis simul cum sacramento quod in hoc revelatur
10: De quinque libris Moisi	11: De quinque libris mosaice legis quomodo per crucem innoventur et exponantur
11: De cherubin tabernaculi et templi	4: De cherubim et seraphim circa crucem scriptis et significatione eorum
12: De lapidus quadratus fundamenti templi	5: De quattuor figuris tetragonicis circa crucem positis et spiritali aedificio domus Dei
13: De seraphin visionis Isaie	4: De cherubim et seraphim circa crucem scriptis et significatione eorum
14: De septuaginta annis captivitatis	10: De numero LXX et sacramentis eius quomodo cruci conveniat
15: De prophetis et prophetii eorum	26: De prophetarum sententiis quae ad passionem Christi et ad nostram redemptionem pertinent

Overall, the comparison demonstrates the degree to which Berthold's reworking does violence to the work he ostensibly merely wishes to explain. Whereas Hrabanus undergirds the structure and organization of his work with numerology, Berthold, while not uninterested in this aspect, pushes it, if not out of the picture, then into the background. In Berthold's work, chapters continue to receive titles that refer to numbers (the twelve apostles, the four Evangelists, the twenty-four elders of the Apocalypse, etc.), but their sequence is not determined by the cosmological harmonies that govern Hrabanus's exposition and that proceed out from and are determined by the four arms of the cross. Rather, they follow one another in a chronological sequence approximately dictated by scripture.[40] Berthold's reworking employs all of the *carmina* with one telling exception: the twenty-eighth and concluding poem in which the author Hrabanus Maurus prays for the salvation of his own soul and whose intexts show him kneeling in adoration of the cross. Berthold literally writes Hrabanus out of the picture. *Carmen* VI is the only poem that does not serve as a pictorial model; its intexts, however, are employed as inscriptions for Berthold's figure 4, which is modeled on Hrabanus's *carmen* X.

As in the Marian supplement that follows, the new structure is essentially historical, with the narrative thrust provided by the history of salvation, beginning with Adam and ending with the angels in heaven. Unlike Hrabanus, whose first poem opens with Christology and cosmology, Berthold begins with Adam and Eve (fig. 1) before tracing, loosely, the history of salvation, through the five books of Moses (fig. 10), the temple (figs. 11–12), the vision of Isaiah (fig. 13), the prophets (fig. 15), the election of the apostles (fig 17), the gifts of the Holy Spirit (fig. 19), Christ's public ministry (fig. 21), before arriving at the crucifixion (fig. 22), shown in figural form (something Hrabanus had studiously avoided). He continues with the four Evangelists (fig. 27) and the ministry of the apostles (fig. 28) and concludes with the twenty-four elders of the Apocalypse (fig. 29), the 144,000 virgins of the Apocalypse (fig. 30), and the nine orders of angels

(fig. 31). In contrast to Hrabanus, whose series of poems begins in heaven with the risen Christ and then descends into the time and space of human history, Berthold's work begins in the world and ascends to heaven. Hrabanus's structure is inverted.

By way of respecting this upending of *In honorem sanctae crucis* and elucidating its rationale, the discussion that follows respects the sequence of subject matter Berthold selected.[41]

Prologue

For Berthold's prologue to the entire sequence, we have to turn to the fifteenth-century copy in Paris (BnF, ms. lat. 8916), as the equivalent portion has been excised from the manuscript in Gotha. Assuming this source can be trusted, the preface consisted in its entirety of the second half of a prayer taken from Hrabanus's explanation of his twenty-first *carmen* (I.C. 21.30–55). Berthold's choice was anything but casual. In singling out this prayer, Berthold recognized its exceptional character. It is the only such prayer in any of the twenty-eight *declarationes*, the explicatory texts that face the poems across each opening.[42] Whereas the first part of the prayer, omitted by Berthold, is addressed to the cross, the second takes the form of a confession in offering praise and thanks: "You are the victory of the eternal King, the joy of the celestial army, the power of those born on earth, you are the remission of sins, the manifestation of piety, the augmentation of merits, the remedy of the weak, an aid to those who labor, a comfort to the exhausted, the safety of the healthy, the serenity of the tranquil, the felicity of the fortunate."[43] As part of his concern that his veneration of the cross not be mistaken for worship of a material object, Hrabanus follows the prayer with an apology, stating that all praise of the cross is directed to Christ and that all praise of Christ is ultimately due to the Father (I.C 21.52–64). Not by accident does Hrabanus's prayer occur within his *declaratio* concerning *carmen* XXI. The poem explains the significance of the number seventy-two, which, according to Hrabanus, stands for both the number of human languages and the

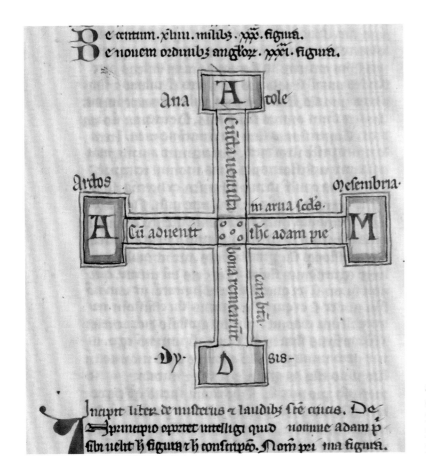

Be centum . xliiii . milibz . xxx . figura.
Be nouem ordinibz anglox . xxxi . figura.

ana A tole

Ardos Oefembria·

A Cu aduentr ihc adam pie M

·Dy· D sis·

Jncipit liber de misteriis τ laudibz sce crucis. De
Jprincipio oportet intelligi quid nomine adam p
sibi uelit ħ figura τ ħ conscripes. Nom pri ma figura.

53. *Figura* 1: On the Name of Adam
(Carmen XII). Berthold of Nuremberg,
Liber de misteriis et laudibus sancte crucis,
Lake Constance region (?), 1292–94. FBG,
Memb. I 80, f. 41r (detail). Photo: FBG.

number of Christ's disciples, whose number accorded precisely with what was needed to bring the light of the faith to all corners of the world (C 21.1–11). In the spirit of a catholic—that is, all-embracing—Church, all peoples should raise their voices in praise.

1. De nomine Adam. Prima figura (Carmen XII; Figure 53)

Berthold begins at the beginning, with Adam and his name, appropriating Hrabanus's declaration that "it is necessary to understand what this figure and its inscription signify." In Hrabanus the statement prefaces *carmen* XII, but in Berthold's exposition it serves as an appropriate introduction to the entire series. Whereas in Hrabanus's picture poem the four letters spelling out the name of Adam themselves constitute the cross, in Berthold's reconfiguration the letters adorn the terminals of a Greek cross, as wide as it is tall. As in Hrabanus, the configuration serves simultaneously as a figure for the

entire cosmos. All of creation—cosmology and history—is combined into a single motif that simultaneously identifies Christ as the new Adam. Berthold's procedure, however, reverses that of Hrabanus. The Carolingian poet subsumes the name of Adam (not his person per se) within the fabric of his poem; the cross qua object is merely implied, not depicted. In contrast, Berthold depicts an inscribed object. The cross that constitutes the *figura* consists of two interlocking sets of lines, one, on the interior, drawn in black, the other, on the exterior, in red. All the elements of the cross, with the exception of the lowermost terminal and the square at the center marked by a quincunx pattern of small circles, are outlined not once but twice, and in two different colors, a technique that when combined with the green shading applied to terminals and center, lends the cross the quality of a three-dimensional object, specifically, a liturgical cross. The cross has been objectified.[44]

With the exception of the designation of the lower terminal, "Disis," which was added by one

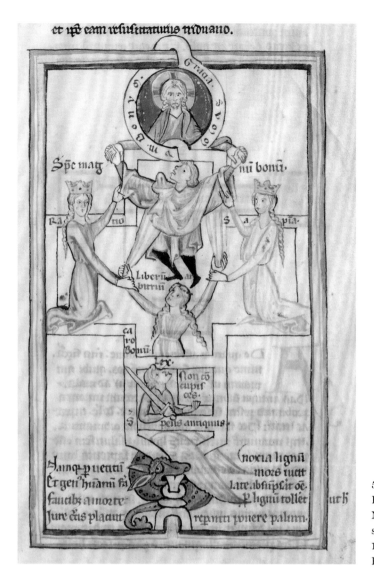

54. *Figura* 2: On the Spirit and the Flesh, Reason, and Wisdom. Berthold of Nuremberg, Liber de misteriis et laudibus sancte crucis, Lake Constance region (?), 1292–94. FBG, Memb. I 80, f. 41r (detail). Photo: FBG.

of the correctors, all the inscriptions are written in the same red ink employed for the rubrics, although, it should be noted, by a different hand. The verses taken from Hrabanus, too long to be accommodated by the arms of the cross, spill over into the adjoining spaces. The terms that Berthold appropriates from Hrabanus to describe his image of the cross are telling. Hrabanus states that the name of the first man, Adam, is disposed in the figure and form of the cross. Aside from its alliteration, Hrabanus's pregnant phrase "in figura et forma" is programmatic, not only for him but also for Berthold. The cross is a sign that in this case takes the form of a Greek cross. It is, however, more than just a signifying shape; it is also a figure in the typological sense

of a prophetic type, a form whose signification includes prefiguration. Hrabanus quotes Romans 5:14, in which Paul describes Adam as "a figure of him who was to come"—that is, Christ. In Berthold's image, as in Hrabanus's *carmen*, the representation of Adam's name in the form of a cross lends Old Testament prophecy and New Testament fulfillment a startling simultaneity.

2. De spiritu et carne, ratione et sapientia. Secunda figura (Figure 54)

Berthold's emphasis on ascent, a basic figure of meditation in Christian texts, explains the interpolation of the second image in his series, the only one appropriated from another work. The

interpolated image depicts the cross as a ladder on which, at the bottom, Free Will (*liberum arbitrium*), seeking the Good (*specie magnum bonum*) and striving toward Christ (*gratia summum bonum*) at the top, is assisted by Reason (*ratio*) and Wisdom (*sapientia*) in escaping the Law (*lex*) and the Old Serpent, Satan (*serpens antiquus*).

By introducing this diagram and recasting Hrabanus in its spirit, Berthold does not simply scramble his source but radically revises it in keeping with the devotional and theological imperatives of his day. Representations of ladders as figures of spiritual or contemplative ascent, of which the most famous is that accompanying the *Scala Paradisi* of John Climacus, a seventh-century monk at the monastery of St. Catherine's on Mt. Sinai, had long been a staple of medieval monastic imagery.[45] John's ladder, which depicts monks attacked by demons tumbling off a ladder on which they clamber toward their heavenly reward, served as the source for a comparable image in the *Hortus deliciarum* compiled circa 1167–85 by abbess Herrad of Hohenburg.[46] The scriptural model for all such imagery was the dream of Jacob, in which he saw angels both ascending and descending a ladder leading up to heaven.[47]

The Rule of St. Benedict of Nursia, the cornerstone of Western monasticism, made Jacob's vision the centerpiece of its chapter on the essential monastic virtue of humility:

> Hence, brethren, if we wish to reach the very highest point of humility and to arrive speedily at that heavenly exaltation to which ascent is made through the humility of this present life, we must by our ascending actions erect the ladder Jacob saw in his dream, on which angels appeared to him descending and ascending. By that descent and ascent we must surely understand nothing else than this, that we descend by self-exaltation and ascend by humility. And the ladder thus set up is our life in the world, which the Lord raises up to heaven if our heart is humbled. For we call our body and soul the sides of the ladder, and into these sides our divine vocation has inserted the

different steps of humility and discipline we must climb.[48]

The annals, martyrology, and chapter office book from Zwiefalen, dated circa 1162, adroitly combines Benedict's image from the Rule with an author portrait of him writing the Rule (fig. 55).[49] The book was used at the office of Prime, held each day in the chapter house, during which a portion of the Rule would be read.[50] Pen and scraper in hand, the saint sits within a towering edifice framed to either side by ladders. In effect, the image creates a mise-en-abyme that identifies the entire image as a vehicle of ascent: as the side rails are to an individual ladder, so too in the drawing are the ladders to the image as a whole. The ladders transform the image into an elaborate didactic lattice. On the ladder to the left, angels ascend and descend, communicating between the blessing Christ at the top and the reclining Jacob at the bottom, who rests his head on the stone of Bethel. Christ, the cornerstone, stands as the new stone of Bethel (cf. Is 28:16: "Therefore thus saith the Lord God: Behold I will lay a stone in the foundations of Sion, a tried stone, a corner stone, a precious stone, founded in the foundation. He that believeth, let him not hasten").[51] To the right a small naked man, armed with sword and shield, occupies the central space on a ladder with seven rungs; heads both male and female occupy the remaining rungs.

At Zwiefalten, as at other reform monasteries in southern Germany, the decision to employ drawing, rather than full-bodied illumination in color and gold, itself represents humility. Elaborating its source, the ladder on the right places Christ holding the lily as a symbol of reward in a roundel in the upper right corner. At the lower right, his counterpart the monstrous three-headed Leviathan, a Christian Cerberus banished from the sacred space at the center, hangs helplessly on the hook held in Christ's right hand by a long rope. His flamelike tongue lolls in the outer margin. Although rooted in Scripture (Job 20:40: "Canst thou draw out the Leviathan with a hook, or canst thou tie his tongue with a cord?"), the image more directly illustrates the theological conceit according to which like a fish

55. Author Portrait of St. Benedict, Annals, martyrology and chapter office book, Zwiefalten, ca. 1162. Stuttgart, Württembergische Landesbibliothek, Cod. hist. 2°. 415, f. 87r. Photo: WLB.

deceived by bait, Satan, able to see Christ's humanity (the bait) but not his divinity (the hook), was entrapped by Christ's death.[52]

The presence of the armed man betrays one iconographic source for the image, the Ladder of St. Perpetua (d. 203), one of two ladder images within the illustrative program of the *Speculum virginum*, a "mirror of virgins" written circa 1140 as an aid in the pastoral care of nuns (fig. 56).[53] In her vision the early Christian martyr sees

a ladder made of bronze, huge, reaching all the way up to the sky—but narrow, so that people could only go up one at a time. There were

iron weapons of all kinds stuck in the rails on both sides—swords, javelins, hooks, daggers, lances. If anyone climbed the ladder carelessly or without looking up, he would be torn up by these weapons, and pieces of his flesh would get caught in them. At the foot of the ladder there was a serpent lying there, huge, waiting in ambush for people who wanted to climb up and frightening them off from climbing up. . . . And down there at the foot of the ladder, as if he were afraid of me, the serpent stuck his head out slowly and I, as if stepping on the first rung of the ladder, stepped on his head. And so I started climbing.[54]

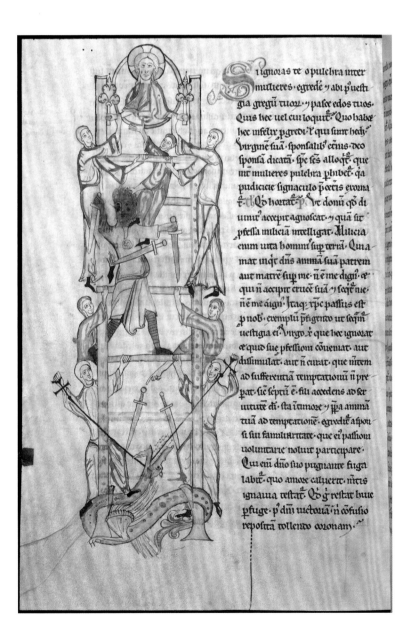

56. Ladder of St. Perpetua, Speculum virginum, Himmerode, early thirteenth century. Baltimore, Walters Art Museum. W.72, f. 82v. Photo: WAM.

Into Perpetua's description the *Speculum Virginum* interpolates a motif from elsewhere in her legend, her combat with an "Egyptian" (in later texts, "Ethiopian") gladiator representing Satan.[55] In the image the cariacatured embodiment of evil, bristling with weapons, stands halfway up the ladder, a barrier to the nuns who, like both Perpetua and the Wise Virgins of the parable (Mt 25:1–13), seek their heavenly reward at the summit. The impact of the *Speculum* was enormous, reaching even into the realm of courtly literature written in the vernacular. In *Der Welscher Gast* (The Italian guest), a mirror (i.e., a moral guide) to correct behavior for courtiers, written in 1215–

16 and extant in some twenty-five manuscripts, the author, Thomasin von Zerlcaere, describes at a great length "two ladders" (*zwei stiege*), one of virtues, one of vices (which in the margins of the manuscript in Gotha are combined into a single vertical, with each ladder departing, one upward, one downward, from the circle at the center; fig. 57).[56] In his words, "one of them takes us up to the highest good, but know that the other one tries at all times to take us down to where the worst evil resides."[57]

Berthold thus had a wide variety of sources on which to draw. Two in particular present themselves: either the *Speculum virginum* itself

57. The Ladders of the Virtues and the Vices. Thomasin von Zerklaere, Der welscher Gast. Gotha, Universitäts- und Forschungsbibliothek, Cod. Memb. I 120, f. 45v (detail). Photo: FBG.

or the twelfth-century *Dialogus de laudibus sanctae crucis*, another work on the cross for which the *Speculum* served as a source, in which the image in question illustrates a section known as the *Homo constat* treatise (fig. 58).[58] Both texts take the form of a Socratic dialogue, a popular didactic genre in the monastic sphere especially when it came to the training of novices, of which the most famous example is the late eleventh-century *Elucidarium* (literally, the book that elucidates) of Honorius Augustodonensis.[59] In the *Speculum virginum*, which sometimes circulated under the title *Dialogus Peregrini et Theodore*, the monk Peregrinus (perhaps identifiable

as Conrad of Hirsau) acts as the teacher while the nun Theodora fulfills the role of the exemplary student. In the *Dialogus* the corresponding roles are designated in generic terms simply as "Magister" and "Discipulus."

Given that Berthold, following Hrabanus, also wrote in praise of the cross, it would have made sense for him to consult the *Dialogus*, which, however, would most likely have been difficult of access, given that it survives in but a single copy (Munich, BSB, Clm 14159). Like Berthold's work, it is in large part predicated on typology. Fifty-one scenes from salvation history leading from the Fall to the Crucifixion com-

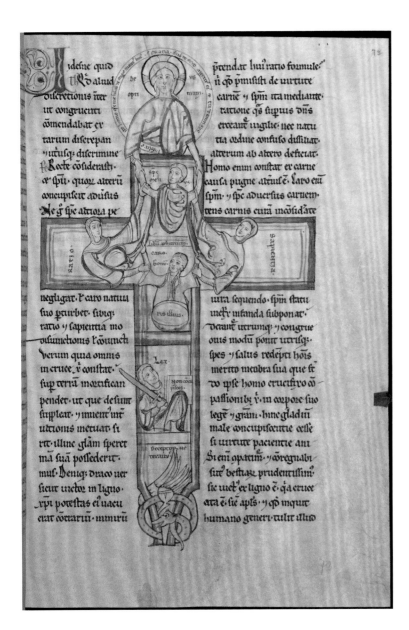

58. The Flesh and the Spirit, Speculum virginum, Himmerode, early thirteenth century. Baltimore, Walters Art Museum. W.72, f. 73r. Photo: WAM.

bined into nine full-page prefatory drawings all refer to the cross, either directly by depicting it or indirectly, with the reference stamped on the image by the inclusion of a red cross as a performative pointer to the priest that he should cross himself. The repetition of the sign of the cross lends it the character of a sacramental sphragis, a seal or identifying sign.[60] Seven additional miniatures (among them the illustration to the *Homo constat* dialogue), some appended to the narrative cycle at the beginning, others placed at the beginning or end of sections of the text, take the form of diagrams or are diagrammatic in nature.

Tempting though it is to posit a connection between the two works, variations in the text of the *Homo constat* excerpt as employed by Berthold appear to preclude the *Dialogus* in Munich as his source.[61] His text, however, also departs in numerous details from that of the *Speculum vir-*

59. *Figura* 3: On the Four Affects of the Soul (Carmen XXI). Berthold of Nuremberg, Liber de misteriis et laudibus sancte crucis, Lake Constance region (?), 1292–94. FBG, Memb. I 80, f. 41v (detail). Photo: FBG.

ginum.[62] It is therefore possible that in drawing on this text and its accompanying illustration, Berthold did not use a copy of the *Speculum virginum* but rather a derivation from it in which the text had already been isolated from its original context. Militating against this possibility, however, is the replication of the image.

The question of Berthold's source is further complicated by the fact that the *Homo constat* treatise also circulated separately. Eleven instances of the text are known: in addition to the manuscript in Gotha, the four fifteenth-century Bavarian copies of Berthold's adaptation of Hrabanus's original (Munich, Bayerische Staatsbibliothek, Clm 3050, 8826, 18188 and 21624, all unillustrated); the richly illustrated *Dialogus de laudibus sanctae crucis* (Munich, BSB, Clm 14159, f. 6r), most likely illuminated circa 1170–75 at St. Emmeram in Regensburg or perhaps at nearby Prüfening; and four miscellanies, the first from the Cistercian monastery of Eberbach (Oxford, Bodleian Library, MS. Laud. misc. 377, f. 44r), dated shortly after 1200, the second from the Egidienkloster in Nuremberg (Nuremberg, SB, Cod. Cent. II, 56, f. 4r), dating to the fifteenth century, the third, of unknown German origin, dating to the late thirteenth century (Paris, BnF, ms. lat. 10630, ff. 151r–151v), and the fourth, written circa 1450 in the Kreuzherrenkloster in Cologne (Cologne, Historisches Stadtarchiv, G. B. 40 206, f. 26r).[63] The origin of this latter copy is of special interest in that the fifteenth-century copy of Berthold's *De laudibus sanctae crucis* now in Paris (BnF, ms. lat. 8916) was written in 1468 by Daniel de Geertruidenberg, a canon from the house of Kreuzherren in Cologne.[64] Given the dedication of his order, it is perhaps not all that surprising to find Berthold's treatise on the cross sharing the shelves with one of its possible sources. The first part of the miscellany in Nuremberg, in which the *Homo constat* treatise (f. 4r) is incorporated into a series of four images prefacing a copy of Hrabanus's *In honorem* (ff. 1r–42v), indicates either that its compiler knew of Berthold's previous amalgamation of the two works or that he, like Berthold, was inspired by their kinship in content to make a similar con-

flation. To the extent the provenance of these various copies can be traced, it is worth noting that five (excluding the twelfth-century *Dialogus* from Regensburg) come from Bavaria and three from the Rhineland. This distribution matches, on the one hand, Berthold's apparent place of origin or at least his mother house (Nuremberg) and, on the other hand, the region (Upper Rhine) where the copies in Gotha and Basel most likely were produced.

Whatever Berthold's model, he alters it, first, by placing it in a different context and, second, by adding to the figure an appropriate set of verses by Hrabanus that speak of the cross as an instrument of victory over death.[65] The figure, which is soteriological in content, maps out the ascent of the soul, identified with Free Will (*liberum arbitrum*), to the highest good (*gratia summum bonum*). In charting the means by which humankind can escape the consequence of the Fall, represented by the person of Adam in the first figure, the appropriated image, which supplements the series of diagrams based directly on Hrabanus, anticipates the overarching framework of Berthold's exposition. In its combination of diagrammatic and figural elements, characteristic of many twelfth-century diagrams, it also supplies a fundamental point of departure for Berthold's own diagrammatic method.

3. De quatuor affectionibus anime. Tertia figura (Carmen XXI; Figure 59)

Although the inscriptions on the arms and terminals of the cross derive from the second, thirteenth, and eighteenth of Hrabanus's *carmina* and the accompanying commentaries, the *figura*'s form most closely matches that of Hrabanus's *carmen* XXIII, whose intext resembles an early medieval liturgical cross with flaring terminals. In Berthold's version the terminals have become rectangular. In conflating visual and verbal elements from multiple sections of his source, the *figura* represents one of the most complex cases of Berthold's reconfiguration of his model. The placement of the *figura*, the third in his series, corresponds with none of its constitu-

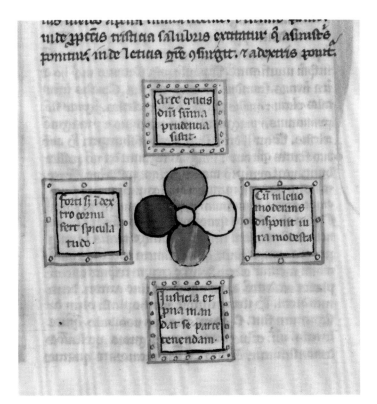

60. *Figura* 4: On the Four Cardinal Virtues (Carmen VI). Berthold of Nuremberg, Liber de misteriis et laudibus sancte crucis, Lake Constance region (?), 1292–94. FBG, Memb. I 80, f. 41v (detail). Photo: FBG.

ent elements in Hrabanus's original. The four-petaled flower reserved against the parchment at the center of the cross and silhouetted in green serves not simply as a decorative element; it refers to the "noble flower painted with the name of the King" (i.e., Christ) with which *carmen* XXIII opens.[66] Whereas in Hrabanus the entire cross is defined as a flower, in Berthold's reworking the flower serves as an adornment of the cross. A metaphor has become an object, one that comes to dominate the diagram in the following *figura*. Hrabanus's choice of words cleverly captures the nature of his images as paintings of words.

4. De quatuor virtutibus cardinalibus. Quarta figura (Carmen VI; Figure 60)

Only loosely related to the visual form of Hrabanus's *carmen* VI, the diagram takes as its point of departure the previous *figura*. The small four-petaled flower at the center of the third *figura* has grown equal in size to the four terminals,

whose frames are filled with small red dots evoking encrustation with jewels or pearls. Hrabanus's explanation of his poem, which provides the bulk of Berthold's commentary, discourses at length on the spiritual fruits of the cross, which is apostrophized as a living plant whose perfume fills the entire world and whose taste satiates the faithful. The spiritual fruits manifest themselves as the four cardinal virtues: Prudence (at the top), Justice (at the bottom), Fortitude (at the left), and Modesty or Temperance (at the right). In Hrabanus's configuration, the seven steps that make up the sides of the four triangles pointing toward the center represent the seven gifts of the Holy Spirit, which inform and enable the virtuous life. In Hrabanus's strictly geometrical image, the gigantic blossom at the center of Berthold's figure is nowhere to be seen. In contrast, Berthold, as is his wont, lends literal embodiment to what in his source remained in the realm of metaphor. The fruits of the cross, namely the four cardinal virtues, constitute the focal point of the image. The four colors amplify the fourfold arrangement; the form of the flower mirrors the structure of the *figura* as a whole. In his brief commentary Berthold explains that the four petals stand for the four virtues: Fortitude is red; Justice, blue; Prudence, pink; and modesty, white (represented by means of reserved parchment). Whereas in Hrabanus the figure within the poem identifies the cross as an instrument of victory over death, in Berthold it serves as an allegory of the virtues of the just man, taking as its point of departure the quotation from Psalm 1:3 ("And he shall be like a tree which is planted near the running waters, which shall bring forth its fruit in due season. And his leaf shall not fall off: and all whatsoever he shall do shall prosper"), also cited by Hrabanus. The flower at the center of the cross thus serves as a figure of spiritual growth that blossoms in the course of the reader's movement through the first three figures. Berthold's reconfiguration of his model permits the *figura* to serve as an elaboration of the allegory appropriated from the *Speculum virginum* (fig. 2), which identifies the cross as both a weapon wielded against Satan and a ladder of spiritual ascent.

The four colors of the flower match those of the tabernacle veil as described in Exodus 26:31 ("Thou shalt make also a veil of violet and purple, and scarlet twice dyed, and fine twisted linen, wrought with embroidered work, and goodly variety"). This same color symbolism is elaborated further in subsequent images, first in the nineteenth *figura* within the christological series (f. 47r: a depiction of the Virgin and Child with the seven gifts of the Holy Spirit identified as the Tree of Jesse (see fig. 89), although bearing a strong resemblance to contemporary representations of the throne of Solomon as the *Sedes sapientiae*), and again in the twelfth *figura* of the Marian series (f. 56v, which also depicts the Tree of Jesse; see fig. 132). In the latter case, the commentary appended to the image is taken from *In honorem sanctae crucis* (I.C 16.97–112), a passage in which Hrabanus specifically invokes the tabernacle veil and identifies violet with celestial conversation, purple with the blood of the Passion, pure white with Christ's inviolable chastity, and scarlet with his perfect charity. Richard of St. Laurent takes up the same color palette, as it were, in his *De laudibus beatae Mariae virginis*, a critical source for Berthold's own Marian compendium, when in his second prologue he writes: "I preferred accordingly, when scarlet and blue, white and purple were lacking to me, devoutly to offer [curtains] of goats' hair (cf. Ex 36:14) that, contrary to the precept of the law, appeared empty in the vision of God or that of the blessed Virgin."[67] Unlike Berthold, Richard hardly dares compare his text to the textile of the tabernacle veil.

5. De esse, vivere, sentire, et intelligere. Quinta figura (Carmen II; Figure 61)

The commentary for the fifth *figura* derives from Hrabanus's *declaratio* for *carmen* II, in which the Carolingian poet notes that the circular letter *O* can be found not only in the four corners but also in the center of his composition (fig. 62). This, he argues, demonstrates that the cross connects all things and that the veneration of Christ conjoins all that is above and below (i.e., in heaven and on earth). Although Berthold retains five

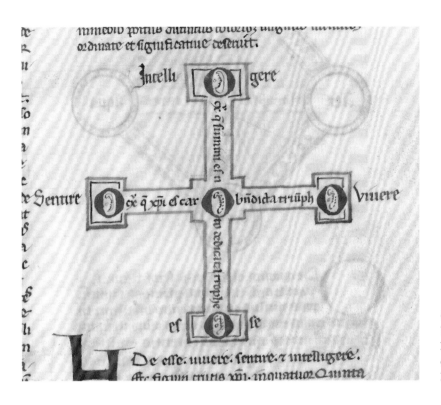

Intelligere

Sentire Viuere

esse

61. *Figura* 5: On Being, Living, Feeling, and Understanding. (Carmen II). Berthold of Nuremberg, Liber de misteriis et laudibus sancte crucis, Lake Constance region (?), 1292–94. FBG, Memb. I 80, f. 42r (detail). Photo: FBG.

of the nine letter *O*s embedded in Hrabanus's intexts, his *figura* otherwise does not resemble the structure of the *carmen* on which it is based. In Hrabanus's poem, the intexts consist of two verses of equal length that link the *O* at the midpoint of each of the four sides of the inner frame to the *O* at the center. Additional *O*s occupy the corners of the composition. Retaining only the intext, Berthold's *figura* eliminates the *O*s in the corners. Moreover, as in Berthold's preceding *figurae*, the rectangular panels occupied by the *O*s lend the cross the character of a material object employed in the liturgy, specifically a processional cross (fig. 63). The gloss stresses the cross as a figure informing the entire cosmos by relating the quaternary of the four attributes distributed in unequal degrees among all creatures (Being, Life, Perception, and Thought) with the four corners of the earth and the four points of the compass.

6) De quatuor elementis. Sexta figura (Carmen VII; Figure 64)

Berthold's sixth *figura* continues to mix and match materials from his Carolingian model

quite freely. Whereas the *figura* itself draws on Hrabanus's *carmen* VII, the inscriptions are taken from the *declaratio* to *carmen* III (see fig. 28). Hrabanus's intexts identify each circle with a series of quaternities: in each case one of the four seasons, winds, elements, and times of day, respectively. Berthold's version reduces this to the four elements alone, with Earth placed, appropriately, at the bottom, Fire at the top, and Air and Water to the left and right respectively. Moreover, whereas in Hrabanus the cruciform pattern underlying the cosmic circles remains merely implicit, in Berthold's version it is made it manifest through the cross-bars and diagonals that connect the circles to one another.

In transforming Hrabanus's *carmen* into a cross-in-square diagram focused on the four elements, Berthold draws on a tradition of diagrammatic representation that extends back to the Carolingian period. Diagrams in copies of a collection of astronomical and computistical texts compiled in Salzburg under Archbishop Arn before 821 place the four elements in the triangular spaces created by two squares, the second rotated within the first so as to map out the four points of the compass, indicated by the

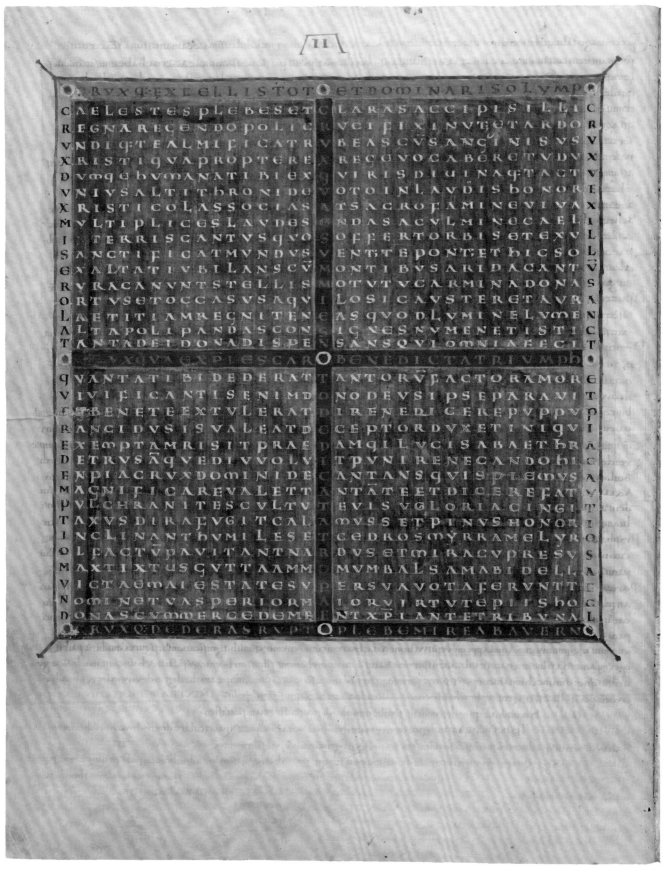

62. Carmen II. Hrabanus Maurus, In honorem sanctae crucis, Fulda, ca. 840. Città del Vaticano, Biblioteca Apostolica Vaticana, Cod. Reg. lat. 124, f 9v. Photo: BAV.

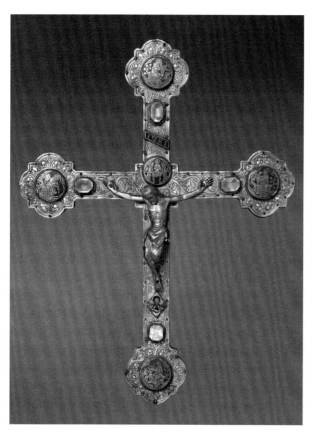

63. Processional Cross, Upper Rhine (Constance), ca. 1300–1310. Gilt copper, champlevé enamel, gemstones, on wood core, without base, 50.2 × 39.4 cm (19¾ × 15½ in). Purchase from the J. H. Wade Fund 1942.1091. Photo: © The Cleveland Museum of Art.

64. Figure 6: On the Four Elements (Carmen VII). Berthold of Nuremberg, Liber de misteriis et laudibus sancte crucis, Lake Constance region (?), 1292–94. FBG, Memb. I 80, f. 42v (detail). Photo: FBG.

65. Lothar of Segni, De missarum mysteriis, figure XVIII, Paris, ca. 1200. FBG, Memb. I 123, f. 3r (detail). Photo: FBG.

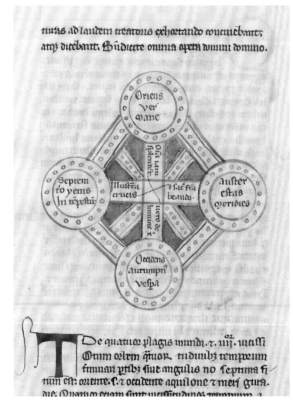

66. *Figura* 7: On the Four Misfortunes of the World and the Four Vicissitudes of the Times (Carmen VII). Berthold of Nuremberg, Liber de misteriis et laudibus sancte crucis, Lake Constance region (?), 1292–94. FBG, Memb. I 80, f. 42v (detail). Photo: FBG.

circles midway along the length of the sides of the outermost square (see fig. 48). Although they differ in their placement of the elements, their presence in both diagrams indicates that the connection between them is more than merely formal. Where Berthold's diagram differs from its earlier medieval precedents is in making the cross connecting the corners visible, a tendency already apparent in some Carolingian variations on the scheme, which makes science subservient to spirituality.[68] A similar diagram occurs among the series created circa 1200 for (and likely by) Lothar of Segni to accompany his treatise *De missarum mysteriis*, of which the earliest extant copy can also be found in Gotha (fig. 65).[69] In Lothar's diagram, the three circles along the horizontal axis, of which the central circle is labeled "CRUX," indicate the cross flanked by candles on the altar. The two candles, which are allegorized as the Jews and the Gentiles, are given a typological gloss. The vertical axis in turn maps out the Adoration of the Magi, with the shepherds (*pastores*) at the top, the cross (i.e., Jesus) at the center, and the magi at the bottom. The texts adjacent to the diagonals read, at the top, "Arise, shine, Jerusalem, for your light is come, and the glory of the Lord is risen upon you," a responsory for Epiphany (taken from Is 60:1), and, at the bottom, "For you were heretofore darkness, but now light in the Lord" (Eph 5:8), both of which are cited in Lothar's commentary.[70]

7. De quattuor plagis mundi et quatuor vicissitudinibus temporum. Septima figura (Carmen VII; Figure 66)

The seventh *figura* expounds the three sets of quaternaries excluded from the previous diagram: the points of the compass, the winds, and the times of the day. To the cross connecting the circular terminals and the diagonals connecting them is added a second, whose arms, painted in blue, divide the central space still further. In this configuration the diagram functions as a variant of the diagram or *rota anni* that illustrates the chapter on the seasons in Isidore of Seville's encyclopedia (XXXV), in which the four sea-

sons and corresponding cardinal directions are arrayed in opposing pairs (fig. 67): *ver/oriens* (spring/east) with *autumnus/occidens* (autumn/west), and *hiemps/septentrio* (winter/north) with *aestas/meridies* (summer/south).[71] To these pairings Berthold, following Hrabanus, adds the four parts of the day: *mane* (morning), *meridies* (midday), *vespera* (nightfall), *intempestum* (dead of night).

8. De diebus anni solaris. Octava figura (Carmen IX; Figure 68)

Berthold's eighth *figura* continues the series of lozenge-shaped images that began with the sixth in the series and all of which are visible within the opening folios 42v–43r. The topic of the diagram is the numerology underlying the solar year. Berthold refers to Hrabanus's commentary

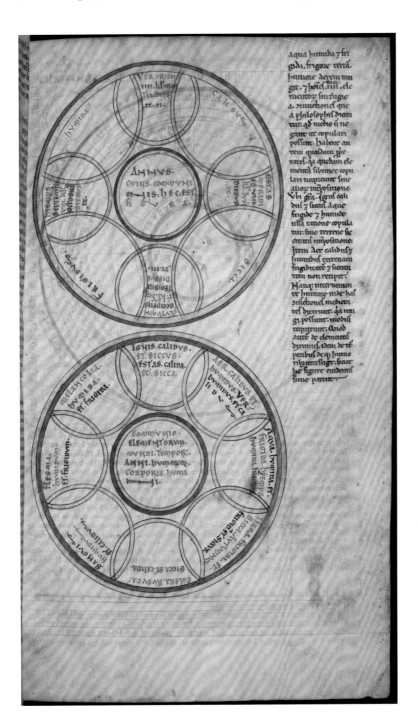

67. Diagram of the Harmony of the Year and Seasons (above); Diagram of the Harmony of the Elements, Seasons, and Humors (below), compendium of computistical texts (Bede, Isidore, Abbo of Fleury), England, late twelfth century. Baltimore, Walters Art Museum, MS. W.73, f. 8r. Photo: WAM.

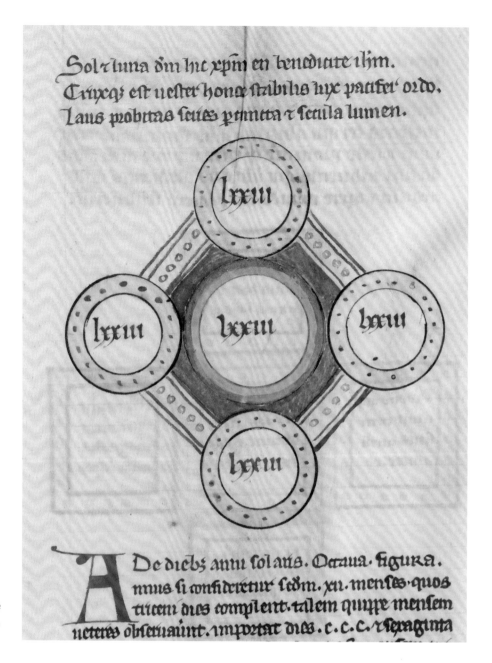

Sol z luna dm luc xpm en benediate iljm.
Cruxeqz est uester honor stabilis lux pacifer ordo,
Laus probitas scies primita z secula lumen.

A De diebs anni sol aris. Octaua. figura.
annus si confideretur secdm. xii. menses. quos
triceni dies complent. talem quippe mensem
ueteres observauint. important dies. c. c. c. z sexaginta

68. *Figura* 8: On the Days of the
Solar Year (Carmen IX). Berthold of
Nuremberg, Liber de misteriis et
laudibus sancte crucis, Lake Constance
region (?), 1292–94. FBG, Memb. I 80,
f. 43r (detail). Photo: FBG.

on his ninth *carmen*, which is devoted to the
same subject, but in the end departs from it dra-
matically. In Hrabanus's original, the intext con-
stituting the cross consists of four hexagons each
containing 91 letters. If one adds to the 364 let-
ters thus enclosed the *C* at the center, one arrives
at 365, the number of days in the year. Berthold,
however, arrives at the same total by dividing
365 by 5, generating the result 73, inscribed as
"LXXIII" in each of the five circles. Rather than
a fourfold image resembling a Greek cross, his
figure resembles a *Maiestas Domini* in which
Christ at the center is surrounded by symbols of

the four Evangelists.[72] A *Maiestas* image with a
similar structure—a rhombus with medallions
at the corners—occurs in the St. Gauzelin Gos-
pels (Nancy, Cathedral Treasury, f. 3v) and in
the Vivian Bible (Paris, Bibliothèque nationale
de France, ms. lat 1, f. 329v), in which the me-
dallions contain the prophets Isaiah, Ezechiel,
Jeremiah and Daniel, who complement the four
Evangelists in the corners (fig. 69).[73] Rooted in
cosmological diagrams of the *tetragonus mun-
dus*, this scheme served to underscore the har-
mony of the four Gospels. The diagram for the
computus by Byrhtferth of Ramsey (ca. 970–ca.

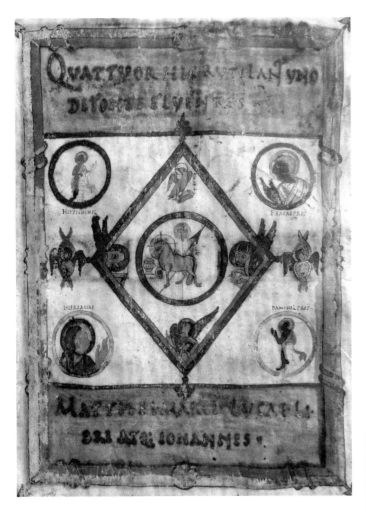

69. Majestas Domini, St. Gauzelin Gospels, Marmoutier, ca. 830. Nancy, Cathedral Treasury, f. 3v. Photo: Beatrice Kitzinger.

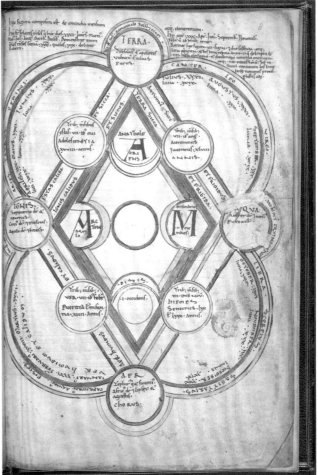

70. Byrhtferth of Ramsey, Computus Diagram, Annals of Peterborough Abbey, Peterborough, after 1122. London, British Library, Harley MS. 3667, f. 8r. Photo: © The British Library Board.

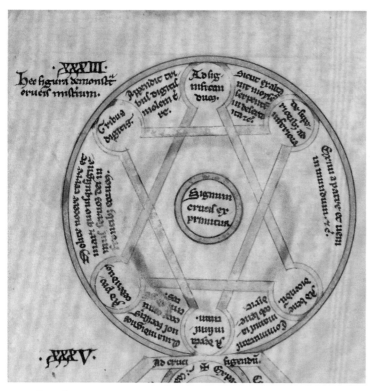

71. Lothar of Segni, De missarum mysteriis, Figure
XXXIII, Paris, ca. 1200. FBG, Memb. I 123, f. 4v
(detail). Photo: FBG.

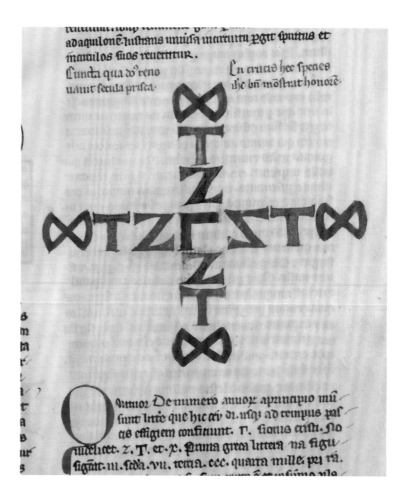

72. *Figura* 9: On the Number of Years from the
Beginning of the World to the Time of the Passion
of Christ (Carmen XIV). Berthold of Nuremberg,
Liber de misteriis et laudibus sancte crucis, Lake
Constance region (?), 1292–94. FBG, Memb. I 80,
f. 43r (detail). Photo: FBG.

1120), which categorizes and coordinates a complex set of interrelated information, displays a similar structure (fig. 70). The diagram links, as does Hrabanus, multiple quaternities, among them, in the outer diamond, the elements, seasons, and winds and, in the inner diamond, the cardinal points and the letters of Adam's name (the latter of which constitutes the subject of a separate section of Hrabanus's work, *carmen* XII).[74] Whereas Byrhtferth most likely based his diagram on an image of Christ in Majesty, the *Maiestas* in the Vivian Bible is based on diagrams. Berthold's reinterpretation of Hrabanus is also unthinkable without the precedent of *Maiestas* images. The thirty-third diagram for Lothar of Segni's *De missarum mysteriis*, which "demonstrates" (*demonstravit*) the gestures made by the celebrant during the Mass (*Gestus sacerdotis in missa*), follows a similar pattern (fig. 71).

9. De numero annorum a principio mundi usque ad tempus passionis Cristi.
Nona figura (Carmen XIV; Figure 72)

Both the inscriptions and the *figura* to which they are attached derive from the fourteenth *carmen* in Hrabanus's set. Berthold's gloss underscores the soteriological message of Hrabanus's poem, which extols the relationship of the cross to the number of years from the creation of the world to the crucifixion. Hrabanus's explanation is based on an elaborate system of gematria, in which the Greek letters are assigned numerical values of symbolic significance. Added together, the letters, which in turn stand for mysteries of the faith, produce the sum of 5231 years, the number supplied by both Jerome and Eusebius.[75] Moving outward from the gamma (3) at the center, each arm of the cross consists of a zeta (7), tau (300), and chi (1000). Each arm of the cross therefore adds up to 1307, a sum that multiplied by four generates a total of 5228. When the value of 3 represented by the central gamma is added to this sum, the total is 5231, the traditional age of the world at the time of the crucifixion of Christ. In Hrabanus's original, the intext consists of Latin letters within the Greek letters that are

73. *Figura* 10: On the Five Books of Moses (Carmen XI). Berthold of Nuremberg, Liber de misteriis et laudibus sancte crucis, Lake Constance region (?), 1292–94. FBG, Memb. I 80, f. 43v (detail). Photo: FBG.

embedded within the text as a whole. The Greek letters contain two verses, one of which, "En crucis haec species Iesus bene monstrat honorem," corresponds to the vertical axis of the cross and in Berthold's version is placed to its right. Missing, however, is the verse formed by the letters of the horizontal cross-arm, "Conputat hunc numerum Iesus quo est passus in arvis," which informs the reader that the number 5231 is the key to the entire image.

10. De quinque libris Moisi. .X. figura (Carmen XI; Figure 73)

Image and inscriptions closely match those that make up the intext of Hrabanus's *carmen* XI, now missing in Gotha, which configures the five books of Moses in the form of the cross (fig. 74). The verses within the five squares match those

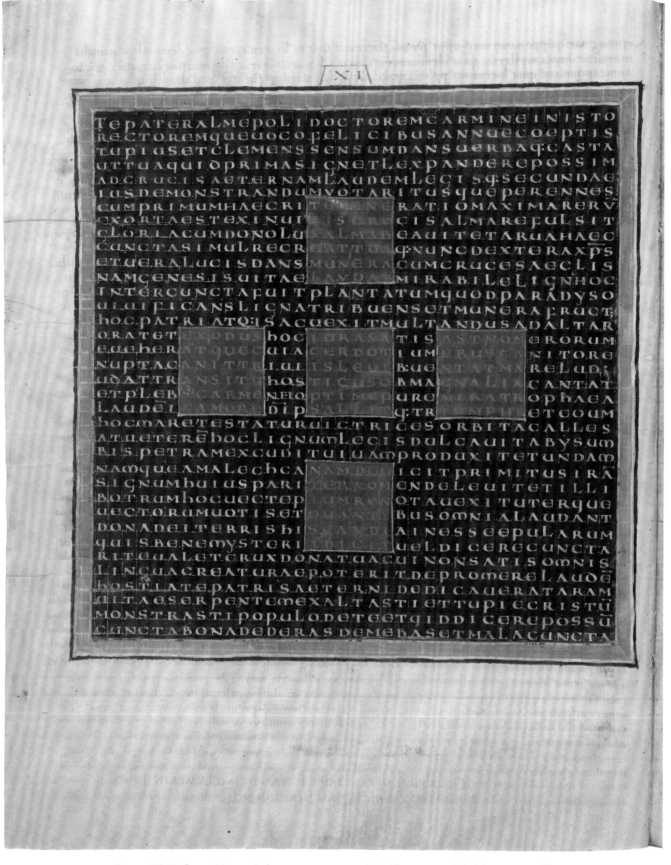

74. Carmen XI. Hrabanus Maurus, In honorem sanctae crucis, Fulda, ca. 840. Città del Vaticano, Biblioteca Apostolica Vaticana, Cod. Reg. lat. 124, f. 18v. Photo: BAV.

75. *Figura* 11: On the Cherubim of the Tabernacle and the Temple (Carmen IV). Berthold of Nuremberg, Liber de misteriis et laudibus sancte crucis, Lake Constance region (?), 1292–94. FBG, Memb. I 80, f. 44r (detail). Photo: FBG.

in Hrabanus's original. Separated from the fabric of surrounding text within which Hrabanus embedded them, the intexts are materialized, if in rather abstract form, as five codices. The squares could be interpreted as representing jewel-encrusted bindings on account of the pink circlets filling their borders. There was a long tradition in Christian art of using geometry to embed cosmic symbolism in treasure bindings of the kind most often reserved for Gospel books.[76] In Berthold's figure the situation is reversed: a cosmic quincunx is created from images of jeweled codices.

11. De cherubin tabernaculi et templi. Undecima figura (Carmen IV; Figure 75)

Although labeled as cherubim, the angels have only two rather than four wings. Their outstretched arms, which stand in for the second pair, are interpreted as referring to the extension of the cross. Berthold's *figura* represents a dramatic departure from his source. Hrabanus's *carmen* IV includes two seraphim and two cherubim, with each pair filling two of the quadrants created by the cross that bisects the page on both horizontal and vertical axes (fig. 76). Berthold eliminates not only the cross but also the sera-

phim (reserved for his thirteenth *figura*). The verses placed above and below the angels' wings correspond to the intext of one of the two heavenly beings in the original *carmen figuratum*. In their poses and disposition, the two angels recall images of the cherubim hovering over the propitiatory in the temple, a deliberate iconographic reference in light of the subject matter of this section, which amplifies the attention paid elsewhere to the color symbolism of the tabernacle veil.[77]

12. De lapidus quadratus fundamenti templi. .XII. figura (Carmen V; Figure 77)

Having introduced the ark of the covenant in his twelfth *figura* in the form of the cherubim who hover over the propitiatory, Berthold, like Hrabanus, proceeds to the temple itself, whose four cornerstones constitute the subject of the subsequent *figura*. Berthold's source is Hrabanus's fifth *carmen*, making this and the preceding image one of only two pairs in the entire series that draw on two successive *carmina* and their commentaries.[78] The alternating colors in Berthold's treatment, with two blue squares framed in red and two red framed in blue, lend the otherwise static image a chiastic diagonality that is absent

76. Carmen IV. Hrabanus Maurus, In honorem sanctae crucis, Fulda, ca. 840. Città del Vaticano, Biblioteca Apostolica Vaticana, Cod. Reg. lat. 124, f. 11v. Photo: BAV.

77. *Figura* 12: On the Square Stone of the Foundation of the Temple (Carmen V). Berthold of Nuremberg, Liber de misteriis et laudibus sancte crucis, Lake Constance region (?), 1292–94. FBG, Memb. I 80, f. 44r (detail). Photo: FBG.

78. *Figura* 13: On the Seraphim of the Vision of Isaiah (Carmen IV). Berthold of Nuremberg, Liber de misteriis et laudibus sancte crucis, Lake Constance region (?), 1292–94. FBG, Memb. I 80, f. 44v (detail). Photo: FBG.

from Hrabanus's original. With one exception—the horizontal of the central cross—all the inscriptions draw on their corresponding intexts.

13. De seraphin visionis Isaie. .XIII. figura (Carmen IV; Figure 78)

The seraphim from Hrabanus's fourth *carmen*, which were omitted from Berthold's eleventh *figura*, here stand alone but filling the entire width of the folio. Their outstretched wings again stand for the extension of the cross, just as the upper and lower pair stand for its height and depth. As in the previous figure, variation in the color scheme, in this case in the sixfold wings of the seraphim, introduces a chiastic element into the otherwise symmetrical image. Whereas in Hrabanus's *carmen* both pairs of angels turn their heads in three-quarters view toward the central axis of the cross, Berthold's seraphim are frontal in their orientation. By devoting two of his *figurae* to a single *carmen* in his source, Berthold underscores the importance of the theme of the

79. *Figura* 14: On the Seventy Years of Captivity (Carmen X). Berthold of Nuremberg, Liber de misteriis et laudibus sancte crucis, Lake Constance region (?), 1292–94. FBG, Memb. I 80, f. 45r (detail). Photo: FBG.

ark in his work, which recurs not only in his commentary on the cross but again in his commentary on Mary.[79]

14. De septuaginta annis captivitatis. .XIIII. figura (Carmen X; Figure 79)

In Hrabanus's tenth *carmen*, seventy letters, divided into five groups of fourteen, each clustered like a constellation, constitute the intexts making up the larger crosslike pattern. In the original the groups of letters, read top to bottom, then left to right, constitute two verses declaring that the cross has conquered death and sin. These verses disappear from Berthold's figure and are replaced within each of the five squares by the inscribed number *XIIII*, the sum of which amounts to seventy. In addition to stating this obvious fact, Berthold's short gloss describes each part as being sealed (*sigillatum*) or imprinted with the number, a term that lends his inscriptions an official imprimatur. Hrabanus's commentary, reprised in part by Berthold, enumerates examples of the mystical significance of the number 70 in scripture, beginning, for example, with the seventy years of captivity predicted by the prophet Jeremiah, to which Hrabanus immediately gives a tropological—that is, moral—gloss, interpreting them as signifying the span of a human life spent in exile on this earth due to the transgression of the Fall. The end of the Babylonian captivity further receives an anagogical—that is, eschatological—gloss in that its conclusion points ahead to the end of time when humankind will be reunited with Christ in heaven. A complementary passage from book 2 sees in the seventy priests of Moses a figure of the perfection of divine teaching represented by the cross. The two verses in red with which Berthold inscribes his figure come from the *carmen* proper, as opposed to its intexts; they too refer to the seventy years of the Babylonian captivity.

Whereas in Hrabanus's *carmen* the five groups of letters remain unframed, Berthold unites them in a tight pattern of adjacent squares. The imitation pearl- or jewel-studded borders links them with the five books of Moses in his tenth figure, an appropriate association

given the typological tenor of the poem, which contains repeated references to Old Testament passages. The central square, in addition to being singled out by pink rather than green frames, is surrounded by a yellow band. Close examination, however, reveals that the yellow pigment represents an attempt to cover underlying preparatory ruling.

15. De prophetis et prophetii eorum. .XV. figura (Carmen XXVI; Figure 80)

Berthold's fifteenth *figura* represents one of his more ambitious creations. In subject the diagram matches Hrabanus's *carmen* XXVI, the commentaries on which also supply the inscriptions. There, however, the resemblance ends. Whereas Hrabanus limits himself to the simplest of crosses dividing the foursquare *carmen figuratum* into four quadrants, Berthold fleshes it out with the half-length figure of David at the center and sixteen additional squares, four constituting each arm of the cross, each inscribed with the name of a prophet. Like the previous diagram, it takes the form of square panels tightly packed together. In anticipation of the second half of his opus, dedicated to the Virgin Mary, his gloss relates the *figura* in turn to the Tree of Jesse, an image of the Davidic line of descent frequently accompanied by images of the prophets (see fig. 29). In Berthold's *figura*, each of the four cross-arms is structured by a green cross dividing the quadrants. On these the illuminator imposes a chiastic pattern by alternating the design of the frames. The arrangement of names in juxtaposed boxes, to which Berthold makes repeated recourse, recalls in general terms the arrangement employed in diagrams of the Tree of Consanguinity in manuscripts of the *Decretum Gratiani*, such as that written in Salzburg during the third quarter of the twelfth century, which contains not one but two versions of the table, one painted in opaque pigments, the other drawn, on facing pages (fig. 81).[80] Although the relationships established among the boxes, in one case filled with names, in the other with bust-length images of generic representatives of an extended family (with generations extending forward and back

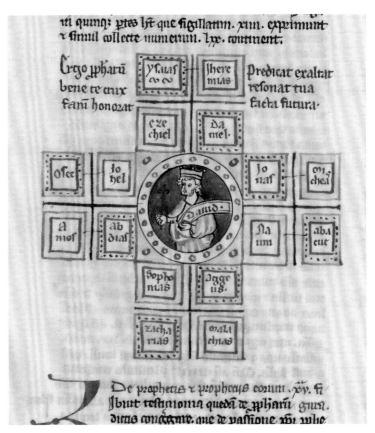

80. *Figura* 15: On the Prophets and Their Prophecies (Carmen XXVI). Berthold of Nuremberg, Liber de misteriis et laudibus sancte crucis, Lake Constance region (?), 1292–94. FBG, Memb. I 80, f. 45v (detail). Photo: FBG.

from the center along the diagonals, and lateral relationships, for example, among brother and sister, nephew and niece, or grandfather and grandmother, expressed horizontally) are not identical, the idea of representing a tight-knit group of related figures within a grid remains the same. In this, however, as in other instances of Berthold's use of such models (see figs. 5, 14 and 28), the boxes in his diagrams represent the very books whose authors' names are impressed on their covers. As is his custom, Berthold lends his *figurae* the appearance of physical objects, especially those objects employed in the cult. In this case, in addition to codices, the *figura* resembles a thesaurus reliquary or a portable altar, such as the portable altar from Stavelot, dated circa 1150–60, with its many inscribed panels and a large rock crystal at the center covering yet another image or inscription (fig. 82).[81] The focus on the cross and on cross-patterns also makes a

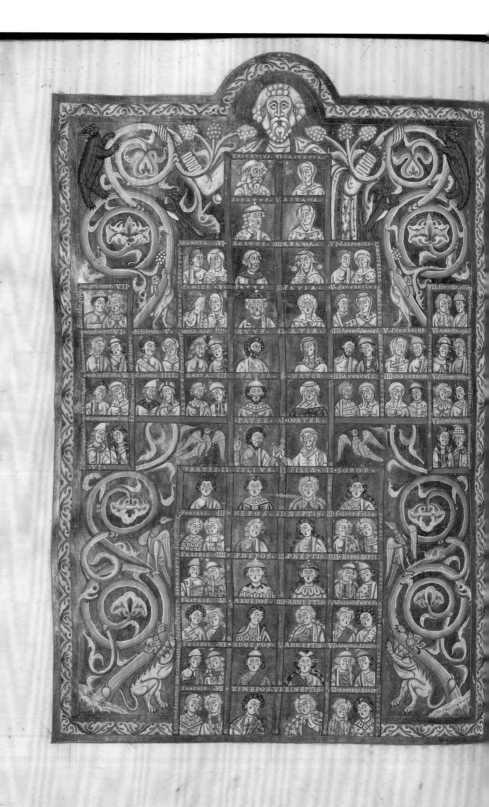

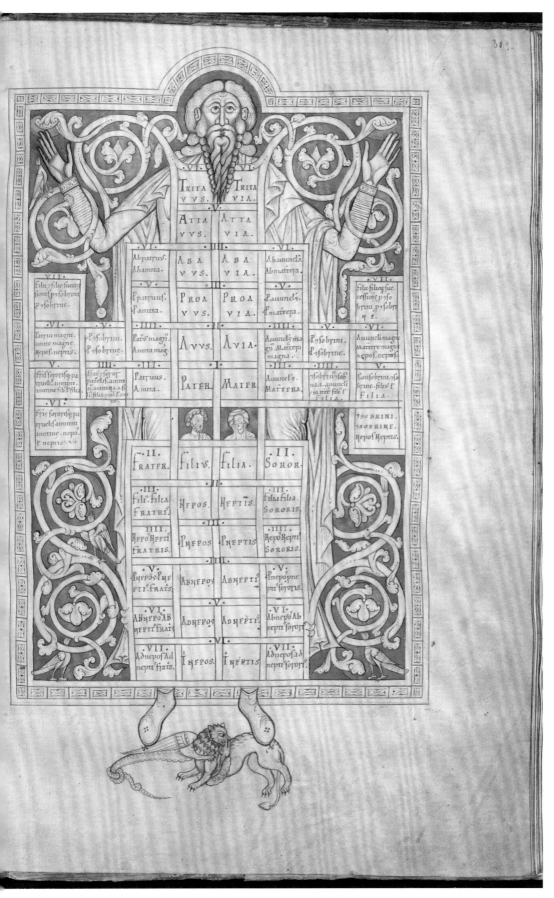

81a–b. Trees of Consanguinity, Salzburg, 1150–75, Munich, Bayerische Staatsbibliothek, Clm 13004, ff. 308v–309r. urn:nbn:de:bvb:12-bsb00108147-3 and urn:nbn:de:bvb:12-bsb00108147-3. Photo: BSB.

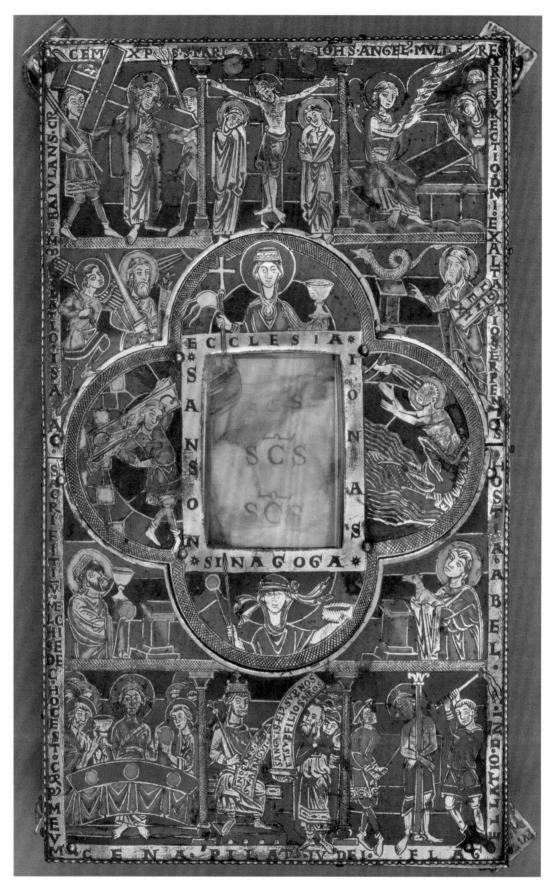

82. Typological Scenes, Portable Altar, Stavelot (Liège), ca. 1160–70, 10 × 27.5 × 17 cm. Brussels, Musées Royaux d'art et d'histoire, inv. no. 1590. Photo: ©RMAH, Brussels.

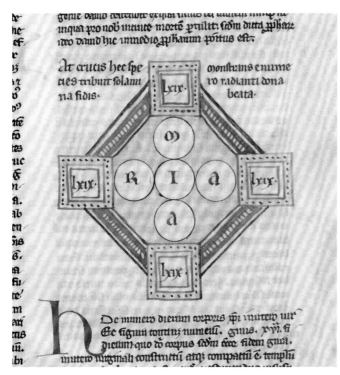

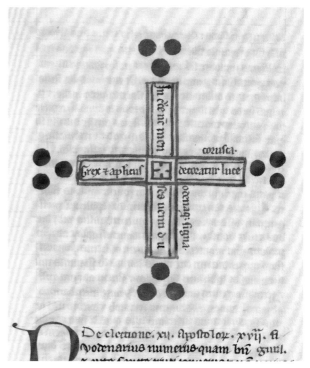

83. *Figura* 16: On the Number of Days the Body of Christ Was in the Womb of the Virgin (Carmen XIII). Berthold of Nuremberg, Liber de misteriis et laudibus sancte crucis, Lake Constance region (?), 1292–94. FBG, Memb. I 80, f. 46r (detail). Photo: FBG.

84. *Figura* 17: On the Election of the Twelve Apostles (Carmen VIII). Berthold of Nuremberg, Liber de misteriis et laudibus sancte crucis, Lake Constance region (?), 1292–94. FBG, Memb. I 80, f. 46v (detail). Photo: FBG.

comparison to a staurothek, such as that manufactured in Mainz or on the Reichenau circa 1010 and presented by Emperor Henry II to the cathedral of Bamberg (Munich, Residenz, Schatzkammer), especially apropos.[82]

16. De munero dierum corporis Christi in utero Virginis. .XVI. figura (Carmen XIII; Figure 83)

Berthold's text draws principally on the commentary to Hrabanus's thirteenth *carmen*. The inscriptions, however, also employ material from the fourteenth. Hrabanus's exposition focuses on the mystical significance of the number 276 (the number of days thought to have been spent by Christ within the Virgin's womb: nine months and six days), which divided by 4 produces 69, which explains why Berthold's image, unlike Hrabanus's picture poem, inscribes each circular terminal of the cross set within a lozenge with the Roman numeral LXIX, the number of letters in each of the four cross-shaped intexts that

in Hrabanus's picture poem mark out a larger cross. In a remarkable departure from his model, however, Berthold inscribes the circles within the lozenge with the five letters of Mary's name: MARIA. The five letters signify the Virgin Mary, but their chiastic arrangement simultaneously identifies them with Christ. By replacing the four crosses that constitute Hrabanus's intexts with a rebus of Mary's name, Berthold shifts the significance of the image from him to her, thereby anticipating the Marian supplement to follow. In effect, from the fourfold pattern of crosses created by Hrabanus, Berthold shapes a womblike space at the center of the image in accord with its subject matter.

17. De electione .XII. Apostolorum. .XVII. figura (Carmen VIII; Figure 84)

The diagram corresponds closely to its source, Hrabanus's *carmen* VIII, which associates the twelve months, signs of the zodiac, winds, and hours of the day (as opposed to night), the ma-

jor prophets, and tribes of Israel with the glory of the cross.[83] The accompanying *declaratio* underpins the linking of these sets of twelve by referring to the description of the Heavenly Jerusalem in Apocalypse 21:10–14, which also revolves around sets of twelve gates, angels, names, tribes, foundations, and apostles. The commentary's pairing of the twelve patriarchs of the Old Testament and the twelve apostles underpins the numerology with typology, whereas the long quotation from the Apocalypse describing the twelve gates on which are inscribed the names of the twelve tribes of Israel lends the exposition an eschatological emphasis. Typology reveals itself to have not a binary but a threefold structure; in addition to linking the Jewish past to Christian revelation, it looks to the consummation of history in the future.

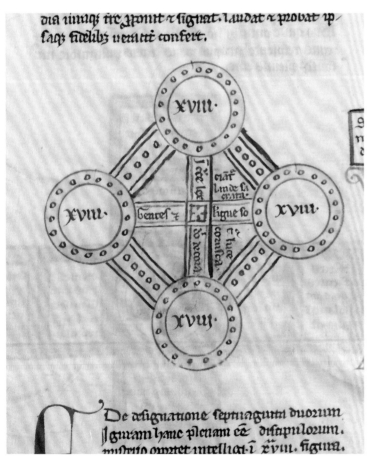

85. *Figura* 18: On the Designation of the Seventy-Two Disciples (Carmen XXI). Berthold of Nuremberg, Liber de misteriis et laudibus sancte crucis, Lake Constance region (?), 1292–94. FBG, Memb. I 80, f. 47r (detail). Photo: FBG.

Whereas in Hrabanus four groups of three diagonals represent the various sets of twelve, in Berthold's simplification each arm of the cross terminates with three large dots, painted alternately in blue or red. The underlying structure, however, which articulates the factors of twelve—a cross with four arms, each of which terminates with a group of three—remains the same. Whereas in Hrabanus each of those elements, distinguished by color, contains short verses embedded within the larger text, in Berthold the surrounding text has vanished. In the poem the allusion to the twelve apostles is but an aside, pairing them with the prophets ("Hoc candor satis micuerunt arma prophetae, / Grex et apostolicus decoratur luce corusca") and linking them to light, an allusion made only slightly more explicit in the secondary commentary provided by book 2.[84] In Hrabanus's figuration, the radiating lines capture the underlying idea of the cross as a cosmic sunburst. Berthold's configuration extinguishes this aspect. The inscriptions reproduce the verses on the vertical and horizontal arms of the cross, but given the smaller size of Berthold's diagram, they spill over its confines, disturbing the symmetry. The ensuing commentary consists almost exclusively of an extensive quotation from Hrabanus's explication (C 8.1–46). Berthold simply summarizes the gist of Hrabanus's commentary, to which he then adds a moralizing and soteriological gloss of his own.

Whereas Hrabanus's poem represents the eighth in his series (of which the first three are missing in Gotha), Berthold's is his seventeenth. As outlined previously, this reordering is anything but willful and indicates that more is at stake than simply making Hrabanus easier to understand. The ordering principle underlying not just the book but also the soul's path to God has undergone a profound transformation. History—specifically, the history of salvation—and the realm of human experience assert themselves over and against numerology, symbolism, and theological argument. Whereas Hrabanus's work can be understood only in the context of the impassioned debates of his time over the status of images, including crosses, Berthold's

reworking, in keeping with the mission of his order, is largely pastoral and devotional.[85]

18. De designatione septuaginta duorum disciplinorum. .XVIII. figura (Carmen XXI; Figure 85)

The *figura* represents the seventy-two disciples of Christ (excluding the twelve apostles; cf. Lk 10:1) by dividing the total into four groups of eighteen. In his customary manner, Hrabanus, followed by Berthold, proceeds by establishing numerical concordances: the seventy-two disciplines preach to seventy-two peoples in seventy-two languages. To these harmonies Hrabanus adds the observation that there are seventy-two canonical books in the Bible (the twenty-four books of the Old Testament multiplied by three, in the name of the Trinity).[86] In its configuration the *figura*'s design closely resembles those employed for *figurae* 6 and 7. There is no relationship whatsoever to the design of Hrabanus's *carmen* XXI, the explanations of which provide the source for Berthold's inscriptions. Whereas Hrabanus's intexts, which together form a cross, each consists of eighteen letters, including the shared letter at the center, in Berthold's design, as in his *figura* 14, inscribed numerals take the places of the equivalent number of letters. From Hrabanus's intexts, Berthold extracts the two verses that, within the heptagons making up the arms of the cross, read left to right and top to bottom, then left to right and top to bottom. The vertical verse reads "The law of the Lord shines in the cross with a dazzling light," the horizontal, "The peoples and the languages are linked in holy praise." Hrabanus is able to accommodate the words as the letters constituting the words are multidirectional; for example, to follow the sense of the horizontal arm of the cross, one must first read the first column of highlighted letters from top to bottom, then the second, then the third, and so on. In the case of the vertical arm, one reads left to right, one row after another, starting at the top and proceeding downward. The cross contained within Berthold's *figura* is not so commodious, which explains why his inscriptions overflow into the spaces between the arms.

19. De septem donis Spiritus Sancti. .XIX. figura (Carmen XVI; Figure 86)

Berthold's introduction into his reworking of Hrabanus of an image of Mary, and, what is more, an image that looks very much like a statue of the Virgin, represents an audacious departure from his model, one that is at odds not simply with its iconography but also with its underlying argument regarding the status of images per se. The *figura* elaborates Hrabanus's design for *carmen* XVI and its accompanying commentaries, the sources of Berthold's text and inscriptions (fig. 88). Whereas Hrabanus doubles the seven gifts of the Holy Spirit, each represented in the

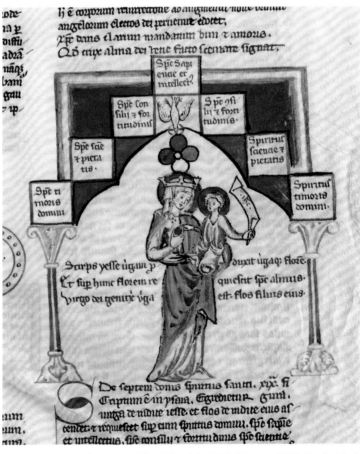

86. *Figura* 19: On the Seven Gifts of the Holy Spirit (Carmen XVI). Berthold of Nuremberg, Liber de misteriis et laudibus sancte crucis, Lake Constance region (?), 1292–94. FBG, Memb. I 80, f. 47r (detail). Photo: FBG.

87. Carmen XVI. Hrabanus Maurus, In honorem sanctae crucis, Fulda, ca. 840. Città del Vaticano, Biblioteca Apostolica Vaticana, Cod. Reg. lat. 124, f. 23v. Photo: BAV.

88. The Virgin Mary as the Throne of Wisdom, Strasbourg Cathedral, central portal, west facade, after 1284.
Photo: Jeffrey F. Hamburger.

form of an inscribed flower, so as to be able to create a symmetrical cross running along both the vertical and horizontal axes, Berthold presents the viewer with a monumental image of the Virgin and Child such as could be seen on the facade of a Gothic cathedral. Standing in the midst of an arched opening, Mary takes on the appearance of a trumeau figure within a portal crowned by a stepped gable (fig. 88). Seated in the crook of Mary's left arm, the Christ Child reaches for the apple in her right hand, a gesture by which he identifies himself as the New Adam. The flower above Mary's head identifies her as the rod (*virga*) of an abbreviated Tree of Jesse. Moreover, the coincidence of her status as *virgo*

with the constellation Virgo assured her a place in the heavens.[87] In the words of Byrhtferth of Ramsey (ca. 970–ca. 1020), who in his commentary on Bede's *De temporibus liber* allegorized the zodiac: "Virgo: Maria quia filium genuit, et virgo permansit" (Virgo: Mary, because she gave birth to a son and remained a virgin).[88] A figure of Christ, the flower illustrates the words of Isaiah's prophecy (Is 11:1: "And there shall come forth a rod out of the root of Jesse, and a flower shall rise up out of his root") with which Berthold, following Hrabanus, opens his commentary.

The single dove at the center, immediately above the Virgin's head, stands in for the full set of seven usually associated with the seven gifts.

The first extant example of the iconography appears on the earliest extant panel painting from German-speaking lands, the antependium from St. Walpurgis in Soest (Münster, Westfälisches Landesmuseum, inv. no. 1 WKV), dated 1170–80, in which the figure of Mary, standing to the right of the Christ in Majesty in the center, effectively holds a diagram of the gifts in her hands.[89] In an arrangement similar to some of Berthold's diagrams, for example, his *figura* 7, six smaller medallions radiate out from the larger central medallion, which represents the first and greatest of the gifts, wisdom, in keeping with the list provided by Isaiah 11:2: "And the spirit of the Lord shall rest upon him: the spirit of wisdom, and of understanding, the spirit of counsel, and of fortitude, the spirit of knowledge, and of godliness." Quoting the Song of Songs 2:1 ("I am the flower of the field, and the lily of the valleys"), Hrabanus identifies Christ's chastity with the lily and his Passion with the rose. Berthold, however, gives the particolored blossom a different interpretation. The petals' colors refer back to the those of the flower incorporated into Berthold's *figura* 4. A reader who recognized the similarity of the color symbolism with that found in *figura* 12 of the subsequent Marian series (f. 56v) would learn there in words lifted from this very section of Hrabanus [C 16.97–112] that the flower's four colors stand for a corresponding number of Christ's virtues: violet for his celestial conversation, purple for the blood of the Passion, pure white for his inviolable chastity, and scarlet for his perfect charity.

Following two passages lifted from Hrabanus, Bertholds adds three more that upon inspection prove to consist of one continuous catena of responses and verses from the office for the Feast of the Nativity of the Virgin. No less crucial to understanding the image of the Throne of Solomon are the following responsory and verse, neither of which, however, is cited. The response reads, "She emits a fragrance beyond all balsams, coloring, and incense," the verse, "purple as the violet, dewy as the rose, gleaming as the lily."[90] A viewer versed in the liturgy would inevitably have been reminded of this passage in the Marian office, with all the resonance it would have

brought with it. Right down to their coloration, Berthold's diagrams and images are rooted in liturgical patterns of thought and perception.

The remainder of Berthold's image illustrates Isaiah's prophecy (Is 11:2:). Inscriptions identifying the seven gifts fill seven boxes arranged in steplike fashion, culminating in the spirit of wisdom and understanding at the apex, which penetrates the horizontal frame, an arrangement similar to that found within the gable of the central portal of the west facade of the cathedral at Strasbourg, which presents Mary on the Solomonic Throne of Wisdom (see fig. 88).[91] A significant part of Hrabanus's commentary as excerpted by Berthold describes the seven gifts not simply as a set but as a series of steps through which the soul ascends to Christ in heaven, imagery of ascent that harks back to the ladder image in Berthold's figure 2, taken from the *Speculum virginum*. The stepped canopy beneath which Mary stands allies the image to representations of the Throne of Solomon (2 Sm 9:17–20; 1 Kgs 10:18–20) such as those in the late thirteenth-century *Verger de Soulas* (fig. 89) or the Gradual of St. Katharinenthal (f. 231v), dated 1312, introducing the Marian sequence "Alma redemptoris mater," in which two series of stepped niches to either side of the throne match its seven steps, an appropriate association in so far as Mary is identified as the *Sedes sapientiae* (Throne of Wisdom).[92] The gigantic initial in the gradual adds another layer of interpretation in that it pairs Mary and John the Evangelist beneath the cross in the lower compartment of the letter *S* with John and the archangel Gabriel, who flank the enthroned Madonna in the upper compartment. Exegesis identified Gabriel and the Evangelist as the protectors of Mary's mind and body respectively.

By making the Virgin Mary bodily present in the midst of a series of images ostensibly dedicated to the mysteries of the cross and, moreover, departing from norms represented by the diagrams that dominate the rest of the series, Berthold both emphasizes the importance of the Incarnation and shifts the emphasis away from Christ to the Theotokos in anticipation of the second part of his opus, where he in fact em-

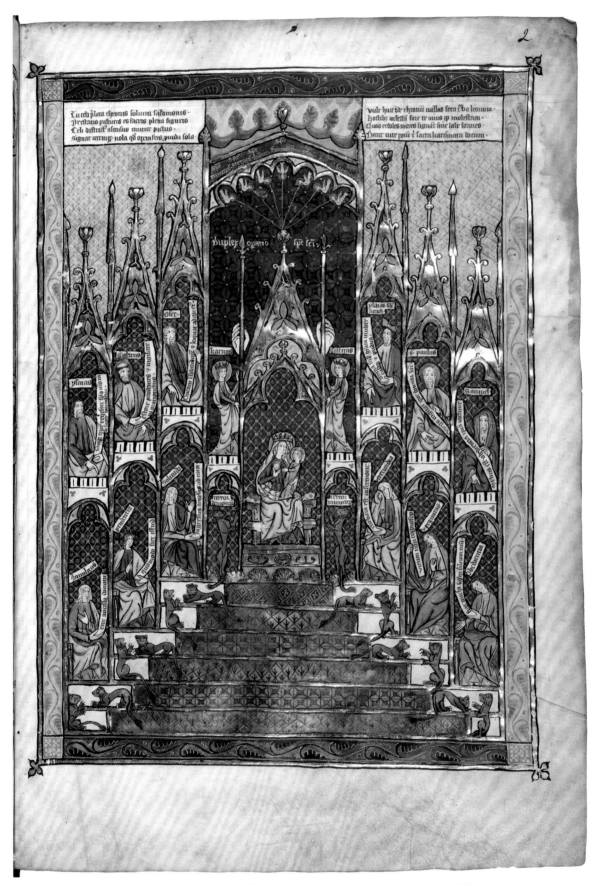

89. Virgin Mary as the Throne of Wisdom. Verger de Soulas, Paris, late thirteenth century. Paris, Bibliothèque nationale de France, ms. fr. 9220, f. 2r. Photo: BnF.

90. *Figura* 20: On the Eight Beatitudes (Carmen XVII). Berthold of Nuremberg, Liber de misteriis et laudibus sancte crucis, Lake Constance region (?), 1292–94. FBG, Memb. I 80, f. 47v (detail). Photo: FBG.

ploys part of the same passage [C 16.97–113] as the commentary on his twelfth Marian *figura*.

20. De octo beatitudinibus. Vicesima figura (Carmen XVII; Figure 90)

Berthold's *figura* and its inscriptions, which are dedicated to the eight Beatitudes, closely adhere to his model, Hrabanus's *carmen* XVII, which is devoted to the same subject (fig. 91). Just as the commentary on the preceding *figura*, Hrabanus's *carmen* XVI, discussed the seven gifts of the Holy Spirit in terms of a gradated process of spiritual ascent, so too in this case a long passage lifted from Augustine defines the Beatitudes in comparable terms.[93] Although in Hrabanus's poem, the eight intexts, one for each beatitude, each take the form of an octagon, in Berthold's version they are reduced to adjoining squares. Berthold, however, departs from his model by

placing a large red rose at the center of his *figura*, where in Hrabanus's version no imagery is present. According to his brief gloss appended to the commentary, the flower stands for spiritual goods or blessings, allied to the eternal rewards discussed in the preceding passage. Although the flower imagery resonates with that in many other *figurae*, it most immediately refers to that in the preceding *figura* of the Tree of Jesse, thereby providing another example of Berthold's careful attention to the effects that tie his diagrams together in a structured sequence.

21. De spatio temporis predicatoris Christi. .XXI. figura (Carmen XXII; Figure 92)

The sources and genesis of Berthold's twenty-first *figura* are more complex than is usually the case, a complexity that reflects that of his models. His commentary consists of passages lifted from the *declaratio* to Hrabanus's *carmen* XX on the significance of the number 120 as well as *carmen* XXII on the Chi-Rho monogram (fig. 93). The latter especially is a tour de force on account of not only the large number of intexts but also its threefold structure: verses inscribed within letters (the intexts) whose component parts, the letters that they contain, function as part of the larger poem that fills the entire folio. Berthold appropriates Hrabanus's detailed explanation of the numerical values of Greek letters, even though in places the discussion is rendered incoherent because words repeated in short succession caused the scribe inadvertently to skip a line and omit a phrase. No Greek, however, appears in Berthold's *figura*. Moreover, his image remains almost entirely independent of the intexts found in either of Hrabanus's poems: in *carmen* XX, four lambdas arrayed in a cross pattern; in *carmen* XXII, the Chi-Rho monogram. In their place Berthold substitutes a *figura* that in its formal features harks back to *figurae* 6, 7, 8, 16, and 18: a rhombus with four medallions at the corners and a fifth medallion at the center. The central medallion contains the abbreviated Latin name of Jesus Christ, a substitute for the Greek monogram. Each of the outer medallions is inscribed with the Roman numeral CCCXV.

SANCTABEATAPOTENSUITAELAVSGLORIACHRISTI
CRUXUENGRANDADEITU SPERAFUNCTIOSAECLI
DICNABONAATQUEPIA FICERASQUIAMEMBRA
STIPITESUSPENSA SUBCARCERISUMBRA
DERIPERASPOPULOS NSUBLIMEREPOSTVM
QUISDEDERASQUONI ATIOLONGAPOLORVM
REDDITAIUREPIISBEATO METSTEMMATEDIGNOS
NAMBONAQUAEINTERRA USARBITERORESERENO
SEMINADISPERSITSACRAMULTIPLICAUITAMAUIT
QUAEQUESEDENSMONTISORAUITINARCEMAGISTER
DISCIPULISTRIBUENSPACTVMPIAFOEDERAIURIS
INCIPIEBATENIMALM FICOTVNCORDINESANCTIS
VIRTVTVHISTITULI SDOMINVSPIAPANDEREDICTA
VTBENEDICTAPATRI SPROLIShocDOGMATESIGNET
CRUXQVIATOTABONA conPLECTITETOPTIMAPERSE
DATDOCETALMAADNEC TITAMANTIBVSATQUEBEATA
SICFELIXDIUINAMARDORETREMENSPREME DAM
q ACETIUSTITIAMHOSTEPIOALC ASE VA
F LENTES VICUPIDOSNAMHISSURSVMOM NADO q
g LS ONS VLAETERNAACSITMISERATIO CE NT
D O A IO D REFECTIOPASTIOLARCAAE TIÑARC E
NO LTO ACTIOCONPETITORE REPEN SQvv ES DE RN
OPS ST NVNCV LEThICATq hocSATISINTE SCVM
LONGEABSVNTbVMILLVESOLoquodPRONVSADORAT
CVMVERBVMHAVDSOL VMMITESSEDINORDINEMORES
OMNITENENSPOSCIT SEMPERhoCTEMPOREQUEOMNI
ERGOBEATORVMESThABITAREINLVCEVOLENTVMET
OCTENOHOCNVMEROVT SVPERARDUADONAREGIRANT
HOCq RESURGENTESREG NVMQUIASICCRUCEUADENT
CRUXUIASCALAROTAPATRIADUXPORTATRIVMphus
UITABEATAHOMINVMMERITORUMETMAXIMAMERCES
BINAQUATERPOSITAEN NIPIAFORMVLAPANDIT
SANCTABONOSBENEDO VMSCANDENDOMERERI
CVNCTIPOTENSqEDE ShOCOMNIPOTENTIS
SPIRITVSIPSEMODI CISSCANDERESEDEM
SEPTENOSq GRADVSS REXERATASTRISQUO
ALTAPOLIHINCPIEPO NIGNOSPANDERETIRE
QUOSCOMITATURAMORR OLuxLAVSBONAVIRTVS
GLORIASTEMMATHRONVSQUISADDITURARCEPOLOR

91. Carmen XVII. Hrabanus Maurus, In honorem sanctae crucis, Fulda, ca. 840. Città del Vaticano, Biblioteca Apostolica Vaticana, Cod. Reg. lat. 124, f. 24v. Photo: BAV.

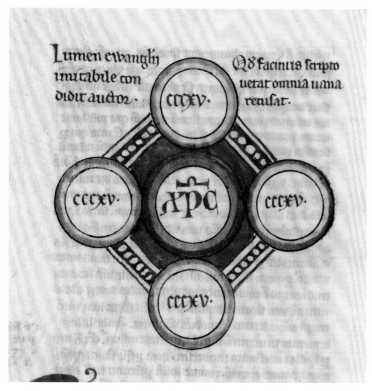

Lumen ewangly
imitabile con
didit auctor .

Qd facinus scripto
uetat omnia uana
renusat.

ccxv.

ccxv.

XPC

ccxv.

ccxv.

92. *Figura* 21: On the Space of the Time of the Preachers of Christ (Carmen XXII). Berthold of Nuremberg, Liber de misteriis et laudibus sancte crucis, Lake Constance region (?), 1292–94. FBG, Memb. I 80, f. 48v (detail). Photo: FBG.

Hrabanus derives this number by way of gematria. The total value of the letters constituting the rho amounts to 1260. To generate a fourfold cross, this number is divided by 4, producing 315. Hrabanus proceeds to calculate the value of the Chi (1335), but Berthold omits this part of his exposition. According to tradition Christ had preached 1260 days on the earth, while 1325 was the number of days during which the Antichrist would reign.[94] Berthold's focus on the life of Christ at the expense of eschatological themes that were more prominent in Hrabanus probably suffices to explain why he truncated his model, particularly given that the subsequent image depicts Christ's crucifixion. The horizontal progress of salvation history takes precedence over the vertical axis of eschatological or analogical explanation.

22. De ipsa imagine salvatoris crucifixi. .XXII. figura (Carmen I; Figure 94)

In this *figura*, which finally introduces the mate-

rial with which Hrabanus opens his series, Berthold abandons the diagrammatic method and substitutes a narrative image that, by virtue of the elimination of all attending figures, whether Mary and John or Christ's tormentors, doubles as a focus of devotional desire. The difference between Hrabanus's rubric and Berthold's is telling. Hrabanus, using a term that he reserves for Christ alone as the true image of the Father within the Trinity, speaks of the "image [*imago*] of Christ extending his arms in the form of the cross" (B 1.2). It is not Christ but rather a very special image of the Savior, not on the cross but with his arms extended as if on the cross. In contrast, Berthold presents his readers with an "image of the crucified Savior," precisely the type of representation Hrabanus scrupulously avoids. The changes in wording and in the conceptions of the image that underlie them encapsulate the differences between Carolingian and high medieval Christology, including attendant attitudes toward images and representation.

Rather than dwelling on Christ's suffering, Hrabanus's poem, the accompanying commentary, and the prose paraphrase in book 2 of his work celebrate the manifestation of his divinity at the crucifixion. Nonetheless, several passages make notably affective appeals to the reader. Of these Berthold selects one from the opening of the *declaratio*, which opens with an injunction to see, "Ecce imago Salvatoris," which cannot but evoke the "Ecce homo" of the Passion (Jn 19:5). What Hrabanus's reader is enjoined to look at, however, is not the Savior himself—an impossibility that attends the faithful in heaven in the form of the vision of God anticipated in *carmen* XXVIII, the last poem in the original cycle— but rather an image (*imago*) of the Savior. Any hint of the narrative context fades to the point of invisibility. In contrast, in Berthold's telling, in which the reader is brought face to face with a piteous image of the suffering Christ, the opening "Ecce homo" immediately evokes its Passion context.

The lack of any allusion to narrative becomes that much clearer if one compares Hrabanus's original conception of the image, which shows Christ alone, embedded in the fabric of the sur-

S ANGUINISERGOSACRINOSFUSIOLAUITETUNDA
SORDIB:ACUNCTISDETERSITETOMNIACHRISTUS
NOXIANĀPASSUSLABESUULITHICQUOQ:NOSTROS
DOLENSARATUMCONTRA BEMTUMCIROGRAPHUM
LUMENEUANGELIIIM A LECONDIDITAUCTOR
QUODFACINSCRIPT ETA MNIAUANARECUSAT
QODUITAMSIGNAN NCUNC EXPENDITURORBE
LUMENUIRTUTUM CENSUET MINANTISUBIGE
INDICATORATU ANDENSQUO STICASCRIPTA
MONSTRANTDO DEIQUANTAOM R:OBTULITORG
ASTDECIESDUODENATENETHICLAUDACARACTER
GRAMMATANECHOCUNASEMELSEDHOCQUATERUNA
MAGNANOTANSFIDEIMISTERIAMAGNAQUEFIDIS
GAUDIADEMONSTRANSMEDICINAEMUNERAGRATA
ETSOCIA EDECUSQUODSPIRITUSA CTORINORE
ARDENSL DEDERATCONCORDIMUN ELINGUAE
HINCQUE CERCOETUSSACRATUM CTATUBIQ:
HOCNOM R EXPANDENSQODSA IN ABYSSO
MUNDI ENA TARETRAHATETP NET OMNES
HISP NISCR SUTQ:INSIGN CRIST UBIQ:
DIGN COMMEND HOMINIQUA AGNARES NAT
INDULTISDONAA UNGENSP BAPROEMIA TI
E RBISDOMINIQ CONDI ROEMIAINAUC T
MULTIPLICATDIGNISIUSTECUMPATRESUPERNO
REGNATORREGNANSCUNCTADICIONEGUBERNANS
QUIPIGNUSDEDERATPARACLITUMIURESALUTIS
UTREGATETSERUETPERDUCATADATRIAUITAEET
PSALLITEDEUOTEUIT MBENEPSALLITECRISTO
GENTESACLINGUAGUE METCOGNOSCITERECEM
UIRTUTEMQ:PATRISGU CUMBITDIRAPOTENTI
MORSQ:SUIETSTIMUL RUMSCITOTEPARENTEM
HAECLAUSCULMENHA ETE EROGERMINEPARTA
AETERNAMREGIEM TEEST TURAEINDIT:ORDO
SERUETUTINDITA ANTUMET ERETDONABEATA
GLORIAHAGCUI USETSUMMA TCAUSAGIETIS
ISTEQUEIURA NECONSERUAT BERACHICEST
QUIBONASUMMACUPITRITEETMEDIOCRIADUCIT

93. Carmen XX. Hrabanus Maurus, In honorem sanctae crucis, Fulda, ca. 840. Città del Vaticano, Biblioteca Apostolica Vaticana, Cod. Reg. lat. 124, f. 27v. Photo: BAV.

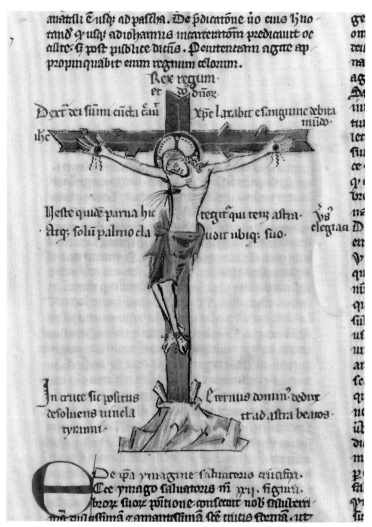

94. *Figura* 22: On the Image of the Crucified Savior (Carmen I). Berthold of Nuremberg, Liber de misteriis et laudibus sancte crucis, Lake Constance region (?), 1292–94. FBG, Memb. I 80, f. 49r (detail). Photo: FBG.

rounding verses, and a related image, adjoined to a manuscript containing *In honorem sanctis crucis*, whose parts date to the twelfth and thirteenth centuries. In the Tuscan manuscript (most likely not from Lucca, its present resting place), the Christ of *carmen* I serves as the model for an additional illustration to the *explicatio* of *carmen* XII (fig. 95).[95] In keeping with the iconography of this holy image, Christ wears a long garment akin to the *colobium* but with longer sleeves. Beneath his outstretched arms stand, on his right, the Virgin Mary and a second female figure; on his left, two saints: Peter and John the Evangelist, who has been displaced from his customary

privileged position. Quotations from Sedulius's *Carmen paschale*, which Hrabanus incorporated into his *carmen* XII, echo the outlines of Christ's head and limbs. The neumed verses immediately below the scene, however, are not by the Carolingian poet; rather, they stem from the hymn "Crux benedicta nitet" (Can 001961, for the Exaltation of the Cross) by Venantius Fortunatus, which begins: "The blessed cross shines bright, where the Lord incarnate hung and with his own blood washes clean our wounds."[96] In the image in Lucca, as in its model and other Carolingian depictions of Christ on the cross, Christ is very much alive, his eyes wide open, his arms extending to embrace the cosmos. *Carmen* I (line 26) describes Christ as reaching out to touch the world, the stars, the sea, and the air, in short, all the elements; *carmen* XII, the explanation of which the image illustrates, is dedicated to the name of ADAM, the four letters of whose name are associated with the four parts of the earth and points of the compass.[97] In the manner of the *syndesmos* figures incorporated into cosmological diagrams, maps, even reliquaries, of the High Middle Ages, Christ, in Hrabanus's words "Lord of the world, the earth, the sea, and the heavens," extends his hands out over the frame, in contrast to all the other picture poems in the cycle, in which the frame remains inviolate (see fig. 20).[98] Hrabanus pointedly does not show the crucifixion per se; no cross is visible. Although Hrabanus specifically asks his reader (lines 1–3) to regard the position of Christ's limbs, there is no hint of pathos: Christ's outstretched hands, he states, teach the necessity that the Creator's will be fulfilled.[99] His *carmen* refers briefly (lines 12–13) to Christ's blood, but only in soteriological terms as a ransom flowing from his right hand.[100] Hrabanus does not depict Christ crucified; a four-nail crucifixion is merely implied. No wounds are visible, whether in Christ's appendages or on his flank.

In contrast, Berthold adopts the three-nail crucifixion that in the visual arts had come into circulation, not without controversy, during the second half of the twelfth century before becoming widely established, at least in Western Eu-

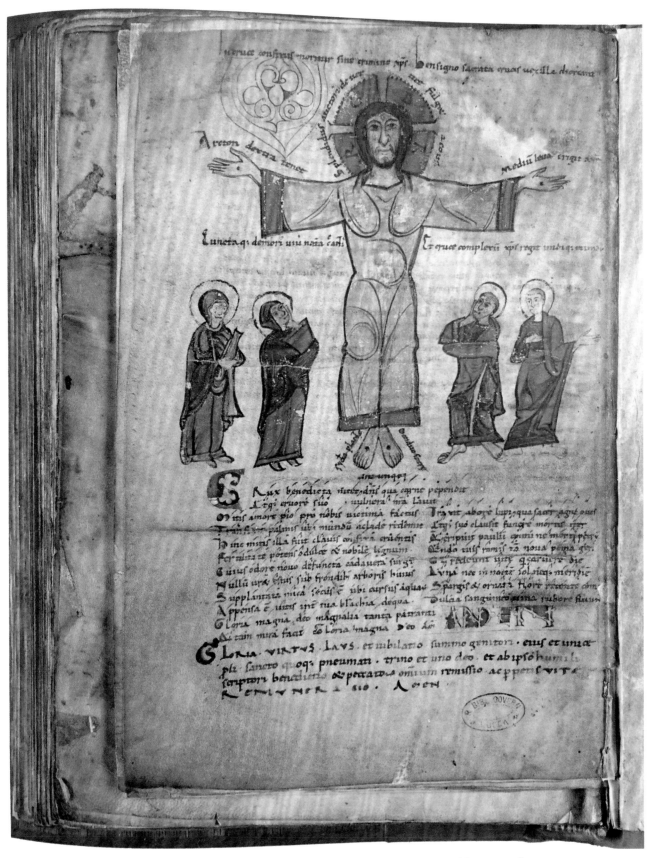

95. Carmen XII. Hrabanus Maurus, *In honorem sanctae crucis*, Lucca, ca. 1200. Lucca, Biblioteca Statale, Ms. 370, f. 121v. Photo: On concession of the Ministry of Cultural Heritage and Tourism—Lucca StPrate Library; further reproduction prohibited.

rope, by the early thirteenth century.[101] Among those who condemned the innovation, associating it with the Albigensians, was Lucas of Tuy in Galicia (d. 1249).[102] Painted as small black dots, the nails in Berthold's rendition are clearly picked out amid the blood flowing from the wounds. In Germany the earliest examples of the novel iconography appear only in the thirteenth century, in the Psalter of Landgraf Hermann I of Thüringia, dated 1217, and the monumental cru-

96. Christ on the Cross, from a Triumphal Cross Group, Naumburg, St. Moritz, ca. 1230. Berlin, Bode Museum; Skulpturensammlung und Museum für Byzantinische Kunst der Staatlichen Museen zu Berlin—Preußischer Kulturbesitz, inv. no. 7089. Photo © Karin Voigt; Art Resource NY.

cifix from the church of St. Moritz in Naumburg, dated circa 1220–30 (fig. 96).[103] The sentiments that such images fostered and to which they gave expression had already been articulated over a century earlier by Elmer of Canterbury, prior of Christ Church from 1128 to 1137, who, in adding to Anselm's collection of prayers and meditations, exclaims in language suffused by imagery from the Song of Songs:

> Sweet is the fastening together of his feet with a nail; for by this he speaks thus, as it were, to us: "Lo now, if you think I ought to fly from you, and so are slow to come to me, knowing that I am swift and fleet-footed as a hind; you see that my feet are so fixed together with a nail that I cannot fly from you at all, because my pity keeps me fastened tight. Nor can I flee from you as your sins have merited, for my hands, they too are fixed with nails."[104]

Elmer employs the rhetoric of "sweet suffering," in which the two meanings of *passio*, suffering and erotic passion, are fused.[105] Elmer clearly distinguishes between Christ's hands, each of which is affixed to the cross by a separate nail, and his feet, which share a single nail. Berthold adopts a comparable passage from one of Elmer's sources of inspiration, Anselm's prayer to Christ, as the commentary to his fifty-third Marian figure, devoted to the topic of Mary's suffering at the Passion, which, however, leaves open the number of nails employed to affix Christ to the cross: "Why could you not bear to see the nails violate the hands and feet of your Creator?"

Berthold's diminutive representation of Christ on the cross invites comparison with two other Dominican images, both in the form of small hand-held processional crosses, the first from the Dominican convent of St. Katharinenthal, dated circa 1250–70 (fig. 97),[106] the second from the Dominican convent of Heilig Kreuz in Regensburg, dated circa 1310 (fig. 98).[107] Such comparisons contribute to localizing the manuscript in Gotha to the Upper Rhenish region, perhaps in Basel or Constance.[108] In Berthold's crucifixion the sharp, angular folds of Christ's

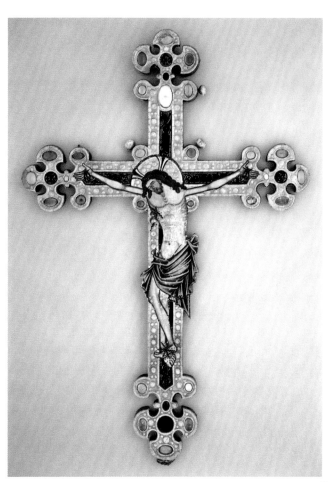

97. Processional Cross, St. Katharinen-
thal, ca. 1250–70, 99.3 × 67 cm. Basel,
Historisches Museum, inv. no. 1905.70.
Courtesy of Historisches Museum Basel.
Photo: M. Babey.

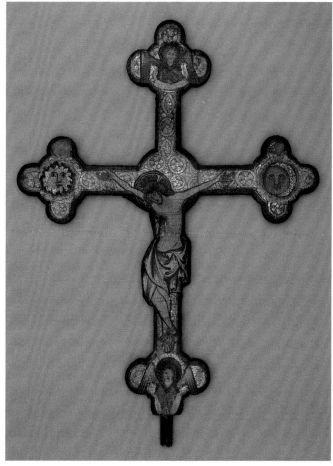

98. Processional Cross, Heilig Kreuz,
Regensburg, ca. 1310, 52 × 40 cm.
Nuremberg, Germanisches National-
museum, KG 1054. Photo: GNM.

purple and pink loincloth—an oblique reference to Christ's royal nature—still bear traces of the so-called *Zackenstil* or jagged style that, drawing on a combination of German and Byzantine sources, perhaps mediated by Venetian art, flourished in various regions, among them Thüringia, the Rhineland, and Regensburg, during the first half of the thirteenth century.[109] The prismatic style, which remains pronounced in the crucifix from St. Katharinenthal, accentuates the angular pose of Christ's body, in which he no longer stands frontally and ramrod straight on the cross but rather hangs and sags, as expressed in these images by the bend in his knees and the characteristic droop of his head.[110] In all three images Christ's head has a marked triangular shape, somewhat blunted in Berthold's book and on the crucifix in Regensburg, while in that from St. Katherinenthal so acute and pointed that its tip seems slotted into the folds of skin on his chest. Each head sports a full head of hair, surprisingly ruddy on both crucifixes, given that red hair was one of the traditional traits of Christ's betrayer, Judas, with a long curly forelock hanging along or over the left shoulder.[111] While the head of Berthold's Christ remains centered at the intersection of the beams of the cross (a fixation underscored by the white lines that mark the median of both beams), on the crucifixion from St. Katharinenthal, Christ's head has sunk to the left, a movement played up by the curve produced by the hollowing out of his torso on its right side, and so deep that it reveals a substantial slice of the blue cross framed within the (restored) gilded surround, which lends the entire object the character of a *staurothek* (a reliquary designed to enclose a fragment of the True Cross).[112] On the crucifix from Regensburg, the fall of Christ's head is still more pronounced; his forehead obscures his shoulder and upper arm, an effect emphasized by disjunction between his dark blue halo and the gilded medallion marking the intersection of the crossbeams (a motif that effectively mimics the eclipse to the right). The decoration of the two sides of the cross refers to Christ's two natures; the one side, featuring the

sun and moon as well as two angels, refers to the hour of Christ's death and hence his humanity; the other side, featuring the four Evangelists, whose presence likens the image to a Majestas Domini, to his divinity.

In the crucifix from Regensburg, painted a full half century after that in Basel and as much as twenty years after the codex in Gotha, the jagged folds have been replaced by soft, curvilinear calligraphy, inspired in large part by contemporary French models in both painting and, especially, sculpture. The later crucifix also takes a softer approach to the modeling of the body: whereas in the thirteenth-century examples Christ's pectorals and ribs and the median line along the abdomen are, to varying degrees, clearly marked out, by the early fourteenth century the lines defining Christ's arms melt into his chest, and his belly sags. One feature that, however, is shared by the two crucifixes that bracket Berthold's in their dates is that they both permit Christ to show more skin. The crucifix from St. Katharinenthal is especially daring in this respect: not only is the loincloth hitched up toward the knot above Christ's knees, exposing his thigh, but it droops to the very bottom of Christ's abdomen, almost exposing his groin. The effect of exposure is exaggerated by the elongation of Christ's body, to which the tiny head seems a slight appendage. By comparison, both Berthold's Crucifixion and the corpus on the crucifix from Regensburg are squat and stocky.

All three images focus on the isolated figure of Christ. That isolation, however, is relative. Berthold's Crucifixion at least implies a surrounding landscape setting by inserting the cross into the rocky summit of Golgotha, which is depicted as a jagged outcrop of rock. Two bloodied wooden pegs hold the cross in place; additional rivulets of blood mark the crannies in the ground. The figuration on the lobed terminals of the processional cross from Regensburg suggest both a narrative and a liturgical context for the image. The personified sun and moon adorning the terminals of the cross-arm—the latter shown eclipsing the sun, of which only a golden crescent remains—make reference to a

specific moment in the Passion narrative (Mt 27:45; Mk 15:33; Lk 23:44). The emergence of the sun's fiery aureole, just as in a real eclipse, succeeds in lending the symbolic imagery the effect of momentary evanescence. It also places the Crucifixion in a cosmic context. To this the imagery on the vertical post of the cross adds a liturgical note. Two angels, dressed as deacons, raise their hands in gestures of acclaim, underscoring the eucharistic import of the event that the cross commemorates, celebrates, and reenacts. When the cross is reversed, the lobes display the four Evangelists, whose presence removes the crucifixion from its immediate historical context to the heavenly sphere. Whereas the one side displays the human Christ within history, the other manifests his celestial divinity.

In Berthold's image, Christ's broken body hangs from a cross identified with the *lignum vitae* by both its rough-hewn branches and its pronounced green color. Blood flows from all five wounds. Three carefully delineated rivulets of blood fall from each hand. The flow of blood on the two processional crosses is equally restrained. More blood spurts from the side wood toward the red rubrics and inscriptions, suggesting that they too are written in blood—a comparison often made in allegories of manuscript manufacture that compared all aspects of the production process to incidents in the Passion, from Christ nailed to the cross (the stretching of the parchment) to its pricking in preparation for ruling (the infliction of Christ's wounds).[113] Even Christ's halo, the foil for his hanging head, is decorated in red.

All three of these images, Berthold's included, stand far removed from the lofty abstraction of Hrabanus's conception. They hover between an eyewitness representation of the central event in salvation history and an image of an image-object, in this case an altar or processional cross. Like Berthold's Crucifixion, the metalwork cross is identified as the *lignum vitae*, in this case by the leafy vine scroll that provides the background to the corpus. In light of the presence of such objects on altars, Berthold's image inevitably takes on a liturgical association with the Mass that rit-

99. *Figura* 23: On the Alleluia and Amen (Carmen XXV). Berthold of Nuremberg, Liber de misteriis et laudibus sancte crucis, Lake Constance region (?), 1292–94. FBG, Memb. I 80, f. 49v (detail). Photo: FBG.

ually recapitulates Christ's sacrifice on the cross. As in the case of many of his other figures, the suggestion of a three-dimensional cult object enhances the effect of bodily presence.

Berthold's Crucifixion and the two Dominican processional crosses participate in a common visual and devotional culture, which in this case is specifically Dominican. At least according to legend, as early as about 1220, the order's constitutions mandated that the cell of each brother might contain "images of the crucified Christ, the blessed Virgin, and our father Dominic."[114] Echoing the legislation of the 1250s, the *Vitae fratrum* by Gerald of Frachet, written in Limoges between 1256 and 1259 and officially promulgated at the meeting of the General Chapter that took place in Strasbourg in 1260, praises the devotional ardor of the order's founding friars by claiming that they "had her image [Mary's] and her Son's in their cells, so that whether reading or praying or sleeping, they

100. Carmen XXV. Hrabanus Maurus, In honorem sanctae crucis, Fulda, ca. 840. Città del Vaticano, Biblioteca Apostolica Vaticana, Cod. Reg. lat. 124, f. 32v. Photo: BAV.

O crux dux mifero latoq; redempto mundo·

O crux que cederas rupto plebem ire ab arno·

O crux que excellis toto et dominaris olimpo·

De niio quadragenario · xx·iiij· figura.
Quadragenarius numerus hic speciem sancte
crucis formata et misterii facramentum conccua dif

might both look upon and be regarded by them
with a loving glance [*oculis pietatis*]."[115] One can
only imagine what Hrabanus would have made
of such a passage, which not only praises images
as objects of devotion, but has them reciprocate
the viewer's gaze.

Berthold's gloss ("This image in the cross
which is around the head contains three letters,
alpha, medium, and omega, which signifies that
all things are comprehended by it, that is, the
beginning, the middle, and the end"), which he
lifts from Hrabanus's explanation of the letter-
ing in Christ's halo (C 1.137–140), points to the
crucifixion as the middle point (*medium* in the
history of salvation standing between the begin-
ning [Alpha] and the end [Omega]).[116] Unlike
Hrabanus, for whom the cruciform image of
Christ represents the image from which his en-
tire treatise extends, for Berthold the image of
Christ crucified, if not situated dead center in his
commentary, is placed very much in the midst of
the flow of sacred history.

23. De alleluia et amen. .XXIII. figura (Carmen XXV; Figure 99)

As in the Carolingian *carmen figuratum* on
which it is based, the letters ALLELUIA surround
the cruciform disposition of AMEN at the center
(fig. 100). Berthold, however, removes the car-
pet of letters within which the two words are
embedded. In contrast to the other *figurae* in the
series, the verses taken from Hrabanus's poem
are written in brown ink rather than red. They
are, moreover, written by a hand distinct from
any other found in the manuscript, suggesting
that they represent, if not an afterthought, then
a correction of an oversight on the part of the
original scribe. The verses speak of the Alleluia
encircling and completing the cross, which, us-
ing Hrabanus's formulation, is characterized as
a "sacred effigy" (*sacra effigia*). In characterizing
a configuration of letters in the form of a cross as
an effigy, Hrabanus uses the term in the sense of
"likeness," an imitation of an object rather than

102. Carmen XVIII. Hrabanus Maurus, In honorem sanctae crucis, Fulda, ca. 840. Città del Vaticano, Biblioteca Apostolica Vaticana, Cod. Reg. lat. 124, f. 25v. Photo: BAV.

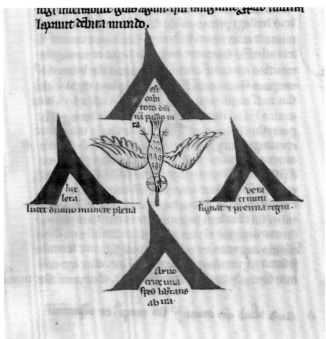

103. *Figura* 25: On the Number of the Jubilee (Carmen XIX). Berthold of Nuremberg, Liber de misteriis et laudibus sancte crucis, Lake Constance region (?), 1292–94. FBG, Memb. I 80, f. 50r (detail). Photo: FBG.

104. *Figura* 26: On the Greek Letter Lamda (Carmen XX). Berthold of Nuremberg, Liber de misteriis et laudibus sancte crucis, Lake Constance region (?), 1292–94. FBG, Memb. I 80, f. 50v (detail). Photo: FBG.

the object itself, a clear indication of the distance between his concept of an image and that prevailing in the High Middle Ages.

24) De numero quadragenario. .XXIIII. figura (Carmen XVIII; Figure 101)

To Hrabanus's eighteenth *carmen* Berthold adds only the abbreviated name of Christ at the center, as he states succinctly in his gloss (fig. 102). In lieu of the forty highlighted letters in Hrabanus's design, Berthold substitutes forty red, blue, and violet dots arranged in a cruciform pattern. The commentary assigns typological significance to the number 40: the Decalogue of the Old Testament, multiplied by the number of Gospels. Instances of the number 40 in scripture adduced by the commentary include the number of days spent by Jesus in the desert undergoing trials, the forty hours between the death of Christ and the resurrection, and the forty post-resurrection days Christ spent on earth prior to his ascension into heaven.

25. De numero iubilei. .XXV. figura (Carmen XIX; Figure 103)

Berthold's *figura* closely matches the intext to Hrabanus's *carmen* XIX, which consists of five letter *X*s—each one itself a representation of the cross—within an array that forms yet another containing them all. Each *X*, moreover, contains ten letters (counting the letter at the intersection twice), fitting in that the *X* also serves as the Roman numeral 10. The jubilee to which the section's rubric refers is from Leviticus 25:10: "And thou shalt sanctify the fiftieth year, and shalt proclaim remission to all the inhabitants of thy land: for it is the year of jubilee." Added together, the five *X*s amount to the fifty-year jubilee proclaimed by the Bible.

26. De littera greca lauda. .XXVI. figura (Carmen XX; Figure 104)

Berthold not only misunderstands the Greek letter that, repeated four times, constitutes the

cross in Hrabanus's *carmen* XX, calling it *lauda* rather than *lambda*, but he also transforms the Carolingian poem, which is devoted to the symbolism of the number 120, into a representation of Pentecost through the addition of the dove of the Holy Spirit that is shown descending at the center. In Hrabanus's commentary, Pentecost is but one of meanings assigned to the mystical number 120. It refers, argues Hrabanus, to the 120 men on whom the Holy Spirit descended at Pentecost, but also to the number of days of penitence following the flood and the height of the Temple of Solomon. As quoted by Berthold, Hrabanus indulges in further number symbolism, pointing out that 15 is the sum of the first five numbers (1–5) and 120, in turn, that of the first fifteen. Following Bede in his commentary on the temple, Hrabanus sees in 15 (the sum of 7 and 8) a figure of the future life (a combination of the repose of the souls of the faithful and their resurrected bodies in heaven). The number 120, in turn, stands for the beatitude of the elect.[117]

Hrabanus's intexts permit the reader to make sense of his symbolism in that each of the four lambdas contains a verse consisting of thirty letters—120 in all. Berthold's image renders the number symbolism rather more opaque.

Berthold's drastic simplification, however, represents more than a reduction in complexity. In keeping with the typological thrust of his project, he transforms figure into narrative, in this case a depiction of an event that fits perfectly in its context within the story told by the larger series. Whereas for Hrabanus the number symbolism is primary, for Berthold it is of secondary significance.

27. De quatuor evangelistis. .XXVII. figura (Carmen XV; Figure 105)

The image of the four Evangelists surrounding the Lamb of God provides one of the most striking illustrations in the manuscript, in large part because of the predominance of figural elements

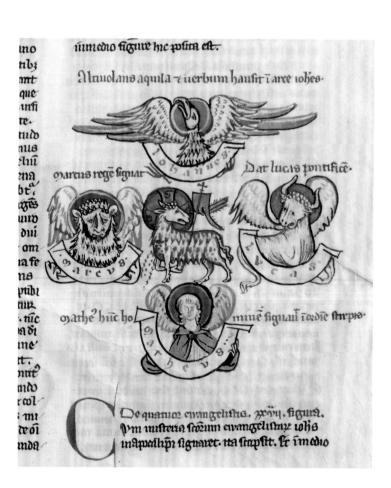

105. *Figura* 27: On the Four Evangelists (Carmen XV). Berthold of Nuremberg, Liber de misteriis et laudibus sancte crucis, Lake Constance region (?), 1292–94. FBG, Memb. I 80, f. 51r (detail). Photo: FBG.

incorporated within the basic quincunx structure derived from images of the *Majestas Domini*. The same holds true of Hrabanus's *carmen* XV. In keeping, however, with the text's emphasis on the Lamb of God at the center ("Agnum vero qui in medio sedis est"), the image, like its model, places the *Agnus Dei* at the center in conformity with Revelation 5:6: "And I saw: and behold in the midst of the throne and of the four living creatures, and in the midst of the ancients, a Lamb standing as it were slain, having seven horns and seven eyes: which are the seven Spirits of God, sent forth into all the earth." Although not a literal illustration of this passage—the seven horns and seven eyes are lacking—the lamb has a wound that is displayed prominently and bleeds profusely, an aspect in which it differs from its Carolingian model and which also re-

lates it to the image of the crucifixion in Berthold's *figura* 22. The lamb's green cross-halo is inscribed with the three transliterated Greek letters, Y.O.S (υἱός, i.e., *son*), which Hrabanus interprets as meaning that the lamb symbolically refers to Christ. With his customary reticence regarding depictions of the crucified Christ, Hrabanus chooses a symbolic image of sacrifice that, by virtue of an inscription, points to its christological content.

The image is more characteristic of the early than of the late Middle Ages. In its disposition and content it can be compared with a late tenth-century ivory plaque, possibly of Beneventan origin, that, in a manner comparable to some early medieval processional crosses, depicts the Lamb at the center of a cross with the four corners filled with the symbols of the Evangelists (fig. 106).[118]

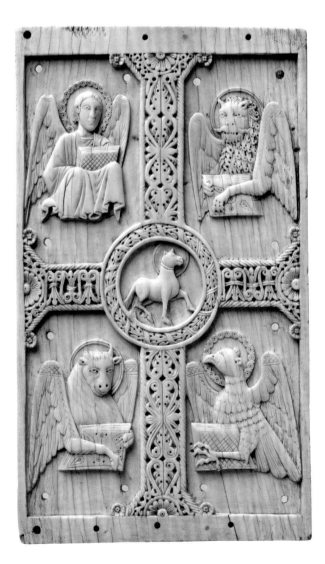

106. Plaque with Agnus Dei on a cross between symbols of the Four Evangelists, 23.5 × 13.7 × 0.9 cm, Benevento (?), ca. 1000–1050. New York, Metropolitan Museum of Art, acq. no. 17.190.38. Photo: Museum.

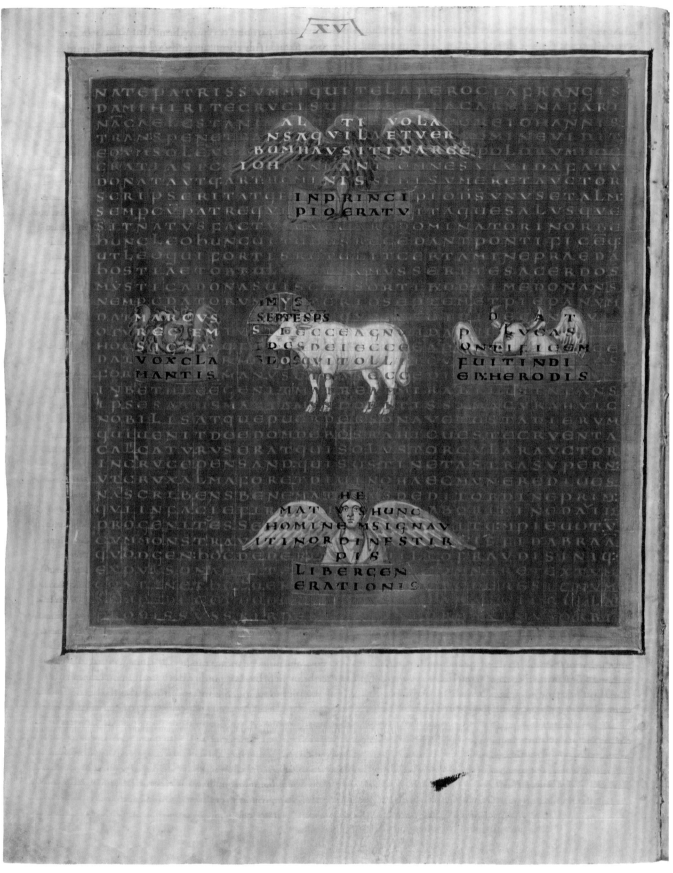

107. Carmen XV. Hrabanus Maurus, In honorem sanctae crucis, Fulda, ca. 840. Città del Vaticano, Biblioteca Apostolica Vaticana, Cod. Reg. lat. 124, f. 22v. Photo: BAV.

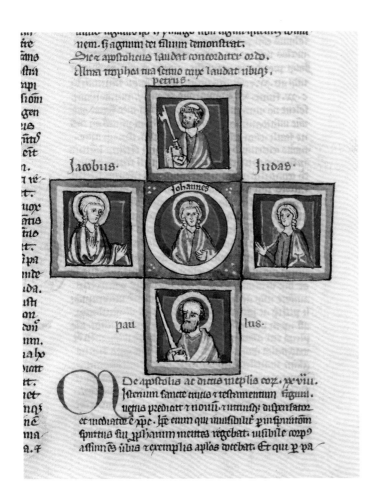

108. *Figura* 28: On the Apostles and Their Sayings in Their Epistles (Carmen XXVII). Berthold of Nuremberg, Liber de misteriis et laudibus sancte crucis, Lake Constance region (?), 1292–94. FBG, Memb. I 80, f. 51v (detail). Photo: FBG.

Berthold's design differs in that like its model, Hrabanus's *carmen* XV, it places John the Evangelist's eagle at the top, marking him as the most sublime of the four (fig. 107).[119]

In assembling the text that accompanies the image, Berthold took even greater liberties with Hrabanus than was his wont, freely mixing passages from the explanations of the *carmina* in part I and their prose equivalents in book 2.

28. De apostolis ac dictis in epistolis eorum. .XXVIII. figura (Carmen XXVII; Figure 108)

Berthold's twenty-eighth *figura* corresponds, at least in principle, with Hrabanus's *carmen* XXVII, which takes as its subject the words of the apostles on Christ's Passion. Berthold's inscriptions come from the same source, but the long excerpt from *In honorem sanctae crucis* stems from the commentary on *carmen* XV, devoted to the four Evangelists. The *figura* employs the quin-cunx structure adopted from a *Majestas Domini* (cf. the preceding *figura*), but in lieu of Christ, a christomorphic John the Evangelist occupies the center.[120] In his gloss Berthold asks his readers to see in John at the center an image of the beloved disciple resting on the breast of Christ: "Iohannes in medio quasi in pectore crucis." The image thus doubles, at least implicitly, as a Last Supper. Peter and Paul occupy the vertical axis of the cross. James the Greater and Judas the horizontal. The pairing of Peter and Paul requires no explanation, although Berthold dutifully provides one. James and Judas (not Iscariot) flank John because they were his brothers according to Matthew 13:55–56, a passage that generated headaches for exegetes bound to uphold Mary's perpetual virginity. The arrangement of Berthold's *figura*, which comprises framed panels enclosing bust-length figures, brings to mind the design of some enameled processional crosses, albeit of a considerable earlier period. The verso of the ninth-century Italian Beresford Hope

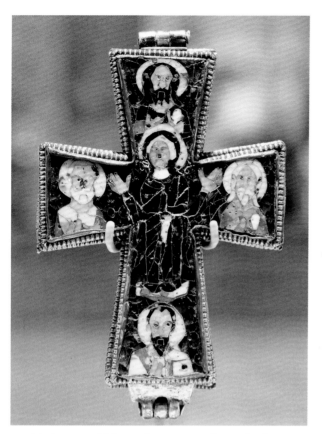

109. Virgin Mary with busts of Sts. Peter, Andrew, John the Baptist, and Paul; Beresford Hope reliquary cross, Italy, ninth century. London, Victoria & Albert Museum, inv. no. 265&A-1886. Photo: © Victoria & Albert Museum.

110. *Figura* 29: On the Twenty-Four Elders (Carmen XXIII). Berthold of Nuremberg, Liber de misteriis et laudibus sancte crucis, Lake Constance region (?), 1292–94. FBG, Memb. I 80, f. 52r. Photo: FBG.

reliquary cross, which likely served as a container for a fragment of the True Cross, displays the Virgin Mary standing at the center, flanked by busts of Saints Peter and Andrew, plus Andrew and Paul above and below (fig. 109).[121] In this, as in other instances, Berthold transforms Hrabanus's ethereal, insubstantial intexts into images akin to material objects.

29. De viginti quatuor senioribus. .XXIX. figura (Carmen XXIII; Figure 110)

Berthold's *figura* offers a close match to Hrabanus's *carmen* XXIII. Twenty-four red, blue, and violet dots take the place of the letters composing the terminals of the cross in the Carolingian intext. In Hrabanus's exposition 24 signifies, inter alia, the number of celestial spheres, hours in the day, books in the Old Testament (including Ruth and Lamentations), the descendants of Aaron,

and the Elders of the Apocalypse. Berthold reduces these myriad meanings to just one, the last, so as to anchor the *figura*'s placement toward the eschatological conclusion to his narrative made up of sequential diagrams.

30. De centum quadraginta quatuor mulieribus. .XXX. figura (Carmen XXIV; Figure 111)

Rather than employ the abstract figuration of Hrabanus's *carmen* XXIV, which employs four pentagons to expound the significance of the number 144, Berthold reverts to a design similar to that which he used for his *figura* 28. In this case, however, the five square panels are devoid of figures. In their place, each arm of the cross encloses the Roman numeral XXXVI, a quarter of the mystical number 144. The center is filled with a bifurcated fleur-de-lis, half white, half red,

111. *Figura* 30: On the 144 Women (Carmen XXIV). Berthold of Nuremberg, Liber de misteriis et laudibus sancte crucis, Lake Constance region (?), 1292–94. FBG, Memb. I 80, f. 52v (detail). Photo: FBG.

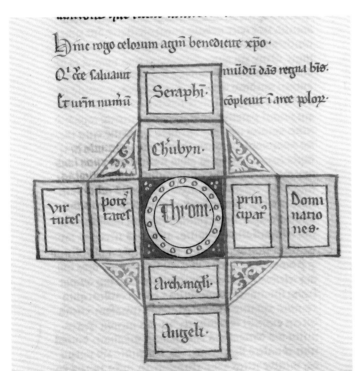

112. *Figura* 31: On the Nine Orders of Angels (Carmen III). Berthold of Nuremberg, Liber de misteriis et laudibus sancte crucis, Lake Constance region (?), 1292–94. FBG, Memb. I 80, f. 53r (detail). Photo: FBG.

against a blue ground. In an interpolation Berthold helpfully explains that the lily refers to the chastity of the 144,000 apocalyptic virgins who danced before the throne (Rev 14:1): "Et quia lilium castitatem representat, ideo in medio crucis positum inventitur." The lily represents the last instance of the flower symbolism that runs as a leitmotif throughout Berthold's reworking of Hrabanus's christological cycle. Once again Berthold simplifies Hrabanus's complex numerology, which unlocks as many mysteries within the number as it has factors, in favor of something resembling linear narrative. In this the penultimate figure in the series illustrating Hrabanus's

In honorem sanctae crucis, the reader is placed before the throne of God in heaven.

31. De novem ordinibus angelorum. XXXI figura (Carmen III; Figure 112)

In an indication of just how radically Berthold reshapes his model, his last *figura*, devoted to the nine orders of angels, corresponds to Hrabanus's *carmen* III. Whereas Hrabanus works his way down, as it were, from God to the world, on the model of the incarnation, Berthold works his way up, in keeping with the trajectory mapped out by the *Homo constat* diagram that he interpolates as his second *figura*, preceded only by Adam in the first. The words that constitute the Carolingian intext (SALVUS CRVX) are banished in favor of another paneled pattern reminiscent of metalwork crosses, to which the illuminator adds corner pieces that recall filigree work in gold.

To recapitulate: Berthold's reordering of Hrabanus is anything but willful. Rather, in keeping with the theological, pastoral, and devotional imperatives of his time, he not only simplifies his source but also scrambles it, but in ways that would have made it easier for his audience to comprehend. In this case easier also means accommodating Hrabanus's cosmological understanding of the cross to a scheme of salvation history that for Berthold's readers would have seemed as natural as creation itself. To borrow a formulation about borrowing from Wolfgang Kemp, it is not as if Berthold's appropriation of Hrabanus represents "an exchange between two epochs that proceeds without consequences or results for either of the participating systems, or, expressed differently, an exchange that does not take place between system and system."[122] One system of thought is assimilated into another, thereby changing them both.

After Berthold's intervention, Hrabanus means something other than what he originally intended. In lieu of Hrabanus's grand cosmic scheme, undergirded by complex numerology, Berthold offers a linear view of sacred history reaching from Genesis to the Apocalypse. In Hrabanus, Christ as he is represented in the first *carmen* stands first and foremost as the Alpha and Omega, a God dwelling in eternity who comprehends all of time. In contrast, in Berthold, Christ operates primarily within time as a historical personage. History intrudes on eternity, and figuration—representations of bodies whether human or angelic—takes the place of text. Even if most of what Berthold has to say is spoken in words appropriated from his Carolingian predecessor, those words, as rearranged, have a different story to tell. The overall tenor of Berthold's presentation is less theological in tone; doctrine gives way to devotion.

Devotion, in turn, demands its objects, in ways that Hrabanus most certainly would have found objectionable. In keeping with the demands of history, the real, in the form of recognizable representations of objects used within the liturgy—processional crosses, crucifixes, books—makes its presence known. Reliquaries of the True Cross commonly incorporated verses in praise of its salvific power.[123] If Hrabanus goes out of his way to stress that any such things, his own *carmina* included—figures, he calls them, reserving *imago* for Christ alone—are mere shadows, at best intimations of the real thing, in Berthold a series of images serves as a summation of sacred history. In Berthold's hands the figural dimension of Hrabanus's *carmina* emerges in the form of geometric pictograms in which, far more prominently than in the picture poems on which they are based, the image of the cross comes to the fore. In their combination of word and image, their directionality, and their interrelating of numbers, names, concepts, persons, and events in sacred history, the images double as diagrams.

Berthold was neither the first nor the last to diagram sacred history. Nor did the tradition of diagrammatic poetry in praise of the cross conclude with Hrabanus. A Bible from the Cistercian (originally Praemonstratensian) monastery of Bredelaer, situated some fifteen kilometers south of Paderborn, written in three volumes between 1238 and 1241, integrates an ambitious cross-diagram with poetry in its praise as the anchor of sacred history (fig. 113).[124] Most books in the Bible are introduced by deftly drawn histori-

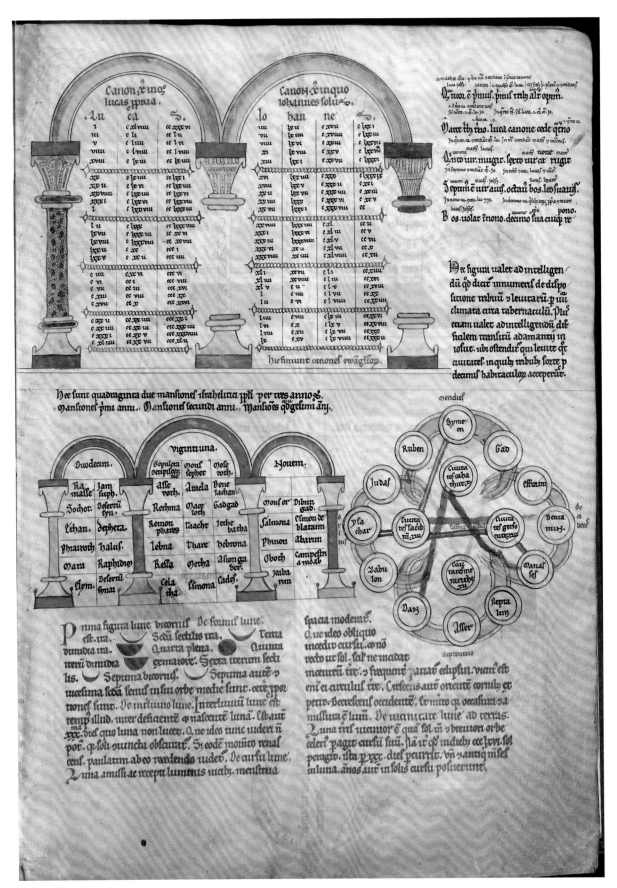

113. Canon Tables, Twelve Tribes of Israel around the Desert Tabernacle. Bredelar Bible, vol. 3, Bredelar, 1241. Darmstadt, Hessische Universitäts- und Landesbibliothek, Hs. 824, f. 65r. Photo: ULB Darmstadt.

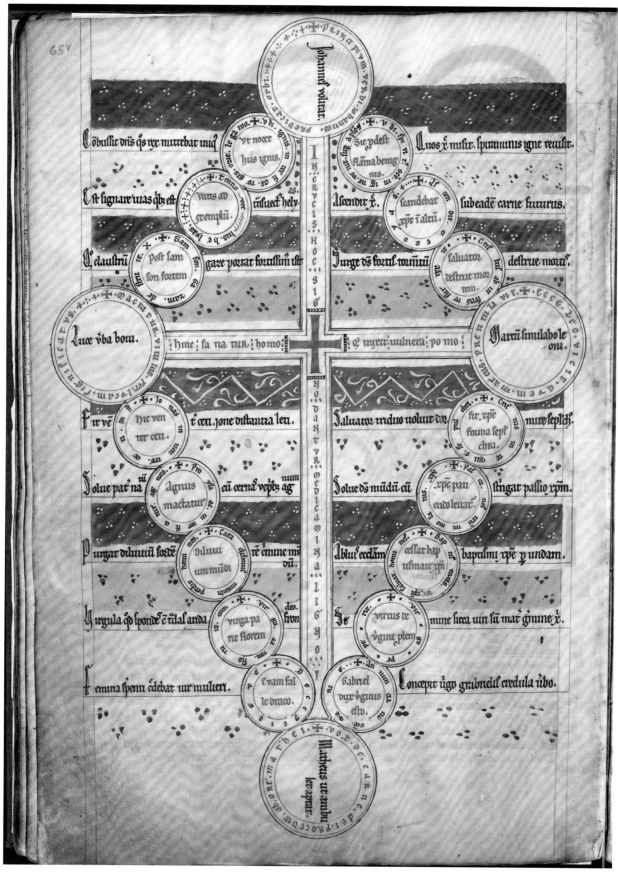

114. Typological Cross. Bredelar Bible, vol. 3, Bredelar, 1241. Darmstadt, Hessische Universitäts- und Landesbibliothek, Hs. 824, f. 65v. Photo: ULB Darmstadt.

Incipit ewangliū secūm math.
LIBER
GENA
TIONIS
IHV XPI.
FILII
DAVIG.
FILII
ABRAOM.

Abraham genuit ysaac. ysa
ac autē genuit iacob. Jacob aū
gen iudam ce frēs eius. Judas aū
genuit phares ce zaram de tha
mar. Phares autē genuit esrō.
Esrom autē genuit aram. Aram
autē genuit aminadab. Ami
nadab autē genuit naason. Na
ason autē genuit salmon. Sal
mon autē genuit booz de raab.
Booz autē genuit obed ex ruth.
Obed autē genuit iesse. Jesse aū
genuit dauid regem. Dauid
autē genuit salomonē ex ea q
fuit urie. Salomon autē genu
it roboam. Roboam autē genu
it abiam. Abia autē gen asa.
Asa autē genuit iosaphat. Jo
saphat autē genuit ioram. Jo

ram autē genuit oziam. Ozias
autē genuit ioatham. Joathas
autē genuit achaz. Achaz autē
genuit ezechiam. Ezechias autē
genuit manassen. Manasses aū
genuit ammon. Ammon autē
genuit yosiam. Josias autē gen
iechoniam ce frēs eius. in trans
migratione babylonis. Ce post
tāsmigrationē babylonis. ie
chonias genuit salathiel. Sala
thiel autē gen zorobabel. Zoroba
bel autē genuit abiuch. Abiud
autē genuit eliachim. Eliachī
autē genuit azor. Azor autē ge
nuit sadoch. Sadoch autē genu
achym. Achim autē gen eliud.
Eliud autē genuit eleazar. Ele
azar autē genuit matham.
Matham autē genuit iacob. Ja
cob autē genuit ioseph uirum
marie. de qua natus ē ihs. qui
uocatur xps

Omnes itaqʒ generationes
ab abraham usqʒ ad dauid
generationes .xiiii. Ce a dauid us
qʒ ad transmigrationē babylonis
gͤnationes .xiiii. Ce a tͣnsmigraci
one babylonis usqʒ ad xpm. ge
nerationes quatuordecim. Xp
autem generatio sic erat

ated initials. What sets this Bible apart, however, is the full-page diagram of the cross that together with the canon tables marks the opening of the Gospels.[125] Emanating from the small Greek cross at the intersection of the arms of a larger Latin cross, the diagram takes the form of a asymmetrical lozenge similar to that found in the *Dialogus de laudibus sanctae crucis* in Munich, which prefaces the praise of the cross proper (fig. 114, and see fig. 116).[126] In the twelfth-century drawing, twelve roundels enclosing busts of the patriarchs, prophets, martyrs, and apostles represent the entirety of the Church gathered in praise of Ecclesia, the bust-length female figure at the point of intersection. The thorn at the bottom of the cross, on which the serpent representing Satan is impaled, likens the symbolic cross to one made of metal and speaks to the apotropaic power attributed to them both, as does the luxuriant foliage, which identifies the cross as an *arbor vitae*.[127] Just as the rubric to Berthold's twenty-first diagram in his work in praise of the cross speaks of the "space of the time of the disciples of Christ," so too the diagram in the *Dialogus* maps out the time of sacred history in spatial terms, beginning at the bottom, then ascending, like the flowering tree of the cross itself, toward the top and sides. At the bottom of the page the inscription reads: "This present image [*figura*] shows [*praetendit*, literally, holds out] that all saints from the beginning of the world until the coming of Christ live in faith in the cross of Christ and saw the Crucified as if through figures [*per figuras quasi*]."[128] The image itself functions as such a figure, yet through the appearance at the terminals of the cross-arms of Christ's face (with closed eyes) and bleeding hands and feet doubles as an image of prophecy's fulfillment. Language of sight and vision courses through the inscription: the figure "shows"; the saints "saw" (*videbant*); the appendages of Christ "appear" (*apparent*). The anthropomorphic scheme of the *syndesmos* (literally, bond), in which the body of the crucified Christ extends to embrace all of time and space, fleshes out the figure and brings the diagram to life, in the words of the inscription, "holding it out" for the viewer to take in.[129]

In the Bredelar Bible four large roundels, connected by series of paired smaller roundels, terminate the arms of the Latin cross proper. In addition to the verse inscriptions identifying each of these elements—most if not all themselves incorporating small crosses marking the point at which one half of a given couplet starts— eight pairs of leonine hexameters, one to the left of the vertical arm, the other to the right, form a field of horizontal bars that elaborate on the subjects of the roundels. Two more verses, written in the same red as the cross at the center of the composition, define the arms of the cross. Interlocking pairs of blue, red, and green panels, in turn enlivened by geometrical patterns in red and white, create a chromatic enjambment cascading down the page.[130] The inscriptions on the cross-arms underscore the medicinal power of the cross; the vertical arm reads "In crucis hoc signo dantur medicamina ligno" (In this sign of the cross / are given the remedies in the wood), the horizontal, "Hinc sanatur homo / Qui traxitur vulnerna pomo" (Hence man is cured / on whom wounds were inflicted by the apple). The larger medallions represent the four Evangelists, with John, associated with the high-flying eagle, placed at the top. The long lines with couplets refer, bottom to top in historical order, to the annunciation, nativity, baptism, crucifixion, triduum (the three days Christ spent in the tomb), the resurrection, the ascension, and the last judgment.[131]

The diagram offers a dense matrix combining word and image, the meter of the verses complementing the number patterns inherent in the imagery. The canon tables on the preceding pages also chart the numerical patterns underlying sacred history by providing a concordance of Gospel passages (see fig. 113). To the series of canon tables the artist added a diagram of the placement of the twelve tribes of Israel around the desert tabernacle, appropriated from Peter of Poitier's *Compendium historiae in genealogia Christi*.[132] Twelve roundels representing the tribes are superimposed on a green quatrefoil, the four lobes of which correspond to the four points of the compass, each marked in red outside the quatrefoil at the ends of the vertical and horizontal axes. Red, blue, light blue, and yellow

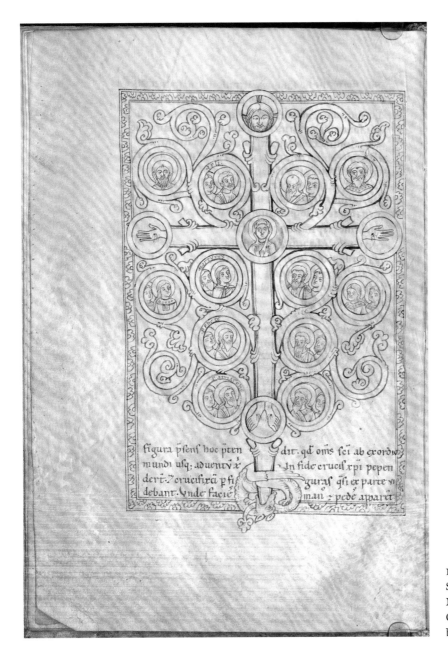

figura p̄senſ hoc p̄ten
mundi uſq̃; aduentū x̄
derit. 7 crucifixā p fi
debant. Vnde facie

dit. q̄ oīs ſc̄i ab exordi
In fide cruciſ xp̄i pepen
gauraſ q̄ſi ex parte vi
man ꝫ pede aparet

116. Adoration of Cross by Prophets and
Saints. Dialogus de laudibus sanctae crucis,
Munich, Bayerische Staatasbibliothek,
Clm 14159, f. 8v. urn:nbn:de:bvb:12-
bsb00018415-2. Photo: BSB.

bars, similar to those that connect the various
elements in some of Berthold's diagrams in his
Marian commentary, trace connections between
the various tribes. The typological imagery woven
throughout the cross diagram serves as a visible
and verbal link between Old Testament prophecy
and New Testament fulfillment, confirming the
unity of scripture. To mark the transition from
figure to fulfillment, the full-page diagram of the
cross gives way across the page to the figurative
initial prefacing the Gospel of Matthew across
the opening that depicts the Tree of Jesse, based
on the vision reported in Isaiah 11:1, in which

the rod (*virga*) growing from the sleeping Jesse's
groin encloses first Mary (*virgo*), then Christ (fig.
115). Diagram gives way to narrative.[133]

Berthold's two-part work follows a similar
trajectory, from past to present, from *signum* to
imago, from diagram to anthropomorphic repre-
sentation, and from figure in the medieval sense
to figuration in the modern, all traced through
the sign of the cross and the image of the cruci-
fixion. His diagrams do not simply trace patterns
of intepretation; they reveal the underlying order
of sacred history.

4

In Praise of the Virgin

Beyond Hrabanus: Berthold's Marian Treatise

In light of the special place of the Virgin Mary in the devotions of the Dominican order, it would have been puzzling had Berthold not decided to grant her a more prominent place than had his Carolingian predecessor. Berthold, however, went further, granting her equal billing by supplementing his commentary on the cross with a second, completed in 1294, whose title, *De misteriis et laudibus intemerate Virginis genitricis dei et Domini nostri Ihesu*, mimics that of its counterpart.

Among the Dominicans, devotion to the Virgin went well beyond the usual and customary, even for an age in which Marian piety underwent an extraordinary efflorescence.[1] Dominicans institutionalized Marian piety, above all by attributing to Mary an instrumental role in the order's foundation. According to a Dominican legend recounted in Gerald of Frachet's *Vitae fratrum*, written circa 1255–60, the order was brought into being to assist the Virgin in the salvation of humankind.[2] A monk experiences a vision in which he sees Mary pleading with Christ to set aside his anger and send preachers out into the world.[3] Humbert of Romans reports a similar vision related to him by a Cistercian who, while preaching to the Albigensians in 1207, saw Mary pleading with Christ for a full three days.[4] Jacobus de Voragine includes both stories in the *Legenda aurea*.[5] Special Dominican devotions to the Virgin included the celebration of the Little Office of the Virgin at Matins and bowing the head each time her name was mentioned in prayers.[6] In 1221 Jordan of Saxony introduced the performance of

the *Salve regina* following Compline, a practice that then was adopted by the entire order.[7] Mary also assumed an important place in the order's sequence repertory, to which it contributed a significant group of Marian compositions.[8] The sequence "Stella maris, O Maria," invoked Mary as "Tu magistra generalis, / Tu ministra specialis" (You, general teacher, / You, special minister), effectively establishing her as the first in the line of the order's administrators.[9] At Vespers, Dominicans chanted the ancient hymn "Sub tuum praesidium" (Under thy protection), which evoked the image of Mary as the Madonna of Mercy—first adopted by the Cistercians and later by the Dominicans—who extends her mantle to shelter members of the order.[10] The *Speculum humanae salvationis*, an immensely influential and profusely illustrated typological work that originally circulated in rhyming Latin verse and whose origins extend back to the early fourteenth century, incorporates the image of the "Schutzmantelmadonna" into its own Marian supplement, in which the chapter in question (38) opens: "Maria est nostra mediatrix, / Consequenter audiamus quomodo etiam est nostra defensatrix" (Maria is our intercessor, / Next we hear how she is also our defender).[11] Following the customary arc of salvation history, the work devotes its last three chapters to the Seven Stations of the Cross, in which Mary serves as an exemplar of compassion, and the Seven Joys and Seven Sorrows of the Virgin.[12]

In joining Christ and the Virgin Mary as partners in the work of salvation, Berthold's work, if hardly as successful, follows much the same model as the *Speculum*. In Gotha the manuscript's codicology, in which Berthold's work on the Virgin continues directly from that on the cross, underscores the essential continuity between its two parts. Taken together, they comprehend the whole of human history as recounted in the Bible. The Marian imagery of the second book is anticipated in the first by the illustration to its nineteenth figure (f. 47r), devoted to the gifts of the Holy Spirit, which is prefaced by a stepped representation of the gifts forming a tabernacle over an image of the Virgin and Child (see fig. 87). The whole constitutes a

highly abbreviated image of the Tree of Jesse. In lieu of Hrabanus's cross-centered cosmology, Berthold's governing principle is the history of salvation, with special emphasis on the intercessory role of the Virgin.

It quickly becomes apparent that Berthold's concern is the salvation not simply of humankind but also of his own soul (and, by extension, of readers willing to follow in his footsteps). In this newfound personal emphasis Berthold is a creature of his age, which also witnessed the emergence of the iconography of particular judgment.[13] The images framing his Marian work express his hopes for salvation in pictorial terms.

The dedication image, along with its accompanying illustration and explanatory text, provides a foretaste of Berthold's method in the sixty chapters that follow (not including the extended dedication and explicit at the end). As in the first part of the work, each section opens with an image that Berthold characterizes as a *figura* but that, in contrast to those in the commentary on Hrabanus, takes on a more overtly diagrammatic appearance. Each figure is paired with an excerpt from an authority, occasionally mediated by the Dominican lectionary, to which are added a few words by Berthold himself commenting directly on the image. Berthold's method, in which he combines, rearranges, and paraphrases excerpts, sometimes employing successive passages from the same source to serve as commentary on several images, is in itself inspired by liturgical practice, in which the nine or twelve lessons for Matins often represent linked passages from the same source.[14] Medieval texts that comment systematically on their own illustrations are relatively rare; in following this procedure Berthold takes Hrabanus's explanations as his model.

Diagramming Mary

From simple building blocks—inscribed lines, circles, squares and rectangles drawn in a limited palette of red, pink, green, blue, purple, with admixtures of white and silver, plus the occasional floral or vegetal motif—Berthold constructs a series of *figurae*, each one simple in itself but in

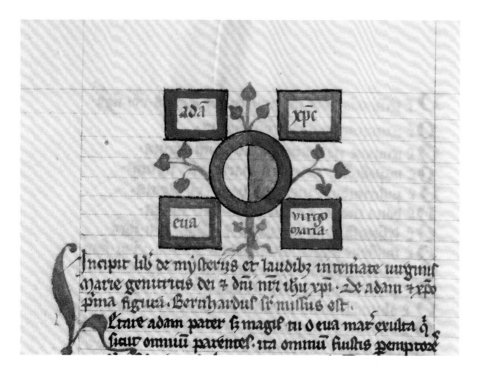

117. *Figura* 1: On Adam and Christ. Berthold of Nuremberg, Liber de misteriis et laudibus intemerate Virginis genitricis Dei et Domini nostri Ihesu, Lake Constance region (?), 1292–94. FBG, Memb. I 80, f. 54v (detail). Photo: FBG.

toto comprising a series of considerable complexity in which echoes and variation, repetition and reinforcement, all play a role. Anthropomorphic imagery, limited to angels, remains rare. All the *figurae* refer to the Virgin Mary, often drawing on the deep repertory of images associated with the Virgin, the majority of Old Testament origin, and then further elaborated with inexhaustible ingenuity in Marian hymns.[15]

Each of the sixty diagrams should be considered individually, in some cases only briefly, before more general conclusions regarding the underlying principles governing Berthold's geometrical exegesis can be drawn.

1. Incipit liber de misteriis et laudibus intemerate Virginis Marie genitricis Dei et Domini nostri Ihesu Christi. De Adam et Christo. Prima figura. Bernardus super Missus est (Figure 117)

> Bernard of Clairvaux, *Homiliae super "Missus est,"* homily 2, part 2.[16]

The opening diagram or figure, which consists of four squares forming the corners of a larger undefined square, has a spare elegance that relies

as much on color as on shape to suggest various patterns of interpretation.[17] The four squares are outlined in green and blue, arranged diagonally with a circle at the center, which is green on the left, blue on the right, and bisected by a green tree with leafy branches that fill the interstices. Within the circle, the trunk of the tree is reduced to a black line that divides the circle into two halves, of which the right is colored pink. The drawing has a basic typological structure that, in keeping with its title, relates the first couple, Adam and Eve, to Christ, the New Adam, and Mary, the New Eve, within a structure that is itself chiastic. Green, the color of the Tree of Life, is associated with Christ and Eve; blue, the celestial color par excellence, with the Virgin Mary and Adam. The only asymmetrical element in the drawing is the shading of the circle, inspired by Song of Songs 5:10, that the accompanying commentary identifies with the city of Jerusalem and that, in keeping with the typological tenor of the drawing, simultaneously represents both the heavenly and the earthly city. In Berthold's words (f. 54v): "This figure contains Adam and Eve and Christ and the Virgin Mary, in particular, in the middle, a representation of the fruit of the tree in distinct colors, the fruit of salvation, that is,

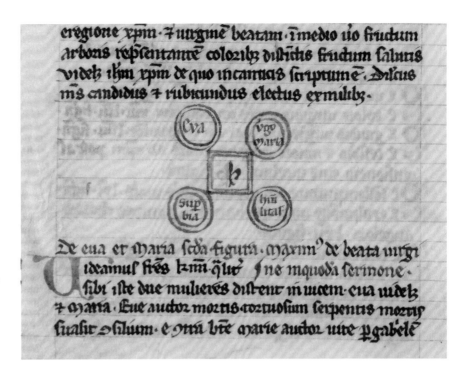

eregione xpm · 7 uurgine beatam · i medio uo frudum
arbons repsentante colorib3 dithtis frudum salutis
uideb3 ihm xpm de quo incarnatus scriptum e. Dilctus
ms candidus 7 rubicundus electus ermilib3·

(Eva) (vgo maria)

♄

(sup bia) (hm litat)

De eua et maria · sda figura · maxim˚ de beata uirgi
ideamus fres hm · qui˚ fine inquoda sermone·
sibi iste due mulieres ditbent in uicem · eua uideb3
7 maria. Eue auctor mortis toztuosum serpentis mortp
siralir ʒfilium · e maria bte marie auctor uite p gabele

Jerusalem, Christ, of whom it is said in the Song of Songs: 'My beloved is white and ruddy, chosen out of thousands.' "[18] In his *Postilla* on the Song of Songs, the Dominican Hugh of Saint-Cher (ca. 1200–1263) records this standard interpretation: "White according to his divine nature, because it is the dazzling radiance of eternal light. Ruddy according to his human nature, because he was formed [literally, coagulated] from the blood of his mother."[19] Berthold identifies this circle as the fruit of the Tree of Life, which in turn is allegorized as both Jerusalem and Christ. In geometric terms, the bifurcation between Old and New Testaments represented by the squares to either side of the diagram and the branching of the tree come together in the unity represented by the circle at the center. It too, however, adopts a bifurcated form insofar as only its right side (from the viewer's perspective) is colored pink in accord with the quotation from the Song of Songs that, in keeping with exegesis of the passage, is interpreted as a reference to Christ. The drawing places Christ and Mary on the sinister side in order to preserve an inherent and underlying sense of passage from left to right—that is, from the Old to the New Dispensation. The accompanying passage, which consists of an excerpt from the second homily in Bernard of Clairvaux's "De laudibus Virginis matris" on Luke 1:26–27, fittingly provides a discussion of Mary as the new Eve.[20] The closing passage from Song of Songs 5:10, appended by Berthold, also served as the basis for an antiphon for the Office of the Nativity of the Virgin (Can 002227).

2. De Eva et Maria. Secunda figura. Maximus de beata Virgine in quodam sermone (Figure 118)

Ildefonsus of Toledo, sermon 12, *De sancta Maria.*[21]

The second diagram represents both a replication and an inversion of the structure of the one that precedes it, to which it is related in content as well as form. In this one sees that Berthold's diagrams unfold in a sequence, not unlike an elaborate piece of origami, in which shapes shift from one configuration to another in order to effect a series of transformations. In lieu of four squares surrounding a circle, in this case four circles surround a square, outlined in paired purple lines, which in turns frames a bifurcated form, in this instance a fleur-de-lis that is yellow on its left side, blue on its right. Viewed accord-

119. *Figura* 3: On the Virtues of the
Soul. Berthold of Nuremberg, Liber
de misteriis et laudibus intemerate
Virginis genitricis Dei et Domini
nostri Ihesu, Lake Constance region
(?), 1292–94. FBG, Memb. I 80, f. 54v
(detail). Photo: FBG.

ing to the division imposed by the central axis,
the circles, like the accompanying commentary,
identify Eve with pride (*superbia*) and Mary
with humility (*humilitas*). Viewed, however,
according to the chiastic diagonals imposed by
the coordination of colors—red for Eve and hu-
mility, green for the Virgin Mary and pride—the
diagram associates each figure with her opposite.
Mary's humility, expressed by the passage from
Luke 1:48, is contrasted to Eve's pride at the Fall.
Berthold's explanation, appended to a passage
from an anonymous sermon sometimes attribut-
ed to Ildefonsus of Toledo, offers a straightfor-
ward explanation of the diagram: "In this figure
Eve is placed with pride and the Virgin Mary
with humility. In the middle in particular [is
placed] a flower of various colors representing
the pride for which Eve was disciplined and the
virtue of humility that God foresaw in the bless-
ed Virgin, as it is written in Luke (1:48): 'he hath
regarded the humility of his handmaid.' "[22] As in
the case of the passage accompanying the pref-
atory image, the anonymous excerpt matches a
reading in the Dominican lectionary, in this case
the first lesson for the Marian Office on various
Sundays following Epiphany and Trinity, which,
however, is attributed to Maximium.[23]

3. De virtitubus anime. Tertia figura.
Anselmus in libro orationum (Figure 119)

Anselm of Canterbury, *Orationes sive meditationes*, prayer 7.[24]

At first glance, the third diagram resembles a
segment from a genealogical diagram, with the
three circles in purple at the bottom descending
from the single blue circle at the top represent-
ing the Virgin Mary. Closer consideration, how-
ever, along with consultation of the commentary,
makes it clear that the diagram, which rep-
resents the "virtues of the soul," should be read
the other way round, proceeding from bottom
to top along the paired green lines that connect
its constituent parts. According to their labels
and the commentary, which quotes a dictate of
Christ reported in all four Gospels (Mt 22:37;
Mk 12:33; Lk 10:27), the three purple circles
represent the heart (*cor*), the soul (*anima*), and
the mind (*mentes*) with which the faithful should
devote themselves to the Lord their God. Here,
however, buttressed by a reference to Proverbs
3:5 ("Have confidence in the Lord with all thy
heart"), that affection is transferred from Christ
to Mary. The commentary is linked closely to the
passage from Anselm's prayer 7 that precedes

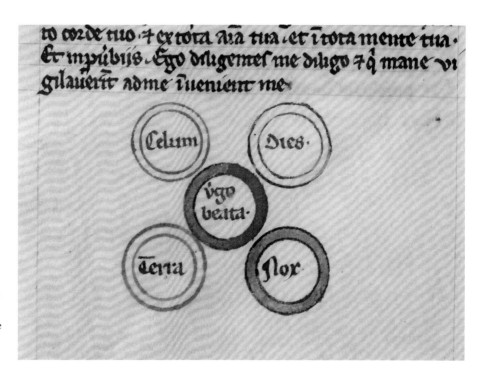

120. *Figura* 4: On the Restoration of Creatures and of Time. Berthold of Nuremberg, Liber de misteriis et laudibus intemerate Virginis genitricis Dei et Domini nostri Ihesu, Lake Constance region (?), 1292–94. FBG, Memb. I 80, f. 54v (detail). Photo: FBG.

it, as it too begins with reference to the heart, mind, and soul with which the worshiper should adore the Virgin Mary: "Oh Mary, thou great Mary, thou who art great among blessed Marys, thou greatest of women: thee, O Lady great and very great, thee my heart wishes to love, thee my mouth longs to praise, thee my mind desires to reverence, thee my soul aspires to entreat, because my whole being commits itself to thy keeping."[25] Consistent with the previous pattern of citation, the passage from Anselm also appears, with minor variations, in the Dominican lectionary, as part of the first and second lessons for the Marian office *Deus omnium*, celebrated on Sundays until the fifth day before the Kalends of August, that is, until the Feast of Mary's Assumption.

4. De renovatione creature et temporis.
Quarta figura. Anselmus in libro orationum
(Figure 120)

Anselm of Canterbury, *Orationes sive meditationes*, prayer 7.[26]

The drawing, "on the restoration of creatures and of time," returns to the quincunx formula employed for *figurae* 1 and 2 to place the Virgin Mary at the center of a diagram that combines cosmology with soteriology. Circles inscribed Heaven (*celum*) and Earth (*terra*), colored blue and green respectively, stand opposite circles labeled Day (*dies*) and Night (*nox*). All four terms appear in Anselm's prayer: "Heaven, stars, earth, waters, day and night, and whatever was in the power or use of men was guilty; they rejoice now, Lady, that they lost that glory, for a new and ineffable grace has been given them through you."[27] The circles inscribed "Day" and "Night" recall the personifications of sun and moon that from the late antique period on flanked the Crucifixion, referring both to the eclipse that marked the crucifixion and the cosmic dimensions of the event.[28] Here, however, the circles are arranged vertically, not horizontally, with the terrestrial realm below, the celestial above, and Mary as intercessor in the middle. A certain asymmetry is introduced insofar as the circle at the center standing for the Virgin (*virgo beata*) participates only in the cosmic colors blue and green, as opposed to the purplish brown employed for Day and Night, which in turn are distinguished from one another by the filling in of the circles surrounding Night, as if to suggest an absence of light. Together with the commentary, the

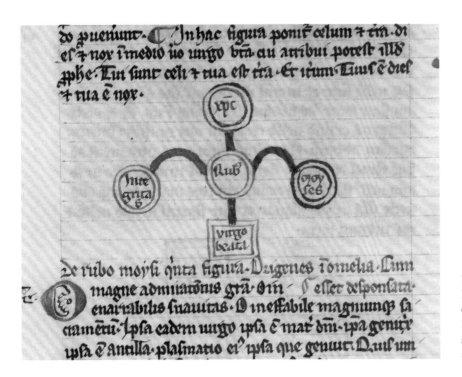

121. *Figura* 5: On the Bush of Moses. Berthold of Nuremberg, Liber de misteriis et laudibus intemerate Virginis genitricis Dei et Domini nostri Ihesu, Lake Constance region (?), 1292–94. FBG, Memb. I 80, f. 55r (detail). Photo: FBG.

drawing represents a gloss on the passage from Anselm that precedes it, which praises not so much the Virgin herself as her fecundity (i.e., her having given birth to Christ), which redeemed and justified the sinful world. The diagram thus serves as an image of the world redeemed by grace.

5. De rubo Moisi. Quinta figura. Origines in omelia Cum esset desponsata (Figure 121)

Origen, homily 17, *In vigilia nativitatis Domini*.[29]

According to the commentary, the diagram represents a schematic representation of the burning bush, a standard typological symbol of the virgin birth of Christ.[30] Just as the bush remained unconsumed by the fire, so Mary's virginity remained intact despite her having given birth to Jesus. The Virgin (*virgo beata*) is placed at the bottom of the diagram, the commentary explains, in accord with her humility; Christ as God at the top, in accord with his having been incarnated out a love to redeem humankind. The circle to the left (*integritas*), the commentary states, represents the law of Moses, the circle to the right (*Moises*) the incorruptibility of the

Virgin. At first these designations are confusing, as just the opposite appears to be the case: the circle labeled "integritas," referring to the Virgin Mary, appears on the viewer's left and that labeled "Moises, on the right. In keeping with Berthold's practice elsewhere in the set of diagrams, however, the diagrams employ heraldic left and right, so that *dexter* (right) in fact refers to the viewer's left.[31] The green bar joining the circle representing Mary's virginal integrity to the burning bush can thus be read as referring to the bush's foliage (Mary's virginity) not having been consumed by the fire, represented by the red bar that connects the bush to the circle representing Moses. The arching of the red and green lines connecting the circles to left and right possibly refers in punning fashion to the ark (*arca*: chest; *arcus*: arch). At the same time they may also represent an attempt to approximate the diagram as a whole to the form of the burning bush. If so, then the *virgo beata* at the bottom might be read as a punning reference to "virga," an association that becomes all the more likely in light of its being made explicit in the next diagram, which juxtaposes *virgo beata* to *virga Aaron*, the rod of Aaron.

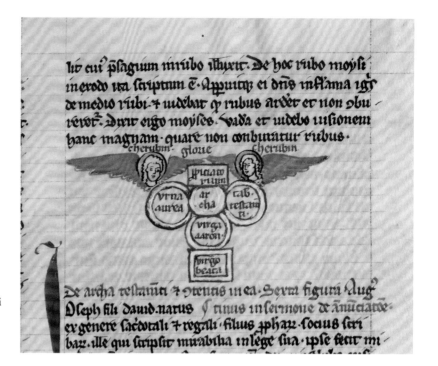

122. *Figura* 6: On the Ark of the Covenant and the Contents within It. Berthold of Nuremberg, Liber de misteriis et laudibus intemerate Virginis genitricis Dei et Domini nostri Ihesu, Lake Constance region (?), 1292–94. FBG, Memb. I 80, f. 55r (detail). Photo: FBG.

6. De archa testamenti et contentis in ea. Sexta figura. Augustinus in sermone de annuciatione (Figure 122)

Ps. Augustine, sermon 195, *De annuntiatione Domini*.[32]

The sixth diagram, representing the ark of the covenant, is the first in the Marian series to combine figurative and diagrammatic features: two truncated cherubim and the circles and rectangles beneath their outstretched wings. The cherubim are shown with only one pair of wings overshadowing the propitiatory—the uppermost rectangle, outlined in blue, beneath which stands the innermost circle, labeled *archa*. The three larger circles below the ark and to the sides represent other prefigurations or symbols of Christ and the Virgin Mary: at the left the golden urns (*urna aurea*), which, according to the commentary, stand for the holy wisdom in Christ, and to the right the tablets of the Law (*tabula testamenti*), which stand for the perfection of the Virgin. Below, the flowering rod of Aaron (*virga Aaron*), placed immediately above the lowermost rectangle, which stands for the Virgin herself (*virgo beata*), goes without com-

mentary, but the juxtaposition of *virga* and *virgo* makes its meaning plain. Aaron's flowering rod served as a common type of the Nativity.[33] The *Speculum humanae salvationis* (chap. 10) also declares the ark to be a type of the Virgin. The composite parts of the diagram constitute, at least approximately, an inverted triangle whose apex, at the bottom, is the Virgin, and whose other two corners coincide with the outstretched wing tips of the two cherubim. The glory of the cherubim (*glorie*) that is placed between their wings and that represents the plenitude of wisdom in the Virgin concealed within the ark, with which she herself is identified, marks the culmination of the diagram. In light of the fact that in previous diagrams the spaces between the congruent circumferences of the circles are left blank—that is, with the parchment reserved—in this instance the filling of these spaces with white pigment probably represents an attempt to convey the brilliant luminosity of the ark and, in turn, the purity of the Virgin with which the commentary associates it.

As in previous cases, the accompanying commentary serves both to explain and to inspire the image that precedes it. This passage, prefaced by

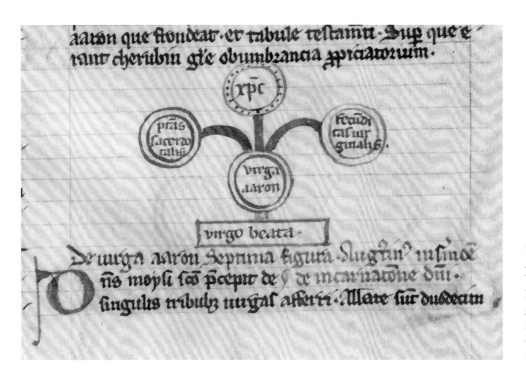

aaron que frondeat er tabule testamu. Sup que e
rant cherubin gfe obumbzanaa ppriaatozium.

xpc

ptas
sacerdo
talis

fecūdī
tas uir
ginalis.

virga
aaron

virgo beata.

De uirga aaron Septima figura. Augustin⁹ in sino
ñs moysi sco pcepit de ƒ de incarnatione dūi.
singulis tribul₃ uirgas afferri. Allare sur duodecim

123. *Figura* 7: On the Rod of
Aaron. Berthold of Nurem-
berg, Liber de misteriis et
laudibus intemerate Virginis
genitricis Dei et Domini nostri
Ihesu, Lake Constance region
(?), 1292–94. FBG, Memb. I
80, f. 55r (detail). Photo: FBG.

the rubric *De archa testamenti et contentis in
ea*, stems from a sermon on the annunciation
by Pseudo-Augustine (identified in the rubric
as Augustine himself).[34] The sermon proves the
source for the first and second lessons for the of-
fice on the first Sunday following the Octave of
Epiphany (a distinctively Dominican way of des-
ignating the feast).[35] In contrast to previous dia-
grams, Berthold's commentary in this instance
extends to a full paragraph (55ʳ) consisting large-
ly of a cento of scriptural passages underscoring
Mary's symbolic identification with the ark of
the covenant. Just as the Old Testament ark held
the old law, so Mary, by virtue of the incarnation,
held within her the new, in the person of Jesus
Christ. Whereas the Jewish ark remained closed,
she, as the Christian ark, opened—imagery that
found expression in a wide variety of artistic
forms, of which the most striking is the Shrine
Madonna.[36] Those looking for a theory of dia-
grammatic method or at least an explanation of
working procedure, however, will be disappoint-
ed. Berthold's commentary is largely descriptive,
associating various elements in the image with
their scriptural counterparts as if this in itself
were explanation enough.

7. De virga Aaron. Septima figura. Augustinus in sermone de incarnatione Domini (Figure 123)

Ps.-Augustine, sermon 245, *De misterio Trinitatis et Incarnationis*.[37]

The diagram adopts the same structure as dia-
gram 5: a schematic rendering of the flowering
rod of Aaron.[38] The "various colors" associated
with the Virgin Mary to which the commen-
tary refers include, first, green, identified with
the "Virgo beata" at the bottom and again at the
right (which the commentary, employing heral-
dic left and right, defines as the "sinister" or left
side) with the fecundity of the Virgin (*fecundi-
tas virginalis*), which the commentary in turn
associates paradoxically with her incorruptibil-
ity. In this the diagram's use of colors remains
consistent with that found in diagram 5. The red
stem on the left (defined as the *dexter* side) links
the blue circle at bottom, representing the "virga
Aaron" itself, with Christ's priestly power (*potes-
tas sacerdotalis*). The purple circle at top, stud-
ded with small red dots, stands for the flowering
rod's fruit, the eschatological Christ in heaven

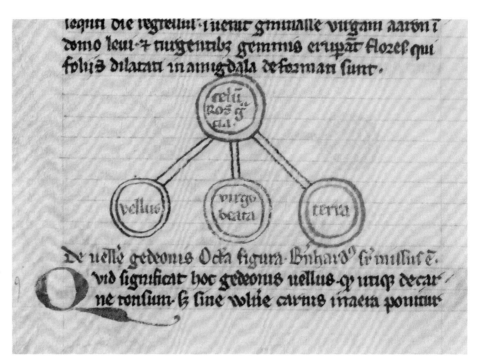

124. *Figura* 8: On the Fleece of Gideon. Berthold of Nuremberg, Liber de misteriis et laudibus intemerate Virginis genitricis Dei et Domini nostri Ihesu, Lake Constance region (?), 1292–94. FBG, Memb. I 80, f. 55v (detail). Photo: FBG.

(according to the commentary, "fructum eius fore celestem"), from which one can infer that the dots represent pearls or, more likely, stars. The commentary quotes Numbers 17:8 to the effect that the rod of Aaron "had bloomed blossoms, which spreading the leaves, were formed into almonds." Despite this reference, the diagrams represents the flowers and fronds of the rod in the form of circles. In the *Speculum humanae salvationis* (chap. 8) the flowering rod of Aaron is a type for the Nativity.

8. De velle Gedeonis. Octava figura. Bernardus sermone Missus est (Figure 124)

Bernard of Clairvaux, *Homiliae super "Missus est."*[39]

The commentary consists for the most part of a lengthy quotation from the account of Gideon's fleece (Jgs 6:36–40), which it interprets in typological terms.[40] At the top stands a blue celestial circle (*celum ros gratia*) identifying the dew of the Old Testament narrative with grace. The dew then "falls" on the fleece (*vellus*), represented by the brown circle to the left; the earth (*terra*), represented by the green circle to the right; or, in its spiritual form, grace, on the Virgin Mary

(*Virgo beata*), represented by the red circle at the center. The three circles along the baseline of the suggested triangle represent a spectrum of interpretive possibilities vis-à-vis the dew at the top, two of them (the fleece and the earth) literal, the third (the Virgin Mary), positioned immediately below the source of grace, in which literal and metaphorical meanings are unified, symbolic. The diagram employs the same form as diagram 3, derived from diagrams depicting the division of the arts or books of the bible (see fig. 119). In the *Speculum humanae salvationis* (chap. 7) Gideon's fleece provides one of the types for the annunciation.

9. De Iherusalem et templum Salomonis. Nona figura, Anselmus in liber orationum (Figure 125)

Anselm, *Orationes sive meditationes*, prayer 7.[41]

The diagram reverts to the quincunx formula found previously in diagrams 1, 2, and 4. Picking up on the architectural imagery in the preceding passage from Anselm's prayer ("Tu aula universalis propitiationis, causa generalis reconciliationis, vas et templum vitae et salutis uni-

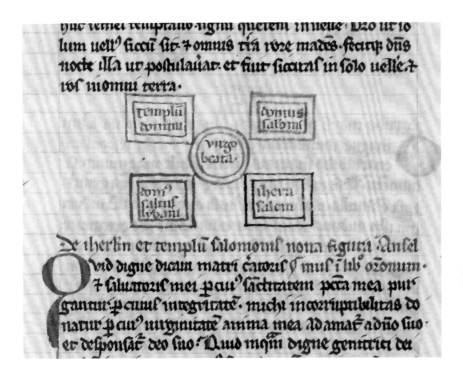

125. *Figura* 9: On Jerusalem and the Temple of Solomon. Berthold of Nuremberg, Liber de misteriis et laudibus intemerate Virginis genitricis Dei et Domini nostri Ihesu, Lake Constance region (?), 1292–94. FBG, Memb. I 80, f. 55v (detail). Photo: FBG.

versorum," the commentary associates the Virgin (*virgo beata*), marked by the purple or, in Basel, pink circle at the center with the four rectangular dwelling places located in the corners, labeled clockwise from the upper left: the temple of the Lord (*templum domini*) in red, allegorized as the Virgin's sanctity; the palace of Solomon (*domus Salomonis*) in green, her dwelling in divine wisdom; the house and forests of Lebanon (*domus saltus Libani*) in blue, her chastity; and the city of Jerusalem (*Iherusalem*) in brown, her love of peace. Looking at the diagram, the reader can pass diagonally via the Virgin from Jerusalem to the Temple or from Lebanon to the house of Solomon. Read horizontally, the Temple is allied at the upper level with the house of Solomon, the house of Lebanon with the city of Jerusalem. In conjunction with Anselm's prayer, the diagram declares that the Virgin is the portal or entrance through which Christ entered the world at the incarnation and through which the redeemed sinner will pass into heaven. Without referring directly to the closed gate (*porta clausa*) of Ezekiel 44:1, in which the prophet relates his having been brought before the gate of the Temple sanctuary and which was appropriated by Christian commentators as a figure of Mary's virginity, the

diagram plays with the paradox of Mary's virginity (the closed gate) that nevertheless enables the redemption of humankind (the open gate). Exegetes never tired of observing that while Eve had closed the gate to paradise, Mary had opened it again.[42] The same imagery is taken up again in the commentary on *figura* 14.

10. De throno Salomonis. Decima figura. Bernardus in sermone de nativitate beate Virginis (Figure 126)

Ps.-Peter Damian, sermon 44, *In nativitate beatissimae Virginis Mariae*.[43]

That figural elements occur so frequently in representations of the temple furnishings is no accident; their presence in scripture served as one of the principal justifications for the use of imagery in the medieval church.[44] In Berthold's rendering, however, the throne itself is not immediately apparent. The diagram presents a schematic rendition of the throne of Solomon, framed by the archangel Gabriel to the left and John the Evangelist to the right.[45] The throne (*thronus*) is represented by the red circle at the center, framed by the heads of two beasts, the li-

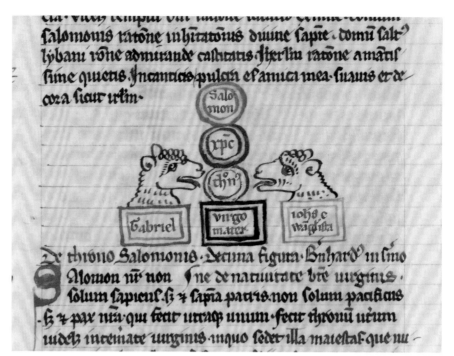

salomonis rarone inhiraroius duune sapie domu salt
lybam rone admirande cassiratis. Hestlin rarone amatis
sime quietis. Incantico pulcra es annua mea. suauis et de
cora sicut urstin.

Salo
mon

xpc

dn̄s

Gabriel virgo
 mater ioh̄s e
 wāgłista

Dr throno Salomonis. Decima figura. Enhard̄ insmo
Salomon nr̄ non ne de natuiirate bt̄e uirginis.
solum sapicul. s̄ ꝫ sapia patris. non solum pacisicus
s̄ ꝫ pax nr̄a. qui secit uttaꝙ̃ unum. secit thronu ut̄um
indeb̄ mcernate uurginis. inquo soderilla maiestas que nu

126. *Figura* 10: On the Throne of Solomon. Berthold of Nuremberg, Liber de misteriis et laudibus intemerate Virginis genitricis Dei et Domini nostri Ihesu, Lake Constance region (?), 1292–94. FBG, Memb. I 80, f. 56r (detail). Photo: FBG.

ons that according to I Kings 10:19 "stood, one at each hand." Although the lions face one another in profile, their bodies, of which only the uppermost portion can be seen, are frontal and fixed to the top of the two rectangles to either side of the central rectangle representing the Virgin Mary (*virgo mater*). The blue oblong to the left represents the archangel Gabriel, the purple oblong to the right John the Evangelist. Above the throne, as if seated upon it, two additional circles identify its occupant as Solomon (literally) and Christ (figuratively). Christ and Solomon's circles are closely related: the former (*Christus*) is blue with a green inner band, the latter (*Salomon*) is green with a white band consisting of reserved parchment. Having extolled the qualities of Salomon, all of which are by extension associated with Christ, the commentary, quoting John 9:27, turns to Gabriel and John the Evangelist as custodians of Mary, thereby identifying them with the lions standing guard on either side of the throne, which is equated with the Virgin as the *Sedes sapientiae*. The association of Mary with the Throne of Wisdom explains why in the *Speculum humanae salvationis* (chap. 9) Solomon's throne serves as a type of the adoration of the magi. The commentary takes its cue from the preceding passage in a sermon on the birth of

the Virgin Mary believed to have been authored by Peter Damian (44 in the traditional numeration), which glosses the two lions of the throne as "the archangel Gabriel and John the Evangelist, of whom one was assigned as guardian to the right, the other to the left of the Virgin. They served carefully keeping watch, Gabriel over her mind, John over her body."[46]

Berthold's depiction of the throne of Solomon is unusual, but as indicated by its sources, it is not made of whole cloth. Atypical is the manner in which Berthold translates exegesis into art. Of this particular iconography only four additional examples exist. Two of them occur in a pair of Dominican liturgical manuscripts from the convent of Paradies bei Soest in Westphalia.[47] In the later of the two, an early fifteenth-century gradual written, inscribed, and illuminated by the nuns of the convent in collaboration with a professional painter from the workshop of Konrad von Soest, the initial for the Assumption of the Virgin, in which the Virgin appears in the guise of the Apocalyptic Woman, is flanked to the left by two zooanthropomorphic figures that combine human heads and torsos with leonine bodies (fig. 127). The figures are labeled John and Gabriel. John, identified by a tiny white eagle on his chest, speaks the opening of his Gospel

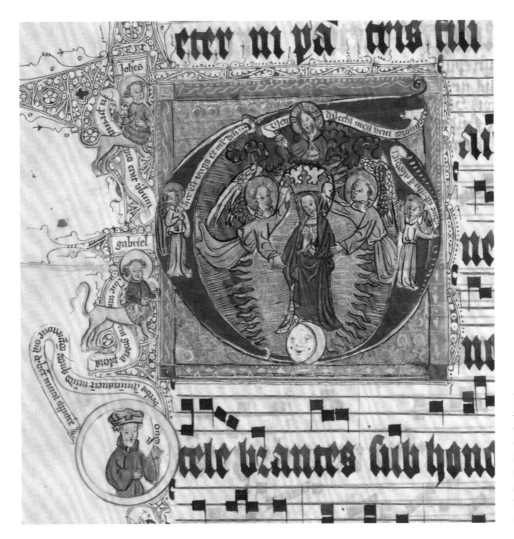

127. John the Evangelist and the Archangel Gabriel as Guardians of the Virgin Mary, Assumption of Virgin, gradual, Paradies bei Soest, ca. 1420. Universitäts- und Landesbibliothek, Dusseldorf, Cod. D 12 (permanent loan by the City of Düsseldorf), f. 201v (detail). Photo: ULB.

(1:1): "In principio erat verbum." Gabriel, in turn, makes his angelic salutation: "Ave Maria gratia plena" (Lk 1:28). Regarding these salient passages from scripture, the man in the marginal roundel immediately below the initial declares: "Dua verba annutiaverunt mundo quorum comparatione omnia debetur muta apparere" (They announced two words to the world in comparison to which all ought to appear mute). Although unidentified, the man most likely represents Albertus Magnus, to whom the popular Marian treatise *De laudibus beatae Mariae Virginis*, written in the mid-thirteenth century by the canon Richard of Saint-Laurent, was attributed.[48] In pairing Gabriel with John as the two angelic guardians of the Heavenly Jerusalem, this Marian *De laudibus* cross-references a separate section on the pair of lions flanking the throne of Solomon ("Titulo de throno de duobus leonibus").[49]

Richard of Saint-Laurent was not the first to identify Gabriel and John with the pair of lions that according to I Kings 19:10 ("and two lions stood, one at each hand") flanked Solomon's throne, as opposed to the six pairs of lions, more commonly depicted, that, according to I Kings 10:20 ("and twelve little lions stood upon the six steps on the one side and on the other"), confront one another on the steps of the *Sedes sapientiae*.[50] A sermon formerly attributed to Peter Damian, now assigned to Nicholas of Clairvaux, secretary to Bernard of Clairvaux from 1145 to 1151, argues that just as Gabriel attended to Mary's mind, so too John attended to her body, consistent with the reading provided by Ps.-Damian in the passage quoted by Berthold of Nuremberg.[51] Berthold's compendium demonstrates that Dominicans had access to Ps.-Damian's sermon, which may provide the starting point for this

particular exegetical tidbit. Given that Richard's text circulated under the name of Albertus Magnus, however, he most likely provided the nuns with their immediate source, especially as Albert was present at the convent's incorporation into the Dominican order in 1255.[52]

Further evidence that the nuns of Paradies tapped into this particular tradition of exegesis comes from an earlier gradual, dated circa 1380, in which, as part an immensely compli-

cated iconographic program, a short inscription identifies the two tiny bust-length figures of the Evangelist John and the archangel Gabriel, who are placed beneath the larger initial of the Death and Coronation of the Virgin as the two *custodes* or guardians of the Heavenly Jerusalem (fig. 128). *De laudibus beatae mariae Virginis* glosses Isaiah 62:6 ("upon thy walls, O Jerusalem, I have appointed watchmen all the day, and all the night, they shall never hold their peace")

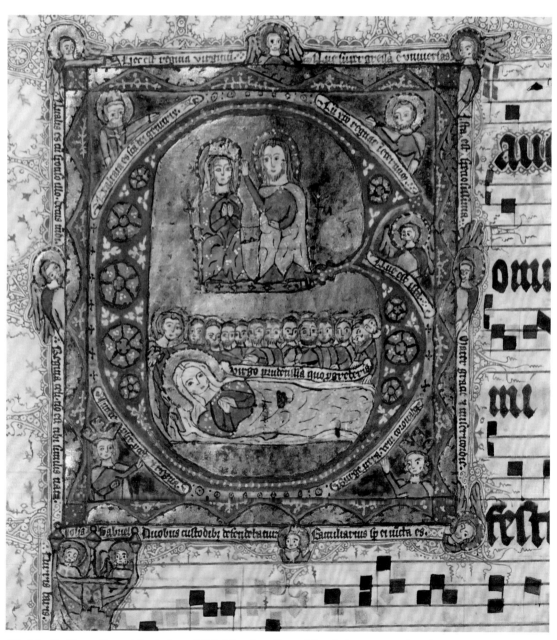

128. John the Evangelist and the Archangel Gabriel as Guardians of the Virgin Mary, Death and Coronation of the Virgin, gradual, Paradies bei Soest, ca. 1380. Universitäts- und Landesbibliothek, Dusseldorf, Cod. D 11 (permanent loan by the City of Düsseldorf), p. 427 (detail). Photo: ULB.

with the words "Vel, isti custodes Gabriel et Johannes." Richard (Albertus) explains further that the guardians signify the virtues of the Virgin, the first of which is virginity.[53]

The Bonmont Psalter, made circa 1260 for a Cistercian nunnery in the diocese of Konstanz or Basel, provides a third example (fig. 129). A full-page miniature, more akin to a colored drawing, forming part of its prefatory cycle depicts Christ crowning Mary atop the towering *Sedes sapientiae*, in which the twelve prophets are matched with the twelve lions on the steps. In the upper left and right corners of the composition, the archangel Gabriel and John the Evangelist are paired with the lions flanking the throne of Solomon.[54] Whereas in the psalter Gabriel and John are simply juxtaposed to the golden lions flanking the summit of the throne, in the grad-

ual D 12, signifier and signified are fused into a single bodies: lions with human heads. Still more elaborate is the *Sedes sapientiae* that features on the full-page frontispiece to the famous Soissons manuscript of Gautier de Coinci's 'Miracles de Nostre Dame,' illuminated by Jean Pucelle shortly before his death in 1334 (fig. 130).[55] In an illusionistic architectural framework resembling an Italian Maestà of the kind Pucelle is known to have seen on his travels in Italy, a Crucifixion fills the space beneath the feet of the enthroned Virgin and Child, which is crowned in turn by the seven gifts of the Holy Spirit.[56] Precisely this sort of image inspired Berthold's representation of Mary with the seven gifts of the Holy Spirit in his reworking of Hrabanus's book 2 (f. 47r; see fig. 86). In the Parisian manuscript, the Crucifixion itself sits beneath a diaphragm arch

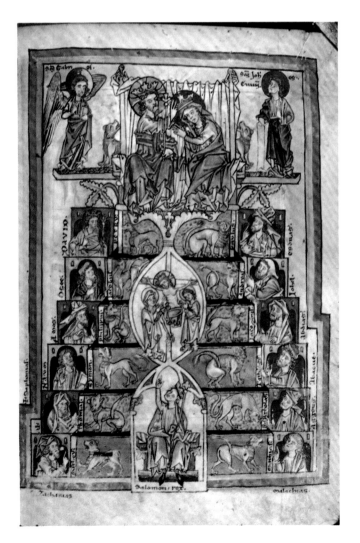

129. Throne of Solomon with John the Evangelist and the Archangel Gabriel as Guardians of the Virgin Mary. Psalter (Cistercian), Upper Rhine?, ca. 1260. Besançon, Bibliothèque municipale, ms. 54, f. 9r. Photo: IRHT.

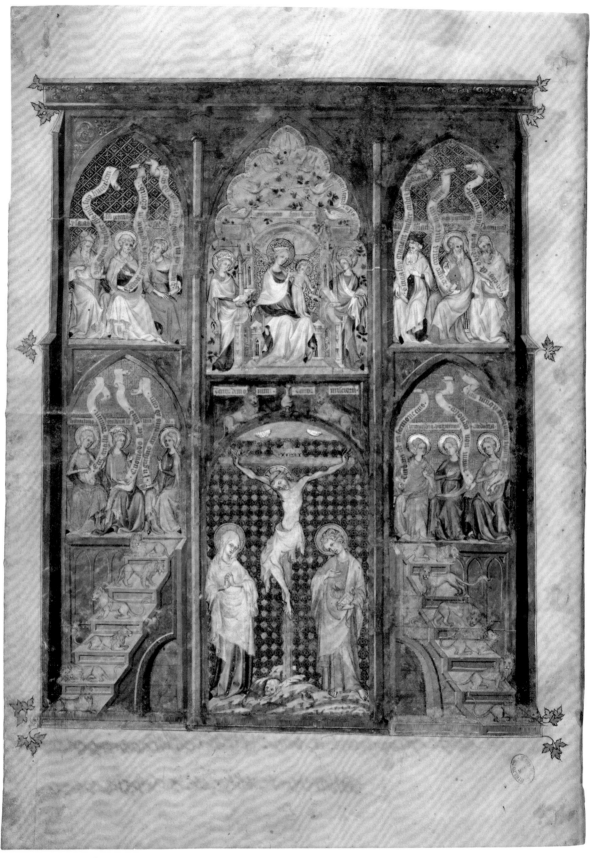

130. Jean Pucelle, Throne of Solomon with John the Evangelist and the Archangel Gabriel as Guardians of the Virgin Mary; Jean Pucelle, Throne of Solomon; Gautier de Coinci, *Miracles de Nostre Dame*, Paris, ca. 1333–34. Paris, Bibliothèque nationale de France, ms. nouv. acq. fr. 24541, f. Av. Photo: BnF.

131. *Figura* 11: On the Prophet David. Berthold of Nuremberg, Liber de misteriis et laudibus intemerate Virginis genitricis Dei et Domini nostri Ihesu, Lake Constance region (?), 1292–94. FBG, Memb. I 80, f. 56v (detail). Photo: FBG.

in whose spandrels crouch two lions flanking a vase of lilies. In keeping with a tradition that associated the throne with the seat of judgment, inscriptions label the lions *terror demonum* and *terror miserorum*.[57] The lions link the two superimposed sections aligned along the vertical axis of the composition. Flanking the throne, the crowned personifications *caritas* and *castitas* highlight Mary and the Evangelist to either side of the cross in their function as virginal intercessors. The vase of lilies between the lions further associates the entire image, and by proxy one of the lions, with the archangel Gabriel, in keeping with Ps.-Damian's interpretation of their meaning.

11. De propheta David. Undecima figura. Beda in omelia Exurgens Maria (Figure 131)

Bede, *Homiliarum evangelii libri II*, bk. 1, homily 4.[58]

The drawing employs the same structure as diagram 2: four circles attached to a central square, or in this case rectangle, filled with a bifurcated floral form, half pink, half purple. A smudge of purple pigment between the two green circles that make up the base of the figure suggests that

there might have been the intention of elaborating it further. According to the commentary, the flower in various colors at the center represents benignity. Taking as its cue Psalm 84:13 ("For the Lord will give goodness: and our earth shall yield her fruit"), which forms the point of departure for the previous passage from Bede's homily on the feast of the Visitation, the diagram joins a green circle at the lower right, representing the earth (*terra*), to the pair of red circles at top, representing the Lord (*dominus*) and Mary (*virgo beata*). The second green circle to the left, representing David (*David*), figures as a type of the Lord, immediately above, just as, also according to Bede's homily, quoting Isaiah 4:2 ("In that day the bud of the Lord shall be in magnificence and glory, and the fruit of the earth shall be high, and a great joy to them that shall have escaped of Israel"), Mary's generative role in the history of salvation is figured by the earth. In light of this exegetical foundation, the meaning of the bifurcated flower at the center becomes clearer. Looking rather like a four-leaf clover, the two green leaves to the right point to Earth and the Virgin Mary, the two pink buds to the left to David and his antitype, the Lord. The bud thus serves as a microcosm of the larger diagrammatic structure

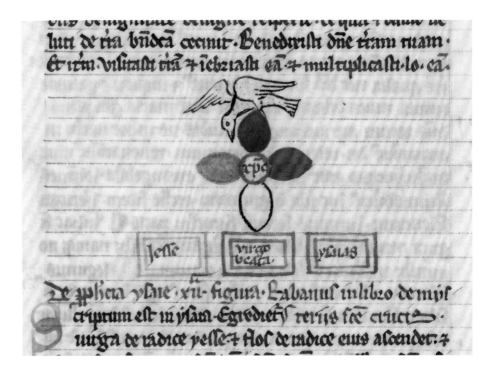

132. *Figura* 12: On the Prophecy of Isaiah. Berthold of Nuremberg, Liber de misteriis et laudibus intemerate Virginis genitricis Dei et Domini nostri Ihesu, Lake Constance region (?), 1292–94. FBG, Memb. I 80, f. 56v (detail). Photo: FBG.

that surrounds it, giving expression to the idea of germination that is central to the idea that underpins the entire image. Just as the Lord subtends David, who is his type, so too the Virgin Mary subtends the earth. Christ and the Virgin Mary occupy the upper level; David, however, remains earthbound.

12. De prophecia Isaie. .XII. figura.
Rabanus in libro de misteriis sancte crucis
(Figure 132)

Hrabanus Maurus, *In honorem sanctae crucis*.[59]

The diagram is first and foremost a schematic representation of the Tree of Jesse (Is 11:1: "and there shall come forth a rod out of the root of Jesse, and a flower shall rise up out of his root").[60] The three rectangles at the bottom represent Jesse to the left, Isaiah to the right, and at the center the Virgin Mary, who is held to be the subject of the prophecy. The tree itself is radically curtailed, so that in lieu of the rod (*virga*) that traditionally rises from the flank of Jesse before culminating in the image of the Virgin and Child, the reader sees only its flower and fruit, Christ, immediately above the rectangle representing the Virgin Mary.

The commentary spells out the color symbolism employed throughout the series. The most beautiful (*iocundissimi*) of flowers, which is identified with the flower of the rod of Jesse, has four colors: "violet and purple and scarlet . . . and linen" (*iacinctino. purpureo. bissono, et coccineo*). Far from representing an arbitrary choice, the four colors chosen by Berthold (including the neutral, undyed linen) match the quartet specified in Exodus 26:31 as those of the tabernacle veil: "Thou shalt make also a veil of violet and purple, and scarlet twice dyed, and fine twisted linen, wrought with embroidered work, and goodly variety."[61] Allegorization of the colors of the veil represents an unbroken thread in biblical exegesis, but Berthold's literal rendition of the color scheme remains quite precocious, given that representations of the tabernacle veil that accurately render the four colors became common only in manuscripts of the *Postillae* of Nicholas of Lyra (ca. 1270–1349) illuminated in the fourteenth century (fig. 133).[62] Whereas Nicholas consistently emphasizes the literal sense at the expense of the allegorical and, much in the manner of Richard of St. Victor, mines Exodus for information in order to reconstruct the appearance of the tabernacle, Berthold uses

133. Curtain of the Tabernacle. Nicholas of Lyra, *Postillae litteralis*, France, ca. 1360–80. New York, Metropolitan Museum of Art, The Cloisters Collection, acq. no. 2011.20.1.

the colors of the veil as a pretext for allegorical flights of fancy.[63] Violet (blue) stands for the celestial conversation between God and men ("celestem eius inter homines conversationem"). The concept of conversation in heaven, an image of fellowship among the saints, traces its origins to Philippians 3:20: "But our conversation is in heaven; from whence also we look for the Saviour, our Lord Jesus Christ." Predicated on the rarity of Tyrian purple, the color, predictably, stands for the blood of the Passion (*passionis sanguinem*), a reminder of Christ's royalty even in death.[64] The pure white or undyed linen, in turn, stands for the inviolate chastity of Christ's

body (*corporis eius inviolatissimam castitatem*). Finally, scarlet, readily associated with the color of Christ's blood, stands for his perfect charity (*principuam ac perfectam caritatem*). Rounding out the composition is the diminutive dove that perches precariously on the uppermost petal. Paraphrasing Luke 3:22, Berthold explains that the bird represents the dove that descended at the moment of Christ's baptism. The compact illustration conflates references to three separate biblical passages: the Tree of Jesse (Is 11:1), a traditional prophetic image of the coming of the Messiah; Christ's baptism (Lk 3:22); and the description of the colors of the tabernacle veil in

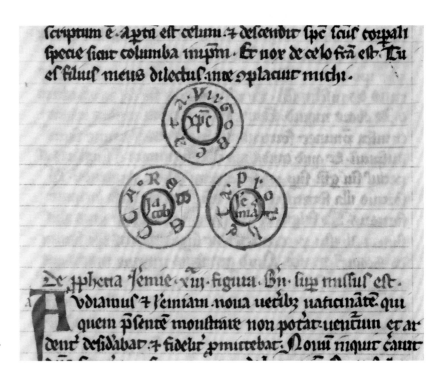

134. *Figura* 13: On the Prophecy of Jeremiah. Berthold of Nuremberg, Liber de misteriis et laudibus intemerate Virginis genitricis Dei et Domini nostri Ihesu, Lake Constance region (?), 1292–94. FBG, Memb. I 80, f. 56v (detail). Photo: FBG.

Exodus 26. The blank parchment of the written page is identified with the veil of the Holy of Holies, suggesting indirectly that the manuscript itself is an ark filled with wisdom.

The same diagram simultaneously illustrates the line of thought worked out in the accompanying passage from Hrabanus Maurus (C 16, 11.14–18), which describes Christ as the true flower that grew from the core of human nature—that is, from the Virgin's womb.[65] Hrabanus compares Christ's chastity to the white of the lily and his blood spilled at the Passion to the red rose. In the diagram, above this flower hovers the dove of the Holy Spirit, which according to Hrabanus represents the divinity that dwells in Christ's body. The three rectangular boxes sitting side by side can thus be seen as occupying a historical, horizontal axis, and the flower itself the center of a vertical, divine axis. Just as the baptism of Christ marked the first manifestation of Christ's two natures within the Trinity, rounded out by the presence of the Holy Spirit, so too in the diagram Christ is manifested in his humanity (the flower that springs from the Virgin below) and his divinity (the dove that alights on the flower from above), all in keeping with the conclusion of Hrabanus's commentary. The diagram reveals

itself as multidirectional in both time and space, just like the phenomena it seeks to encapsulate and describe.

13. De prophetia Ieremie. .XIII. figura. Bernardus super Missus est (Figure 134)

Bernard of Clairvaux, *Homiliae super "Missus est,"* homily 2, part 8.[66]

The diagram, dedicated to the prophet Jeremiah's foretelling of the Virgin Mary, introduces a fresh form perfectly attuned to its incarnational subject matter: congruent circles placed one within the other, but with the interstitial space wide enough to accommodate inscriptions. In this case the inscriptions identify the three circles that together make up a triangular form as Christ surrounded by the Virgin Mary (*virga beata*), Jacob (*Iacob*) surrounded by Rebekah (*Rebecca*), and Jeremiah (*Ieremias*) surrounded by his moniker, *propheta*. Each component of the tripartite *figura* consists in turn of two parts: an inner circle, demarcated in green, combined with an outer circle, demarcated, along with the inscriptions, in red. The double circles give literal expression to the idea of circumscription,

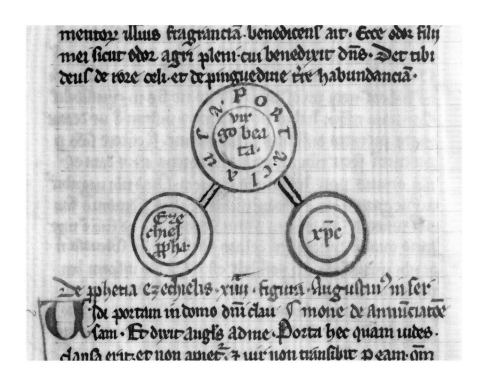

mentoz illius fragrancia · benedicenf air · Ecce odoz filij
mei sicut odoz agri pleni · cui benedixit dns · Det tibi
deus de roze celi · et de pinguedine tre habundanciā ·

De pphetia ezechielis · xiiij · figura · Augustin' in ser-
-[ſc]a portam in domo dñi clau[?] S mone de Annūciatō-
-sam · Et dixit angt's ad me · Porta hec quam uides-
sancta erit · et non aniet · + uir' non trānsibit p eam · ōm

135. *Figura* 14: On the Prophecy of
Ezekiel. Berthold of Nuremberg, Liber de
misteriis et laudibus intemerate Virginis
genitricis Dei et Domini nostri Ihesu,
Lake Constance region (?), 1292–94.
FBG, Memb. I 80, f. 57r (detail). Photo:
FBG.

used in the commentary to characterize the
Virgin Mary's having surrounded Christ in her
womb and Rebekah's having "clothed" Jacob in
much the same manner. Rebekah's pregnan-
cy serves as a type of Mary's. The imagery of
clothing and surrounding comes together in the
passage from Genesis 27:16 that describes how
Rebekah placed "the little skins of the kids . . .
about his [Jacob's] hands, and covered the bare
of his neck," to which is joined a passage from
Genesis 27:27: "And immediately as he [Isaac]
smelled the fragrant smell of his garments, bless-
ing him, he said: Behold the smell of my son is
as the smell of a plentiful field, which the Lord
hath blessed." In the preceding passage, taken
from a homily by Bernard of Clairvaux, the Cis-
tercian also dwells on the miracle of pregnancy,
described in terms of circumscription, based on
Jeremiah 31:22–23 (which explains his pres-
ence in the diagram): "For the Lord hath creat-
ed a new thing upon the earth: A woman shall
compass a man. Thus saith the Lord of hosts,
the God of Israel."[67] In the typological handbook
known as the *Biblia pauperum*, the same verse
is deployed alongside the Annunciation togeth-
er with Isaiah 7:14: "Therefore the Lord him-
self shall give you a sign. Behold, a virgin shall

conceive, and bear a son, and his name shall be
called Emmanuel."[68]

14. De prophetia Ezechielis. .XIIII. figura. Augustinus in sermone de annunciatione (Figure 135)

Ps.-Augustine, *De Annunciatione Dominica*.[69]

The diagram of Ezekiel's prophecy uses three sets
of paired circles, two with uninscribed interstitial
spaces, one with the space between the circles
broad enough to permit inclusion of an inscrip-
tion, *porta clausa*, a reference to Ezekiel 44:2
("And the Lord said to me: This gate shall be
shut, it shall not be opened, and no man shall
pass through it: because the Lord the God of Is-
rael hath entered in by it, and it shall be shut"),
commonly read as a typological figure of the Vir-
gin Mary.[70] Ezekiel duly appears in the smaller
red circle at lower left, Christ in the green circle
opposite. Both the circles at the base are con-
nected to the larger circle representing the closed
door with paired purple bands. Quoting the story
of Joseph's dream as recounted in Matthew 1:20
("But while he thought on these things, behold
the angel of the Lord appeared to him in his

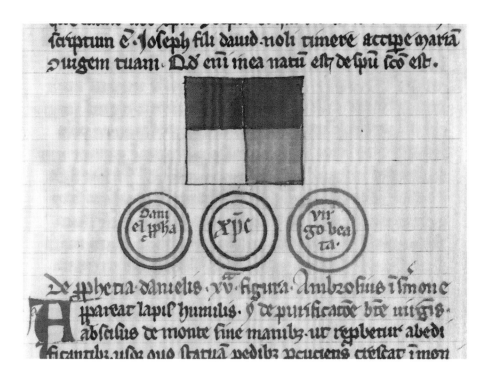

136. *Figura* 15: On the Prophecy of Daniel. Berthold of Nuremberg, Liber de misteriis et laudibus intemerate Virginis genitricis Dei et Domini nostri Ihesu, Lake Constance region (?), 1292–94. FBG, Memb. I 80, f. 57r (detail). Photo: FBG.

sleep, saying: Joseph, son of David, fear not to take unto thee Mary thy wife, for that which is conceived in her, is of the Holy Ghost"), the commentary conventionally identifies the space sealed by the closed door with Mary's womb, in which Christ was conceived by the grace of the Holy Spirit and from which he exited when he was born. The entire image and the accompanying commentary represent an elaboration of the imagery introduced in the pseudo-Augustinian homily on the annunciation that precedes them, which extends the symbolism of the closed door to the gates of paradise. Taken as a whole, the complete combination of text and image constitutes an invitation to meditate on the incarnation as the pathway to salvation.

15. De propheta Daniclis. .XV. figura. Ambrosius in sermone de purificatione beate Virginis (Figure 136)

Ambrosius Autpertus, *Sermo in purificatione sanctae Mariae.*[71]

The diagram represents the vision of Daniel that concludes with the triumphant proclamation quoted at the end of the commentary (Dn 2:44: "But in the days of those kingdoms the God of heaven will set up a kingdom that shall never be destroyed, and his kingdom shall not be delivered up to another people, and it shall break in pieces, and shall consume all these kingdoms, and itself shall stand for ever"). To this quotation is appended the prophet's statement (Dn 2:45) that "the dream is true, and the interpretation thereof is faithful," an assertion that by implication carries over to the interpretation offered by the commentator himself. The link to Daniel makes it easy to account for the presence of two of the three circles that form the baseline of the image: that to the left, in blue, which represents Daniel (*Daniel propheta*) and that at the center, in purple, which represents Christ, the Messiah to whom Daniel's reading of Nebuchadnezzar's dream is taken to refer.

Without reference to Fulgentius's homily on the purification of the Virgin, however, the presence of the third circle, to the right, in green, would be more difficult to explain. Fulgentius compares Mary to the "stone cut out of the mountain without hands," which Berthold proceeds to gloss as an allusion to the virgin birth: Christ is the quadrangular stone (*Christum forma quadrangulari*) in the diagram, which was quarried without hands—that is, born from the Virgin without human contact.[72] The analogy between the four colors of the cloth of the tab-

ernacle and the stone uncut by human hands makes more sense in light of the imagery of cloth as flesh veiling the incarnate Christ employed in the commentary on *figura* 13. The same passage serves as a type of the Nativity in numerous sources, including the *Figurae bibliorum* otherwise known as the Eton Roundels (Eton College Library, Ms. 177).[73]

No immediate explanation is given for the four colors, which, however, are identical to those attributed to the veil of the tabernacle according to Exodus 26 in the commentary on *figura* 12. Here they are associated with four virtues of Christ as enumerated by Paul in 1 Corinthians 1:30: "But of him are you in Christ Jesus, who of God is made unto us wisdom, and justice, and sanctification, and redemption." Berthold draws on the tradition of allegorizing the four colors of the tabernacle veil in terms of the four cardinal virtues, prudence, temperance, fortitude, and justice. For example, in his commentary on Exodus, Bruno of Segni (ca. 1047–1123), who largely follows Bede (the first exegete to comment on the relevant passages line by line), had no hesitation in assimilating the four colors of the veil to cosmic and moral quaternities, among them the four elements and the four cardinal virtues.[74] Similar exegetical constructions find their way into vernacular literature, most notably the "Vorauer Bücher Mosis," which were composed in Austria (Kärnten) circa 1130–40.[75] The tabernacle veil comes to stand for the art of allegory itself, understood as a kind of veiling (*integumentum*); as Bruno puts it, "The doctor of the gentiles, blessed Paul, lived from the art of tent-making. The apostles wove so many curtains."[76] In this light Berthold also would have understood his art as a form of veiling and veiling.

The *Antiquities of the Jews* of Josephus provides the foundation for this tradition of allegorizing the tabernacle veil, indeed all the temple furnishings.[77] In keeping with Alexandrine practice, Josephus allegorizes in order to defend the Jews against charges of literalism:

> But one may well be astonished at the hatred of symbolism of the tabernacle and the vestments. which men have for us and which

they have so persistently maintained, from an idea that we slight the divinity whom they themselves profess to venerate. For if one reflects on the construction of the tabernacle and looks at the vestments of the priest and the vessels which we use for the sacred ministry, he will discover that our lawgiver was a man of God and that these blasphemous charges brought against us by the rest of men are idle. In fact, every one of these objects is intended to recall and represent the universe, as he will find if he will but consent to examine them without prejudice and with understanding.[78]

Regarding the tabernacle veil, the historian continues: "The tapestries woven of four materials denote the natural elements: thus the fine linen appears to typify the earth, because from it springs up the flax, and the purple the sea, since it is incarnadined with the blood of fish; the air must be indicated by the blue, and the crimson will be the symbol of fire."[79] Focusing on imagery of cloth as flesh veiling the incarnate Christ amplifies the analogy drawn in the fifteenth *figura* between the corresponding quaternities of the four colors of the tabernacle veil and the four sides of stone uncut by human hands. Serving as an invisible bridge between these two sets of symbols is Paul's declaration in Hebrews 10:19–20 that identifies the veil with Christ's body: "Having therefore, brethren, a confidence in the entering into the holies by the blood of Christ; a new and living way which he hath dedicated for us through the veil, that is to say, his flesh."

16. De santificatione Virginis beate in utero matris. .XVI. figura. Bernardus in epistola ad canonicos Lugdunenses (Figure 137)

Bernard of Clairvaux, *Epistola* 174, part 5.[80]

The diagram addresses the hotly contested issue of Mary's sanctification in the womb (as opposed to her immaculate conception).[81] Unlike the Franciscans, the Dominican Order, to which Berthold belonged, did not accept the doctrine of her immaculate conception, which was relatively novel at the time he was writing. The commen-

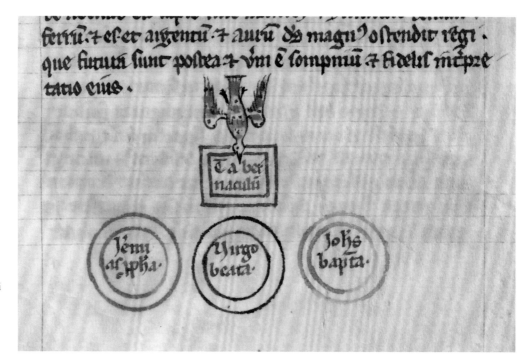

137. *Figura* 16: On the Sanctification of the Virgin in the Womb of the Virgin. Berthold of Nuremberg, Liber de misteriis et laudibus intemerate Virginis genitricis Dei et Domini nostri Ihesu, Lake Constance region (?), 1292–94. FBG, Memb. I 80, f. 57r (detail). Photo: FBG.

tary quotes Luke 1:15 ("and he shall be filled with the Holy Ghost, even from his mother's womb"), the angel's address to Zechariah, father of John the Baptist. The image, however, applies these words not to the Baptist but rather to Mary, who is identified with the rectangular celestial tabernacle (*Tabernaculum*), traced in blue, over which hovers the dove of the Holy Spirit. Completing the vertical axis is a double circle representing Mary (*virgo beata*), who thereby is identified with the tabernacle. As in diagram 11, Mary becomes the subject of infusion by the Holy Spirit, as if she took the place of Christ at the baptism. A second circle, to the right, drawn in purple, represents John the Baptist, who here is literally displaced by Mary. Opposite John, the equivalent circle, in green, represents Jeremiah (*Ieremias propheta*). The commentary quotes the words spoken by the Lord to the prophet (Jer 1:5: "Before I formed thee in the bowels of thy mother, I knew thee: and before thou camest forth out of the womb, I sanctified thee, and made thee a prophet unto the nations"), which here are appropriated and applied to Mary in order to demonstrate, rather illogically, that she was not sanctified before the annunciation ("que non ante annuniciationem sanctificata est"), despite their literal meaning. Berthold then at-

tempts to seal the argument with a quotation from Exodus 40:31–32 ("postquam cuncta perfecta sunt"): "After all things were perfected, the clouds covered the tabernacle of the testimony, and the glory of the Lord filled it." Once again Mary's womb is likened to the Old Testament tabernacle, and the dove of the Holy Spirit to the cloud that hovered over it.

17. De nativitate ipsius. .XVII. figura. Damascenus libro quarto (Figure 138)

John of Damascus, *De fide orthodoxa*, chap. 87.[82]

This diagram, devoted to the nativity, marks a shift in the cycle away from prophecy to the events of Mary's life. In keeping with its genealogical subject matter, the diagram reverts to the arborial imagery last employed in the first diagram in the series. In this case it is used to depict Mary as the rose of Jericho (Sir 24:18: "I was exalted . . . as a rose plant in Jericho"). The rose's four petals surround a yellow bud and are enclosed in a white circular band outlined in purple. The roots of the tree that bears the rose are placed between two rectangles, that on the left outlined in blue for Hannah (*Anna Samuelis*), mother of the prophet Samuel, that on the

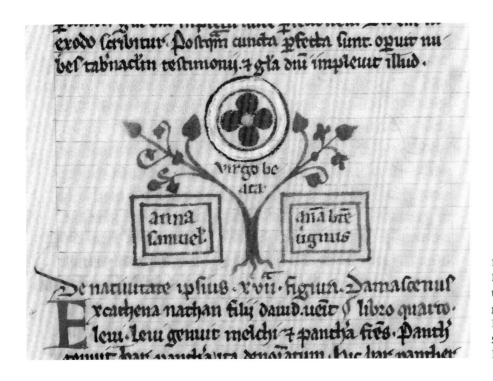

138. *Figura* 17: On the Nativity Itself. Berthold of Nuremberg, Liber de misteriis et laudibus intemerate Virginis genitricis Dei et Domini nostri Ihesu, Lake Constance region (?), 1292–94. FBG, Memb. I 80, f. 57v (detail). Photo: FBG.

right outlined in green for Anne, mother of the Virgin Mary (*Anna beate virginis*). The two are connected not only in that both give birth to sons unexpectedly, Hannah the mother of Samuel after long barrenness, but also because, according to Luke 2:36–38, Anna witnessed the presentation of Jesus in the temple, where, according to legend, she also tutored the Virgin Mary. The closing reference to a common Marian response (Can 006024) cements the liturgical underpinnings of Berthold's commentary.

18. De tempore nativitatis eius. .XVIII. figura. Bernardus in sermone de nativitate beate Virginis (Figure 139)

Pr »Peter Damian, sermon 44, *In nativitate beatissimae Virginis Mariae*.[83]

In keeping with its focus on the time of Christ's birth, the diagram combines astrological lore with biblical exegesis. The sign of the constellation Leo, ruled by the sun and associated with the element fire, signifies the onset of autumn (July 22–August 23) and hence the cooling of the heat of the righteous anger of the sun of justice (*sol iusticiae*). Translated into Marian terms, according to the commentary, this cooling of the

Sun/Son's anger at humanity's sinfulness signifies the Virgin's intercessory power, exemplified, according to a Victorine treatise, by the Virgin's intercession for the simoniac bishop Theophilus.[84] The diagram's uppermost circle, however, depicts the ensuing astrological constellation, identified as the Sun in Virgo (*sol in virgine*), whose duration runs from August 24 to September 22.[85] Drawn in an appropriate fiery red, the circle further brings to mind the "mulier in sole" (woman clothed in the sun) of Revelation 12, traditionally interpreted as a figure of the Virgin Mary.[86] Berthold might also have had in mind Song of Songs 6:10 (*electa ut sol*), commonly read as a reference to the Virgin Mary.[87] The image thus culminates not with Leo, the symbol of Christ's anger—what the commentary calls the "ira iudicis"—but rather the "virga inclita." Both Christ in a pink circle and the Virgin Mary (*virgo beata*) in a blue circle are shown as subservient to the sway of the sun above them. Below, in two earthbound green rectangles corresponding to Christ and Virgin and groom and bride, stand Ahasuerus and Esther. Just as Esther mollified the Persian king's anger against the Jews, so Mary mollifies the righteous anger of Christ against humankind by virtue of her intercession on its behalf.

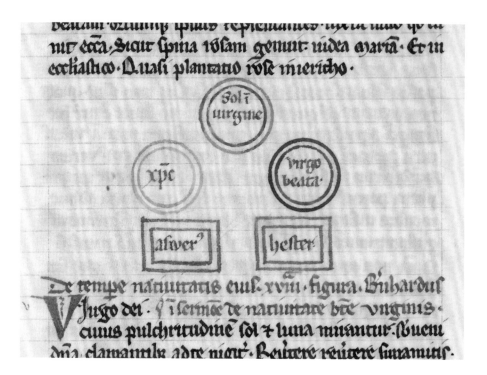

139. *Figura* 18: On the Time of His Birth. Berthold of Nuremberg, Liber de misteriis et laudibus intemerate Virginis genitricis Dei et Domini nostri Ihesu, Lake Constance region (?), 1292–94. FBG, Memb. I 80, f. 57v (detail). Photo: FBG.

The reading by an anonymous Victorine, which Berthold attributes to Bernard of Clairvaux, provides a point of departure for the mix of astronomical and biblical exegesis found in the commentary, as it begins with a declaration that the sun's and moon's beauty pales in comparison to the Virgin's. There follows a passing gloss on Song of Songs 6:12: "Return, return, O Sulamitess: return, return that we may behold thee"an appeal from the bridegroom that in an inversion of the usual pattern (according to which the bride of the Song represents the soul), here stands in for the voice of the worshiper, who pleads with the Sunamite to return, as in her hands resides the treasure of God's mercy ("in manibus tuis sunt thesauri misericordiae Dei"). The interpretation of the Song of Songs makes more sense in this context when one recalls that in the Bible, and hence in the reader's memory if not in Berthold's compilation, it is preceded by a comparison of her beauty, once again, to that of the sun and moon (Song 6:10: "Who is she that cometh forth as the morning rising, fair as the moon, bright as the sun, terrible as an army set in array?"). Given its central place in the Marian liturgy, virtually every word in the Song of Songs receives a Marian inflection.[88] As in virtually every other respect, Berthold's imagery finds its ultimate anchor in the Bible.

19. De impositione nominis Maria. .XIX. figura. Bernardus super Missam est (Figure 140)

Bernard of Clairvaux, *Homiliae super "Missus est,"* homily 2, part 17.[89]

Although the diagram on Mary's name extends the astronomical imagery found in the previous figure, the commentary does little to add to the reading from Bernard of Clairvaux, which offers an explanation for why the Marian epithet *stella maris*, whose origins remain inadequately understood, is fitting to the Virgin.[90] Having compared Mary's conception without losing her virginity to the purity of a star's radiation, Bernard continues to invoke the same passage from Numbers 24:17 repeated in the commentary: "I shall see him, but not now: I shall behold him, but not near. A star shall rise out of Jacob," to which it adds, "and a rod out of Israel." The passage provided an antiphon and response for the Octave of the Epiphany (Can 004358a, 601729), the fourth Sunday in Advent (Can 006302,

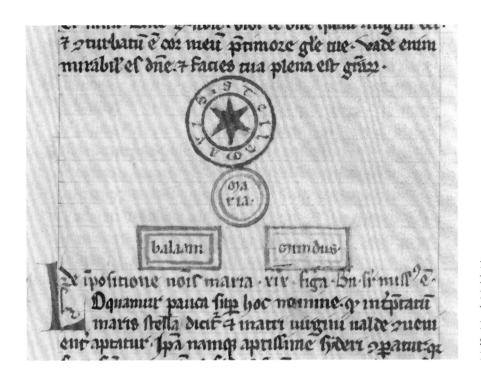

140. *Figura* 19: On the Bestowing of the Name of Mary. Berthold of Nuremberg, Liber de misteriis et laudibus intemerate Virginis genitricis Dei et Domini nostri Ihesu, Lake Constance region (?), 1292–94. FBG, Memb. I 80, f. 58r (detail). Photo: FBG.

007338), the Conception of the Virgin (Can 800474), and the Annunciation (Can 203739). The diagram presents a straightforward illustration of these messianic ideas. At the top, slightly out of alignment in Gotha (but not in Basel), a large six-pointed star is enclosed within a double blue celestial circle (*stella maris*).[91] Immediately below, a pink circle represents the Virgin Mary. As in the preceding diagram, the historical level is reduced to the horizontal axis at the bottom of the image, reinforced by two rectangles, that to the left, in green, representing Balaam (*Balaam*), that to the right, in green and yellow (only yellow in Basel), the world (*mundus*) that the star irradiates. Balaam's prophecy was usually held to predict the coming of the magi (as, for example, in the Eton Roundels) but here refers to Mary as the star of the sea.[92]

20. De pulcritundine Virginis beate. XX. figura. Anselmus in libro orationum (Figure 141)

Anselm of Canterbury, *Orationes sive meditationes*, prayer 7.[93]

The diagram on Mary's beauty, which in its structure harks back to those in Berthold's com-

mentary on Hrabanus, provides an elegant encapsulation of the commentary's comparison of Mary (*virga beata*), represented by the pink rectangle at the center, with four female heroines of the Old Testament who are cited in the following order, each accompanied by a scriptural tag: Rebekah (Gn 24:15: "Behold Rebecca came out, the daughter of Bathuel, son of Melcha, wife to Nachor the brother of Abraham, having a pitcher on her shoulder: n exceeding comely maid, and a most beautiful virgin, and not known to man"); Abisag (3 Kgs 1:3–4: "So they sought a beautiful young woman in all the coasts of Israel, and they found Abisag a Sunamitess, and brought her to the king. And the damsel was exceeding beautiful"), Judith (Jdt 11:19: "There is not such another woman upon earth in look, in beauty, and in sense of words"), and Esther (Est 2:15: "For she was exceeding fair, and her incredible beauty made her appear agreeable and amiable in the eyes of all"). The marriages or admiration of all these women served as types for the Assumption and Coronation of the Virgin.[94] Color imposes a chiastic pattern on the set of rectangles, linking Rebekah and Esther, both defined by green boxes, along a diagonal running from upper left to lower right, and Abisag and Judith, within blue

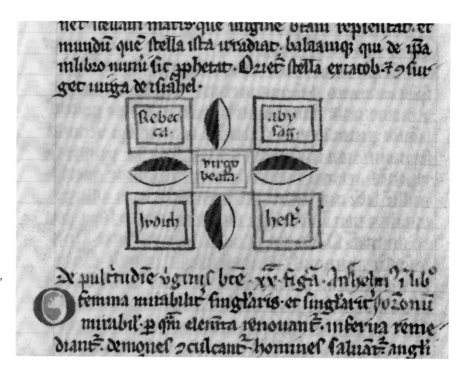

141. *Figura* 20: On the Beauty of the Blessed Virgin. Berthold of Nuremberg, Liber de misteriis et laudibus intemerate Virginis genitricis Dei et Domini nostri Ihesu, Lake Constance region (?), 1292–94. FBG, Memb. I 80, f. 58r (detail). Photo: FBG.

boxes, along the diagonal running from upper right to lower left. The underlying cross imagery is made explicit in the four almond-shaped petals that expand outward from the rectangle at the center, representing the Virgin Mary, each of which is divided along its length and colored half red, although not in a manner consistent with rotation around the center. The commentary explains the paired colors through reference to Song of Songs 5:10: "My beloved is white and ruddy, chosen out of thousands," adding that "this is in a manner that is fitting between beloved (female) and beloved (male)." In this Berthold elaborates the preceding prayer by Anselm that as part of its extravagant praise of the Virgin speaks of her being "delectabilis ad amandum."

21. De bona in dole et moribus eius, XVI, [sic: XXI] figura. Ambrosius in libro de virginitate (Figure 142)

Ambrosius, *De virginibus*, bk. 2, chap. 2, part 6.[95]

The diagram summarizes the contents of the commentary, which compares the Virgin Mary (*virgo beata*), represented by the blue box at the top, first, to Susanna (Sus 13:1: "Now there was a man that dwelt in Babylon, and his name was

Joakim: And he took a wife whose name was Susanna, the daughter of Helcias, a very beautiful woman, and one that feared God. For her parents being just, had instructed their daughter according to the law of Moses"), represented by the green rectangle, then to the bride of Song of Songs (7:1: "How beautiful are thy steps in shoes, O prince's daughter") represented by the pink rectangle. The commentary, although uncomplicated, provides a fitting extension of the previous image's systematic comparison of Mary to Old Testament heroines, as well as to Ambrose's letter to virgins, in which he holds up Mary's chastity and virtue as a model to his readers.

22. De desponsatione inter ipsam et Ioseph. .XXII. figura. Bernardus super Missus est (Figure 143)

Bernard of Clairvaux, *Homiliae super "Missus est,"* homily 2.[96]

At first glance the diagram depicting the Marriage of the Virgin appears asymmetrical, if not in form then in content, as on the right it pairs Christ with Mary (*virgo beata*), in blue and green circles respectively, but on the left, using the same colors, the Old Testament Joseph (*Ioseph patriarcha*) with Joseph (*Ioseph*) the husband

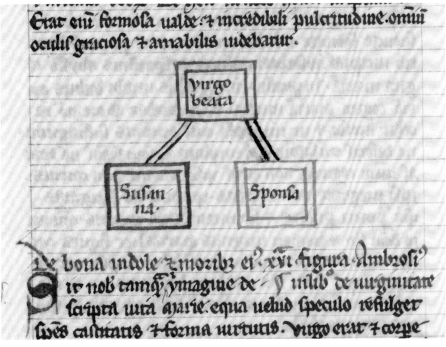

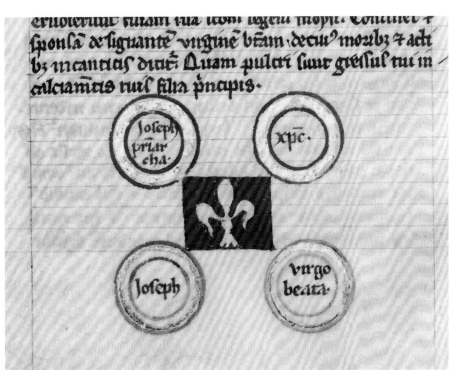

of the Virgin. Whereas the upper two circles, in blue, are filled with white pigment, the lower pair, in green, are filled with silver. In Basel (f. 19r) the circular frames are not filled in. The commentary confronts this issue directly, stating that the lily at the center, reserved against plain parchment within a rectangle shaded in red, represents not only the chastity of Christ and his mother but also that of the two Josephs, both of whom were also beautiful. To this end Berthold recapitulates the story from Genesis 39 of Joseph and Potiphar's wife, where it is said, "And Joseph was of a beautiful countenance, and comely to behold" (Gn 39:6). To this account he then compares what Matthew 1:19 reports concerning Joseph, the bridegroom of Mary: "Whereupon

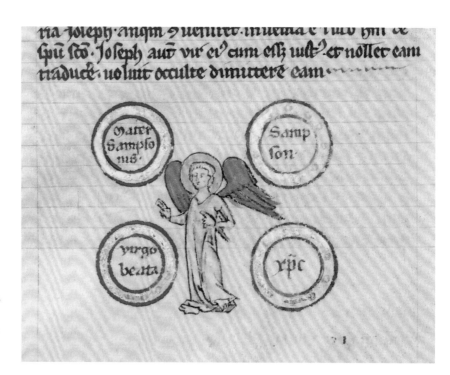

144. *Figura* 23: On the Sending of the Angel to the Blessed Virgin. Berthold of Nuremberg, Liber de misteriis et laudibus intemerate Virginis genitricis Dei et Domini nostri Ihesu, Lake Constance region (?), 1292–94. FBG, Memb. I 80, f. 58v (detail). Photo: FBG.

Joseph her husband, being a just man, and not willing to expose her, was minded to put her away privately." These comparisons, read in conjunction with the preceding passage from Bernard of Clairvaux, make clear that the coloring of the circles in the diagram provides the key to their interpretation and that they are to be read not vertically, in columns, but horizontally, in rows. Just as the patriarch Joseph is, as Bernard states, a type of Christ, on account of his ability to interpret dreams (analogous to Christ's ability to penetrate the mysteries of heaven), his imprisonment in Egypt (analogous to Christ's imprisonment by Herod in the Passion), and his ability to feed his people (analogous to Christ's providing his flock with the living bread of the sacrament), so too Joseph the husband of Mary served her in every way, prudently providing her with solace, nourishing her, and remaining faithful to her. The comparison only really makes sense, however, when one considers the immediately following verses in Matthew (1:20–23) that relate the story of Joseph's dream and thereby provide an approximate point of comparison to the dreams interpreted by the patriarch of the same name. The white lily of chastity at the center of the diagram represents precisely what draws all four figures together.

23. De missione angeli ad virginem beatam. .XXIII. figura. Beda in omelia "Spiritus missus est" (Figure 144)

Bede, *Homeliarum evangelii libri II*, bk. 1, homily 3.[97]

The diagram focuses on the strong angel that features in Bede's homily on the annunciation, which interprets Gabriel's name as meaning "the strength of God" (*fortitudo dei*) and quotes Psalm 23:8 ("The Lord who is strong and mighty: the Lord mighty in battle") as a prooftext. The angel turns to the left in a pose commonly associated with the annunciation, blessing with his right hand and pointing with his left. In Basel (f. 20r) the angel's hands droop rather than point, thereby stripping the figure of its iconographic associations. Although in most instances Annunciation scenes show Gabriel entering from the left, in this case he gestures toward the right so that he can face the blue circle in the lower left corner (*virgo beata*). According to the commentary, just as Mary gave birth to the Savior of Israel in the person of her son, Jesus, represented by the red circle to the lower right, so too the mother of Samson, represented by the blue circle at the upper left (*mater Sampsonis*) gave birth to the conqueror of the Philistines, represented by the

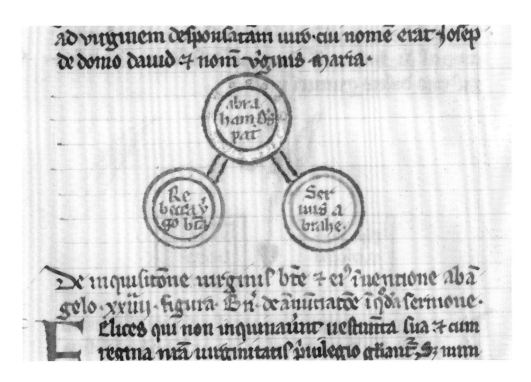

red circle at the upper left (*Sampson*). The bands encompassing all four circles are filled with small circles, like dots; these were then largely covered up by the application of white pigment, much of which has flaked off.

24. De inquisitione Virginis beate et eius inventione ab angelo. .XXIIII. figura. Bernardus de annunciatione in quodam sermone (Figure 145)

Bernard of Clairvaux, *Sermones in assumptione beatae Mariae Virginis*, sermon 6, part 1.[98]

The three-part diagram, dedicated to Gabriel's questioning of the Virgin, draws an analogy between the servant of Abraham (*servus Abrahe*), represented by the green circle to the right, questioning Rebekah at the well (Gn 24), represented by the red circle to the left (*Rebecca virgo beata*) and the archangel Gabriel, the servant of God, questioning the Virgin Mary at the annunciation. The *Speculum humanae salvationis* also employs Rebekah at the well as a type of the annunciation.[99] Whereas in previous diagrams, individual biblical figures were always represented separately, such that in this case one might have expected as many as six geometric figures in

toto—three for Abraham, Rebekah, and the servant, and another trio for God the Father, Mary, and Gabriel—here Abraham and God the Father are consolidated into one. The simplification not only makes the diagram less intricate but also underscores the typological unity between Abraham and God, whose common circle is distinguished from the others by the application of red dots and white pigment.

25. De plenitudine et redundancia gratie. XXV. figura. Iheronimus in sermone de assumptione (Figure 146)

Paschasius Rasbertus, *De assumptione sanctae Mariae Virginis*.[100]

The foursquare diagram on the plenitude of grace in the Virgin Mary is constructed from four circles. This typically paradisiacal iconography traditionally applied to Christ is transferred to the Virgin Mary, who is represented by the green rectangle at the center (*Virgo beata*). Rather than interpreting Mary as the New Eve, as might be expected, the configuration identifies Mary as the paradise in which God placed Christ, the New Adam, from whom flowed four spiritual virtues: mercy for sinners, consolation for the afflicted, grace for the just, and joy for the beat-

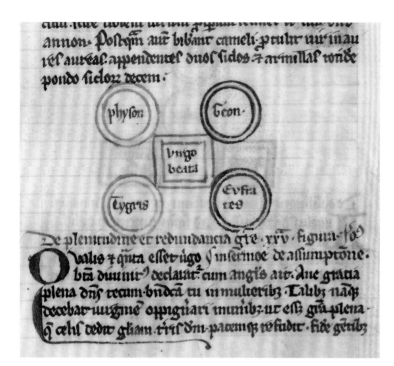

146. *Figura* 25: On the Plenitude and Redundancy of Grace. Berthold of Nuremberg, Liber de misteriis et laudibus intemerate Virginis genitricis Dei et Domini nostri Ihesu, Lake Constance region (?), 1292–94. FBG, Memb. I 80, f. 59r (detail). Photo: FBG.

147. *Figura* 26: Of the Shadowing of the Highest Virtue. Berthold of Nuremberg, Liber de misteriis et laudibus intemerate Virginis genitricis Dei et Domini nostri Ihesu, Lake Constance region (?), 1292–94. FBG, Memb. I 80, f. 59v (detail). Photo: FBG.

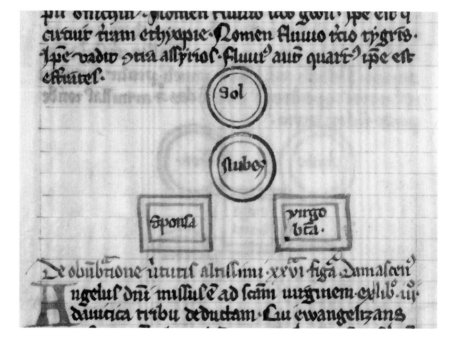

ified, which are identified in turn with the four rivers of paradise: the Phison (*Phison*) in pink, Gihon (*Geon*) in blue, Tigris (*Tigris*) in yellow gold, and Euphrates (*Eufrates*) in red.

26. De obumbratione virtutis altissimi. XXVI. figura. Damascenus libro tertio (Figure 147)

John of Damascus, *De fide orthodoxa*.[101]

The diagram represents a gloss on the Song of Songs 2:3: "I sat down under his shadow, whom I desired: and his fruit was sweet to my palate." Just as the bride of the Canticle seats herself in the shadow of the bridegroom, so too the Virgin Mary, by virtue of the incarnation, places herself in the shadow of his divinity. The sun (*sol*), represented by the red circle at the top of the figure, irradiates the clouds (*nubes*), represented by the brown circle, reinforced or overdrawn

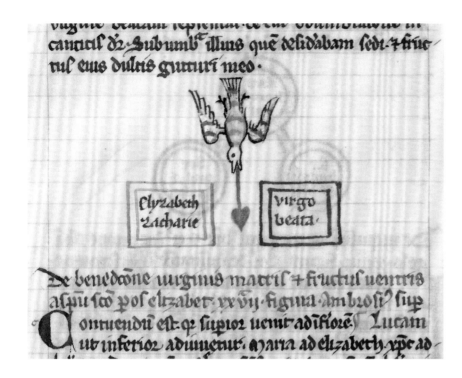

148. *Figura* 27: On the Benediction of the Virgin Mother and the Fruit of Her Belly by the Holy Spirit through the Mouth of Elizabeth. Berthold of Nuremberg, Liber de misteriis et laudibus intemerate Virginis genitricis Dei et Domini nostri Ihesu, Lake Constance region (?), 1292–94. FBG, Memb. I 80, f. 59v (detail). Photo: FBG.

in blue, immediately below it. The two green rectangles at the bottom, that on the left representing the bride (*sponsa*), that on the left the Virgin Mary (*virgo beata*), make the analogy explicit although Christ's divinity and humanity, for which the sun and clouds were traditional images, are not figured directly.[102] In keeping with the passage from John of Damascus's *De fide orthodoxa* in the Latin translation by Burgondio of Pisa (d. 1193), from which Berthold excises most of the Greek terminology, the light of the sun stands for Christ's divinity, the cloud that obscures that light his humanity. To the passage from the Song of Songs the commentary adds Isaiah 19:1 ("Behold the Lord will ascend upon a swift cloud, and will enter into Egypt"), a passage here implicitly interpreted as referring to the incarnation, with the cloud representing Christ's assumption of a human body, and Egypt the land of exile, in this case not from Israel but rather from heaven. Together with the two texts, the image seek to explain the mystery of how the divine and the human could be combined in one entity.

27. De benedictione virginis matris et fructus ventris a Spiritu Sancto per os Elizabet. .XXVII. figura. Ambrosius super Lucam (Figure 148)

Ambrose, *Expositio euangelii secundum Lucam*, bk. 2.[103]

The diagram, which represents Elizabeth's benediction of Mary, consists of three elements: two rectangles, the left one in pink, representing Elizabeth (*Elizabeth Zacharie*), the other on the right in blue, representing Mary (*virgo beata*), divided by a downward pointing dove that carries in its beak an arrowlike green frond with a single heart-shaped leaf. According to the commentary, the diagram offers a schematic representation of the visitation (Lk 1:39–45), at which Elizabeth cried out, "Blessed art thou among woman, and blessed is the fruit of thy womb," which it compares to the dove coming to Noah on the ark following the flood with an olive branch in its beak signifying that, according to Genesis 8:11, "the waters had ceased upon the earth." Elizabeth welcoming Mary, it is implied, is like the dove who came to Noah, signifying that the world and, with it humankind, receives the proverbial second chance. The link between the commentary and the passage that precedes it, an excerpt from

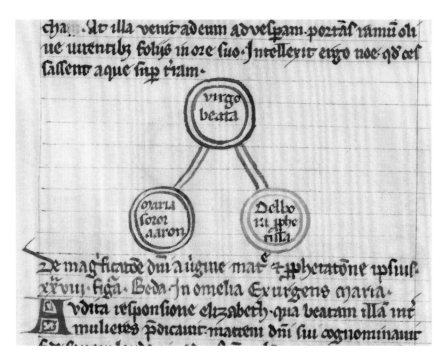

149. *Figura* 28. On the Magnification of the Lord by the Virgin Mother. Berthold of Nuremberg, Liber de misteriis et laudibus intemerate Virginis genitricis Dei et Domini nostri Ihesu, Lake Constance region (?), 1292–94. FBG, Memb. I 80, f. 60r (detail). Photo: FBG.

Ambrose's commentary on Luke, is provided by the church father's identification of Christ with the fruit of the tree that Berthold's commentary, in turn, identifies with the fruit of Mary's womb as enunciated by Elizabeth at the visitation.

28. De magnificatione Domini a Virgine matre et prophetatione ipsius. .XXVIII. figura. Beda in omelia Exurgens Maria (Figure 149)

Bede, *Homeliarum evangelii libri II*, bk. 1, homily 4[104]

The diagram compares the song of exultation of Mary (*virgo beata*) at the Visitation, represented by the blue circle at the apex of the implied triangle, with that of Mary (Miriam) the prophetess and sister of Aaron (*Maria soror Aaron*), represented by the red circle at lower left, at the drowning of Pharaoh's hosts in the Red Sea (Gn 1:20), and that of Deborah (*Delborah prophetissa*), represented by the pink circle at lower right, at the deliverance of Israel from Jabin and Sisara (Jdg 4:4). Both prophetesses are construed as prefigurations of the Virgin Mary and connected to her by pairs of green lines. The typological handbook *Pictor in carmine* also associates the *Canticum Mariae* at the visitation with the sister of Aaron and the prophetess Deborah.[105]

29. De exultatione spiritus eius in Domino. .XXIX. figura. Hugo de sancto Victore super Magnificat (Figure 150)

Hugh of St. Victor, *Explanatio in Canticum beatae Mariae*.[106]

The triangular diagram, again devoted to Mary's exultation, is made up of three circles and takes much the same form as that which precedes it, with the only difference, other than the identification of the circles, being their coloration. Once again the Virgin Mary (*virgo beata*) serves as the apex. The two circles at the bottom, that in blue to the left representing Hannah the mother of Samuel (*Anna Samuelis*), that in red to the right representing the bride of Christ (*sponsa Christi*). The commentary likens Hannah's rejoicing as expressed in her canticle (1 Kgs 2: "My heart hath rejoiced in the Lord, and my horn is exalted in my God: my mouth is enlarged over my enemies: because I have joyed in thy salvation") with that expressed by Mary in the Magnificat (Lk 1:46–55), the subject of the preceding commentary by Hugh of St. Victor. The commentary introduces a further point of comparison from the Song of Songs (1:3: "The king hath brought me into his storerooms: we will be glad and rejoice in thee, remembering thy breasts more than wine").

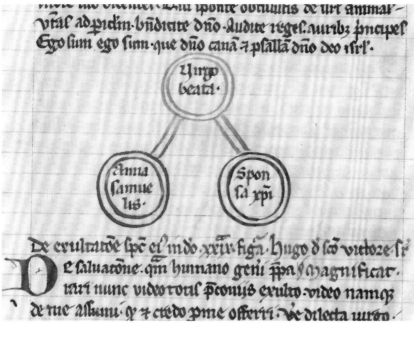

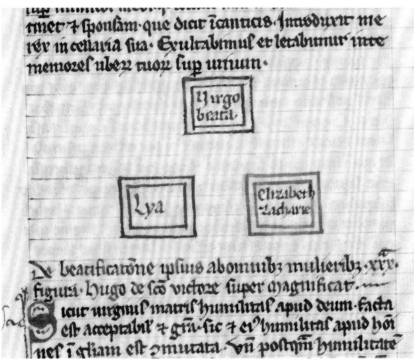

30. De beatificatione ipsius ab omnibus mulieribus. .XXX. figura. Hugo de sancto Victore super Magnificat (Figure 151)

Hugh of St. Victor, *Explanatio in canticum beatae Mariae*.[107]

The diagram, which prefaces an additional passage from Hugh of St. Victor on the Magnificat, focuses on Mary's beatification over all over women. It offers three rectangles representing, in red, the Virgin Mary (*virgo beata*), in blue, Leah (*Lia*), and in green, Elizabeth (*Elizabeth Zacharie*) without any lines connecting them. The commentary likens Leah, who bore a son, Asher, by Jacob for the barren Rebekah, to Elizabeth, who rejoiced at Mary's pregnancy. By implication, the commentary, citing Genesis 49:20 ("Asher, his bread shall be fat, and he shall yield

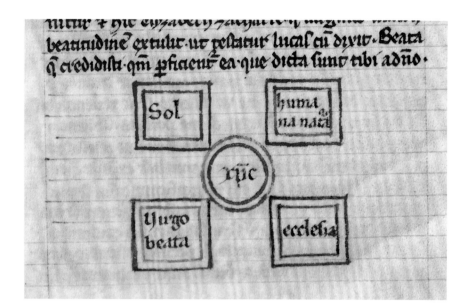

152. *Figura* 31: On the Progress of Christ in the Manner of a Spouse from the Virginal Womb. Berthold of Nuremberg, Liber de misteriis et laudibus intemerate Virginis genitricis Dei et Domini nostri Ihesu, Lake Constance region (?), 1292–94. FBG, Memb. I 80, f. 60v (detail). Photo: FBG.

dainties to kings"), asks the reader to compare Asher to Elizabeth's son, John the Baptist. At first glance, the analogy drawn between Leah and Elizabeth does not make much sense: Leah stood in for Rebekah, who was infertile as was Elizabeth before the miraculous conception of John the Baptist. The subject of infertility also forms the focus of Hugh's commentary. What the two women have in common, however, is less their condition prior to conceiving than the fact that both give birth to sons who, in the commentary's terms, herald the coming of Christ. The diagram thus serves less to liken the two of them to Mary as the mother of Christ than to place them in a similar position vis-à-vis the Virgin. Leah in effect serves as a type of Elizabeth.

31. De processu Christi admodum sponsi ex utero virginali. .XXXI. Glosa super psalmum decimum octavum (Figure 152)

Peter Lombard, *Commentarius in psalmos Davidicos.*[108]

The diagram's title compares Christ's birth to his "progress" as spouse from Mary's virginal womb. A green circle representing Christ stands at the center of four rectangles paired by their coloration. The pair of blue rectangles at the top represent the sun (*sol*) and human nature (*humana natura*); the pair of rectangles at the bottom, heightened in red after having initially been traced in pink and blue, represent Mary (*virgo beata*) and the Church (*ecclesia*). Citing Ephesians 5:25–27 ("Husbands, love your wives, as Christ also loved the church, and delivered himself up for it"), the commentary explains that the Church is the bride of Christ in disguise, in whose love the body of the Virgin was assumed. For an explanation of the two rectangles at the top one must turn to the excerpt from Peter Lombard's commentary on the Psalms, where it is argued that God married human nature as did Christ in the Virgin's womb, whence Christ proceeded like a groom from the marital bedchamber. This imagery in turn derives from Psalm 18:6: "He hath set his tabernacle in the sun: and he, as a bridegroom coming out of his bride chamber, hath rejoiced as a giant to run the way." In this instance Mary herself is not characterized as a vessel or container—that is, the tabernacle; rather, the tabernacle stands for God's divinity that is placed in Mary's womb, the sun. This pair of relationships—of Christ to the Virgin and of the tabernacle to the sun—is expressed by the juxtaposition to the left of the diagram of the two rectangles, one blue, one red, with the green circle representing Christ. The rectangles on the other side represent Christ's marriage to human nature at the incarnation and thereby, allegorically, to the Church. The diagram as a whole thus represents the infusion of divinity into the created world and its institutions.

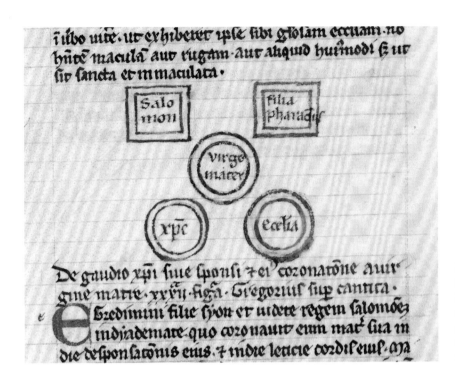

153. *Figura* 32: On the Joy of Christ or the Spouse and His Coronation by the Virgin Mother. Berthold of Nuremberg, Liber de misteriis et laudibus intemerate Virginis genitricis Dei et Domini nostri Ihesu, Lake Constance region (?), 1292–94. FBG, Memb. I 80, f. 60v (detail). Photo: FBG.

32. De gaudio Christi sive sponsi et eius coronatione a Virgine matre. .XXXII. figura. Gregorius super Cantica (Figure 153)

Gregory the Great, *Super Canticum canticorum expositio*.[109]

Rather than referencing Mary's coronation by Christ, the rubric refers to Christ's joy at his coronation by Mary. A red circle representing the Virgin (*virgo mater*) stands at the center of two rectangles and two circles that are paired not by shape but by color, respectively blue and green. The first pair, to the left, are blue and represent Solomon and Christ. The second pair, to the right, are green and represent Pharaoh's daughter (*filia pharonis*) and the Church (*ecclesia*). Solomon prefigures Christ in the magnitude of his wisdom, his marital fidelity (in that Christ is faithful to his bride, the Church), and the sublimity of his glory. As stated in 1 Kings 3:1, Solomon "made affinity with Pharaoh the king of Egypt: for he took his daughter, and brought her into the city of David." What this means, the diagram implies, is that just as Solomon's marriage to Pharaoh's daughter cemented the establishment of his capital in Jerusalem, so too Christ's marriage to the Virgin signifies the establishment of the Church. According to this logic, the city of Jerusalem becomes a type of the Church, and both brides—Solomon's and Christ's—are married to Wisdom incarnate in their respective spouses.

33. De gaudio fecunditatis virginis matris. .XXXIII. figura. Maximus de virgine beata in quodam sermone (Figure 154)

Ps.-Ildefonsus, *De sancta Maria*, sermon 12.[110]

The diagram celebrates the fecundity of the Virgin. The angel with outstretched arms that descends from a heavenly cloud at the center effectively forms a divider at the center, separating the four circles from one another in quadrants defined by the vertical axis of its body and horizontal axis of its wings. According to the commentary, the angel is the one who, as described in Luke 2:10, brings "tidings of great joy, that shall be to all the people." The angel, however, descends, not to the shepherds of the Lukan narrative but rather to Christ and the Virgin Mary in green and red circles at the bottom, who represent the content, not the audience, of his address. Above, to either side of an impressionistic cloud painted over the angel's lower limbs in blue, silver, red, and green, Sarah (*Sara*) and

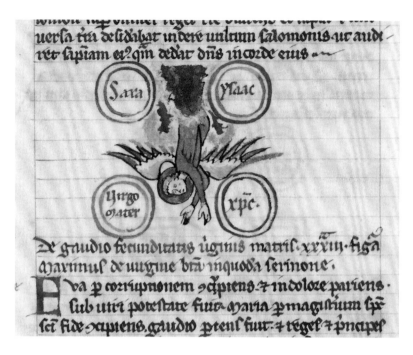

154. *Figura* 33: On the Joy in the Fecundity of the Virgin Mother. Berthold of Nuremberg, Liber de misteriis et laudibus intemerate Virginis genitricis Dei et Domini nostri Ihesu, Lake Constance region (?), 1292–94. FBG, Memb. I 80, f. 61r (detail). Photo: FBG.

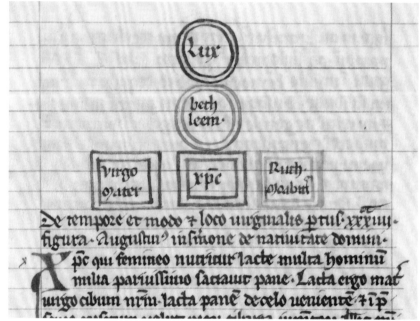

155. *Figura* 34: On the Time and Manner and Place of the Virginal Birth. Berthold of Nuremberg, Liber de misteriis et laudibus intemerate Virginis genitricis Dei et Domini nostri Ihesu, Lake Constance region (?), 1292–94. FBG, Memb. I 80, f. 61r (detail). Photo: FBG.

Isaac (*Isaac*) fill blue and green circles. Just as Sarah, who was beyond her childbearing years, gave birth to Isaac, whom Abraham would later obediently offer up in sacrifice, so too Mary gave birth to God's sacrificial Son, Christ. These typological parallels are buttressed further by the Pseudo-Ildefonsine sermon on Mary that paints Mary as the new Eve. The *Pictor in carmine* also employs the story of Isaac and Sarah as a type for the incarnation.[111]

34. De tempore et modo et loco virginalis partus. .XXXIIII. figura. Augustinus in sermone de nativitate Domini (Figure 155)

Ps.-Augustine, *De nativitate Domini*, sermon 369.[112]

The diagram maps the time, manner, and place of the virginal birth of Christ. In both the diagram and the commentary, everything depends on the imagery of light, represented by the red circle at the top of the central column that con-

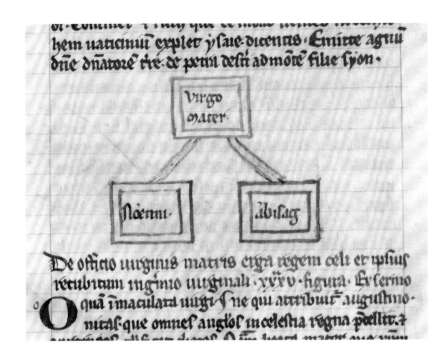

156. *Figura* 35: On the Office of the Virgin Mother concerning the King of Heaven and His Reclining in the Lap of the Virgin. Berthold of Nuremberg, Liber de misteriis et laudibus intemerate Virginis genitricis Dei et Domini nostri Ihesu, Lake Constance region (?), 1292–94. FBG, Memb. I 80, f. 61r (detail). Photo: FBG.

sists at its base of Christ, in a green rectangle, and at its center of Bethlehem (*Bethleem*) in a pink circle. Just as light irradiates the mind by penetrating the eye during the course of the day, so too the light of the Lord's mercy penetrates the darkened heart. Furthermore, just as light can clarify by passing through something without breaking it, the invisible light of the Son of God penetrated the Virgin without violating her virginity.[113] The light of God came into the world in Bethlehem, just as Ruth, an ancestor of David and hence of Christ, represented by the yellow gold rectangle to the right, came to Bethlehem from the desert of Moab, an Old Testament precedent that the commentary glosses with a passage not from the book of Ruth but rather from Isaiah 16:1 ("Send forth, O Lord, the lamb, the ruler of the earth, from Petra of the desert, to the mount of the daughter of Sion"), a text used as a responsory during the season of Advent to herald the coming of Christ. Bethlehem—which, as noted by the commentary, means "house of bread"—serves as the focal point where Ruth, like Mary after her, and the divine light of God that is Christ all converge. Imagery of both light and food is interwoven in the reading from Augustine's sermon on the Nativity, which also served as a lesson in the Dominican liturgy for the second Saturday following the Octave of Epipha-

ny. The closing verse from Isaiah (16:1), formed part of both antiphons and responses employed during Advent and at the Feasts of the Annunciation and Nativity (Can 002642, 006655, 006656, 007553a, 008051).

35. De officio Virginis matris erga regem celi et ipsius recubitum in gremio virginali. .XXXV. figura. Ex sermone qui attribuitur Augustino (Figure 156)

Ps.-Alcuin, *De nativitate perpetuae Virginis Maria*, homily 3.[114]

Continuing the extensive series devoted to the miracle of the incarnation, the diagram addresses the paradox of the king of heaven having lain in Mary's womb. The diagram compares Mary (*Virgo mater*), in a pink rectangle, to Naomi (*Noemi*) and Abisag (*Abisag*), in blue and green rectangles respectively.[115] The connections between Mary and the two Old Testament women are drawn red lines that were partially erased before being redrawn in yellow. To the account of the birth of Ruth's son, Obed (Ruth 4:16–17), the commentary appends the story of Abisag being brought to King David in his old age (3 Kgs 1:1–4). These comparisons indicate that the lines connecting both Old Testament women to Mary should be viewed as ascending, rather than descending,

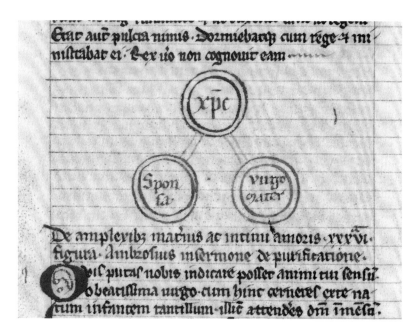

157. *Figura* 36: On the Maternal Embrace and Its Loving Intimacy. Berthold of Nuremberg, Liber de misteriis et laudibus intemerate Virginis genitricis Dei et Domini nostri Ihesu, Lake Constance region (?), 1292–94. FBG, Memb. I 80, f. 61v (detail). Photo: FBG.

as they trace Mary's lineage going back to the house of David and beyond, in which both earlier women participated by virtue of giving birth to sons. The point of departure for the diagram can thus be found in the genealogical imagery from a homily on the birth of the Virgin by pseudo-Alcuin that celebrates her as the "generator" and "gestator" of Christ.

36. De amplexibus maternis ac intimi amoris. .XXXVI. figura. Ambrosius in sermone de purificatione (Figure 157)

Ambrosius Autpertus, *Sermo in purificatione sanctae Mariae*, sermon 2.[116]

The diagram consists of three parts: a blue circle at the top, standing for Christ, connected by yellow bands to two additional circles, one red on the left representing the bride (*sponsa*), the other in green on the right representing the Virgin Mary (*virgo mater*). The commentary consists of little more than a quotation from Song of Songs 8:6 ("Put me as a seal upon thy heart, as a seal upon they arm, for love is strong as death"), indicating that Christ's love for his mother is to be identified with that of the bridegroom for the bride. The verse was occasionally employed as an antiphon for the Feast of the Purification (Can 203856).

37. De osculis maternis ac casti pudoris. .XXXVII. figura. Maximus de virgine beata in quodam sermone (Figure 158)

Ps.-Maximus, *De Assumptione beatae Mariae Virginis*, sermon 11.[117]

The diagram adopts the erotic bridal imagery of Song of Songs to characterize the chaste love between bride and bridegroom (Christ and the Virgin). The flower, which, as described in the accompanying commentary, is varied in color, half red, half white (i.e., reserved parchment), represents the chaste kiss that according to Christian commentary opens the Song of Songs (1:1: "Let him kiss me with the kisses of his mouth"), to which is added Song of Songs 8:1 ("Who shall give thee to me for my brother, sucking the breasts of my mother, that I may find thee without, and kiss thee, and now no man may despise me"). The verses make perfect sense as glosses on the sermon that precedes them, which Berthold erroneously attributes to Maximus and which sing the praises of the lips that kissed and the breasts that suckled the Christ Child. Two green rectangles, that on the left representing the bride (*sponsa*), that on the right representing the Virgin (*virgo mater*), frame the red rectangle at the center representing Christ that doubles as a figure of the bride-

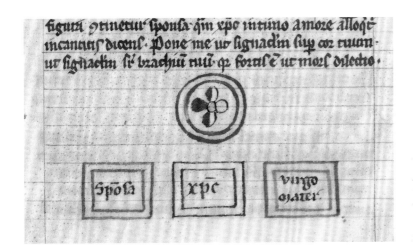

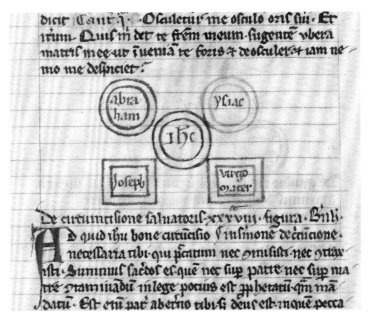

158. *Figura* 37: On the Maternal Kiss and Also Chaste Modesty. Berthold of Nuremberg, Liber de misteriis et laudibus intemerate Virginis genitricis Dei et Domini nostri Ihesu, Lake Constance region (?), 1292–94. FBG, Memb. I 80, f. 61v (detail). Photo: FBG.

159. *Figura* 38: On the Circumcision of the Savior. Berthold of Nuremberg, Liber de misteriis et laudibus intemerate Virginis genitricis Dei et Domini nostri Ihesu, Lake Constance region (?), 1292–94. FBG, Memb. I 80, f. 61v (detail). Photo: FBG.

groom of the Song of Songs. In the liturgy the opening verse of Song of Songs (1:1), included at the end of the commentary, was employed in conjunction with the Feast of the Assumption (Can 00203745, 602552a) as well as with the Nativity (Can 002227a).

38. De circumcisione salvatoris. .XXXVIII. figura. Bernardus in sermone de circumcisione (Figure 159)

Bernard of Clairvaux, *Sermones in circumcisione Domini,* sermon 2.[118]

Focused on the circumcision, the diagram resumes the narrative sequence of the events of Mary's life as they relate to Christ. Two green rectangles representing Joseph (*Ioseph*) and Mary (*virgo mater*) are marshaled along with two circles, one blue, representing Abraham (*Abraham*), the other yellow, representing Isaac (*Isaac*), around the red circle at the center, which stands for Christ. Abraham saw to it that his son Isaac was circumcised as a sign of the covenant between God and the Israelites (Gn 17:9), and according to Luke 2:21, which the commentary quotes, Joseph brought Jesus to the temple to be circumcised. In light of these parallels, the logic behind the construction of the diagram is not immediately apparent. One might have expected that, analogous to Isaac's position vis-à-vis his father, Christ would occupy the position held by the Virgin Mary opposite Joseph. Nor is the diagram's structure explained by the quotation from

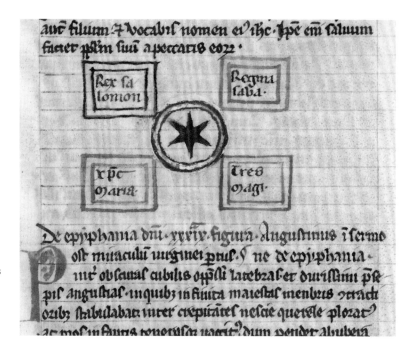

160. *Figura* 39: On the Epiphany of the Lord. Berthold of Nuremberg, Liber de misteriis et laudibus intemerate Virginis genitricis Dei et Domini nostri Ihesu, Lake Constance region (?), 1292–94. FBG, Memb. I 80, f. 62r (detail). Photo: FBG.

Bernard of Clairvaux's sermon on the circumcision, which asks why, in light of the Savior's perfection, the circumcision was even necessary. The conception of the diagram, however, appears to be based on the principle of parentage. Abraham and Isaac represent the lineage that lead to the birth of the Messiah in the person of Jesus, and so do his immediate parents, Joseph and Mary. By placing the circumscribed Christ at the center, the diagram focuses on Jesus as the fulfillment of the Old Covenant and the creator of the New Covenant that replaces it, thereby doing away through his self-sacrifice, anticipated by the bloodletting of the circumcision, with circumcision itself.

39. De epiphania Domini. .XXXIX. figura. Augustinus in sermone de epiphania (Figure 160)

Ps.-Augustine, *In epiphania Domini* I, sermon 17.[119]

The diagram for the Epiphany provides a neat and parallel between the Queen of Sheba (*regina saba*), represented by the green rectangle to the upper right, who brought gifts of aromatic spices to Solomon (*rex salomon*), represented by the red rectangle to the upper left (1 Kgs 10), and the three magi (*tres magi*), represented by the pink

rectangle at the lower right, who brought their gifts to Christ and the Virgin, represented by the green rectangle at the lower left. The star that guided the magi (Mt 2:10) figures prominently at the center in red, surrounded by a celestial blue circle augmented with silver. *Pictor in carmine* also employs the queen's gift of spices to Solomon as a type of the Adoration of the Magi.[120]

40. De purificatione Virginis matris. .XL. figura. Bernardus in sermone de purificatione (Figure 161)

Bernard of Clairvaux, *Sermones in purificatione beatae Mariae Virginis*, sermon 3, part 1.[121]

Next in the series is the diagram for the Purification of the Virgin. Two confronted doves with upraised wings and downturned heads divide the diagram into four quadrants, which are occupied by four circles, each in a different color: blue at the upper left for Hannah (*Anna*), red at the upper right for Samuel (*Samuel*), red over green at the lower left for Mary (*virgo mater*), and finally pink at the lower left for Christ. Just as Hannah presented Samuel in the temple (1 Sam 1:24–28), so too Mary presented Christ at the temple bringing two turtledoves, in keeping with the prescriptions laid down in Leviticus

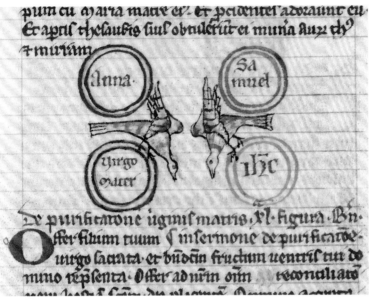

161. *Figura* 40: On the Purification of the Virgin Mother. Berthold of Nuremberg, Liber de misteriis et laudibus intemerate Virginis genitricis Dei et Domini nostri Ihesu, Lake Constance region (?), 1292–94. FBG, Memb. I 80, f. 62r (detail). Photo: FBG.

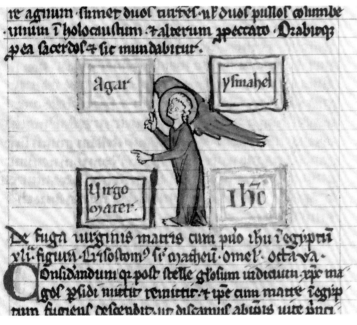

162. *Figura* 41: On the Flight of the Virgin Mother with Her Son Jesus into Egypt. Berthold of Nuremberg, Liber de misteriis et laudibus intemerate Virginis genitricis Dei et Domini nostri Ihesu, Lake Constance region (?), 1292–94. FBG, Memb. I 80, f. 62v (detail). Photo: FBG.

12:8. In the diagram the doves at the center thus do double duty, representing the offerings for both rituals of presentations, that of Anna and that of Mary.

41. De fuga Virginis matris cum puero Ihesu in Egyptum. .XLI. figura. Crisostomus super Mattheum omelie octava (Figure 162)

Johannes Chrysostomus, *Opus imperfectum*, homily 8, part 2.[122]

The diagram on the Flight into Egypt draws a simple typological parallel between Hagar (*Agar*)

and Ishmael (*Ismahel*), represented by the pair of rectangles at the top, who were cast out by Sarah but comforted by an angel (Gn 21), and the Virgin Mary (*virgo mater*) and the Christ Child on the flight into Egypt (Mt 2), represented by the opposing pair at the bottom. The coloration creates a chiastic pattern that is enhanced by the dynamic pose of the angel, who is seen in a combination of profile and three-quarter views, with his gesticulating hands and wing (only one is visible) forming a rotating movement. Whereas the boxes representing Hagar and Christ are drawn in yellow (in the case of Christ, highlighted with

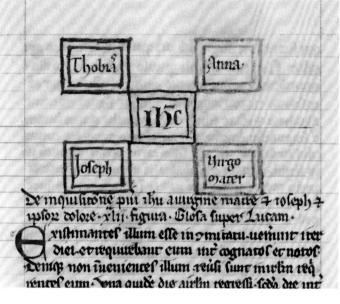

163. *Figura* 42: On the Questioning of the Boy Jesus by the Virgin Mother and Joseph and of Their Anguish. Berthold of Nuremberg, Liber de misteriis et laudibus intemerate Virginis genitricis Dei et Domini nostri Ihesu, Lake Constance region (?), 1292–94. FBG, Memb. I 80, f. 62v (detail). Photo: FBG.

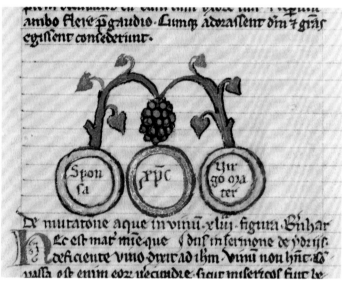

164. *Figura* 43: On the Changing of Water into Wine. Berthold of Nuremberg, Liber de misteriis et laudibus intemerate Virginis genitricis Dei et Domini nostri Ihesu, Lake Constance region (?), 1292–94. FBG, Memb. I 80, f. 63r (detail). Photo: FBG.

a white band), those of Mary and Ishmael are drawn in a combination of yellow and red.

42. De inquisitione pueri Ihesu a Virgine matre et Ioseph et ipsorum dolore. .XLII. figura. Glosa super Lucam (Figure 163)

Glossa ordinaria.[123]

Once again the diagram, which corresponds to the episode of Christ in the Temple as he was sought by his parents, draws a simple typological parallel between the story of Tobias (*Thobias*) and his wife, Anna (*Anna*), as related in the book of Tobias (or Tobit), which tells the story of

their travails and their son's protracted absence, and that of Mary and Joseph seeking their son in the Temple (Lk 2:42–51). The elderly Tobias provides a type for Joseph (*Ioseph*), both of whom are represented, one above the other, by rectangles painted in dark green, a color not previously seen in the series, which is heightened in blue. Anna provides a type for Mary (*virgo mater*), both of whom are represented by rectangles painted in yellow, then heightened in green. Christ, in a red rectangle at the center of the quincunx, the corners of which touch those of the surrounding figures, doubles as a figure of the young Tobit, who was guided by the archangel Raphael.

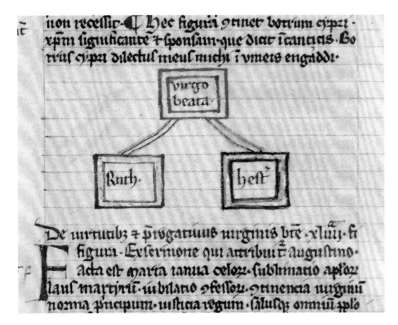

non recessit· ¶ Hec figura ꝯtinet botrum cypri·
xpm significante· ꝲ sponsam·que diat ī canticis· Bo
trus cypri dilectus meus michi ī vineis engaddi·

virgo beata·

Ruth· *hest²*

De virtutibz ꝲ progatiuis uirginis bte ·xluij· fi
figura· Ex sermone qui attribuit̄ augustino·
Acta est marta ianua celoꝝ· sublimatio apłoꝝ·
laus martyrū· iubilatio ꝯfessoꝝ· ꝯtinencia uirginū·
norma ꝓncipum· iustitia regum· salusqȝ omniū ꝑplo

165. *Figura* 44: On the Virtues and Prerogatives of the Blessed Virgin. Berthold of Nuremberg, Liber de misteriis et laudibus intemerate Virginis genitricis Dei et Domini nostri Ihesu, Lake Constance region (?), 1292–94. FBG, Memb. I 80, f. 63r (detail). Photo: FBG.

43. De mutatione aque in vinum. .XLIII. figura. Bernardus in sermone de idriis (Figure 164)

Bernard of Clairvaux, *Sermones in dominica .I. post octavam epiphaniae*, sermon 1, part 2.[124]

The diagram offers a simple gloss on the Marriage of Cana (Jn 2:1–11) employing Song of Songs 1:13: "A cluster of cypress my love is to me, in the vineyards of Engaddi." Christ, figuring both himself and the bride of the Canticle, occupies the center in the form of a blue circle enhanced with a green band heightened with white punctuated by red dots. Christ is flanked by the bride (*sponsa*) and Mary (*virgo mater*), each represented by a circle providing a base for a vine that arches toward the center, weighed down by a large bunch of purple grapes.

44. De virtutibus et prerogatius Virginis beate. .XLIIII. figura. Ex sermone qui attribuitur Augustino (Figure 165)

Alcuin, *De nativitate perpetuae Virginis Mariae*, homily 3.[125]

By way of praising the Virgin, specifically her virtues and prerogatives, the diagram simply likens her to two Old Testament heroines, Ruth (*Ruth*) and Esther (*Hester*). Mary (*virgo beata*), placed in a green rectangle at the apex of the implied triangle, is linked by yellow lines heightened in red, with Ruth, in a blue box enhanced in white with red dots, and Esther, in a red and blue box, enhanced in the same fashion. The commentary consists of extended quotations from Ruth 3:11 and Esther 15:13–15.

45. De caritate eius. .XLV. figura. Bernardus in sermone de assumptione (Figure 166)

Bernard of Clairvaux, *Sermo in dominica infra octavam assumptionis beatae Mariae*.[126]

Following a lengthy passage from a sermon by Bernard of Clairvaux for the Assumption of the Virgin, the commentary on the Virgin's charity consists of a short gloss on an equally simple diagram. At the top, looking rather like the oculus from a stained-glass window, a four-petaled flower with its petals colored alternately red and pink around a central yellow bud, sits within a blue circle composed of two bands. Below are two rectangles, that on the left in red and orange (in fact, yellow overlaid with red), that on the right in purple laid over blue, representing Deborah (*Delbora*) and Mary (*virgo mater*) respectively. The gloss simply qualifies the two colors of the flower's petals, red and pink, as those

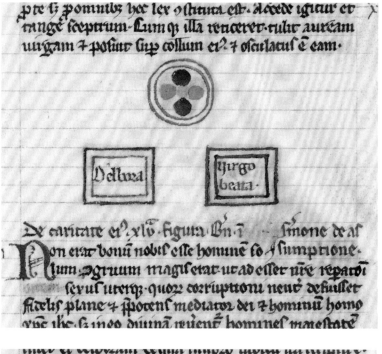

166. *Figura* 45: On Her Charity. Berthold of Nuremberg, Liber de misteriis et laudibus intemerate Virginis genitricis Dei et Domini nostri Ihesu, Lake Constance region (?), 1292–94. FBG, Memb. I 80, f. 63r (detail). Photo: FBG.

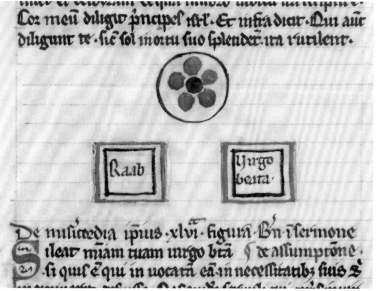

167. *Figura* 46: On Her Mercy. Berthold of Nuremberg, Liber de misteriis et laudibus intemerate Virginis genitricis Dei et Domini nostri Ihesu, Lake Constance region (?), 1292–94. FBG, Memb. I 80, f. 63v (detail). Photo: FBG.

of charity (*caritas*) and experience (*experimentia*), then provides two passages from Judges, the first from the Canticle of Deborah (Jdg 5.9. "My heart loveth the princes of Israel"), the second from verse 31 of the same chapter: "but let them that love thee shine, as the sun shineth in his rising." Mary, like Deborah before her, is singled out for her love of the Lord and for having rejoiced in his victory. The diagram shows the flower of charity growing in the light of their love, which is compared to that of the sun.

46. De misericordia ipsius. .XLVI. figura. Bernardus in sermone de assumptione (Figure 167)

Bernard of Clairvaux, *Sermones in assumptione beatae Mariae Virginis*, sermon 4, part 8.[127]

The diagram on Mary's mercy provides a variant on the one that precedes it. A schematic flower, set in a circle traced in purple, with five green petals surrounding a purple bud in a format again reminiscent of the oculus of a stained-

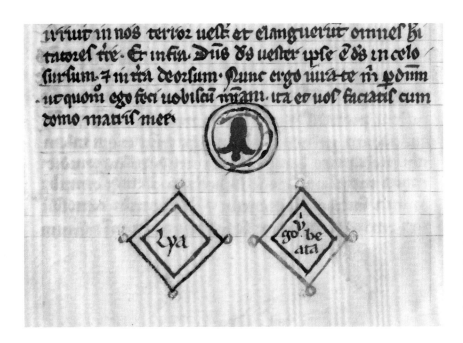

168. *Figura* 47: On Her Humility. Berthold of Nuremberg, Liber de misteriis et laudibus intemerate Virginis genitricis Dei et Domini nostri Ihesu, Lake Constance region (?), 1292–94.FBG, Memb. I 80, f. 63v (detail). Photo: FBG.

glass window, stands above two rectangles, each in three colors: green, white, and red. That on the left represents Rahab (*Raab*), who hid the spies sent by Joshua to Jericho; that on the right represents Mary (*virgo beata*). The commentary attaches to Rahab two passages from Judges: 2:8–9 ("Behold the woman went up to them, and said: I know that the Lord hath given this land to you: for the dread of you is fallen upon us, and all the inhabitants of the land have lost all strength") and 2:11–12 ("For the Lord your God he is God in heaven above, and in the earth beneath. Now therefore swear ye to me by the Lord, that as I have shewn mercy to you, so you also will shew mercy to my father's house"). The basis for the comparison is provided by the preceding passage from Bernard of Clairvaux's commentary on the assumption. Like Rahab, the Virgin Mary pleads for mercy before the Lord.

compares Mary (*virgo beata*) with Leah (*Lia*), and both with a blue flower resembling a violet suspended from a short green stem that the commentary identifies as a symbol of humility. Quoting Genesis 29:31–32 ("And the Lord, seeing that he despised Leah, opened her womb, but her sister [Rachel] remained barren. And she conceived and bore a son, and called his name Reuben, saying: The Lord saw my affliction: now my husband will love me"). Combined with the passage from Jerome's letter to Eustochium in praise of a life of virginity, the diagram serves to extol Mary's humility on the model of Leah. Both women are represented by diamond-shaped lozenges colored alternately red and blue with small green circles heightened with dabs of white at the corners. The colors serve to identify both symbols with the colors of the flower, whose stem is highlighted in the same fashion.

47. De humilitate eius. .XLVII. figura. Ieronimus in sermone de assumptione (Figure 168)

Paschasius Radbertus, *De assumptione sanctae Mariae Virginis*.[128]

The subset of diagrams comparing attributes of the Virgin to various flowers continues with the theme of humility. The tripartite diagram

48. De prudencia et sapientia ipsius. .XLVIII. Bernardus super Missus est (Figure 169)

Bernard of Clairvaux, *Homiliae super "Missus est"*, homily 4, part 3.[129]

The diagram, dedicated to the Virgin's prudence and wisdom, consists of three circles. The commentary first compares the prudence of the Vir-

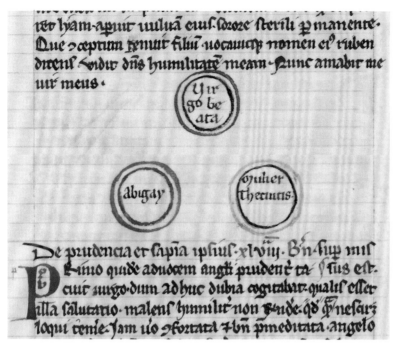

169. *Figura* 48: On Her Prudence and Wisdom. Berthold of Nuremberg, Liber de misteriis et laudibus intemerate Virginis genitricis Dei et Domini nostri Ihesu, Lake Constance region (?), 1292–94. FBG, Memb. I 80, f. 63v (detail). Photo: FBG.

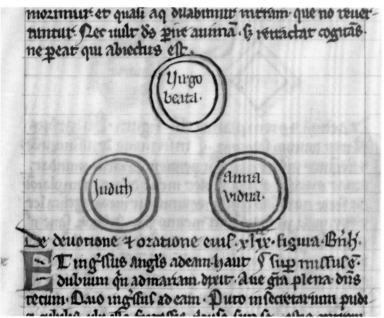

170. *Figura* 49: On Her Devotion and Prayer. Berthold of Nuremberg, Liber de misteriis et laudibus intemerate Virginis genitricis Dei et Domini nostri Ihesu, Lake Constance region (?), 1292–94. FBG, Memb. I 80, f. 64r (detail). Photo: FBG.

gin (*virgo beata*) with that of Abigail (*Abigail*), adducing passages from 1 Samuel 25:3 and 36: "And she was a prudent and very comely woman" and "And Abigal came to Nabal: and behold he had a feast in his house, like the feast of a king, and Nabal's heart was merry: for he was very drunk: and she told him nothing less or more until morning."[130] There follows a comparison of the Virgin with the woman of Thecua, taken from 2 Samuel 14:1, 12–14: "And Joab the son of Sarvia, understanding that the king's heart was turned to Absalom, sent to Thecua, and fetched from thence a wise woman," and "Then the woman said: Let thy handmaid speak one word to my lord the king. And he said: Speak. And the woman said: Why hast thou thought such a thing against the people of God, and why hath the king spoken this word, to sin, and not bring home again his own exile? We all die, and like waters that return no more, we fall down into the earth: neither will God have a soul to perish, but recalleth, meaning that he that is cast off should not

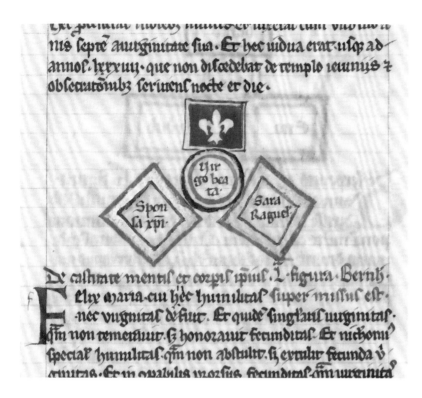

171. *Figura* 50: On the Chastity of Her Mind and Body. Berthold of Nuremberg, Liber de misteriis et laudibus intemerate Virginis genitricis Dei et Domini nostri Ihesu, Lake Constance region (?), 1292–94. FBG, Memb. I 80, f. 64r (detail). Photo: FBG.

altogether perish." The circle representing Mary, which, as the *tertium comparationis*, crowns the composition, consists of red, white, and blue rings; those representing Abigail and the woman of Thecua are green and purple (over green) and red and yellow respectively.

49. De devotione et oratione eius. .XLIX. figura. Bernardus super Missus est (Figure 170)

Bernard of Clairvaux, *Homiliae super "Missus est"*, homily 3, part 1.[131]

The three-part diagram compares the piety of the Virgin Mary (*virgo beata*), specifically her devotion and prayer, represented by the red circle at the crown of the composition, to that of Judith (*Iudith*) and the widow Anna (*Anna vidua*), the former represented by green circles laid over yellow, the latter by green and blue circles also laid over yellow. Three passages from the book of Judith exemplify her piety: "And she made herself a private chamber in the upper part of her house, in which she abode shut up with her maids. And she wore haircloth upon her loins, and fasted all the days of her life, except the sabbaths, and

new moons, and the feasts of the house of Israel" (Jth 8:5–6); "Judith went into her oratory: and putting on haircloth, laid ashes on her head: and falling down prostrate before the Lord, she cried to the Lord" (Jth 9:1); and "Nor from the beginning have the proud been acceptable to thee: but the prayer of the humble and the meek hath always pleased thee" (Jth 9:16). To these Old Testament testimonies are added one from Luke 2:36–37: "And there was one Anna, a prophetess, the daughter of Phanuel, of the tribe of Asher; she was far advanced in years, and had lived with her husband seven years from her virginity. And she was a widow until fourscore and four years; who departed not from the temple, by fastings and prayers serving night and day."

50. De castitate mentis et corporis ipsius. .L. figura. Bernardus super Missus est (Figure 171)

Bernard of Clairvaux, *Homiliae super "Missus est"*, homily 1, part 9.[132]

The diagram speaks to the chastity of Mary's mind as well as that of her body. Two green, white, and red lozenges representing, on the left,

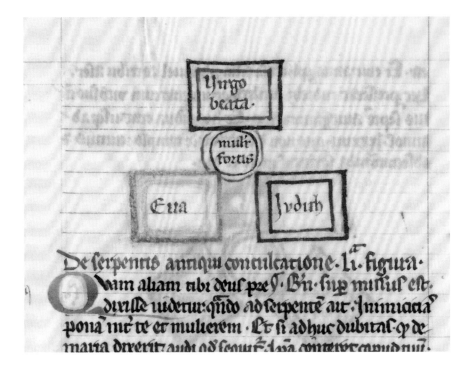

172. *Figura* 51: On the Treading of the Old Serpent. Berthold of Nuremberg, Liber de misteriis et laudibus intemerate Virginis genitricis Dei et Domini nostri Ihesu, Lake Constance region (?), 1292–94. FBG, Memb. I 80, f. 64v (detail). Photo: FBG.

the bride of Christ (*sponsa Christi*) and Sarah (*Sara Raguelis*) support a red, white, and green circle representing the Virgin Mary (*virgo beata*), atop of which perches a white lily within a blue rectangle framed in red, the symbol of her chastity. The bride of the Song of Songs is defined by a paraphrase of Song of Songs 4:1 ("How beautiful art thou, my love, how beautiful are thou. they eyes are doves' eyes"), followed by Song of Songs 2:2 ("As the lily among thorns, so is my love among the daughters," the direct source of the symbol in the image. To explicate Sarah, the commentary adduces Tobit 3:16–17: "Thou knowest, O Lord, that I never coveted a husband, and have kept my soul clean from all lust. Never have I joined myself with them that play: neither have I made myself partaker with them that walk in lightness."

51. De serpentis antiqui conculcatoine. .LI. figura. Bernardus super Missus est (Figure 172)

Bernard of Clairvaux, *Homiliae super "Missus est"*, homily 2, part 4.[133]

The central figure in the diagram, the green and red circle representing the "Mulier fortis" of Ec-

clesiasticus 26:2 ("A virtuous woman rejoiceth her husband: and shall fulfill the years of his life in peace," incorrectly identified as coming from Proverbs), stems not from the commentary per se but rather from Bernard of Clairvaux's homily, which bases itself in turn on the typological relationship between Eve, who trampled the head of the serpent (Gn 3:15: "I will put enmities between thee and the woman, and thy seed and her seed: she shall crush thy head, and thou shalt lie in wait for her heel") and the Virgin Mary. All three personages represented by rectangles, the Virgin Mary (*Virgo beata*) at the apex, and Eve (*Eva*) and Judith (*Iudith*) at the base, share in the "strong" or virtuous woman's strength, a process of participation suggested by the overlapping of the geometric forms. Eve's trampling of the serpent is compared with Judith's beheading of Holofernes (Jth 13:6): "And Judith stood before the bed praying with tears, and the motion of her lips in silence, saying: strengthen me, O Lord God of Israel, and in this hour look on the works of my hands, that as thou hast promised, thou may raise up Jerusalem thy city: and that I may bring to pass that which I have purposed, having a belief that it might be done by thee," to which are added three further passages: "Strengthen me, O Lord God, at this hour. And she struck

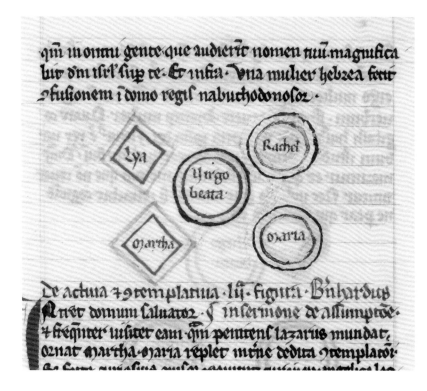

qm in omni gente que audierit nomen tuu. magnifica
bitur dm isrl sup te. Et infra. Vna mulier hebrea fecit
confusionem i domo regis nabuchodonosor.

Lya

Rachel

Virgo
beata.

Martha

Maria

De activa 7 9 templatiua. lij. figura. Bñhardus
in sermone de assumptoe.
+ frequnter usitet eam qm penitens lazarus mundat,
ornat martha maria replet mente dedita contemplatoi

173. *Figura* 52: On the Active and the Con-
templative. Berthold of Nuremberg, Liber
de misteriis et laudibus intemerate Virginis
genitricis Dei et Domini nostri Ihesu,
Lake Constance region (?), 1292–94. FBG,
Memb. I 80, f. 64v (detail). Photo: FBG.

twice upon his neck, and cut off his head" (Jth
13:9–10) and "Blessed art thou, O daughter, by
the Lord the most high God, above all women
upon the earth. Blessed be the Lord God who
made heaven and earth, who hath directed thee
to the cutting off the head of the prince of our
enemies. Because he hath so magnified thy name
this day, that thy praise shall not depart out the
mouth of men who shall be mindful of the power
of the Lord for ever" (Jth 13:23–25); "Blessed art
thou by thy God in every tabernacle of Jacob, for
in every nation which shall hear thy name, the
God of Israel shall be magnified on occasion of
thee" (Jth 3:31); and "One Hebrew woman hath
made confusion in the house of king Nabucho-
donosor" (Jth 14:16).

52. De activa et contemplativa. .LII. figura. Bernardus in sermone de assumptione (Figure 173)

Bernard of Clairvaux, *Sermones in assumptione beatae Mariae
Virginis*, sermon 2, part 7.[134]

Unlike Martha and Mary, the two sisters of
Lazarus, whose home was visited by Christ and
the disciples as related in Luke 10:38–42, the

Virgin was seen as exemplifying both the active
and the contemplative life. Mary's placement
at the center of the diagram reflects this duali-
ty, which was also a topos in Marian commen-
tary.[135] Rachel and Leah (Gn 29), the two daugh-
ters of Laban and both brides of Jacob, serve as
standard figures of the active and contemplative
lives. Here they are paired with their New Testa-
ment counterparts, Mary and Martha. Whereas
the figures representing the *vita activa*, on the
left, are shown as yellow and green lozenges,
those representing the *vita contemplativa*, on
the right, are shown in red and blue circles paint-
ed over white grounds applied rather sloppily to
the underlying parchment.

53. De dolore Virginis matris cura passionem Ihesu Christi. .LIII. figura. Anselmus in libro orationum (Figure 174)

Anselm of Canterbury, *Orationes sive meditationes*,
prayer 2.[136]

Berthold's fifty-third Marian diagram, on Mary's
grief at the Passion, extends the allegoresis of the
Temple veil still further by associating its four
colors with the four arms of the cross. A yellow

174. *Figura* 53: On the Suffering and Grief of the Virgin Mother during the Passion of Jesus Christ. Berthold of Nuremberg, Liber de misteriis et laudibus intemerate Virginis genitricis Dei et Domini nostri Ihesu, Lake Constance region (?), 1292–94. FBG, Memb. I 80, f. 65r (detail). Photo: FBG.

and red rectangle representing the Virgin (*virgo mater*) stands at the foot of a four-colored Greek cross with a clearly defined pedestal and flaring terminals. The arms of the cross are colored, respectively, blue, pointing up toward heaven, white on the right side, purple on the left side, and red at the base. Close examination reveals that originally the entire cross was red; the other colors are overpainted. To the left of the cross, a rectangle defined by two bands, the outermost green over yellow, the innermost blue over green, encloses the name of Naomi (*Noemi*); to the right the equivalent rectangle, whose outermost band is painted in white over yellow, the innermost green over pink, encloses the widow of Zarephath (*vidua sareptaa*), whose story provided a common type of the crucifixion.[137]

The commentary carefully defines the meaning of the four colors of the cross, correlating them with the position of its various members. The red of the base or lower portion stands for the splendor or glory of Christ's compassion. The white of the dexter side (to the viewer's left) stands for his innocence and piety. The purple of the sinister side (to the viewer's right) stands for the covenant of his love. Finally, the blue of the upper portion stands for the disclosure through Christ's death of celestial beauty. Two authorities

from the Old Testament are cited to buttress this allegorical reading of the cross, of which the first are the words of the Lord to Elias (1 Kgs 17:9–10, 12): "Arise, and go to Sarephta of the Sidonians, and dwell there: for I have commanded a widow woman there to feed thee. He arose and went to Sarephta. And when he was come to the gate of the city, he saw the widow woman gathering sticks. . . . Behold I am gathering two sticks that I may go in and dress it, for me and my son, that we may eat it, and die." This passage was usually thought to point to either the carrying of the cross or the crucifixion itself.[138] The second passage comes from the book of Ruth 1:20: "Call me not Noemi, (that is, beautiful), but call me Mara (that is, bitter), for the Almighty hath quite filled me with bitterness. I went out full, and the Lord hath brought me back empty. Why then do you call me Noemi, whom the Lord hath humbled and the Almighty hath afflicted?" The second passage, sometimes employed as a type for the deposition and lamentation, clearly is chosen to anticipate specifically the wine mixed with gall offered to Christ at the crucifixion, and the bitterness of the Passion as a whole, whose ugliness offers a contrast to the celestial beauty extolled as a property of the upward-pointing arm of the cross.[139]

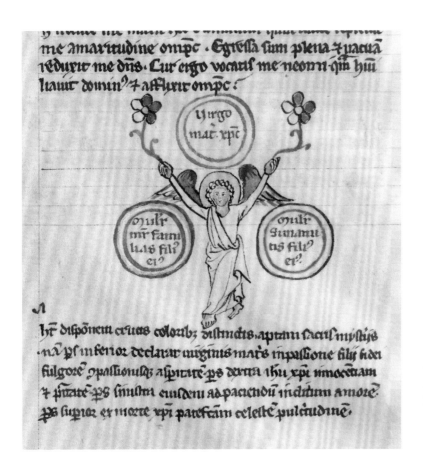

175. *Figura* 54: On the Joy of the Virgin Mother at the Resurrection of Christ. Berthold of Nuremberg, *Liber de misteriis et laudibus intemerate Virginis genitricis Dei et Domini nostri Ihesu*, Lake Constance region (?), 1292–94. FBG, Memb. I 80, f. 65r (detail). Photo: FBG.

54. De gaudio virginis matris ex Christi resurrectione. .LIIII. figura. Damascenus libro quarto (Figure 175)

John of Damascus, *De fide orthodoxa*.[140]

In contrast to the theme of grief, the subject of the prior diagram, the fifty-fourth in the series turns to Mary's joy at the resurrection. In the most dynamic diagram in the entire series, an angel with short outspread wings and flowering vines held in his upraised hands races toward the viewer to announce and express the resurrection. In rushing outward, the image places the reader in Mary's viewing position. For once, the commentary greatly exceeds in length the reading to which it is attached (in this case an excerpt from Burgundio of Pisa's translation of John of Damascus that encapsulates the Virgin's passage from sorrow to joy at the news of the resurrection). It begins with two passages gleaned from 1 and 2 Kings, both of which involve reanimated children returned to their mothers, the "mulier mater familias filius eius" represented by the red, white, and green circle on the left, and the "Mulier Sunamitis filius eius" represented by the circle on the right: "And the Lord heard the voice of Elias: and the soul of the child returned into him, and he revived. And Elias took the child, and brought him down from the upper chamber to the house below, and delivered him to his mother, and said to her: Behold thy son liveth" (1 Kgs 17:22–24); "Eliseus therefore went into the house, and behold the child lay dead on his bed. And going in he shut the door upon him, and upon the child, and prayer to the Lord) and the child gaped seven times, and opened his eyes. And he called Giezi, and said to him: Call this Sunamitess. And she being called, went in to him: and he said: Take thy son. And Eliseus returned to Galgal" (2 Kgs 4:32, 35–38). The resuscitation of the Sunamite's child provided a type of the resurrection as well as of various miracles performed by Christ.[141] The commentary follows with an explication of the flowers held by the angel. Quoting Psalm 27:7 ("And my flesh

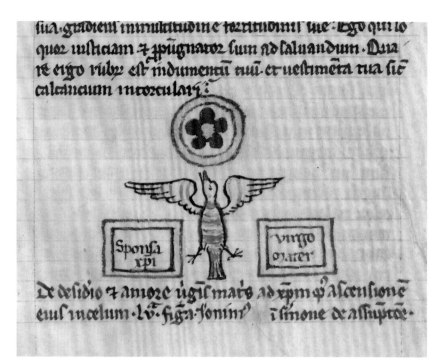

176. *Figura* 55: On the Desire and Love of the Virgin Mother at Christ's Second Ascension into Heaven. Berthold of Nuremberg, Liber de misteriis et laudibus intemerate Virginis genitricis Dei et Domini nostri Ihesu, Lake Constance region (?), 1292–94. FBG, Memb. I 80, f. 65r (detail). Photo: FBG.

hath flourished again, and with my will I will give praise to him"), the commentator notes that the multicolored green and white flower held in the angel's left hand expresses joy at the resurrection. In turn, the red and white coloration of the flower in the angel's right hand stands for the beauty of the resurrected Christ, as announced by the angel in Matthew 28:3: "And his countenance was as lightning, and his raiment as snow." A passage from Song of Songs 5:10 ("My beloved is white and ruddy, chosen out of thousands") reinforces the color symbolism, making clear that in this case the words from Matthew are taken to apply not to the angel, which is the literal sense, but rather to Christ himself.[142] In addition to underpinning Berthold's symbolic use of color, the excerpt from Song of Songs 5:10 ("My beloved is white and ruddy") served as an antiphon for the Feast of the Nativity of the Virgin (Can 002227). The commentary concludes with a passage from Isaiah 63:1 that, in part, provides the underpinnings of the popular allegory of Christ in the Winepress, a common typological figure of the Passion that was read on Wednesday of Holy Week: "Who is this that cometh from Edom, with dyed garments from Bosra, this beautiful one in his robe, walking in the greatness of his strength? I, that speak justice, and am a defender to save.

Why then is they apparel red, and thy garments like theirs that tread in the winepress?"[143]

55. De desiderio et amore Virginis matris ad Christum secundum ascensonem eius in celum. .LV. figura. Ieronimus in sermone de assumptione (Figure 176)

> Paschasius Radbertus, *De assumptione sanctae Mariae Virginis*.[144]

The theme of the diagram is Mary's desire and love for Christ following his ascension. The commentary identifies the flower at the top, which surrounds a yellow bud with red petals within a band shaded a greenish white and enclosed in blue concentric circles, as the flower of love. The spread-eagled dove whose entire body is covered with green and white bands, some touched with red, flies up toward the flower between the blue and red rectangles representing, respectively, the bride (*sponsa Christi*) and Mary (*virgo mater*). It further identifies as that of Song of Songs 2:9— "Thy cheeks are beautiful as the turtledove's, thy neck as jewels"—to which, using traditional paradisiacal symbolism signifying the passage beyond death to eternity, it adds Song of Songs 2:13: "The voice of the turtle is heard in our

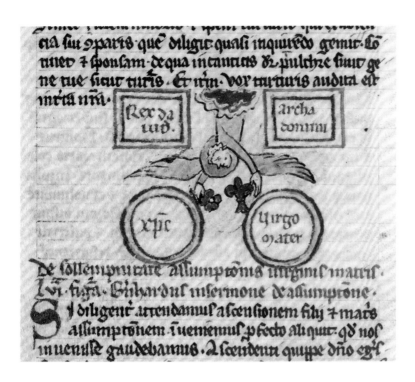

177. *Figura* 56: On the Solemnity of the Assumption of the Virgin Mother. Berthold of Nuremberg, Liber de misteriis et laudibus intemerate Virginis genitricis Dei et Domini nostri Ihesu, Lake Constance region (?), 1292–94. FBG, Memb. I 80, f. 65v (detail). Photo: FBG.

land." The two rectangles to either side of the dove employ a double frame consisting of blue and red over pink. The plumage of upward flying dove takes the form of green, yellow, and pink bands, touched with red.

56. De sollempnitate assumptionis Virginis matris. .LVI. figura. Bernardus in sermone de assumptione (Figure 177)

Ps.-Peter Damian, *In assumptione beatissimae Mariae Virginis*, sermon 40.[145]

The diagram both illustrates and explicates the assumption of the Virgin. At the center, an angel with outspread wings presents Christ and the Virgin, each represented by a blue, green, and red tricolor circle, with a red rose and a blue lily of the valley respectively (cf. Song of Songs 2:1: "I am the flower of the field, and the lily of the valleys"). According to the commentary, the angel represents the entire army of angels who jubilantly greeted the Virgin Mary in heaven following her assumption. The commentary identifies the following passage from the Song of Songs as coming from the Septuagint translation, but in fact it represents the First Nocturn for Matins of the Assumption.[146] The blue, green, and red rect-

angles at the top representing King David (*Rex David*) and the ark of the covenant (*archa Domini*) draw a parallel with David's joy at the arrival of the ark as recounted in 2 Kings 6:12–15:

And it was told kind David, that the Lord had blessed Obededom, and all that he had, because of the ark of God. So David went, and brought away the ark of God out of the house of Obededom into the city of David with joy. And there were with David seven choirs, and calves for victims. And when they that carried the ark of the Lord had gone six paces, he sacrificed an ox and a ram: And David danced with all his might before the Lord: and David was girded with a linen ephod. And David and all the house of Israel brought the ark of the covenant of the Lord with joyful shouting, and with the sound of trumpet.

David's joy at the arrival of the ark in Jerusalem served as a type for the coronation of the Virgin upon her assumption into heaven.[147] The set of typological relationships established by the commentary sees in David a type of Christ, and in the ark a type of the Virgin brought into Jerusalem, that is, heaven. Just as the ark contained the Old Law, Mary contained the New Law in the

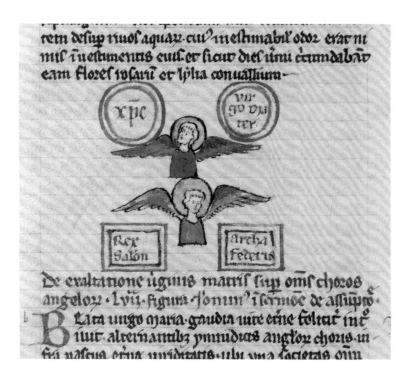

rem defup rruof aquay cuf mefhmabil odor erar m
mif fuefhmenrs cuif er ficur dief mui exmidabar
eam flozef rofani er lylia conuallmm·

xpc

vir
go ma
ter

Rex
Salon

archa
federis

De exaltatione uginis matrif fuy omif choros
angelou·Lvii·figura·fomm·i fermoe de affumpto·
Beata uigo maria·gaudia uure etne foliuf me
iuir· alternanublz ynmdicas anglox chorus m
fua nafcua erna mmidraris·ubi uua facieras oim

178. *Figura* 57: On the Exaltation
of the Virgin Mother above All
the Choirs of Angels. Berthold of
Nuremberg, Liber de misteriis
et laudibus intemerate Virginis
genitricis Dei et Domini nostri
Ihesu, Lake Constance region (?),
1292–94. FBG, Memb. I 80, f. 65v
(detail). Photo: FBG.

person of Christ. The commentary closes with a response for the Feast of the Assumption (Can 007878). The diagram shows evidence of extensive retouching; the angel has been repainted in its entirety over a white ground.

57. De exaltatione Virginis matris super omnis choros angelorum. .LVII. figura. Ieronimus in sermone de assumptione (Figure 178)

Paschasius Radbertus, *De assumptione sanctae Mariae Virginis.*[148]

The diagram expresses the exaltation of Mary above all the choirs of angels. Two bust-length angels with outstretched wings, the upper one colored purple, the lower one colored green, are superimposed between, at the top, two blue and green circles, representing Christ and the Virgin (*virgo mater*), and at the bottom two blue, green, and red rectangles representing Solomon (*rex Salomon*) and the ark of the covenant (*archa federis*). Taking up the argument of the previous diagram, the image essentially provides an image of supercession, as is elaborated in the commentary, attributed to Jerome, but in fact a series of excerpts from Pascasius Radbertus's treatise on the

assumption of the Virgin that served in the Dominican rite as the source for the lessons for the feast. The New Law, embodied by Christ as given birth by the Virgin, surpasses the Old Law, which was literally enclosed within the ark. Just as the seraphim (here distinguished not by the number of their wings but rather by the color purple) surpass the green cherubim within the heavenly hierarchy, so too Christ surpasses Solomon and Mary surpasses the ark. To drive the point home, the commentary quotes 1 Kings 8:1–2, 5–6, which relates how the ark was removed from Sion from Jerusalem and brought to Solomon:

Then all the ancients of Israel with the princes of the tribes, and the heads of the families of the children of Israel were assembled to king Solomon in Jerusalem. that they might carry the ark of the covenant of the Lord out of the city of David, that is, out of Zion. And all Israel assembled themselves to king Solomon on the festival day in the month of Ethanim, the same is the seventh month. . . . And king Solomon, and all the multitude of Israel that were assembled unto him went with him before the ark, and they sacrificed sheep and oxen that could not be counted or numbered. And the priests brought in the

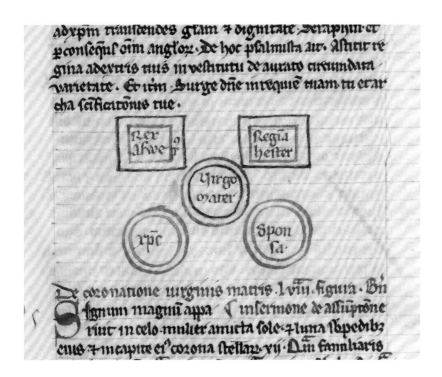

adxpm transcendes glam 7 dignitate seraphin et
pconsequs oim anglox. De hoc psalmista aut. Astitit re
gina adextris tuis in vestitutu de aurato circumdata
varietate. Et itm. Surge dne in requie tuam tu et ar
cha scificationis tue.

Rex
Ahwe

Regina
hester

Virgo
mater

xpc

Spon
sa.

De coronatione uirginis matris. Lviij. figura. Bn
signum magnum appa ¶ in sermone de assumptione
riuit in celo mulier amicta sole 7 luna sub pedibz
eius 7 in capite ei corona stellarum xij. Dm familiaris

179. *Figura* 58: On the Coronation of the Virgin Mother. Berthold of Nuremberg, Liber de misteriis et laudibus intemerate Virginis genitricis Dei et Domini nostri Ihesu, Lake Constance region (?), 1292–94. FBG, Memb. I 80, f. 65v. Photo: FBG.

ark of the covenant of the Lord unto its place, into the oracle of the temple, into the holy of holies under the wings of the cherubim.

Having defined the place and context of the cherubim in relation to the ark, the commentary moves on to Mary's place above even the seraphim by quoting the epithalamic Psalm 44:10, which here applies to Mary sitting at Christ's right side in heaven—"The queen stood at thy right hand, in gilded clothing; surrounded with variety"—and Psalm 131:8, "Arise, O Lord, into thy resting place; thou and the ark, which thou hast sanctified." The former psalm verse was applied in a similar fashion at the Offertory of the Mass for the Common of Virgins. The latter was frequently employed as a verse during the Easter season (Can 006069a).

58. De coronatione Virginis matris.
.LVII. figura. Bernardus. in sermone de assumptione (Figure 179)

Bernard of Clairvaux, *Sermo in dominica infra octavam assumptionis beatae Mariae*, part 6.[149]

The last and culminating event in the narrative sequence expressed in diagrammatic terms is the coronation of the Virgin. Each set of geometric figures framing the blue and red circle at the center representing the Virgin Mary (*virgo mater*) is paired with a biblical quotation explaining its presence. The first—the two red and blue rectangles representing Ahasuerus (*rex Ahuerus*) and Esther (*regina Hester*)—corresponds to a passage from Esther 2:16–17: "So she was brought to the chamber of king Assuerus in the tenth month, which is called Tebeth, in the seventh year of his reign. And the king loved her more than all the women, and she had favor and kindness before him above all the women, and he set the royal crown on her head." The marriage of Ahasuerus and Esther also served as a type of the coronation of the Virgin in the *Biblia Pauperum*.[150] Mary, in turn, is matched with Song of Songs 4:8: "Come from Libanus, my spouse, come from Libanus, come: thou shalt be crowned from the top of Amana, from top of Sanir and Hermon, from the dens of the lions, from the mountains of the leopards." As in the *Speculum humanae salvationis* (chapter 36), the woman clothed in the sun serves as a type of the coronation of the Virgin.[151] Song of Songs 4:8, which closes the commentary, found use as an antiphon at both the Feasts of the Nativity and of the Assumption (Can 005162).

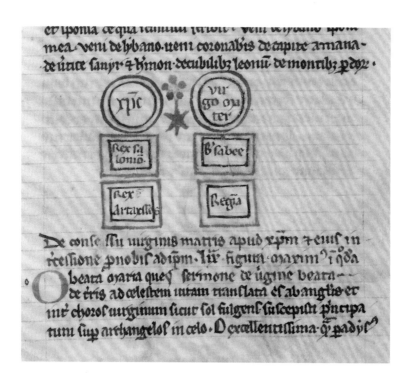

180. *Figura* 59: On the Avowal of the Virgin Mother by Christ and Her Intercession to Him for Us. Berthold of Nuremberg, Liber de misteriis et laudibus intemerate Virginis genitricis Dei et Domini nostri Ihesu, Lake Constance region (?), 1292–94. FBG, Memb. I 80, f. 66r (detail). Photo: FBG.

59. De confessu Virginis matris apud Christum et eius intercessione pro nobis ad ipsum. .LIX. figura. Maximus. In quodam sermone de Virgine beata (Figure 180)

Ildefonsus of Toledo, *Sermones*, *De assumptione beatae Mariae*, sermon 9.[152]

The diagram serves as a figure of the Virgin's intercession before Christ on behalf of humankind. The flower symbolism used throughout the series continues with a flower representing the mutual love of Christ and the Virgin as described in Song of Songs 7:10: "I am my beloved's, and his turning is towards me." The diagram illustrates this reciprocal affection by doubling the five-budded purple flower with a six-pointed green star immediately below it between blue, green, and red circles representing Christ and the Virgin (*virgo mater*) respectively. The heavenly couple are compared first to Solomon (*rex Salomon*) and Bathsheba (*Batsabee*). In connection with the first comparison, the commentary quotes 1 Kings 2:19–20: "Then Bethsabee came to king Solomon, to speak to him for Adonias: and the king arose to meet her, and bowed to her, and sat down upon his throne: and a throne was set for

the king's mother, and she sat on his right hand. And she said to him: I desire one small petition of the, do not put me to confusion. And the king said to her: My mother, ask: for I must not turn away thy face." There follows a lengthy passage from 2 Esdras 2:1–6 about the prophet Nehemiah's appeal to King Artaxerxes and his queen to return to the land of his father:

And it came to pass in the month of Nisan, in the twentieth year of Artaxerxes the king: that wine was before him, and I took up the wine, and gave it to the king: and I was as one languishing away before his face. And the king said to me: Why is thy countenance sad, seeing thou dost not appear to be sick? This is not without cause, but some evil, I know not what, is in thy heart. And I was seized with an exceeding great fear. And I said to the king: O king, live for ever: why should not my countenance be sorrowful, seeing the city of the place of the sepulchres of my fathers is desolate, and the gates thereof are burnt with fire? Then the kings said to me: For what dost thou make request? And I prayed to the God of heaven. And I said to the king: If it seem good to the king, and if thy servant hath found favor

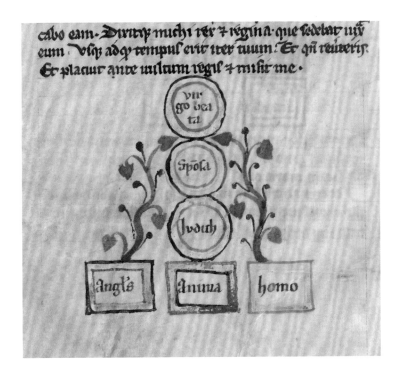

181. *Figura* 60: On the Reverence of All Creatures in Heaven, on Earth, and in Hell for the Virgin Mother and Our Lord Jesus Christ. Berthold of Nuremberg, Liber de misteriis et laudibus intemerate Virginis genitricis Dei et Domini nostri Ihesu, Lake Constance region (?), 1292–94. FBG, Memb. I 80, f. 66r (detail). Photo: FBG.

in thy sight, that thou wouldst send me into Judea to the city of the sepulchre of my father, and I will build it. And the king said to me, and the queen that sat by him: For how long shall thy journey be, and when will thou return? And it pleased the king, and he sent me.

Both pairs of Old Testament kings and queens are represented schematically by pairs of rectangles—the upper pair, for Solomon and Bathsheba, green over yellow and red; the lower pair, for Artaxerxes (*Artaxsses*) and his unnamed queen (*regina*), green and red.

60. De respectu omnis creature celestium terrestrium et infernorum ad Virginem matrem et eius perpetua memoria et laude. .LX. figura. Bernardus in sermone de Spiriti Sancto (Figure 181)

> Bernard of Clairvaux, *Sermones in die pentecostes*, sermon 2, part 4.[153]

The diagram, which speaks to Mary's adoration by all creatures, can only be understood in light of the excerpts from Bernard of Clairvaux's sermon for the second Sunday in Pentecost, which provided lessons for the Dominican lectionary. The excerpts from the sermon open by defining the Virgin's womb as the center of the earth ("terrae medium"). As Bernard explains, "Those in heaven look to her to be restored; those in hell to be delivered. Those who have gone before us [look to her] that the prophets may be found worthy of belief; those who follow us that they may win glory." In the diagram, the bride of the Song of Songs and Judith represent "those who have gone before us" as well as the "prophets." Three rectangles forming a baseline in turn represent heaven (*angelus ratione celestium*, labeled *angelus*), drawn in red, white, and blue, corresponding with those who, according to Bernard, look to the Virgin for restoration; hell (*anima ratione infernorum*, labeled *anima*), drawn in green, white, and red, corresponding with those who, again according to Bernard, plead with her for forgiveness; and the earth (*homo ratione terrestrium*, labeled *homo*), drawn in green, white, and yellow, corresponding with those who finally, according to the Cistercian father, will follow in seeking glory. Two green vines sprouting red buds spring from the boxes representing the celestial and terrestrial realms reach up toward the circle representing the Virgin, a symbolic repre-

sentation of the praises and prayers offered by both groups.

Rather than placing the Virgin at the center, the diagram underscores her preeminence by placing the red, white, and green circles that represents her (*virgo beata*) at its apex. Immediately below stand her typological counterparts: the bride (*sponsa*) and Judith (*Iudith*), both in identical circles. Complementing the circle representing Judith, the commentary quotes Judith 15:9:

> And Joachim the high priest came from Jerusalem to Bethulia with all his ancients to see Judith. And when she was come out to him, they all blessed her with one voice, saying: Thou art the glory of Jerusalem, thou art the joy of Israel, thou art the honour of our people: For thou hast done manfully, and thy heart has been strengthened, because thou hast loved chastity, and after thy husband hast not known any other: therefore also the hand of the Lord hath strengthened thee, and therefore thou shalt be blessed for ever. And all the people said: So be it, so be it.

The Bride's presence is elaborated in turn by Song of Songs 6:8, which also provided an antiphon for the Feast of the Assumption (Can 005396): "The daughters saw her, and declared her most blessed: the queens and concubines, and they praised her." To these testimonies are added three passages from Ecclesiasticus 24 that had a fixed place in Marian exegesis:[154] "I made that in the heavens there should rise light that never faileth, and as a cloud I covered all the earth, I dwelt in the highest places, and my throne is in a pillar of cloud. I alone have compassed the circuit of heaven, and have penetrated into the bottom of the deep, and have walked in the waves of the sea, And have stood in all the earth: and in every people, and in every nation I have had the chief rule: And by my power I have trodden under my feet the hearts of all the high and low. . . . Come over to me all ye that desire me, and be filled with my fruits . . . unto everlasting generations. . . . They that explain me shall have life everlasting." (24:6–11, 26, 31). The last

verse should surely be taken as a self-conscious reference on the part of the compiler, Berthold, to his own activity, and leads directly to the final section of the commentary, which constitutes a prayer to the Virgin on his own behalf.[155]

Epithets and Emblems

Berthold's Marian compendium is essentially sui generis.[156] It is therefore difficult to contextualize. In its combination of words and diagrammatic images accompanied if not directly explained by a short text, Berthold's method could loosely be characterized as emblematic.[157] One need not insist on a precise comparison to the emblem in its classic form as it emerged in the sixteenth century, which usually, if not always, consisted of a tripartite composition consisting of a motto (*inscriptio*), an image (*pictura*), and an epigram (*subscriptio*). Emblems often stood for concepts, but more important than their meaning in many respects was the interplay among the their parts, which required a process of puzzling out on the reader's part. Berthold's image-text units works in much the same way. First, an enigmatic image (in the form of a diagram, often with strong figural underpinnings) integrates a few terms defining key personages whose relationships in turn stand for or are elaborated in terms of concepts. This word-image complex then is followed by a passage from an authority, to which in turn is appended a brief commentary. Whereas in some cases Berthold transforms a metaphor into a figural motif, in other cases, objects are translated into diagrams or at least figures made up of geometrical components disposed in a diagrammatic manner.

Although focused on the Virgin Mary, Berthold's *Liber de misteriis et laudibus intemerate Virginis Marie genitricis Dei et Domini nostri Ihesu Christi*, to use its full title, is not a theological summa. Theological issues revolving around the Virgin—for example, her precise role in the incarnation or her status as co-redemptrix—are not directly treated. Nor are authorities gathered in any systematic fashion around particular issues or ideas. One work that provides a useful point of comparison, and not only on account of

its title, is Richard de Saint-Laurent's *De laudib-us beatæ viriginis libri XII*, which also circulated under the name *Mariale*.[158] Already in Berthold's day, Richard's work—the largest compendium of Marian epithets from the Middle Ages—circulated under the name of the Dominican Albertus Magnus. One early copy (Paris, BnF, ms. lat. 3173) had belonged to Hugh of Saint-Cher (ca. 1200–63), the Dominican theologian, cardinal, and prolific biblical commentator.[159] One of two illuminated copies of this very popular work prefaces each of the twelve chapters plus the preface with an elegant initial, of which the first, for the preface, shows the Virgin appearing in a vision to Albertus Magnus, who also appears in three of the other illustrations (bks. 4, 8, and 9; fig. 182).[160] The initial follows the text in casting the Dominican's inspiration on the model of that of John the Evangelist in the Apocalypse.

A recapitulation of the contents of Richard's Marian *summa* serves to give a sense of its range.[161] Book 1 is devoted to the angelic salutation (the *Ave Maria*), and book 2 to Mary's willingness to serve with all her senses and all the parts of her body as a vehicle of salvation. Book 3 proceeds to her twelve privileges (corresponding to the twelve stars in the crown of the Apocalyptic Woman; fig. 183). Book 4 attends to her virtues; 5 to her beauty; and 6 to her names (*mater, amica, soror, charissima, filia, sponsa, uxor, vidua, mulier bona, virgo, virago, princeps, regina*), some of which are inscribed in gold within the corresponding initial (fig. 184). Book 7 catalogs Mary's celestial and astral epithets (*caelum, firmamentum, sol, luna, horizon, lucifer, aurora, diluculum, mane, lux, dies, nubes*), and book 8 her terrestrial names (*terra, area, campus, ager, mons, collis, desertum, petra*).[162] Berthold's diagrams with astrological content consistently place Mary in her role as intercessor between heaven and earth. Book 9 of Richard's work turns to imagery of water and, in particular, all the receptacles to which she can be compared (twenty-one in all). Expanding the theme of enclosure (both Mary within closed spaces and enclosing the Christ Child within her), book 10 takes up buildings and other structures (of which the first and most important is the ark, the sec-

182. Virgin Appearing to the Author. Richard of Saint-Laurent, De laudibus beatae Mariae virginis, Paris, ca. 1275. Wellesley, Wellesley College, Special Collections, MS 19, f. 1r (detail). Photo: James H. Marrow.

ond a throne, followed by twenty-nine others; fig. 185). In cataloging images that liken Mary to military defenses and ships, the first being the City of God, book 11 turns to the theme of Mary as an embodiment of the Church Militant. Book 12, the concluding section, explores the ramifications of one sole image, the *hortus conclusus* from the Song of Songs and its aromatic trees and plants.[163]

In the first of his two prologues, Richard compares the process by which he compiled the work to that of collecting honey and wax.[164] The bulk of the massive work consists of a tissue of scriptural citations interlaced with paraphrases that double as commentary by revealing the allegorical sense of the literal quotation, combined with brief passages culled from a predictable range of patristic and monastic authorities, of whom his favorite is Bernard of Clairvaux. In

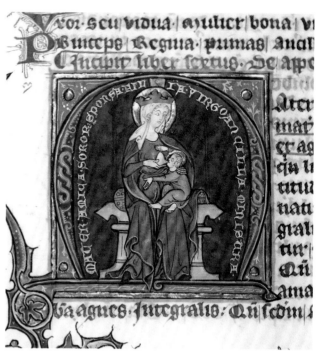

183. Apocalyptic Woman. Richard of Saint-Laurent, De laudibus beatae Mariae virginis, Paris, ca. 1275. Wellesley, Wellesley College, Special Collections, MS 19, f. 90v (detail). Photo: James H. Marrow.

184. Names of Mary. Richard of Saint-Laurent, De laudibus beatae Mariae virginis, Paris, ca. 1275. Wellesley, Wellesley College, Special Collections, MS 19, f. 192r (detail). Photo: James H. Marrow.

sum, the work offers a mix of theological, exegetical, and devotional material. Despite the work's length, it is written in a kind of scholastic shorthand demanding a more fluid expansion. It is less a work of literature than a reference work that aims to provide the makings of other texts. Of these, the most important would have been sermons.

Fully half of the sixty passages selected to stand in as commentary in Berthold's Marian compilation are labeled in their rubrics as *sermo*. *Sermo*, of course, simply means speech and in this context may simply refer to readings from the lectionary, although in this case the excerpts actually come from homiletic texts. Berthold's commentary, however, is unlikely to have served the production of yet more sermons, although it was written by a Dominican preacher. Berthold may well have borrowed his title from his predecessor, but the genuinely Dominican work is too idiosyncratic in character, if not in content, to have served as a sermon aid. Its contents, moreover, would not have been appropriate for the contemporary manner of composing sermons,

which, rather than commenting closely on the Gospel reading for the day verse by verse, departed from what was known as the *thema*. The *thema*, which consisted of no more than a single verse usually taken from the liturgical readings for a given feast, was then developed in a highly structured manner to produce a text whose divisions and subdivisions the Dominican Jacobus de Fusignano famously compared to the branching of a tree ("predicare est arborisare").[165] For this purpose a set of aids including biblical distinctions and exempla collections would have been among the standard tools. Berthold's *De laudibus* would have been of no help whatsoever.[166]

Berthold's book is not a preaching manual or even an aid to preaching, but rather an aid to meditation. But this is not to say that it is geared toward what is problematically called "private devotion."[167] The work finds its place within the context of the communally celebrated liturgy of the Divine Office. Berthold's commentary resembles a lectionary—specifically in the way he strings substantial and successive excerpts of established authorities into a series of readings.

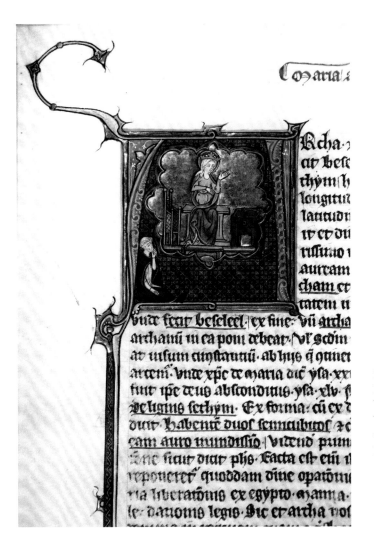

185. Mary as the Ark of the Covenant. Richard of Saint-Laurent, *De laudibus beatae Mariae virginis*, Paris, ca. 1275. Wellesley, Wellesley College, Special Collections, MS 19, f. 264r (detail). Photo: James H. Marrow.

Some of them in fact come from the Dominican lectionary, drawing not just on the same sources but on precisely the same excerpts, indicating that the lessons, not the primary texts, were his point of reference.

Berthold's meditational method revels in a torrent of Marian epithets. A homily for the Feast of the Annunciation by Peter of Celle (ca. 1115–83), bishop of Chartres, hails the Virgin Mary in a firework of images taken from the Song of Songs, the core text of the Marian liturgy:

O, Mary, behold, he filled your empty perfume jars! Behold, your vessels are full of the purest wine! Behold, your chests are filled with exceedingly fine garments! Behold, in your ark is the living bread which descended from heaven! Behold, your bed is flowering! Behold, your house of cedar wood and cypress coffers, of columns carrying four walls: Prudence, Fortitude, Justice, and Temperance! Behold the prepared throne of Wisdom, which teaches what to do and what not to do![168]

No less important than the epithets themselves and their parenthetical moralization is the repeated injunction to see. Rooted in *lectio divina*, the homily represents an invitation to a seeing with the inner eye of the sort that was integral to monastic meditation and contemplation (which, in fact, in its root sense means to see or to behold).

Berthold's commentary resonates with liturgical practice in other ways as well. Hymns to the Virgin had been established in liturgical celebrations from as early as the eighth century and

no doubt even earlier. The vast corpus of hymns devoted to Mary kept pace with the growth of her cult from the late eleventh century, reaching an apogee in the thirteenth century, when Latin hymnody spilled over into various vernaculars.[169] In their content, hymns both matched and helped drive developments in Marian theology. Liturgical songs in honor of the Virgin often proceed by piling one typological allusion on top of another. One hymn casts Mary as the *stella maris* (see *figura* 19), the Tree of Jesse (*figura* 12), Gideon's fleece (*figura* 8), the stone of Daniel (*figura* 15), and light as a metaphor for the incarnation (*figura* 34).[170] Another likens the Virgin to the ark of Noah (*figura* 27), a throne (*figura* 10), the Tree of Jesse (*figura* 12), the star of Jacob (*figura* 19), various Old Testament heroines (Esther, *figurae* 44 and 57; Sarah, *figurae* 33 and 50; Judith, *figura* 49), and the rivers of paradise (*figura* 22).[171]

The florid epithets attached to the Virgin also lent themselves to elaboration in sequences, the chants performed after the Alleluia in the mass (hence their name).[172] The sequence "Salve mater salvatoris," which was written by Adam of St. Victor for the Feast of the Birth of the Virgin and was adopted by the Dominicans as part of their standard set of sequences, characterizes Mary successively as a vessel, rose without thorns, closed gate, fountain in the garden, unguent jar, flower of the field, lily of the valley, celestial paradise, the throne of Solomon, pure white ivory and gold, a palm tree, the sun, moon, and stars, and a shield.[173] In the context of such compositions, Berthold's Marian compilation can be characterized as a hymnodic rhapsody in prose of which each section, and hence each diagram, encapsulates a single pregnant epithet paired with an Old Testament episode (or episodes) interpreted in typological terms. Since many of the epithets themselves are taken from the Wisdom books of the Old Testament, his method is not only ingenious but fitting. Despite outward appearances, Berthold's work is less scholastic or even didactic than it is poetic. Liturgical poetry does not serve as a source per se; rather, it testifies to similar habits of mind. The point was praise rooted in the language of the Bible and endlessly elaborated to suggest a plenitude of meaning and ultimately of divine grace. Berthold's diagrams can be understood in similar terms: a fixed number of elements recombined in a series of recursive patterns designed to instruct and delight his readers and to provide them with material for meditation.

5

Typological Logic

Taking Truth's Measure

The ties linking theology, exegesis, and geometry are as old as Christianity itself. If one includes the Platonic tradition, which retained a place of critical importance within theological discourse throughout the Middle Ages, then their association is more ancient still.[1] It is also ambiguous. According to a legend attested no earlier than the sixth century CE—that is, approximately a millennium after Plato's lifetime—the inscription above the door to his Academy read "Let no one ignorant of geometry enter here."[2] In the *Meno* episode involving the slave boy (80d1–86d2), Plato employs a geometrical problem to introduce the concept of *anamnesis* (knowledge as recollection). Using a diagram, Socrates interrogates Meno's slave, whose status precludes his receiving a name, concerning the proportions of the square in order to prove that the boy is able to understand geometrical problems not on the basis of any teaching but purely on the basis of recollection. Socrates concludes: "If the truth of all things always existed in the soul, then the soul is immortal. Wherefore be of good cheer, and try to recollect what you do not know, or rather what you do not remember." In the experiment that Plato describes, diagrams function as tools for thinking in concrete spatial terms.[3] In the *Republic* (509d–IIe), however, Socrates argues that diagrams, as visual images, are a means, not an end: dialectic, the highest human science, is superior in that, unlike geometry, it does not rely on visible images (including those that can be imagined), rising instead

to intelligible objects—that is, the transcendent Forms.[4] Already at the beginning of a long tradition, the stage is set for a contentious debate about the relative merits and truth value of visual versus verbal representations.

In the twelfth century the *Meno* was translated into Latin by Henricus Aristippus of Calabria, but like virtually the entire Platonic corpus, it remained essentially unknown to medieval thinkers, who had access only to the *Timaeus* in the translations, first, of Cicero and later, in the fourth century, of Calcidius.[5] In this idiosyncratic work of cosmology, regarded nonetheless in the Middle Ages as representative of his thought, Plato argued that everything in the universe could be analyzed in terms of five shapes, four of which corresponded to the four elements, with the fifth matching the universe as a whole.[6] Diagrams accompanied by marginal glosses occasionally were added to those portions of the text dealing with arithmetic, geometry, music, astronomy, and logic.[7] In his short treatise *De ordine* (2.15.42), Augustine, writing about geometry as part of a program of the liberal arts that lead the mind to God, reflects this Neoplatonic view:

> Reason stepped out onto the domain of
> the eyes. Surveying the earth and the heavens,
> it found that nothing but beauty pleased it:
> within beauty forms, within forms, propor-
> tion, within proportion number. It asked itself
> where in the real world this or that straight,
> curved, or other lines as conceived by the intel-
> ligence might be. It found reality far inferior.
> Nothing real stood comparison with what the
> mind could see. It analyzed these forms one by
> one and arranged them into a discipline which
> it called *geometry*.[8]

Augustine describes a process by which the intelligible enters into and informs the sensible world, which then, in turn, can serve as a ladder leading back to invisible truths.[9] Among images, diagrams seem uniquely suited to mediating between the two realms. Not only are they hybrid in form, combining words and images; they also

chart a middle ground between the visible and the invisible, serving as "intermediary objects between the sensible and intelligible."[10] As representations of rational thoughts, they fall short of the Forms; yet they serve to represent those Forms in sensible terms.

Tools and Tokens: Playing with Berthold's Diagrams

Despite a strong Neoplatonic current in Dominican thought around 1300, Berthold's writings shows no signs of his having been a Neoplatonist.[11] Like Plato, however, he uses a series of simple shapes—in his case two- rather than three-dimensional—to describe a Christian cosmos that reveals its truth over time through salvation history. Cosmological diagrams accompanying a supplement to the *Institutiones* of Cassiodorus adopt a similar strategy. Each of the four elements—earth, fire, air, and water—is assigned a different geometrical shape, in the manner of tokens that in turn can be manipulated (fig. 186).[12] In the upper part of the image, the four elements are interconnected by means of a syzygy diagram. In the lower portion, the three-dimensional solids matching each of the elements are reduced to planar figures: earth, a rectangle (*cybos*: cube), fire, a triangle (*pyramis*: pyramid), air, a circle (*sphera*: sphere), and water, a rectangle defined by wavy lines (*icosehedron*: a polyhedron with twenty faces). From these basic constituents, everything in the cosmos can be assembled.

Taken singly, Berthold's diagrams are simple. As a series, however, they become considerably more complex. Their components function in part as mnemonic tokens. Given a certain repetitiveness and duplication among them, however, they can be likened more persuasively to pieces on a game board. As the pieces are moved around, the players think about them in relation to one another according to certain sets of rules. As in Berthold's series, a temporal as well as a spatial element is at play: at stake is not just the matrix of pieces that presents itself at any given moment but also what has happened

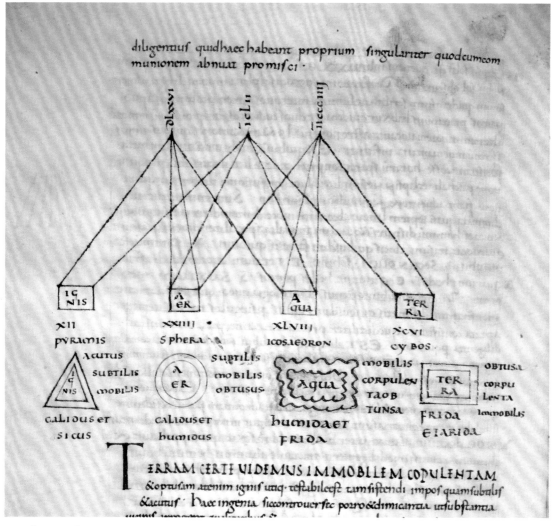

186. The Four Elements. Treatise on the elements, miscellany (Cassiodorus, Augustine), northeastern France, tenth century (belonged to Reichenau). Karlsruhe, Badische Landesbibliothek, Ms. Aug. perg. 106, f. 43v. Photo: BLB.

and what might happen next. Games involving sets of pieces whose interactions are governed by a particular set of rules effectively resemble diagrams in motion. As in a diagram, process—the process by which a given configuration is generated and that by which it is read or acted upon—performs a constitutive role. The manipulation of the parts, whether the pieces of the game or the components of the diagram, rather than some process performed on the object, in fact constitutes the object, just as the operations of a machine form part and parcel of what it is. Indeed, in the age of computers the operations performed by machines are, as in a diagram, as much mental as they are physical.

The comparison of Berthold's diagrams, singly and serially, to a board game is neither idle nor ahistorical. Just as in the present diagrams play a central role in game theory (of the analytical, strategic sort), so too in the Middle Ages, diagrams were linked to games that were intended to be edifying as well as entertaining. No less a figure than the cardinal Nicholas of Cusa himself invented a peculiar bowling game, which he characterizes as a "speculationis figuratio" (a figure of but also for speculation in that the game represents less an actual sport than an object of meditation and philosophical conjecture) and which he allegorizes at great length in his treatise *De ludo globi*.[13] Played on a circular field

with nine concentric circles corresponding to the nine orders of angels, the game is said to require a ball scooped out on one side, which causes it to spiral inward toward the center. Whereas the ball and its vicissitudes represent the path of the soul, the center, itself providing the tenth element or Pythagorean decad that comprises all the other numbers, represents Christ, who, in keeping with the old adage, is the circle whose circumference is nowhere and whose center is everwhere.[14]

The Constantinian poet Optatian, an important source for Hrabanus Maurus, invites a comparison of his gridded poems with the grid of a gameboard, stating in *Carmen* 2.1: "I, Publilius Optatianus Porfyrius, have played these things" ("Publius Optatianus Porfyrius haec lusi").[15] There survives at least one medieval example of a *carmen figuratum* figured after a board game, Mühle, otherwise known as Merrils or Nine Men's Morris (fig. 187). The poem *Metrum* XXVII in the *Liber de distinccione metrorum* by Iacobus Nicholai de Dacia (Denmark) forms part of a series commissioned in 1363 by Mary de Sancto Paulo (Marie de St. Pol), duchess of Pembroke, best known as the founder of

187. Metrum XXVII. Iacobus Nicholai de Dacia, Liber de distinccione metrorum, Cambridge (?), 1363. London, British Library, Cotton MS. Claudius A.XIV, f. 21r. Photo: © British Library Board.

Pembroke College, Cambridge.[16] Like the other poems in the series, the one based on a board game deals with death, most particularly that of her husband, Aymer de Valences, duke of Pembroke, who had passed away in 1324. The poem consists of four strophes, the first three constituted successively by the verses making up the three squares, one set inside the other (identified as the outermost, median, and smallest squares), that mark the paths along which the game pieces can move, the fourth and final strophe by the words, all beginning with the letter *M* (as a small illuminated initial), that join the three squares to one another.[17] In these poems, as in other *carmina figurata*, words constitute the structure of the diagram and lend themselves to combinatory readings, in this instance, given the subject matter, less playful than mournful.

The circles, squares, and triangles that constitute the building blocks of Berthold's diagrams specifically bring to mind an instructional board game known as Rithmomachy (De pugna numerorum, or the Battle of the Numbers). The game's origins can be traced to the monastic schools of the eleventh century.[18] The rules of this Ludus philosophorum, or Philosopher's Game, were first recorded by the monk "Asilo," probably to be identified as Adelbero, bishop of Würzburg (ca. 1010–90), and Hermannus Contractus (1013–54), a monk of Reichenau. In each case the author presumes knowledge of Boethius's *De institutione arithmetica*.[19] By inculcating Boethian principles, both mathematical and moral, the game sought to instruct its players as well as to entertain them.[20] In addition to providing a virtuous leisure activity, the game gave access to Wisdom in the form of the rules of numbers that governed creation.[21] So central to the game was the conception of devout didacticism that it numbers among the permitted pastimes of the inhabitants of Thomas More's *Utopia*, where "they know nothing about gambling with dice, or other such foolish and ruinous games." Rather, Utopia's inhabitants "play two games not unlike chess." Of these, "one is a battle of numbers [i.e. Rithmomachy], in which one number captures another."[22]

The board on which rithmomachy was played is recorded in—what else?—a diagram (fig. 188) included in a mid-twelfth-century composite collection of scientific texts from Normandy, perhaps Mont-Saint-Michel or Coutances, in which it follows a brief text on the topic by Odo of Tournai (1060–1113).[23] An early modern diagram from a printed treatise on the game is both easier to read and locates the game pieces of various shapes and numerical values in their positions prior to the start of play (fig. 189). At first blush it might seem odd that within the twelfth-century compendium an explanation of monastic pastimes keeps company with texts covering the *quadrivium* (arithmetic, geometry, music, and astronomy), as well as practical applications in areas as varied as geography, surveying, metrology, alchemy, and organ building (some profusely illustrated with diagrams)—in short, a combination of the liberal and mechanical arts. Among the authors included are Ptolemy, Martianus Capella, and Albumasar.[24] The rules of the game, however, make plain the rationale for its inclusion.

Played on a board eight squares wide and sixteen long, the game pitted odd versus even numbers, a topic central to Boethius's treatise and demonstrated by the most ambitious of its explanatory diagrams (see fig. 17). Numerical relationships based on multiplication are visualized within rows and columns (which Boethius defines as the diagram's "latitude" and "longitude"). The game pieces took the form of Boethian solids: rounds, triangles, squares, and pyramids (the latter composite pieces made by stacking several others atop one another). The three so-called proper types of victory were attained by achieving certain "harmonies" of pieces corresponding to three types of numerical proportion or progression, arithmetic, geometric, and harmonic. In order to win, players had to carry out a specific set of mathematical operations.

Students acquainted with such pedagogic and mnemonic tools would have found the visual repertory of Berthold's diagrams readily recognizable. In Berthold's case there are no rules, other than those dictated by doctrine (and in

188. Rythmomachy Diagram. Composite collection of scientific texts, Normandy, perhaps Mont-Saint-Michel or Coutances, mid-twelfth century. Avranches, Bibliothèque municipale, ms. 235, f. 77v. Photo: Bmun.

this context, it should be stressed that the rules of rithmomachy were themselves not entirely codified). The "pieces," however, still serve as tokens and markers of memory and meditation.[25] Having mastered Berthold's visual language, his students can proceed to generate exegetical patterns and theological harmonies of their own. If in the case of rithmomachy the rules were derived from Boethius, in the case of Berthold's diagrams they were descended, first, from the protocols that governed typological exegesis and, second, as will be explored later in this chapter,

from the liberal art of logic, which as a master method remained as central to the scholastic as to the monastic curriculum.

Tracing the Invisible: Diagramming Doctrine

As much as any proof text, medieval diagrams served as demonstrations. Diagrams were useful, even essential, yet texts that justify their use them remain as rare as any such sources from the period. All rely on two related topoi, first,

189. Rythmomachy Game
Board. Jordanus Nemorarius,
Arithmetica decem libris
demonstrata, Musica libri
demonstrata quator, Epitome
in Libros arithmeticos diui
Seuerini Boetij, Rithmi-
machie ludus qui et pugna
numerorum appellatur, Paris,
in oficina Henrici Stephani,
1514. Photo: Charles Babbage
Institute, Tomash Collection.

that sight is superior to hearing, and second, that vision can provide access to the invisible. Whereas the first justification is essentially practical, the second is philosophical. In "The Marriage of Philology and Mercury," a treatise on the seven liberal arts that became a handbook on the topic, the early fifth-century author Martianus Capella describes the personifications of Philosophy and Paedia carrying "an abacus board, a device for delineating figures; upon it the straightness of lines, the curves of circles, and the angles of triangles are drawn. The board can represent the entire circumference and the circles of the universe, the shapes of the elements, and the very depths of the earth; you will see there represented anything you could not explain in words."[26] Even in this practically oriented passage, the philosophical dimension enters in: the abacus aids in explanation, but what it enables is an understanding of cosmology. Also writing in the early fifth century, Macrobius (1.21.3) underscores the practicality of diagrams, observing that "since our eyes often open the way to the understanding of a problem, it would be well to

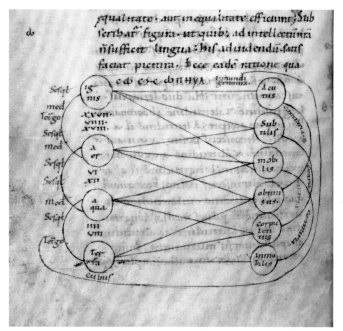

190. Syzygy Diagram. Adalbold of Utrecht, commentary on Boethius, Consolatio philosophiae, northern France, tenth century. Paris, Bibliothèque nationale de France, ms. lat 7361, f. 51v (detail). Photo: BnF.

191. Porphyrean Tree. Adalbold of Utrecht, commentary on Boethius, Consolatio philosophiae, northern France, tenth century. Paris, Bibliothèque nationale de France, ms. lat 7361, f. 46v (detail). Photo: BnF.

draw a diagram" (in this case of the zodiac).[27] After precise instructions for drawing the necessary diagram are given, nearly the entirety of what remains of the chapter (1.21.3–28) addresses an issue that "the diligent inquirer will find . . . needs explaining. After noting the marks on the zodiac that were used to assist in the demonstration, he will say: 'Who ever discovered or established twelve divisions in the sky when there are no demarcations for any of them apparent to our eyes?' "[28] The answer, in brief, is the Egyptians. What matters, however, is that Macrobius makes explicit the role of diagrams in charting the invisible, "the evidence of things not seen," in the words of the writer of Hebrews (11:1), even if here they are applied to scientific or moralizing, not religious, subject matter.

The use of diagrams in navigating the passage from what can to what cannot be seen recurs in commentaries on Boethius's *The Consolation of Philosophy*. Boethius's jail ballad provided the Middle Ages with its most important example of *opus geminatum*, the genre combining poetry and prose to which Hrabanus's *In honorem* belonged. In his commentary on Boethius' text, Adalbold, bishop of Utrecht from 1010 to 1026, supplements his introduction to a syzygy diagram of the elements with an element of elevation: "Because our language does not suffice to convey these things to the intellect, it suffices for the figure written below to be seen"[29] (fig. 190). Diagrams, he suggests, are particularly appropriate to the representation of concepts. The same manuscript places a Porphy-

rean Tree, which distinguished genera and species, opposite the opening of book 3, metrum 9, a touchstone of cosmological thought throughout the Middle Ages: "O God, Maker of heaven and earth, Who governs the world with eternal reason, at your command time passes from the beginning. . . . It was the form of the highest good, existing within You without envy, which caused You to fashion all things according to the eternal exemplar. You who are most beautiful produce the beautiful world from your divine mind and, forming it in your image, You order the perfect parts in a perfect whole"[30] (fig. 191). The diagram represents a comparable imposition of order on the natural world.

The philosopher and cosmologist William of Conches (ca. 1090–after 1154) also accompanied his diagrams, in particular a map of the world, with instructions insisting on the utility of diagrams, arguing that "because it is easier to store in our minds what we see before us, let us draw what we have been speaking about in a diagram."[31] In making such comments, medieval authors echoed Aristotle's De anima (431a16–17), later quoted by Thomas Aquinas: "Nihil potest homo intelligere sine phantasmate" (Man cannot perceive or understand anything without mental images).[32] William and Thomas emphasize memory and understanding respectively, but to the extent that it was memory that held images in the mind and made them available for thought, the distinction is less critical than it might at first appear. Elsewhere, in De memoria et reminiscentia (449b31–450a1), Aristotle makes clear that his observation regarding the indispensable nature of mental images as instruments of philosophical discourse applies especially to diagrams: "It is not possible to think without an image. For the same effect occurs in thinking as in drawing a diagram."[33] Aristotle does not say that in order to think one has to draw or even that drawing diagrams helps with thinking; rather, as part of his effort to distinguish thought from imagination and memory (and humans from animals), he draws the reader's attention to the "effect" that thinking and generating a diagram have in common: the re-

quirement to think things through rationally in a step-by-step fashion.[34]

Plato, in whose thought geometrical diagrams sustain demonstrations of the transcendent Forms, also underscored the utility of diagrams in the process of understanding the underlying nature of the cosmos. In the Timaeus he states: "To describe the dancing movements of these gods . . . , to tell all this without the use of visible models would be labor spent in vain."[35] In some medieval texts such instructions, which originated at the highest level of philosophical ratiocination, often served simply as didactic pointers. Pseudo–Hugh of St. Victor's moralizing treatise De fructibus carnis et spiritus, which directs "novices and untutored men" toward "two little trees" in the form of paired Trees of the Virtues and Vices, offers but one example: "It is good to represent the fruits of humility and pride as a kind of visual image so that anyone studying to improve himself can clearly see what things will result from them."[36] In a late thirteenth-century example from the diocese of Constance, appended to a Bible, the fruits of the flesh are easily distinguished from the fruits of the Spirit by the direction of their growth; whereas the former, associated with the old Adam (vetus Adam) hang downward, the latter, associated with Christ, the New Adam (novus Adam), spring upward (fig. 192). The opposition between the two provides a medieval example of what researchers in artificial intelligence sometimes call a "free ride," defined as the possibility that "expressing a set of information in diagrams can result in the expression of other, consequential information" that "enables us to skip certain mental deductive steps and to substitute them with the task of comprehending the consequences from the diagrams."[37] Others have commented on what they call a "look-see" phenomenon in the case of diagrams.[38] Peirce already recognized this potential of the diagram: "For a great distinguishing feature of the icon is that by the direct observation of it other truths concerning its object can be discovered than those which suffice to determine its construction."[39] In the case of the paired diagrams from the Bible, one need not read the

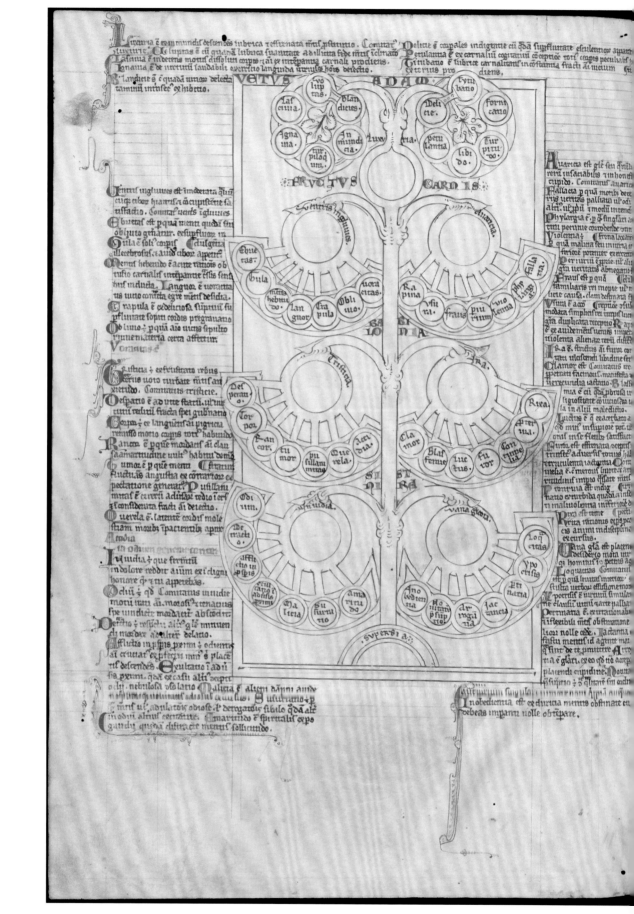

VETVS ADAM

FRVCTVS CARNIS

BABILONIA · LVXVRIA · AVARICIA · TRISTICIA · IRA · INVIDIA · VANA GLORIA · SVPERBIA

(central diagram — tree of vices; circle labels include: voliptas, blandicies, lascivia, ignavia, immundicia, turpiludium, delicie, fornicatio, petulantia, libido, turpitudo, titubatio; Gula: ebrietas, mens hebetudo, languor, crapula, obliuio; Auaricia: rapina, vsuri, fraus, prurium, violentia, fallacia, phylargia; Tristicia: desperatio, torpor, rancor, timor, pusillanimitas, querela, tedium; Ira: rixa, apertua, contumelia, clamor, blasfemie, luctus, furor; Inuidia: odium, detractio, afflictio in psperis, exultatio in aduersis, malicia, susurratio, amaritudo; Vana gloria: loquacitas, ypocrisis, iactancia, inobedientia, nouitatum psuptio, arrogantia, iactantia)

Text transcription of this heavily abbreviated medieval Latin manuscript is not reliably legible.

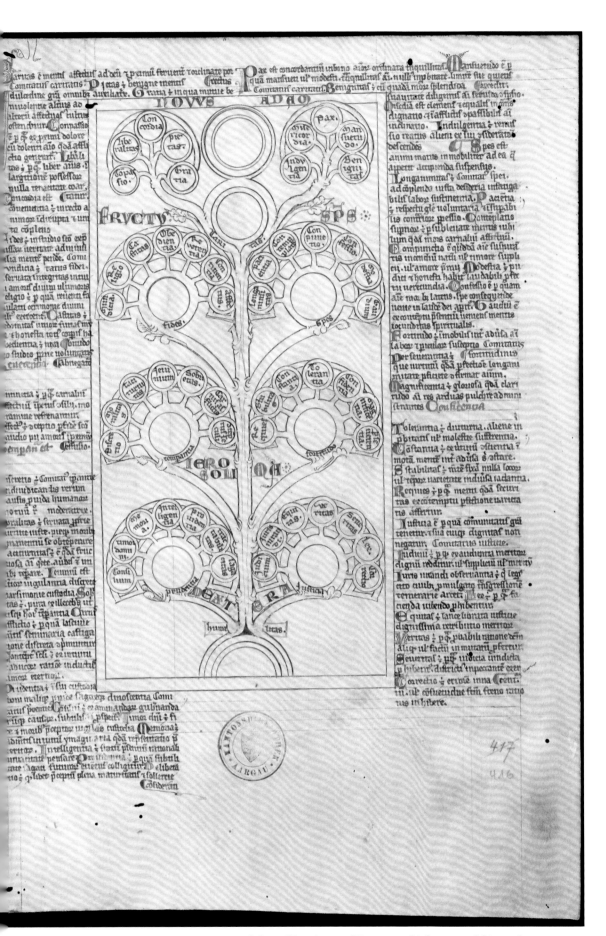

192. De fructibus carnis et spiritus, appended to Bible, Diocese of Constance, third quarter of thirteenth century. Aarau, Aargauer Kantonsbibliothek /MsWettF 11, ff. 415v–416r. Photo: www.e-codices.unifr.ch.

text of the treatise or even the titles of the two diagrams ("Vetus Adam, Fructus carnis, Sinistra" [Old Adam, Fruits of the Flesh, Left] and "Novus Adam, Fructus Spiritis, Ierosolima" [New Adam, Fruits of the Spirit, Jerusalem]) in order to understand, quite simply, that one represents the bad and the other the good.

One of the most important functions of medieval *figurae* was to function as aides-memoires.[40] A letter by Gerbert of Aurillac (ca. 946–1003) documents the use of diagrams for this purpose.[41] He writes: "It is for them [the best scholars] that last autumn I drew up a diagram of rhetoric on twenty-six leaves of parchment sewed together, and forming in all two columns side by side each of thirteen leaves. It is without doubt a device admirably adapted for the ignorant and useful to the studious scholars in order to help them understand the subtle and obscure rules of rhetoric and to fix these in their memory."[42] Gerbert's didactic aid is usually described as a roll, but a roll would not normally have required the joining of pieces of parchment side by side as well as end to end. Whatever its format, two single columns each thirteen leaves long represents a great deal of real estate to devote to rhetoric, implying an unusually detailed diagram of which, unfortunately, no trace survives. Given its extent, it is hard to imagine that the principal purpose of such an object was simply to provide material for rote memorization. One can more easily imagine it as a point of departure, a medieval conversation piece unfurled in a classroom, whether on a wall or on a table.

Yet memory, even as a productive rather than simply reproductive practice, provides only part of the picture. Hovering between text and image, abstraction and representation, diagrams also demarcated the boundary between what could and could not be seen. The prophetic exegete, Joachim of Fiore (ca. 1132–1202), whose diagrams, whether of trees, animals, or geometrical figures, are vehicles, not representations of his thought, makes this point plain.[43] Some things are more easily expressed in images than in words, he says. Images also have their limits, however: "For so long as figures are shown, the truth of the figures is not fulfilled. Where, how-

ever, that which the figures foretell has begun to be fulfilled, it is necessary to empty out the figures entirely."[44] For his trinitarian diagrams in the *Psalteriun decem cordarum*, in particular the three circles interlaced around the tetragrammaton IEUE, Joachim probably drew on the *Dialogus contra Judaeos* by the converted Jew Petrus Alfonsi (1062–1140), for whom the pairs of letters derived from the holy name (IE, EU, UE) stood for the three persons of the Trinity (fig. 193).[45] Alfonsi's rebus in turn provided the model for the so-called *Scutum fidei* or Shield of Faith, in which the corners of the triangle, embodying the concept of three in one, were filled with the Latin names of the three persons, *Pater, Filius,* and *Spiritus Sanctus* (fig. 194).[46] Referring his readers to a "geometrical diagram," Peter writes: "Indeed the Trinity is something subtle and ineffable and difficult to explain. . . . Look, as I was saying, at the name, three letters in four figures (for one of them is written twice). . . . If you connect them [the letters] in order, there will be just one name, as occurs in this geometrical diagram."[47] As Barbara Obrist has argued, Joachim's works register a reevaluation of the visual sign, and not simply as a didactic, demonstrative device.[48] His *figurae* have a special status: their imagery is rooted in the Bible; they therefore open themselves to moments of illumination. In keeping with Neoplatonic tradition, the geometrical figures of which Joachim was so fond, in particular the triangle and the circle as supposedly natural signs of the Trinity in its multiplicity and its unity, conform to divine exemplars defined in terms of number and thus can serve as signs superior to words.[49] Hence Joachim's repeated reminders to his readers that his figures have more to offer the contemplative mind than do his discursive explanations.[50] Appealing to the *oculus mentis*, the eye of the mind, the *figurae* stand at the boundary between the visible and the invisible.

Measured against this tradition, Berthold's diagrammatic method can be considered fundamentally old-fashioned. Its roots lie in the monastic, not the modern scholastic tradition, in the *Logica Vetus* rather than the *Logica Nova* and other modern techniques of diagrammatic

193. Tetragrammaton. Petrus Alfonsi, Dialogi contra Iudaeos, England, twelfth century. Cambridge, St. John's College, MS. E.4, f. 153v. Photo: By permission of the Master and Fellows of St. John's College, Cambridge.

194. Scutum fidei (Shield of Faith). Peter of Poitiers, Compendium geneaologia Christi, England, ca. 1210. London, BL, Cotton MS. Faustina B VII, f. 42v. Photo: © British Library Board.

division.[51] The Old Logic was founded in those works of Aristotle that had been translated into Latin prior to the first half of the twelfth century (the *Categories* and *On Interpretation*, both in the translations of Boethius) as well as Porphyry's *Isagoge*. In contrast, the New Logic, following new translations in particular of Aristotle's *Posterior Analytics* and the rediscovery of Boethius's previously lost translations of the *Prior Analytics*, *Topics*, and *Sophistical Refutations*, acquired a broader range of applications that, over time, permitted its practitioners to encroach on the purview of theologians, a movement that ultimately led to the Condemnations of 1277 at the University of Paris, less than two decades prior to Berthold of Nuremberg's activity.[52] By Berthold's day, theologians had begun to use mathematical theorems to lend their arguments the character and force of geometrical demonstrations.[53] Already in the first half of the

thirteenth century, William of Auxerre (d. 1231) applied Euclid's analysis of angles to make his case for the incommensurability of divine love (charity).[54] Aquinas, whose writings rapidly escaped the censure of 1277, argued that the sum of human goodness could never be eliminated by sin, just as no quantity could ever be reduced to nil by being repeatedly divided in half.[55] Albertus Magnus employed the same logic to make the case that even an indefinite number of intercessions could not cancel out a punishment in its entirety.[56]

To judge from his extant writings, Berthold had no interest in such mathematical and geometrical techniques of theological analysis. Further still, his work betrays no trace of scientific diagrams, whether those of the early or High Middle Ages, such as those created by William of Conches in the twelfth and Robert Grosseteste in the thirteenth century.[57] Although he was not

uninterested in Hranbanus's numerology, his focus remains the associative web drawn by scriptural metaphors. In this his method differs little from that of his high medieval predecessors.[58] As an approach, however, it was sanctioned by no less a Dominican authority than Thomas Aquinas, who, in the opening section of his *Summa Theologiae* (1q1a9), devoted to the question of "whether the Holy Scripture should use metaphors," argued that

> it is befitting Holy Writ to put forward divine and spiritual truths by means of comparisons with material things. For God provides for everything according to the capacity of its nature. Now it is natural to man to attain to intellectual truths through sensible objects, because all our knowledge originates from sense. Hence in Holy Writ, spiritual truths are fittingly taught under the likeness of material things. This is what Dionysius says (*Coel. Hier.* i): "We cannot be enlightened by the divine rays except they be hidden within the covering of many sacred veils." It is also befitting Holy Writ, which is proposed to all without distinction of persons—"To the wise and to the unwise I am a debtor" (Rom. 1:14)—that spiritual truths be expounded by means of figures taken from corporeal things, in order that thereby even the simple who are unable by themselves to grasp intellectual things may be able to understand it.[59]

Aquinas here provides the means with which to justify the use of diagrams according to the theory of speculation, rooted in exegesis of Romans 1:20: "For the invisible things of him from the creation of the world are clearly seen, being understood by the things that are made." Although in this highly influential passage Paul principally had in mind "the things that are made" by God the Creator, by the High Middle Ages, in a critical turn, they had also come to designate the exact opposite of what Paul had in mind in arguing against idols, namely, artifacts of human manufacture.[60] By virtue of their materiality and visibility, diagrams remain corporeal (tantamount in some ways to what Bruno Latour has called

"inscriptions"), yet by virtue of their abstraction and basis in the truths of geometry, they are capable of serving as similitudes of the divine.[61] Such figures, Aquinas adds, are useful instruments of pedagogy: "The very hiding of truth in figures is useful for the exercise of thoughtful minds and as a defense against the ridicule of the impious." In the words of a historian of modern science, drawing on theories of the extended mind: "Cognitive artefacts [such as diagrams] are not only intended as representations . . . but they are also inviting their user to rely on them as instruments to generate and further explore the represented objects of knowledge."[62]

Throughout the Middle Ages, from Cassiodorus to Cusanus (and indeed well beyond), geometry retained its place not simply as a propaedeutic to advanced study but also as an instrument of Christian exegesis, theology, and contemplation.[63] Manipulations of geometrical forms lent themselves to metaphorical elaboration that in turn endowed theological argument with the apparent necessity of a proof. Number provided the language of cosmology (the study of the ordering of the world). In the words of Joachim of Fiore, "there exists a certain living order in the divine works."[64] It is not simply that geometry served exegesis; exegesis demanded the revelation of an underlying order of both creation and history that could best be expressed in abstract geometrical terms. Geometry was the means by which the intellect could "see."[65]

The Diagrammatic Mode in Medieval Art

Geometrical forms had played a role in the diagrammatic exposition and expression of religious ideas from the early Middle Ages.[66] Although a case can be made for late antiquity (one thinks, for example, of the geometrization of floor mosaics), the ninth century, precisely the period during which Hrabanus wrote, marked a watershed in terms of these developments.[67] It was during the Carolingian era that, in the words of Bianca Kühnel, "the diagram began to be systematically mobilized to express theological concepts."[68] Words—the Word—and number and geometry together expressed the perfection of the

Creator and his creation.[69] During his lifetime Hrabanus would have witnessed the fusion of diagrams with figural imagery within an integrated system of representation that was to remain characteristic of medieval art until at least the end of the thirteenth century, whether in manuscript illumination or in monumental art (e.g., cathedral facades and stained glass).[70]

The recent explosion of interest in diagrams and "diagrammatology" has largely left unquestioned the extent to which a diagrammatic mode of representation defines medieval art or serves as one of its most salient characteristics. The history of medieval art history, however, reveals that the primacy of diagrams and, more generally, geometry as a governing framework for medieval art has been hotly debated. For Meyer Schapiro, the role of the geometrical armatures within, over, and around which medieval imagery coalesced represented a question of central concern from early in his career, in 1931, when he took issue with the conception of the frame and its role in medieval art as proposed by the formalist French art historian Henri Focillon and his student Jurgis Baltrušaitis.[71] In his book on Romanesque sculpture, published in the same year, Baltrušaitis proposed a "law of the frame," arguing that medieval art was governed by schematic systems consisting of geometrical armatures within which figures were distorted to a greater or lesser degree.[72] In his review of Baltrušaitis's book, his dissertation on the sculpture of Moissac, and related publications, Schapiro took violent issue with this characterization of medieval art, which he also framed in political terms, relating it to the question of the "freedom" of the medieval artist.[73]

Although Schapiro's later work, which reflected a fascination with semiotics, sometimes has been characterized as representing an abandonment of his earlier political commitments, his essay "On Some Problems in the Semiotics of Visual Art," published in 1973, reveals profound continuities of concern. In addressing issues of framing, Schapiro makes it clear that the examples he has in mind come from the realm of Romanesque sculpture:

Our conception of the frame as a regular enclosure isolating the field of representation from the surrounding surfaces does not apply to all frames. There are pictures and reliefs in which elements of the image cross the frame, as if the frame were only a part of the background and existed in a simulated space behind the figure. Such crossing of the frame is often an expressive device; a figure represented as moving appears more active in crossing the frame, as if unbounded in his motion. The frame belongs then more to the virtual space of the image than to the material surface; the convention is naturalized as an element of picture space rather than of the observer's space or the space of the vehicle. In medieval art this violation of the frame is common, but there are examples already in classical art. The frame appears then not as an enclosure but as a pictorial milieu of the image. And since it may serve to enhance the movement of the figure, we can understand an opposite device: the frame that bends and turns inward into the field of the picture to compress or entangle the figures (the trumeau of Souillac, the Imago Hominis in the Echternach Gospels).[74]

Schapiro sees geometrical frames not as constraints but rather as suggestive of space: not an illusionistic space within the image, as in postmedieval painting, but instead as a space within and against which the pictorial or sculptural protagonist (what he calls the "vehicle") or, by proxy, the viewer moves vis-à-vis his milieu.[75] In this view the diagram serves dynamism, not stasis.[76]

Hrabanus expressed his own views on the importance of geometry among the liberal arts in an early work, *De institution clericorum*, a handbook on the training of priests. In a reflection of Neoplatonism, Hrabanus opens his chapter on geometry by defining it, as would others, as a middle ground between intelligible forms and the visual representation of ideas: it is both the "contemplation of forms" (*contemplativa formarum*) and "the visual documentation" of the philosophers (*documentum etiam visuale*

philosophorum).[77] Cassiodorus, on whom Hrabanus draws in addition to Augustine, Gregory, and, above all, Isidore, had argued that the art of geometry came into being because it prompted studious persons to seek knowledge of invisible things.[78] The forms into which its categories could be classified embraced celestial as well as terrestrial objects (*in terrestribus sive in caelestibus*).[79] To drive the point home, Hrabanus supplements his source with a biblical touchstone: the God-given dimensions of the tabernacle and the Temple, both of which represent numerical and physical manifestations of the divine.[80] Such comparisons were not idle: for his abbey at Fulda, Hrabanus commissioned a reliquary that itself took the form of the ark, including cherubim, handles, and rings (cf. Ex 25:10–22), a visible demonstration in gold that such ideas could take on physical, material form.[81]

Boethius (ca. 480–524) and his successor as *magister officiorum* under the Ostrogoth king Theoderic, Cassiodorus (ca. 485–ca. 585), were among the Middle Ages' principal masters when it came to the study of mathematics and geometry. Christian aristocrats who devoted their lives to learning, the art of geometry included, both Boethius and Cassiodorus stand at the origin of the medieval diagrammatic tradition. Moreover, they were not alone. Another such figure, the Gallo-Roman Claudianus Ecdidius Mamertus (d. ca. 473), brother of St. Mamertus, bishop of Vienne, did not write on geometry per se but harnessed it in his treatise *De statu animae*, written circa 469–70. Drawing on Neoplatonist epistemology, he argued against those who maintained the corporeality of the soul.[82] Mamertus asks: "What does Marcus Varro . . . seek to gain by an almost divine disputation in his musical writings, his geometrical ones, in the books of philosophical matters, if it not be to draw away the soul in certain wondrous ways that belong to an eternal art from the visible to the invisible, from what has place to what has no place, from the corporeal to the incorporeal?"[83] Mamertus's words adumbrate by six centuries the watchword of another inheritor of the Platonic tradition, Hugh of St. Victor, who, in his commentary on the *Hierarchia Caelestis* of the

Pseudo-Dionysius, famously stated: "Per signa sensibilibus similia invisibilia demonstrata sunt" (invisible things are shown through signs like sensible things).[84]

In good Platonic fashion, Mamertus uses geometry to makes his case.[85] He also draws, as Megan McNamee has put it, on the "use of pictures by medieval annotators to spur the minds of their readers to a desired kind of imaging and, through this, understanding."[86] From as early as the ninth century, copies of Mamertus's treatise, probably reflections of earlier exemplars, contain geometrical figures in the margins as aids to understanding, if not as visualizations of theological concepts per se, then as a means of defining the terms of the argument. A copy from the scriptorium of Saint-Martin in Tournai, dated to the early eleventh century, contains not only Mamertus's treatise (fig. 195) but also that of his opponent Faustus of Rietz (d. ca. 490). Each of the marginal figures is tied to the related portion of text by sigla placed within or alongside the figure in question as well as in the appropriate interlinear space.[87]

The seemingly modest marginal drawings accompanying Mamertus's treatise are similar in kind to those deployed by Macrobius, to whose *Commentary on Cicero's Dream of Scipio* Mamertus may in fact have turned for a precedent for his practice.[88] Parsing those things that can be seen with the body and those things that are perceptible to the soul, Mamertus begins by defining his terms, working his way up from point to line to parallel lines to his first figure (*figura*), the triangle, then the circle and the square, describing all of these geometrical concepts as part of "eternal and unchanging knowledge, crystal clear to every human mind, even the uneducated" (bk. 1, chap. 25), the latter phrase an echo of the demonstration of *amamnesis* in Plato's *Meno*.[89] His definition of *figura* as an enclosed planimetric form matches precisely that of Cassiodorus: "Figura est quae sub aliquo vel a quibus terminis continetur."[90] Geometrical forms express "laws that are indissoluble and eternal." Having quoted Ephesians 3:18 ("What is the breadth, and length, and height, and depth . . . ?"), a passage that also serves as an oblique reference to the

The Latin manuscript text shown in the image is a medieval geometry treatise with marginal diagrams including a line, a triangle, a circle (labeled A and B), and a square (labeled G).

195. Claudianus Mamertus, De statu animae, Tournai, Saint-Martin, early eleventh century. Boston Public Library, MS f Med. 15, f. 18v. Photo: BPL.

cross, his chapter on geometry concludes with a prayer: "Let us bring this in us to that which made us, let us not reproach our God, saying to him: you were not able to make something like yourself, because if I am a body, I am not like you."[91]

The role of number and shape not simply in describing but, further, in justifying visible, material manifestations of the divine assumes still more concrete form in the *Flores epytaphii sanctorum* by Thiofrid, abbot of Echternach (d. 1110), a work in praise of relics—one of only two works on the subject from the entire Middle Ages (the other being *De pignoribus sanc-*

torum of Guibert of Nogent, written ca. 1120).[92] For Thiofrid, the materiality not only of relics themselves as corporeal remains but also of the costly containers in which they are housed poses in the most pointed and paradoxical fashion the question of the relation of the material and immaterial, the visible and the invisible, all the more so in that his work was written in the wake of the establishment of a feast in honor of the monastery's relics by his predecessor, Reginbert (1051–81).[93] The work thus takes on an apologetic aspect. Divided into four chapters, the *Flores* deals with the bodies of the saints (bk. 1), their tombs and reliquaries (bk. 2), their

other manifestations, whether in the form of their names or contact relics (*brandea*), both of which possess sacred powers (bk. 3), and finally the instruments of martyrdom (bk. 4). Theofrid cites the same Old Testament precedents invoked by other authors seeking to justify the ornamentation of churches (e.g., the breastplate of Aaron, the ark of the covenant). In addition to Theophilus, author of *De diversis artibus*, a theologically informed handbook on forms and methods of craftsmanship required in the making of the *ornamenta ecclesiae*, these include the only somewhat younger Hugh of St. Victor, who in his commentary on Pseudo-Dionysius's *In Hierarchiam celestem* declares: "All sacred figurations and sensible signs whether in the Old or in the New Testament, namely, the tabernacle of the covenant, and the ark of the testament, and others of this kind which scripture proposes in order to demonstrate invisible things, . . . all are undoubtedly to be contemplated as sacred signs."[94] Thiofrid marshals other arguments as well. In book 2, addressed to works of human manufacture, the role of geometry comes to the fore. Although clear in stating that the bodily remains within the shrine are of incomparably greater value than the costly materials of which the shrine itself is made, and that the worshiper should regard such objects with spiritual, not corporeal, sight, Thiofrid is also at pains to justify donations to his own institution.

Materials are ennobled by their form. Chief among these forms for Thiofrid is the pyramid, at the apex of the series of Boethian solids, whose terms of definition he derives from Boethius's *De institutione arithmetica* (2.2). According to the late antique philosopher, whom he quotes directly, the pyramid is to solid figures as the triangle is to plane numbers. Just as the triangle is the first planar figure (since one cannot form such a figure from two lines alone), the pyramid is the first figure possessing depth. Citing the form of the ark of Noah as a biblical precedent, Thiofrid allegorizes the form of the ciborium, a pyramid set atop a cube, as the Trinity resting atop the Church.[95] The columns supporting the corners of the pyramid are in turn compared with the saints, and the rounded forms on the exterior (it

is not quite clear to what Thiofrid is referring) represent the souls of the dead gathered in heaven. Christ himself can be compared to a pyramid, as the latitude (in the sense of reach) of God's laws and the narrowness (in the sense of strictness) of Christ's life lead to the great height of his interminable glory. Summing up this part of his argument, Thiofrid declares that such basic geometric forms as the triangle, rectangle, and circle are most apt for fashioning reliquaries because they are directly derived in a single line (*circumductio unius lineae*) from the Divinity.[96] In Thiofrid's account, it is less the materials per se, which he elsewhere calls gold in another color (*mutato colore lutum*), than their geometric forms that permit them to serve as vehicles capable of transporting the worshiper toward the divine.

Thiofrid's invocation of Noah's ark as an example of divinely sanctioned geometry brings to mind the three treatises written on or around the biblical vessel by Hugh of St. Victor (ca. 1096–1141): *De arca Noe morali*, *De arca Noe mystica*, and *De vanitate mundi*.[97] Of these, the second, which went through several versions, offers a general point of comparison to Berthold's joint treatises in that it combines a diagrammatic account of sacred history with ladder imagery outlining a process of spiritual ascent. It is unclear, perhaps even doubtful, that the diagram which Hugh describes was ever realized; no copies, whether in whole or in part, survive, despite the extensive manuscript transmission of the text.[98] Hugh himself opens his tract by evoking a mental image, analogous to the *imago Dei* after whose likeness humankind had been fashioned, imprinted on the heart, the seat of the soul: "I depict it [the ark] as an object, so that you may learn outwardly what you ought to do inwardly, and that, once you imprint the form of this example in your heart, you will be glad that the house of God has been built inside of you." Mankind, deformed by the Fall, can work towards its own restoration by a process of edification.[99]

The complexity of Hugh's ark has suggested to some that rather than a diagram in a manuscript, it more likely was displayed within the monastery as a wall painting or wall hanging.[100]

While in the case of Hugh there is no evidence to support such a contention, there is no doubt that decorative didactic schemes of this sort existed. At Augsburg, Wilhelm Wittwer's *Catalogus abbatum*, a late medieval source documenting the buildings and interior decoration of the Benedictine monastery of Sts. Ulrich and Afra, credits Abbot Udalschalk (r. 1127–51), a contemporary of Hugh's, with having designed a diagram of the microcosm and microcosm that stood in an unidentified location.[101] Wittwer even went so far as to draw a copy of the lost original, not from the monument itself, which had already been destroyed at the time he was writing, but from manuscript copies that he had at his disposal.[102] The diagram, which is described as being composed of "two figures or wheels with verses and other figures" ("due figure sive rote cum metris et allis figuris conpositis") and attributed to the "most learned" abbot ("per abbatem Vodalscalcum doctissimum"), placed the wheel of the macrocosm above, that of the microcosm below. In the uppermost diagram, the surrounding figures represented the winds and the four points of the compass, in the lower the zodiac—a scheme that ultimately derived from Isidore's *De natura rerum*.

Hugh's composition, regardless of whether it was executed, was considerably more ambitious. Drawing on the tradition of exegesis that read scriptural structures, not only the ark but also the tabernacle, the temple, and the Heavenly Jerusalem as figures of the divine, Hugh pursues the art of interior edification.[103] In keeping with Thiofrid's description, the ark is wide at the bottom and narrow at the top. As Hugh describes it there is a central column that stands for Christ. Like Theofrid (who, however, described a pyramid that he in turn compared to the form of the ark), Hugh allegorizes the vessel as the Church. Here, however, Hugh's interpretation takes a temporal turn. "The length of the Church," he says, "is its temporal duration, just as the width of the Church is its number of affiliated peoples." The ark is framed in terms of salvation history: "The length of the Church is its extension in time: going from the past through the present into the future. Its extent in time is from the be-

ginning of the world until the end, because the Holy Church began from the beginning of the world in its faithful and will remain until the end of time."[104]

To the geometrical figure of the ark is added temporal extension. Whereas Berthold's scheme incorporates only one ladder, Hugh's structure contains twelve, each with ten rungs: "three from each corner, four in each room, different ones in different corners."[105] His inclusion of ladders, in addition to drawing on one of the most common images of spiritual ascent, perhaps was prompted by their inclusion in contemporary representations of the ark.[106] In the full-page initial *A* for Adam that opens the copy of Orosius's *Historiarum adversum paganos libri septem* illuminated at Zwiefalten circa 1160–70, two ladders lead the crowd of animals up to the double-arced entrance (that, however, for some reason has been erased; fig. 196).[107] Noah, his wife, and their sons and daughters surround the vessel, the men placed on the heraldic right, the women on the left. Scenes from sacred history—Adam delving and Eve spinning at the apex, the drunkeness of Noah in the terminals—flesh out the letter with additional scenes from sacred history. From bottom to top, the ladders mark a process of physical ascent through space, but read from top to bottom, which is also the direction of reading, they chart the passage of time as a historical process of descent. In Hugh's construction the twelve ladders add a tropological dimension to his construction, identifying it as a figure not simply of the Church but also of the soul.[108] Hugh identifies the twelve ladders with the teaching of the apostles, the ten rungs with the Ten Commandments, and the four corners with the teaching of the Evangelists.[109] Whether Hugh's work was realized or to have remained a meditative construct, his devotional and diagrammatic structure, drawing on Pseudo-Dionysius's conception of a heavenly hierarchy linking the terrestrial and celestial realms, identifies all visible signs as stepping stones toward the divine.[110] His diagram translates nature and history, specifically salvation history, into visible signs that speak of invisible things.[111] In Hugh's practice, as in that of some of his contemporaries, edification as moral

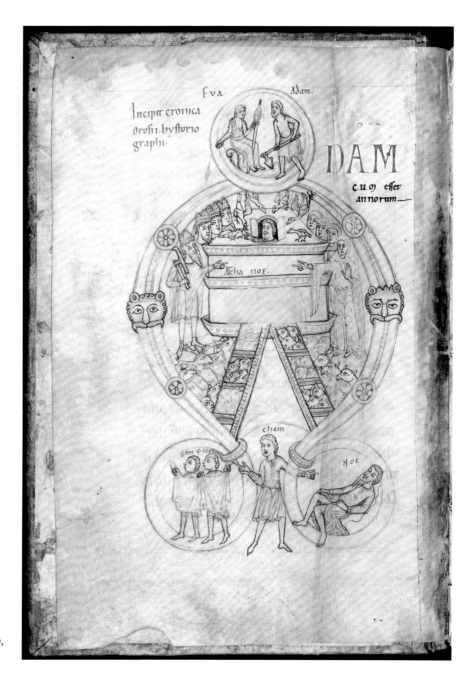

Incipit croica Orosii hystorio graphi.

EVA. Adam.

DAM cuo eſſet annorum

Aicha noe.

cham

ſem et iaph. noe

196. Initial *A* for Adam. Orosius,
Historiarum adversum paganos
libri septem, Zwiefalten, ca. 1160–
70. Stuttgart, Württembergische
Landesbibliothek, Cod. hist. 2° 410,
f. 1v. Photo: WLB.

elevation and as the process of erecting a struc-
ture are combined into a single process.[112]

Within the Dominican order, the preacher
and mystic Heinrich Seuse (ca. 1295/1297–1366),
who spent most of his career in Konstanz, offers
an instructive point of comparison to Berthold.
At least a generation younger than the *lector*
from Nuremberg, Seuse also provided his own
writings, specifically the authoritative collection
known as the *Exemplar*, with illustrations.[113] The
majority of the images represent visions recount-
ed in the text, either those of the protagonist, the

Servant, who cannot be immediately identified
with Seuse himself, or those of Elsbeth Stagel
or another of the nuns who play for the reader
the role of his model students and interlocutors.
Only the penultimate illustration and the last
within the "Life of the Servant," the first book of
the *Exemplar*, employs a diagrammatic device, a
red line that strings the various vignettes togeth-
er by way of compelling the viewer to read them
in a particular order (fig. 197).[114] In its overall
structure the image rather resembles a wheel of
fortune, except that in this case it is not a rul-

Die alt der ewige gotheit willoses abgründe des nie anvang hat noch dem ende

Anderm anschlag ken ich aller ding vgessen wan es ist grundelos und vngemessen

Ich bin in got ver hangen niemen kan mich hie er langen

Hie ist der geist in geistige und wirt in der dey heit der personen funden

Die sinne sint nur erwurcket die hohen liecht sint über wurcket

Dirist menschlichü geschaffen heit gebildet nach der gotheit

Ach lug ich müs sterben bit vn mit grim gengst sterben

verlasse ich her mich hetten wu wir im ewiez syn

Dirist der per son der theit nnen schlich ein keit von dem vatter vsgegangen lob sey

Dirü figur in der dey uff stigenpet schlicher naturn

Dirist der tod

Anmen ken weil ich zu got nemen wan du bist ga ein kurtez leben

Die ist der welt ruine der nie mer jemmer ein ende

197. Mystical Way. Heinrich Seuse: Exemplar, Strasbourg, ca. 1360. Strasbourg, Bibliothèque nationale et universitaire, ms. 2929, f. 82r. Photo: Coll. and photo. BNU de Strasbourg.

er but rather the soul whose progress is traced, first down, from heaven to earth and the valley of death, and then up again to heaven. Using the metaphor of a stone thrown into still water, the Dominican describes the rings radiating from its point of impact, which he then compares to the three persons of the Trinity. The three rings—a diagrammatic element within the diagrammatic whole—appear in the upper left-hand corner of the image, behind the veil of the tabernacle, at the end (but also at the beginning) of a path that leads both from and to the Godhead.

Seuse's introduction to his discussion of the image summarizes several strands in the tradition of the diagrammatic image:

How can one form images of what entails no images or state the manner of something that has no manner (of being)? No matter what one compares it to, it is still a thousand times more unlike than like. But still, so that you may drive out one image with another, I shall now explain it to you through images and by making comparisons, as far as this is

possible, for these same meanings beyond images—how it is to be understood in truth, and thus conclude a long discussion with few words.[115]

Seuse, at least one generation younger than Berthold, employs his didactic diagram in the service of mystical theology. In fact, in its recursive circular structure his drawing reminds one of nothing so much as Klee's diagram of artistic process and perception (see fig. 7). Seuse's paradoxical formula—"to drive out one image [*bilde*] with another"—exploits the ambiguity of the term's Latin equivalent, *imago*, to suggest how an image perceived with the senses can return the contemplative soul to its font and origin in the Godhead, precisely the process his diagram depicts, through the abandonment of all images.[116] The paradoxical combination of cataphatic (positive) and apophatic negative) approaches draws on the Dionysian tradition. And his promise to be brief refers not only to the fact that his work is drawing to its close—indeed, having fulfilled her function within the text, his exemplary student Elsbeth, who models reception for the reader, dies—but also to the belief, exemplified by Joachim of Fiore, that a diagrammatic image can indeed be worth a thousand words in its ability to manifest in an instant an illumination that could only be inadequately explained in "long discussion."

The *figurae* that introduce each section of Berthold's Marian compendium draw on some of the same traditions of diagrammatic representation. In the end, however, their sheer number—Berthold's is perhaps the largest such collection to have survived from the entire Middle Ages—speaks to ambitions of a different kind. Seuse's diagram marks the culminating moment in a pedagogic program whose ultimate goal is mystical union gained by weaning oneself from all images, what Meister Eckhart called *Bildlosigkeit*.[117] In contrast, Berthold, while employing abstraction, revels in his images; he ends by portraying himself praying to an image of the Madonna and the incarnate Christ Child. Berthold's images distinguish among many Marian attributes, qualities, and predicates, all defined in terms of imagery drawn from scripture; his compilation, which has deep liturgical roots and, like the liturgy, delights in metaphoric biblical imagery, reads like a series of Marian hymns translated into diagrams. Seuse, on the other hand, in his drive toward union, seeks to leave all predication, liturgical or otherwise, behind. Despite his rich use of imagery, some of it drawn from vernacular literature, his method is in the end apophatic, not cataphatic. The kaleidoscopic similarities and differences among Berthold's images, as well as their color symbolism, support the reader's effort to remember a great mass of material and, in remembering, to master a system through which new combinations can be generated. Seuse, however, wishes his readers to forget. Whereas Seuse wishes to transport his readers into the Holy of Holies beyond the tabernacle veil, Berthold is satisfied to remain without, contemplating its variegated colors. Like Joachim's figures, Berthold's stand in for scripture; their purpose is to reveal hidden, often typological, relationships by translating them into an abstract language of demonstration. Seuse's image makes no reference to scripture; its basis lies in theological discourse. In brief, whereas Seuse's diagram is modern, Berthold's diagrammatic method, like his textual sources, remains monastic. Berthold, however, is not entirely old-fashioned in his approach. As *lector*, Berthold was first and foremost a teacher, and it is to the practical side of teaching in the schools as well as their curriculum that one must turn in order to determine with greater precision the sources, not so much of his message as of his manner of presenting it.

The Logical Basis of Berthold's Diagrammatic Method

Diagrams were the stuff of the schools; it is impossible to imagine the medieval curriculum, whether monastic or clerical, without them.[118] As part of a pedagogic program inherited from antiquity, diagrams were deployed in the *quadrivium* and in the *trivium*.[119] Spatial reasoning thus formed part of every student's toolkit. In an English manuscript of Aristotle's *Logica nova*,

dated circa 1225, which includes the *Sophistici Elenchi*, *Topica*, and *Analytica Priora et Posteriora*, the two figures in the lower margin, Hippocrates of Chios (ca. 470–ca. 410 BCE) and Bryson of Heraclea (late fifth century BCE), could also represent medieval masters participating in a debate about the classic conundrum of how to calculate the quadrature of the circle (*Soph. E.* 2.171b12–18; 171b34–172a7; fig. 198).[120] In each of the two miniature diagrams, the pricking holes left by the compass as well as faint traces of the diagonals defining the squares testify to the precision the artist sought to achieve. Also visible are the faint sketches in lead left as a guide for the illuminator as well as the initial indications for the rubrics written in partially erased brown ink. The precision of the geometrical figures matches that of the overall mise-en-page, which is ruled so as to allow for layer after layer of commentary, marginal as well as interlinear.

The glosses inscribed in the manuscript's margins could be viewed as a concretization of the intense oral argument that characterized classroom debate. A mid-twelfth-century Parisian manuscript of the *Isagoge*, an introduction to Aristotle's *Categories* by the Greek logician Porphyrius (ca. 200–300 CE) that circulated in a Latin translation by Boethius, also places the reader, if indirectly, in the midst of such a disputation (fig. 199).[121] *Dialectica domina*, Lady Dialectic, a towering figure reminiscent of Lady Philosophy as she appears to Boethius in a dream he describes at the beginning of *The Consolation of Philosophy*, stands at the center, holding in her left hand a snake, her attribute, a symbol of cleverness, and in her right a no less serpentine tree diagram, in fact, the Porphyrian tree of genera and species that became a classroom classic.[122] At the top of the tree, *Substantia*, occupying the central roundel, sprouts two branches labeled *Corporea* and *Incorporea* (corporeal and incorporeal). The subsequent set of terms divides *Corpus*, body, between *Animatum* and *Inanimatum* (animate and inanimate). The final division distinguishes *Rationale anima* (the rational soul) between *Homo* and *Deus*, man and God. As noted by Umberto Eco, the Porphyrian system employs the dictionary model of semantic representation, as opposed to the encyclopedic; rather than attempting to describe a given thing or term as it exists in the world, with all of its accidents, it analyzes it linguistically by taking "into account only those properties *necessary and sufficient* to distinguish that particular concept from others."[123] Whereas according to Aristotle (*Posterior Analytics* 3.3.90b.30) there are four predicables (genus, proprium or unique property, definition, and accident), according to Porphyry, who takes Aristotle as his point of departure but adds the predicable of species, there are five.[124] Neither Aristotle nor Porphyry, it appears, visualized the branching model of logical analysis in the form of a diagram, as did the Middle Ages. In its exemplary instantiation, of which the dangling vinelike tree in the manuscript from Paris offers a classic example, the diagram arranges all of creation into a ladderlike set of hierarchical divisions that ultimately leads to God.

That the differences defined by the tree are accidents, and that accidents can be multiplied indefinitely, is a problem of categorization that the diagram conveniently elides.[125] The image, however, offers more than the diagram itself, which would have sufficed for didactic purposes. The demonstrative display places the diagram at the center of an exemplary dialogue, as if to show how it should be used performatively.[126] At the top Plato engages Aristotle in dialogue; below, Socrates and Magister Adam likewise converse. Adam, of course, is the exemplar of all humans, one of the subdivisions of the diagram's final set of categories. Adam does not simply represent the category of humankind, however. Due to his having assigned names to the animals, he represents the quintessential philosopher and logician.[127] In addition, his act of discrimination and denomination underwrites the use of inscriptions in medieval images. In effect, the discussants in the corners supply the learned disputation in which the reader is then expected to participate.

Berthold's diagrams, composed of triangles, squares, lozenges, and circles with an admixture of figural imagery, fall into three basic categories: (1) those in which the components are tied together by lines, many of them akin in structure

198. Hippocrates of Chios and Bryson of Heraclea discussing the Quadrature of the Circle. Aristotle, Logica nova, England, ca. 1225. London, British Library, Royal MS. 12 D II, f. 10r (detail). Photo: © British Library Board.

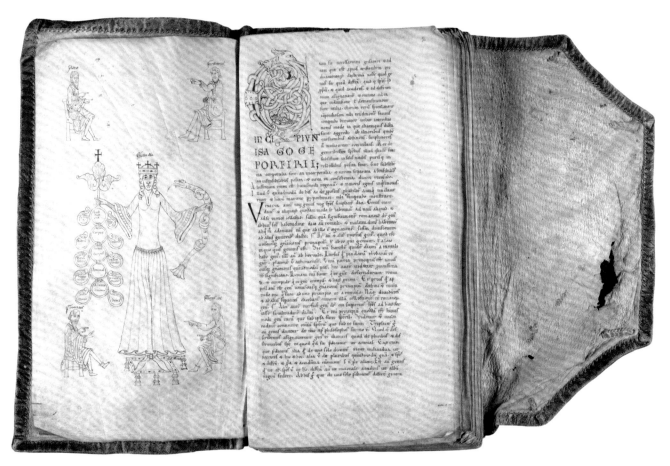

199. Tree of Porphory. Boethius, Logica vetus, Paris, ca. 1140. Darmstadt, Hessische Universitäts- und Landesbibliothek, Hs. 2282, ff. 1v–2r. Photo: ULB Darmstadt.

to a segment of a Porphyrian tree as well as to genealogical imagery, (2) those based on a quincunx pattern, which take the logicians' square of opposition as their point of departure, and (3) a more miscellaneous set consisting of those in which the individual parts, ranging from two to six in number, are arranged in a variety of patterns. Whereas the third category in its use of changing constellation of basic geometric shapes recalls the movement of pieces in the game of Rithmomachy, the first and second categories are in their arrangement indebted to the underlying diagrammatic structures of logic.

In structure and to a certain extent in content, the Porphyrian tree was closely related to genealogical imagery. Predicated on the etymological kinship between genus and generation, species descended from "parent" genera along the length of the tree. Berthold's diagrams, in connecting circles, squares, and triangles filled with the names of holy personages with short, stubby lines in ascending and descending patterns, borrow from the visual stock-in-trade of both topics as presented in textbooks. Similar schemes were used to categorize the branches of the liberal arts themselves.[128] This genealogical shorthand provides a perfect fit for the underlying narrative thrust of Berthold's commentary and its emphasis on the outline of sacred history. A sketch for (or a copy of) one such tree diagram, closely resembling the simple structure of many of Berthold's diagrams, occupies the final page of an eleventh-century codex containing works by, among others, Boethius, Porphyrius, and Walahfried Strabo (fig. 200).[129] The diagram's incomplete state makes it easier to detect the holes left at the center of each circle by a compass (although the shakiness of the lines, drawn in ink, suggests that they were added freehand, perhaps over tracing).

200. Diagram (unfinished). Boethius, Porphyrius, Walahfried Strabo, etc., Philosophical Miscellany, St. Gallen, ca. 1100. St. Gallen, Stiftsbibliothek, Cod. Sang. 831, p. 362. Photo: www.e-codices.unifr.ch.

Genealogy was the determinant of social rank in the High Middle Ages, so it is not surprising in turn that conceptions of sacred history reflected societal preoccupations with familial descent and that, moreover, genealogical structures governed other areas of thought.[130] Diagrams in the form of family trees extended the reach of the Holy Family to encompass ever more members.[131] In a full-page diagram illustrating a copy of Gautier de Coinci's *Miracles de Nostre-Dame* (Paris, BnF, Arsenal, ms. 3517, f. 7r), illuminated in Paris circa 1300, three branches descend from Anne, the mother of Mary, enthroned at the apex of a triangle (fig. 201). On her right Anne is flanked by

Joachim and on her left by Cleophas and Salome, the three men whom she was believed to have married in succession (*trinubium*), each whom fathered one of the three Marys the Virgin, Mary Cleophas, and Mary Salome. As the diagram demonstrates, from the first marriage descended Christ, seated at the lower left; from the second, Joseph and Judas Thaddaeus (both of whom, identified as "fratres domini," are shown in Christ's company; James the Lesser and Simon, also said to be descended from Cleophas, are not named, even though the diagram depicts three disciples); and from the third, James the Greater and John the Evangelist, at the lower right.

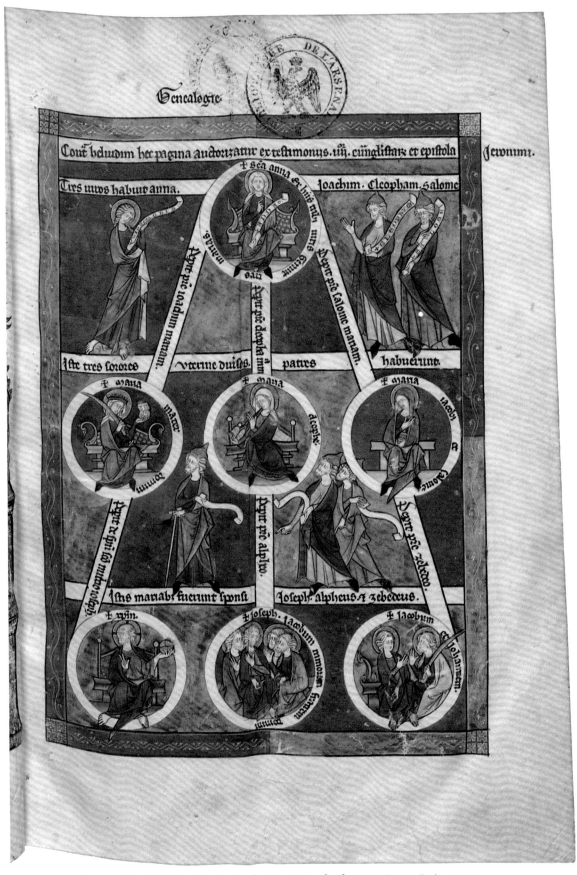

201. Diagram of the Holy Kinship. Gautier de Coinci, Miracles de Nostre-Dame, Paris, ca. 1300. Paris, BnF, Arsenal, ms. 3517, f. 7r. Photo: BnF.

Such diagrams could extend farther still. A northern French or Flemish miscellany dating to the second quarter of the thirteenth century prefaces a collection of texts by Jacques de Vitry with a crystalline diagram of the Holy Kinship extended to include one of its more tenuous members, St. Servatius of Maastricht (fig. 202).[132] According to a legend first witnessed in the tenth century by Heriger, abbot of Lobbes (ca. 925–1007), Servatius, who is said to have died in 384, was the great-great-grandson of the maternal aunt of Mary the mother of God.[133] As in Berthold's diagrams, double lines filled with colored dots trace family ties. At the top, identified as sisters (*Sorores*) are Anne and Esmeria. Whereas Anne of course is the mother of Mary who is the mother of Christ (the line of descent depicted at the left), Esmeria, occupying the right half of the upper roundel, is the mother of both Elizabeth, the mother of John the Baptist, and Eliud. Eliud, in turn, is the father of Emiu, who is the ancestor of Servatius. The philosopher and mathematician Gilles Châtelet (1944–

99), whose *Les enjeux du mobile* (translated into English as *Figuring Space*), whose range of reference includes such medieval authors as Hugh of St. Victor and Nicole Oresme, could have had just such a diagram in mind when he wrote: "Diagrams are in a degree the accomplices of poetic metaphor. But they are a little less impertinent—it is always possible to seek solace in the mundane plotting of their thick lines—and more faithful: they can prolong themselves into an operation that keeps them from becoming worn out. Like the metaphor, they leap out in order to create spaces and reduce gaps: they blossom with dotted lines."[134] In the case of the inverted family tree of the patron saint of Maastricht, Servatius himself, placed on the central axis yet standing apart from the remaining roundels, represents the tree's ultimate fruit. The diagram both respects the gap dividing him from the Holy Family and at the same time draws him near.

The extent to which abstract thought can or should be conceptualized in spatial terms remains a subject of intense debate among psy-

202. Diagram of the Holy Kinship including St. Servatius of Maastricht. Miscellany, northern France or Flanders, second quarter of the thirteenth century. London, British Library, Burney MS. 351, f. 110r (detail). Photo: © British Library Board.

chologists, linguists, and computer scientists.[135] The issue is ancient—as old as writing as a graphic system. Insofar as writing, whether on a page or, for that matter, any other surface, establishes a web of relationships among various linguistic units more complex than could ever be established in speech, it takes on a diagrammatic dimension.[136] Hrabanus's *carmina figurata* offer prime examples of this phenomenon. Are diagrams and diagrammatic modes of reasoning simply aids to, even crutches for, cognition, or are they part of its inherent architecture? The debate can and has been framed in terms of Nelson Goodman's distinction between digital and analog models, with the diagram representing an example of the differentiated, syntactical "digital" mode, whose categoric distinctions stand in contrast to the density and continuity of the "analog" mode.[137] In distinguishing between "homologous" and "homomorphic" traditions of representation, Peter Galison draws a similar division between images that are mimetic, fine-grained, and continuous and those that, relying on discrete datasets, seek to represent "the logical relation among events."[138] To borrow the terminology devised by Galison along with Lorraine Daston to describe the role of visualization in the sciences, diagrams represent Berthold's standardized "working-objects."[139] By virtue of their unfolding serial structure, however—comparable, in a sense, to sacred origami—Berthold's figures combine the continuity of the analog realm and the discrete, incremental character of the digital. Mediating between the two is the outline.[140] As observed by a student of graphs: "An outline translates between two forms of intelligibility—image and reading text. The visual form has a mimetic relationship not primarily to what it is expressing, but to how it is being ordered."[141] In Berthold's diagrammatic works, his ordering and reordering of his material is no less important than the substance of the diagrams themselves.

Gallison and Daston appeal to what they call "the disciplinary eye, analogous to what art historians call the period eye."[142] Baxandall's period eye is too general and in some ways too arbitrary a concept, however, to capture the phenomenon in question, given that the skills involved in creating and manipulating such diagrams remained the preserve of a small subset of the population. In Berthold's case, the intellectual environment in question consisted of university students, especially Dominican novices and friars in training. Modern analysts of diagrams such as computer flowcharts refer to them as boundary objects, not because of their hybrid nature, hovering between text and image, but rather because each is an "artefact that simultaneously inhabits multiple intersecting social and technical worlds."[143] In Berthold's case, the two worlds between which his diagrams mediate are that of the cleric concerned with theology and that of the classroom teacher interested in logic. "In each of these worlds, the boundary object has a well-defined meaning that 'satisf[ies]' the informational requirements' of the members of that community; at the intersection of these worlds, the boundary object is flexible enough in meaning to allow for conversation between multiple communities."[144] Each world is governed by rules, but the rules are flexible enough to accommodate the other.[145]

Such systems of categorization trace their origins to the semiotics of Peirce, who in defining diagrams as a subclass of icons stated, "Many diagrams resemble their objects not at all in looks; it is only in respect to the relations of their parts that their likeness consists."[146] Elsewhere he argues that the class of icons includes "every diagram, even although there be no sensuous resemblance between it and its object, but only an analogy between the relations of the parts of each."[147] Berthold did not go as far as Peirce, who confessed, "I do not think that I ever *reflect* in words: I employ visual diagrams, firstly, because this way of thinking is my natural language of self-communion, and secondly because I am convinced that it is the best system for the purpose."[148] Berthold hardly sets words aside, but no less than the pragmatist philosopher, he regarded the diagram as a necessary method of analysis and exposition.

Diagrams not only represent process but are produced by the process of drawing. As a result of the actions, real or imagined, required to design and manipulate them, that process in turn introduces an element of the material and corpo-

real into an area that is usually associated purely with cogitation and ideation. Once diagrams are viewed as material objects as well as abstractions, they can be seen as telling stories, not simply as representing noncontingent truths.[149] In the words of Brian Rotman, "To exclude diagrams . . . is to occlude materiality, embodiment, and corporeality, and hence the immersion in history and the social that is both the condition for the possibility of signifying and its (moving) horizon."[150] In Berthold's case, then, one pressing question concerns the immediate historical horizon within which he could have conceived of diagramming sacred history in the first place.

In its translation of argument by analogy into spatial terms, Berthold's diagrammatic method is heavily indebted to the use of diagrams in textbooks on logic. Logic diagrams employed in the medieval schools, in particular that known as the square of opposition, provide a point of entry not simply into the sources for Berthold's

diagrams but also into his diagrammatic method (fig. 203). As Walter Ong observed in his monograph on the logician Petrus Ramus (1515–72), the "geometrization of logic has much more to do with medieval developments in logic than with the logic of the ancient world. . . . Preoccupation with quantity here translated itself into geometrical arrangements of words in space."[151] Ong's formulation regarding quantity, words, and space itself provides an apt characterization of the *carmina figurata* of Hrabanus Maurus, in which numerology plays a critical role, right down to the dimensions of the poetic field. Moreover, Christianity, despite being predicated on paradoxes—the virgin birth, the human God, and, not least, a divinity who was both three and one—did not shy away from the language of logic. In treatises with names such as *De modo predicandi ac sylogizandi in Divinis*, syllogistic logic was applied to the mysteries of the Trinity.[152] The Shield of Faith, both a three-sided triangle and

203. Square of Opposition. Boethii Peri hermeneias Aristotelis Libri V, diocese of Constance (?), tenth century. Einsiedeln, Stiftsbibliothek, Cod. 301(469), p. 98 (detail). Photo: www.ecodices. unifr. ch.

CHAPTER FIVE

a single geometric figure, provides a potent example: the phrase "non est" (is not) that links the three corners to one another and the word "est" (is) that in turn links the corners to the word "Deus" as the center, recast trinitarian theology in terms of propositional logic, resulting in twelve separate statements: (1) the Father is God, (2) the Son is God, (3) the Holy Spirit is God, (4) God is the Father, (5) God is the Son, (6) God is the Holy Spirit, (7) the Father is not the Son, (8) the Father is not the Holy Spirit, (9) the Son is not the Father, (10) the Son is not the Holy Spirit, (11) the Holy Spirit is not the Father, and (12) the Holy Spirit is not the Son. Read in combination with one another, the propositions mapped out by the diagram effectively generate a Christian creed.

Ong published his book on Ramus in 1958. From a present-day perspective, he appears to have paid insufficient attention to the Middle Ages and too much to the claims of analytical philosophy regarding the semantic content of proof. It is therefore not surprising that his claim that the geometrization of logic "proved fruitless" now appears overly hasty. According to Ong, "The impulses stimulated by quantification would prove fruitful only when translated not into geometry but, centuries later, into the algebra which, with Boole and Frege, has brought about the impressive development of modern mathematical logic."[153] Frege's *Begriffschrift* (Concept-writing), Ong argues, "was to do for the nineteenth-century mathematical practice of reasoning from concepts, *Denken in Begriffen*, what Euclid's diagrams, Arabic numeration, and Descartes' symbolic language had done for earlier forms of mathematical practice; it was to provide a system of written marks within which to reason in mathematics."[154]

Ong's declaration effectively reiterates David Hilbert's statement of principle, made in 1894 near the beginning of his lectures that led to his groundbreaking *Grundlagen der Geometrie* (Foundations of geometry), published in 1899, that "a theorem is only proved when the proof is completely independent of the diagram."[155] In his critique of Euclid, Moritz Pasch (1843–1930), Hilbert's immediate point of reference, had ar-

gued that "the appeal to a figure is, in general, not at all necessary. It does facilitate essentially the grasp of the relations stated in the theorem and the constructions applied in the proof. Moreover, it is a fruitful tool to discover such relationships and constructions. However, if one is not afraid of the sacrifice of time and effort involved, then one can omit the figure in the proof of any theorem; indeed, the theorem is only truly demonstrated if the proof is entirely independent of the figure."[156] Both Pasch and Hilbert advocated for an arithmetization of geometry.[157] Like Pasch, however, Hilbert did not entirely reject diagrams as heuristic instruments.[158] Rather, for him they embodied an alternative manner of proceeding, not that which "seeks to crystallize the logical relations inherent in the maze of material that is being studied, and to correlate the material in a systematic and orderly manner," but rather that which represents "the tendency towards intuitive understanding," which "fosters a more immediate grasp of the objects one studies, a live rapport with them, so to speak, which stresses their contentual relations." The word that Hilbert uses for intuitive understanding, *Anschauung*, carries with it connotations of vision. In fact, it is the same word used in German to describe the vision of God—no doubt the farthest thing from the mind of Hilbert, who once said: "Galileo was no idiot. Only an idiot could believe that science requires martyrdom – that may be necessary in religion, but in time a scientific result will establish itself."[159] Yet Hilbert's emphasis on the immediacy of diagrams as well as the liveliness of their appeal to the imagination is one that medieval students of diagrams would readily have understood.

Transformed by the means and methods of computer graphics as well as the design of the underlying software, diagrammatic representation and reasoning have staged a forceful comeback over the past several decades.[160] The "free ride" pursued by researchers in cognitive psychology and artificial intelligence is in many respects identical to the sense of intuitive immediacy that, in contrast to the discursive parataxis of language, led medieval users of diagrams to associate them with the instantaneity of insight into

the divine. More recently, Gottfried Boehm has taken up this thread in a rather neo-Romantic fashion by stating of pictures that "their evidence is not that of the sentence."[161] In particular, the study of chaos and fractals has demonstrated that figures can reveal dimensions of relevant theorems that cannot be ascertained by computational means.[162] An article written in 1994—from the accelerated standpoint of the present almost a modern Middle Ages in terms of the development of computer technology—observes that:

> diagrams are a kind of *analogical* (or *direct*) knowledge representation mechanism that is characterized by parallel (though not necessarily isomorphic) correspondence between the structure of the representation and the structure of the represented. . . . The analogical representation can be said to *model* or *depict* the thing represented, whereas the propositional representation rather *describes* it. . . . The needed information can usually be simply *observed* (or *measured*) in the diagram, whereas it must be *inferred* from the descriptions of the facts and axioms comprising the propositional representation.[163]

In other words, rather than being mutually exclusive, text (or in this case algebra) and image (in this case diagram), rather than being mutually exclusive systems of signification, complement one another.

Going even further, not only do diagrams appear to be simply useful, but it seems they are necessary, as text- and image-based modes of representation cannot fully exclude each other. In the words of Rüdiger Campe, "By showing images and differential signs side by side, diagrams do not erase but, on the contrary, repeat and exhibit the distinction between image and differential notation through which they come into existence in the first place. Such re-emergence of the constitutive differentiation within a differentiated realm is what Niklas Luhmann, in his theory of forms, has called 're-entry': the re-entry of the formative act within its own product, the form. Thus we might contend that diagrammat-

ics means the re-entry of the distinction between image and writing within image or writing."[164] In its framing of the relationship between text and image as each containing within itself the seed of the other, Luhmann's analysis clearly owes a debt to Derrida's notion of the *supplément* as both addition and substitution.[165] The diagram compensates for something of which the text itself is not capable, yet as an image nonetheless remains dependent on the text in order to be comprehensible.

The debate over figure versus formula, diagrams versus sentential proofs, however, is hardly limited to postmodernist philosophy. Rather, it is at the heart of current debates regarding the role of representation in both mathematics and logic.[166] Logic remains the area of modern philosophy still most closely associated with diagrams, although the algorithm, represented in the form of a flowchart, has become virtually omnipresent, if not on then beneath the surface of things, controlling their appearance.[167] Observing that twentieth-century philosophers of mathematics dismissed diagrams in favor of logic, Kenneth Manders argues that philosophers have ignored what he calls the "representational contrast" between diagrams and text-based arguments.[168] In his words, which can shed light on medieval as well as modern practice, "If it is to give a nontrivial grip on life, in its particular way, an intellectual practice must give us—all too finite and human beings—a game we can play; and play well, together, and to our profit. To succeed in this, intellectual practices harness our abilities to *engage* their artifacts, as I will call it, to produce, preserve, and respond to artifacts in controlled ways. . . . The detour through artifacts is the trick,"[169] In Berthold's case, his diagrams represent the artifacts in question. They function as material extensions of his working mind.[170]

A large group of Berthold's diagram employ variations on a quincunx pattern: four circles, squares, or rectangles arranged symmetrically around a fifth such shape at the center. The type occurs repeatedly in the commentary on Hrabanus (figs. 4, 5–8, 10, 12, 14–15, 18, 21, 27, and 28), not surprising in that their basic structure resembles that of a *Maiestas Domini* such as

could be found in almost any Gospel book, but especially those from the early medieval period. The *Maiestas Domini* itself was founded on cosmological diagrams; the quincunx lays bare the image's underlying scaffolding.[171] A dramatic example of the extent to which medieval artists thought in terms of such diagrammatic armatures can be found in a Saxon copy of Lothar of Segni's *De miseria conditionis humanae* dating to the first half of the thirteenth century (fig. 204).[172] At first glance the disposition of the figures, a man with halo and outstretched arms at the center with four smaller male figures in the corners holding speech scrolls and gesticulating toward the center, immediately makes one think of the omnipresent image of Christ in Majesty. A

second glance, however, along with the inscription atop the image, reveals that rather than Christ, the miniature depicts Job. Rather than sitting enthroned within a mandorla of light, Job is surrounded by, not to put too fine a word on it, a pile of shit, the proverbial dung heap. The four figures in the corners are his fair-weather friends who mock him. The question arises: why did the artist have recourse to a familiar image in order to create something shockingly unfamiliar? Reliance on readily available patterns proves an insufficient answer. The miniature self-consciously selects an appropriate model: the abject Job, a type of the Man of Sorrows, prefigures the Christ of the Passion, surrounded by his tormentors (cf. Ps 21:17–19: "For many dogs have encompassed

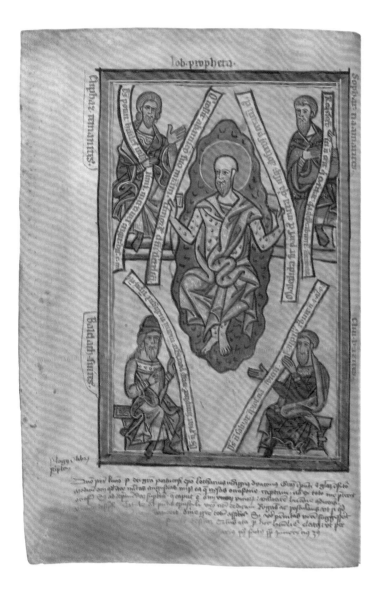

204. Lothar of Segni, De miseria conditionis humanae, Saxony, 1200–1250. Berlin, Staatsbibliothek zu Berlin— Preussischer Kulturbesitz, Ms. lat. qu. 657, f. 27r. Photo: bpk Bildagentur; Art Resource, NY.

me: the council of the malignant hath besieged me. They have dug my hands and feet. They have numbered all my bones. And they have looked and stared upon me. They parted my garments amongst them; and upon my vesture they cast lots."[173] To understand the image, the viewer must, in effect, see beyond its surface to the underlying diagrammatic configuration that structures its meaning in precise and appropriate ways.

In looking at Berthold's quincunx diagrams, his viewers would also have seen clear signs of Christ. The diagrams carry still other connotations, however, that require a keener understanding of the relationship of the parts to the whole. In particular, the quincunx pattern of many of the diagrams in the Marian section (figs. 1–2, 4, 9, 11, 20, 22–23, 25, 27–29, 38–42, 52, and 56–59) rely not simply for their architecture but also for the relationships among their parts on a diagram that would have been intimately familiar to Berthold's students: the square of opposition.[174] Rooted in Aristotle's distinction (in chapter 7 of his *De Interpretatione*) between contradiction (a pair of affirmative and negative statements) and contrariety (mutually exclusive propositions), the square constituted a fundamental part of medieval teaching on logic.[175] As an actual diagram, the square appears to have originated in the *Peri Hermeneias* of Apuleius of Madaura, a Neoplatonic philosopher of the second century.[176] Like so much else, however, it was transmitted to the Middle Ages through the writings of Boethius.[177] The square was applied to such standard topics as the relations of propositions, the construction of syllogisms (in particular the *inventio medii*, the identification of their middle term), the mathematics of musical intervals, and the relationship of elements within natural philosophy.[178] In other words, it could be found throughout the syllabus. Included in treatises on logic as an integral part of their presentation, it also appears in more ad hoc fashion, added by scribes in the margins to provide clarification of concepts.[179] The square, quite simply, became part of every student's toolkit.

As a tool for logic, the square has a mixed reputation and has lost much of its relevance, de-

spite recent attempts at rehabilitation.[180] Within art history, however, a variant on the square, known as a Klein diagram, has reasserted its persuasive power. In Rosalind Krauss's essay "Sculpture in the Expanded Field" (1979), then again in her book *The Optical Unconscious* (1993), the diagram was deployed to remap modernism as a topography rather than a linear narrative conceived of as "the history of an ever more abstract and abstracting opticality."[181] Krauss based her diagram in turn on the semiotic square, known as the Greimas square after the semiotician Algirdas Julien Greimas (1917–92).[182] Describing the diagram that serves as the instrument of her analysis, Krauss states, "I start with a square. In its upper right corner I write 'figure' and in its upper left I write 'ground.' I want this square to represent a universe, a system of thinking in its entirety, a system that will be both bracketed by and generated from a fundamental pair of oppositions. . . . But the universe I am mapping is not just a binary opposition, or axis; it is a fourfold field, a square."[183] The objects that interest Krauss, of course, could not be more different from those that fascinate Berthold. What the two have in common, however, is the way in which the square permits certain operations on those objects to be performed.[184] And what Berthold seeks to perform, at least in part, is an exercise in typological thought to which his diagrams are intended lend the force and authority of a logical demonstration.

Diagrams such as the square are neither illustrations of the texts that they accompany nor mere adjuncts to argument. Rather, they are tools with which to think—and, in Berthold's hands, with which to create. In the square of opposition, four concepts or propositions are placed at the corners. The top pair, defining the square's upper horizontal, represents contrary terms; the bottom two, along the lower horizontal, the subcontraries. Each term at the bottom stands as the subaltern (a specific instance, as opposed to the universal proposition) in relation to the term directly above it, along the vertical sides of the square. The diagonals mark contradictory terms. In his treatise on Aristotelian logic, the *Summulae logicales*, the thirteenth-century scholar Pe-

ter of Spain, whose precise identity remains unknown, provides clear definitions of these terms:

> The universal affirmative and universal negative with the same subject and the same predicate are contraries, like "every man runs" and "no man runs." The particular affirmative and particular negative with the same predicate are subcontraries, like "a–certain man runs" and "a–certain man does not run." The universal affirmative and particular negative, or the universal negative and particular affirmative, with the same subject and the same predicate, are contradictories, like "every man runs" and "a–certain man does not run." The universal affirmative and particular affirmative, or the universal negative and particular negative, with the same subject and the same predicate, are subalternates, like "every man runs" and "a–certain man runs" or "no man runs" and "a–certain man does not run."[185]

To exemplify these definitions and to make them easier to remember, Peter proceeds: "This is clear from the diagram," namely the square of opposition.

Nicole Oresme (1320–82), a philosopher and polymath, provides an example of this way of thinking in action—and on the parchment page. His *Le libre du ciel et du monde*, a translation of and commentary on Aristotle's *De caelo* commissioned by Charles V of France and completed in 1377, presents three instances of the square, which he likens to "that used to introduce children to logic," spread across several folios, as part of his argument against Aristotle's proposal that the world is ungenerated and indestructible (fig. 205).[186] For obvious reasons, this claim was objectionable from a Christian point of view, so much so that it stood at the heart of the various propositions successively condemned in Paris and Oxford in 1270 and 1277.[187] In the second of the three diagrams, the circles at upper left and upper right, labeled *a* and *b*, correspond to the propositions "Tousjours estre" (always existing) and "Tousjours non estre" (always nonexisting), while those at the lower left and lower right, labeled *g* and *d*, match those reading "avoire com-

mencement" (having a beginning) and "avoir fin" (having an end). The middle term, at the intersection of the diagonals, is marked "convertibles," meaning that the subject and predicate of a syllogism constructed from such a square can be interchanged without affecting its truth content. In the subsequent square, inserted into the right-hand column, the circle at upper left is inscribed *e*, "sans commencement" (without beginning), that at the upper right *l*, "sans fin" (without end), that at the lower left *t*, "avoir fin" (having an end), and that at the lower right *z*, "avoir commencement" (having a beginning), whereas the diagonals connecting the corners are labeled "contradictoires" (contradictions). The commentary accompanying the second of these squares offers the following explanation:

> Let us assume that always-being is *a* and always-not-being is *b*, having-a-beginning is g and having-an-end is *d*. With this assumption, *g* will necessarily be intermediate between *a* and *b*, for neither past nor future times of *a* and *b* have a limit. And we cannot say of *a* that it has not existed at some time and will not exist at some time; and the same holds for *b*. But that which had a beginning must have a time limit as to both beginning and end, and it must have an end in actual fact or potentially so that it will become a fact. Now the time of *a* and of *b* has no past or future limit. Consequently, *g* will exist through a limited period of time, and then it will not exist; the same is true of *d*. Thus, *g* and *d* have both beginning and end, the one implying the other; that is, everything having a beginning has an end, and everything having an end has had a beginning.[188]

In each instance of the square, the illuminator employs two distinct colors—red and black—to distinguish and highlight the operative oppositions. Oresme marshals the tools of logic—visual as well as verbal—to challenge the authority of Aristotle's assertion, contrary to Christian belief, that the created world is without beginning or end.

Berthold need not have drawn directly on a logical or scientific treatise. In at least one in-

205. Squares of Opposition. Nicole Oresme, Le libre du ciel et du monde, Paris, 1377. Paris, Bibliothèque nationale de France, ms. fr. 1082, f. 53v. Photo: BnF.

stance, however, the same diagram, disposed in a similar manner, can be documented as having formed part of the visual culture in which Dominican novices were educated.[189] The diagram and another derived from it occur among the twenty nine illustrations to a Dominican treatise of anonymous authorship, the *Libellus de consolatione et instructione novitiorum* (A little book for the consolation and instruction of novices), dated circa 1300. Although the manual survives in only a single early fourteenth-century manuscript from the important Dominican library at Toulouse, its text indicates that it was approved in 1283 at the general chapter of the order in Montpellier, which suggests it might have received or at least was intended for wider distribution.[190] The anonymous author neatly en-

capsulates the devotional aspect of diagrammatic didacticism in alliterative prose: "I therefore paint here certain images I made so that desolate novices might find consolation in them and so that a little flame of newly fervent and more devout devotion might be kindled, making perceptible matter from celestial signification."[191] The images, the diagrams included, are intended to ignite devotional desire.

The first diagram, limited to a single column of the text, provides the reader with "a certain geometric demonstration through which it is proven that those who indulge in the trappings of the world will be sentenced to the punishment of hell" (fig. 206).[192] For this, geometry supplies "necessary arguments." At first the instructions read as if they were taken from a textbook on

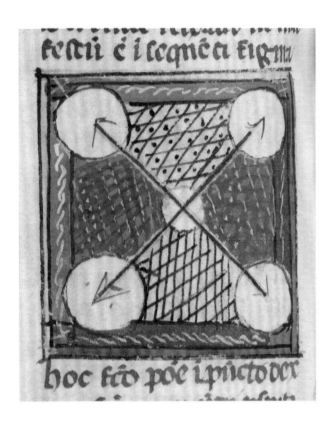

206. Square of Opposition. Libellus de conso-
latione et instructione novitiorum, Toulouse,
ca. 1300. Toulouse, Bibliothèque municipale,
ms. 418, f. 144v (detail). Photo: © Gaston
Boussières.

geometry. The reader is told to lay out the figure
of which the miniature heading the chapter pro-
vides a set-piece demonstration:

> Indeed, for this purpose the geometric
> art will serve you—to prove and to visualize,
> almost by necessity, the argument that those
> who have indulged in the trappings of the
> world during their lifetimes will be sentenced
> to the punishment of hell, and those who die
> in penitential suffering reach the repose of
> the blessed. And you will be able to prove this
> by geometric rationale through this method,
> if you should make two points on the right
> side one after the other, then make another
> two points on the left side; the ones on the
> right the same as the others on the left, such
> that those four points are made into a kind of
> square; and in the middle of those points (i.e.
> in the middle of the square shape) you should
> make one point. Yet then it is possible if, from
> the upper points (the right and the left, of
> course) two straight lines are extended to the
> point placed in the middle, at which there is
> a necessary convergence, and if you were to

extend those two straight lines further to the
two other lower points, namely the right and
left, at which points the lines are finally ended,
by necessity that line which had begun at the
upper right point would be finally brought to
an end at the point positioned in the lower left;
and so similarly from the opposite perspective,
that line would be finally brought to an end at
the lower right point, which had begun at the
upper left, as is clear in the following figure.[193]

In short, what the reader is directed to produce,
either before his mind's eye or on a wax tablet or
a scrap of parchment, is the geometric armature
of the square of opposition.

What follows, however, are instructions not
on how to use the square to solve problems in
logic but rather on how to apply a moral gloss,
in the words of the *Libellus*: "And these things
which have been said are sufficiently clear in the
following figure, since geometry, serving salvif-
ic wisdom in this way, teaches how to produce
it."[194] As in the case of board games, process is
key. The product is a second diagram that comes
at the end of the chapter (fig. 207).[195] The reader

207. Parable of Dives and Lazarus imposed on Square of Oppostion. Libellus de consolatione et instructione novitiorum, Toulouse, ca. 1300. Toulouse, Bibliothèque municipale, ms. 418, f. 146r (detail). Photo: © Gaston Boussières.

is instructed to transform what was originally a bare-bones logic diagram into an elaborate lesson in salvation. The manuscript demonstrates what is intended in a diagram almost four times the size the first, which spans the entire width of the page.

Four roundels, outlined alternately in yellow and blue, create the familiar chiastic pattern. The blue and yellow lines that intersect at the center further reinforce the cross scheme. The accompanying text that, given its unique nature, is worth quoting at length, instructs the reader both on how to produce and on how to interpret the resulting image:

> When this has been done, at the upper right point put "the prosperity of the world"

and on that some lustful person indulging in its trappings, like the rich banqueter. At the one upper left point put "the penalty of penance" and on that poor and afflicted humble penitent, like Lazarus, full of sores and looking beggarly. At the single middle point put "death" and for the two other lower points write "the repose of the blessed" at the right point and "hell and the punishments of the damned" at the one left point. It is necessary, however, for the one living at the right point (i.e., in the prosperity of the world like a wealthy banqueter), just like the one living at the left point (i.e., in penitential suffering like a poor and beggarly Lazarus), should come to the middle point, to death that is, since it is written of each "The rich man died," and again,

"It happened that the beggar died." Moreover neither the rich man nor Lazarus will be able to stay at the point [*in puncto*] of death, since the soul does not die when it is disjoined from the body. Therefore it is necessary that these two men, the rich man and the poor man, should pass to the other two points, namely the right and the left. Therefore if those two lines along which the rich man and the beggar arrived at the middle point, that is, death, are extended by a straight diameter of the other, that one, whose line (i.e., present life) was at the right point, by which we mean in the trappings of this world, through which he came to the middle point (i.e., death), must, having passed through the middle point (i.e., death), be brought over at last to the left point (i.e., the punishment of hell). So it is forever without end. Likewise also, by contrast, that one whose line (i.e., present life) was at the left point (i.e., in the penalty of penance), through which he came to the middle point (i.e., to death), must, having passed through the middle point in death, be brought over at last to the right point (i.e., into the rest of the blessed). And so forever without end.[196]

The treatise's instructions combine method and moral; the reader is told not only which image should be placed where but also how they should be both inscribed and interpreted. Were the manuscript not illuminated, one could easily assume that the images the author describes ought only to be imagined, rather in the manner in which a reader versed in the *ars memorativa* might populate the various houses or chambers making up a memory palace. In this case, however, the manuscript's makers adopted the author's insistence on visualization. As a result, the text is treated, first, as a set of instructions to the illuminator and, second, as a step-by-step introduction to its iconography.

Whereas the text asks the reader to populate the preexisting diagram with scenes from the parable of Dives and Lazarus, the miniature fleshes out the image right before his eyes within an armature that structures the process of interpretation. The two inscriptions that run vertically to the left and right of the dividing line set the tone. That to the left reads, "The life of the penitent is different," that to the right, "The life of sinners is different."[197] In keeping with the model provided by the square of opposition, the two scenes are contraries of one another. Occupying the upper left roundel is a penitent in a hair shirt. The accompanying inscription reads: "The difficulty of the world. Lazarus the beggar doing penance." Opposite him, to the right, in a scene reminiscent of the feasting that represents the occupation of the month for January, a man seen in profile drinks wine from a cup while sitting at a table laden with culinary delights. The inscription above him reads: "The prosperity of the world. A rich beggar abusing indulgences."

Two further vertical inscriptions define the difference between the subcontraries at the lower level.[198] The first, to the left of the central divider, reads: "The punishment of hell is different. These are some of the punishments of hell," while that to right reads: "The rest of heaven is different. These are some of the delights of heaven." Indeed they are: the roundel to the left shows the gluttonous sinner who formerly feasted at the upper right now being devoured within the hell mouth at the lower left. His reversal of fortune is reflected by the equal but opposite transformation along the opposing diagonal, that running from upper left to lower right, where Lazarus stands, flanked by adoring angels. The inscription above his head reads: "The right part. The compatriots of the holy fathers. Lazarus the beggar," whereas that above the rich man to the left reads: "The punishment of hell. The rich banqueter." Across the upper and lower horizontals, beggar and banqueter represent contraries and subcontraries respectively; they are opposed to one another. Along the diagonals, each is transformed into the contradiction of his former self, with the two states, whether of suffering and salvation along the left-to-right diagonal or luxury and damnation along the right-to-left diagonal, a state that mutually excludes that which existed previously. Less logical are the subaltern relationships defined by the vertical sides of the square, which explains why the author conveniently fails to explain them.

Not only the figure itself but also its directionality is allegorized. The author first glosses the diagonal running from upper left to lower right:

> And therefore according to the righteousness of divine justice that rich banqueter has passed from the trappings of the world to the punishments of hell, as is natural concerning the reward for those who "spend their lives in prosperity and in a moment [*in puncto*] go down to hell." And that beggar deservedly passed from the penalties of penance to the lap of Abraham (i.e., to the rest of the blessed fathers), as is natural concerning the reward for those about whom the Spirit (obviously of God) [said]: "Blessed are the dead who die in the Lord. Indeed from this moment the Spirit says that he may rest from his labors." Since, according to philosophy, every movement is from opposition, in opposition, therefore there is no movement in the trappings of this world to the delights of heaven, and from the punishments of heaven to the punishments of hell, but rather, by contrast, one moves from the trappings of the world to the punishments of hell, and from the penalties of penance one moves to the delights of heaven. And therefore it has been written about each: "It happened that the beggar died and was carried by angels into the lap of Abraham. But the rich man also died, and was buried in hell." Therefore Abraham said to the rich man experiencing torment: "Son, remember that you received prosperity in your life, and likewise Lazarus took on what was bad. But now he is comforted, whereas you are tormented." Let him say, as it were, "While alive, you were on the right side because you received prosperity in your life, and while Lazarus was alive he was on the left side, since likewise he took on his own evil; and therefore Lazarus, now dead, is on the right side, because he is now comforted; whereas you, now dead, are on the left side. You are now tormented."[199]

Despite being quartered, the miniature in the *Libellus*, contrary to custom, does not, like a Last Judgment, adopt heraldic left (*sinister*, i.e., the viewer's right) and right (*dexter*, i.e., the viewer's left). The failure to do so is all the more striking in light of the miniature's subject matter; a medieval viewer would expect to see hell on the right and heaven on the left. In this case, however, the structure of the square of opposition overrides the usual orientation.

Having allegorized the left-to-right diagonal, the author then turns to its converse: "Something is said about this right and left side [of the square] in Genesis allegorically [*in figura*]. Abraham said to Lot: "I beg there be no quarrel between me and you. For we are brothers. If you will go left, I will take the right. If you will choose the right, I will proceed to the left."[200] There follows a potted allegorical dialogue between Spirit and Flesh:

> Therefore sometimes the spirit says to the flesh, having been conquered by its lust, "I beg there be no quarrel between me and you. For we are brothers. If you carry on to the left, namely by humbling yourself in this world with/through penance, I will take the right in the future [i.e., to heaven as depicted in the lower right roundel]. . . . If you will choose the right in this world [that is, by abusing its trappings and sins], I will proceed to the left in the future, that is, with the damned" [as depicted at the lower left].[201]

In pitting flesh against spirit, the dialogue enacted by the *Libellus* recalls the action at the center of one of the two ladder diagrams in the *Speculum Virginum*, the very one from which the ladder diagram in Berthold's commentary on Hrabanus was derived (see fig. 58). On the ladder, whose form mimics that of the cross, Reason and Wisdom, the two female personifications occupying the cross-arms, assist Flesh (*caro bonum*), who in turn clings to the trailing ends of the cloak worn by the Spirit (*spiritus melius*). Beneath Flesh, the Law, incarnated by a woman holding the sword of sacrifice and a book labeled "Do not lust" (*non concupisces*), looks upward, even as she is left behind, not only spatially but

also, more importantly, temporally. The New Law supersedes the Old.

The *Libellus* in Toulouse provides incontrovertible evidence that at least in some quarters, the square of opposition formed part of the formal education of Dominican novices. It also shows that, as in Berthold's practice, the square as an armature could then be put to effective use within other contexts, in this case, moral instruction. Thomasin von Zerklaere's *Der Welscher Gast*, a didactic work in the vernacular addressed to a literate aristocratic readership, likewise assumes easy familiarity with the square. Within his illustration of the Seven Liberal Arts, it represents Dialectic.[202] In the manuscript in Gotha, Aristotle kneels before the enthroned Dialectic like a lover before his lady (fig. 208).[203] The two hold aloft a square of opposition packed with tiny inscriptions. That joining the two uppermost corners reads *Omnis nullus contrariae* (All not any contraries); the two lower corners, *Quidam quidam non* (A certain thing, not a certain thing). The sides are each inscribed *Subalternae* (Subalternatives); the diagonals, *Contradictoriae* (Contraries). The related verses (vv. 8941–44) simply declare, "Dialectics also has its followers, and the best are Aristotle and Boethius, Zeno and Porphyrius."[204] The poem provides no explanation of the square nor, for that matter, of any of the other diagrams chosen to exemplify

other arts, presumably because, at least for some readers, none was needed. The diagrams serve less as tools for use than as attributes of the various branches of learning, all the more in that the inscriptions are written in Latin rather than the vernacular of the poem. Nonetheless, in most of the manuscripts, care was taken to depict them as accurately as possible.

The use of diagrams as the attributes and instruments of the arts was not confined to codices; they also appear on the walls of churches, whether in monumental frescoes, as in Italy, or scratched into plaster, as at the Romanesque church at Bro in Gotland, Sweden, where at some point, most likely in the thirteenth century, someone, perhaps a schoolteacher, inscribed a syllogism and a square of opposition, together with some of the associated terminology (*subalternae*, *affirmate universale*, and *particulare affirmate*) on a surface in the tower, along with a cosmological diagram of the four elements and their properties.[205] In effect, what this learned graffiti present is a medieval blackboard. At the other end of the scale is the mural (Ferrara, Pinacoteca), now dismounted, from the Augustinian church of S. Andrea in Ferrara, which was painted circa 1378 by Serafino de Serafini (1349–93).[206] In light of the fact that the fresco is now partially lost, manuscript miniatures such as the frontispiece by Nicolò di Giacomo

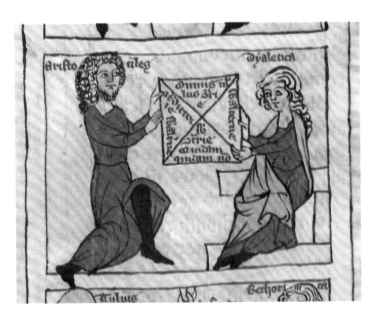

208. Aristotle Kneeling before Dialectic. Thomasin von Zerklaere, Der Welscher Gast, eastern Franconia (?), ca. 1340. FBG, Memb. I 120, f. 65v. Photo: FBG.

209. Frontispiece. Bartolo de Sassoferrato, In primam et secundam partem Infortiati commentaria. In primam et secundam Digesti novi partem commentaria, Bologna, ca. 1360–70. Madrid, Biblioteca Nacional, Mss/197, vol. 2, f. 4r. Photo: Biblioteca Nacional.

for Bartolus de Sassoferrato, *Lectura super digesto novo*, dated circa 1360–70, provide a more reliable record of both its overall program and the content of its *tituli* (fig. 209).[207] At the left in the uppermost tier, among the arts, Theology, dressed in a white mantle, looks toward the center to the order's patron, Augustine, who holds two small mirrors, that on the *dexter* side, the viewer's left, labeled *sapientia* (Wisdom), that on the right *scientia* (Knowledge or Philosophy). To each side, four historical figures embody each of these broad categories of human understanding: on the left the holy saints and prophets Jerome, John the Evangelist, Paul, and Moses; on the right four philosophers, Aristotle, Plato, Socrates, and Seneca. Above the figures embodying Wisdom stands the diagrammatic *rota in medio rotae* (cf. Ez 1:15–16), the wheel within a wheel, itself a symbol of the invisible world; at its center is an open Bible, the attribute of the personification of Wisdom. Above the four philosophers stands a diagram of Creation, the attribute of Philosophy, with the earth at the center, followed by the three other elements (Water, Air, Fire), the seven planets, and the zodiac. In keeping with tradition, the spheres are depicted as a hierarchical series of congruent circles. Comparable to a set of jamb figures on the facade of a Gothic cathedral, the second tier consists of Virtues trampling figures exemplifying the Vices, beneath whom, in the third and lowermost tier of the image, are shown, as if in a series of classroom scenes, representatives of the Seven Liberal Arts. At the center of the fresco sits the personification of Faith, with a tree diagram of the Credo enumerating the articles of faith in front of her; the tree grows from the Church in which it is rooted.[208] Serafini's mural, a gigantic diagrammatic scaffold for the various branches of knowledge, was not confined to the cloister; rather, it stood on the inner face of the west facade of the church. It was assumed that visitors would be able to decode its complex pictorial program.[209]

Berthold relied on similar schemes and on his readers' familiarity with them. In this he was not alone. Writing in the mid-fourteenth century, the same Iacobus Nicholai de Dacia whose

Metrum XXVII took as its point of departure the board for Nine Men's Morris, based another poem, his *Metrum* XXIII, on the square of opposition (fig. 210).[210] In the center, at the point at which the diagonals representing contradictions converge, stands an illuminated initial *M* for *Mors*. A reproach against Death's destructive power, the poem, like the square, requires that the reader combine its component parts according to the logical patterns (contrareity, subcontradiction, subalternation, and contradiction) that the square maps out. Thus the top horizontal, read from left to right along the line of contrareity, reads, "Mors nox tetra replet mundum satis anxietate" (Death makes the dark night and the world replete with anxiety); that along the lower horizontal, the line of subcontrareity (the first of several which only fully make sense when combined with others), "Latro vulnero dat mortis laquem michi cerno" (A robber inflicts wounds; the noose of death shows itself to me); those along the vertical lines of subalternation, "Mors Misere Lacerat Fraudes Fabricat Quasi Latro" (Death inflicts suffering; he fabricates deceipt like a thief) and "Anxietate teror iam flens finem modo cerno" (Crying with anxiety, I decay; I see the end coming); and those along the diagonals of contradiction, "Mors geminat fletum mors turbat cetera cerno" (Death doubles tears, the other visibly confuses Death) and "Latro tibi lucrum mors vim rapit anxietate" (A robber robs you of wealth; Death seizes you forcefully with anxiety). As James explains in the comments attached to the poem, many other combinations are possible as well: "They [the verses] can always be read in a backwards manner or in a direct manner progressing from side to side, from one corner to another, the contraries, subcontraries, subalternates, and contradictions of the opposite corners and in other diverse ways, and thus one ascends to thirty-two verses or more." The logic of the patterns plotted by the poem match the inevitability of death that the poem laments in interlocking repetitive verses.

What the *Libellus* spells out in painstaking, pedantic detail, Berthold takes for granted. In the first diagram of his Marian treatise (see fig. 117), which offers an encapsulated lesson in basic

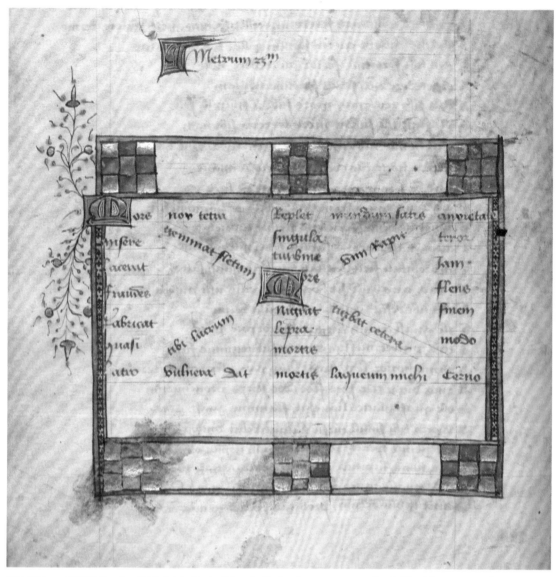

210. Metrum XXIII. Iacobus Nicholai de Dacia, Liber de distinccione metrorum, Cambridge (?), 1363. London, British Library, Cotton MS. Claudius A.XIV, f. 17v. Photo: © British Library Board.

typology, Adam, at the upper left, is the partner, yet superior, of the subaltern Eve (who, by virtue of having been formed from Adam's rib, could be thought of as literally being merely a part of her male progenitor). In the case of Christ and Mary, the diagram posits the same relationship, although in this instance just how one represents the particular, the other, the universal, remains unclear, suggesting that there were limits on the degree to which theology could be recast in terms of rigorous logic. The efficacy of the diagram, however, extends quite far. Adam supplies the contrary of the New Adam, Christ. Moreover, Adam and Mary, like Christ and Eva, are contradictions of one another. Transecting the simple yet elegant image, which is rooted in the chiastic structure of the square of opposition, the bipartite tree suggests both the Tree of Life and the Tree of Knowledge. As in Oresme's instances of the square of opposition, Berthold's diagram makes use of color to clarify relationships. Whereas Oresme employs a chiastic arrangement of green and red to enhance his diagram's legibility, Berthold introduces a symbolic dimension. The Dominican associates green, the color of the Tree of Life, with Christ and Eve; blue, the celestial color par excellence, with the Virgin Mary and Adam.

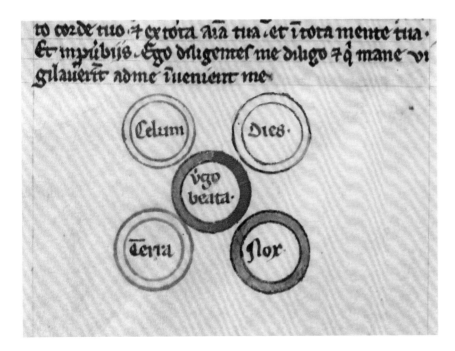

to corde tuo · et ex tota aïa tua · et in tota mente tua · Et in prïbus · Ego diligentes me diligo · et q̄ mane vi gilauerit ad me ïuenient me ·

211. *Figura* 4: On the Restoration of Creatures and of Time. Berthold of Nuremberg, Liber de misteriis et intemerate Virginis genitricis Dei et Domini nostri Ihesu, Lake Constance region (?), 1292–94. FBG, Memb. I 80, f. 49r (detail, on its side). Photo: FBG.

The structure of the square of opposition as applied to quincunx figures does not carry through the entire series. In fact, of the remaining seventeen *figurae* that employ the layout (2/4/9/11/20/22/25/32/31/38/39/40/42/52/56/57/58), only the following pair (2 and 4) applies its logic rigorously. Elsewhere Berthold uses the configuration variously, for example, to create centralized compositions (as in figure 25, in which Mary stands at the center of the four rivers of paradise) or to establish parallel pairs (as in figure 40, which compares Hannah's presentation of Samuel in the temple (1 Kgs 1:23–26) to Mary's presentation of Christ. That the three instances in which the square clearly served as model all come at the beginning of the series suggests it represented Berthold's point of departure. In the words of Mary Carruthers, "The square serves the generation of arguments and composition of new thoughts from these inventions."[211] In the second figure Eve and Mary stand as contraries; Pride and Humility, subalternate to Eve and Mary respectively, are subcontraries. Along the diagonal axes, Eve and Humility are contradictory, as are Mary and Pride. The next diagram to employ the quincunx pattern, the fourth in the series, appears to abandon the logic of the square (see fig. 120). Heaven and Day are not contraries, nor are Earth and Night. If,

however, one rotates the square so that the two roundels on its right side instead form its uppermost edge, the familiar rules once again apply (fig. 211). Now Day and Night stand as contraries of one another, as do Heaven and Earth. Heaven is subaltern to Day as Earth is to Night. Heaven and Night on the one hand and Earth and Day on the other provide the pair of contradictions.

The logic of the square of opposition is closely linked to that of typology. Most of Berthold's diagrams, at least in his Marian compendium, are figural in this root sense: they diagram prefigurations of the Virgin Mary and their relationship to New Testaments antitypes from the life of the Virgin.[212] Following its emergence in the early Christian period and its codification in the twelfth century, above all in the art of the Mosan region and in the great stained-glass programs of early Gothic cathedrals, typology entered an era of unprecedented expansion during the thirteenth century.[213] This was the period that witnessed the creation and dissemination of typological manuals or handbooks that both systematized and popularized typological imagery to an unprecedented degree. Illustrated copies of these books, to which visual figuration was as fundamental as its verbal elaboration, themselves employed elements of the diagrammatic method. From the later thirteenth century right

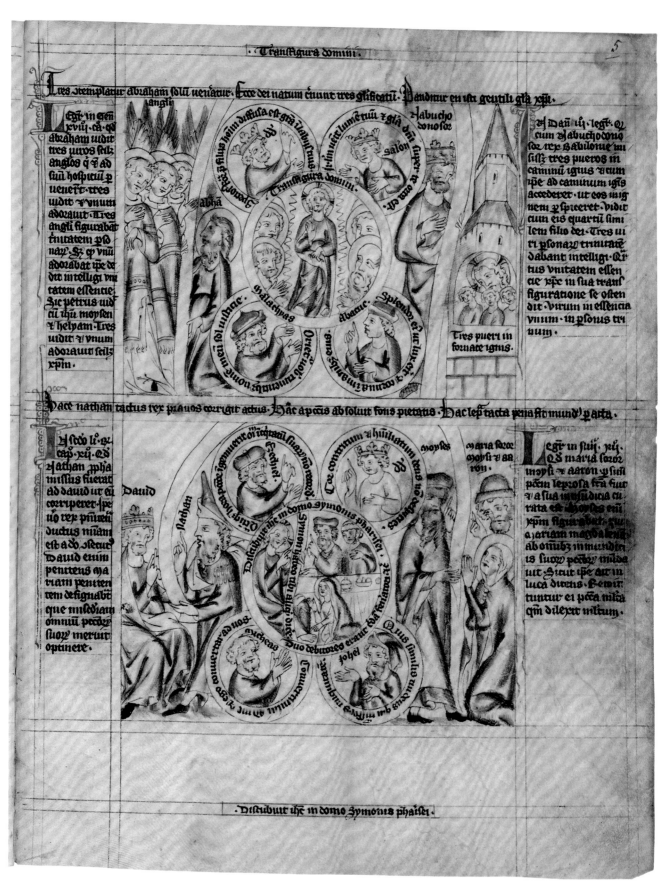

212. Transfiguration; Christ in the House of Simon the Pharisee. Biblia pauperum, southern Germany, ca. 1330–40. Munich, Bayerische Staatsbibliothek, Clm 23426, f. 5r. Photo: BSB.

through the end of the Middle Ages, the *Biblia pauperum* and the *Speculum humanae salvationis* provided standard points of reference.[214]

There are relatively few precedents for Berthold's reduction of typological pairings to geometric patterns. Herrad of Landsberg's *Hortus deliciarum* contained two complex typological diagrams, both in the form of *rotae*.[215] Typological art, however, traditionally narrative in content but schematic in form, always included an element of diagrammatic abstraction simply by virtue of operating within a highly structured system of comparison and opposition.[216] In early copies of the *Biblia pauperum*, each page relied on a basic quincunx pattern derived from representations of the *Majestas Domini*.[217] Even without consideration of the content that filled the five roundels, four smaller ones in the corners (types) surrounding a single large one at the center (antitype), the composition itself sufficed to say Christ (fig. 212).[218] Juxtapositions of Old and New Testament subject matter depicted in like manner gave what might otherwise seem obscure or far-fetched analogies a seeming logic all their own.[219] So irresistible was the visual logic of typological analogy that Jewish artists were compelled to create alternate ways of depicting episodes from the Hebrew scriptures in order to avoid typological implications.[220]

Typology, which traced Christ's ancestors down the Davidic line, necessarily dealt with genealogical subject matter. In the second part of Berthold's compendium, that dedicated to the Virgin Mary, in which typology is the predominant theme, parallels between his diagrams and the genealogical imagery in works such as Peter of Poitiers's *Compendium historiae in genealogia Christi* are especially apropos.[221] Techniques of representing logical and genealogical relationships overlap in Peter's representation of the complicated line of descent from Solomon, in which his task was to harmonize the contradictory accounts of Christ's ancestry according to Matthew 1:1–17 and Luke 3:23–38. According to the Church historian Eusebius (in the translation of Rufinus of Aquileia), who cites the historian Sextus Julius Africanus (ca. 160–240),

Matthew recounts the biological, Luke the legal ancestry:[222]

> Matthan and Melchi each begot a son at different times from the same wife, Estha, because Matthan, whose descent was through Solomon, was the first to take her as wife; he died, leaving one son, Jacob. Since the law does not forbid a widow to marry another man, Melchi, whose family was descended through Nathan, took Matthan's relict as wife after his death, since he was of the same tribe, but not from the same family. From her he too got a son named Heli, and thus it came about that Jacob and Heli were brothers from the same womb, their fathers being of different families. One of them, Jacob, took the wife of his brother Heli, in accordance with the law, when he died without children, and begot Joseph. Joseph was his son by the nature of procreation, and it is written accordingly: "Jacob begot Joseph." According to the precept of the law, however, he was Heli's son; it was his wife whom Jacob had taken, because he was his brother, in order to raise up seed for his brother.[223]

To clarify these tangled relationships—which amount to what technically, according to Deuteronomy 25:25–26, is termed a Levirate marriage in which the brother of a deceased man is obliged to marry his brother's widow—and to make them easier to remember, Peter provides a diagram based on the square of opposition (fig. 213).[224] In a copy of his *Compendium* (Aarau, Aargauer Kantonsbibliothek, MsWettF 9), illuminated in Basel in the second quarter of the fourteenth century, Matthan and Melchi, the two husbands (in that order) of Estha, placed at the center, occupy the roundels constituting the upper right and left corners of the square, whereas the sons of each of those unions, Jacob and Eli respectively, occupy those at the lower right and left.[225] Matthan and Jacob represent the direct line of descent, indicated by the thick red line that connects Matthan to his ancestor Solomon, above, and to his descendant Joseph, below. The horizontal bar

213. Estha, Matthan, Melchi, Heli, and Jacob. Peter of Poitiers, Compendium historiae in genealogia Christi, Basel (?), ca. 1325–50. Aarau, Aargauer Kantonsbibliothek /MsWettF 9, f. 243v. Photo: www.e-codices.unifr.ch.

connecting the two fathers, Melchi and Matthan, reads "ligatus enim occisus" (connected because killed), a reference to Melchi's having succeeded Matthan following the latter's death as Estha's husband. Mapped onto the square of opposition, their relationship is contrary in that they could not have been married to the same woman simultaneously. The bar connecting Eli and Jacob, the two sons, reads "uterini fratres" (uterine brothers), identifying them as stepbrothers by the same mother. Mapped onto the square in the same fashion, their relationship, analogous to that of their fathers, is subcontrary. The vertical lines connecting fathers and sons read "carnalis filius" (carnal sons), the equivalent in the square to subalternation. Finally, the diagonals linking the two fathers via Estha to the two sons read "coniuges filius" (conjugal son) and represent the lines of contradiction connecting the corners in that Matthan is not the father of Eli while Melchi, in turn, is not the father of Jacob.

Peter of Poitiers's *Compendium* normally occupied a long roll, conducive to its unfurling of sacred history. In the manuscript from Basel, however, in which the work is combined within a codex with the *Historia scholastica* of Petrus Comester and the set of didactic diagrams known

as the *Speculum theologiae* attributed to John of Metz, one has only to look across the opening to see on display a variety of other diagrammatic techniques employed by Berthold, including descending trees employing both straight and curved lines to connect roundels standing for protagonists of sacred history.[226] Dominating the spine of the page are the roundels representing Joseph, Mary, and Christ (fig. 214).[227] It is striking that despite Joseph's not having been Christ's father, in keeping with the laws of patrilineal descent, Mary's roundel is less than half the size of that of either male figure.

In some respects Berthold's Marian compendium provides a worthy predecessor of the Dominican Franz von Retz's *Defensorium inviolatae perpetuaeque virginitatis castissimae genetricis Mariae*, composed circa 1400. Largely typological in content, von Retz's treatise, like Berthold's Marian supplement, focuses exclusively on the Virgin Mary.[228] But unlike Berthold's work, which remained a unicum, the *Defensorium* had a significant impact on the visual arts in the fifteenth century.[229] Its imagery found its way into print, first in two block book editions (1470 and 1471), then in as many as five further incunables (ca. 1475–99), of which the most extensively il-

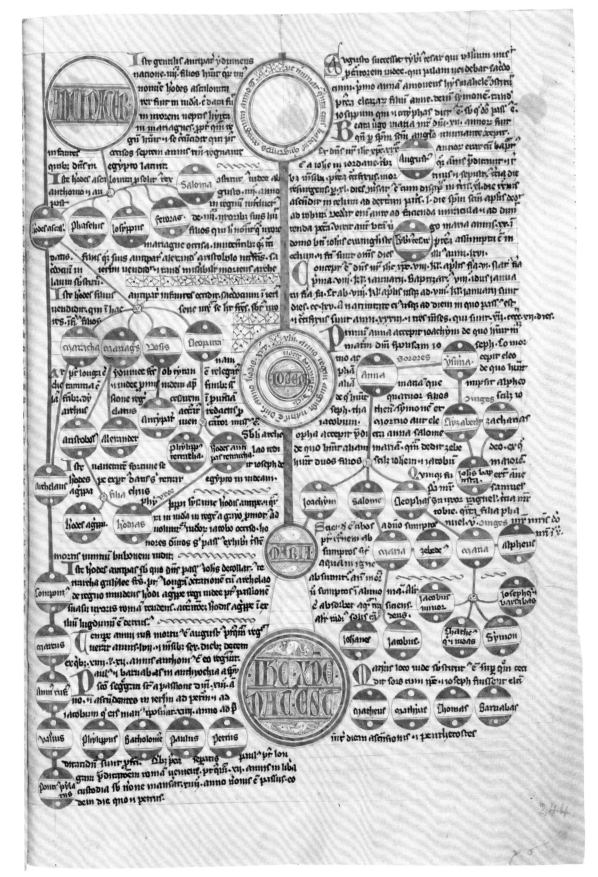

214. Ancestry of Christ. Peter of Poitiers, Compendium historiae in genealogia Christi, Basel (?), ca. 1325–50. Aarau, Aargauer Kantonsbibliothek /MsWettF 9, f. 244r (detail). Photo: www.e-codices.unifr.ch.

lustrated reproduced an expanded repertory of fifty-four types, thus ensuring its wider dissemination.[230] The work also had an impact on sculpture and panel painting.[231] The central panel of a triptych from Cologne, dated circa 1420–30, the wings of which depict Sts. Augustine and Jerome, provides a powerful example of the extent to which the diagrammatic mode of image making remained a constant through the end of the Middle Ages (fig. 215).[232] In its diagrammatic format, it recalls the disposition of earlier medieval works such as the Alton Towers Triptych (see fig. 3). At the center, within a rectangular field inscribed with words taken from Revelation 12:1, Mary is enthroned on a *Faldstuhl*, the folding chair associated with rulers. Not only the inscription but also the twelve stars engraved and punched into the gold background that radiate from her crown identify her as the *Mulier amicta*

sole, the woman clothed in the sun. Beneath her blue mantle appear the tips of the crescent moon corresponding to the remainder of the verse: "et luna sub pedibus eius" (and the moon beneath her feet). Filling the four triangular fields formed by the surrounding rhombus are four animals, whose symbolism ultimately derives from the *Physiologus*, which serve as types of Christ: from the top, the unicorn resting in a virgin's lap (annunciation); the pelican pecking its breast so as to feed its young with its blood (crucifixion); the lion licking its cubs for three days to bring them to life (the *triduum* or three days in the tomb); and the phoenix rising from its funeral pyre (resurrection). Four semicircular lobes protruding from the sides of the rhombus, explicitly identified as speech scrolls by their curling ends, represent four biblical types of Mary's virginity: from the upper right, the flowering rod of Joseph; the

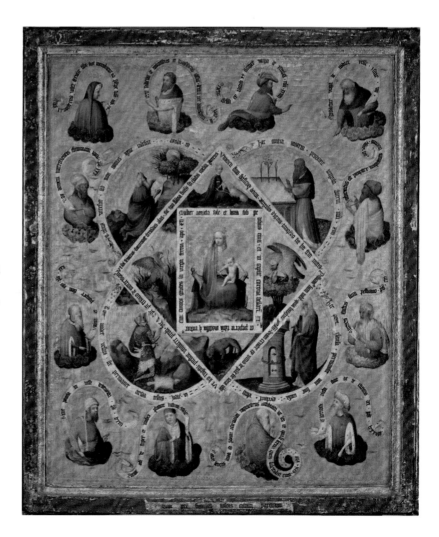

215. Types of Mary's Virginity, central panel from triptych, Santa Maria ad Gradus, Cologne, ca. 1420–30, Bonn, VVR-LandesMuseum, Inv. no. 9. Photo: LVR-LandesMuseum, Bonn, Foto: Jürgen Vogel.

porta clausa or closed door of Ezekiel 44:2 ("This gate shall be shut, it shall not be opened, and no man shall pass through it: because the Lord the God of Israel hath entered in by it, and it shall be shut"), here set within a tower similar to that of St. Barbara; Gideon's fleece; and the burning bush. Surrounding the geometric matrix are the twelve major prophets, each of whom holds his prophecy on a speech scroll whose irregular curves enliven the otherwise static symmetry of the figure at the center.

Whereas in Berthold's work the images are relatively modest and the texts very long, Franz von Retz's *Defensorium* integrates text and image more thoroughly by giving the two components approximately equal weight.[233] Each image of a type of Marian virginity (43 to 46 in the various manuscript copies with illustrations) is accompanied by a verse couplet, a question posed to the reader demanding closer scrutiny, and an answer in the form of an abbreviated reference to an authority, often but not exclusively patristic.[234] The authorities are not spelled out in full, and no doubt many readers or viewers never had them to hand; thus the references serve primarily as a gesture to authority rather than cues to closer study. Berthold's work demands more of his readers. Some of the questions in the authorities appended to the diagrams are called out in the margins as cues to contemplation and meditation. Unlike Franz von Retz, who expands the traditional repertory of Marian types by incorporating numerous examples from secular and natural history, Berthold limits himself strictly to scripture.[235] In this respect the *Defensorium* is no less typical of the second half of the fourteenth century than Berthold's work is of the late thirteenth. The greatest typological compendium of Franz von Retz's time, the *Concordantiae caritatis*, also stands apart from works such as the *Biblia pauperum* and *Speculum humanae salvationis*, let alone earlier compendia such as *Rota in medio*, *Pictor in carmine*, and the *Eton Roundels*, by virtue of its vast expansion of the typological repertory.[236] Despite such differences, Berthold's work and that of Franz von Retz can be seen as part of a larger continuum. Both authors refer to their images, whether diagrams or representations of scenes, as *figurae*, language that in the context of typological argument means far more than simply an illustration.[237]

Considered within a broader historical perspective but also within the context of contemporary diagrammatic practices, Berthold's Marian compendium appears less idiosyncratic than its status as a unicum might suggest. If its textual components, mediated in part by the liturgy, look back to classics of the patristic period and the High Middle Ages, the ways and means by which those sources are selected and combined is very much of a piece with scholastic habits of compilation and textual presentation.[238] The elevation of Mary to a position essentially coequal with that of Christ reflects her importance within the ideology and self-image of the Dominican order. The methods that Berthold deploys to generate diagrammatic images are admittedly somewhat old-fashioned; already in the twelfth century, Abelard had proposed a rectangle (i.e., a double square) as opposed to the traditional square of opposition so as to be able to take into account the terms of what today would be called propositional logic.[239] The idea of so copious a compendium of diagrams, however, is very much of its time. In Berthold's compendium, diagrams do not serve simply to demonstrate a particular argument; they provide the spine and structure of the entire work.

The late thirteenth century was, simply put, mad for diagrams. Diagrams served as standard tools in mathematics, astronomy, optics, logic, music, theology, natural philosophy, and, not least, pastoral care. The combination of systematic scholastic method with the pastoral impulses prompted by the Fourth Lateran Council encouraged the packaging of learning in diagrammatic compendia, of which the most widely disseminated was the *Speculum theologie*.[240] Other such compendia, such as the *Verger de Soulas* (Paris, BnF, Ms. fr. 9220; see fig. 89), survive, like Berthold's compendium, in lavish "one-offs."[241] Diagrams became such an integral part of education that they found their way into vernacular literature, not only Thomasin's *Welscher Gast* but also, for example, the *Breviari d'amor* of Matfré Ermengaud (d. 1322).[242] Diagrams provided the

common parlance of pedagogy across numerous disciplines. This is the context in which Berthold's work and, more important, his working methods must be located.

Berthold's diagrams demonstrate that skills acquired in dealing with diagrams in one discipline could easily be transferred to another. Diagrams, however, represent more than just another mode of image making appropriate to particular types of subject matter. Long before they became indispensable aids within modern scientific discourse, diagrams and the habits of mind required to read them had become deeply ingrained among educated readers.[243] Medieval diagrams did not simply represent or reproduce information; they enabled and enacted a frame of mind. In their performative dimension, they generated knowledge, and in the process, they endowed those that used them with a way of both conceptualizing and constructing a world. To employ a linguistic analogy, one might say that rather than simply transmitting words or concepts or even the meaning of those concepts, diagrams provide a syntax in the sense of a set of rules that enable analysis and contemplation. As in the Middle Ages the world, time, history, and, not least, theological truth became subjects of diagrammatic representation, diagrams and diagrammatic images emerged as among the principal vehicles through which insight into such subjects could be gained. Despite their spidery scaffolding, diagrams provided a reliable, sturdy, and dependable ladder leading to the world of invisible things.

Drawing Conclusions

The Maker's Mark

Berthold's *De laudibus* closes as it began: with an image of him offering up his devotions to the Virgin Mary (fig. 216). As at the opening of his treatise, so too at the close: Berthold speaks in words taken from someone else, in this case a homily attributed to Bede on the Assumption of the Virgin, an excerpt that also served as a reading in the Dominican office for the feast.[1] Berthold—who is identified in the following explicit as the one who wrote with Hrabanus ("conscripsit"), put his text in order ("ordinavit," in his case, the order of salvation history), and edited it ("edidit"), that is, selected appropriate excerpts from it—kneels in prayer before a deliberately ambiguous image that could represent either the Virgin and Child enthroned or a statue of the enthroned Virgin and Child.[2] The ambiguity, which is by no means unique to this image of Mary, lends it the quality of an image that has come to life in response to the petitioner's supplications.[3] Wearing the black and white habit of his order, Berthold raises his hands toward the Virgin, who wears a crown, and the Christ Child, marked by a cross-halo, both of whom respond by turning toward him. Mary holds a red apple in her hand, a common attribute identifying her as the new Eve. With his outstretched right hand, the Christ Child blesses Berthold. What he holds in his left hand is unclear; in its current state it resembles a small ladle. It originally overlapped the black outline of the throne, which, having been damaged by an erasure, has partially been restored in brown ink.

Berthold's gesture does not embody what by the High Middle Ages, had become the now classic gesture of prayer with joined hands.[4] Rather, it resembles, without matching, a distinctive mode of Dominican

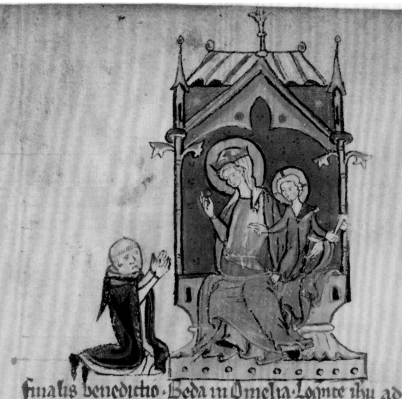

Beda

finalis benedictio · Beda in Omelia · Loqute ihu ad
veneranda dña electa et p electa que mar̃ turbata
eſt · et uirgo eſſe non deſinit · O admiranda puella
que ſaluo uirginitatis pudore ſuum genuit genitorẽ·
O felix ancilla que creatorem et gubernatorem genuit
vniuerſor̃ · ⁊ uirgo p manſit metuum· O benedicta
mater q̃ inferni uaſtatorem · celi reparatorem · n̄ ſ̃ in Salua
torem · mundi redemptorem · dm̃ omnipotentẽ · dm̃
celi ⁊ terre ⁊ omnia continentem ſuo p̃tulit utero · an
gelor̃ leticiam · hom̃ uitam · celor̃ glam̃ · ſc̃or̃ coronam
paradiſi lucernam · Amen ⁊·

 et
Hunc libr̃ de myſteriis et laudib; intemate uir
ginis Marie conſcripſit· ordinauit et edidit frat̃r
Bertoldus de ordine fr̃m predicator̃· quidam lector
Nurẽbgenſis · Anno dm̃· a̅)· cc̃ xcuij · Anima et̃
p̃merita et interceſſiones ipſius uirginis beate ge
nitricis dei et dm̃ nr̃ ihu xp̃i requieſcat impace·
Amen ⁊· o noli dc̃le nõ opõtuus· ut nome tuũ
p̃maneat ī libro uite·

216. Authorial subscription. Berthold of Nuremberg, *Liber de misteriis et laudibus intemerate Virginis genitricis Dei et Domini nostri Ihesu*, Lake Constance region (?), 1292–94. FBG, Memb. I 80, f. 67r (detail). Photo: FBG.

prayer, enumerated in *De modo orandi corporaliter sancti Dominici*, a thirteenth-century devotional manual written for Dominican novices, as the fifth of nine such modes, associated with meditation.[5] The resemblance is not exact: Dominic stands, whereas Berthold kneels. The manuscripts of *De modo orandi*, however, vary in their details, even among themselves, putting the lie to precise prescriptions.[6] Of this manner of prayer *De modo orandi* reports, "Sometimes, when he was in the convent, the holy father, Dominic, would stand upright before the altar with his entire body above his feet. . . . He held his hands out, open before his breast, like an open book."[7] The copy of the manual in the Vatican Library (Ms. Ross. 3, f. 9r) correspondingly represents the fifth mode as a series of gestures: reading the image from left to right, Dominic stands, first, with hands upraised in a manner resembling the ancient *orans* gesture, second, with hands clasped, and third, with his hands held closely together, as in the representation of Berthold. *De modo orandi* was directed toward an audience of Dominican novices; had Berthold members of the same audience in mind, they conceivably could have seen in his gesture a reference to a specific form of prayer practice. Just as Berthold, in writing his book, imitated Hrabanus, so too they, in praying as Berthold prayed, could imitate their Dominican superior. A Dominican novice reading Berthold's book could have imagined himself listening attentively to Berthold and, like and through Berthold, to the Virgin Mary and the Christ Child, whose dynamic postures suggest precisely the kind of interaction that the description of the fifth mode of prayer in *De modo orandi* suggests.

Excluding the framing dedication images, the number of illustrations in Berthold's Marian supplement totals sixty, a number that coincides with the number of parts in the Dominican rosary, if one includes the centerpiece, which joined the shorter and longer sections.[9] The shorter part consisted of five beads for praying the Pater Noster, three Ave Marias, and one Gloria Patri and was attached via the centerpiece to the larger loop of five decades (sets of ten beads), which were used to count the Hail Marys prayed for each of the mysteries. Each decade was divided from the others by a single bead for an Our Father. Berthold's set of sixty Marian diagrams might also have been intended to evoke a rosary with six rather than five decades.[10] As a whole, then, the commentary, despite its early date, could be understood as an allegorical rosary devotion of a very personal nature in which the reader is invited both to pray for the salvation of Berthold's soul and to follow in his footsteps in seeking the Virgin's mercy and mediation.

At the time Berthold wrote, however, rosary devotions had yet to crystallize into the established genres and customs first established in systematic fashion with the growth of rosary confraternities over the course of the fifteenth century. Rosary devotions aside, the structure of Berthold's work, not only its Marian commentary but also that on the cross, is governed by an overarching numerology that confirms that the two parts should be considered a unified whole. Codicological evidence confirms that the manuscript originally opened with a complete copy of Hrabanus's *In honorem sanctae crucis*, which was replaced in the fifteenth century by a fresh copy.[11] Berthold combined Hrabanus's twenty-eight *carmina* with thirty-one explanatory chapters. Why, one might ask, did Berthold not simply complement Hrabanus's poems with a corresponding number of explanatory diagrams, but instead extend the series with an additional three images? The answer would seem to be that 28 plus 31, plus the image that serves both to conclude the commentary and introduce the Marian supplement, adds up to 60, providing the perfect complement to the sixty Marian images that follow, not including the final dedicatory image. Berthold's doubling of Hrabanus, which he then redoubled in his independent work, provided a total of 120 images, not including the initial dedication to Hrabanus, which could well have been excluded because of its decreased relevance to Berthold's enterprise.[12] Or else both of his own dedicatory images could have been excluded from the count, in which case, Hrabanus's could have been included. Either way, Berthold's project emerges not as the straightforward didactic exercise he describes in his prologue but

rather as an unusually ambitious undertaking, which no doubt explains in part why no complete copy was ever produced. That Berthold does not articulate this ambition in his prologue is of no significance; in his prefatory material Hrabanus also described himself as "unworthy."[13] Berthold's play with numbers would also be completely in accord with the numerology articulated throughout Hrabanus's work.

If this numerological reading of Berthold's work is correct, it has significant consequences for our understanding of its evolution. To judge from the authorial subscriptions alone, one could conclude that after he finished the first half in 1292, the decision to proceed with the second part, completed in 1294, represented an afterthought. If, however, Berthold conceived of the two books, the first in praise of the cross, the second in praise of the Virgin, as complementary halves of a vast devotional diptych, then it is far more likely that they were planned together from the start. The addition of three images to the first set, so that Hrabanus's twenty-eight poems are joined by thirty-one diagrams, plus the concluding dedicatory image on folio 54r, ensured that the total in the first book would amount to sixty, thereby complementing the sixty set out in the book to follow. In this context the decision to increase the total number of divisions from twenty-eight to thirty-one, rather than seeming arbitrary, suddenly makes sense.

Not everything, however, admits of a solution.[14] Close examination of the concluding image to Berthold's Marian work indicates that the tiny Dominican kneeling in prayer was added by a hand other than that which executed all the other illustrations. The quality of the drawing, especially in the face and hands, is noticeably less assured than that of the Madonna and Child, which, while not of the highest quality, is nonetheless the work of a practiced professional. In contrast, the figure of the Dominican Berthold could aptly be described as the work of an amateur. Yet the figure can hardly be considered an afterthought; the displacement to the right of the canopied structure sheltering the Virgin and Child, counteracted by their pronounced movement and glances directed to the viewer's

left, demands such a figure's presence. The illustration clearly was conceived with the presence of a kneeling supplicant in mind.[15] Yet the figure that currently occupies the space reserved for such a figure clearly represents an addition or replacement. Traces of brown ink just visible to the left and especially to the right of the Dominican's face indicate the possibility of an erasure. Moreover, darker blotches immediately above the figure where pores in the parchment skin are more visible suggest that something has in fact been scraped away.

Not only the picture but also the adjoining text underwent alternation. In contrast to all the other rubrics introducing blocks of commentary, that introducing the passage from Bede was left blank. For reasons that cannot be elucidated, both scribe and artist (assuming that they were two different people) failed at the very end to bring the work to completion. Moreover, the scribe apparently also made errors in the authorial subscription. Two words, no longer legible, were erased and replaced in brown ink with Berthold's proper titles, "predicator" (associating him with the order "of the preachers") and "lector," that is, a teacher. The same scribe added a short phrase akin to an anathema following the explicit's Amen: "O noli delere nomen compositoris, ut nomen tuum permaneat in libro vite" (Oh, do not delete the name of the author, so that your name may remain in the book of life). Here too the wording contains an unusual twist. It would have been more consistent to have written "nomen suum" (his name). Rather, however, than enjoining the reader not to erase the author's name so that it might remain in the book of life, the wording assures whoever has perused (or perhaps copied) the manuscript that his, the reader's, name will remain inscribed in the heavenly book.

The injunction's wording derives from the penultimate verse of Revelation (22:19): "And if any man shall take away from the words of the book of this prophecy, God shall take away his part out of the book of life, and out of the holy city, and from these things that are written in this book." As appropriated in the subscription to Berthold's book, the words acquire unexpected

resonance. To begin with, Berthold (or whoever added this directive) associates his book with that invoked by John (and hence, indirectly, with John as the author of the book of Revelation).[16] In the case of Berthold, however, the eschatology is intensely personal: the focus becomes the preservation not only of his words but also of his soul. The words resonate still further when considered in conjunction with the erasures immediately above, which clearly were not part of the original plan. In this case an erasure was necessary to correct the record so that the author would be remembered appropriately. And then, of course, there is the ultimate irony of Berthold having done to Hrabanus just that from which the injunction itself insists that the reader or copyist abjure.

The presence of corrections to both text and image presents several possibilities. Both the corrections and the addition have the ring of officious alterations made by the author himself. If the image of the Dominican was added by the same hand, then it presents not just a representation of but also, in effect, a self-representation by Berthold of Nuremberg, in which case the image would offer the visual equivalent of the authorial subscription that follows. Whether the person (or persons) who completed both text and image at the end of the manuscript were one and the same person cannot be known, although it seems sensible to apply Ockham's razor and assume that they were. Assuming that the added words and image come from his own hand, then Berthold could not have chosen to end his work on a more personal note.

There is, however, a problem with this proposal. The paleography of the written corrections (the boxy form of the letters, their sharp scrifs, the use of a short commalike arc as opposed to a thin dashlike stroke) clearly indicates a date in the fifteenth century and very probably the late fifteenth century.[17] Berthold cannot have made them himself. This makes the question of why the figure of the author was originally omitted only more pressing, unless one accepts that it, like the words "predicator" and "lector" below, represents a replacement. If this is the case—and one can only speculate—then, in correcting the image,

the fifteenth-century scribe who undertook the emendations might similarly have been motivated by a desire for accuracy. Might Berthold not have been shown in a proper Dominican habit? Yet this suggestion in turn raises questions of its own: why, in what appears to have been the presentation copy of the work, errors at so critical a juncture were made in the first place.

However one seeks to explain the final dedication image and its accompanying authorial subscription, Berthold's work, despite its ostensibly objective cast as a work of discursive, didactic theology and commentary, in fact proves deeply personal in content, intention, and form. Perhaps it was its personal character that deprived it of wider dissemination. Bethold's compendium and commentary is not only commodious but also eccentric. As the preceding chapters have sought to demonstrate, however, no matter its isolation and idiosyncrasies, it exemplifies broader tendencies in the theology, piety, and practice of the later thirteenth century.

Berthold's work is Janus-faced: both conservative and forward looking. Although very much of a piece with contemporary and later typological compendia, in form and method it remains deeply rooted in monastic tradition, and not only because it takes Hrabanus Maurus's treatise as its point of departure. In the words of Rachel Fulton, writing about Honorius Augustodenensis's early twelfth-century *Sigillum sanctae Mariae*,

> the movement (*ductus*) here is exegetical, rather than philosophical; this is no Anselmian meditation on the nature of God or the Incarnation but, rather, a meditation structured wholly according to the mnemonic requirements of *lectio divina*. A phrase in the liturgical text first calls to mind each image. . . . It is then paused over while its various tropes are unlocked and expanded, "chewed over" until they release the sweet honey stored in the waxy cells of memory, the purpose of the exercise being to set the mind in play and to keep its attention long enough for the images to create new impressions, new chains (*catenae*) of meaning and remembrance.[18]

In like fashion, Berthold's mode of proceeding is monastic, not scholastic. Yet in terms of its outward presentation, its layout and apparatus, the manuscript in Gotha is entirely up to date.

What, one can ask, might Hrabanus have made of Berthold's transformation of his work? In light of the Carolingian monk's request in the prologue to *In honorem sanctae crucis* that nothing be altered lest it disturb the balance between text and image or introduce error, he probably would have been dismayed. What would surely have shocked him most is the way in which Berthold transformed the sign of the cross into an image of the Crucified. The seeds of this process of transformation, rich in ramifications, could be traced all the way back to the Carolingian period, when distinctive Western attitudes toward imagery had already begun to jell. The response of the Synod of 825 to a request for support from Byzantine emperor Michael II already provides strong evidence for a parting of the ways. By the time Bishop Gerard of Cambrai (1012–1151) assembled arguments against heretics, recorded and elaborated in the mid-eleventh century *Acta Synodi Atrebatensis*, the shift toward a more somatic, incarnational form of piety, in keeping with changing views on the Eucharist, focused less on the cross as *signum* than on Christ as *corpus*.[19] This shift constituted what Brigitte Bedos-Rezak has aptly called an "anthropomorphic turn."[20] As she notes, Gerard, who sought to counter the heretics' opposition to sacred images, "discursively transformed the cross into a crucifix.' "[21] With reference to the technology of sealing, Bedos-Rezak argues that

for eleventh- and twelfth-century theorists, the traditional semiotics inherent in early medieval thought . . . seemed inadequate to rebut attacks against physicalism. . . . Prescholastic thinkers needed to develop both a theory to support a representational system in which material entities were central to signification, and the system itself. Pre-scholastics reconceived signifying modes that would enable signs to be experienced as if the referent, the other, the absent one, were present and, if not identical at least identifiable through resem-

blance. . . . Medieval semiotics thereby shifted emphasis from transcendence to immanence, from deferral to reference, from representation to actualization.[22]

Berthold's book provides an eloquent manifestation of this profound shift in attitudes toward the visible and the corporeal as represented and embodied by the image. In his case, the shift becomes that much more manifest by virtue of having been applied to Hrabanus, a paradigmatic example of the point of view that had previously prevailed. The sign has become sensible, a *figura*: figural in the sense of relating to, representing, making present the human body, in particular the body of Christ.

In Berthold, however, effects of presence are held in check by the spare visual rhetoric of the diagram. The body of Christ, whether experienced in the Eucharist or in other media, could never be pure presence: Christ remained absent as well as present.[23] Berthold deals with this conundrum by matching representations of bodies with geometrical shapes that shape and structure responses that are as intellectual as they are emotional. In this regard Berthold remains the heir of Hrabanus, who, depending on one's perspective, overlaid words with images or images with words. Nonetheless, Berthold's diagrams, despite their abstraction, designated *figurae*, prove figural in a deeper sense: not only in their typology, according to which they figure by way of foreshadowing, but also by evoking and encapsulating biblical metaphors that constituted the stuff of biblical commentary. In lieu of Hrabanus Maurus's complete integration of text and image, Berthold provides diagrammatic images of scriptural history accompanied by theological, homiletic, and liturgical commentary. Within such relational configurations, each element and each aspect of each element—shape, size, color, placement, sequence—becomes richly meaningful in and of itself and, still more important, in relation to the other elements within each diagram and the series as a whole. Each figure, therefore, does not simply designate but also commemorates; the figures draw on deep reserves of memory, liturgy, commentary, and cult. The figures do

217. Hertwig Candelabra, St. Nicholas, Gross Comburg, ca. 1135–50 (detail). Photo: Jeffrey F. Hamburger.

218. Hertwig Candelabra, St. Nicholas, Gross Comburg, ca. 1135–50 (detail). Photo: Jeffrey F. Hamburger.

not so much offer solutions as set the mind, the heart, but also the eye in motion; they provide prompts to meditation on the meaning of sacred history.

Berthold's concept of salvation history is typical of his age. Despite profound differences in content and method—prose versus poetry, diagrams versus narrative imagery—his work sits well alongside the contemporary typological work the *Speculum humanae salvationis*. In each an ever broadening, more expansive, even comprehensive, conception of salvation history provides a framework for prayer, meditation, and contemplation, within which Mary's role comes to rival that of Christ. In both sections of Berthold's opus, the way in which one figure, kaleidoscopelike, generates the forms and patterns of those that follow, enhances the sense of a narrative, albeit one made up of diagrams, not historical scenes. An increased emphasis on salvation history as the salient structuring principle characterizes works with a strong diagrammatic component from as early as the twelfth century; examples include Lambert of St. Omer's *Liber floridus*, Hildegard of Bingen's *Liber scivias*, and Herrad of Hohenberg's *Hortus deliciarum*.[24] Berthold's incorporation of Mary, however, is

more modern. Mary's prominence, in turn, places themes of supplication and intercession at the center.

Modern also is Berthold's tendency to employ diagrams as meditational vehicles rather than principally as a way of representing abstract entities or of suggesting the invisible through the visible.[25] Although in his use of basic geometry Berthold draws on a tradition that associated simple geometric forms such as the circle, the square, and the triangle with the demonstration of immutable truths (whether theological, as in the case of the triangle, or mathematical and geometrical, as in the case of the game of Rithmomachy), his deployment of these elements is less mystical than practical. In his handling of them, the forms become tools with which to think—and to pray. The diagrams are also playful, however, in the way in which, like the pieces on a game board, they invite the reader to take them up and rearrange them, whether on the page or in the mind. The geometry of Berthold's diagrams, which combine order and complexity, interlace and imagination, differs little from that applied across so many genres and media within medieval art, whether front and center, as on the Alton Towers Triptych (fig. 3) or, less conspicuously, on

the undersides of the twelve tower lanterns that mark the circumference of the great chandelier, five meters in diameter, named after its donor Hertwig, at the Abbey of St. Nicholas at Groß-comburg in Swabia, dated circa 1135–50, as an image of the Heavenly Jerusalem (figs. 217–18).[26] Each of these mesmerizing designs presents the viewer looking up from below with a diagram whose circles and crosses multiply to create an ordered, yet boundless, even dizzying cosmos, one which points to the generative power of both divine and artistic creation.

Although each of Berthold's diagrams is relatively simple in itself, in their totality they express and point toward the order underlying the divine plan of salvation. This order is expressed through geometry and, in the Marian section of his composite work, above all in the visual language of logic. By adapting schemata from schoolbooks that would have been familiar to his readers, Berthold not only ensured his audience's ability to understand his work as well as its underlying method but also insisted on what at least to him was the self-evident logic of the Christian scheme of salvation. His diagrams trace history, not only on the page but also in the experience of his reader. They unfold in time, as does the manuscript itself as one moves from column to column, folio to folio, beginning to end. The sheer density of the program of diagrammatic illustration, apparently unmatched in scope, represents a constitutive part of its meaning. On its face, Berthold's rewriting of Hrabanus Maurus's masterwork, *In honorem sanctae crucis*, achieved only limited success. Measured against his model, however, his method speaks volumes about the aims and methods of diagrammatic devotion in the High Middle Ages and, more generally, the nature of diagrams, now as well as then.

<div align="right">

Appendix

</div>

Description and Partial Edition of Forschungsbibliothek Gotha der Universität Erfurt, Memb. I 80

Physical Description

ff. 67 (modern foliation, black ink, upper right corner; f. 67r, upper right corner: *90 folia*, light brown ink, crossed out), 345 × 248 mm, trimmed;

I. ff. 1r–40v, white, somewhat rough parchment: 233 × 185 mm, 39–56 lines, ruled in hard point (ff. 3r–28r full across; ff. 38v–40v in two columns), single vertical and single horizontal bounding lines; no pricking; written in a neat Gothic hybrida, with four-line initials, rubrics, and underlining in red.

II. ff. 41r 53v (yellowish, smooth parchment): 236 × 171 mm., 53 lines, in two columns; ruled in lead, single vertical and double upper horizontal bounding lines (lower horizontal bounding linc[s]) no longer visible due to rubbing; on some folios pricking in outer margin; written by two hands (with the break at f. 50r, column 2, between lines 31 and 32) in a compact Gothic script in various shades of brown ink; three- to one-line initials, rubrics, paraph marks, and signatures in red; capitals stroked in red. Corrections in the margins throughout.

III. ff. 54r–67r (yellowish, smooth parchment): 237 × 174 mm., 53 lines, in two columns; ruled in brown ink, single vertical, double upper and triple lower horizontal bounding lines, full across; on some folios pricking in outer margin; written in a compact Gothic script in brown ink that can be distinguished from that in part II by its tighter spacing, its spikier appearance, and the distinctive form of the letter *g*; three-, two-, and one-line initials in

red, blue, and green, some with floral decoration in alternating colors, with rubrics and paraph marks in red; capitals stroked in red. Corrections in the margins throughout.

Collation

I. ii (paper, modern) + I² (ff. 1–2; 2v blank); II⁸ (ff. 3r–10v); III⁸ (11r–18v); IV¹⁰ (ff. 19r–28v); V⁶ (ff. 29r–34v); VI⁸⁻² ⁽ᵛⁱⁱ⁻ᵛⁱⁱⁱ⁾ (ff. 35r–40v); catchwords and signatures.

II–III. VII¹⁰⁻³ ⁽ⁱ⁻ⁱⁱⁱ⁾ (ff. 41r–46v; signature IIII); VIII⁸ (ff. 48r–55v; signature V); IX¹²⁻¹ ⁽ˣⁱⁱ⁾ (ff. 56r–67v; xii = f. 67 (glued to first of two flyleaves to repair tears in parchment) + ii (paper, modern).

Contents

I. f. 1v: Presentation image: Hrabanus Maurus with Alcuin presenting his book to St. Alban.

f. 2r: Table of contents (four-line decorative scribal initial; alternating lines in dark brown and red ink). f. 2v blank.

ff. 3r–40v: Hrabanus Maurus, *In honorem sanctae crucis. Merito quippe sanctorum angelorum ordines* . . . [f. 40v] . . . *ibique tibi laus perpetua per cuncta sonabit secula. Amen.*

Colophon, *Auctor est Rabanus. Scriptor* <erased> *extat.* (in cartouche) *et finis deus sit bendedictus. Amen.*

II. ff. 41r–53v: Table of contents (incomplete at beginning): . . . *De numero iubilei. xxv. figura.* . . . *De novem ordinibus angelorum. xxxi. figura.* [figure 1] *Incipit liber de misteriis et laudibus sancte crucis. De nomine Adam prima figura. In principio oportet intelligi quid sibi velut hec figura et hec conscriptio.* . . . [f. 53v] *O crux alma Dei, usque huc, quantum potui, laudem et gloriam tuam descripsi; sed quia in his mortalibus perpetem triumphum plene invenis et perfectum honorem quem expetis, confer te ad celestia angelorum agmina, ibique tibi laus perpetua per cuncta sonabit secula. Amen.*

III. ff. 54v–67r: *Explicit liber de misteriis et laudibus s. crucis. Amen. Hunc librum ordinavit et conscriptsit ex libro Rabani de sancta Cruce diffuso in scriptura et difficili in intelligentia ad honorem et laudem ipsius preclare ac salutifere*

crucis. Frater Bertoldus, de ordine fratrum predicatorum, quondam lector Nurinbergensis. Anno domini. M°.CC°.XCII°. Anima eius per gratiam Ihesu Christi, qui in ipsa cruce perpendit, requiescat in pace. AMEN.

Incipit prefatio in librum de mysteriis et laudibus intemerate virginis genitricis dei et domini nostri Ihesu. Damascenus libro quarto. [Presentation miniature] *Incipit liber de mysteriis et laudibus intemerate virginis Marie genetricis dei et domini nostri Ihesu Christi. De Adam et Christo prima figura.* . . . [f. 67r] *Hunc liber de mysteriis et laudibus intemerate virginis Marie conscript. ordinavit et edidit frater Bertoldus de ordine fratrum predicatorum quondam lector Nurembergensis. Anno domini. M°.CC°.XCIII. Anima eius pro merita et intercessiones ipsius virginis beate genitricis dei et domini nostri Ihesu Christi requiescat in place.* [added] *Amen. Noli delere nomen compositoris, ut nomen tuum permaneat in libro vite.*

Binding

Modern (19th century), 355 × 260 mm, brown leather, mottled in black, black fillet around edges, rubbed and worn, especially at the corners, over cardboard, traces of tooled or stamped ownership mark at center of front cover, scraped off (letters? crown?); five leather straps on spine, with small floral stamps in between them; traces of a square label at top of spine, removed; a small label at bottom, with *80* in red ink; pastedown and flyleaf, paper (19th century).

Provenance

Entered the Herzogliche Bibliothek Gotha before 1689.[1] *M.n.46.* in black ink, upper left corner of front pastedown; *Tax: M. 3000*, in pencil, upper right corner of front pastedown; label glued in at center of front pastedown: *Rhabani Mauri Liber de Sancta cruce—Vorauβgass (?): Intercessio Albini (Alcuini) pro Mauro; f. 41. Fratris Bertoldi Liber de misteriis & laudibus sancta crucis; Jacobs Gotha I, p. 98* (corrected in pencil: *97*), *III, p. 35* (corrected: *38*), cursive, in black; added in blue ballpoint: *Miniatur Bl. 1v; farb.*

u. z.T. figürl. Darstellungen Bl. 3v–27v; 41–47v, 48v–53, 54–67; cf. Mon. typ. 1503 fol. 1 (black ink, different hand). Folio 1r (lower right corner, black ink): *in december 1857 F.I.* (possibly 1837).

Partial Edition

The following partial edition of Gotha, Memb. I 80 excludes the first fifteenth-century section, which contains Hrabanus's *carmina figurata*. Spelling has been regularized and proper names capitalized. The apparatus has been kept to a minimum, primarily because it makes no sense to reproduce the variants and sources noted in editions of the works on which Berthold's commentary depends. Instead, readers are referred to the standard editions cited in the notes. The prologue to Berthold's commentary on Hrabanus, now missing in Gotha, as well as a portion of the table of contents is taken from the manuscript in Paris, BnF, ms. lat. 8916. For each section, the inscriptions are provided first, followed, for the commentary on Hrabanus and in those cases in which they exist, by a comparison to those in Paris. Rubrics are given in bold. Passages from Hrabanus Maurus (inscriptions included) and other authors quoted by Berthold are reproduced in italics, with those parts omitted vis à vis the best available editions shown within angle brackets < >. Berthold's additions or alterations are indicated *in recte*. For those sections original to the manuscript—that is, Berthold's commentary—the sources of biblical quotations and paraphrases are noted in parentheses. Slight variations in word order are passed over without comment.

Except in those cases in which Berthold drew on the readings in the Dominican lectionary, there is no way, short of identifying the manuscripts from which he was working, of knowing whether the changes were simply copied from his exemplars or whether he introduced them himself. To judge from the paleographical evidence, the thirteenth-century portion of the manuscript represents the work of at least three scribes. It appears that two hands collaborated on the first part (the commentary on Hrabanus), completed in 1292. The first hand is more disciplined, compact, and elegant, the second somewhat larger and looser, with the change occurring on f. 50r, column 2, between lines 31 and 32. The Marian supplement, completed in 1294, is written by a third hand with a less rounded, more vertical script. In keeping with Dominican custom, both parts of Berthold's opus have been carefully corrected; the corrections to the portion completed in 1292 were added by two clearly distinguishable hands both different from the two that corrected the Marian supplement. There are, however, no correction marks of the kind commonly employed by Dominicans; perhaps they were trimmed. The corrections, which are much more extensive in the Marian section, are both interlinear and marginal. Additional punctuation has been added in minute marks whose black color distinguishes them from the original brown ink. More substantial corrections in the form of omitted passages are placed in the outer and lower margins. Rather than indicating that the book was carelessly produced, the corrections testify to its makers' concern that it render the texts as accurately as possible.

In one instance, in the commentary accompanying *figura* 54 in the Marian section (f. 65r), the scribe both omitted a long passage, which the corrector supplied in the lower margin, and inverted the sequence of two major sections of the text he did include. The inversion is corrected with two small letters, *a* and *b*, added above the word "Continet," which opens each section, a repetition that readily explains the scribe's error due to eye skip, but that also makes clear that the manuscript was copied from an exemplar. Assuming that the manuscript, which on the grounds of style and paleography can be dated very close to the dates of composition provided in the text, is indeed the original copy, the scribe must have been working from a rough copy prepared by the author.

Incipit prefatio in librum tertium. De misteriis et laudibus Sancte Crucis. (Paris, BnF, ms. lat. 8916, ff. 55v–56r)

[I.C 21.30–55] *<O vere bona et vere sancta crux Christi* [. . .] *crucifixo in te Christo regi deputatur.*

Qui cum Patre et Spiritu Sancto vivit et regit per omnia secula seculorum. Amen. **Explicit prefatio.**

Incipiunt Tituli.

De nomine Adam. Prima figura.

De spiritu et carne ratione et sapiencie.

De quatuor affectionibus anime.

De quatuor virtutibus cardinalibus.

De esse, vivere, sentire, et intelligere.

De quatuor elementis.

De quatuor plagis mundi et quatuor vicissitudinibus temporum.

De diebus anni solaris.

De numero annorum a principio mundi. usque ad temporum passionis Christi.

De quinque libris Moisi.

De cherubin tabernaculi et templi.

De lapidibus quadratus fundamenti templi.

De seraphim visionis Isaie.

De septuaginta annis captivitatis.

De prophetis et propheciis eorum.

De numero dierum corporis Christi in utero Virginis.

De electione duodecium Apostolorum.

De designatione .LXXII.orum discipulorum.

De septem donis Spiritus Sancti.

De octo beatitudinibus.

De spatio temporis predicationis Christi.

De ipsa imagine salvatoris crucifixi.

De alleluia et Amen.

De numero quadragenario.> (Gotha, Mem. I 80, f. 41r: col. 1)

De numero iubilei. .XXV. figura.

De littera greca lauda. .XXVI. figura.

De quatuor evangelistis. .XXVII. figura.

De apostolis ac dictis in epistulus eorum. .XXVIII. figura.

De. xxiiii. senioribus. .XXIX. figura.

De centum .X.L.IIII. milibus. .XXX. figura.

De novem ordinibus angelorum. .XXXI. figura.

FIGURE 1 [*Carmen* XII] (f. 4, col. 1)

Terminals: A (Anatole); D (Disis); A (Arctos); M (Membria)

Vertical: *Cuncta venusta bona remearunt, cara beata* [B 12.7]

Horizontal: *Cum advenit Iesus Adam pie in arua secundus* [B 12.8]

Paris, BnF, ms. lat. 8916, 56r

Vertical: *O crux que dederas rupto* [B 2.35 & C 2.97]

Horizontal: *Plebem ire ab averno.* [B 2.35 & C 2.97]

Incipit liber de misteriis et laudibus sancte crucis. De nomine Adam. Prima figura.

In principio oportet intelligi quid sibi velut *hec figura et hec conscriptio.* [C 12.2–58]. In principio oportet intelligi quid sibi velut *hec figura et hec conscriptio.* [. . .] *in cruce erant occisuri* [. . .], *et ipse* eam resuscitaturus triduano.

FIGURE 2 (f. 41, col. 2)

Christ (at top of ladder): *Gratia summum bonum*

Beneath Christ: *Specie magnum bonum*

Free Will (beneath Spirit): *Liberum arbitrium*

Reason (to left of Free Will): *Ratio*

Wisdom (to right of Free Will): *Sapientia*

Good Flesh (beneath Free Will): *Caro bonum*

Law (beneath Flesh): *Lex*

Ancient Wisdom (beneath Law): *Sapiens antiquus / noxia lignum.*

Tablet held by Wisdom: *Non concupisces.*

Both sides of cross:

Nam quia per vetitum mors vicit noxia lignum. [B 21.5–8]

Et genus humanum fera late absumpsat omne,

Faucibus a morte per lignum tollerat ut hoc,

Iure crucis placuit reparanti ponere palum.

Paris, BnF, ms. lat. 8916, f. 56v

Although the outline of the frame and the cross were sketched in, they were never executed.

De spiritu et carne, ratione et sapientia. Secunda figura.

Homo constat treatise = *Speculum virginum* (bk. 8: *De fructi carnis et spiritus*).[2]

Homo <enim> constat ex carne et spiritu, quorum alterum causa pugne alterius est.

[...] *sicut ait apostolus: Et quod erat contrarium, nimirum humano generi, tulit de medio affigens cruci sue.*

FIGURE 3 [*Carmen* XXI] (f. 41v, col. 1)

Vertical: *Arbor sola tenens varios virtute colores* [B 13.10]

Horizontal: *Pulchra nites cultu, te visu gloria cingit.* [B 2.27]

Terminals: *Concupiscentia*; *Timor*; *Leticia*; *Tristicia*

Paris, BnF, ms. lat. 8916, f. 56v

Vertical: *O crux que Cristi es caro.* [B 2.18 & C 2.90]

Horizontal: *Benedicta triumpha.* [B 2.18 & C 2.90]

The inscriptions differ, but the form of the figure remains the same.

De quatuor affectionibus anime. Tertia figura.

[C 2.24–74] *Anime quatuor affectiones* [...] *qui dilexit me et tradidit semetipsum pro me.* ¶ *Hoc etiam sciendum quod expectatum bonum concupiscentiam constituit presens non leticiam. Similiter autem expectatum malum timorem presens non tristiciam, et hac sancte cruci apte conveniunt. Inde non concupiscentia regni futuro provenit et Deo in superiore parte crucis ponitur. Inde timor ductus fideles a pena futura liberat, et inimo ponitur inde pro peccatis tristicia salubris excitatur, que a sinistris ponitur, in de leticia gratie consurgit, et a dextris ponitur.*

FIGURE 4 [*Carmen* VI] (fol. 41v, col. 2)

Arce crucis Domini summa prudentia sistit. [C 6.72]

Iustitia et prona mandat se parte tenendam. [C 6.76]

Forti sed in dextro cornu fert stipulatudo. [C 6.80]

Cum in levo modernans disponit iura modesta. [C 6.84]

Paris, BnF, ms. lat. 8916, f. 57r

The inscriptions are identical, but the diagram differs. Whereas in Gotha the inscriptions are confined to separate squares that merely imply the arms of a Greek cross, in Paris they are inscribed on the arms of a yellow cross with flaring arms that is reinforced by protruding semicircles on the upper and lateral arms. A foot with an effaced inscription provides the base. In lieu of a bud with four petals, each with a distinctive color, in Gotha, in Paris a single large ornamental blossom occupies the center of the cross. As in the other figures in Paris, penwork flourishes, here in red, along the diagonals accentuate the cross.

De quatuor virtutibus cardinalibus. Quarta figura.

[C 6.1–48] *Quantos <ergo> et quales fructus lignum sancte crucis germine suo proferat* [...] *quia omnium bonorum in ea crucifixus est auctor.* ¶ [D 6.12–16] *In hac figura quattuor principalium virtutem series continentur nomina prudentie videlicet iustice, fortitudinis, et temperantie ex quibus omnium virtutum series procedit, et quibus ratio bene vite consistit. Nos quoque in medio ponitus distinctis coloribus singulis virtutibus ordinate et significative deservit.*

FIGURE 5 [*Carmen* II] (fol. 42r, col. 2)

Vertical: *O crux que summi es noto dedicata trophe.* [C 2.89]

Horizontal: *O crux que Christi es caro benedicta triumpho.* [C 2.91]

Terminals: *Intelligere*; *Esse*; *Sentire*; *Vivere* [C 2.15]

Paris, BnF, ms. lat. 8916, f. 57r

The inscriptions on the arms of the cross are omitted.

De esse, vivere, sentire, et intelligere. Quinta figura.

[C 2.1–23] *Hec figura crucis Christi in quatuor cornibus cuncta complecti predicat* [...] *intellectu discernunt.* [C 2.75–85] *Omnia <ergo> hec sancte cruci conveniunt*

[. . .] *per Iesum Christum Dominum nostrum.* ¶ [C 2.103–108] *O litteram, que circuli habet similitudinem* [. . .] *que deorsum sunt.*

FIGURE 6 [*Carmen* VII] (f. 42v, col. 1)
Vertical: *Salve sancte salus, Christi, o tu passio leta.* [B 3.1]
Horizontal: *Namque salus hominum es, rerum pulchra renovatio.* [B 3.6]
Terminals: *Ignis*; *Terra*; *Aer*; *Aqua*

Paris, BnF, ms. lat. 8916, f. 57v
Vertical: *En tronus hic regis.* [B 4.19 & C 4.68]
Horizontal: *Hec concilatio mundi.* [B 4.19 & C 4.68]
The bars linking the circles at the terminals of the cross are omitted.

De quatuor elementis. Sexta figura.
[C 7.1–65] *Quaternarium numerum perfectione sacratum pene nullus ignorat* [. . .] *et crebris micat ignibus ether.* ¶ [C 7.41–46] *Igitur dum omnia per crucem constat esse recuperata* [. . .] *omnia opera Domini* Domino.

FIGURE 7 [*Carmen* VII] (f. 42v, col. 2)
Vertical: *Omnia iam splendet vero de lumine Christi.* [B 7.1]
Horizontal: *Illustra crucis et sacre facta beando.* [B 7.2]
Terminals: *Oriens ver mane; Occidens autumpnus vespera; Septemrio iems in tempestum; auster estas meridies.* [C 7.77, 78, 81, 83]

Paris, BnF, ms. lat. 8916, f. 57v
Vertical: *O crux dux misero.* [C 2.98]
Horizontal: *Latoque redemptio mundo.* [C 2.98]
Terminals: *Oriens ver mane; occidens autumpnus vespera; Septemrio iemps intempestum; Auster estas meridies.* [C 7.77, 78, 81, 83]
Bars linking the circles at the terminals of the cross are missing, as are the diagonals protruding from the center.

De quattuor plagis mundi et quatuor vicissitudinibus temporum. Septima figura.
[C 7.5–67] *Totum orbem quatuor terminari partibus sive angulis notum est, oriente scilicet et occidente, aquilone et meridie. Quatuor* etiam *sunt vicissitudines temporum* [. . .] *et magis quieti quam alicui operi tempus opportunum sit.* Hec figura etiam in formis speritis posita est, quia [C 7.65–66] *tempora <namque> circulis transerunt, et vicissitudines quatuor ternorum mensium orbibus eunt.*

FIGURE 8 [*Carmen* IX] (f. 43r, col. 1)
Center: Lxxiii
Terminals: Lxxiii; Lxxiii; Lxxiii; Lxxiii
Sol et luna Deum hic Christum en benedicite Ihesum. [B 9.1–3]
Cruxque est vester honor stabilis lux pacifer ordo.
Laus probitas series per cuncta et secula lumen.

Paris, BnF, ms. lat. 8916, f. 58r
The bars linking the circles at the terminals of the cross are omitted, as is the inscription placed above it.

De diebus anni solaris. Octava figura.
[C 9.29–45] *Annus <etiam unus,> si* secundum *.XII. menses <integri> considerentur* [. . .] *sic annus circuitu solis animadversus est.* Unde si accipiatur annus solaris dabit dies .CCC.LXV. lxv. et quadrantem. Qui quadrans habet .V. horas et est quarta pars diei naturalis, qui cum sua nocte .XXIIII. horis constat et sic [] qui est incrementum bissexti [. . .] Et si pars accipiatur pro toto per synodoche, ita ut quadrans pro uno die ponatur, erint anni solaris dies ccc.lxvi. Sed nunc subtracto ipso quadrante ut equalitas in cruce inveneri possit. secundum priorem positionem annus solaris haberit .CCC. et .LXV. dies. Qui si dividantur equaliter in quinque partes in qualis inveniuntur .LXXIII., ut in figura crucis apparet. ¶ [D 9.25–31] *O sacrum germen* [. . .] *in celesti beautdine*

<ipsi> perpetua fulgeant claritate. ¶ Hec figura similiter informis orbicularibus ponita est propter anni in se revisionem et solis revolutionem. Annus quippe ab eo quod semper veritatir, et in se redeat nomen accept. Dicit etiam Ecclesiastes (Sir 1:5–6): Oritur sol et occidit, et ad locum suum revertitut, ibique renascens girat per meridiem, et flectitur ad aquilonem, lustrans universa in cirucitu pergit spiritus et in circulos suos revertitur.

FIGURE 9 [*Carmen* XIV] (f. 43r, col. 2)
Cuncta quia Dominus renovavit secula prisca. [B 14.12]
En crucis hec species Ihesus bene monstrat honorem. [C 14.127]

Paris, BnF, ms. lat. 8916, f. 58r
The inscription above the figure is omitted. Flourishes terminating in flowers are added along the diagonals.

De numero annorum a principio mundi usque ad tempus passionis Cristi. Nona figura.
[C 14.18–97] *Quatuor <igitur> sunt littere que* hic *crucis effigiem conficiunt, G videlicet Z, T et .X.* Prima greca littera significat iii, secunda, .VII., tercia, .CCC., quarta mille. Prima fidem ostendit *que sursum erecta est et in summo plana <est>* [. . .] Tercia *littera que* notat .CCC. et *crucis similitudinem habet,* caritatem significat. O magna enim caritas Dei in cruce erga nos illuxit qui proprio filio suo non perpercit, sed pro nobis omnibus tradidit illum. Hec *dupliciet compingitur forma* [. . .] *et immensa propter Deum.* [C 14.53–66] *Quarta littera, que* mille importat eternam beatudinem significat, ratione ultime perfectionis. *Nam millenarius numerus* [. . .] in altitudine divinam contemplationem. Hec scribere hic lineis circumductis, [C 14.103–108] *quoniam mille significat* [. . .] *ubi sanctorum laus sine fine manebit* [. . .] Ipsa etiam littera est prima nominis Christi et bene hic convenit huic rationi, quia ipse gaudium nostrum cui dicamus cum

propheta (Ps 15:10): Adimplebis me leticia cum vultu tuo, quod autem a prima littera in medio posita, alie in quatuor partibus deducuntur, significat [I. C 14.119–123] *quod post passionem Christi* [. . .] *per fidei et spei et charitatis dona mererentur pervenire.* [C 14.1–16] *In hac pagina continetur* [. . .] *tertia die resurrexit, fiunt omnes anni V.M.CC.XXXI.* ¶ Igitur demonstrantur sanctam crucem omnia tempera mundi in electis Dei, qui ab initio fuerunt santificare et regnum celeste promittere, quid pro redemptorem nostrum cunctis fidelibus tribuetur, qui verbo eius obedientes corde credulo et opere mundo Deo placere studuerunt.

FIGURE 10 [*Carmen* XI] (f. 43v, col. 2)
Top: *Te genesis crux alma beat tua munera laudat.* [C 11.80]
Left: *Exodus atque canit transitus carnem amore.* [C 11.83]
Center: *Iura sacerdotis Leviticus optime psallit.* [C 11.85]
Right: *Ast numerus cantat magnalia mira triumphi.* [C 11.87]
Bottom: *Nam Deuteronomium renovantis gaudia dicit.* [C 11.90]

Paris, BnF lat. 8916, 35v
Top: *Te Genesis crux alma beat tua munera laudat.* [C 11.80]
Left: *Exodus atque canit transitus carnem amore.* [C 11.83]
Center: *Iura sacerdostis Leviticus optime psallit.* [C 11.85]
Right: *Ast numerus cantat magnalia mira triumphi.* [C 11.87]
Bottom: *Nam Deuteronomium renovantis gaudia dicit.* [C 11.90]

De quinque libris Moisi. .X. figura.
[C 11.14–18] *Lex ergo haustum sitientibus prebuit* [. . .] *refrigerabat potu.* [C 11.36–73] *Igitur cum* [. . .] *amaritudo* [. . .] *et misterii sacramentum appareat.* ¶ In capite itaque, *hoc est, in culmine sancte crucis* [. . .] *et sine ipso factum est nihil.* ¶ *In*

ima <vero> parte crucis [. . .] *per crucem renovasse.* ¶ *Exodus vero bene in dextra ponitur* [. . .] *per Domini potentiam citius compressas.* ¶ *At Leviticus, in medio omnium stans* [. . .] *exauditus est pro sua reverentia.* ¶ Non modo autem numeriis et ordo librorum legis verum etiam mistica sacra in eis expressa, veraciter sancte cruci conveniunt. [D 11.11–19] *Nam cum primum* [. . .] *ad locum immolationis sue.* [II. D 11.42–47] *Ad huius instar Moises* [. . .] *quosque credentes promereri posse predicant.* Hoc serpens eneus exaltatus a Moise *populo demonstrast quo salvari Iesus ab hostibus possit.*

FIGURE 11 [*Carmen IV*] (f. 44r, col. 2)
Hinc signant cherubin hec labbara sancta triumphum. [C 4.79–80]
Distensis que alis brachia tensa notant. [C 4.78]

Paris, BnF, ms. lat. 8916, f. 59r
Blank

De cherubin tabernaculi et templi. Undecima figura.
[C 4.4–10] *Quanta provisione ac dispensatione divina clementia* [. . .] *mundo intimare decrevit.* [C 4.49–51] *Illa .II . que in tabernaculo sive templo fabricata erant* [. . .] *imaginem preferebant?* [C 4.59–64] *Hec <ergo> iuxta archam et propitiatorium stabant* [. . .] *in passione Christi salvandorum rite intimabant.* [D 4.54–66] *Hec itaque animalia* [. . .] *probavit amando.*

FIGURE 12 [*Carmen V*] (f. 44r, col. 2)
Vertical: *Inclita crux Domini Christi fundamen et aule.* [C 5.73]
Horizontal: *Quadratas iungis in firmo tramite petras.* [B 5.21]
Lower left: *Te patriarcharum laudabilis actio signat.* [C 5.88]
Lower right: *Plebsque prophetarum divino famine iussa.* [C 5.90]
Upper left: *Agmen apostolicum pangit tua rite trophea.* [C 5.93]

Upper right: *Martyrum et ipse chorus effuso iure cruore.* [C 5.95]

Paris, BnF, ms. lat. 8916, f. 59r
Vertical: *Inclita crux Domini.* [C 5.73]
Horizontal: *Christi fundamen et aule.* [C 5.73]

De lapidus quadratus fundamenti templi. .XII. figura.
[C 5.10–27] Ad templum misticum Ecclesie *pertinet ipse mediator Dei et hominum* [. . .] *qui est Christus Iesus.* [C 5.35–40] *Huius fundamenti primi lapides* [. . .] *fidelium sequitur.* [C 5.52–71] *Bene* itaque *in libro Regum scriptum est* [. . .] *digne compleretur officium, nisi ipse sacerdos in cruce fieret sacrificium.* ¶ [D 5.26–30] *O inclita crux Domini* [. . .] *in firmo fidei fundamento.* [D 5.16–19] Tu *firmaque erecta es columpna* [. . .] *aula videlicet iusti regis sponsique Ecclesie.* [D 13.20–21] *In te ecclesiarum Salvatoris celsitudo consistit, et unitas fidelium in fide et pace permanebit.*

FIGURE 13 [*Carmen IV*] (f. 44v, cols. 1–2)
Signa crucis Christi ast seraphin celestia monstrant. [C 4.73–74]
Pennarum atque situ hac cuncta sacrata probant.

Paris, BnF, ms. lat. 8916, f. 59r
Blank.

De seraphin visionis Isaie. XIII figura.
[C 4.6–7] Divina pietas numpis [*sic*] *spiritibus angelicis* [] *ante videri voluit.* [C 4.18–48] Unde *propheta Isaias* [. . .] *de Iudeis videlicet atque gentibus.* [D 4.57–60] *Ipsa quoque seraphin* [. . .] *et vitia recedant dicant.*

FIGURE 14 [*Carmen X*] (f. 45r, col. 1)
Center: lxiiii
Terminals: *.XIIII.; .XIIII.; .XIIII.; .XIIII.*
Iheremias decies septenos scripsit et annos. [B 10.29–30]
Post quos ipse suos a vinclis solveret auctor.

Paris, BnF, ms. lat. 8916, f. 59v

Although the cross, with its constituent parts represented as circles, not squares, bears the same numbers, the accompanying inscription has been omitted.

De septuaginta annis captivitatis. .XIIII. figura.

[C 10.1–48] *Septuagenarium <quippe> numerum* [. . .] *regnum intrabunt eternum.* Moises etiam *per* [D 10.37–51] *.LXX. presbiteros* [. . .] *per crucis sacramentum nobis fieri significavit. ¶ O crux benedicta Dei!* [. . .] *tibi veracissime esse deditum.* Hec figura quinque partes habet que sigillatum .XIIII. exprimunt et simul collecte numerum .LXX. continent.

FIGURE 15 [*Carmen* XXVI] (fol. 45v, col. 1)
Ergo prophetarum bene te crux famen honorat.
[B 26.1–2]
Predicat exaltat resonat tua facta futura.
Center: David
Top row: *Isaias*; *Iheremias*
Second row: *Ezechiel*; *Daniel*
Third row: *Osee*; *Iohel*; *Ionas*; *Micheas*
Fourth row: *Amos*; *Abdias*; *Naum*; *Abacuc*
Fifth row: *Sophonias*; *Aggeus*
Sixth row: *Zacharias*; *Malachias*

Paris, BnF, ms. lat. 8916, f. 59v

In keeping with his aversion to figural drawing, the artist has replaced the figure of David at the center with a simple inscription, "David." The surrounding names are reduced to "Isaias," above; "Daniel," below; "Ieremias," at left, "Ezechiel," at right. The accompanying inscription has also been omitted. Diagonal pen flourishing, however, has been added.

De prophetis et prophetii eorum. .XV. figura.

[C 26.1–3] *Libuit testimonia* [. . .] *et ad sancte crucis gloriam pertingerent.* [C 26.8] *David ergo propheta atque psalmista.* [C 26.14–18] *Et quod in ligno passurus esset* [. . .] *Isaias quoque hinc ait*: [C 26.24–27] *Dominus posuit in eo iniqui-*

tatem [. . .] *et non aperiet os suum.* [C 26.32–35] *Ieremias <autem> ex persona Domini dicit* [. . .] *et nomen eius non memoretur amplius.* [C 26.38–42] *Ezechiel <ergo> signaculum crucis* [. . .] *que fiunt in medio eius.* [C 26.54–71] *Daniel <vero> cronographus certissimus* [. . .] *et usque ad consummationem et finem perseverabit desolatio.* [C 10.80–87] *Confirmabit* inquit *multis ebdomadibus pactum* [. . .] *in testimonium occisus est.* [C 10.61–76] Hec etiam sciendum que *iste ebdomade numerantur* [. . .] *Christus occisus est, sed in fine septuagesime ebdomadis.* [C 26.72–86] *Osee* [. . .] *de ereptione nostra* [. . .] *et alieni non pertransibunt per eam amplius, et reliqua.* (Ioel 3:18) Et erit in die illa stillabunt montes dulcedinem, et colles fluent lacte et melle, et per omnes rivos Iuda ibunt aque. Et fons de domo Domino Deo egredietur, et irrigabit torrentem spinarum. [C 26.87] *Amos ait:* [C 26.90–96] *In die illa, inquit* [. . .] *ponent insidias super te.* [D 26.48–49] *Ionas <quoque> suo exemplo tridvanam Domini sepulturam prefiguravit.* [C 26.104–112] *Ipsum montem Domini* ac *ducem ostendens* [. . .] *et egressus eius ab initio a diebus eternitatis. ¶ Naum <vero> ultorem Dominum predicat inimicis* [. . .] *et sciens sperantes in se.* Et item (Nah 1:15). Ecce super montes pedes evangelizantis et annunciantis pacem. *¶ Abacuc luctrator fortis et rigidus* [. . .] *Ibi abscondita est fortitudo eius. ¶* [C 26.124–148] *Sophonias prope esse adventum diei Domini narrat* [. . .] *Aggeum Dominum Patrem inducit* loquentem. Nolite inquit timere, quia hoc dicit: (Agg 2:6–7) Dominus exercitium. *Adhuc* unum *modicum est* [. . .] *dicit Dominus exercitium. Zacharias* quoque ait (Zach 9:9–10): Exulta satis fila Sion. iubila filia Ierusalem ecce rex tuus venit tibi iustus et salvator tuus. Ipse pauper et ascendens super asinum et super pullum filium asine. Et item *ex persona Domini* dicit (Zach 11:12): *Appenderunt mercedem meam* [. . .] *Malachias salubrem*

adventum Domini <narrat> ipsumque [D 26.62–63] *et purgare ministros suos examinatione valida*, ut *possint* ei *sacrificia offerre iustitie* describet. [C 26.148–155] *Et statim, inquit* […] *et placebit Deo sacrificium Iuda et Ierusalem* (Mal 3:4) sicut dies seculi et sicut anni antiqui. Et item (Mal 4:2): Orietur vobis timentibus nomen meum sol iusticie et sanitas in pennis eius. Hec figura ordinate continet nomina omnium prophetarum et prophetancium de Christo et eius passione. Et quia virgo beata de progenie David descendit ex qua filius Dei carnem assumpsit in qua pro nobis in cruce mortem pertulit. secundem dicta prophetarum ideo David in medio prophetarum ponitus est.

FIGURE 16 [*Carmen* XIII] (f. 46r, col. 2)
At crucis hec species tribuit solamina fidis.
　　[B 14.30]
Monstras e numero radianti dona beata.
　　[B 13.28]
Center: *MARIA*
Terminals: *.LXIX.; .LXIX.; .LXIX.; .LXIX.*

Paris, BnF, ms. lat. 8916, f. 60r
The diagram has undergone a dramatic transformation. The bars constituting a lozenge surrounding the cross-shaped figure of MARIA at the center have disappeared. The insertion of small decorative lozenges between the circles containing the letters extends the arms of the cross, making its presence more apparent. The accompanying inscriptions have been omitted.

De munero dierum corporis Christi in utero Virginis. .XVI. figura.
[C 13.2–6] Hec figura totius […] *numerum dierum* […] *predixit ipse Salvator.* Ubi notandum quod numerus senarius pro anno positus intelligamur. [C 13.13–22] *Dixerunt enim .XLVI. annis edificatum templum* […] *conceptus creditur.* [C 13.26–39] natusque <traditur> *.VIII. kalendas Ianuarias.* […] *ut in ipsa resurgeret.* Si ergo dividatur numerus

iste in quattuor partes equales, inquales reperiuntur .LXIX. et ita ibi relutet numerus senarius et novenarius, quia etiam a misterio non vacat. [C 13.50–61] *Quid enim in novenario* […] *sicut dictum est ad illos.* ¶ Hoc etiam devote considerandus est quod ipsa beata et intemererata Virgo de qua Filius Dei carnem assumpsit, quam pro nobis aptulit et in cuius utero tot spatio dierum requievit misterio crucis expers credenda non est, nam in eius nomine quod .V. litteris scribere crux exprimitur, ut in figura signatum est. ¶ [D 13.39–54] *O crux sancta!* […] *cuius imperium super humerum eius esset.*

FIGURE 17 [*Carmen* VIII] (f. 46v, col. 2)
Vertical: *In cruce nunc menses uenti duodenaque signa.* [C 8.58]
Horizontal: *Grex et apostolicus decoratur luce corusca.* [C 8.60]

Paris, BnF, ms. lat. 8916, f. 60v
Vertical: *O crux que summi es no-*
Horizontal: *to dedicata tropheo.* [C 2.87]
The terminals of the cross are rendered in three dimensions. Rather than triplets of small circles representing the twelve apostles in two pairs of blue and red, each group of three contains, alternately, two green and one blue or one blue and two green dots. The abbreviation of the inscriptions so as to keep them contained within the cross arms and the changes in color suggest the artist's primary interest was decorative, not symbolic.

De electione XII Apostolorum. .XVII. figura.
[C 8.1–46] *Duodenarius <ergo> numerus* […] *per Iesum Christum facta est.* Hec figura in partibus quatuor .III. continet, rita numerum duodenarium complet, quia duodecim apostolorum doctrina per quatuor plagas mundi in fide sante Trinitatis diffusa est. ¶ [D 8.45–50] *Hec* […] *distributio duodenarii* […] *ipsaque fidelibus veraciter confert.*

FIGURE 18 [*Carmen* **XXI**] (f. 47r, col. 1)

Vertical: *In cruce lex Domini decoratur luce corusca.* [C 21.68]

Horizontal: *Gentes et lingue sociantur laude sacrata.* [C 21.72]

Terminals: *.XVIII.; .XVIII.; .XVIII.; .XVIII.*

Paris, BnF, ms. lat. 8916, f. 60v

Vertical: *Crux vexillum sancto et*

Horizontal: *Pia cautio seculo.* [C 2.101]

The inscriptions have been both changed and abbreviated; the bars connecting the circular terminals of the cross have been eliminated.

De designatione septuaginta duorum disciplinorum. .XVIII. figura.

[C 21.1–14] *Figuram hanc <igitur> plenam esse misterio oportet intelligi* [. . .] *per evangelium Trinitatis in .LXXII. discipulis intimatur.* Tercia enim .XXIIII., .LXXII. fiunt. Hec figura inutroque tramite, id est, in eo, qui sursum et in eo qui transversum vadit [C 21.22–29] *sexies senarium ostendit* [. . .] *electos Dei pervenire edocet.*

FIGURE 19 [*Carmen* **XVI**] (f. 47r, col. 2)

Christus dans clarum mandatum bini et amoris. [B 16.21]

Quod crux alma Dei benefacto scemate signat.
Stirps Iesse virgam produxit virgaque florem.[3]
Et super hunc florem requiescit spiritus almus.
Virgo Dei genitrix virga est, flos filius eius.

Top row: *Spiritus Sapiencie et intellectus.*

Second row: *Spiritus Consilii et fortitudinis; Spiritus consilii et fortudinis.*

Third row: *Spiritus scienie et pietatis; Spiritus scientie et pietatis.*

Fourth row: *Spiritus timoris Domini; Spiritus timoris Domini.*

Scroll held by Christ Child: *Ihesus*

Paris, BnF, ms. lat. 8916, f. 61r

Top row: *Spiritus sapiencie.*

Second row: *Et intellectus; Spiritus scientie.*

Third row: *Spiritus consilii; et pietatis.*

Fourth row: *Et fortitudinis; Spiritus timoris Domini.*

All the other inscriptions have been eliminated, as has been the dove descending from the top of the diagram. The flower with petals in four colors has been replaced by a decorative blossom.

De septem donis Spiritus Sancti. .XIX. figura.

[C 16.1–18] *Scriptum est in Isaia: Egredietur virga de radice Iesse* [. . .] *et in sanguine passionis rose ruborem ostendit* [C 16.30–41] *Sed queri potest cur propheta a Spiritu sapientie numerare inceperit* [. . .] *ad ima usque progreditur.* [C 16.52–96] Dicit ergo propheta: *Initium sapientie timor Domini* [. . .] *pacificataque omnia sunt in ipsa que in celo et que in terra sunt.* ¶ [D 16.22–27] *Isaias* itaque *propheta divinitus inspiratus* [. . .] *et Spiritum timoris* Domini *nuncupavit. Christus* etiam [D 16.34–37] *post resurrectionem suam in suos discipulos sufflans* [. . .] *transversa quoque fraternum commendat amorem.* Descriptus est hic flos in medio donorum spiritalium [C 16.97–102] *coloribus precipuis, id est* [. . .] *ultra omnes mirabiliter ostendit.* [C 16.C 107–113] *In iacintho quippe intelligimus* [. . .] *quia totius decoris pulcritudine intus forisque plenus erat.*

FIGURE 20 [*Carmen* **XVII**] (f. 47v, col. 2)

Fifth row: *Regna poli Domini vult pauperis esse beati.* [C 17.119]

Fourth row: *Atque solum mites semper habitare supernum.* [C 17.121]

Third row: *Felices flentes quis consolatio in alto est; Nam iusti cupidos eterna refectio sanciplate Menta pias sursum miseratio larga repensat; Corda serena Deum cernent et in arce superna.* [C 17.124, 126, 128, 130]

Second row: *Pacificos Dominus prolis complectit amore.* [C 24.133]

First row: *Pro Christo afflictos regnum iam spectat Olimpi.* [C 24.136]

Paris, BnF, ms. lat. 8916, f. 60v

Fifth row: *Regna poli Domini vult pauperis esse beati.* [C 17.119]

Fourth row: *Atque solum mites semper habi-*

tare supernum. [C 17.121]

Third row: *Felices flentes quis consolatio in alto est; Nam iusti cupidos eterna refectio complet; Mente pios sursum miseratio larga repensat; Corda serena Deum cernent et in arce superna.* [C 17.124, 1 26, 1 28, 1 30]

Second row: *Pacificos Dominus prolis complectit amore.* [C 24.133]

First row: *Pro Christo afflictos regnum iam spectat Olimpi.* [C 24.136]

Although the form of the cross has been changed through the addition of flaring forms and teardrop forms in green suggesting encrusted gemstones, in this case the inscriptions have not been changed or abbreviated.

De octo beatitudinibus. Vicesima figura.

[C 17.1–89] *Octo ergo beatitudinum series hic in specie sancte crucis notantur* [. . .] *quia per ipsam ad celeste regnum vere conscenditur.* [C 17.99–114] *In erecto stipite in immo pauperes spiritu collocantur* [. . .] *eos interius sublevat ascensus contemplationis.* ¶ [D 17.41–54] *Igitur quicunque eternam lucem veraciter querit* [. . .] *promereri possumus gaudia sempiterna.* Et quia hac bona spiritualia decoratur cantate et meritoria redduntur, ideo rosa ipsam representans hic in medio posita est.

FIGURE 21 [*Carmen* XXII] (f. 48v, col. 1)
Center: *Christus*
Terminals: *Lumen evangelii imitabile condidit auctor. Quod facinus scripto vetat omnia vana recusat.* [C 20.5–6]

Paris, BnF, ms. lat. 8916, f. 61v
Although the Roman numerals in the outlying circles have been retained, the accompanying inscription has been omitted, as have been the bars connecting the circles.

De spatio temporis predicatoris Christi. .XXI. figura.

Tempus quo Christe se manifestavit mundo et predicavit, pensatur spatio trium annorum et dimidi, quod satit dies mille.CC.LX.

[C 22.18–28] *Menses enim trium semis annorum* [. . .] *seu persecutionis molestiam ab infidelibus vel a falsis fratribus patitur.* ¶ Hic numeris in litteris grecis sub una parte monogrammatis exprimitur. Monogramma enim comprehendit duas litteras nominis Christi .I. X. et P. et X. continet sub se [C.22.67–69] *tria nomina <similiter continet> Domini, in octo litteris conscripta, <id est> .I.Θ.H.O.C.X. P. H. C. T. Y. C. I. H. C. V. C.,* hic est theos Christus Ihesus. Octo autem littere sunt hee, que hic numerum exprimunt, [C 22.29–30] *quem Danielis prophetia predixit, in Antichristi tempori futurum.* [C.22.70–74] Θ. notans [. . .] *H. littera que in medio litterarum octo sita est vicem* clavis *obtinens.* H. enim .VIII. exprimit. [C.22.29–39] *Ita enim* in Daniele *scriptum est* [. . .] *Dilatio regni sanctorum probatio est patientie.* ¶ Post vero que altera pars est in monogrammate continet in se tria nomina. *<I> .O. C. O. T. O. H. P. I. H. C. Y. C. A. A. H. Θ. I. A.* [. . .] hec est [C 22.46–66] *salutaris Salvator veritas.* [. . .] *que in <P.> conscripte sunt, numero. XV.* [. . .] et exprimunt numerum dierum manifestationis et predicationis Christi, *quarum prima est O* [. . .]. *et ita millenarius et ducentenarius et sexagenarius numerus in P. invenitur.* Ut autem plane veritas innotescat. numeris simpliciter hic ponitur. Qui si equaliter dividetur in quatuor. inequales parte ponit .CCC.XV, ut in figura patet. In medio vero ponitur Christe qui interpretare iunctus quia ipse iunctus Spiritu Sancto venit predicare mundo. [C.19.73–91] Unde *veniens Nazareth in synagoga legebat capitulum de Isaia propheta* [. . .] *et mirabantur in verbis gratie que procedebant de ore eius.* ¶ Hoc etiam sciendum de etate Christi, que ipse Ihesus dum bap- [f. 49r: col. 1] tizaretur, ut idem evangelista Lucas ait, erat incipiens quia annorum .XXX.I. tricesimus annum inceperat .XIII. terram diebus eius peractis, et secundum hic inxit terram .XXXII. annis et dimidio quia eodem die revolutio anno comittit aquam

in vinum et insequenti pascha, id est, in pascha trecesimi primi annius incarceratus est Iohannis. Et in pascha sequenti, id est, .XXXII. anni. decollatus est Iohannes. Et in tertio pascha, id est, .XXXIII. anni passus est Christe, et ita iunxit .XXX. duobus annis integris et de tricesimo tertio anno quantum fluxit tem'poris a natali usque ad pascha, que pro dimiduo anno computatur. Crisostomus tamen dicit cum iam complevisse tricesimus annum et post. xxx. annos venisse ad baptismum, et secundum hic vixit Christus triginta tribus annis integris et tantum de quanto quantum anatali est usque ad pascha. De predicatione vero eius hic notandus que usque ad Iohannis incarcerationem predicavit occulte, sed post public dicens: (Mt 3:2) Penitentiam agate approprinquabit enim regnum celorum.

FIGURE 22 [*Carmen* I] (f. 49r, col. 1)

Foot of the cross: *In cruce sic positus desolvens vinela tyranni. Eternus Dominius dedux it ad astra beatos.* [C 1.121–125]

Right margin: *Versus elegiaci* [C 1.131–132]

Flanking body: *Veste quidem parua hic tegitur qui tenet astra. / Atque solum palmo claudit ubique suo.* [C 1.132–133]

Arms of crucifix: *Dextra Dei summi cuncta Ihesus; Christus laxabit e sanguine debita mundo.* [C 1.112, 115]

Upper terminal: *Rex regum et Domini dominorum* [C 1.137]

Paris, BnF, ms. lat. 8916, f. 62r
Blank

De ipsa imagine salvatoris crucifixi. .XXII. figura.

[C 1.1–15] *Ecce imago Salvatoris* [. . .] *qui in mundo est concupiscentie corruptionem,* ut innuit apud Petrus. [D 1.23–27] *Hic Deus est* [. . .] *et ex lumine lumen est.* [D 1.58–62] *Hic utique ante luciferum* [. . .] *qui est super omnia Deus benedictus in secula.* Et quia Christus Ihesus Deus et homo est, que nomina ad divinam vel que ad humanam pertineant, naturam per subtenexam

expositionem potest agnosci. Christus grece a crismate est appellatus, hic est unctio. [C 1.27 106] *Sacerdotes enim et reges apud Iudeos sacra unctione in veteri testamento ungebantur* [. . .] *et habitavit in nobis.* ¶ [D 14.21–28] *Denique principium libri Genesis manifestissime comprobat* [. . .] *sabbato in sepulcro requievisse Redemptor demonstretur.* ¶ [C 1.137–140] Hec imago *in cruce quae circa caput est continet tres litteras, hoc est A., M., –., quod significat omnia ab ipso comprehendi, initium,* videlicet *medium et finem.* [f. 49v: col. 2]

FIGURE 23 [*Carmen* XXV] (f. 49v, col. 2)
ALLELUIA; AMEN

Alleluia crucis circumdans cornua complet. [B 25.16–17][4]

Et sacram effigiem celesti carmine signat.

Nempe Amen in medio vite signacula spondet. [B 25.15]

Paris, BnF, ms. lat. 8916, f. 62r
Other than the addition of a background that lends the figure a more substantial, object-like form, no significant changes have been introduced.

De alleluia et amen. .XXIII. figura.

In Apocalipsi celestis laus et benedictio exprimitur in alleluia et amen. [C 25.9–28] Unde *ibi scriptum est* [. . .] *tunc autem perfecte.* [C 25.43–59] *Hec ergo duo verba hebraica* [. . .] *<quia> nova conditur benedictio.*

FIGURE 24 [*Carmen* XVIII] (fol. 50r, col. 1)
Center: *IHESUS*

O crux dux misero latoque redemptio mundo. [C 2.100]

O crux que dederas rupto plebem ire ab averno. [C 2.97]

O crux que excellis toto et dominaris Olimpo. [C 2.95]

Paris, BnF, ms. lat. 8916, f. 62v
The verses above the figure have been omitted, and the forty dots extending from the

center in four triangular groups of ten are less consistent in the patterns formed by color, here light green and blue in lieu of red, blue, and pink.

De numero quadragenario. .XXIIII. figura.

[C 18.1–10] *Quadragenarius <itaque> numerus <secundum hunc modum> hic speciem* sancte *crucis format* [. . .] *et evangelii maiestas concorditer astruunt.* [C 18.21–61] *Numerus iste laboriosi huius temporis sacramentum est* [. . .] *cruciantur reprobi.* [C 18.75–82] Merito ergo et *crux ipsa sancta sanctorum dici potest* [. . .] *ut in nomine Iesu omne genu flectatur celestium terrestrium et infernorum.* ¶ [D 14.45–53] *Species <quippe> ergo sancte crucis grandis est consolatio fidelibus* [. . .] *eterna visione Dei Christi electorum comprobavit.* Et quia in gloria huius nominis Ihesu celos ascendit Christus, ideo habet nomen in medio numeri quadragenarii in signum positum est.

FIGURE 25 [*Carmen* XIX] (fol. 50r, col. 2)
Quinqua salutarem numerum hic ginta beate. [B 19.22–23]
Dat crucis hec species divino munere plena.

Paris, BnF lat. 8916, 62v

The accompanying inscriptions have been omitted; the four Roman numeral *X*s have been placed on a ground that makes the underlying figure of the cross more explicit.

De numero Iubilei. .XXV. figura.

[C 19.1–71] *Numerus quinquagenarius qui in.<quinque> X.* littera quam quies ponita exprimitur: *que <et> denarii notat summam* [. . .] *qui credunt in eum.* ¶ [D 19.34–57] *Numerum ergo quinquagenarium* [. . .] *qui sanguine proprio universa laxavit debita mundo.*

FIGURE 26 [*Carmen* XX] (fol. 50v, col. 2)
Top: *Est orbi toto Domini nam passio vita.* [C 20.65]
Left: *Lux leta lucet divino munere plena.* [C 20.69]
Right: *Veraci nutu signat et premia regni.* [C 20.71]
Bottom: *Aruo crux uno spes libertatis ab ira.* [C 20.67]

Paris, Bn, ms. F lat. 8916, f. 63r

Vertical: *Aruo crix uno spes* [C 20.67]
Horizontal: *liberatis ab ira.* [C 20.67]
The inscriptions, which are placed on a yellow cross placed between the four letters, have been drastically abbreviated. The following explanation of the figure has, exceptionally, been expanded from a single column to full across on the last twelves lines of the page in order not to leave a blank at the bottom of the page. The blank was created by the scribe when he decided that there would not be enough room at the bottom of the first column for the following figure.

De littera greca lauda. .XXVI. figura.

[C 20.1–59] *Sancte crucis formam lamda greca littera lauda.* [. . .] *per quatuor loca posita exprimit* [. . .] *et perpetuo cantubunt.* [D 20.19–32] ¶ Igitur *lauda littera, secundum significationem suam quater posita* [. . .] *coruscante simul frequentia miraculorum.* [D 21.25–32] ¶ *Denique sancta atque magnifica crux* [. . .] *ad alta celorum bene meritos postmodum elevat.* ¶ Quia vero Spiritus Sanctus super apostolos in linguis igneis descendit et corda fidelum centum vidilicet viginti sua illustratione perfudit. Ideo columba ore ignem baiulans in medio figure hic posita est.

FIGURE 27 [*Carmen* XV] (fol. 51r, col. 2)
Iohannes. *Altivolans aquila et verbum hausit in arce Iohannes.* [C 15.103]
Marcus. *Marcus regem signat.* [C 15.99]
Lucas. *Dat Lucas pontificem.* [C 15.101]
Matheus. *Matheus hunc hominem signavit in ordine stirpis.* [C 15.97]

Paris, BnF, ms. lat. 8916, f. 63v

Blank

De quatuor evangelistis. .XXVII. figura.

[C 15.9–17] Cum misteria sanctorum evange-
listarum Iohannes in Apocalipsi signaret,
ita scripsit: Et in medio [. . .] *qui sunt*
.VII. spiritus Dei missi in omnem terram.
[C 15.23–41] *Quando <ergo> dicitur*
in circuitu sedis quatuor esse [. . .] *in*
libris sancti evangelii omnes concorditer
testantur. ¶ Mattheus itaque iure in imo
positus speciem hominis tenet [. . .] *ex*
terrenis parentibus eum carnem assumere
intimavit. [D 15.39–48] significans ipsum
de stirpe David secundum hominem esse
natum [. . .] *qui est salvator omnium*
hominum maxime fidelium. ¶ [C 15.41–
54] *Marcus vero et Lucas* [. . .] *et ipse*
erit exspectatio gentium. [D 15.22–25]
Idem etiam *in misterio .VII. panum* [. . .]
ipsum sacerdotem esse insinuat. [D 15.26–
37] *O tu, evangelista Lucas* [. . .] *et celesti*
benedictione ditavit. [C 15.62–67] *Ioannes*
autem speciem aquile in se ostendit [. . .]
et Deus erat verbum. ¶ [C 15.107–117] Hoc
etiam sciendum quod *agnus <quippe> qui*
in medio stat [. . .] *sed agnum Dei filium*
demonstrat.

FIGURE 28 [*Carmen* **XXVII**] (fol. 51v, col. 2)

Center: *Iohannes*

Top: *Petrus*

Bottom: *Paulus*

Left: *Iacobus*

Right: *Iudas*

Sic et apostolicus laudat concorditer ordo. [B
27.33]

Alma trophea tua sermo crux laudat ubique.
[D 27.11]

Paris, BnF, ms. lat. 8916, f. 63v

The bust-length figures of the apostles have
been eliminated, leaving only their inscri-
bed names.

De apostolis ac dictis in epistolis eorum.
.XXVIII. figura.

Misterium sancti crucis et testamentum vetus
predicat et novum, et utriusque [C 27.17–
22] *dispensator et mediator est Christus.*

[. . .] *per crucis sue potentiam promis-*
sionem complevit. ¶ Hanc vitalem ac
salutiteram unitandamque virtutem crucis
princeps apostolorum Petrus innuit in
epistola sua cum [C 27.42–48] *ait: Chris-*
tus semel pro peccatis nostris mortuus est
[. . .] *cuius livore sanati estis.* Idem etiam
in actibus apostolorum Christo in cruce
passo testimonium perhibet dicens: [C
27.33–37] *Et nos testes sumus omnium*
[. . .] *postquam resurrexit a mortuis.* [C
27.49–60] *¶ Iacobus quoque frater Domini*
ad idem exemplum nos hortatur dicens
[. . .] *quoniam misericors Dominus et*
miserator. ¶ Ioannes apostolus confiden-
tiam de misericordia eius nobis tribuit
dicens [. . .] *et nos debemus pro fratribus*
animas ponere. [C 27.112–116] *In Apoca-*
lypsi [. . .] *sepius ipse liber commemoret.*
[D 27.39–42] *¶ Iudas quoque* apostolus
<servus Christi> [. . .] *et incredulos per-*
didisse. [C 27.64–75] *Commonere autem*
[. . .] *sub caligine reservavit. ¶ Paulus*
<vero> apostolus et doctor gentium [. . .]
ut pene totus in hoc versetur. Et bene
verbum non crucis verbum salutis est,
unde ad Corinthios scribens ait: [C 27.82–
83] *verbum <enim> crucis pereuntibus*
quidem stultitia est, his autem qui salui
fiunt, id est, nobis virtus Dei est. Ad huius
crucis patientiam et fructum sub exemplo
crucifixi hortatur apostolus ad Hebreos
sic scribens (Hb 12:1). Per patienciam
curramus ad propositum nobis certamen
aspicientes in auctorem fidei et consum-
matorem ihesum qui proposito sibi gaudio
sustinvit crucem confusione contempta
atque in dextera Dei sedet. [D 27.52–56]
Ecce, sancta crux [. . .] *vetera et nova*
omnia pacificas. ¶ In hac figura Petrus
quia princeps apostolorum in superior
parte positus est paulus quia novissiumus
vocatione in ima. iacobus a dextris quia
frater Domini. Iudas a sinistris. Iohannes
in medio quasi in pectore crucis. Ipse enim
imminente passione super pectus ihesu
in cena recubuit, et ei pendenti in cruce
specialiter astuit.

FIGURE 29 [*Carmen* XXIII] (fol. 52r, col. 2)

Vertical: *Fortis conplevit Christus sua famina virtus.* [C 23.63]

Horizontal: *Victor consignans ihesu pia premia clarus.* [C 23.70]

Paris, BnF lat. 8916, 64r:

Vertical: *O crux que excellis toto* [B 2.1 & C 2.92]

Horizontal: *Et dominaris Olimpo.* [B 2.1 & C 2.92]

The inscriptions have been altered, and the color pattern of the dots at the cross-terminals has been changed from red, blue, and pink to red and light green.

De viginti quatuor senioribus. .XXIX. figura.

[C 23.1–35] *Crucis Domini quatuor cornua senarius numerus decenter concludit* [. . .] *Data est inquit michi omnis potestas in celo et in terra,* propter obedientiam enim mortis, ut innuit apostolus in nomine Iesu omne genuflectat celestium et terrestrium et infernorum. [. . .] [C 23.42–58] *De throno ergo isto procedunt fulgura* [. . .] *et ego mundo.* Sanitam igitur crucem [D 4.39–46] *magis decet thronum imperialem vocari* [. . .] *et virtutis premia capimus.*

FIGURE 30 [*Carmen* XXIV] (f. 52v, col. 2)

Framing upper arm: *Immaculata cohors cantas tu vocibus illic.* [C 24.96]

Above and below left arm: *Carmina que nullus diffuso famine cantat.* [C 24.100]

Above and below right arm: *Hic vester grex tu solus et splendidus ordo.*[5] [C 24.102]

Framing lower arm: *Ihesus ovat quo pascit virginis agnus.* [C 24.98]

Terminals: *.XXXVI.M.; .XXXVI.M.; .XXXVI.M.; .XXXVI.M.*

Paris, BnF, ms. lat. 8916, f. 64v

All the inscriptions aside from the Roman numerals have been omitted. The bifurcated red and white fleur-de-lis at the center has been reduced to an indeterminate silver blossom.

De Centum quadraginta quatuor mulieribus. .XXX. figura.

Beatorum vitam in celis ratione ultime perfectionis numerus millenarius designat que specilater in pulcritudine castitis resplendet quam. C.XLIIII. [C 24.5–6] *albatorum qui cum agno super montem Sion stabant,* declarant: Hic enim verus virginibus que [C 24.40–59] *Deum ex toto corde* [. . .] *sedecies autem novem .C.X.IIII.* adimplent, numerus quoque finitus ibi pro infinitus ibi pro infinito ponitus est et *<ut> cum de his qui in arcioris vite gradu constituti* [. . .] *quamvis ad eorum premia non assurgant.* [C 24.72–76] *Habent quippe nomen eius* [. . .] *et frequenti manus inscriptione signatur.* Hic. IIII. partes [f. 53r: col. 1] crucis continent .XXXVI, que in unim collecta faciunt .C.XLIIII. Et quia lilium castiatem representat. ideo in medio crucis positum inventitur. [C 24.3–25]
¶ *Millenario multiplicato in Apocalypsi multitudo <illa> signatorum* [. . .] *que fiunt in medio eius.*

FIGURE 31 [*Carmen* III] (f. 53r, col. 1)

First row: *Seraphin*

Second row: *Cherubin*

Center: *Throni*

Third row: *Virtutes; Potestates; Principates; Dominationes*

Fourth row: *Archangeli*

Fifth row: *Angeli*

Hinc rogo celorum agmen benedicite Christo. [C 3.34–36]

Qui cruce salvavit mundum dans regna beatis.

Et vestrum numerum complevit in arce polorum.

Paris, BnF, ms. lat. 8916, f. 64v

The inscriptions remain the same, but the underlying sense of hierarchy has been dissipated by the elimination of the triangular forms nesting between the cross arms.

De novem ordinibus angelorum. XXXI figura.

[C 3.1–7] Pulchro *sanctorum angelorum ordines* ac *celestis militie exercitus* [. . .]

verum etiam tempore resurrectionis passionis eius, [. . .] *triumphum* nobilem ipsos clare annunciasse narrat. Te itaque benedictam venerandam ac laude dignam crucem Christi. mira angelorum facta ordinate respiciunt. [. . .] *[D 3.16–24] Michael* namque, *dux et princeps plebis Dei* [. . .] *ante tribunal decantet Domini.* [D 3.38–46] ¶ *Hoc tu, Gabriel* [. . .] *luculento sermone pronuntiaveras.* ¶ *Quid et tu, o Raphael medicina Dei?* [. . .] *eternam lucem humano generi reddidit.* [C 3.11–44] ¶ *Novem* autem *sunt ordines angelorum* [. . .] ac ad eius *magnificentiam et potentiam narrandam decenter competunt.* ¶ *Quem enim angeli et archangeli in infima parte crucis positi denuntiant* [. . .] *Data est, michi omnis potestas in celo et in terra.* Quem vero alium principatus et dominationes in sinistro positi designant, nisi eum de quo dictum est: *Et factus est principatus super humerum eius* [. . .] *sed etiam in futuro,* cui laus honor et gloria sit cum Deo Patre et Spiritu Sancto in secula secularum. Amen.

Finalis Benedictio

[D 2.4–31] *O sancta crux Christi* [. . .] *diutius irrisionis eulogio progeniem eius in exsilio dampnatam fatigaret.* [D 3.4–7] *<O tu> Salve, crux veneranda Dei* [. . .] *terrigenasque indesinenter uiges.* [D 3.11–12] *Te totus orbis beatificat, te celorum agmina collaudant.* [D 13.5–12] *Arbor odoris suavissimi et expansione pulchrarum frondium latissima* [. . .] *quia claritas Christi in te crucifixi gloriosam et speciosam et venerabilem omnibus te exhibuit.* [D 13.16–19] *Varias quidem virtutum species in sinu tuo demonstras* [. . .] *et pro Christo animas nostras ponere fortiter suades.* [D 28.60–64] *O crux alma Dei, usque huc, quantum potui, laudem* et gloriam *tuam* descripsi*; sed* quia in his mortalibus perpetem triumphum plene invenis et perfectum honorem quem expetis, *confer te ad celestia angelorum agmina, ibique tibi laus perpetua per cuncta*

sonabit secula. Amen. [f. 54r: col. 1]

Basel, UB, Cod. B IX 11, f. 1v
The miniature has been excised.

Explicit liber de misteriis et laudibus sancte crucis. Amen.

Hunc librum ordinavit et conscriptsit ex libro Rabani, De sancta cruce, diffuso in scriptura et difficili in intelligentia, ad honorem et laudem ipsius preclare ac salutifere crucis. Frater Bertoldus, de ordine fratrum predicatorum, quondam lector Nurinbergensis, anno Domini .M.CC.XCII. Anima eius per gratiam Ihesu Christi, qui in ipsa cruce pependit, requiescat in pace. AMEN.

Dedication Image (f. 54r, col. 1)[6]

Incipit prefatio in librum de misteriis et laudibus intemerate Virginis genitricis Dei et Domini nostri Ihesu. Damascenus libro quarto.

John of Damascus, *De fide orthodoxa*, chap. 87.[7]

De sancta et superlaudibili semper Virgine et Dei genitrice Maria mensurate assummentes et quod firmissimum representantes. Quod principaliter et vite Dei gentrix et est et nominatur. [. . .] *Ipsa est enim que* perpetuo *previsivo* [. . .] *Et flos de radice eius ascendet.* Amen.

FIGURE 1 (f. 54v, col. 1)

Incipit liber de misteriis et laudibus intemerate Virginis Marie genitricis Dei et Domini nostri Ihesu Christi. De Adam et Christo. Prima figura. Bernardus super Missus est.

Bernard of Clairvaux, *Homiliae super "Missus est,"* homily 2, part 2.[8]

Letare pater Adam [. . .] *quia in ipso vivificasti me.* ¶ Hec figura continet Adam et Eva, et eregione Christum, et Virgine beatam. In medio vero fructum arboris representationem coloribus distinctis fruc-

tum salutis videlicet Iherusalem Christum, de quo in Canticis (Ct 5:10) scriptum est: Dilectus meus candidus et rubricundus; electus ex milibus.

FIGURE 2 (f. 54v, col. 1)

De Eva et Maria. Secunda figura. Maximus de beata Virgine in quodam sermone.

Ildefonsus of Toledo, sermon 12, "De sancta Maria."[9]

Videamus, fratres karissimi, qualiter sibi iste due mulieres distent. [. . .] *Ecce ancilla Domini fiat michi secundum verbum tuum.* ¶ In hac figura ponitur Eva cum superbia et Virgo beata cum humilitate. In medio vero flos variis coloribus representas et vitium elationis per quod Eva Deo displicuit et virtutem humilitatis quam Deus in virginie beata prerecognovit, sicut in Luca (Lc 1:48) scriptum est: Respexit humilitatem ancille sue.

FIGURE 3 (f. 54v, col. 2)

De viribus [*sic*: virtutibus] **anime. Tertia figura. Anselmus in libro orationum.**

Anselm of Canterbury, *Orationes sive meditationes*, prayer 7.[10]

Maria, tu illa magna [. . .] *Genitrix vite anime mee, altrix reparatoris carnis mee, lactatrix salvatoris totius substantie mee!* ¶ Hec figura continet virtutes anime virginem beatam ordinate respicientes, ut ipsa sua mater propter Christum, et (cf. Mt 22:37; Mc 12:30; Lc 10:27) ex toto corde et ex tota anima et in tota mente diligatur. Sic enim in Matheo (Mt 22:37) scriptus est: Diliges Dominum Domini tuum ex toto corde tuo, et ex tota anima tua, et in tota mente tua. Et in Proverbiis (Pr 8:17): Ego diligentes me diligo, et qui mane vigilaverint ad me, invenient me.

FIGURE 4 (f. 54v, col. 2)

De renovatione creature et temporis. Quarta figura. Anselmus in libro orationum.

Anselm of Canterbury, *Orationes sive meditationes*, prayer 7.[11]

Per fecunditatem tuam, domina, mundus pec-

cator est iustificatus [. . .] *Hec tanta bona per benedictum fructum benedicti ventris benedicte Marie mundo provenerunt.*

¶ In hac figura ponitur celum et terra, dies et nox in medio vero virgino beata, cum attribui potest illud prophete. (Ps 88:1) Tui sunt celi et tua est terra. Et iterum. (Ps 73:16) Tuus est dies, et tua est nox.

FIGURE 5 (f. 55r, col. 1)

De rubo Moisi. Quinta figura. Origines in omelia Cum esset desponsata.

Origen, homily 17, "In vigilia nativitatis Domini."[12]

O magne admirationis gratia! [. . .] *Ita et hec sancta Virgo genuit Dominum, sed intacta permansit.* ¶ Hec figura continet rubum variis coloribus distinctum ac misteriis apertum, nam pars eius inferior Virginis beate designat, humilitatem pars superior Dei ad incarnandum genusque humanum redimedium amorem, pars dextra Virginis matris incorruptionem, pars sinistra legis moisi, peccatique ac tribulationis fulgorem formidinem et asperitatem, que omnia Christus abstu- [f. 55r: col. 2] lit, cuius persagium in rubo illuxit. De hoc rubo Moise in Exodo (Ex 3:2–3) ita scriptum est: Apperuitque ei Dominus in flamma ignis de medio rubi: et videbat que rubus arderet, et non conbureretur. Dixit ergo Moises [Ex 3:3]: Vadam, et videbo visionem hanc magnam, quare non conburatur rubus.

FIGURE 6 (f. 55r, col. 2)

De archa testamenti et contentis in ea. Sexta figura. Augustinus in sermone de annuciatione.

Ps. Augustine, sermon 195, "De Annuntiatione Domini."[13]

Ioseph fili David, natus ex genere sacerdotali [. . .] *Sicut audivimus, sic* vidimus in civitate Domini <virtutum>, in civitate Dei nostri. ¶ In hac figura ponitur archa deaurata inter et extra significans virginis beate mundiciam mentis et corporis. (cf. Hbr 9:4) Urna aurea habens manna

animam Christi plena sapientia, qua reficitur et angeli virga aaron virginitate fecunditate. Tabule testamenti legis perfectionem in virgine. Cherubin glorie, Virginis beate plenitudine scientie. Propiciatorium et inter Deum et hominem virginis beate mediationem. Ei namque specialiter post Christum datum est, ut sit propiciatio nostris, De arca quodque et contentis in ea ad Hebreos, ita scriptum est (Hbr 9:3–4): Post velamentum autem secundum, tabernaculum, quod dicitur sancta sanctorum: habens aureum turibulum, et archam testamenti circumtectam ex omni parte auro, in qua urna aurea habens manna, et virga Aaron, que frondeat, et tabule testamenti, superque erant cherubin glorie obumbrantia propiciatorum.

FIGURE 7 (f. 55r, col. 2)
De virga Aaron. Septima figura. Augustinus in sermone de incarnatione Domini.

Ps.-Augustine, sermon 245, "De misterio Trinitatis et Incarnationis."[14]

Dominus Moisi sancto precepit [. . .] *dicente <beato> apostolo* (Col 1:20): *Quia ipse per sanguinem crucis sue pacificavit omnia que in celis sunt et que in terris.* ¶ Hec figura continet virgam variis coloribus, que in sui infima parte exprimit virginis beate castitatem, in superiori fructum eius fore celestem, in parte dextra sacerdotale Christi potestatem, in sinistra ipsius virginis secunda incorruptionem. De hac virga in Numeris (Nm 17:6) ita scriptum est: Locutusque est Moises ad filios Israel: et dederunt ei omnes principes virgas per singulas tribus: fuerentque virge .XII. absque virga Aaron. Quas cum posuisset Moises coram Domino in tabernaculo testimonii, sequenti die regressus invenit germinasse virgam Aaron in domo Levi: et turgentibus gemmis eruperat flores, qui foliis dilatati in amigdala deformati sunt.

FIGURE 8 (f. 55v, col. 1)
De velle Gedeonis. Octava figura. Bernardus sermone Missus est.

Bernard of Clairvaux, *Homiliae super "Missus est."*[15]

Quid significat hoc *Gedeonis vellus* [. . .] *Quod et fecerunt: etenim in omnem terram exivit sonus eorum, et in fines orbis terre verba eorum.* ¶ In hac figura interferitur Virgo beata cum rore et velle secundum significationem congruam sibi. De hoc velle Gedeonis in libro Iudicum (Idc 6:36–37) ita scriptum est: Dixitque Gideon ad Dominum: Si salvum facis per manum meam Israel, sicut locutus es, ponam hoc vellum lane in area: si ros in solo velle fuerit, et in omni terra siccitas, scio quod per manum meam, sicut locutus es, liberabis Israel. Secundumque est ita: et de nocte consurgens expresso vellere, concham rore conplevit. Dixitque rursum ad Deum: Ne irascatur furor tuus contra me si ad huc semel temptavero, signum querens in vellere. Oro ut solum vellus siccus sit, et omnis terra rore madens. Fecitque Dominus nocte illa ut postulaverat: et fiut siccitas in solo vellere, et ros in omni terra.

FIGURE 9 (f. 55v, col. 2)
De Iherusalem et templum Salomonis. Nona figura. Anselmus in liber orationum.

Anselm, *Orationes sive meditationes,* prayer 7.[16]

Quid <enim> digne dicam matri creatoris et salvatoris mei [. . .] *tu peperisti mundo reconciliatorem quem reus non habebat.* ¶ Hec figura continet quedam magnifica Virginem beatam pulchre respicientia, vidilecet templum Domini ratione sanctitatis eximie, domum Salomonis ratione in habitationus divine sapientie, domum saltus Libani ratione admirande castitatis, Iherusalem ratione amantis sume quietis. In Canticis (Ct 6:3): pulchra es amica meam, suavis et decora sicut Ierusalem.

FIGURE 10 (f. 56r, col. 1)
De throno Salomonis. Decima figura. Bernardus in sermone de nativitate beate Virginis.

Ps.-Peter Damian, sermon 44, "In nativitate beatissimae Virginis Mariae."[17]

Salomon noster, non solum sapiens, sed et sapientia Patris [. . .] *luminis* serenum, *habitaculum pacis?* ¶ In hac figura continetur Christus per Salomonem figuratur. Tribus namque nominibus in scripturis Solomonem vocatum legimus: Salomon videlicet, Ecclesiasten Ididera, filius regis immo et rex nec solum filius Dei, sed autem Deus. Idida, id est, dilectus Domini illuxit in baptizante cum paterna vox protestaretur dicens: Hic est filius meus dilectus. Ecclesiastes idem concionatur in predicatione. Salomon vero, id est, pacificus in passione. Vel Salomon, id est, pacificus est nobis in hoc exilio. Ecclesiastes, id est, concionator erat in iudicio. Idida idem amabilis erit in regno, in exilio purus. in iudicio iustus, in regno gloriosus. Continetur autem hic Gabriel archangelus ratione custodie singularis, et Iohannes evangelista ratione cure familiaris, de quo et Iohanne scriptum est: (Io 19:27) Deinde dicit discipulo (Io 19:26–27): Ecce mater tua. Et ex illa hora accepit eam discipulus in suam.

FIGURE 11 (f. 56v, col. 1)

De propheta David. Undecima figura. Beda in omelia Exurgens Maria.

Bede, *Homiliarum evangelii libri II*, bk. 1, homily 4.[18]

De <huius> ortu fructus psalmista mistico sermone testatur dicens [. . .] *de nostra natura mortalem Deus susceperat virtute resurrectionis inmortalem iam redditam ad celos sublevavit.* ¶ Hec figura in se continet florem vario calore, benignitatem representatem continet, et Virginem beatam quando Dominus benignitatem benigne respexit, de qua et David veluti de terra benedicta cecinit (Ps 84:2): Benedixisti Domine terram tuam. Et item (Ps 64:10): Visitasti terram, et inebriasti eam; et multiplicasti locupletare eam.

FIGURE 12 (f. 56v, col. 1)

De prophecia Isaie. .XII. figura. Rabanus in libro de misteriis sancte crucis.

Hrabanus Maurus, *In honorem sanctae crucis*.[19]

[C 16.1–26] *Scriptum est in Isaia: Egredietur virga de radice Iesse* [. . .] *dedit ut Deus.* ¶ In hac figura continetur flos descriptus [C 16.97–112], *quatuor coloribus precipius* [. . .] *quia totius decoris pulcritudine inter foris que plenus erat.* Continetur est hic columba Spiritum Sancti representans qui in spem scriptum est (Lc 3:21–22): Aperta est celum: et descendit Spiritus Sanctus corporali specie sicut columba in ipsum: et vox de celo facta est: Tu es filius meus dilectus, in te conplacuit michi.

FIGURE 13 (f. 56v, col. 2)

De prophetia Ieremie. .XIII. figura. Bernardus super Missus est.

Bernard of Clairvaux, *Homiliae super "Missus est,"* homily 2, part 8.[20]

Audiamus et Ieremiam nova veteribus vaticinantem [. . .] *maturitate sensuum, non corpulentia membrorum.* ¶ Hec figura continet Virginem beatam, que Christum circumdedit, quem Deus Pater per omnibus in benedictionibus dulcedinis prevenit. Et Rebeccam, que Iacob vestivit ac circumdedit. cum a patre suo Isaac in misterio et figura benedictionem accepit. Sic namque in Genesi scriptum est (Gn 27:15–16): Vestibus Esau valde bonis, quas apud se habebat domi, induit eum: pelliculasque edorum circumdedit manibus, et colli nuda protexit. Et infra (Gn 27:27): Statimque ut sensit vestimentorum illius fragrantiam, benedicens ait: Ecce odor filii mei sicut odor agri pleni, cui benedixit Dominus. Det tibi Deus Deus rore celi et de pinguendine terre habundantiam.

FIGURE 14 (f. 57r, col. 1)

De prophetia Ezechielis. .XIIII. figura. Augustinus in sermone de annunciatione.

Ps.-Augustine, *De Annunciatione Dominica*.[21]

(Ezek 44:1–2): *Vidi portam in domo Domini clausam.* [. . .] *nec in parturitione inventa sum cum dolore.* ¶ In hac figura continetur porta clausa (Ez 44:2) Virgine beatam representans per quam Christus natus exiit, et ipsam Virginem beatam inclusam que clauso utero Christum concepit de Spiritum Sancto, sicut ut in Mattheo (Mt 1:20) scriptum est: Joseph fili David, noli timere accipere Mariam conuigem tuam: quod enim mea natum est, de Spiriti Sancto est.

FIGURE 15 (f. 57r, col. 2)

De propheta Danielis. .XV. figura. Ambrosius in sermone de purificatione beate Virginis.

Ambrosius Autpertus, *Sermo in purificatione sanctae Mariae.*[22]

Appareat <interim> lapis humilis abscissus de monte sine manibus [. . .] *quia secundum humanitatem filium recognovisti, lactasti, fovisti, abluisti.* ¶ Hec figura continet lapidem abscisum de monte sine manibus, id est, Christum forma quadrangulari, quem ad Corinthios apostolus quatuor virtutes salutates de Christo enumerans. Ait (1 Cor 1:30): Qui factus est nobis sapientia a Deo, et iusticia, et sanctificatio, et redemptio, de hoc est monte Virgine scilicet beatam ac lapide inde abciso Christo, videlicet in Daniele (Dn 2:44–45) ita scriptum est: In diebus autem regnorum illorum suscitabit Deus celi regnum, quod in eternum non dissipatur, et regnum eius populo alteri non tradetur: conminuet autem, et consumet universa regna hec, et ipsum stabit in eternum. Secundum quod vidisiti, quod de monte abcisus est lapis sine manibus, et conminuit testam, et ferrum, et es, et argentum, et aurum, Deus magnus ostendit regi, que futura sunt postea et verum est sompnium, et fidelis interpretatio eius.

FIGURE 16 (f. 57r, col. 2)

De santificatione Virginis beate in utero matris. .XVI. figura. Bernardus in epistola ad canonicos Lugdunenses.

Bernard of Clairvaux, *Epistola* 174, part 5.[23]

Est itaque Virgo regia veris honorum titulis cumulata que *procul dubio sancta* fuit *antequam nata.* [. . .] *vite <et> iustitieque munus omnibus obtineret.* ¶ In hac figura continentur columba Spiritum Sanctam representans qui Iohannem baptistam in utero matris et replevit et sanctificavit ut in Luca (Lc 1:15) scriptum est: Et Spiritu Sancto replebitur ad hic ex utero matris sue. Ponitur Ieremias propheta de cuius sanctificatione in Ieremia (Ir 1:15) dicitur: Priusquam te formarem in utero, novi te: et antequam exires de vulva, sanctificavi te. Interseritur et hic testimonii tabernaculum Virginem beatam signans que non ante annunciationem sanctificata est, sicut nec tabernaculum nube opertum, et gloria Domini inpletum ante perfectionem. Sic enim in Exodo (Ex 39:41–42) scribitur: Postquam cuncta perfecta sunt, operuit nubes tabernaculum testimonii, et gloria Domini implevit illud.

FIGURE 17 (f. 57v, col. 1)

De nativitate ipsius. .XVII. figura. Damascenus libro quarto.

John of Damascus, *De fide orthodoxa*, chap. 87.[24]

Ex cathena <igitur> Nathan filii David venit Levi [. . .] *et templum sanctum et admirabile altissimi Dei dignum demonstratur.* ¶ Hec figura continet Annam Samuelis et Annam beate virginis, quoniam utraque edidit fructum repromissionis. Habet est rosam superpositam virginem beatam in tempore ipsius reprouentantes iuxta illud, quod canit ecclesia. (Can 006024: Nativity, Purification, and Assumption of Mary) Sicut spina rosam genuit Iudea Mariam. Et in Ecclesiastico (Sir 24:18): Quasi plantatio rose in Iericho.

FIGURE 18 (f. 57v, col. 2)

De tempore nativitatis eius. .XVIII. figura. Bernardus in sermone de nativitate beate Virginis.

Ps.-Peter Damian, sermon 44, "In nativitate

beatissimae Virginis Mariae."[25]

Virgo Dei <genetrix>, cuius pulcritudinem sol et luna mirantur [. . .] *et in tua protectionis muniamur demmorari.* ¶ In hac figura includitur sol in virgine, quoniam sol existens in leone, declarat iusticiam et iram iudicis. Postea cum est in Virgine facta iam circa estus et ardores ipsius solis tempore et refigerio aeris designat mitigationem factam, ergo iustitiam Dei et iram. Bene ergo nunc nascitur Virgo beata tempore, vidilicet autumpnali insignum, quod ipsa est Virgo inclita, que habet refrigerare et mitigare iram iudicis exigentibus nostris delitis. Hec declarat est in figura Asuerus, Christum significans, et Hester virginem beatam demonstrans, de quo in Hester (Es 5:1–3) ita scriptum est: Die autem tertio induta est Hester regalibus vestimentis, et stetit in atrio domus regie, quod erat interius, contra basilicam regis: at ille sedebat super solum in consistorio palacii contra ostium domus. Cumque vidisset Hester reginam stantem, placuit oculis eius, et extendit contra eam virgam auream, quam tenebat manu. Que accedens, osculata est summitatem virge eius. Dixitque ad eam rex: Quid vis, Hester <regina>, que est petitio tua? Etiam si dimidiam partem regi petieris, dabitur tibi, et infra. (Es 5:9–12) Ingressa igitur cuncta per ordinem ostia, stetit contra regem, ubi ille residebat super solum regni sui, induitus vestibus regiis, auroque fulgens, et pretiosis lapidibus, eratque terribilis aspectu. Cumque elevasset faciem, et ardentibus [. . .] *in pallorem colore mutato, lassum super ancillam reclinavit caput. Convertitque Dominus spiritum regis in manusuetudinem, et festinus ac meruens exiliunt de solio, et sustenans eam ulnis suis donec veniret ad se, hiis verbis blandiebatur: Quid habes, Hester? Ego sum frater tuus: noli metuere. Et infra.* (Es 15:16–17) *Que respondit: Vidi te, domine, quasi angelum Dei, et conturbatum est cor meum pre timore glorie tue. Valde enim mirabilis es, domine, et facies tua plena est gratiarum.*

FIGURE 19 (f. 58r, col. 1)

De impositione nominis Maria. .XIX. figura. Bernardus super Missam est.

Bernard of Clairvaux, *Homiliae super "Missus est,"* homily 2, part 17.[26]

Bernardus. *Loquamur pauca et super hoc nomine* [. . .] *Et nomen Virginis Maria.* ¶ Hec figura continet stellam maris, que Virgine beatam represent, et mundum quem stella ista irradiat. Balaamque, qui de ipsa in libro Numeri (Nm 24:17) sic prophetat: Orietur stella ex Iacob, et consurget virga de Israhel.

FIGURE 20 (f. 58r, col. 2)

De pulcritundine Virginis beate. XX. figura. Anselmus in libro orationum.

[Anselm of Canterbury, *Orationes sive meditationes*, prayer 7.][27]

O femina mirabiliter singularis et singulariter mirabilis [. . .] *Ne abscondas te, domina, parum videnti anime te querenti.* ¶ In hac figura includitur flos diversis coloribus, candidi videlicet et rubeo, ut sit quod a modo conformitas inter dilectam et dilectum, de cuius venustate in Canticis (Ct 5:10) scriptum est: Dilectus meus candidus, et rubricundus, electus ex milibus. Continentur autem hic mulieres suo decore Virginis beate pulcritudinem signaliter demonstrantes. De Rebecca namque in Genesi (Gn 24:15) dicitur: Ecce Rebecca egrediebatur, filia Bachuelis, filii Melche uxoris Machor fratris Abraham, habens idriam in scapula sua: puella decora minis, virgoque pulcherima, et incognita viro. De Abisag sunamite in libro Regum (I Reg 1:3) scriptum est: Quesierunt <igitur> adolescentulam speciosam in omnibus finibus Israel, et invenerunt Abisag sunamitem, et ad duxerunt eam ad regem. Erat autem pulchra nimis. De Iudit in libro Iudit (Idc 11:19) dicitur: Non est talis mulier super terram in aspectu, in pulcritudine, et in sensu verborum. De Hester in libro Hester (Es 2:15) scriptum est: Erat enim formosa valde, et incredibili pulcritudine, omnium oculis gratiosa et amabilis videbatur.

FIGURE 21 (f. 58v, col. 1)

De bona in dole et moribus eius. XVI. figu-ra.[28] **Ambrosius in libro de virginitate**

Ambrose, *De virginibus*, bk. 2, chap. 2, part 6.[29]

Sit <igitur> nobis tamquam in imagine descripta virginitas vita Marie [. . .] ut ipsa species corporis fieret simulacrum mentis, et figura probitatis. ¶ Hec figura continet Susannam de cuius bona indole et conversatione in Daniele (Dn 13:1–3) ita scriptus est: Erat vir in Babilone, et nomen eius Ioachim: et accepit uxorem Susannam, filiam Helchie, pulchram nimis, et timentem Deum: parentes enim illius, cum essent iusti, erudierunt filiam suam secundum legem Moisi. Continet autem sponsam designatem Virginem beatam de cuius moribus et actibus in Canticis (Ct 7:1) dicitur: Quam pulcri sunt gressus tui in calciamentis, tuis filia principis.

FIGURE 22 (f. 58v, col. 1)

De desponsatione inter ipsam et Ioseph. .XXII. figura. Bernardus super Missus est.

Bernard of Clairvaux, *Homiliae super "Missus est,"* homily 2.[30]

Illa utique fuit ratio desponsationis Marie [. . .] factus est pudicitie fidelissimus testis. [. . .] Conice et ex proprio vocabulo [. . .] solum denique in terris sibi magni consilii coadiutorem fidelissimum. ¶ In hac figura interferitur lilium castitatem significans et non modo Christo matrique eius. Verum et utrisque Ioseph congrue ac pulcher conveniens. De Ioseph namque patriarcha in Genesi (Gn 39:6–9) scriptum est: Erat autem Ioseph pulchra facie, et decoris aspectu. Post multos itaque dies iecit domina sua oculos in Ioseph, et ait: Dormi mecum. Qui nequamque acquiescens operi nefario, dixit ad eam: Ecce Dominus meus, omnibus michi traditis, ignorat quid habeat in domo sua: nec quicquam est qui in mea non sit potestate, vel non traditur michi, preter te, que uxor eius es: quomodo ergo possum hoc malum facere, et peccare in Dominum meum? De Ioseph autem sponso Virginis beate in Matheo (Mt 1:18–19) dicitur: Cum esset desponsata mater eius Maria Joseph, antequam convenirent inventa est in utero hominis de Spiritu Sancto. Ioseph autem vir eius cum esset iustus, et nollet eam traducere, voluit occulte dimittere eam.

FIGURE 23 (f. 58v, col. 2)

De missione angeli ad Virginem beatam. .XXIII. figura. Beda in omelia Spiritus missus est.

Bede, *Homeliarum evangelii libri II*, bk. 1, homily 3.[31]

Aptum profecto humane restaurationis principium ut angelus a Deo mitteretur [. . .] et ab earum tirannide mundum veniebat eripere. ¶ Hec figura continet in se spiritem angeli figure et figurato apte convenientem. De figura namque in libro Iudicum .XIII. scriptum est (Idc 13:2–3): Erat quidam vir de Saraa, et de stirpe Dan, nomine Manue, habens uxorum sterilem. Cui apparuit angelis Domini, et dixit ad eam: Sterilis es et absquc libcris, sed concipies, et paries filium: Et sequitur (Idc 13:7): Erit enim nazareus Dei ab infancia sua, et ex matris utero. Et ipse incipiet liberare Israel de manu Philistinorum. Et infra (Idc 13:24): Peperit itaque filium, et vocavit nomen eius Sampson. Crevitque puer, et benedixit ei Dominus. Cepitque spiritus Domini esse cum eo. De figuratio autem in Lucam (Lc 1:26) dicetur. Missus est angelus Gabriel a Deo in civitatem Galilee, cui nomen Nazareth, ad Virginem desponsatam iuro, cui nomen erat Ioseph, de domo David: et nomen Virginis Maria.

FIGURE 24 (f. 59r, col. 1)

De inquisitione Virginis beate et eius inventione ab angelo. .XXIIII. figura. Bernardus de annunciatione in quodam sermone.

Bernard of Clairvaux, *Sermones in assumptione beatae Mariae Virginis*, sermon 6, part 1.[32]

Felices qui non inquinaverunt vestimenta sua [. . .] *Quod ex te nascetur sanctum, vocabitur Filius Dei.* ¶ In hac figura includitur Abraham et Deus Pater quoniam utraque nuntium direxit, ille propter sacramentum coniugalis societatis, hic propter misterium incarnationis. Continetur est hic Rebecca et servus Abrahe, de quo in Genesi (Gn 24:11–22) ita scriptum est: Cumque camelos fecisset accumbere extra opidum iuxta puteum aque vespere, eo tempore quo solent mulieres egredi ad hauriendam aquam, dixit: Domine Deus Domini mei Abraham, occurre, hodie michi, obsecro, et fac misericordiam cum Domino meo Abraham. Ecce ego esto propter fontem aque et filie hintatorum huius civitatis egredientur ad haurienda aquam. Igitur puella, cui <ego> dixero: Inclina idriam tuam ut bibam: et illa responderit: Bibe, quin et camelus tuis potum: tribuam. Ipsa est quam preparasti servo tuo Isaac: et per hoc intelligam quod feceris misericordiam cum Domino meo. Necdum intra se verba compleverat, et ecce Rebecca egrediebatur, filia Batuel, filii Melche uxoris Nachor fratis Abraham, habens idriam in scapula sua: puella decora nimis, virgoque pulcherrima, et incognita viro: descenderat autem ad fontem, et impleverat idriam suam, ac revertebatur. Occuritque ei servus, et ait: Pauxilum aque ad bibendum michi prebe de idria tua. Et respondit: Bibe, domine mi: celeriterque deposuit idriam super ulnam suam, et dedit ei potum. Cumque ille bibisset, adiecit: Quin et camelis tuis hauriam aquam, donec cuncti bibant. Effundensque idriam in canalibus, recurrit ad puteum ut hauriret aquam: et hastam omnibus camelis dedit. Ille autem contemplabatur eam tacitus, scire volens utrum prosperum fecisset iter suum Dominus, an non. Postquam autem biberant cameli, protulit vir inaures aureas, appendentes duos siclos, et armillas tondere pondo siclorum decem.

FIGURE 25 (f. 59r, col. 2)

De plenitudine et redundancia gratie. .XXV. figura. Iheronimus in sermone de assumptione.

Paschasius Rasbertus, *De assumptione sanctae Mariae Virginis.*[33]

Qualis et quanta esset [. . .] *quod per Gabrielem Marie divinitus nuntiatur et per Christum adimpletur.* ¶ Hec figura continet paradisum cum quatuor fluminibus, quem Virgo beata est vere paradisus voluptatis inquam posuit Deus hominem quem formaverat id est Christum. De ipsa autem ratione plenitudinis gratie egrediuntur quatuor fluvii spiritalis. Primus miserationum: hic vadit contra peccatores. Secundus consolationum: hic vadit contra eos qui in affectione sunt. Tercius gratiarum: hic vadit contra iustos. Quartus gaudiorum: hic vadit contra beatos. Ab ipsa enim recipiunt peccatores misericordiam, afflicti consolationem, iusti anguistium gratie beati gaudia glorie. De paradiso terresti in Genesi (Gn 2:8–14) ita scriptum est: Plantaverat autem Dominus paradisum voluptatis ad irrigandum paradisum, qui inde dividitur in quatuor capita. Nomen uni Phison. Ipse est qui circuit omnem terram Evilath ubi nascitur aurum et aurorum terre illius optimum est. Ibique invenitur bedellium et lapis onichinus. Nomen fluvius secundo Geon. Ipse est qui circuit terram Ethyopie. Nomen fluvio tertio Tigris. Ipse vadit contra Assirios. Fluvius autem quartus ipse est Eufrates.

FIGURE 26 (f. 59v, col. 1)

De obumbratione virtutis altissimi. .XXVI. figura. Damascenus libro tertio.

John of Damascus, *De fide orthodoxa.*[34]

Angelus <enim> Domini missus est [. . .] *quam assumpsit humana natura unam naturam perficiens compositam.* In hac figura ponitur sol et nubes que faciunt obumbrationem. Sol ratione deitatis, nubes ratione assumpte carnis que a pondere peccati fuit inmunis. Iuxta illud Isaie (Is 19:1): Ascendet Dominus super nubem

levem, et ingredietur Egiptum. Continetur
et sponsa Virginem beatam representans
de cuius obumbratione in Canticis (Ct 2:3)
dicitur: Sub umbra illius quem deside-
rabam sedi, et fructus eius dulcis gutturi
meo.

FIGURE 27 (f. 59v, col. 2)

**De benedictione virginis matris et fructus
ventris a Spiritu Sancto per os Eliza-
bet. .XXVII. figura. Ambrosius super
Lucam.**

Ambrose, *Expositio evangelii secundum Lu-
cam*, bk. 2.[35]

*Contuendum est <enim> quia superior venit
ad inferiorem* [. . .] *nunc fructificat in
nobis, nunc rediviua corporis resurrectione
reparatur.* ¶ Hec figura continet spem,
columbe Spiritum Sanctum representans
qui per os Elizabeth fructum benedictum
ad vesperam diei in ore suo ad archam
portavit ramum olive virentis. Sic enim in
Genesi (Gn 8:10–11) scriptum est: Ex-
pectatis ultra septem diebus aliis, rursum
dimisit columbam ex archa. At illa venit
ad eum ad vesperam, portans ramum olive
virentibus soliis in ore suo: intellexit ergo
Noe quod cessassent aque super terram.

FIGURE 28 (f. 60r, col. 1)

**De magnificatione Domini a Virgine matre
et prophetatione ipsius. .XXVIII. figura.
Beda in omelia Exurgens Maria.**

Bede, *Homeliarum evangelii libri II*, bk. 1,
homily 4.[36]

*Audita <ergo> responsione Elisabeth . . .
quibus humano generi in eternum consu-
lere non desistit enumerat.* ¶ In hac figura
ponitur Maria soror Aaron prophetissa
que magnifice Domino gratias ceciunt,
et gloriose honorificavit. Sic namque in
Exodo (Ex 15:20–21) scribitur: Sumpsit
<ergo> Maria prophetissa, soror Aaron,
timpanum in manu sua: egresseque sunt
omnes mulieres post eam cum timpanis et
choris, quibus procinebat, dicens: Cante-
mus Domino, gloriose enim honorificatus
est: equm et ascensorem deiecit in mare.

Continetur est hic Delbora prophetissa de
qua in libro Iudicum (Idc 4:4) scriptum
est: Erat autem Dealbora prophetissa uxor
Lapidoth, que iudicabat populum in illo
tempore. Et sedebat sub palma, que ex no-
mine illius vocabitur, inter Rama et Bethel
in monte Effraim: ascenderuntque ad eam
filii Israel in omen iudicium. Et infra. (Idc
5:1–3): Cecineruntque Delbora et Baruch
filius Abinoem in die, illo dicentes: Qui
sponte obtulistis de Israel animas vitas
ad periculum, benedicte Domino. Audite
reges, auribus <percipte> principes (Ex
3:14): Ego sum ego sum, que Domino
canam et psallam Domino Deo Israel.

FIGURE 29 (f. 60r, col. 2)

**De exultatione spiritus eius in Domino.
.XXIX. figura. Hugo de sancto Victore
super Magnificat.**

Hugh of St. Victor, *Explanatio in Canticum
beatae Mariae*.[37]

De salvatione quam humano generi populari
nunc video totis preconiis exulto video
namque de me assumo, qui et credo pro
me offerri. *Vere dilecta* Virgo, Maria, [. . .]
*in cellam illam vinariam a rege sponso tuo
introducta* [. . .] *et in salvatore misericor-
dia commendetur.* ¶ Hec figura continet
Annam Samuleis, qui ratione accepte
fecunditatis figuraliter cum Virgine beata
in Domino exultavit. De ipsa namque in
libro Regum (1Sm 2:1) scriptum est: Exul-
tavit cor meum in Domino, et exaltatum
est cornu meum in Deo meo: dilatatum est
os meum super inimicos meos: quoniam
letata sum in saluturi tuo. Continet et
sponsam, que dicit in Canticis (Ct 1:3):
Introduxit me rex in cellaria sua; exultabi-
mus et letabimur in te, memores uberum
tuorum super vinum.

FIGURE 30 (f. 60v, col. 1)

**De beatificatione ipsius ab omnibus mu-
lieribus. .XXX. figura. Hugo de sancto
Victore super Magnificat.**

Hugh of St. Victor, *Explanatio in canticum
beatae Mariae*.[38]

Sicut Virginis matris humilitas *apud Deum facta est acceptabilis* et *grata* […] *que ab omni futura generatione beata vocabor pro fructu fecunditatis mee.* ¶ In hac figura ponitur Lia de cuius beatitudine ac beatificatione in Genesi (Gn 30:12–13) ita scriptum est: Peperit quoque Zelpha alterum. Dixitque Lia: Hoc probitudine mea: beatam quippe me dicent omnes generationes: proptea appellavit eum Aser. Aser significat Christum, qui est refectio animarum. De benedictione enim Aser in Genesi (Gn 49:20) scriptum est: Aser, pinguis panis eius, et prebebit delicias regibus. Ponitur autem hic Elizabeth Zacharie, qui Virginis matris beatitudinem extulit ut pestatur Luca (Lc 1:45) cum dixit: Beata qui credisti, quoniam perficientur ea, que dicta sunt tibi a Domino.

FIGURE 31 (f. 60v, col. 1)

De processu Christi admodum sponsi ex utero virginali. .XXXI. Glosa super psalmum decimum octavum.

Peter Lombard, *Commentarius in psalmos Davidicos.*[39]

Dominus belligerare volens adversus regna temporalium errorum posuit tabernaculum suum […] *ut significaretur quod ecclesiam sibi Virginem copularet.* ¶ Hec figura continet ecclesiam veluti Christi sponsam in cuius amore carnem de Virgine assumpsit et in hunc mundum processit et mortem sustinuit. Ad Ephesos (Eph 5:25–27) namque scriptum est: Viri, diligite uxores **vestras**, sicut et Christus dilexit ecclesiam, et semetipsim tradidit per **ea**, ut illam sanctificaret, mundans lavacro a qui in verbo vite, ut exhiberet ipse sibi gloriosam ecclesiam, non habentem maculam, aut rugam, aut aliquid huiusmodi, sed ut sit sancta et immaculata.

FIGURE 32 (f. 60v, col. 2)

De gaudio Christi sive sponsi et eius coronatione a Virgine matre. .XXXII. figura. Gregorius super Cantica.

Gregory the Great, *Super Canticum canticorum expositio.*[40]

(Ct 3:1) *Egredimini, filie Sion, et videte regem Salomonem in diademate, quo coronavit eum mater sua in die desponsationis eius, et in die letitie cordis eius.* […] *diadema membrorum bene capitis scriptura predixit.* ¶ In hac figura continetur Salomon Christum prefigurans in magnitudine sapientie, in coniugali federe, in sublimitate glorie. Christus namque est Dei virtus et Dei sapientia, et de sapientia Salomonis in libro Regum (1 Rg 3:12) scriptum est: Ecce feci tibi secundum sermones tuos, et dedi tibi cor sapiens et intelligens, in tantum ut nullus ante te similis tui fuerit, neque post te surrecturus sit. Christus copulavit sibi ecclesiam de gentibus, et de coniugio Salomonis iterum (1 Rg 3:1) scriptum est: Confirmatum est regnum in manu Salomonis et affinitate conuinctus est pharaoni regi Egypt. Accepit namque filiam eius et adduxit in civitatem David. Christus refulsit in gloria quasi unigentius a patre plenus gratia et veritate, et de magnificentia et gloria Salomonis. Ibidem in libro Regum (1 Rg 10:23) scriptum est: Magnificatus est rex Salomon super omnes reges terre diviciis et sapientia. Et universa terra desiderabat videre vultum Salomonis, ut audieret sapientiam eius, quam dederat Dominus in corde eius.

FIGURE 33 (f. 61r, col. 1)

De gaudio fecunditatis Virginis matris. .XXXIII. figura. Maximus de Virgine beata in quodam sermone.

Ps.-Ildefonsus, *De sancta Maria*, sermon 12.[41]

Eva per corruptionem concupiens […] *Eva obfuit, Maria profuit.* ¶ Hec figura continet spem angeli experimentem eum qui est magni consilium angelis et eius nativitatem annunciationem, sic in Lucam (Lc 2:10–11) scriptum est: Ecce <enim> evangelizo vobis gaudium magnum, quod erat omni populo: quia natus est nobis hodie Salvator, qui est Christus Dominus, in civitate David. Continet autem Saram

gaudium habentem exortu Isaac, Virginem matrem prefigurantem. Sic namque in Genesi (Gn 21:6) legitur: Dixitque Sara: Risum fecit michi Deus et quicumque audierit conridebit michi. [f. 61r: col. 2]

FIGURE 34 (f. 61r, col. 2)

De tempore et modo et loco virginalis partus. .XXXIIII. figura. Augustinus in sermone de nativitate Domini.

Ps.-Augustine, sermon 369, "De nativitate Domini."[42]

Christus qui femineo nutritur lacte […] *quod elegit ut illinc procederet* velut *sponsus de thalamo suo, quo mortalibus oculis videri posset, et augmento lucis annue lucem se venisse mentium* ostendet.[43] ¶ In hac figura continetur misterium lucis ratione irradiationis mentium quod innuit augem cum cursus dierum (Ps.111:4) quo: Exortum est in tenebris lumen rectis, corde misericors, et miserator, Dominus. Continetur et ratione assimililationis, ut quem ad modum lux visibilis intrum transiens non irrumpit sed amplius clarescere facit, sic lux invisibile Dei Filius de Virgine procederis integritatem eius non minuit sed sacravit. Continetur et Bethleem qui interpretatur domus panis, quia ibi nascitur ille qui dicit (Io 6:51): Ego sum panis vivus, qui de celo descendi. Continetur autem Ruth que de Moab veniens in Bethlehem vaticinium explet Isaie (Is 16:1) dicentis: Emitte agnum, Domine, dominatorem terre, de petra deserto ad montem filie Sion.

FIGURE 35 (f. 61r, col. 2)

De officio Virginis matris erga regem celi et ipsius recubitum in gremio virginali. .XXXV. figura. Ex sermone qui attribuitur Augustino.

Ps.-Alcuin, homily 3, "De nativitate perpetuae virginis Mariae."[44]

O quam immaculata virginitas […] *qui regebat universum mundum a qua sustinebatur gestator orbis!* ¶ Hec figura in misterio habent Noemi et Obed de quibus in Ruth (Rt 4:16–17) ita scribitur: Susceptumque Noemi puerum in sinu suo, et nutricis ac gerule officio fungebatur. Vincine autem mulieres congratulantes ei, et dicentes: Natus est filius Noemi: vocaverunt nomen eius Obed: hic est pater Isai, patris David. Habent autem Abisag sunamitem et David de quibus testatur liber Regum. (1 Rg 1:1–4) sic dicens: Et rex David senuerat, habebatque etatis plurimos dies: cumque opiretur vestibus, non calefiebat. Dixerunt ergo ei servi sui: Queramus Domino nostro regi adolescentulam virginem, et stet coram rege, et foveat eum, […] *et calefaciat dominum nostrum regem. Quesierunt igitur adolescentulam speciosam in omnibus finibus Israel, et invenerunt Abisag sunamitem, et adduxerunt eam ad regem. Erat autem pulcra nimis, dormiebatque cum rege, et ministrabat ei: rex vero non cognovit eam.*

FIGURE 36 (f. 61v, col. 1)

De amplexibus maternis ac intimi amoris. .XXXVI. figura. Ambrosius in sermone de purificatione.

Ambrosius Autpertus, *Sermo in purificatione sanctae Mariae*, sermon 2.[45]

Quis putas nobis indicare posset […] *verum etiam angelica stupescit natura!* ¶ In hac figura continetur sponsa quam Christus intimo amore alliquitur in Canticis (Ct 8:6) dicens: Pone me ut signaculum super cor tuum, ut signaculum super brachium tuum, quia fortis est ut mor dilectio.

FIGURE 37 (f. 61v, col. 1)

De osculis maternis ac casti pudoris. .XXXVII. figura. Maximus de Virgine beata in quodam sermone.

Ps.-Maximus, sermon 11, *De Assumptione beatae Mariae Virginis*.[46]

O felix Maria, o genitrix gloriosa […] *quas formavit suggeret ubera que implevit.?* ¶ Hec figura habet florem suo colore vario castum amorem osculantium se scilicet matris et filii, sponse et sponsi demonstrantem, unde sponsa hic ponitur que pre-

sentiam sponsi optans dicit Canticis prima (Ct 1:1): Osculetur me osculo oris sui. Et iterum (Ct 8:1): Quis michi det te fratrem meum, sugentem ubera matris mee, ut inveniam te foris, et deosculetur <te>, et iam nemo me despiciet?

FIGURE 38 (f. 61v, col. 2)

De circumcisione salvatoris. .XXXVIII. figura. Bernardus in sermone de circumcisione.

Bernard of Clairvaux, *Sermones in circumcisione Domini*, sermon 2.[47]

Ad quid enim Ihesu bone *circumcisio necessaria tibi* [. . .] cui *nec mortuo* quidem *difficile fuit* eam *custodire ne corrumperetur.* ¶ In hac figura continetur Abraham et Isaac filius eius, (Gn 22) quem Abrahe primo datum est signaculum circumcisionis, et ipse Isaac octavo (Gn 17:26) die circumcisus est, de quibus Ihesus Christus secundum carnem processit. In Genesi (Gn 17:9) namque scribetur: Dixitque Deus ad Abraham iterum: <Et> Tu ego custodies pactum meum, et semen tuum post te in generationibus suis. Hoc est pactum meum quod observabitis inter me et vos, et semen tuum post te: circumcidetur ex vobis omne masculinum: et circumcideris carnem proputii vestri, ut sit in signum federis inter me et vos. Infans octo dierum circumcidetur in vobis. Et infra (Gn 21:3–5): vocavitque Abraham nomen filii sui, quem genuit ei Sara, Isaac: et circumcidet eum octava die, sicut precepat ei Deus, cum esset centum annorum. Continetur et hoc nomen Ihesus, quem scriptum est in Luca (Lc 2:21): Postquam consummati sunt dies octo, ut circumcideretur puer, vocatus est nomen eius Ihesus. Hoc nomen delatum est ad Virginem matrem, et ad Ioseph putatinum patrem. Ad Virginem est quidem sicut in Luca (Lc 1:31) scribitur: Ecce concipies in utero, et peries filium, et vocabis nomen eius Ihesus. Ad Ioseph vero ut in Matheo dicitur (Mt 1:20–21): Ioseph fili David, noli timere accepere <Mariam> coniugem tuam: quod enim in ea natum

est, de Spiritu Sancto est. Pariet autem filium: et vocabis nomen eius Ihesus: ipse enim salvum faciet populum suum a peccatis eorum.

FIGURE 39 (f. 62r, col. 1)

De epiphania Domini. .XXXIX. figura. Augustinus in sermone de epiphania.

Ps.-Augustine, sermon 17, "In epiphania Domini I."[48]

Post miraculum Virginei partus [. . .] *reddunt et ipsa sidera testimonium.* ¶ Hec figura continet regem Salomonem et regina Saba eo quod magi veniunt ad Christum verum Salomonem visa nova stella cum munerum sacramento, sicut ipsa ad regem Salomonem venit audita ipsius fama cum aromatibus et auro. In libro namque Regum (1 Rg 10:1–2) scriptum est: Sed et regina Saba, audita fama Salomonis in nomine Domini, venit temptare eum in enignatibus. Et ingressa Iherusalem cum conmitatu multo, et diviciis, camelis portantibus aromata, et aurum infinitum nimis, et gemmas pretiosas, venit ad regem Salomonem. Et infra (1 Rg 10:10): Dedit ergo rego centum .XX. talenta auri, et aromata multa nimis, et gemmas pretiosas: non sunt allata ultra aromata tam multa, quam ea que dedit regina Saba regi Salomoni. Continet etiam spem stelle que magos cum gaudio ad Christum perduxit ut testatur Matheus (Mt 2:10–11) evangelista. dicens. Videntes autem stellam gavisi sunt gaudio magno valde. Et intrantes domum, invenerunt puerum cum Maria matre eius, et procidentes adoraverunt eum: et apertis thesauris suis obtulerunt ei munera, aurum, thus, et mirram.

FIGURE 40 (f. 62r, col. 2)

De purificatione Virginis matris. .XL. figura. Bernardus in sermone de purificatione.

Bernard of Clairvaux, *Sermones in purificatione beatae Mariae Virginis*, sermon 3, part 1.[49]

Offer filium, tuum *Virgo sacrata* [. . .] *sed*

quia ipse *voluit.* ¶ In hac figura continetur Anna et Samuel eo, quod sicut ipsa in domum Domini adduxit Samuelem, ita et Virgo beata in templum Domini presentavit salvatorem. In libro namque Regum (1 Sm 1:23–24) scriptum est: Mansit <ergo> mulier, et lactavit filium suum, donec amoneret eum a lacte. Et adduxit eum secum, postquam ablactaverat, in vitulis tribus, et tribus modiis farine, et amphora vini, et adduxit eum in domum Domini in Silo. Puer autem erat ad huc infantulus: et immolaverunt vitulum, et obtulerunt puerum Heli. Continetur et partuturum, aut duo pulli columbarum. Unde in lege Domini in Levitico (Lv 12:8) dicitur: Quod si non invenerit manus eius, nec potuerit offerre agnum, sumet duos turteres vel duos pullos columbe, unum in holocaustum, et alterum pro peccato: orabitque pro ea sacerdos, et sic mundabitur.

FIGURE 41 (f. 62v, col. 1)
De fuga Virginis matris cum puero Ihesu in Egyptum. .XLI. figura. Crisostomus super Mattheum omelie octava.

Johannes Chrysostomus, *Opus imperfectum,* homily 8, part 2.[50]

Considerandum quia post stelle glorisum Iudicium*: <Nam> quidem* Christus *magos persidi* mittit *remittet* [. . .] *necque iocunditates <sinit> habere continuas.* ¶ Hec figura habet Agar Egyptiam et Ismahel, nam sicut ipsa cum puero fugit in solitudinem, ita et Virgo mater cum Ihesu descendit in Egypti regionem. Habet et spem angeli, nam angelis et Agar consolatus fuit, et Ioseph de fuga in Egyptum, et reditu in sompnis instruxit. In Genesi (Gn 21:14) namque scriptum est: Surrexit <itaque> Abraham mane, <et> tollens panem et utrem aque, imposuit scapule eius, tradititque puerum, et dimisit eam. Que cum abisset, errabat in solitudine Bersabee. Et infra (Gn 21:17): Vocavitque angelis Domini Agar de celo, dicens: Quid agis Agar? Noli timere: exaudivit enim Deus vocem pueri de loco in quo

est. Surge, tolle puerum, et tene manum eius: quia ingentem magnam faciam eum. In Matheo (Mt 2:13) autem scriptam est: Ecce angelus Domini apperuit in sompnis Ioseph, dicens: Surge, et accipe puerum, et matrem eius, et fuge in Egyptum, et esto ibi dum dicam tibi. Futurum est enim ut Herodes querat puerum ad perdendum eum. Et infra (Mt 2:19–20): Defuncto autem Herode, ecce apparuit angelis Domini in sompnis Ioseph in Egipto, dicens: Surge, et accipe puerum, et matrem eius, et vade in terram Israhel: defuncti sunt enim qui querebant animam pueri.

FIGURE 42 (f. 62v, col. 2)
De inquisitione pueri Ihesu a Virgine matre et Ioseph et ipsorum dolore. .XLII. figura. Glosa super Lucam.

Glossa ordinaria.[51]

(Lc 2:44–45) Existimantes illum esse in comitatu, venerunt iter diei et requitebant eum inter cognatos et notos. Denique non invenientes illum, regressi sunt in Ierusalem requirentes eum. *Una quidem die a Ierusalem regressi* [. . .] *et alii quicumque viderunt.* (Lc 24:48–49) Et dixit mater eius ad illum: Fili quid fecisti nobis. Ecce pater tuus et ego dolentes querebamus te. Et ait ad illos: Quid est quod me querebatis. Nesciebatis quem in hiis que patris mei sunt oportet me esse. *Non eos quia filium querunt vituperat* [. . .] *quasi filius hominis cum parentibus quo iubent regreditir.*[52] (Lc 4:51) Et hoc est quod subditur. Descendit cum eis et venit Nazereth et erat subditus illis *Magister quippe virtutis officium implet pietatis. Miramur si defert honorem patri qui subditus est matri. Ista subiectio non est necessitatis sed pietatis. Quid enim parentibus debeamus ostendit.*[53] ¶ In hac figura continetur Thobias et Anna uxor eius, nam sicut ipsi dolebant de absentia filii sui. Ita Maria et Iosph de absencia Ihesu Christi. In Thobia (Tob 10:3–5) enim sic scriptum est: Cepit autem contristari nimis ipse et Anna uxor eius cum eo: et ceperunt ambo simul flere: eo

quia die statuto minime revertere tibi filius eorum ad eos. Flebat igitur mater eius irremediabilibus lacrimis, atque dicebat: Heu, heu me, fili mi! Ut quid te misimus peregrinari, lumen oculorum nostrorum, baculum senectutis nostre, solatium vite nostre, spem posteritatis nostre. Omnia simul in te uno habentes, non te debuimus dimitte ire a nobis. Et infra (Tob 10:7): Illa autem nullo modo consolari poterat, sed cottidie exiliens circumspiciebat, et circuibat vias omnes, per quas spes remeandi videbatur, ut procul videret eum, si fieri posset, vehemtem. Et infra (Tob 11:5–6): Anna vero sedebat secus viam, cottidie in supercilio montis, unde respicere poterat de longinque. Et dum exedere loco spe-[f. 63r: col. 1] cularetur adventum eius, videt a longe, et ilico agnovit vementem filium suum: Et currens nunciavit viro suo, dicens: Ecce venit filius tuus. Et infra (Tob 11:10–12): Unde contigit ut exurgens cecus pater <eius>, cepit offendens pedibus currere: et data manu puero, occurrrit obviam filio suo. Et suscipiens osculatus est eum cum uxore sua, et ceperunt ambo flere per gaudio. Cumque adorassent Deum, et gratias egissent conscederunt.

FIGURE 43 (f. 63r, col. 1)

De mutatione aque in vinum. .XLIII. figura. Bernardus in sermone de idriis.

Bernard of Clairvaux, *Sermones in dominica .I. post octavam epiphaniae*, sermon 1, part 2.[54]

Hec est mater misericordie [. . .] *ab animo non recessit.* ¶ Hec figura continet botrum cipri, Christum significantem et sponsam, que dicit in Canticis (Ct 1:13): Botrus cipri dilectus meus michi in vineis Engaddi.

FIGURE 44 (f. 63r, col. 1)

De virtutibus et prerogatius Virginis beate. .XLIIII. figura. Ex sermone qui attribuitur Augustino.

Alcuin, *De nativitate perpetuae Virginis Mariae*, homily 3.[55]

Facta est Maria ianua celorum [. . .] *victorio-*

sa in transeuntibus. ¶ In hac figura continetur Ruth ratione virtutis, quia in libro Ruth (Rt 3:11) scriptum est: Scit enim omnis populis qui habitat intra portas urbis mee, mulierem te esse virtutis. Et infra (Rt 4:11): faciat Dominus hanc mulierem, que ingreditur domum tuam, sic Iachel et Hiam, que edificaverunt domum Israel, ut sic ex virtutis in Effrata, et habeat celebre nomen in Bethlehem. Continetur et Hester ratione prerogative singularis, nam ei quasi a ceteris distincte spali, excellencia dicitur a rege Assuero in libro Hester (Est 15:13–14): Non enim pro te, sed pro omnibus hec lex constituta est. Accede igitur, et tange sceptrum. Cumque illa reticeret, tulit auream virgam, et posuit super collum eius, et osculatus est eam.

FIGURE 45 (f. 63r, col. 2)

De caritate eius. .XLV. figura. Bernardus in sermone de assumptione.

Bernard of Clairvaux, *Sermo in dominica infra octavam assumptionis beatae Mariae.*[56]

Non erat bonum nobis esse hominem solum [. . .] *ut non sit qui se abscondat a calore eius.* ¶ Hec figura continet florem suo colore caritatem experimentem. Continet et Delbooram, de qua in libro Iudicum (Id 5:9) ita scriptum est: Cor meum diligit principes Israel. Et infra (Id 5:31)dicit: Qui autem diligunt te, sicut sol in ortu so splendent, ita rutilent.

FIGURE 46 (f. 63v, col. 1)

De misericordia ipsius. .XLVI. figura. Bernardus in sermone de assumptione.

Bernard of Clairvaux, *Sermones in assumptione beatae Mariae Virginis*, sermon 4, part 8.[57]

Sileat misericordiam tuam Virgo beata [. . .] *exspectantibus miseris vita perdita data.* ¶ In hac figura continetur flos suo colore misericordiam experimens. Continetur et Raab ratione misericordie quam exhibuit exploratoribus Iericho. Sic enim scriptum est in Iosue (Ios 2:8): Ecce mulier ascendit ad eos, et ait: Novi quod tradiderit Do-

minus vobis terram: etenim irruit in nos terror vester, et elanguerunt omnes heritatores terre. Et infra (Ios 2:11–12): Dominus <enim> Deus vester ipse est Deus in celo sursum et in terra deorsum. Nunc ergo iura te michi per Dominum, ut quomodo ego feci vobiscum misericordiam, ita et vos faciatis cum domo patris mee.

FIGURE 47 (f. 63v, col. 1)

De humilitate eius. .XLVII. figura. Ieronimus in sermone de assumptione.

Paschasius Radbertus, *De assumptione sanctae Mariae Virginis.*[58]

Et vos igitur, *o filie, si vere virgines vultis esse* [. . .] *et ideo divinitus* illustrata. ¶ Hec figura continet florem humilitatem preferentem. Continet et Liam ratione humilitatis, de quam in Genesi (Gn 29:31) ita scriptum est: Videns autem Dominus quod despiceret Liam, aperuit vuluam eius, sorere sterili permanente. Que conceptum premuit filium, vocavitque nomen eius Ruben, dicens: Vidit Dominus humilitatem meam: nunc amabit me vir meus.

FIGURE 48 (f. 63v, col. 2)

De prudencia et sapientia ipsius. .XLVIII. Bernardus super Missus est.

Bernard of Clairvaux, *Homiliae super "Missus est,"* homily 4, part 3.[59]

Primo quidem advocatum angeli *prudenter tacuit* [. . .] *tunc scio vere quia respexit humilitatem ancille sue.* ¶ In hac figura continetur Abigail, ratione prudencie, de qua in libro Regum (1 Sm 25:3) scriptum est: Eratque mulier illa prudentissima et speciosa. Et infra (1 Sm 25:36): Venit autem Abigail ad Nabal: et ecce erat ei convivium in domo eius, quia conviviam regis, et cor Nabal iocundum: erat enim ebrius nimis: et non indicavit ei verbum pusillum aut grande usque mane. Continetur et mulier et Thetuites ratione sapientie, de qua autem in libro Regum (2 Sm 14:1) sic scribitur: Intelligens autem Ioab [f. 64r: col. 1] filius Sarvie, quod <cor> regis

versum esset ad Absolon, misit Thecuitam, et tulit inde mulierem sapientem. Et infra (2 Sm 14:12–14): dixit ergo mulier, loquatur ancilla tua ad dominum meum regem verbum. Et ait: Loquere. Dixitque mulier: Quare cogitasti huiusmodi rem contra populum Dei, et locutus est rex verbum istud, ut peccet, et non reducat eiectum suum? Omnes morimur, et quasi aqua dilabimur in terram, que non revertuntur: nec vult Deus perire animam, sed retractat cogitans ne pereant qui abiectus est.

FIGURE 49 (f. 64r, col. 1)

De devotione et oratione eius. .XLIX. figura. Bernardus super Missus est.

Bernard of Clairvaux, *Homiliae super "Missus est,"* homily 3, part 1.[60]

Et ingressus angelus ad eam [. . .] *sed hominibus, non angelis.* ¶ Hec figura continet Iudith viduam, de qua in libro Iudith (Idt 8:5) ita scribitur: In superioribus domus sue fecit sibi secretum cubiculum, in quo cum puellis suis clausa morabatur, et habens super lumbos suos cilicium, ieuinabat omnibus diebus vite sue, prcter sabbata et nemenias et festa domus Israel. Et infra (Idt 9:1): Iudith ingressa est oratorium suum: et induens se cilicio, postuit cinerem super capud suum: et prosternes se, clamavit ad Dominum. Et infra (Idt 9:16): Nec superbi ab initio placuerunt tibi: sed humilium et mansuetorum tibi semper placuit depecatio. Deus celorum, creator aquarum, et Dominus totius creature, exaudi me miseram depecantem, et de tua misericordia presumcntcm. Continet autem Annam vidua prophetissam, de qua in Luca (Lc 2:36–37) sic scriptum [f. 64r: col. 2] est: Et erat Anna prophetissa, filia Phanuel, de tribu Aser: hec processerat in diebus multis, et vixerat cum viro suo annis septem a virginitate sua. Et hec vidua erat usque ad annos .LXXXIIII.: que non discedebat de templo, ieiuniis et obsecrationibus serviens nocte ac die.

FIGURE 50 (f. 64r, col. 2)

De castitate mentis et corporos ipsius. .L. figura. Bernardus super Missus est.

Bernard of Clairvaux, *Homiliae super "Missus est,"* homily 1, part 9.[61]

Felix Maria, cui nec humilitas, nec virginitas defuit. [. . .] *a prophetis promissam.* ¶ In hac figura continetur flos suo colorem castiatem demonstrans. Continetur autem sponsa quam commendat sponsus in Canticis (Ct 1:14) dicens: Ecce tu pulcra es, amica mea! Ecce tu pulcra <es>, oculi tui columbarum. Et iterum: Sicut lilium inter spinas, sic amica meam inter filias. Continetur et Sara filia Raguel que proficiens castitatem suam, sic aut adduum, ut in Tobia (Tob 3:16) scriptum est: Tu scis, Domine, quia numquam concupivi virum, et mundam servavi animam meam ab omni concupiscencia. Numquam cum ludentibus miscui me: neque cum hiis, qui in levitate ambulant, participem me prebui.

FIGURE 51 (f. 64v, col. 1)

De serpentis antiqui conculcatione. .LI. figura. Bernardus super Missus est.

Bernard of Clairvaux, *Homiliae super "Missus est,"* homily 2, part 4.[62]

Quam aliam tibi Deus predixisse videtur [. . .] *sed a summo celo egressio eius.* ¶ Hec figura habet Evam ocasione cuius datur ad serpentem in Genesi (Gn 3:15): In inimicitias ponam inter te et mulierem, et semen tuum et semen illius: ipsa conteret caput tuum, et tu tu insidiaberis calcaneo eius, habet autem fortem mulierem, de qua Salomon in Proverbiis loquitur investigando, quam autem Gabriel Dei fortitudo, habet autem Iudith que capud Holofernis amputavit, de qua in libro Iudith scriptum est: (Iud 13:6): Stetitque Iudith ante lectum, orans cum lacrimus, et labiorum motu in silentio, dicens (Idt 13:7–10): Confirma me, Domine Deus Israhel, et respice in hac hora ad opera manuum mearum, ut, sicut promisti, Ierusalem civitatem tuam erigas: et hoc quod credens

per te posse fieri cogitavit, proficiam. Et infra (Idt 13:7): Conforma me, Domine Deus Israhel, in hac hora. Et percussit bis in cervice eius, et abscidit capud eius. Et infra (Idt 13:24–25): Benedicta es tu, filia, a Domino Deo excelso per omnibus mulieribus super terram. Benedictus Dominus, qui creavit celam et terram, qui te direxit in vulnera capitis principis inimicorum nostrorum: quia hodie nomen tuum ita magnificavit, ut non recedat laus tua de ore hominum, qui memores fuerint virtutis Domini in eternum. Et infra (Iud 13:31): Benedicta tu a Deo tuo in omni tabernaculo Iacob, quoniam in omni gente, que audierit nomen tuum, magnificabit dominum Israhel super te. Et infra (Iud 14:16): Una mulier hebrea fecit confusionem in domo regis Nabuchodonosor.

FIGURE 52 (f. 64v, col. 2)

De activa et contemplativa. .LII. figura. Bernardus in sermone de assumptione.

Bernard of Clairvaux, *Sermones in assumptione beatae Mariae Virginis,* sermon 2, part 7.[63]

Intret <ergo> domum salvator [. . .] *nihilominus tamen in fimbriis aureis circumamicta est varietate.* ¶ In hac figura continetur non solum Martha et Maria, sed et Lia et Rachel filie Laban, que etiam proprius qualitatibus activam significant vitam atque contemplativam, de quibus in Genesi (Gn 29:16) ita scriptum est: Habebat vero duas filias: nomen matoris Lia, minor <vero> Rachel appellatus. Sed Lia lippis erit oculis: Rachel decora facie, et venusto aspectu.

FIGURE 53 (f. 65r, col. 1)

De dolore Virginis matris cura passionem Ihesu Christi. .LIII. figura. Anselmus in libro orationum.

Anselm of Canterbury, *Orationes sive meditationes,* prayer 2.[64]

Cum Deus offensus sponte moriebatur [. . .] *Cum acciperes in filium discipulum pro*

magistro, servum pro Domino? ¶ Hec figura habet dispositionem crucis coloribus distinctis aptavi sacris misteriis, nam pars inferior declarat Virginis matris in passione filii fideo fulgorem compassionisque asperitatem, pars dextra Ihesu Christi innocentiam et pietatem. Pars sinistra eiusdem ad paciendum inclitum amorem, pars superior ex morte Christi pateficiam celestem pulcritudinem. Continet viduam Sareptanam misterium crucis exprimencium, de qua in libro Regem. (1 Rg 17:9–10) scriptum est: Factus est sermo Domini ad Helyam Thesbitem dicens: Surge, et vade in Sereptam Sidoniorum, et manebis ibi: precepi enim ibi mulieri vidue, ut pascat te. Surrexit, et abiit in Sereptam. Cumque venisset ad portam civitatis, apparuit ei mulier vidua colligens ligna duo. Et infra (1 Rg 17:12): En colligo duo ligna ut ingrediar et faciam illud michi et filio meo, ut comedamus, et moriamur. Continet et Noemi, que a dolore virgini matri se socians, orbata filiis, sic loquitur in libro Ruth (Rt 1:20–21): Ne vocetis me Noemi, id est, pulchram, sed vocate me Mara, hec est amaram, quia valde replevit me amaritudine omnipotens. Egressa sum plena, et vacuam reduxit me Dominus. Cur ergo vocatis me Neomi, quam humiliavit Dominus, et afflixit omnipotens.

FIGURE 54 (f. 65r, col. 1)

De gaudio virginis matris ex Christi resurrectione. .LIIII. figura. Damascenus libro quarto.

John of Damascus, *De fide orthodoxa*.[65]

Ipsa beata, et earum que super naturam donationum digna effecta [. . .] *Deum carne mortuum predicans.* ¶ In hac figura ponitur mulier mater familias, de cuius filii resuscitatione in libro Regum (1 Rg 17:22–24) sic scriptum est: Exaudivit Dominus vocem Helie: et reversa est anima pueri intra eum, et reiuxit. Tulitque Helyas pueram, et deposuit eum de cenaculo in inferiorem domum, et tradidit matri sue, et ait illi: En vivit filius tuus. Dixitque mulier

ad Helyam: Nunc iusto cognovi quoniam vir Dei es tu, et verbum Domini in ore tuo verum est. Ponitur autem mulier sunamitis, de cuius filii resuscitatione. Autem in libro Regum (2 Rg 4:32–38) sic scribitur: Ingressus est <ergo> Heliseus domum, et ecce puer mortuus iacebat in lecto eius: Et ingressus clausit ostium super se, et super puerum, et oravit ad Dominum. Et infra (2 Rg 4:35–38): Et oscitavit puer septies, aperuit oculos. At ille evocavit Giezi, et dixit ei: Voca sunamitem hac. Que vocata, ingressa est ad eum. Qui ait: Tolle filium tuum. Venit illa, et coruit ad pedes eius, et adoravit super terram: tulitque filium suum, et egressa est. Et Heliseus reversus est in Galgala. Ponitur autem hic angelus manu sinistra, tenens florem vario colore gaudium floride resurrectionis exprimentem. In propheta namque dicit Christus (Ps 27:7): Et refloruit caro mea, et ex voluntate mea confitebor illi. Manu verbo dextra ferens florem distincto colore, et qualitatem annunciatis angeli, et pulcritudinem resurgenis Christi ascendentisque dcsignatcm. De annunciate, nomen angelo in Matheo (Mt 28:3) scriptum est: Erat autem aspectus eius sicut fulgur: <et> vestimenta eius sicut nix. De resurgente etiam Christo dicit sponsa videlicet ecclesia in Canticis (Ct 5:10): Dilectus meus candidus et rubicundus; electus ex milibus. Et de ipso ascendente in Isaia scribitur (Is 63:1–2): Quis est iste, qui venit de Edon, tinctis vestibus de Bosra? Iste formosus in stola sua, gaudiens in multitudine fortitudinis sue. Ego qui loquor iusticiam, et propugnator sum ad salvandum. Quare ergo rubrum est indumentum tuum, et vestimenta tua sicut calcantium in torculari?

FIGURE 55 (f. 65r, col. 2)

De desiderio et amore Virginis matris ad Christum secundum. ascensonem eius in celum. .LV. figura. Ieronimus in sermone de assumptione.

Paschasius Radbertus, *De assumptione sanctae Mariae Virginis*.[66]

Puto autem quod quicquid cordis est [. . .] *et ideo <quamsaepe> locorum recreabatur visitationibus.* ¶ Hec figura continet florem amoris et speciem turturis, qui ex absencia sui comparis, quem diligit quasi inquirendo gemit. Continet autem sponsam de qua in Canticis (Ct 1:9) dicitur: Pulcre sunt gene tue sicit turturis. Et iterum (Ct 2:12): Vox turturis audita est in terra nostra.

FIGURE 56 (f. 65v, col. 1)

De sollempnitate assumptionis Virginis matris. .LVI. figura. Bernardus in sermone de assumptione.

Ps.-Peter Damian, sermon 40, "In assumptione beatissimae Mariae Virginis."[67]

Si diligenter attendamus ascensionem Filii [. . .] *et cui donare dignatus est.* ¶ In hac figura ponitur David et archa Domini, quam ipse David cum sollempnitate deduxit in civitatem David. Sic namque in libro Regum (2 Sm 6:12–15) scriptum est dixitque David: Ibo et reducam archani domum cum benedictione in domum meam. Abiit ergo David, et adduxit archam Dei de domo Obededom in civitatem David cum gaudio: et erant cum David septem chori, et victima vituli. Cumque transcendissent qui portabant archam Dei sex passus, immolabant bovem et arietem, et David percutiebat in organis arinigatis et saltabat totis viribus ante Dominum: porro David accinctus erat ephod lineo. Et David et omnis domus Israel ducebant archam testamenti Domini, in iubilo, et in clangore buccine. Ponitur autem species angeli, exprimens militiam angelorum in assumptione Virginis matris iubilantium. Qui manu tenens et florem rosarum et lilium conuallium, iusta illud in Canticis. Secundum translationem septuaginta: (Can 007878: Responsory, Assumption of Virgin) Vidi speciosam, sicut columba ascendentem desuper rivos aquarum, cuius inestimabile odor erat nimis in vestimentis eius, et sicut dies verni circumdabant eam flores rosarum et lilia convallium.

FIGURE 57 (f. 65v, col. 2)

De exaltatione Virginis matris super omnis choros angelorum. .LVII. figura. Ieronimus in sermone de assumptione.

Paschasius Radbertus, *De assumptione sanctae Mariae Virginis.*[68]

Beata Virgo Maria, *gaudia vite eterne feliciter hodie introivit* [. . .] *ut cum eo regnare possit in perpetuum.* ¶ Hec figura continet speciem cherubin, quia Salomon archam Dei detulit subiter alas cherubin. Sic enim in libro Regum (1Rg 8:1–2) scriptum est: Tunc congregati sunt omnes maiores natu Israel cum principibus tribuum, et duces familarum filiorem Israel ad regem Salomonem in Ierusalem: ut deferrent archam sedis Domini de civitate David, id est, de Sion. Convenitque ad regem Salomonem universus Israel in mense Bethanim, in sollempni die: ipse est mensis septimus. Et infra (1 Kg 8:5–6): Rex autem Salomon, et omnis multitudo Israel, qui convenerat ad eum, gradiebatur cum illo ante archam, et immolabant oves et boves absque estimatione et numero. Et intulerunt sacerdotes archam federis Domini in locum suum, in oraculum templi, in sanctum sanctorum subter alas cherubin. Continet autem speciem seraphin eo que Virgo mater velut regina celi subvecta est usque ad Christum transcendens gloriam et dignitatem seraphin et per consequens omnium angelorum. De hoc psalmista (Ps 44:10) ait: Astitit regina a dextris tuis in vestitutu de aurato, circumdata varietate. Et iterum (Ps 131:8): Surge, Domine, in requiem tuam, et arca sanctificationis tue.

FIGURE 58 (f. 66r, col. 1)

De coronatione Virginis matris. .LVII. figura. Bernardus in sermone de assumptione.

Bernard of Clairvaux, *Sermo in dominica infra octavam assumptionis beatae Mariae*, part 6.[69]

(Apc 12:1) Signum magnum apparuit in celo, mulier amicta sole, et luna sub pedibus eius, et in capite eius corona stellarum

.XII. *Quam familiaris ei facta es domina* [. . .] *et coronam pulchritudinis ponens in capite tuo.* ¶ In hac figura ponitur Hester, de cuius coronatione in libro Hester (Es 2:16–17) scriptum est: Ducta est itaque ad cubiculum regis Assueri mense decimo, qui vocatur Thebethe, in .VII. anno regni eius. Et amavit eam rex plus quam omnes mulieres, habuitque gratiam et misericordiam coram eo super omnes mulieres, et posuit diadema regni in capite eius. Ponitur et sponsa de qua in Canticis (Ct 4:8) scribitur: Veni de Libano, sponsa mea: veni de Libano, veni coronaberis: de capite Amana, de vertice Sanur et Hermon, de cubilibus leonum, de montibus pardorum.

FIGURE 59 (f. 66r, col. 1)

De confessu Virginis matris apud Christum et eius intercessione pro nobis ad ipsum. .LIX. figura. Maximus. In quodam sermone de Virgine beata.

Ildefonsus of Toledo, *Sermones*, sermon 9, "De assumptione beatae Mariae."[70]

O beata Maria que de terris ad celestem vitam translata es [. . .] *et nos appareamus in gloria.* ¶ Hec figura continet florem amoris Virginis matris respicientis ad Christum et converso iusta illud in Canticis (Ct 7:10): Ego dilecto meo, et ad me converso eius. Continet et Salomonen et Bersabee matrem eius, quia in libro Regum (1 Rg 2:19–20) scriptum est: Venit Bersabe ad regem Salomonem, ut loquenter ei pro Adonia: et surrexit rex in occursum eius, adoravitque eam, et sedit super thronum suum: positusque est thronus matri eius regis, que sedit ad dexteram eius. Dixitque ei: Petitionem unam parvulam ego deprecor te, ne confundas faciem meam. Dixitque ei rex: Pete, mater mi: necque enim fas est ut avertam faciem tuam. Continet et regem Artaxersem et eius reginam. Scribitur enim in Neemia (Neh 1:1–6) dic: Factum est in mense Nisam, anno vicesimo Artaxersis regis, et vinum erat ante eum, et levam vinum, et dedi regi: et eram quasi languidus ante faciem eius.

Dixitque michi rex: Quare vultus tuus trutis est, cum te egrotum non videam? Non est hoc frustra, sed malum nescio quod in corde tuo est. Et timui valde, ac nimis: et dixi regi: Rex in eternum vive: quare non mereat vultus meus, quia civitas domus sepulcrorum patris mei deserta est, et porte eius conbuste sunt igni? Et ait michi rex: Pro quare postulas? Et oravi Deum celi, et dixi ad regem: Si videtur rego bonum, et si placet ferinus tuus ante faciem tuam, ut mittas me in Iudeam ad civitatem sepulchri patris mei, et edificabo eam. Dixitque michi rex, et regina que sedebat utraque eum: usque ad quem tempus erit iter tuum, et quando reverteris? Et placuit ante vultum regis, et misit me.

FIGURE 60 (f. 66v, col. 1)

De respectu omnis creature celestium terestrium et infernorum ad Virginem matrem et eius perpetua memoria et laude. .LX. figura. Bernardus in sermone de Spiriti Sancto.

Bernard of Clairvaux, *Sermones in die pentecostes*, sermon 2, part 4.[71]

Deus rex noster ante secula operatus est [. . .] *et de te benigna manus* creatoris *quidquid creaverat recreavit.* ¶ In hac figura ponitur angelus ratione celestium, anima ratione infernorum, homo ratione terrestrium. Ponitur et Iudith de qua in libro Iudith (Idt 15:9) scriptum est: Ioachim autem summus pontifex de Ierusalem venit in Bethuliam cum universis presbiteris suis ut videret Iudith. Que cum exisset ad illum, benedixeret illam omnes una voce, dicentes: Tu gloria Ierusalem, tu leticia Israel; tu honorificencia populi nostri: quia fecisti viriliter, et confortatum est cor tuum, eo quod castitatem amaveris, et post virum tuum, alterum nescieris: ideo et manus Domini confortavit te, et propter hoc eris benedicta in eternum. Et dixit omnis populis: Fiat, fiat. Ponitur autem sponsa de qua in Canticis (Ct 6:8) dicitur: Viderunt illam, filie Sion, et beatissimam predicaverunt; regine et concubine, <et>

laudaverunt eam. In Ecclesiastico (Sir 24:6) etiam scriptum est: *Ego feci in celis ut orietur lumen indeficiens, et sicut nebula texi omnem terram. Ego in altis habitavi, et thronus meus in columpna nubus. Girum celo circuivi sola, et in profundum abissi penetravi: et in fluctibus maris ambulavi. Et in omni terra steti: et in omni populo, et in omni gente primatum habui: et omnium excellencium et humilium corda virtute calcavi.* Et infra (Sir 24:26): *Transite ad me, omnes concupiscitis me, et a generatione seculorum.* Et iterum (Sir 24:28): *Memoria mea in generatione seculorum.* Et iterum (Sir 24:31): *Qui elucidant me, vitam eternam habebunt.*

Dedication Image (f. 67r, col. 1)[72]

Finalis benedictio. Beda in omelia loquente Ihesu ad turbas.

Dominican Lectionary: Vigil of the Assumption.[73]

O veneranda domina electa et preelecta [. . .]
O benedicta mater que inferni vastatorem
celi reparatorem nostrum salvatorem
mundi redemptorem Deum omnipotentem,
Dominum celi et terre, et omnia conti-
nentem suo protulit ex utero, angelorum le-
ticiam, hominum vitam, celorum gloriam,
sanctorum coronam paradisi lucernam!
Amen.

Hunc librum de misteriis et laudibus intemerate[74] Virginis Marie conscripsit. ordinavit et edidit frater Bertoldus de ordine fratrum predicatorum,[75] quodam lector[76] Nurembergenis. Anno Domini .M.CC.XCIIII. Anima eius pro merita et intercessiones ipsius Virginis beate genitricis Dei et Dominum nostri Ihesu Christi requiescat im pace. Amen. O noli delere nomen compositoris, ut nomen tuum. permaneat in libro vite.[77]

Notes

Preface & Acknowledgments

1. Hrabanus Maurus, *In honorem*, D 0, lines 1–11: "Mos apud ueteres fuit ut gemino stylo propria conderent opera, quo iucundiora simul et utiliora sua legentibus forent ingenia. Vnde et apud saeculares et apud ecclesiasticos plurimi inuenientur qui metro simul et prosa unam eamdemque rem descripserant. Vt de ceteris taceam, quid aliud beatus Prosper ac uenerandus uir Sedulius fecisse cernuntur? Nonne ob id gemino styli caractere duplex opus suum edunt, ut uarietas ipsa et fastidium legentibus auferat, et si quid forte in alio minus quis intellegat, in alio mox plenius edissertum agnoscat."

2. As noted by Ernst, *Carmen figuratum*, 684–91, to date the only attempt to analyze Berthold's work besides Müller, *Hrabanus Maurus*, 145–56. See also Ferrari, *Il "Liber sanctae crucis"*, 40, 62, 236, 340, 356, 376–77, 417, and 435. The manuscript receives passing mention in Kitzinger, "Recasting Hrabanus," 221–41, which discusses an earlier instance in the reception and transformation of Hrabanus's *carmina figurata*. My thanks to Prof. Kitzinger for sharing her article with me before its publication.

3. Rockar, *Abendländische Bilderhandschriften*.

4. Hamburger, *"Haec figura demonstrat," Wiener Jahrbuch für Kunstgeschichte*, 2009, 7–78, revised and translated as *"Haec figura demonstrat": Diagramme in einem Pariser Exemplar von Lothars von Segni ,De missarum mysteriis' aus dem frühen 13. Jahrhundert*, Wolfgang Stammler Gastprofessur für Germanische Philologie: Vorträge 19 (Berlin: De Gruyter, 2013).

5. Hamburger, "Hrabanus redivivus."

Introduction

1. See, e.g., Nagel, *Medieval Modern*, Hahn, *The Reliquary Effect*, as well as earlier exhibition catalogues from the German-speaking world, such as Bartl-Fliedl and Geissmar, *Die Beredsamkeit des Leibes*; Westermann-Angerhausen et al., *Joseph Beuys und das Mittelalter*; and Gerchow, *Ebenbilder*.

2. For a summary of scholarship on the triptych, with some, but hardly all, of the relevant bibliography, see the online entry on the object at the website of the Victoria and Albert Museum, http://collections.vam.ac.uk/item/O115267/alton-towers-triptych-triptych-unknown/ (accessed December 10, 2017).

3. See most recently Balace et al., *Une renaissance*, as well as the trenchant review by Gajewski in *Burlington Magazine*.

4. Morgan, "Iconography of Mosan Enamels."

5. See Kemp, "Mittelalterliche Bildsysteme"; Kemp, "Visual Narratives"; and Kemp, *Narratives of Gothic Stained Glass*, originally published as *Sermo corporeus*. See also Bogen, "Verbundene Materie," color plates 5–6.

6. O'Reilley, *Studies in the Iconography*, 436, tentatively posits a relationship between the two trees and early Christian representations of the Tree of Life in which two smaller trees spring from the roots.

7. For the healing power of the cross, see Kessler, "A Sanctifying Serpent."

8. For the scheme's relationship to cosmological diagrams, see Katzoff, "Alton Towers Triptych." Hughes, "Art and Exegesis," 183–85, offers the triptych as an example of what he calls visual exegesis combining allegory and typology.

9. For the combination of these two modes in medieval art, see Pächt, "Practice of Art History," 31–40.

10. A similar play of the open and closed frame can be observed in the Seilern Triptych (London, Courtauld Institute of Art) attributed to the artist variously known as the Master of Flémalle or Robert Campin.

11. To the point of being excluded from editions of the texts, as pointed out by Franklin, "Diagrammatic Reasoning," 57.

12. See, e.g., Evans, "Geometry of the Mind," and Murdoch, *Album of Science*, 62–71.

13. See Miller, *Reading Cusanus*.

14. The literature is vast; I cite only Roberts, *Existential Graphs*; Shin, *Iconic Logic of Peirce's Graphs*; and Pietarinen, "Diagrams or Rubbish." Shin, Lemon, and Mumma, "Diagrams," in *Stanford Encyclopedia of Philosophy*, produces a helpful overview and bibliography.

15. See the essays in Engel et al., *Das bildnerische Denken*, which, however, with a few exceptions, underestimate the ways in which Peirce's doodles deconstruct, rather than reinforce, his system of thought. Susan Howe incorporates a selection of both the logical and more whimsical drawings into her poetic collage, *Pierce-Arrow*, where of them she says simply: "Putting thought in motion to define art in a way that includes science, these graphs, charts, prayers and tables are free to be drawings, even poems" (ix).

16. With regard to the visualization of information, one could point to the series of publications by Tufte, beginning with *Visual Display of Quantitative Information*, as well as those of Lima: *The Book of Trees*, and *The Book of Circles*.

17. See Stjernfelt, *Diagrammatology*. It is particularly in the context of German *Bildwissenschaft* that this area of inquiry has flourished in recent years (albeit sometimes without adequate attention to previous scholarship, particularly in English); see Bauer and Ernst, *Diagrammatik*; Schmidt-Burkhardt, *Kunst der Diagrammatik*; Schneider et al., *Diagrammatik-Reader*; and Wöpking, *Raum und Wissen*, 6–10.

18. Kühnel, *End of Time*.

Chapter 1

1. See Oberweis, "Die mittelalterlichen T-O Karten."

2. See Günzel and Nowak, *KartenWissen*, and Ljungberg, "Diagrammatic Nature of Maps."

3. See Pápay, "Kartenwissen." Bosteels, "Text to Diagram," referring to the work of Deleuze and Guattari, speaks of a turn from "text to territory" in recent cultural criticism.

4. Sorrer and Wyss, "Pfeilzeichen," 171–72. Schmidt-Burkhardt, *Kunst der Diagrammatik*, 33, also draws the connection between Klee and diagrams. For the role of arrows in diagrams, see Denis, "Arrows in Diagrammatic and Navigational Spaces."

5. For discussions of this drawing, see Bunge, *Zwischen Intuition und Ratio*, 200–205, and Marx, *Balancieren im Zwischen*, 11–19.

6. Klee, *Notebooks*, 76. In context, the original reads "Kunst gibt nicht das Sichtbare wieder, sondern macht sichtbar"; see Klee, *Kunst-Lehre*, 60.

7. Klee, *Schriften*, 66–67: "Auf dem unteren, im Erdzentrum gravitierenden Weg, liegen die Probleme des statischen Gleichgewiches, die mit den Worten: 'Stehen trotz allen Möglichkeiten zu fallen' zu kennzeichen sind. Zu den oberen Wegen führt die Sehnsucht, von der irdischen Gebundenheit sich zu lösen, über Schwimmen und Fliegen zum freien Schwung, zur freien Beweglichkeit."

8. Goodman, *Ways of Worldmaking*, 1.

9. See Mann, "Best of All Possible Worlds."

10. The best overviews of medieval diagrams remain Evans, "Geometry of the Mind," and Murdoch, *Album of Science*. See also Buettner, "Images, diagramme et savoirs"; Guerrini, *Giocchino da Fiore*; and Schmitt, *L'histoire en lignes*.

11. Peirce, "Logic as Semiotic," 98.

12. See Volkert, *Die Krise der Anschauung*.

13. See Netz, *Shaping of Deduction*. See also Netz, "Greek Mathematical Diagrams," and, for further commentary, the review of Netz's book by Latour, "Netz-Works of Greek Deductions." For an opposing view on the relationship of philosophy and mathematics in the Greek world, but one which fails to take note of Netz's contributions, see Engels, "Geometrie und Philosophie."

14. An aspect stressed by North, "Diagram and Thought," 266.

15. Krämer, "Zur Grammatik der Diagrammatik," offers a definition in terms of ten partially overlapping characteristics. Diagrams (1) involve text and image, (2) are material, (3) artificially flat, (4) imply alignment and directionality, (5) are graphic artefacts, (6) relational, (7) structurally relational, (8) are founded on normative sociability, (9) operability, and (10) mediality. The list is expanded and reordered in Krämer, *Figuration, Anschauung, Erkenntnis*, 59–86. The added categories are simultaneity and referentiality.

16. See Lemon and Pratt, "Spatial Logic," and Lemon and Pratt, "Insufficiency of Linear Diagrams."

17. See, e.g., Vidler, "Diagrams of Diagrams," and Vidler, "What Is a Diagram Anyway?"

18. Worm, "'Ista est Jerusalem.'"

19. Münkner, *Eingreifen und Begreifen*, and Schmidt, *Interactive and Sculptural Printmaking*.

20. For a discussion of diagrams that emphasizes their "dynamic, fluctuating process occurring between static structures," see Zdebik, *Deleuze and the Diagram*, 1–2.

21. See Gattis, *Spatial Schemas*, 6–7.

22. See Bretscher-Gisiger and Gamper, *Katalog*, 107–10. A full digitization can be found at http://www.e-codices.unifr.ch/en/searchresult/list/one/kba/WettF0009 (accessed July 10, 2017).

23. For a description of the manuscript, see Bretscher-Gisiger and Gamper, *Katalog*, 107–10. Beer, *Beiträge zur oberrheinischen Buchmalerei*, 27–29, esp. 28, and cat. no. 3, 58–60, localizes the manuscript to Basel on the basis of its decoration. Moore, *Works of Peter of Poitiers*, 169, counts the diagram of the seven-armed candelabrum among doubtful or spurious works.

24. Hamburger et al., *Beyond Words*, cat. no. 94, 121–22.

25. See Peter Bloch, "Siebernarmige Leuchter in christlichen Kirchen," *Wallraf-Richartz-Jahrbuch* 23 (1961), 55–190.

26. For the Guidonian hand and related imagery, see Sherman, *Writing on Hands*.

27. It reads, in part: "Tres calami, id est tria brachia, ex uno latere prodeunt, et tres ex altero, quia ante incarnationem domini et post tres gradus fidelium fuerunt in ecclesia: scilicet coniugatorum, continentium et prelatorum. Unde tres viros tantum liberandos Ezechiel predixit, scilicet Noe, Daniel enim Job. In Noe prelatos, in Daniele continentes scilicet virgines, in Job bonorum coniugatorum vitam ostendit. Hii sunt qui, secundum evangelium, in lecto, in agro, in mola, reperientur in die iudicii, quorum singuli assumentur et quidam relinquentur. In lecto enim quies continentum, in agricultura industria predicantium, in giro mole labor conjugatorum exprimitur. Et quia de singulis quidam sunt eligendi, quidam sunt reprobandi, ideo dicitur: 'Unus assumetur et alter relinquetur.' . . . Quartus autem, ciphus, spera et lilium, que super omnes calamos sunt iuxta sublimitatem candelabri, proprie ad Christum pertinent, qui in se ipso figuram ostendit ciphi. Bene hic ciphus, spere et lilium; altiora calamus eminet, quia donum quod Christus contulit omnem transcendit modum humane capacitatis. Unicuique enim nostrum data est gratia secundum mensuram donationis Christi. In ipso autem habitat omnis plenitudo divinitatis corporaliter, quia omnes spirituales donationes et gratia ecclesie de Christo sunt."

28. Peter of Poitiers, *Allegoriae*, 104–5.

29. For imagery of this kind, see Preisinger, *Lignum vitae*. The inscriptions correspond to those listed in appendix 3, 254–56 (Version A).

30. For the diagram as a mental machine, see Carruthers, "Moving Images," 294.

31. See Koetsier and Bergmans, *Mathematics and the Divine*, and, for Euclid, Stevens, "Euclidean Geometry." Readers will find a fuller consideration of the diagrammatic tradition as it informs Berthold's practice in chap. 5.

32. From Blake's *Laocoön*; see Blake, *Complete Poetry and Prose*, 274.

33. See Hamburger, *"Haec figura demonstrat."* For a fuller treatment, see now Lentes, "Die Auffaltung der 'mysteria involuta.'"

34. For examples, see d'Alverny, "Le cosmos symbolique"; Cleaver, "On the Nature of Things"; and Wimmer, *Illustrierte Aristotelescodices*. For modern applications, see Gangle, *Diagrammatic Immanence*.

35. For the scientific tradition, see Murdoch, *Album of Science*; also Voigts, "Scientific and Medical Books"; Kühnel, *End of Time*; Blume, "Körper und Kosmos"; and Liess, *Astronomie mit Diagrammen*.

36. For the mathematicians, see p. 243.

37. Mullarkey, *Post-Continental Philosophy*, 157. See also Zdebik, *Deleuze and the Diagram*, and Dupuis, *Gilles Deleuze*.

38. For the rhetoric of fiction and the suspicion associated with it, see Swearingen, *Rhetoric and Irony*.

39. Following Freedberg, *Power of Images*.

40. See, e.g., Oliver, "Diagrammatic Reasoning"; Anderson and McCartney, "Diagram Processing," which focuses on the "practice of computing directly with pictorial, or analogical, representations" (183); Boutilier, "Influence of Influence Diagrams."

41. Roberts, *Existential Graphs*, and Shin, "How Do Existential Graphs Show What They Show?" without any reference to Roberts's study. Peirce's process provides the inspiration for the recent exhibition, curated by Nina Samuel, *My Brain Is in My Inkstand*.

42. For Peirce's critique, see Greaves, *Philosophical Status of Diagrams*, 162–75.

43. The source for Peirce's statement is MS Am 1632 (683), Peirce Papers, Houghton Library, Harvard University, not, as many secondary sources suggest, MS 682, which represents the essay as it was published in *The Essential Peirce: Selected Philosophical Writings*, vol. 2, *(1893–1913)*, ed. Peirce Edition Project (Bloomington: Indiana University Press, 1998), 463–74. The remainder of the passage has, unfortunately, taken on a life of its own in an inaccurate form. Leja, "Peirce, Visuality, and Art," quotes Peirce (again citing MS 682, not the actual source, MS 683) as follows, combining the quotation with a paraphrase which attempts to render Peirce's somewhat convoluted prose more comprehensible: "'Reasoning is dependent upon Graphical Signs,' Peirce wrote. 'By "graphical" I mean capable of being written or drawn, so as to be spatially arranged. . . . I do not believe on can go very deeply into any important and considerably large subject of discussion' without using space as a field in which to arrange mental processes and images of objects." The original reads in full: "Reasoning is dependent upon Graphical Signs. By 'graphical' I mean capable of being written or drawn, so as to be spatially arranged. It is true that one can argue *viva voce*; but I do not believe one can go very deeply into any important and considerably large subject of discussion with calling up in the minds of one's hearer's mental images of objects arranged in ways in which *time*, without *space*, is incapable of serving as the field of representation, since in time of two quite distinct objects one must be antecedent and the other subsequent. Of course, the one temporal relation can be spatially imaged in various ways. But the combined field of space and time seems [alone] to be adequate to the imaging of Lorentz's explanation of the famed experiment of Morley and Michaelson [sic.], etc." (MS 683, sheets 59–60). In a good deal of secondary literature, however, Leja's combination of quotation and paraphrase has been taken to be quotation only and reproduced without reference to the original source, a process made more problematic by the inaccurate source attribution. To make matters worse, Peirce's essay is sometimes cited as ". . . Reasoning in Security and Liberty." For his help in untangling the genealogy of this ps.-Peircean passage, I am deeply indebted to Prof. André De Tienne, director and general editor, Peirce Edition Project, Institute for American Thought, Indiana University–Purdue University Indianapolis, who generously provided me with the information presented here. For an example of the erroneous passage attributed to Peirce due to this classic example of an (erroneous) footnote loop, see Meyer-Krahmer, "My Brain Is Localized," also available in French as "Écriture et dessin," accessed June 21, 2017, https://genesis.revues.org/1228?lang=en#bodyftn19. For another, see Wirth, "Logik der Streichung," 39.

44. Aristotle, *On Memory*, 48.

45. Quoted after MS Am 1632 (619), Peirce Papers, Houghton Library, 8, of which a digitization can be found at https://www.fromthepage.com/display/display_page?page_id=15813 (accessed June 6, 2017).

46. For the trajectory of the tradition leading up to Frege's banishment of diagrams, see Volkert, *Die Krise der Anschauung*.

47. On the relationship of imagination to truth in the context of diagrams, see North, "Diagram and Thought," 265–67.

48. See Wells, "Die Allegorie," and Bezner, *Vela veritatis*. See also Stock, *Myth and Science*, 49–53.

49. Cf. Camille, "Dissenting Image," 144: "In the scholastic world images would always have this ambiguous position, being both useful tools of pedagogical practice in logical diagrams and astronomical and geometrical calculations but also false simulacra that led the mind away from truth."

50. Franklin, "Diagrammatic Reasoning," 83–84. Franklin adds: "At the leading edge of science, this picture is no longer true. Two developments especially have made the difference: psychological experiments on mental images, and scientific visualization by computer" (85). On this debate, see further Block, *Imagery*.

51. See n. 43.

52. Aristotle, *On Memory*, 48, which provides a clear, concise discussion of Aristotle's views on the subject (5–7).

53. Cf. Blackwell, "Diagrams about Thoughts."

54. Blackwell, *Thinking with Diagrams*. For further meditations on this topic, see Krämer, "Trace, Writing, Diagram"; Krämer, "Punkt, Strich, Fläche"; and Krämer and Ljungberg, *Thinking with Diagrams*.

55. For the term *operative*, see Krämer, "Operative Bildlichkeit."

56. For an introduction to Peirce's thought, see De Waal, *Peirce*, and for the roots of his triadic system in Kant and Hegel (whom he disliked), Sowa, *Knowledge Representation*, 58–62. See also Paolucci, "Semiotics, Schemata, Diagrams, and Graphs."

57. Peirce, *Writings*, vol. 1, *1857–1866*, xxx–xxxii.

58. See Spinks, *Peirce and Triadomania*.

59. Of the vast literature on marginalia, I cite only Randall, *Images in the Margins*; Camille, *Image on the Edge*; and Wirth, *Les marges à drolleries*.

60. See Peirce, *Writings*, vol. 1, *1857–1866*, xxvii–xxx. See Topa, "Circle of Categories."

61. See Topa, *Die Genese der Peirc'schen Semiotik*, vol. 1, *Das Kategorienproblem (1857–1865)*, 265–78, with an illustration of Peirce's drawing of the "Tremont Turbine" (but without mention of Peirce's contemporary Adams). See also Samuel, "My Brain Is in My Inkstand," 13–14, and Engel, "Peircean Labyrinth," 30.

62. For the celebrated passage, see Adams, *Education of Henry Adams*, 380.

63. For this aspect of Peirce's drawings, see Engel, "*Epistêmy* und andere Grotesken." Peirce's marginal drawings invite comparison to medieval marginalia, not only in their form, but also their function.

64. In particular, the diagrams of Opicinus de Canistris have been associated with psychotic states, an interpretation which continues to be maintained, e.g., most recently by Roux and Laharie, *Art et folie au Moyen Age*, and Roux, *Opicinus de Canistris*, although other approaches rooted in Opicinus' cultural context have been proposed, in particular, by Whittington, *Body-Worlds*.

65. See Johnson, *Memory, Metaphor*.

66. For examples, see Obrist, "Image et prophétie," and Obrist, "La figure géometrique."

67. Hamburger, *Rothschild Canticles*, 127–33. See also Meier, "Monastisches Gesellschaftsmodell."

68. Meier, "Malerei des Unsichtbaren."

69. Bolzoni, *Web of Images*, 83–114; Salonius and Worm, *The Tree*; and Preisinger, *Lignum vitae*.

70. Zorach, *Passionate Triangle*, 51–67. The triangle as a symbol of the Trinity plays a key role in the works of Petrus Alfonsi and Joachim of Fiore; see Tolan, *Petrus Alfonsi*, 36–39; Obrist, "La figure géometrique"; and Ernst, "Das Diagramm." For the Shield of the Trinity illustrated here, see Evans, "Illustrated Fragment." For Trinitarian visions, see McGinn, "'Trinity Higher Than Any Being!,'" and McGinn, "Theologians as Trinitarian Iconographers."

71. Augustine, *Contra Faustum* 20.6 (*PL* 42:371–72), a passage discussed by McGinn, "'Trinity Higher Than Any Being!'"

72. Nicholas of Cusa, *De docta ignorantia*, 25, lines 5–12: "Alii peritissimi Trinitati superbenedictae triangulum trium aequalium et rectorum angulorum compararunt; et quoniam talis triangulus necessario est ex infinitis lateribus, ut ostendetur, dici poterit triangulus infinitus. . . . Alii, qui unitatem infinitam figurare nisi sunt, Deum circulum dixerunt infinitum. Illi vero, qui actualissimam Dei existentiam considerarunt, Deum quaso sphaeram infinitam affirmarunt."

73. Mahnke, *Unendliche Sphäre*; Müller, "Gott ist (k)eine Sphäre"; and Beccarisi, "'Deus est sphaera intellectualis.'"

74. Translation from Levine, "The Pearl-Child," 246. For the Latin, see Dreves, *Ein Jahrtausend*, 1:343: "Linearis rectae creatio / Circulatur et fit perfectio, / Cum extrema conectit unio / Tuo, virgo, vernanti gremio. / Artem nosti quadrantem circuli, / Quem quadrasti carnis quadrangulum / Sphaerae Dei dans per miraculum. / Sauciatum sanando saeculum." For similar conceits in Dante, see Levine, "Squaring the Circle." Dante, who in the Paradiso, bk. 12, vv. 139–41, mentions Hrabanus Maurus in the same breath of Joachim of Fiore, almost certainly knew the copy of *In honorem* housed in the Dominican convent where he had studied, now Florence, Biblioteca Medicea Laurenziana, MS Pluteo 31 sin. 9, for which see Chiodo, *Ad usum fratris*, 208–13 (cat. no. 33).

75. Eco, "From the Tree," 62–67. See also Eco, "From Metaphor to *Analogia Entis*."

76. See Hamburger, "Revelation and Concealment"; Wallis, "What a Medieval Diagram Shows"; and McGinn, "Image as Insight."

77. See Schmitt, "Les images classificatrices"; Kühnel, "Carolingian Diagrams"; and Gormans, "Imaginationen des Unsichtbarens." One wonders how Tversky, "Spatial Schemas in Depictions," 79, could possibly have come to the conclusion that: "Depictions, such as maps, that portray visible things are ancient whereas graphics, such as charts and diagrams, that portray things that are inherently not visible, are relatively modern inventions."

78. Kottje, *Verzeichnis*, 59, cat. no. 333, assumes that Berthold's name constitutes evidence that the manuscript was written in Nuremberg.

79. Flint, "Honorius Augustodunensis."

80. For further discussion of the manuscript's localization on the basis of style, see p. 57.

81. For the text and its history, see Perrin's introduction to Hrabanus Maurus, *In honorem*; Hrabanus

Maurus, *Louanges*; Ferrari, *Il "Liber sanctae crucis"*; and, for further bibliography, Aris and del Barrio, *Hrabanus Maurus in Fulda*.

82. As was recognized by Müller, *Hrabanus Maurus*, 145–56, who in a brief excursus devoted to the work pinpointed many of its salient features.

83. See Kottje, *Verzeichnis*, 258. Ernst, *Carmen figuratum*, 309–23, also provides a list of manuscripts organized by century.

84. See Pächt, *Buchmalerei des Mittelalters*, translated by Kay Davenport as *Book Illumination in the Middle Ages*; and Hamburger, *Script as Image*.

85. For examples of such readings, see Gameson, "A Scribe's Confession", and Kitzinger, "Recasting Hrabanus."

86. See Schmitt, "Rituels de l'image," 1:422–31.

87. See, e.g., Elkins, *Domain of Images*, 213–35. See also Elkins, "Logic and Images," together with the reply by Galison, "Reflections on *Image and Logic*."

88. See Galison, *Image and Logic*, 19–20.

89. Joselit, "Dada's Diagrams," 223.

90. Cf. Deleuze and Guattari, *Rhizome: Introduction*, who emphatically distinguish the model of the rhizome from that of the tree: "La logique binaire est la réalité spirituelle de l'arbre-racine . . . Cette pensé n'a jamais compris la multiplicité . . . Le système-radicelle, ou racine fasciculée, est la seconde figure du livre, dont notre modernité se réclame volontiers . . . Un rhizome comme tige souterraine se distingue absolument des racines et radicelles. Principes de connexion et d'hétérogénité: n'importe quel point d'un rhizome peut être connecté avec n'importe quel autre, et doit l'être. C'est très différent de l'arbre ou de la racine qui fixent un point, un ordre" (13–17). For the translation, see Deleuze and Guattari, *Thousand Plateaus*, 15. Eco, "From the Tree," makes much the same distinction in identifying the Enlightenment and, in particular, Diderot and d'Alembert's *Encyclopédie* (1751–1765), as the moment of transition from one model to the other. Bender and Marrinan, *Culture of Diagram*, which makes essentially the same point, fails to include Eco's publication in its bibliography.

91. Gombrich, *Art and Illusion*. See also Wood, "Art History Reviewed VI."

92. For the centrality of the cross as a graphic sign in early medieval art, see Hahn, "The Graphic Cross."

93. See Hurtado, "Staurogram in Early Christian Manuscripts," and Hurtado, "Earliest Christian Graphic Symbols."

94. Chazelle, *Crucified God*, and Noble, *Images*, 347–51.

95. Fer, *The Infinite Line*, 80. See also Harnish, *Serial Images*.

96. See de Freitas, "Diagram as Story." Cf. Krämer, "Operative Bildlichkeit," 105: "Das diagrammatische ist ein operatives Medium, welches infolge einer Interaktion innerhalb der Trias von Einbildungskraft, Hand und Auge zwischen dem Sinnlichen und dem Sinn vermittelt, indem Unsinnliches wie beispielsweise abstrakte Gegenstände und Begriffe in Gestalt räumlicher Relationen verkörpert und damit nur 'denkbar' und versehbar, sondern überhaupt erst generiert werden. Die Signatur unserer Episteme verdankt sich in vielen Hinsichten den Kulturtechniken des Diagrammatologischen—bleibe dies nun implizit oder sei es explizit." Some of the same ideas are expounded in Krämer, "Punkt, Strich, Fläche," and Krämer, "Trace, Writing, Diagram."

97. Halimi, "Diagrams as Sketches," 388.

98. Poggenpohl and Winkler, "Diagrams as Tools."

99. I draw this formulation from Krämer, "'Operationsraum Schrift.'"

100. *Poetae latini*, ed. Dümmler, 544–47, vv. 99–102: "Arbor habebat ea, et folia, et pendentia poma, / Sique venustatem et mystica plura dabat. / In foliis verba, in pomis intellige sensus, / Haec crebo accrescunt, illa bene usa cibant." I have used the translation provided by Carruthers, *Craft of Thought*, 213, esp. 212. See also Maas, "Zur Rationalität."

101. See Kemp, *Christliche Kunst*. For applications of Kemp's ideas, see Bogen, "Verbundene Materie," and Mohnhaupt, *Beziehungsgeflechte*. See also Reudenbach, "Salvation History," and Reudenbach, "Heilsgeschichtliche Sukzession."

102. The critical essay remains Auerbach, "Figura." For a new edition of the original essay with commentary, see Balke and Engelmeier, *Mimesis und Figura*.

103. For medieval texts that lend the geometrical definition of a figure a theological tenor or employ it to make theological arguments, especially regarding the soul's capacity to see the invisible, see Evans, "'Sub-Euclidean' Geometry"; Zaitsev, "Meaning of Early Medieval Geometry"; and Cain, "Standing of the Soul."

104. Mitchell, *Iconology*, and Mitchell, *Picture Theory*.

105. As modern theoreticians do in speaking of diagrams; see, e.g., Gangle, *Diagrammatic Immanence*, 6: "diagrams imply a partial blurring between object and sign. In other words, diagrams are essentially iconic. They are what they mean. . . . Diagrammatic thought is situated on a terrain wherein problems of linguistic signification and representation are relatively circumscribed from the outset. This is because diagrams are constituted always to some degree by a mode of representation (*Vorstellung*) that

is *also* an 'immediate' non-linguistic presentation (*Darstellung*). . . . Diagrams thus represent systems of relations and at the same time instantiate (at least some of) those relations directly. In this way the 'content' of a diagram is already at least partly present and immediately in its 'form.' Its syntax is already an instance of its semantics." For the Middle Ages, see Bogen and Thürlemann, "Jenseits der Opposition."

106. Schmitt, "La culture de l'*imago*." See also Dürrig, *Imago*; Otto, *Die Funktion des Bildbegriffes*; Javelet, *Image et ressemblance*; and Bedos-Rezak, *When Ego Was Imago*.

107. Arnulf, *Versus ad picturas*.

108. For Byzantine art, see Maguire, "Validation and Disruption."

109. See Rotman, *Mathematics as Sign*, 51; also Rotman, "Thinking Dia-grams."

110. Cf. Knoespel, "Diagrammatic Writing," ix–x: "We might instead approach Châtelet's discussion of physics, mathematics and philosophy as a discourse reminiscent of the seductive strategies for thinking about optical mathematics and physics in provocative French texts such as the *Roman de la Rose*."

111. Jun, Kim, and Lee, "System Diagrams," 74: "A system diagram should be regarded as a visualization of the organizing principle of the system; thus, the diagram is altered to become a place that opens up a user's possibilities of action and enables effective use of the system. In turn, the key to system diagrams is not simply to represent a relationship among things—it is to understand the relationship of how the system is organized, according to the intent of the designer, the purpose of user-action, and the collective function."

Chapter 2

1. Studies include Müller, *Hrabanus Maurus*; Sears, "Word and Image"; Ernst, *Carmen figuratum*, 222–332; Ferrari, *Il "Liber sanctae crucis"*; Reudenbach, "Das Verhältnis"; Heck, "Raban Maur"; Ernst, "Die Kreuzgedichte"; Ernst, "Text und Intext"; Embach, *Die Kreuzesschrift*; and Perrin, *L'iconographie*; Aris and del Barrio, *Hrabanus Maurus in Fulda*.

2. For the genre, see Peignot, *Du Calligramme*; Higgins, *Pattern Poetry*; Adler and Ernst, *Text als Figur*; Polara, "La poesia figurata"; Higgins, "Pattern Poetry: A Symposium"; and Ernst, *Carmen figuratum*, to which now can be added Ernst, *Visuelle Poesie*, 111–233, with extensive bibliography. For an isolated example, dating to the late twelfth century, see Tomaschek, "*Vivet in Admundo*." Two additional picture poems by Hrabanus survive, the first consisting of a dedication to the empress Judith, the second, dedicated to the four evangelists, for which see Ernst, *Carmen figuratum*, 297–304.

3. On medieval expressions of cosmic harmony in various media, see Boskoboynikov, *Ideas of Harmony*.

4. Perrin, *L'iconographie*, 31.

5. The commentary in Perrin, *L'iconographie*, includes notes on the meter(s) of each poem.

6. Discussed in great detail in Ernst, *Carmen figuratum*, 226–92. Ernst's analysis should be complemented by that offered by Perrin, *L'iconographie*.

7. As noted by Squire, "Optatian and His Lettered Art." See also Squire, "POP Art."

8. For the manuscript, see Dufour, "La composition," 211–12, and for other examples of this same type, among them the Oviedo Cross in the Silos Codex of Beatus of Liébana (London, BL, Add. MS. 11695, f. 5v), see Bischoff, "Kreuz und Buch," 2:296.

9. For the distinction, see Kitzinger, "Instrumental Cross."

10. As observed by Perrin, *L'iconographie*, 93, who also points out that Hrabanus's metric conceit is based on Porfyrius, *carmen* 15, 11 (Porphyrius, *Carmina*, ed. Polara).

11. For number symbolism in Hrabanus, see Klingenberg, "Hrabanus Maurus"; Taeger, *Zahlenzymbolik bei Hraban*; Ernst, "Zahl und Maß"; and Ernst, "Die Kreuzgedichte." Perrin, *L'iconographie*, 30–40, provides the most comprehensive treatment.

12. See Bright, "Carolingian Hypertext," 357–58, on the role of numerology. The fullest account of Hrabanus's number play can be found in Perrin, *L'iconographie*, 30–40.

13. Guillaumin, "Boethius's *De institutione arithmetica*."

14. Boethius, *Boethian Number Theory*, 74.

15. Galileo, *Essential Galileo*, 183.

16. Perrin, *L'iconographie*, 37–38.

17. Müller, "Admirabilis forma numeri." See also Mellon, "Inscribing Sound."

18. See Suckale-Redlefsen, *Die Handschriften*, vol. 1, cat. no. 20, 30–39; Mayr-Harting, *Church and Cosmos*, 160–69; and Cochrane, "Secular Learning."

19. From the large literature, I cite only Hofmann, *Das Satorquadrat*; Hofmann, "Satorquadrat"; and, with criticism of Hofmann's interpretation, Marcovich, "Sator Arepo—Georgos Harpon (Knophi) Harpos," and Marcovich, "Sator Arepo—Georgos Harpon."

20. Odo of Cluny, Sermo XV: *De sancta cruce* (*PL* 142:1031–36, here 1034B): "Hic tale de laude crucis orditus est opus et textuit et texendo perfecit, quo pretiosius ad vivendum, amabilius ad legendum, dulcius ad retinendum, nec laboriosius ad scribendum potest invenire nec poterit." For the changing critical fortunes of the poem, see de Lubac, *Medieval Exegesis*, 1:109–12n34.

21. Vincent quotes only the *versus intexti*; see Franklin-Brown, *Reading the World*, 235–45.

22. The most recent edition is Publilius Optatianus Porphryius, *Carmina*, ed. Polara (1973). For commentary, see Levitan, "Dancing at the End"; Ernst, *Carmen figuratum*, 95–142; Squire, "Patterns of Significance"; Squire and Witten, "*Machina sacra*"; and Squire and Wienand, *Morphogrammata*. I was unable to consult Bruhat, "Les Carmina figurata."

23. *Carmen* I, lines 1–8: "Quae quodam sueras pulchro decorata libello / farmen in Augusti ferre Thalia manus, / ostro tota nitens, argento auroque coruscis / scripta notis, picto limite dicta notans, / scriptoris bene compta manu meritoque renidens / gratificum, domini visibus apta sacris, / pallida nunc, atro chartam suffusa colore, / paupere vix minio carmina dissocians." For a commentary on the poem, see Ernst, *Visuelle Poesie*, 30–31. For further consideration of the role of color in Optatian, see Habinek, "Optatian and His Ouevre," 409–17.

24. Squire, "Patterns of Significance," 108–9.

25. Bruhat, "Les poèmes figurées."

26. Squire, "Patterns of Significance," 109.

27. Cicero, *De divinatione*. My thanks to David Ungvary for having brought this passage to my attention.

28. Hrabanus Maurus, *In honorem*, A 7, lines 53–56: "De cetero autem moneo lectorem, ut huius conscriptionis ordinem teneat, et figuras in eo factas ubique seruare non negligat, ne operis pretium pereat, et utilitas lectionis minuatur."

29. For these and related phenomena, see Hamburger, *Script as Image*.

30. All of these features, among many others, are described in detail by Derolez, "Observations on the Aesthetics."

31. See Chapter 1, note 85.

32. Perrin's introduction to Hrabanus Maurus, *In honorem*, xxx–lv, establishes a stemma. For a list of extant manuscript copies, ordered by century, see Ernst, *Carmen figuratum*, 309–23.

33. See Schmitz, "*O praeclarum*"; Perrin, "Un nouveau regard"; Hrabanus Maurus, *In honorem*, xcii–xcv; Perrin, "Dans les marges"; and Deloignon, "Un modèle de virtuosité." A copy by Reinhardius Eltmann, dated 1581, after the edition of 1503, to which he added other materials, including a self-portrait, was recently sold by Ketterer Kunst: Sale 405 / Rare Books, May 27–28, 2013, lot 3, Hamburg, accessed May 31, 2017, www.kettererkunst.com. Given its possibly ephemeral nature, I reproduce the online description here: "Very clean and magnificently executed transcription of the famous early medieval picture poetry of Hrabanus Maurus, written and drawn after the work's first edition from 1503 by the private scholar Reinhardius Eltmann (around 1585). 103 ll., of which 125 pp with writing; also with 3 loosely inserted double sheets (of which 4 pp with writing and drawing). Size of sheet 31 : 20,8 cm. Red and brown ink. Together with 6 large drawings in feather as well as 32 full-page poems with figures and 1 full-page allegoric genealogic tree in feather drawing with watercolor.—Contemp. vellum binding. Condition: Inner joints somewhat shaken, front board slightly warped. Very well-preserved manuscript in contemp. original binding, with Eltmann's rep. monogram stamp, additionally with quaint dialog by his hand on pastedown, between this manuscript and a fictitious thief, who, after a quarrel, has the last word: 'Satis est verborum, iam pallium subj(acet)' (engl. 'Enough said, and puts it under his cloak'). Below with ms. ownership entry 'Schaffratt 1846' as well as with ms. entry and ex-libris of Carl Reichensperger (19th century)."

34. The image has previously been described as an engraving, yet the breaks in the lines are characteristic of woodcut blocks.

35. See Dane, "Two-Color Printing," and Dane, "The Red and the Black."

36. Schipper, "Secretive Bodies," 194–97, notes the implicitly sensual aspects of this part of the image but proceeds to offer a far-fetched interpretation of it as a part of a web of references to what lies beneath: "Christ's penis, which is not just a penis, but also the creator (or the creative power) who makes the created world visible for mankind."

37. Worm, "Mittelalterliche Buchmalerei," 1:158, mentions the Rudolfine copy en passant in the context of a broader discussion of early modern copies of medieval illuminated manuscripts. To say, however, as she does, that these copies are "exact" brushes over numerous changes of the kind discussed here.

38. For the evidence suggesting an imperial destinatee, see Sears, "Louis the Pious." The circumstances of Rudolf's loan are well documented; see Wilhelmy, "Rabans 'De laudibus,'" and Ernst, *Carmen figuratum*, 321–22. The loan request, which still survive in the archives at Fulda, was issued on June 15, 1598; the monastery's reply, dated August 4, 1598, survives in Vienna; see Kotzur, *Rabanus Maurus*, cat. no. 14, 112–13.

39. See Sears, "Louis the Pious," and, for the manuscript from Metten, Suckale, *Klosterreform und Buchkunst*, 64–68.

40. For Aachen reliquary bust, see Schmitz-Clivier-Lepie, *Die Domschatzkammer zu Aachen*, 58–59; Falk, "Bildnisreliquiare"; and Minkenberg, "Die Karlsbüste."

41. In addition to Suckale, *Klosterreform und Buchkunst*, 18–19 and 132–39, see Redlich, *Tegernsee und die deutsche Geistesgeschichte*.

42. See Krings, *Das Prämonstratenserstift*, and Hamburger, "Hand of God." The diagrams in the Arnstein Bible have since been discussed further by Schonhardt, *Kloster und Wissen*.

43. Gameson, "A Scribe's Confession." For another instance of transformation through copying, see Kitzinger, "Recasting Hrabanus."

44. For the High Middle Ages, see Fulton, *From Judgment to Passion*.

45. Jacobs and Ukert, *Beiträge zur älteren Litteratur*, 1:97–98, 3:35–38; Müller, *Hrabanus Maurus*, 145–56; and Ernst, *Carmen figuratum*, 684–91. The manuscript is previously mentioned by Jöcher, *Allgemeines Gelehrten-Lexicon*, 1036: "BERTHOLDUS Teuto, ein deutscher Dominikaner zu Ende des 13. Seculi, lehrte zu Nürnberg die Theologie, und arbeitete über Rab. Mauri opera *de cruce praemissa intercessione Albini*, das der vermehrt und erläutert hat; schieb auch *de mystheriis & laudibus intemeratae virginis Mariae*, welche beyde Wercke in der fürstlichen Bibliothek zu Gotha im MSt. liegen." See also Kaeppeli, *Scriptores Ordinis Praedicatorum*, 1:240–41 (no. 668–69).

46. For a full codicological description, see the appendix.

47. Tentzel, *Monatliche Unterredungen*, 1:209: "Ich habe auch ein sehr alt *Manuscriptum* gesehen, des mit vielen wunderlichen *Inventionen* angefüllten Buchs vom Lobe des heiligen Creutzes *Hrabani Mauri*, der erst zu *Fulda* gewesen, hernach Erzbischiff zu Meyntz worden. Auf desselben ersten Blat stehet ein Gemählde, welches in vielen Stücken dem oberwehnten sehr gleich kommt. Denn es sitzt auch in mit der dreyfachen Crone gezierter Bischoff auff dem Stuel giebt mit der rechten Hand den Seegen, mit der Lincken fasset er das Buch, welches ihm vin zweyen vor ihm knienden Personen überreicht wird, und hinter ihm stehet einer, der den Bischoffs-Stab hält. Die zweene auf den Knien liegenden sind *Alcuinus* und *Hrabanus*, aber der sitzende ist nicht der Papst, sondern der Ertzbischoff zu Tours in Franckreich, an welchen die '*intercessio Albini pro Mauro*' unzugleich die *Dedication* gerichtet ist."

48. Knepper, *Jakob Wimpfeling*; Spitz, *Religious Renaissance*, 41–60; Mertens, "Jakob Wimpfeling (1450–1528)"; and Mertens, "Wimpfeling (Wimphelng, -ius, Sletstattinus), Jakob."

49. For a digitization, see http://www.e-codices.unifr.ch/en/list/one/ubb/B-IX-0011 (accessed June 18, 2017), where a full description plus a supplementary description by Balázs Nemes are provided.

50. For the library of the Dominicans in Basel, see Schmidt, "Die Bibliothek," 227 (no. 338), and for the Latin translation of the original vernacular Mechthild von Magdeburg, ‚*Lux divinitatis*'. For literary culture in Basel, see Virchow, "Basel."

51. For the style of the manuscript, see p. 57.

52. For further details, see Müller, *Hrabanus Maurus*, 145n303, repeated by Ernst, *Carmen figuratum*, 684. Clm 3050, from Andechs, is dated 1456 (f. 22v); Clm 8826, from the Franciscan house in Munich, is dated 1428 (f. 191v); Clm 18188, from Tegernsee, is dated 1446 (f. 20v); Clm 21624, from Weihstephan, is dated 1430 (f. 131v).

53. For this distinction I am indebted to Daniel Heller-Roazen.

54. Elkins, *Domain of Images*, 234.

55. Kühnel, *End of Time*, and Taub, *Science Writing*, esp. 100–10 on the (lost) diagrams in Aristotle's Meteorology and his commentators.

56. The diagrams of the Ophite sect of Gnosticism offer an example that, to the best of my knowledge, has been ignored in the literature on medieval diagrams; see most recently Ledegang, "Ophites and the 'Ophite' Diagram," and Rasimus, *Paradise Reconsidered*, 15–18. See also Bouché-Leclercq, *L'Astrologie greque*, 276–88 (on astrological diagrams), and, for the association of geometric designs with magic, Maguire, "Magic and Geometry."

57. See Kühnel, *End of Time*.

58. Although Ernst, *Carmen figuratum*, 317 and 690, lists the manuscript in Paris, he attributes the additions to Daniel rather than Berthold, presumably because he relies on the description provided by Lehmann, *Mitteilungen aus Handschriften*, 2:39–40. The other manuscripts signed by Daniel are listed in the unpublished description of the manuscript in Paris by Marie-Pierre Lafitte, who generously permitted me to see it. The colophon on f. 48r reads: "Explicit Deo juvante opus Magnencii Hrabani Mauri in honore sancte Crucis conditum atque per me fratrem Danielem ordinis Sanctae Crucis anno Domini M°CCCC° LXVIII;" that on f. 55v: "Explicit secundus liber Rabani episcopi Maguntini de misterio et laudibus Sancte Crucis per me fratrem Danielem de Monte Sancte Gertrudis cruciferum seu Crucis gestatorem Coloniensis conventus professum anno videlicet Domini M° CCCC° XLVIII" [sic; should read LXVIII]; that on f. 76r: "Explicit opus mirabile cujusdam Porphirii philosophi christiani ad Constantinum imperatorem directum de laude ejusdem Constantini per me fratrem Danielem de Monte Sancte Gertrudis ordinis Cruciferorum Coloniensis conventus professum [. . .] Colon [. . .] anno Domini M° CCCC° LXVIII in crastino octavarum pasche ipsa scilicet die sancti Marci evangeliste ad gloriam et honorem Domini nostri Jesu Christi amen." Daniel de Geertruidenberg's hand can also be found in a Bible, in Brussels, Bibliothèque royale Albert I^er, Mss. 9153–9155 (see Masai and Wittek, *Manuscrits datés conservés*, no. 421 [Mss. 9153–54–55], 25–26,

pl. 737–740) and in Cologne, Historisches Stadtar-chiv, GB, f° 90, f° 168, 4° 100, 4° 106, 4° 134, 4° 218; see Vennebusch, *Die theologischen Handschriften*, 1:66–69, 146–47; 2:107–10, 115–16, 150–52, 232–36, as well as Bénédictins du Bouveret, *Colophons de manuscrits*, vol. 1, no. 3269. The manuscript in Paris is described briefly in Séguy et al., *Le Livre*, cat. no. 198c [n.p.]. I was unable to consult Gotenburg, "Die Handschriften der Kölner Kreuzbrüder." The fact that in the manuscript in Paris, the rubric to the pro-logue that is missing in Gotha identifies Berthold's reworking of book 2 of Hrabanus's treatise as book 3 (f. 55v: Incipit prefacio in librum Tertium. de mis-teriis et laudibus Sancte Crucis) could be construed as indicating that in the model and hence also in the manuscript in Gotha in its original state, Berthold's work (part 3) was preceded by the *carmina* (part 1), and Hrabanus's explanations (part 2).

59. Keussen, *Die Matrikel*, 1:484.

60. The edition announced by Müller, *Hrabanus Maurus*, 146n303, never appeared.

61. See Hidrio, *L'iconographie*, 130–40, and, for further discussion, pp. 91–95.

62. Müller, "Irritierende Variabilität." For analo-gous phenomena in the transmission of other works, see Trexler, "Legitimating Prayer Gestures"; Trexler, *The Christian at Prayer*; and Hamburger, "*Haec Figura demonstrat*."

63. Freed, *Friars and German Society*, 217.

64. See the appendix.

65. See Belting, "Zwischen Gotik," and Saurma-Jeltsch, "Der Zackenstil."

66. Swarzenski, *Die lateinischen illuminierten Handschriften*, vol. 1, cat. no. 48, 129–130; vol. 2, figs. 587–607. For a summary of the scholarship link-ing the manuscript to St. Katharinental, see Kessler, *Gotische Buchkultur*, 60 and 216–23 (cat. no. 18).

67. The fragments, formerly in the Forrer collec-tion in Strasbourg, are discussed and reproduced by Swarzenski, *Die lateinischen illuminierten Hand-schriften*, 1:53n5, 128, and figs. 583, 586 and 586 bis. The fragments corresponding to Swarzenski's figures 583 and 586, depicting the Christ Child being bathed by Midwives and the Death and the Assumption of the Virgin, are now in the Staatliche Graphische Sammlung in Munich (inv. no. 40258–59). The Crucifixion reproduced here (Swarzenski, fig. 585) is today in the Liberna Collection, Hilversum, M. 2; see de Hamel, *Liberna Foundation*, xi and 8–9. Yet a third fragment depicting the Virgin and Child and Benedict with a group of Benedictine monks (Swarzenski, fig. 584) is now in the National Gallery of Art, Washington D.C., Rosenwald Collection, B-15, 391, for which see Nordenfalk et al., *Medieval and Renaissance Miniatures*, 128–30, fig. 35e. See also

Hamburger, "Magdalena Kremer, Scribe and Painter," rev. and trans. as "Magdalena Kremerin, Schreiberin und Malerin."

68. See the appendix.

69. For dedication images in the early and High Middle Ages, see Prochno, *Das Schreiber- und Dedikationsbild*, and, for scribal dedicatory imag-es, Gameson, "'Signed' Manuscripts," and Palazzo, *Portraits d'écrivains*. For dedication images in the later Middle Ages, see Schottenloher, "Buchwid-mungsbilder"; Benesch, "Dedikations- und Präsenta-tionsminiaturen," kindly made available to me by Dr. Maria Theisen.

70. Beer, "Die Buchkunst," 154–55.

71. John of Damascus, *De fide orthodoxa*, 318–19 (section 1156, chap. 87, lines 114–18).

72. Urfels-Capot, *Le sanctoral*, 116.5 (Nativity of the Virgin).

73. On the "liveliness" of Marian images, see Smith, "Bodies of Unsurpassed Beauty," and Ham-burger, "Rahmenbedingen."

74. Sauerländer, "Die Naumburger Stifterfig-uren," 176.

75. See, e.g., van Eck, *Art, Agency and Living Presence*.

76. Väth, *Die illuminierten Handschriften*, cat. no. 86, 117–20.

77. *Krone und Schleier*, cat. no. 275, 385. Addi-tional cuttings from the same manuscript, one of a priest experiencing a vision of the Man of Sorrows (BF1044), the other of a nun experiencing a vision of the crucifixion (BF1045) as she prays on behalf of souls in purgatory, are held by the Barnes Col-lection, Philadelphia. The contrast in size between the subjects of these visions and the sculpture in the miniature in Berlin underscores its status as a "real" image on the altar.

78. Urfels-Capot, *Le sanctoral*, 97.8–9 (Vigil of Assumption).

79. Klemm, *Die illuminierten Handschriften*, 1:61–63, with previous bibliography.

80. See Classen, "Bemerkungen zum Kollektar"; and *Krone und Schleier*, cat. no. 332, 427–28 (Jeffrey F. Hamburger).

81. For the profession of Dominican nuns, see the discussion by Schlotheuber in Hamburger et al., *Liturgical Life*, 1:55–67.

82. See Andreas Rüther, "Profeß," in: *LM* 7 (Mu-nich: Deutscher Taschenbuch Verlag, 2002), cols. 240–41, and Machilek, "Zu einem Profeßzettel."

83. For *figura* 16 in the Marian section, see pp. 171–72.

84. Famous examples of a series of dedicatory images in a single manuscript include those in the Ottonian Hornbach Sacramentary, for which see Bloch, *Das Hornbacher Sakramentar*, the Egbert

Psalter, for which see *Psalterium Egberti*, and the Egmond Gospels, for which see Ciggaar, "Dedication Miniatures." For early medieval author portraits (other than of the evangelists), see Skubiszewski, "Fortunat et Baudonivie."

85. For the image of Louis, see Sears, "Louis the Pious," and Perrin, "La représentation figurée."

86. "Rabanum memet clemens rogo, Christe, tuere, O pie iudico"; see Perrin, *L'iconographie*, 95.

87. Hrabanus Maurus, *In honorem*, C 28, lines 58–59: "Imago uero mea, quam subter crucem genua flectentem et orantem depinxeram, asclepiadeo metro conscripta est." Ernst, "Die Kreuzgedichte," 26, characterizes these verses as an early form of artistic signature.

88. For a comparison of Hrabanus's use of a profile portrayal with a frontal image of Godefroy de Saint-Victor from the twelfth century, see Bonne, "L'image de soi." Bonne calls the image a "self-portrait," as does Ganz, "Individual and Universal Salvation."

89. Ernst, *Carmen figuratum*, 168–78, drawing on Meyer, "Crux, decus es mundi."

90. See Venantius Fortunatus, *Poems*, 74–81; for the first of the two dedicated to the cross, see also Ehlen, "Venantius Fortunatus." See also Graver, "*Quaelibet Audendi*"; Polara, "I carmina figurata"; and Walz, "Text im Text."

91. The translations of this and the following passages are taken from Venantius Fortunatus, *Poems*, 74–81.

92. Homburger, *Die illustrierten Handschriften*, 162–63, suggested that the last portion of the manuscript, from f. 162 on, was, in contrast to the rest of the book, written in northern France some fifty years after the other two parts, which Bischoff, *Katalog der festländischen Handschriften*, 1:117, localized to Mainz; see also Bischoff, *Manuscripts and Libraries*, 62. According to a note in the library's files, however, Martin Germann considered Homburger's hypothesis both unlikely and superfluous. My thanks to Dr. Florian Mittenhuber, the curator of the manuscript collection, for sharing this information. See also Schaller, "Die karolingischen." See also Ernst, *Carmen figuratum*, 168–78. For Cassiodorus, see Troncarelli, *Vivarium*, and Gorman, "Diagrams in Cassiodorus' *Institutiones*."

93. Hrabanus Maurus, *De universo, PL* 111:333 (bk. 12, chap. 2): "Iterumque centesimus sextus psalmus quatuor cardinibus terrae spatia conprehendiut dicens: A solis ortu et occasu, ab aquilone et mari, cuius rei eudentissimum quoque euangelii extat exemplum ubi dicit: Emittet angelos suos cum tuba et uoce magna et congregabit a quatuor angulis terrae. Vnde merito estimo perquirendum, quemadmodum terra possit et quadratio et circulus conuenire, dum scemata ipsa sicut geometrici dicunt uideantur esse diuersa. . . . Quattuor autem cardinibus eam formari dicit, quia quattuor cardines quattuor angulos quadrati significant, qui intra praedictum terrae circulum continentur. Nam si ab orientis cardine in austrum et in aquilonem singulas rectas lineas ducas, similiter quoque et si ab occidentis cardine ad praedictos cardines, id est austrum et aquilonem singulas rectas lineas tendas, facis quadratum terrae intra orbem praedictum, sed quomodo quadratus iste demonstratiuus intra circulum scribi debeat, Eoclides in quarto libro Elementorum euidenter insinuat, quapropter recte scriptura sancta faciem terrae et orbem uocat, et quattuor eam dicit cardinibus contineri." A new and more reliable edition is forthcoming in CCCM.

94. Honorius Augustodunensis, *Commentarium in psalmos, PL* 193:1356D (on psalm 36): "Hic numerus sexies in se replicatur quia ad perfectionem hortatur," cited by Meyer and Suntrup, *Lexikon*, col. 707.

95. Kessler, "'Hoc visibile imaginatum.'"

96. See Kessler, *Illustrated Bibles*, 51–53; Kühnel, *End of Time*; and Poilpré, *Maiestas Domini*. See also O'Reilley, "Patristic and Insular Traditions."

97. For the first type of image, see Bloch, "Dedikationsbild"; for the second, see Lacher, "Devotionsbild." See also Bergmann, "PRIOR OMNIBUS AUTOR," and Beys, "La valeur des gestes."

98. Stones, *Gothic Manuscripts*, vol. 1, part 1, 125; vol. 1, part 2, cat. no. III-44, 257–58; vol. 2, part 1, 263, 306, 398; vol. 2, part2, 258.

99. The inscription is augmented by notes on the recto of the flyleaf: "Robertus de Bethunia, 14us Abbas de Claro cuius effigies hic, visitor altera pagina, versa." For a fuller description of the manuscript, see Châtillon, "L'héritage littéraire," and Stones, *Gothic Manuscripts*. As noted by Clark, "Three Manuscripts," as early as ca. 1200, the abbey's manuscripts show that the traditional Cistercian strictures on illumination were honored in the breach.

100. Stones, *Gothic Manuscripts*, vol. 1, pt. 2, cat. III-95, 456–62.

101. For some of the difficulties in identifying the figure in both images as the author, as opposed to the recipient of the work, see the nuanced discussion in Peters, *Das Ich im Bild*, 106–9, which expands on that in Peters, "Werkauftrag und Buchübergabe," 52.

102. Philippe de Beaumanoir, *Coutumes*.

103. Reproduced in color in Peters, *Das Ich im Bild*, fig. 58.

104. For a lector's duties and role in the convent, see Mulchahey, "*First the Bow*," 138–40. On Dominican education, see also Berg, *Armut und Wissenschaft*, esp. 135–36 on Teutonia between 1260 and 1300.

105. Mulchahey, *"First the Bow,"* 137, after Humbert of Romans, *De vita regulari*, 2:254: "Officium boni lectoris est conformare se capacitati auditorum; et utilia, et expedientia eis faciliter et intelligibiliter legere; opiniones novas refugere, et antiquas, et securiores tenere; ea quae non bene intelligit nunquam dicere."

106. Constable, "Popularity of Spiritual Writers."

107. Mulchahey, *"First the Bow,"* 472–79.

108. Mulchahey, *"First the Bow,"* 473.

109. Humbert of Romans, *De eruditione praedicatorum*, 1.7, in Humbert of Romans, *De vita regulari*, 2:398: "Circa secundum notandum quod artes, quae consistunt in operando, melius addiscuntur ostensione exempla, quam doctrina verbi." Cited by Mulchahey, *"First the Bow,"* 477.

110. For the original, which, while almost certainly not authentic, reflects Eckhart's views, see *Deutsche Mystiker*, 2:599, lines 19–24: "Ez sprichet meister Eckehart: wêger wêre ein lebemeister denne tûsent lesemeister; aber lesen unde leben ê got, dem mac nieman zuo komen. Solte ich einen meister suochen von der geschrift, den suohte ich ze Parîs und in hôhen schuolen umbe hôhe kunst. Aber wolte ich frâgen von vollekomenem lebenne, das kunde er mit niht gesagen." For what it meant to be a "lesemeister" in the circle of Eckhart, see also Löser, "Meister Eckhart"; also, in the same volume, Senner, "Meister Eckhart."

111. Parkes, "Influence"; Palmer, "Kapitel und Buch"; and Sandler, *"Omne bonum."* For the Latin vocabulary of the related genre of colophons, see Reynhout, *Formules latines*.

112. Batiffol, *History of the Roman Breviary*, 119: "Post hunc Bonifacius papa, qui inspirante sancto spirito et regulam conscripsit et cantilena anni circuli ordinavit."

113. Sicardus of Cremona, *Chronica*, 144: ". . . qui Moralia, Dialogum, Pastoralem, Registrum et alia multa conscripsit et ecclesiam etiam nocturnis et diurnis officiis ordinavit."

114. Hugh of St. Victor, *Didascalicon*, 50.4: "Deinde Plato discipulus eius libros multos *De republica* secundum utramque iustitiam, naturalem scilicet et positivam, conscripsit. deinde Tullius in Latino sermone libros *De republica* ordinavit." For the translation, see *Interpretation of Scripture*, eds. Harkins and von Liere, 117–18: "Subsequently his disciple, Plato, wrote the many books of the *Republic* from the perspective of both kinds of justice, namely, the natural and positive. Then Cicero composed his own *Republic* in Latin."

115. *Urkundenbuch Halberstadt*, 166, no. 2844 (1374): "Dominus Ludolfus de Neindorp, ecclesie nostre Halb. quondam canonicus et portenarius pie recordationis, in curia Romana noviter defunctus, legitime sanus mete et corpore legaliter fecit et ordinavit ac sua manu propria conscripsit . . ."

116. Benjamin, *Arcades Project*, 460 (N1a,8).

117. Parkes, "Influence"; Minnis, "Late-Medieval Discussions"; Rouse and Rouse, "Ordinatio and Compilatio Revisited"; and Hathaway, "Compilatio," who offers some corrections to previous accounts. For further discussion and bibliography, see Kumler, "Handling the Letter," 98n31.

118. Hathaway, "Compilatio." Keen, "Shifting Horizons," stresses the active role of the reader.

119. Rouse and Rouse, *Preachers, Florilegia and Sermons*, 7–11.

120. Discussed by Parkes, "Influence," 58–59.

121. Mitchell, "Diagrammatology."

122. There are surprisingly few studies of this topic; see, e.g., Byrne, "Manuscript Ruling." For a meditation on similar considerations as they relate to typography, see Drucker, *Diagrammatic Writing*.

123. Ingold, *Lines*, 156–57.

124. For the term's medieval semantics, see Kuchenbuch and Kleine, *"Textus' im Mittelalter."* According to Semper, *Four Elements*, weaving constituted one of the four elements of architecture. See also Buchmann and Frank, *Textile Theorien*.

125. Such divisions could themselves be diagrammed; see Even-Ezra, "Schemata as Maps," and Even-Ezra, "Visualizing Narrative Structure."

126. See Brady, "Rubrics of Peter Lombard's Sentences," cited and enlarged upon by Angotti, "Formes et formules brèves." See more generally Illich, *In the Vineyard*, 93–114.

127. Peter Lombard, *Sententiae*; PL 192:522: "Ut non sit necesse quaerenti, librorum numerositatem evolvere, cui brevitas, quod queritur, offert sine labore . . . ut autem quod quaeritur, facilius occurat, titulos quibus singulorum librorum capitula distinguuntur, praemisimus." Translation from Rouse and Rouse, *"Statim invenire."*

128. See also Rouse, "La diffusion en Occident," and Palmer, "Kapitel und Buch," 43–88.

129. Ernst, *Carmen figuratum*, 684–85, makes the possible if somewhat implausible suggestion that if one includes the table of contents one reaches thirty-four, the symbolic *numerus passionis*.

130. For a full description of the text, see the appendix.

131. I borrow this terminology from Angotti, "Formes et formules brèves," 63.

132. Angotti, "Formes et formules brèves," 68–69.

133. For the text, Hugh of St. Victor, "De tribus gestorum," 484–93; translation taken from Carruthers and Ziolkowski, *Medieval Craft of Memory*, 32–40, esp. 38, revising the translation and enlarging

on the discussion in Carruthers, *Book of Memory*, 261–66. See also Zinn, "Hugh of St. Victor."

134. Carruthers and Ziolkowski, *Medieval Craft of Memory*, 38.

135. For a paleographical analysis, see the introduction to appendix.

136. Studies of medieval source marks are few and far between; see, e.g., Laistner, "Source-Marks." Claudius of Turin states that he employed source marks so that his readers would not think that he was plagiarizing; see Gorman, "Commentary on Genesis," 286.

137. Hrabanus Maurus, *Epistolae*, 402–3 (Ep. 14), cited by Knibbs, "Manuscript Evidence," 156: "Praenotavique in marginibus paginarum aliquorum eorum nomina, ubi sua propria verba sunt; ubi vero sensum eorum meis verbis expressi aut ubi iuxta sensus eorum similitudinem, prout divina gratia mihi concedere dignata est, de novo dictavi, *M* litteram Mauri nomen exprimentem, quod meus magister beatae memoriae Albinus mihi indidit, prenotare curavi, ut diligens lector sciat, quid quisque de suo proferat, quidve in singulis sentiendum sit, decernat."

138. Angotti, "Formes et formules brèves," discusses the development of such systems in manuscripts of the Lombard.

139. For identification of Berthold's authorities, see the appendix.

140. For the genre, see Wilmart, "Un répertoire d'exégèse"; Rouse and Rouse, "Biblical *distinctiones*"; Bataillon, "Intermédiares"; Bataillon, "Tradition of Nicolas of Biard's Distinctiones"; and Dahan, "Genres, Forms and Various Methods," 220–22.

141. Copeland and Sluiter, *Medieval Grammar*, 281.

142. Parkes, *Pause and Effect*, 35–40 and 173. For Isidore's definition, see *PL* 82:97.

143. Giraud, "Dominican Scriptorium."

144. Urfels-Capot, *Le sanctoral*, 567 ("In legendis et sermonibus et omeliis interdum decisa sunt aliqua, retentis aliis sub eisdem verbis; quod designatur per signum .A°. positum a principio;" "interdum autem, licet raro, abreviata est aliqua hystoria sub aliis verbis; quod designatur per signum .T. positum a principio"), with further discussion of specific examples, 583–609.

145. Urfels-Capot, *Le sanctoral*, 567: "interdum autem ponuntur omnia sine decisione vel mutatione notabile verborum; et tunc non ponitur aliquod signum ab inicio."

146. Parkes, *Pause and Effect*, 306.

147. For Bernard's Marian piety, see Leclercq, "Saint Bernard."

148. On the origin of the *questio*, the disputation exercise, the *reportatio* and their evolution see: Wei-

jers, *Terminologie des universités*, 335–72; Weijers, *La "disputatio"*; and Weijers, *In Search of Truth*.

149. Richalm von Schöntal, *Liber revelationum*, 156 (section 128, lines 5–17): "Quidam frater cum post completorium super lectum suum sederet, vigilans vidit ante se Q litteram multociens a se invicem separatim scriptam tamquam de zinobrio puro in ea forma, qua illa littera capitalis formari solet; et multum intendebat, nec paterat intelligere, quid significaret."

150. For further discussion, see Hamburger, "Iconicity of Script."

151. Andersson-Schmidt and Hedlund, *Mittelalterliche Handschriften*, 98–99: ff. 91v–120r. Other works in the codex include Burchardus de Monte Syon, *Descriptio terrae sanctae* (ff. 1r–2r); *De nominibus pertinentibus ad virtutes et vitia* (ff. 59r–82v); Johannes Andreae, *Summa super quarto libro Decretalium* (ff. 83r–90r); and *Testamenta duodecim patriarcharum* (ff. 121r–135r). The three florilegia by Berthold of Wimpfen have been edited; see *Texte*, ed. Beccarisi, 2:167–218.

152. Palazzo, "Philosophy and Theology," 92, comes to the same conclusion.

153. Bertholdus de Wimpfen, *Hortus spiritalis*, in *Texte*, ed. Beccarisi, 174.4–6: "Hic libellus potest appellari Hortus spiritalis, quia in eo velut in horto secundum dicta praeclara beati Bernardi inveniuntur spiritualiter suavitates odoris et flores fructusque honoris et honestatis."

154. The fact that the scribe, in a considerable case of eye skip, jumped from the beginning of the second work to the beginning of the third, which was then simply crossed out (f. 106r), confirms that he was copying from another manuscript.

155. Palazzo, "Philosophy and Theology," 92.

156. As noted by Palazzo, "Philosophy and Theology," the *ordinatio* of the first two works, which are divided into subsections, each with its own list of headings, differs from that of the third, which is not subdivided and therefore has a single list of headings, comparable to what is found in the manuscript in Gotha.

157. As do Sturlese, "Philosophische Florilegien," 164–65, and Palazzo, "Philosophy and Theology," 90–93. Johanek, "Bruder Berthold," 808, who speculates that Berthold of Nuremberg might have been the author of the legal compendium known as the "Summa Johannis," was the first to point out the coincidence of names, but left open whether the two Bertholds could be identified with one another. The manuscript in Uppsala was noted by Lehmann, *Skadinaviens Anteil*, 65, without, however, his having commented on the possible identify of the author.

158. For the library, see Staub, *Geschichte*. Extant volumes are listed in Krämer, *Handschriftenerbe*, 2:838–40.

159. Sturlese, "Philosophische Florilegien," 164–66.

160. For Berthold's sources, see the appendix.

Chapter 3

1. Schmitt, "La culture de l'imago."

2. See Hamburger, "Place of Theology," and Hamburger, "Visible, yet Secret."

3. See Ladner, "Der Bilderstreit." For a full account, see Noble, *Images*, esp. chaps. 6–7: "The Age of Second Iconoclasm" and "Art and Argument in the Age of Louis the Pious."

4. Reudenbach, "Imago—Figura," 30.

5. Hrabanus Maurus, *Carmina*, 196–97, as revised by Haefele, "Decerpsi police flores," 68–71. Translation from Ganz, "*Pando quod ignoro*," 29. Appleby, "Instruction and Inspiration," 99, uses the same passage to argue for Hrabanus' materialist understanding of images.

6. Hrabanus Maurus, *De Universo*, 21, chap. 9, col. 563: "Pictura est imago exprimens speciem rei alicuius, quase dum visa fuerit, ad recordationem mentem reduxit." For text, see Hrabanus Maurus, *De Universo*, ed. Schippers (n.d.), soon to be superceded by a new edition in the Corpus Christianorum.

7. Isidore of Seville, *Etymologiarum*, 19.16.1: "Pictura autem est imago exprimens speciem rei alicuius, quae dum visa fuerit ad recordationem mentem reducit. Pictura autem dicta quasi fictura; est enim imago ficta, non ueritas. Hinc et fucata, id est ficto quodam colore inlita, nihil fidei et veritatis habentia." Translation from Isidore of Seville, *Etymologies*, 380.

8. *Pingere* and *fingere* were paired in classical Latin; see Otto, *Die Sprichwörter*, 135 (no. 659). For hymns, see *AH* 41:231, on the virtues ("Purus esto, no tu fictus / Et deferens munditiam, / Tu mendax non sis [hec] pectus, / Tu retine fiduciam, / Tu legaliter sis dictus / Et geres tu constantiam"), or still more germane, *AH* 17:101, on the stigmata of St. Francis ("Glorioso quinario Remansit carne picta, / Haec mira diva pictio Non infacta vel ficta / Pes, manus, latus lilio / Florescunt mirifario, / Caro fulget afflicta"), in which the five wounds are said to have been painted in Francis's flesh, not merely invented, a striking application of the topos in so far as knowledge of the miracle of the stigmatization was propagated in large part through paintings, and some Franciscans went so far as to appeal to the paintings as proof of the miracle's reality; see Vauchez, "Les stigmates." For his help with these hymns, my thanks to Jan Ziolkowski.

9. For a summary and analysis, see Chazelle, "Memory, Instruction, Worship," 192–95, and for the broader context within Carolingian debates, Chazelle, *Crucified God*, 118–27, and Noble, *Images*, 244–86, esp. 263–78.

10. *Concilia Aevi Karolini*, ed. Werminghoff, 519, lines 30–31.

11. As argued by Reudenbach, "Das Verhältnis." See also Spilling, *Opus Magnentii*, 23–24.

12. See Chazelle, *Crucified God*, 103–14, and Noble, *Images*, 347–51. It is surprising that Sepière, *L'image d'un Dieu*, 137, makes only passing mention of Hrabanus.

13. William Schipper, without underestimating Hrabanus' achievement, exaggerates when he claims that Hrabanus' *carmina* are inspired in their format, substance and every aspect of their meaning by Porfyrius' example; see Schipper, "Rabanus Maurus," 4–8.

14. Reudenbach, "Imago—Figura."

15. Hrabanus Maurus, *In honorem*, A 7, lines 53–56: "De cetero autem moneo lectorem, ut huius conscriptionis ordinem teneat, et figuras in eo factas ubique seruare non negligat, ne operis pretium pereat, et utilitas lectionis minuatur."

16. Reudenbach, "Das Verhältnis."

17. Becht-Jördens, "*Litterae illuminatae*," 340–42.

18. Hrabanus Maurus, *In honorem*, A 7, lines 20–21. A similar balance between seeing and reading is articulated in Hrabanus' definition of the form of letters as something both written and perceived: "figura, qua scripta aspicitur et notatur;" Hrabanus Maurus, *De rerum naturis*, PL 111:617, cited by Carmassi, "Übergänge," 413.

19. Schwarz, *St. Peter*, 10–18.

20. For these two figures, see Noble, *Images*, 179–207 and 287–312.

21. For an analysis and contextualization of the pictorial program, see Raaijmakers, "Word, Image and Relics," 396–99, and Raaijmakers, *Making of the Monastic Community*, 219–21.

22. Kloft, "Hrabanus Maurus."

23. Brower, *Fuldensium Antiquitatum*, 162–63 (chap. 15: Montis S. Petri monumenta): "Ornavit hanc olim basilicam inscriptioni versuum suorum Hrabani," cited by Kloft, "Hrabanus Maurus," 376. A digitization can be found at https://archive.org/stream/fuldensiumantiqu00brou#page/162/mode/2up (accessed June 21, 2017).

24. Cf. Kessler, "Pictorial Narrative"; Belting-Ihm, "Zum Verhältnis"; and Arnulf, *Versus ad picturas*.

25. Raaijmakers, "Word, Image and Relics," 400–402.

26. Paris, BnF, ms. lat. 8916, f. 54r: "Hunc librum ordinavit et conscripsit ex libro Rabani de sancta Cruce diffuso inscriptum et difficili in intelligentia ad honorem et laudem ipsius preclare ac salutifere crucis." I quote the passage from the manuscript in Paris, as it has been excised from the codex in Gotha.

27. Müller, "Gott ist (k)eine Sphäre," 317.

28. For illuminated copies of Aristotle, see Camille, "Discourse of Images"; Camille, "Illuminating Thought"; Wimmer, "Schnittstellen"; and Wimmer, *Illustrierte Aristotelescodices*.

29. As pointed out by Perrin, *L'iconographie*, 61. For further discussion, see Reudenbach, "Imago—Figura."

30. Auerbach, "Figura." This, of course, is the thesis which Auerbach developed most famously in *Mimesis*. See also Paccagnella and Gregori, *Mimesis*.

31. For contextualization, see Damrosch, "Auerbach in Exile"; Shahar, "Auerbach's Scars"; Zakai and Weinstein, "Erich Auerbach"; and Porter, "Erich Auerbach." For criticism and commentary, see Landauer, "Mimesis"; Zlatar, *Epic Circle*, 47–180, esp. 49–64; and Gellrich, "*Figura*."

32. Ernst, *Carmen figuratum*, 689, notes Berthold's emphasis on salvation history and the *ordo temporaneus*.

33. Quintilian, *Instituto Oratoria*, 3:352–53.

34. Stevens, "Fields and Streams," 173.

35. Alcuin, *Ars grammatica*, *PL* 101:858, translation from Copeland and Sluiter, *Medieval Grammar*, 281. For further discussion of such critical marks, see Steinova, "*Psalmos, notas, cantus*."

36. In Thomas Aquinas, *Metaphysicorum Aristotelis exposito*, 453 (bk. 9, lectio 10, 1888): "Dicit ergo primo, 'quod diagrammata,' idest descriptiones geometriae 'inveniuntur,' idest per inventionem cognoscuntur secundum dispositionem figurarum in actu."

37. Aelred of Rievaulx, *Sermones*, sermon 33.1, lines 6–13: "Ille populus habebat festiuitates et sacramenta sua, et nos [habemus] similiter festiuitates et sacramenta nostra. Sed in illis erat umbra et imago quaedam earum rerum quae uentura erant; in nobis uero est ueritas, id est illa quae tunc significata sunt. Ideo dicit Apostolus: Omnia in figura contingebant illis; scripta sunt autem propter nos. Ibi prophetabantur, hic implentur"; trans. from Aelred of Rievaulx, *Liturgical Sermons*.

38. Paris, BnF, ms. lat. 8916, f. 54r: "Ipsa est enim que perpetuo previsio et consilio filio Dei predeterminata et diuersis imaginibus et sermonibus prophetarum per Spiritum Sanctum persignificata."

39. In *Epistolam ad Hebraeos*, 17.5 (*PG* 63:130); for the translation see Chrysostom, *Homilies*, 210–11. For further discussion of the topos, see Kessler, *Spiritual Seeing*, 54.

40. Hrabanus's insistence on the cosmological significance and reach of the four arms of the Cross does not accord with the generalization posited by Ladner, "St. Gregory of Nyssa," who associates such ideas more with the Byzantine East than with the Latin West.

41. For a detailed accounting of Berthold's sources, see the appendix.

42. Hrabanus does not figure prominently in histories of prayer, despite his having been a student of Alcuin, author of important *libelli precum*, for which see Waldhoff, *Alcuins Gebetbuch*.

43. In *De institutione clericorum*, Hrabanus himself defined confession as follows: "Cuius nominis duplex significatio est: aut enim in laude intelligitur confessio . . . aut in denudatione peccatorum." See Hrabanus Maurus, *De Institutione*, 92 (2.14).

44. A similar process can already be observed in the eleventh-century copy of *In honorem sanctae crucis* (Paris, BnF, ms. lat. 11685) as discussed by Kitzinger, "Recasting Hrabanus."

45. For the tradition of ladder imagery, see Heck, *L'Échelle celeste*, esp. 84–87 on the image from Zwiefalten discussed here.

46. See Herrad of Hohenbourg, *Hortus deliciarum*, 1:352–53 (f. 215v), pls. 124, 158; 2:201 (no. 296). See also Joyner, *Painting the Hortus Deliciarum*.

47. Kaufmann, *Jakobs Traum*; also Cahn, "Ascending."

48. Benedict of Nursia, *Order of St. Benedict*.

49. Von Borries-Schulten, *Die Romanischen*, 1:97–111 (cat. no. 64) and vol. 2, pls. 232–58. Digitization accessed June 19, 2017, http://nbn-resolving.de/urn:nbn:de:bsz:24-digibib-bsz3494064648.

50. For the function of such books, see Huglo, "L'Office du Prime"; Stein-Kecks, "Quellen zum capitulum"; and Stein-Kecks, *Der Kapitelsaal*, 26–52. For illuminated examples, see Hamburger, "Magdalena Kremer, Scribe and Painter," and Hamburger, "Magdalena Kremerin, Schreiberin und Malerin."

51. Ladner, "Symbolism."

52. A similar image can be found in Herrad of Hohenbourg, *Hortus deliciarum*, 1:134–35 (f. 84r); 2:135 (no. 101). See also Zellinger, "Der geköderte Leviathan"; Marchand, "Leviathan"; and Jacoby, "Der Kampf."

53. *Speculum uirginum*, 221; Mews, *Listen, Daughter*. See also Bailey, "Judith, Jael, and Humilitas"; Hidrio, *L'iconographie*, 140–50.

54. For the *Acta Perpetuae*, see *Passion de Perpétue*, 113–16 (4.3–7); for the English translation, see "The Passion of Saints Perpetua and Felicity," trans. Joseph Farrell and Craig Williams, in Bremmer and Formisano, *Perpetua's Passions*, 16. See also Shaw,

"Passion of Perpetua"; Cotter-Lynch, *Saint Perpetua*; and Kitzler, *From "Passio Perpetuae."*

55. *Passion de Perpétue* 18.7, and Salisbury, *Perpetua's Passion*, 110. For the shift in the characterization of the gladiator, see Cotter-Lynch, *Saint Perpetua*, 128.

56. From the large literature, I cite only the following: Wenzel and Lechterman, *Beweglichkeit der Bilder*; Stolz, *Artes-liberales-Zyklen*, esp. 1:160–88; Wenzel, "Bilder für den Hof"; and Starkey, *A Courtier's Mirror*, esp. 77–83 on the ladder imagery.

57. Thomasin von Zirclaria, *Der wälsche Gast*, lines 5905–10: "Ich hân iu nu genuoc geseit / von zwein stiegn.diu eine treit / uns hin zem oberisten guot, / sô wizzet daz diu ander muot / uns ze leiten zaller vrist / dâ daz niderst übel ist." Translation from Thomasin von Zirclaria, *Der Welsche Gast*, eds. Gibbs and McConnell, 125.

58. *Speculum uirginum*, 221; Mews, *Listen Daughter*; and Hartl, *Text und Miniaturen*, appendix B.2. Most recently Rainini, *Corrado di Hirsau*, has argued that both works are to be attributed to the same author and that he, in turn, should be identified as Conrad of Hirsau. See also Rainini, "From Regensburg." For further commentary on this vexed topic, see Graf, "Zu Marco Raininis Buch."

59. Flint, "'Elucidarius.'" For the origins and development of the genre, see Fontaine, "Le genre littéraire"; von Moos, "Gespräch"; and Hempfer and Traninger, *Der Dialog*.

60. Dölger, *Sphragis*.

61. Hartl, *Text und Miniaturen*, appendix B, 4.

62. Hartl, *Text und Miniaturen*, 32–39, leaves open the question of whether the *Dialogus* in Munich derives the text from the *Speculum virginum* or an independent version of the *Homo constat* treatise. Rainini, *Corrado di Hirsau*, ascribes both works to the same author.

63. For the manuscript in Oxford, see Palmer, *Zisterzienser*, 76–80, 294; for that in Nuremberg, see Schneider, *Die lateinischen mittelalterlichen Handschriften*, 182–83. For those in Cologne, Paris and Munich, see Hartl, *Text und Miniaturen*, appendix B, 7–9. A microfilm of the copy in Cologne has been digitized: http://historischesarchivkoeln.de/en/dokument/1515328/Best.+7004%2B206%2B (accessed November 4, 2017).

64. For further discussion of this manuscript, see pp. 54–55.

65. Hrabanus Maurus, *In honorem*, B 21, lines 5–8.

66. Hrabanus Maurus, *In honorem*, B 23, line 1.1: "Nobilis ecce micat flos regis nomine pictus."

67. Albertus Magnus, *Opera omnia*, 36:3: "Malui siquidem cum mihi deessent coccus et hyacinthus, byssus et purpura, de pilis caprarum devotus offerre, quam contra praeceptum legis in conspectu Dei vel ipsius beatae virginis vacuus apparere."

68. Kühnel, *End of Time*, 156–59.

69. Hamburger, "*Haec figura demonstrat*," and Lentes, "Die Auffaltung der 'mysteria involuta.'"

70. Can 007729: "Surge illuminare Ierusalem quia venit lumen tuum; Et gloria domini super te orta est."

71. Gorman, "Diagrams in Isidore's 'De natura rerum,'" and, for the manuscript reproduced here, Cleaver, "On the Nature of Things."

72. Kessler, *Illustrated Bibles*, 50–53; Cohen, *Uta Codex*; Poilpré, *Maiestas Domini*; Kühnel, *End of Time*, 181–85; and O'Reilley, "Patristic and Insular Traditions."

73. For the Gauzelin Gospels in relation to Hrabanus's *carmen* 15, see Kessler, *Illustrated Bibles*, 42–43, and Thunø, *Image and Relic*, 58–59.

74. Baker, "More Diagrams." For further bibliography, see http://digital.library.mcgill.ca/ms-17/apparatus.php?page=Digital_J_Bibliography (accessed March 12, 2016).

75. For further explanation, see Perrin, *L'iconographie*, 78–80.

76. Rainer, *Das Buch*.

77. See pp. 166–68.

78. The other pair consists of Berthold's twenty-ninth and thirtieth figures, matching Hrabanus's twenty-third and twenty-fourth.

79. See pp. 156–57.

80. Melnikas, *Corpus of Miniatures*, and Schadt, *Die Darstellungen*.

81. Gilt bronze with enamel and rock crystal over wood core, $10 \times 27.5 \times 17$ cm, Brussels, Musées royaux d'Art et d'Histoire, Musée du Cinquantenaire, no. 1590. Green, "Reading the Portable Altar"; Gudera, *Der Tragaltar aus Stavelot*; and Wittekind, *Altar, Reliquar, Retable*.

82. For the staurothek, see Klein, *Byzanz*.

83. Vetter, "Programm und Deutung," 41, makes passing reference to this image in the manuscript in Gotha, which he knew from microfilm. See also Vetter, "Zum 500," 124.

84. Hrabanus Maurus, *In honorem*, B 8, lines 18–19, and D 8, lines 23–26: "Quotquot ergo a principio hos radios rite agnoscentes venerabantur, perpetuae lucis munere perfruuntur, crebroque hoc iubare vibrabant arma prophetarum, et sors apostolica praedicans hac luce nobiliter coruscabat."

85. Chazelle, *Crucified God*, 118, notes of Hrabanus's representation of Christ crucified (I.B.1), "this figure seems divorced from temporal considerations, whether the historical circumstances of the crucifixion or the return at the end of time."

86. Perrin, *L'iconographie*, 87.

87. See Hinkle, "Cosmic and Terrestrial Cycles."

88. For the gloss on Bede, see *PL* 90:361. See further Lapidge, "Byrhtferth of Ramsey."

89. For the iconography of the Seven Gifts of the Holy Spirit, see Rademacher-Chorus, "Maria"; for the antependium, Poeschke, *Das Soester Antependium*. See also Löer, "Walburgiskloster."

90. "Flegrescit ultra omnia balsama pigmenta et timiamata; Purpurea ut viola roscida ut rosa candens ut lilia." Both were incorporated into the Marian sequence, "Aurea virga prime matris," for which see Boynton, "Rewriting the Early Sequence," 32–33, 39.

91. See McKenzie, "Virgin Mary."

92. See Ransom, "Bernardian Roots"; Ransom, "Innovation and Identity"; and Schmidt, *Das Graduale*, 163–66.

93. Augustine of Hippo, *De sermone Domini*, 1.11, lines 188–255.

94. Perrin, *L'iconographie*, 88–89.

95. Dalli Regoli, "Testimonianze," 99–101, and Morello and Wolf, *Il volto di Cristo*, cat. no. VI/2, 265 and 271 (Michele Camillo Ferrari), where it is argued, contrary to received opinion, that the image does not represent the earliest extant depiction of the city's celebrated cult image, the *Volto Santo* of Lucca. See also Ungruh, "Paradies und *vera icon*," 323–27.

96. Venantius Fortunatus, *Poems*, bk. 2.1, 68–69.

97. Hrabanus Maurus, *In honorem*, B 1, line 26: "Ad quem mundus pertinet, astra ac pontus et aether;" B 12, 25–31: "Hic dominus mundi, terrae, pontique, polique / . . . Quattuor ipse dabit totius conditor Adam / . . . En anatol, dysis, arcton, mesembria haec sic / Designant odis arte."

98. Esmeijer, *Divina Quaternitas*, 97–106.

99. Hrabanus Maurus, *In honorem*, B 1, lines 1–3: "Ast soboles Domini et Dominus dominantium, ubique hic / Expansis manibus, morem formantis habendum en / Perdocet."

100. Hrabanus Maurus, *In honorem*, B 1, lines 12–13: "Tradi summo cuncta decent, quia sanguina demptam / Dextera deripuit praedam proba, sancta, profundo."

101. Wirth, "Die Entstehung."

102. Lucas of Tuy, *De altera vita*, 120–21 (bk. 2, chap. 9, lines 130–36): "In derisum etiam et opprobrium crucis Christi imaginem crucifixi unum pedem super alium uno clauo figentes aut euacuare aut in dubium ducere fidem sanctissimae crucis et sanctorum patrum traditiones, nouitatum diuersitate superinducta, contendunt, quod clarius demonstrabimus, si quod actum est in confinio Galliarum in castro, quod Monculis dicitur, ut relatio patefecit, in medium proferamus." For further commentary, see Gilbert, "Statement of the Aesthetic Attitude," 130–

31, and Binski, "Crucifixion," 348.

103. For the crucifixion group from the church of St. Moritz, Naumburg, St. Mortiz (Berlin, Bode-Museum, SPKB, inv. no. 7089–90), ca. 1220–30, see Kunz, *Bildwerke*, cat. no. 48, 143–51. For the relief of the Crucifixion from Thienen/Tirlemont, dated 1149 (Brussels, Musées royaux d'art et d'histoire, no. 354), see *Tesori dell'arte mosana*, pl. 7. See further Lipton, "'Sweet Lean of His Head,'" 1184.

104. The prayer was often attributed to Anselm himself; see Wilmart, "Les méditations," and, for his other writings, Elmer of Canterbury, "Écrits spirituels," 45–117. For the translation, see Anselm of Canterbury, *Meditations and Prayers*, 134–35. For Anselm's place in the history of prayer, especially in German-speaking lands, see Hamburger and Palmer, *Prayer Book*, 415–18.

105. For the history of the topos, see Ohly, *Süsse Nägel*.

106. Andrä et al., *750 Jahre*. The cross is mentioned in passing in Lutz, "Drop of Blood."

107. Andrä et al., *750 Jahre*, 67 and 88–89, cat. no. 103 (Achim Hubel); *Krone und Schleier*, 403–4, cat. no. 302 (Robert Suckale), and *Mittelalter: Kunst und Kultur*, 134–35, 404, cat. no. 202.

108. See p. 57.

109. Belting, "Zwischen Gotik," and Saurma-Jeltsch, "Der Zackenstil."

110. See Lipton, "'Sweet Lean of His Head.'"

111. Mellinkoff, "Judas's Red Hair."

112. See Klein, *Byzanz*.

113. Kesting, "Maria als Buch," and Richter, "Die Allegorie." See also Spalding, "Middle English Charters," and Steiner, *Documentary Culture*, 193–228.

114. See *Constitutiones Fratrum* (1886), 102, Dist. 1, cap. 9, no. 175: "Fratres in cellis habeant imaginem Crucifixi et Beatae Virginis. Ita enim ordinatum fuit in primo Capitulo Ordinis sub Beato Dominico Patre nostro celebrato, anno Domini 1220." For the same passage, see "Constitutiones Fratrum S. Ordinis Praedicatorum Lovanii MDCCCLXXXV," in *Constitutiones et Acta*, ed. Istituto Sotrico Domenicano, chap. 9 (De lectis), section 175. The date, however, is suspect, given that no such prescription for the year in question is included in the *Acta Capitulorum*, ed. Reichert, and that rules issued in subsequent decades continued to be suspicious of images, characterizing them as "curiosities."

115. See Gerard of Frachet, *Vitae fratrum*, 149 (4.1): "In cellis eciam habeant eius et filii crucifixi ymaginem ante oculos suos, ut legentes et orantes et dormientes ipsas respicerent, et ab ipsis respicerentur oculo pietatis." Translation adapted from the abridged version in Gerard of Frachet, *Lives of the Brethren*, 134.

116. "Hec imago in cruce que circa caput est continet tres litteras: hec est A M W, que significat omnia ab ipso comprehendi initium videlicet medium et finem."

117. Perrin, *L'iconographie*, 86–87.

118. Cf. also the St. Gauzelin Gospels, Nancy, Cathedral Treasury, f. 3v, reproduced in Kessler, *Illustrated Bibles*, fig. 64.

119. Hamburger, *St. John the Divine*.

120. For Christomorphic representations of John the Evangelist, see Hamburger, *St. John the Divine*.

121. Williamson, *Medieval Treasury*, 62–63.

122. Kemp, "Visual Narratives," 89.

123. For diagrammatic poems in honor of the cross from the post-Carolingian period, see Ernst, *Carmen figuratum*, 333–87, 502–21, 709–15. For verse inscriptions, see Debiais, "Carolingian Verse." See also Chazelle, *Crucified God*, 132–33.

124. In addition to Staub and Knaus, *Die Handschriften*, cat. no. 37, 69–72, see Schneider, "Semantische Symmetrien," 1:226–28; Stein, *Das Kloster Bredelar*; and Uhlemann, "Zwei Bibelhandschriften."

125. The same diagram, in less elaborate form, can be found in a Bible, ca. 1220, from the Praemonstratensian abbey of Wedinghausen bei Arnsberg (Darmstadt, Hessische Landesbibliothek, Hs. 48,1, f. 222r). For a discussion of both diagrams, see Ernst, *Carmen figuratum*, 639–46.

126. Hartl, *Text und Miniaturen*, 458–60.

127. See Kessler, "A Sanctifying Serpent"; also Lutterbach, "Der Christus medicus," and Sauser, "Christus Medicus."

128. Hartl, *Text und Miniaturen*, 459: "Figura praesens hoc praetendit, quod omnes sancti ab exordio mundi usque adventum Christi in fide crucis Christi pependerunt et crucifixum per figuras quasi ex parte videbant. Unde facies manus et pedes apparent."

129. For the *syndesmos* figure, see Esmeijer, *Divina Quaternitas*, 97–128.

130. Ernst, *Carmen figuratum*, proposes that the three colors respectively might symbolize heaven, the blood of Christ's sacrifice, and the *arbor vitae*. As important as any symbolism, however, is the dynamism which the colors add to the composition.

131. For a transcription of the verses, see Swarzenski, *Die lateinischen illuminierten Handschriften*, 1:98, reproduced in Ernst, *Carmen figuratum*, 644–45.

132. For this diagram and its own typological function within Peter's work, see Worm, "'Ista est Jerusalem,'" 146–51.

133. The Bible contains yet another diagram, f. 163v, a *rota* of the winds, based on Isidore. The drawing reinforces the cosmological content of the diagram of the twelve tribes in that it, too, is organized around the four points of the compass.

Chapter 4

1. In addition to Rubin, *Mother of God*, see Schreiner, *Maria*. For the Dominicans in particular, see Duval, "La dévotion mariale," and D'Amato, *La devozione a Maria*.

2. Gerard of Frachet, *Vitae fratrum*. For the history of the text, see Tugwell, "L'évolution des 'Vitae fratrum,'" and Boureau, "'Vitae fratrum,' 'Vitae patrum.'"

3. Gerard of Frachet, *Vitae fratrum*, 6–7.

4. Humbert of Romans, *De vita regulari*, 2:135.

5. Iacopo da Varazze, *Legenda Aurea*, 1:808–11.

6. Lohrum, "Dominikaner."

7. Maler, "Studien zur Geschichte"; Bonniwell, *History of the Dominican Liturgy*; and Canal, *Salve regina misericordiae*.

8. Fassler, "Music and the Miraculous." See further Fassler's contributions to Hamburger et al., *Liturgical Life*, 211–81.

9. *Analecta Hymnica*, eds. Dreves and Blume, 55.429, as noted by Fassler, "Music and the Miraculous," 230.

10. Förster, "Die ältesten marianische Antiphon"; Reisner, "Sub tuum praesidium confugimus"; and Donadieu-Rigaut, *Penser en images*, 75–78.

11. Lutz and Perdrizet, *Speculum humanae salvationis*, 1:78, lines 1–2.

12. From the enormous literature on the *Speculum*, I cite only Palmer, "'Turning Many to Righteousness,'" which reviews and revises the current state of thinking about the work's origins.

13. Osbourne, "'Particular Judgment'"; Baschet, "Jugment dernier"; Baschet, "Une image"; and Brilliant, "Envisaging the Particular Judgment."

14. For the medieval vocabulary of compilation and its connotations, see Hathaway, "Compilatio," and Minnis, "Late-Medieval Discussions."

15. Salzer, *Sinnbilder und Beiworte*, written prior to the publication of the *Analecta Hymnica*, remains a valuable source. See also Szövérffy, *Marianische Motivik*. The most useful study remains Meersseman, *Der Hymnos Akathistos*. For Latin and vernacular texts such as the "Advocationes b. Mariae," organized on similar principles, see Kornrumpf, "Zweiundziebzig Namen Marias," with additional bibliography. Some relevant material can also be found in Barré, *Prières anciennes*.

16. Bernard of Clairvaux, *Opera*, vol. 4, 22, line 20–23, line 10. Richard of Saint-Laurent, *De laudibus beatae Mariae virginis*, in Albertus Magnus, *Opera omnia*, 36:7, incorporates precisely the same

passage: "Notandum etiam quod Eva triplicem guerrum fecerat super se; ad deum per superbiam; quia voluit esse ut deus sciens bonum, et malum Genesis 3. Iuxta se, ad proximum per avaritiam; infra se, ad carnem suam per gulam. Sed Maria Eva filia pacem fecit ad deum per humilitatem; ad proximum per charitatem; ad carnem per virginitatem. Et sic eisdem litteris, sed transversis de Eva factum est Ave. Ave enim Eva est retrograda. Item Beatus Bernardus super illud Lucae 1., etc."

17. For color symbolism in Hrabanus, see Perrin, *L'iconographie*, 23–24; Carmassi, "Purpurismum in martyrio," 1:255–59.

18. FBG, Memb. I 80, f. 54v: "In medio vero fructum arboris representationem coloribus distinctis fructum salutis videlicet Iherusalem Christum, de quo in Canticis scriptum est: Dilectus meus candidus et rubricundus electus ex milibus."

19. Hugh of Saint-Cher, *Opera Omnia*, vol. 3, 131v: "Candidus secundum divinam naturam, quia est candor lucis aeterne. Rubicundus secundum humanam naturam, quia matris sanguine coagulatus."

20. Bernard of Clairvaux, *Homiliae super "Missus est,"* 2.2.20; *Bernardi Opera*, ed. Leclercq and Rochais, 4:22.

21. Urfels-Capot, *Le sanctoral*, *16.1 (10th Sunday after "Deus omnium"); cf. *PL* 96:279–280. "Deus omnium" is the incipit or, in Dominican usage, the *officium* of the first Sunday after Trinity. Also in keeping with Dominican usage, the lectionary counts not from the Feast of the Trinity but rather from the octave.

22. Ildefonsus of Toledo [?], Sermon 12, *De sancta Maria*, *PL* 96:279D–280: "In hac figura ponitur Eva cum superbia et Virgo beata cum humilitate. In medio vero flos variis coloribus representans et vitium elationis per quod Eva Deo displicuit et virtutem humilitatis quam Deus in virgine beata prerecognovit sicut in Luca scriptum est: Respexit humilitatem ancille sue."

23. Urfels-Capot, *Le sanctoral*, *16 (10th Sunday after "Deus omnium").

24. Anselm of Canterbury, *Orationes*, 18.4–19.28.

25. Anselm of Canterbury, *Orationes*, 18.4–7: "Maria, tu illa magna Maria, tu illa maxima beatarum Mariarum, tu illa maxima feminarum. Te, domina magna et valde magna, te vult cor meum amare, te cupit os meum laudare, te desiderat venerari mens mea, te affectat exorare anima mea, quia tuitioni tue se commendat tota substantia mea." For the translation, see *Scholastic Miscellany*, ed. Fairweather, 201.

26. Anselm of Canterbury, *Orationes*, 20.59–21.74; Urfels-Capot, *Le sanctoral*, *25.2 (19th Sunday after "Deus omnium"). The passage selected by Berthold extends that chosen for the lesson by one

sentence, suggesting that Anselm's prayer, rather than the lectionary, served as the immediate source.

27. Anselm of Canterbury, *Meditations and Prayers*, prayer 7, lines 118–22.

28. Schiller, *Passion of Jesus Christ*, 109.

29. *PL* 95:1163.

30. Molsdorf, *Christliche Symbolik*, no. 855, and Zchomelidse, "Das Bild im Busch."

31. Dietmaring, "Die Bedeutung von Rechts," and Lurker, "Die Symbolbedeutung von Rechts."

32. *PL* 39:2110; cf. Urfels-Capot, *Le sanctoral*, *1.2–S1 (after the octave of Epiphany). The lectionary cannot have served as the immediate source, as the passage quoted is both longer and adheres to the wording of the original source.

33. Molsdorf, *Christliche Symbolik*, no. 856.

34. Ps. Augustine, Sermo CXCV, *De Annuntiatione Domini*, *PL* 39:2107–10, here 2110.

35. Urfels-Capot, *Le sanctoral*, section *1.2–S1 (after the octave of Epiphany).

36. Radler, *Die Schreinmadonna*; Rimmele, "Die Schreinmadonna"; Katz, "Mary in Motion"; Gertsman, "Pilgrim's Progress"; Pinkus, "Eye and the Womb"; and Gertsman, *Worlds Within*.

37. *PL* 39:2197–98

38. Salzer, *Sinnbilder und Beiworte*, 33–35.

39. Bernard of Clairvaux, *Opera*, vol. 4, 25, line 17–26, line 8.

40. Molsdorf, *Christliche Symbolik*, no. 857.

41. Anselm of Canterbury, *Orationes*, 19.32–54.

42. See Guldan, *Eva und Maria*, and Kingsley, *Bernward Gospels*, 20. See also Katz, "Behind Closed Doors."

43. *PL* 144:737–39.

44. See, e.g., Van Engen, "Theophilus," and Gearhart, *Theophilus*, 83–86.

45. Molsdorf, *Christliche Symbolik*, no. 854.

46. *PL* 144:739C: "Gabriel archangelus et Joannes evangelista, quorum alter dexterae Virginis, alter sinistrae custos deputatus est. Gabriel enim mentem, Joannes carnem pervigili sollicitudine servaverunt." The discussion here draws on that in Hamburger et al., *Liturgical Life*, 1:530–37.

47. For the Gradual D 12 in Düsseldorf, see Löer, *Gotische Buchmalerei*, and Hamburger et al., *Liturgical Life*, 189–207 and passim. For the relationship with Konrad von Soest, see *Krone und Schleier*, 350–53, cat. no. 233 (Stefan Kemperdick).

48. Châtillon, "L'héritage littéraire"; Omont, "Richard de St-Laurent"; Solignac, "Richard de Saint-Laurent"; and Roten, "Richardus von St. Laurentius."

49. Albertus Magnus, *Opera omnia*, 36:553 (Richard of St. Laurent, *De laudibus beatae mariae virginis libri XII*, 11.1.27): "Commendatur haec

civitas a custodibus murorum, id est, Angelis. Unde dicit ei totat Trinitas, Is. LXII, 6: Super muros tuos, Jerusalem, constitui custodes, id est, Angelos. Vel isti custodes Gabriel et Johannes. (Titulo de throno de duobus leonibus)."

50. Forsyth, *Throne of Wisdom*, and Gerhardt, "Die *tumba gygantis*."

51. Peter Damian, Sermo XLIV, *In navitate beatissimæ virginis Mariæ*, Paris 1853 (*PL* 144:736–40, here 739C): "Duo leones sunt Gabriel archangelus et Joannes evangelista, quorum alter dexterae Virginis, alter sinistrae custos deputatus est. Gabriel enim mentem, Joannes carnem pervigili sollicitudine servaverunt. Qui bene leones dicunter, propter rugitum altisonae vocis; duo enim verba nuntiaverunt orbi terrae qualia nec dicta sunt nec dicentur, et in quorum comparatione omnis muta debeant apparere. 'Ave Maria gratia plena, Dominus tecum,' ait archangelus. Audisne in hoc verbo incarnationem Dei, redemptionem hominum, renovationem mundi? 'In principio erat Verbum,' dixit Evangelista. Animadvertis hic Verbi divinitatem, Ecclesiae fidem, haereticorum silentium, locum quietis, secretum solitudinis, luminis arcanum, habitaculum pacis? Ob hanc fortassis causam vocavit Jacobum et Joannem Boanerges, id est, filios tonitrui." The passage is quoted by Ragusa, "*Terror Demonum*," 100. As noted by Ragusa, Richard of Saint Laurent, *De laudibus*, 10.2.17 (Albertus Magnus, *Opera omnia*, 36:468), provides an alternative explanation, identifying the two lions with the two St. Johns ("Duo leones isti Gabriel et Joannes Evangelista a dextris et a sinistris"). Ragusa, however, fails to note that elsewhere, in the passage discussed here, the same text provides an interpretation that accords with that found in Nicholas of Clairvaux. Cf. the *Libellus de corona virginis* [of uncertain authorship], *PL* 96:283–318, here 317B: "Duae manus thronum complectentes, duae vitae sunt, scilicet activa et contemplativa, quae in te cum catena charitatis conjunguntur. Duo leones sunt Gabriel archangelus et Joannes evangelista, quorum alter dexterae tuae, alter sinistrae casti deputati sunt. Leones dicuntur propter rugitum altisonae eructationis, quorum unus dicit: Ave, gratia plena, etc. Alius dicit: In principio erat Verbum," etc. A similar line of argument occurs in a work of uncertain authorship attributed to Hugh of St. Victor, *De Beatae Mariæ semper virginis præconiis*, *PL* 177:770–72, here 771D: "Hi sunt Gabriel et Johannes: quorum alter dextrae, alter sinistrae virginis est custos deputatus. Gabriel mentem; Ioannes carnem servavit. Et bene leones propter altissimae vocis rugitum: quorum unus, 'Ave, gratia plena.' Alter: 'In principio erat verbum,' clamando, talia orbi nuntiaverunt, ut de eorum operatione quidquid dicitur sit quasi mutum.

Nobis itaque virgo, cuius pulchritudinem sol et luna mirantur, subveni clamantibus: Revertere, revertere, Sunamitis." The various interpretations are combined in a sermon by Anthony of Padua for the 5th Sunday after Trinity; see Anthony of Padua, *Opera Omnia*, 238: "Duo leones, id est, Gabriel & Ioannes Evangelista, vel Joseph & Joannes, stabant hinc & inde juxta manus: Joseph juxta activam, & Ioannes juxta contemplativam."

52. Heinrich von Herford, *Chronicon*, 2:201: "Et tunc monasterium sororum ordinis predicatorum apud Sosatum, quod dicitur Paradysus, recipit [sc. Albertus Magnus] et fundari iubet, et sorores per se introducens, benedictione sua stabilivit." For further discussion, see Hamburger and Schlotheuber, "Books in Women's Hands."

53. Albertus Magnus, *Opera omnia*, 36:553 (Richard of St. Laurent, *De laudibus beatae mariae virginis libri XII*, 11.1.27): "Per istos custodes signantur Virginis virtutes. Prima custos sobrietas, cuius contrarium corrumpit virginitatem."

54. For the Psalter in Besançon, see Franzen-Blumer, "Zisterziensermystik," and Eggenberger, "Psalterium eines Cistercienser-Klosters."

55. See Ragusa, "*Terror demonum*," and Duys, "Reading Royal Allegories," 215–20. See also Krause and Stones, *Gautier de Coinci*.

56. Rademacher-Chorus, "Maria."

57. Ragusa, "*Terror demonum*."

58. Bede, *Opera homiletica*, lines 72–86.

59. Hrabanus Maurus, *In honorem*, I C, lines 16.1–26.

60. Molsdorf, *Christliche Symbolik*, no. 876; Watson, *Early Iconography*; Baert, *Aan de vruchten*; and Lepape, "Le végétal."

61. For Christian exegesis of the Temple veil, see Gurtner, "Veil of the Temple"; for its reflections in Christian art see Hamburger, "Body vs. Book," 118–23, and Kessler, "Sacred Light."

62. See Klepper, *Insight of Unbelievers*; Kaczynski, "Illustrations of Tabernacle"; Rosenau, "Architecture of Nicolaus de Lyra"; Shailor, "New Manuscript"; Cahn, "Notes on the Illustrations"; and Bromberg, "Context and Reception History."

63. See Cahn, "Architectural Draftsmanship"; Cahn, "Architecture and Exegesis"; Schröder, "Die Rekonstruktion"; and Prica, "'Figuram invenire.'" See also Meier, "Monastisches Gesellschaftsmodell."

64. Carmassi, "Purpurismum in martyrio."

65. "Florem vero Dominum Jesum, qui de cortice humanae naturae splendidissimus erupit, quia sine sorde peccatorum ex virginali utero natus processit; qui et in carnis suae castitate candorem lilii demonstravit, et in sanguine passionis rosae ruborem ostendit. Super illum ergo requiescit Spiritus Domini,

hoc est, aeterna habitatione permanebit, quia in eo habitat omnis plenitudo divinitatis corporaliter."

66. Bernard of Clairvaux, *Opera*, vol. 4, 26, line 10–27, line 17.

67. See Schedl, "FEMINA CIRCUMDABIT VIRUM.'"

68. See, e.g., Unterkircher, *Die Wiener Biblia Pauperum*, vol. 2 (facsimile), f. 1v, and vol. 3 (transcription), f. 1v.

69. Urfels-Capot, *Le sanctoral*, 35.1–2 (Annunciation Sunday); cf. *PL* 39:2107–8. The match between the reading provided by Berthold and the lesson's reworking of the pseudo-Augustinian sermon indicates that the lectionary served as his source. For further discussion of applications of this sermon, see Clayton, *Cult of the Virgin Mary*, 199–201.

70. Molsdorf, *Christliche Symbolik*, no. 858; Salzer, *Sinnbilder und Beiworte*, 26–28.

71. Ambrosius Autpertus, *Opera, Sermo in purificatione Sanctae Mariae*, chap. 3, lines 30–39. The same sermon serves as a source for three lessons for the feast in the Dominican lectionary; see Urfels-Capot, *Le sanctoral*, 27.1–3 (Purification of the Virgin).

72. Salzer, *Sinnbilder und Beiworte*, 7–8, 113n7.

73. Henry, *Eton Roundels*, 109, who lists other examples in stained glass and painting, 110n4.

74. *PL* 162:317C: "Per haec enim quatuor elementa, et quatuor virtutes principales significantur." For Bede's foundational exegesis in his *De Tabernaculo* and *De Templo*, see Holder, "New Treasures," and Morrison, "Bede's *de tabernaculo*."

75. See Hennig, "Vorauer Bücher Mosis," and Wells, *Vorau Moses*, 73–118.

76. *PL* 163:317C: "Unde doctor gentium beatus Paulus de arte scenofactoria vivebat. Tot enim cortinas texuerunt apostoli."

77. See Dronke, "Tradition and Innovation," 60–61, on the symbolism of tetrads.

78. Josephus, *Jewish Antiquities*, 5:403 (3.7.7).

79. Josephus, *Jewish Antiquities*, 5:405 (3.7.7).

80. Bernard of Clairvaux, *Opera*, vol. 7, 390, lines 15–20.

81. Gay-Canton, *Entre dévotion*.

82. John of Damascus, *De fide orthodoxa*, 320–21 (section 1157, chap. 87, lines 36–64); cf. Urfels-Capot, *Le sanctoral*, 116.3b (Nativity of the Virgin). Berthold's commentary draws on the same source as two of the lessons for the feast in the Dominican lectionary.

83. *PL* 144:740; some of the added words recur in Hugh of St. Victor, *Tractatum moralia fragmentum* (*PL* 177:771), which derives in part from the original.

84. Hugh of St. Victor [?], *De Beatae Mariæ sem-* per virginis præconiis (*PL* 177:770–72). See further Marci, "La Legenda di Teofilo"; Jackson, "Influence of the Theophilus Legend"; and Root, *Theophilus Legend*.

85. Salzer, *Sinnbilder und Beiworte*, 32–33.

86. Burger, *"Mulier Amicta Sole"*; Vetter, "Mulier amicta sole"; and Vetter, "Virgo in sole."

87. Molsdorf, *Christliche Symbolik*, no. 866.

88. See Ohly, *Hohelied-Studien*; Reidlinger, *Die Makellosigkeit*; Matter, *Voice of My Beloved*, 151–77; and Fulton, "Mimetic Devotion."

89. Bernard of Clairvaux, *Opera*, vol. 4, 34, line 15–35, line 13. Richard of Saint-Laurent cites precisely the same passage in bk. 1, chap.1; see Albertus Magnus, *Opera omnia*, 36:8.

90. Calabuig, *"Stella maris"*; and Lausberg, *Der Hymnus*.

91. Molsdorf, *Christliche Symbolik*, no. 868.

92. Henry, *Eton Roundels*, 109.

93. Anselm of Canterbury, *Orationes*, 21.82–91; Urfels-Capot, *Le sanctoral*, *25.3 (19th Sunday after "Deus omnium"). The fact that the reading here is longer than the lesson indicates that Berthold drew directly on Anselm rather than relying on the lesson as an intermediary source.

94. Molsdorf, *Christliche Symbolik*, nos. 951, 975, 977.

95. Ambrose, *De virginibus*; cf. Urfels-Capot, *Le sanctoral*, 119.1–3 (Nativity of the Virgin). In this case also, Berthold consulted the source of the lectionary, not the lectionary itself.

96. Bernard of Clairvaux, *Opera*, vol. 4, 29, line 12–33, line 22.

97. Urfels-Capot, *Le sanctoral*, 35.8–9 (Annunciation Sunday); cf. Bede, *Opera homiletica*, bk. 1, homily 3, lines 10–26.

98. Bernard of Clairvaux, *Opera*, vol. 5, 260, line 12–261, line 11.

99. Lutz and Perdrizet, *Speculum humanae salvationis*, vol. 2, pl. 14.

100. Paschasius Radbertus, *De partu Virginis*, lines 213–64; cf. Urfels-Capot, *Le sanctoral*, 116.6 (Nativity of the Virgin). Berthold draws directly on the lectionary's source rather than on the lectionary itself.

101. John of Damascus, *De fide orthodoxa*, 170–73 (sections 984–85, chap. 46, lines 4–46).

102. Deshman, "Another Look."

103. Ambrose, *Expositio*, lines 311–40. Ambrosius's commentary on Luke served as a source for lessons in the Dominican lectionary; see Urfels-Capot, *Le sanctoral*, 68.7–9 (Peter and Paul); 137.8 (Luke).

104. Bede, *Opera homiletica*, bk.1, homily 4, lines 145–61. Bede's homilies on Luke also served as a source for the Dominican lectionary; see Urfels-Capot, *Le sanctoral*, 35.7b–9 (Annunciation).

105. Wirth, *Pictor in carmine*, 3.1–2.

106. *PL* 175:416–18.

107. *PL* 175:424.

108. *PL* 191:208–9.

109. *PL* 79:507.

110. Urfels-Capot, *Le sanctoral*, *16.2 (10th Sunday after "Deus omnium"); cf. *PL* 96:280.

111. Wirth, *Pictor in carmine*, 1.2.

112. Urfels-Capot, *Le sanctoral*, *2.3B (2nd Sunday after the octave of Epiphany); cf. *PL* 39:1655–66. To count from the octave of the feast rather than from the feast itself is a distinctively Dominican custom.

113. Meiss, "Light as Form."

114. Urfels-Capot, *Le sanctoral*, *32.2 (26th Sunday after "Deus omnium"); cf. *PL* 101:1307.

115. Salzer, *Sinnbilder und Beiworte*, 132.

116. Urfels-Capot, *Le sanctoral*, 27.2–3 (Purification of Virgin); cf. Ambrosius Autpertus, *Opera*, chap. 3, lines 43–57.

117. Urfels-Capot, *Le sanctoral*, *17.2–3 (11th Sunday after "Deus omnium"); cf. *PL* 57:866.

118. Bernard of Clairvaux, *Opera*, vol. 4, 277, line 11–278, line 22.

119. Augustine of Hippo, *Opera Omnia*, 404–5. The ps.-Augustinian corpus of sermons is among the sources most heavily drawn upon by the Dominican lectionary.

120. Wirth, *Pictor in carmine*, 14.3.

121. Bernard of Clairvaux, *Opera*, vol. 4, 342, line 15.

122. The Dominican lectionary draws on Ps. Chrysostomos, *Opus imperfectum in Matheum*, the text which Berthold identifies as his source; see Urfels-Capot, *Le sanctoral*, 14.1 (John), 16.1–3 (Holy Innocents), 128.1, 6a (Matthew), yet that work does not include the passage provided here. The source, rather, is another authentic work (in translation), Chrysostomus, *In Matthaeum homiliae Aniano interprete: Homilae I–XXV*, accessed September 5, 2018, http://web.wlu.ca/history/cnighman/ ChrysostomHomiliaeInMattheumAnianoInter- prete1503.pdf. Berthold's commentary consists of two passages, quoted in reverse sequence, suggesting that there probably was an intermediary source, most likely a set of lessons. For the passages in question, see also Paris, BnF, ms. lat. 1776, ff. 52r–52v. Digitization accessed March 29, 2016, http://gallica.bnf.fr/ ark:/12148/btv1b90764860/f1.item.

123. *Biblia latina cum glossa ordinaria*, 4:148–49. The Dominican lectionary draws on the *Glossa ordinaria*, without, however, employing the passage used here; see Urfels-Capot, *Le sanctoral*, 137.9 (Luke).

124. Urfels-Capot, *Le sanctoral*, *14.3 (8th Sunday after "Deus omnium"); cf. Bernard of Clairvaux, *Opera*, vol. 4, 315, lines 10–16.

125. Urfels-Capot, *Le sanctoral*, *32.1 (26th Sunday after "Deus omnium"); cf. *PL* 101:1306.

126. Urfels-Capot, *Le sanctoral*, *11.1–3 (5th Sunday after "Deus omnium"); cf. Bernard of Clairvaux, *Opera*, vol. 5, 262, line 12–263, line 21.

127. Urfels-Capot, *Le sanctoral*, *13.1–2 (7th Sunday after "Deus omnium"); cf. Bernard of Clairvaux, *Opera*, vol. 5, 249, lines 17–250, line 4.

128. Paschasius Radbertus, *De partu virginis*, lines 880–88, 872–74 (the second part of the passage precedes the first). The Dominican lectionary draws on this text, but not the passage employed here; see Urfels-Capot, *Le sanctoral*, 99.1–3 (Assumption), 100.1–3 (2nd feast of Assumption within the octave), 101.1–3 (3rd feast of the Assumption within the octave), etc.

129. Bernard of Clairvaux, *Opera*, vol. 4, 49, lines 7–20. The Dominican lectionary makes use of this widely disseminated set of sermons by Bernard; see Urfels-Capot, *Le sanctoral*, 118.1 (Nativity of Virgin).

130. Molsdorf, *Christliche Symbolik*, no. 935.

131. Bernard of Clairvaux, *Opera*, vol. 4, 36, lines 4–24.

132. Bernard of Clairvaux, *Opera*, vol. 4, 20, lines 16-23; cf. Urfels-Capot, *15.1–2 (9th Sunday after "Deus omnium"). Berthold draws on Bernard directly, not the abbreviated version in the lectionary.

133. Berthold of Clairvaux, *Opera*, vol. 4, 23, lines 24–25, line 12.

134. Bernard of Clairvaux, *Opera*, vol. 5, 236, lines 23–37.

135. Górecka, *Das Bild Mariens*, 566–72.

136. Anselm of Canterbury, *Orationes*, 7-8, lines 40-45.

137. Molsdorf, *Christliche Symbolik*, nos. 384, 419.

138. Molsdorf, *Christliche Symbolik*, nos. 384, 419.

139. Molsdorf, *Christliche Symbolik*, nos. 464, 474.

140. John of Damascus, *De fide orthodoxa*, 325, lines 124–31.

141. Molsdorf, *Christliche Symbolik*, no. 525.

142. Although scripture makes it clear that these words refer to the face and garments of the angel. The passage sometimes served as the basis for colorful depictions of the angel in representations of the Resurrection; see Petzold, "'His Face Like Lightning.'"

143. Bidon, *Le pressoir mystique*; Thomas, *Die Darstellung Christi*; and Hansbauer, "Christus in der Kelter."

144. Urfels-Capot, *Le sanctoral*, 99.2–3 (Assumption); cf. Paschasius Radbertus, *De Assumptione*, 83,

lines 691–95; 82, lines 689–90; 83–84, lines 696–709; and 85, lines 715–17.

145. *PL* 144:717–18.

146. Can 005407: "Vidi speciosam sicut columbam, ascendentem desuper rivos aquarum: cujus inaestimabilis odor erat nimis in vestimentis ejus: Et sicut dies verni circumdabant eam flores rosarum et lilia convallium."

147. Molsdorf, *Christliche Symbolik*, no. 974.

148. Urfels-Capot, *Le sanctoral*, 98.5–6 (Assumption, lessons 4–6); cf. Paschasius Radbertus, *De partu Virginis*, 118–25, lines 182–89, 308–16, 340–45, and 352–53.

149. Bernard of Clairvaux, *Opera*, vol. 5, 266, line 9–274, line 11; cf. Urfels-Capot, *Le sanctoral*, 102.2–3 (Assumption). Although Berthold's excerpts are closely related to those found in the lectionary, the wording indicates that he must have consulted the original.

150. Molsdorf, *Christliche Symbolik*, no. 977.

151. Molsdorf, *Christliche Symbolik*, no. 978.

152. *PL* 96:272; Urfels-Capot, *Le sanctoral*, *18:2–3 (12th Sunday after "Deus omnium").

153. Urfels-Capot, *Le sanctoral*, 14.1 (8th Sunday after "Deus omnium"); cf. Bernard of Clairvaux, *Opera*, vol. 5, 167, lines 22–168, line 8.

154. Hamburger, *Rothschild Canticles*, 94–96.

155. Berthold may have taken his cue from Richard de Saint-Laurent, who uses the same passage in the first of his two prologues to his *De laudibus sanctae Mariae virginis*; see Albertus Magnus, *Opera omnia*, 36:1: "Licet autem non ignoraverim Beatam Virginem exaltari, accendente homine ad cor altum; complacuit tamen de eius laudibus saltem modicum quid elucidare ad praesens, urgente me charitate eius, et magnitudine promissorum. Qui elucidant me, inquit, vitam aeternam habebunt."

156. Richards, "Marian Devotion," 189–91, provides a useful list of the major Marian works of the High Middle Ages.

157. For a relatively recent introduction to the topic, see Daly, *Companion to Emblem Studies*. Other authors have compared certain medieval images to modern emblems; see, e.g., Holtgen, "Arbor, Scala und Fons vitae."

158. See p. 161.

159. Bataillon et al., *Hugues de Saint-Cher*.

160. The description borrows in part from that in the entry on the manuscript in the exhibition catalogue Hamburger et al., *Beyond Words*, cat. no. 135, 172 (Jeffrey F. Hamburger and Alison Stones). See also Stones, *Gothic Manuscripts*, vol. 1, bk. 2, cat. no. I-39, 81–82, and Lilian Armstrong's entry, cat. no. 2 in Katz and Orsi, *Divine Mirrors*, 153–55, where the author mistakenly is said to have lived in the twelfth century.

161. For a more comprehensive summary, see Fulton, *Mary and the Art of Prayer*, esp. 247–308.

162. For celestial imagery applied to the Virgin, with particular emphasis on the thirteenth century, see also Hinkle, "Cosmic and Terrestrial Cycles," who argues that in the sculpture on the west façade of Notre-Dame in Paris, the months corresponding to the four seasons are correlated with the four major feasts of the Virgin. See also Hübner, *Zodiacus Christianus*, 197. For a related German text, with illustrations of subjects from the Old and New Testament tied to images of the zodiac and the labors of the months, see Palmer, "Nativitätsprognostik."

163. See Fulton, "Virgin in the Garden."

164. Albertus Magnus, *Opera omnia*, 36:2: ". . . studiosa sedulitas ad favos conficiendos undecumque potest, colligit mel et ceram."

165. On the *sermo modernus*, see Mulchahey, *"First the Bow,"* 401–19, and for Dominican Marian sermons in the thirteenth century, Gaffuri, "La predicazione domenicana." For Jacobus's *Tractatus de arte praedicandi*, see Wenzel, *Art of Preaching*, 3–97. See also Dieter, "*Arbor picta*"; Berns, "Baumsprache und Sprachbaum"; Bolzoni, *Web of Images*, 83–114; and Wedell, "Zachäus auf dem Palmbaum."

166. In their relative brevity, departing from a biblical verse, and in combining scripture with a patristic passage, Berthold's practice also loosely resembles that found in collections of *collationes*, brief talks held before the evening meal. For the genre, see Fra Nicola da Milano, *Collationes*, 23–24.

167. Hamburger, "Seeing and Believing."

168. *PL* 202:725A (sermon 28): "O Maria, ecce unguentum exinanitum omnia vasa tua implevit; ecce dolia tua plena sunt vino meracissimo; ecce scrinia tua referta sunt vestibus valde bonis, ecce in arca tua est panis vivus qui de coelo descendit; ecce lectulus tuus floridus; ecce domus tuae ligna cedrina, laquearia cypressina; columnae portantes quatuor parietes, prudentia, fortitudo, justitia, temperantia: ecce sedes sapientiae parata, quae docet facienda et non facienda."

169. Richards, "Marian Devotion."

170. Cf. *Lateinische Sequenzen*, 205 (no. 266, stanzas 7–8): "Sicut vitrum radio / Solis penetratur, / Inde tamen laesio Nulla vitro datur: / Sic, immo subtilius, / Matre non corrupta, / Deus Dei filius / Sua prodit nupta."

171. *Lateinische Sequenzen*, 209 (no. 273): "Orbis totus gratuletur, / Christianus praelaetetur, / Signum sacrum ammiretur, / Quo creator collaudetur. // Archa Noë fabricatur, / Per quam mundus liberatur, / Thronus regi praeparatur, / Ubi . . . impetratur. // Virga Iesse gignit florem, / Apis mellis dat dulcorem, / Coelum stillat nobis rorem, / Stella Iacob fert

splendorem. // Haec est Hester imperatrix, / Sara risus generatrix, / Thecuites advocatrix, / Iudith hostis triumphatrix. // Paradisus voluptatis / Est Maria, praestans gratis / Signum immortalitatis / Ad fontem iocundatis. // Paradisum hunc quaeramus / Cibum vitae glutiamus / Aquas dulces hauriamus, / Ut feliciter vivamus."

172. For a comparison of a Marian panel to a painted hymn, see Suckale, "Die Glatzer Madonnentafel."

173. See Fassler, *Gothic Song*, and Grosfillier, *Les séquences*, 415–20, 708–11. For Dominican sequences, see Fassler, "Music and the Miraculous," and Hamburger et al., *Liturgical Life*, 211–81.

Chapter 5

1. For the longue durée, see the essays in Koetsier and Bergmans, *Mathematics and the Divine*, esp. Mueller, "Mathematics and the Divine in Plato," 99–121, which deals with both the Timaeus and the Republic, and O'Meara, "Geometry and the Divine in Proclus," 133–45.

2. Saffrey, "ΑΓΕῶΜΕΤΡῆΤΟΣ Μ DEIS EISITῶ."

3. As argued by Krämer, "Is There a Diagrammatic Impulse with Plato?" See also Krämer, "Gedanken sichtbar machen." Cf. the characterization of Ljungberg, *Creative Dynamics*, 5: "Diagrams are spatial embodiments of knowledge with a peculiar potential to stimulate new cognitive engagements. This lies in their capacity to abstract and to generalize, which makes them ideal not only for activities such as solving problems, hypothesizing or just tracing imaginary journeys on a map—or in the mind."

4. Patterson, "Diagrams," 26, on the "distinctively Platonic concern having to do with certain mistaken assumptions fostered by the habitual practice (hexis) of thinking imagistically about purely intelligible objects that have no literally visualizable properties."

5. Plato, *Meno*.

6. For the expression of this system in the visual arts, see Bagnoli, "Le fonti e I documenti"; Bagnoli, "Syzygy al Anagni." See also Vossen, "Über die Elementen-Syzygien," and Caiazzo, "Harmonie et mathématique."

7. Somfai, "Eleventh-Century Shift," 16–18: "These diagrammatic *variae lectiones*, which have been completely ignored in modern editions and in the scholarly literature, are an invaluable aid to understanding how the *Commentary* was interpreted. They reveal a grasp of concepts which cannot be found in the textual glosses. . . . The musical and astronomical diagrams, in particular, were closely studied and evolved into complicated visual interpretations." See also Somfai, "Calcidius' 'Commentary.'" and Huglo, "L'étude des diagrammes."

8. Augustine of Hippo, *De ordine*, 104–7: "Hinc est profecta in oculorum opes et terram coelumque collustrans, sensit nihil aliud quam pulchritudinem sibi placere, et in pulchritudine figuras, in figuris dimensiones, in dimensionibus numeros; quaesivitque ipsa secum utrum ibi talis linea talisque rotunditas vel quaelibet alia forma et figura esset, qualem intellegentia contineret. Longe deteriorem invenit et nulla ex parte quod viderent oculi cum eo quod mens cerneret comparandum. Haec quoque distincta et disposita in disciplinam redegit appellavitque *geometriam*."

9. Hamburger, "Speculations on Speculation."

10. The formulation is that of Krämer, "Is There a Diagrammatic Impulse with Plato?," 175.

11. Imbach, "Le Néo-Platonisme"; and Sturlese, "Tauler im Kontext."

12. For the *Excerptum de quattuor elementis*, see Obrist, *La cosmologie médiévale*, 1:284–89.

13. Nicholas of Cusa, *De ludo globi*; for commentary, see Gandillac, "Symbolismes ludiques"; Senger, *Ludus sapientiae*; and Albertson, "Mapping the Space of God."

14. In addition to Mahnke, *Unendliche Sphäre*, see Harries, "Infinite Sphere."

15. See Körfer, "*Lector ludens*."

16. See Iacobus Nicholai de Dacia, *Liber*, 154–55; Kabell, "Nachträgliches"; Ernst, *Carmen figuratum*, 717–20; and Ernst, *Visuelle Poesie*, 347–69. For a northern French illuminated copy (MS M.108, P. Morgan Library and Museum, New York) of the treatise on board games, including chess and merrils, and contemporary with Berthold of Nuremberg, known as the *Bonus socius*, see Stones, *Gothic Manuscripts*, vol. 1, bk. 2, cat. III-118, 515–16.

17. So that, e.g., the final strophe reads: "MonstruM MendosuM MunduM Maculat spaciosuM; MeumbruM MorborsuM, MiseruM! Michi quid? modo prosuM!"

18. See Smith and Eaton. "Rithmomachia"; Borst, *Das mittelalterliche Zahlenkampfspiel*; Folkerts, "La rithmomachie"; Folkerts, "'Rithmomachia'"; Moyer, *Philosophers' Game*; and Stigter, "Rithmomachia," with additional bibliography. See also Guillaumin, "Boethius's *De institutione arithmetica*," 159–60. For diagrammatic principles in and applied to another game, see Bogen, "Das Diagramm als Spiel," translated into English as "The Diagram as Board Game."

19. For Hermannus, see Folkerts, "Hermanns Schrift."

20. Evans, "Rithmomachia."

21. Moyer, *Philosophers' Game*, 25–28.

22. More, *Utopia*, 46.

23. Folkerts, "La rithmomachie." For a complete digitization of the manuscript, see http://bvmm.

irht.cnrs.fr/sommaire/sommaire.php?reproduction-Id=5632 (accessed June 15, 2017). Another such diagram, dating to the thirteenth century, can be found in MS Auct. F.5.28, f. 16r, Bodleian Library, Oxford, accompanying a short text (ff. 15v–16r) which opens "Ex numeris sese respicientibus proportione . . ." For a full description of the manuscript, which contains numerous other diagrams, see https://ptolemaeus.badw.de/ms/398 (accessed December 25, 2018).

24. For a description of the manuscript's contents, see in addition to *Science antique*, David Juste, "MS Avranches, Bibliothèque Municipale, 235," *Ptolemaeus Arabus et Latinus. Manuscripts*, http://ptolemaeus.badw.de/ms/285 (updated January 4, 2017).

25. Cf. Carruthers, *Book of Memory*, 150: "The use of 'imagines rerum' as 'sites' for memorial composition ('compositio') is therefore a kind of 'remembering.' This also helps to explain the curious nature of a medieval diagram; rarely is it a diagram *of something*, as ours are. Rather, it requires one to stay and ponder, to fill in missing connections, to add to the material which it presents. It is a meditational artifact, an 'imago rerum,' and not primarily informational in its usefulness."

26. Martianus Capella, *Marriage of Philology and Mercury*, 217–18 (section 579).

27. Macrobius, *Commentarii*, 1.21.3: "Et quia facilior ad intellectum per oculos via est, id quod sermo descriptsit visus adsignet." For the translation, see Macrobius, *Dream*, 175. For further discussion, see Obrist, *La cosmologie médiévale*, 172–90; Eastwood and Graßhoff, *Planetary Diagrams*; and Eastwood, *Ordering the Heavens*, 31–94.

28. Macrobius, *Dream*, 176.

29. For Adalbold, see Silk, "Pseudo-Johannes Scottus," 24–25: "Quod ut facilius et alia omnia innotescant quaecumque supra dicta sunt, in subiecta descriptione monstrabitur;" also Huygens, "Mittelalterliche Kommentare," 417, lines 212–13. See more generally Courcelle, "Étude critique," and Courcelle, *La Consolation de Philosophie*, 297–99. On syzygy diagrams in the visual arts, see Bagnoli, "Syzygy at Anagni." The passage in Adalbold is discussed by Curschmann, "Epistemological Perspectives," fig. 1, revised in Curschmann, *Wort–Bild–Text*, 1:21–67.

30. See Verboon, "Medieval Tree." For the translation, see Boethius, *Consolation of Philosophy*, 46–47.

31. William of Conches, *Dragmaticon*, 166 (5.9.5): "Sed quia facilius animo colloguntur quae oculis subiciuntur, id quod diximus in visibili figura depingamus." For the translation, see William of Conches, *A Dialogue on Natural Philosophy*, trans. Ronca and Curr (1997), 110. See also van Run, "'Quia facilior.'"

32. Aristotle, *De Anima* 3.7. For Aquinas, see *Sentencia de sensu*, tr. 21. 2 n. 4: "nihil potest homo intelligere sine phantasmate."

33. Aristotle, *On Memory*, 48, which provides a clear, concise discussion of Aristotle's views on the subject (5–7).

34. Specifically, Aristotle argues that an object of thought is like a diagram in that it is not dependent on a specific size, even though in placing something before one's eyes or in drawing a diagram, it acquires one. For further discussion, see Schofield, "Aristotle on the Imagination."

35. Plato, *Complete Works*, 1244d.

36. Cited by Gill, "Role of Images," 122. See *PL* 176:997–1010, unfortunately a corrupt version of the text; also Bultot, "Konrad von Hirsau," and Fingernagel, "'De fructibus carnis.'"

37. See Shimojima, "Operational Constraints," further elaborated in Shimojima, *Semantic Properties*. See also Wöpking, "Space, Structure, and Similarity."

38. Nelsen, *Proofs without Words*, vi. Nelson, however, adds that "Of course, 'proofs without words' are not really proofs." My thanks to Stuart Schieber for bringing this publication to my attention.

39. Charles S. Peirce, Manuscripts on Existential Graphs, Houghton Library, Harvard University, MS Am 1632 (787). Peirce precedes this remark by observing: "Particularly deserving of notice are icons in which the likeness is aided by conventional rules. Thus, an algebraic formula is an icon, rendered such by the rules of commutation, association, and distribution of the symbols. It may seem at first glance that it is an arbitrary classification to call an algebraic expression an icon; that it might as well, or better, be regarded as a compound conventional sign. But it is not so." The context is important in so far as the following sentence, quoted here, has been invoked by Horst Bredekamp in support of his picture act theory; see Bredekamp, "Picture Act," 14, where it is said to define "the very essence of picture act theory." Bredekamp takes aim at the critique of his theory as a variant of animism by stating: "This kind of critique is grounded neither in essential philosophical traditions nor evolutionary theory. Its vain but understandable vehemence stems from a painful inability to overcome a constructivist conceptualization of subjectivity and its world-defining telos" (5). Important to note are (i) that Peirce acknowledges, rather than rejects, the contributing role of conventions; (ii) that he is speaking of algebraic symbols, not pictures per se; and (iii) that Peirce's focus is on the reliability of reason, not on what Bredekamp defines as the "energeia" of an object or picture "that approaches human beings independently, and

ultimately liberates them from the ego-logics of constructivism, representationalism, and neurocentrism, and the rivalry between image and language as well as that between the visual and the tactile" (32). This said, one does not have to concur with Bredekamp's attribution of an Ego to artifacts to find much of value in his theory. On the passage in question, see also Paolucci, "Semiotics, Schemata, Diagrams, and Graphs," and Alexander Gerner, "Diagrammatic Thinking," in *Atlas of Transformation*, accessed July 12, 2017, http://monumenttotransformation. org/atlas-of-transformation/html/d/diagrammatic-thinking/diagrammatic-thinking-alexander-gerner. html: "Diagrammatic thinking therefore first makes the principle of diagrammatic reasoning accessible by introducing new elements through iconicity and through the operations of 'hypostatic abstraction' and theoretical abstraction. One has to be careful not to adopt a trivial similarity definition when speaking about diagrams as part of iconicity. From a non-trivial standpoint similarity cannot be equated with 'identity' with the object, nor can similarity be psychologized to refer to merely subjective judgments or feelings of resemblance."

40. Carruthers, *Book of Memory*, 250–55.

41. Darlington, "Gerbert, the Teacher," esp. 472 on epistle 92, and Cavicchi, "Reflections on the Teaching."

42. Gerbert of Aurillac, *Correspondance*, 219–20 (letter 92): ". . . quod interdum nobilissimis scolastis disciplinarum liberalium suaves fructus ad vescendum offero. Quorum ob amorem etiam exacto autumno quandam figuram edidi artis rethoricase, dispositam in VI et XX membranis sibi invicem conexis et concatenatis in modum antelongioris numeri, qui fit ex bis XIII. Opus sane expertibus mirabile, studiosis utile, ad res rethorum fugaces et caliginosissimas comprehendendas atque in animo collocandus." Translation from Darlington, "Gerbert, the Teacher," 472. Gerbert also wrote pattern poems; see Brockett, "Frontispiece of Paris."

43. See also Gábor, "Diagrammatic Design," 623.

44. Joachim of Fiore, *Liber de Concordia*, 413 (bk. 4, chap. 37, lines 111–12): "tamdiu enim ostenduntur figure quamdiu veritas figurarum consummata non est. Ubi autem incipit consumari quod prenuntiaverunt figure, oportet ex toto evacuari figuras." Reeves and Hirsch-Reich, *"Figurae" of Joachim of Fiore*, 20–22, cite a number of relevant passages in Joachim's writings, as does Obrist, "Le système pictural." See also McGinn, "Image as Insight."

45. Other diagrams in the same manuscript represent the climate zones of the earth, the movement of the sun relative to the earth, the four elements (syzygy), and the diatessaron and diapente. Montague Rhodes James's description of the manuscript, together with images of the diagrams, can be found at http://www.joh.cam.ac.uk/library/special_collections/manuscripts/medieval_manuscripts/medman/E_4.htm.

46. For the Shield of Faith, see Evans, "Illustrated Fragment," Šmahel, "Das 'Scutum fidei,' " and Pavlíek, "*Scutum fidei christianae*."

47. See Tolan, *Petrus Alfonsi*, 36–39, esp. 38; also Resnick, "Priestly Raising of the Hands."

48. Obrist, "Le système pictural," 220–21.

49. Obrist, "La figure geómetrique." See also Devriendt, "Du triangle au Psaltérion."

50. Obrist, "La figure geómetrique," 311–12, compiles examples of such sentiments.

51. For logic as it was practiced in Berthold's day, see Ebbesen, "What Counted as Logic."

52. See Uckelman, "Logic and the Condemnations of 1277," who, however, argues that the impact of the Condemnations has been greatly exaggerated.

53. For the "mania" for mathematics in fourteenth-century theology, see Murdoch, "From Social into Intellectual Factors"; also Murdoch, "*Mathesis in philosophiam*." Citing Murdoch, Olson, "Measuring the Immeasurable," 414–15, observes:

> The calculators and the people they influenced applied various "measure languages" (analytical terminology used to discuss such subjects as proportion, infinity and continuity, and local motion) not only to problems in logic and natural science, but also to philosophical and theological questions. For example, the mathematical distinction between the infinite and the finite was applied to the theological issue of distinguishing the love due God from that due one's fellow creatures, and as a means of demonstrating how there could be variation within species and yet incommensurability between species. The language of intension and remission of forms (acceleration/deceleration, or increase/decrease in qualities such as heat) was used to analyze questions of the movement of the will. Euclid was important to anyone thinking along such lines. The clarity and explicitness of the Elements in its structure and its proofs made it the quintessential model for mathematical/scientific thinking and the presentation of demonstrative arguments.

In Dominican theology, Albertus Magnus plays an important role in this respect, although, as an Aristotelian, Albert does not attribute any underlying reality to geometric forms; see Molland, "Mathematics in the Thought."

54. Baladier, "Intensio de la charité."

55. Tummers, "Geometry and Theology," 112–14.

56. Tummers, "Geometry and Theology," 116–18.

57. For the earlier period, see Kühnel, *End of Time*; Ramírez-Weaver, *Saving Science*; and Anderson, *Cosmos and Community*. For the High Middle Ages, see Müller, *Visuelle Weltaneignung*, and Obrist and Caiazzo, *Guillaume de Conches*.

58. Meier, "Die Quadratur des Kreises," 47–48, 52.

59. Translation from http://www.newadvent.org/summa/1001.htm#article9 (accessed May 7, 2017).

60. Hamburger, "Speculations on Speculation."

61. See Latour, "Visualisation and Cognition." For studies of modern diagrams that make use of Latour's concept, see, e.g., Klein, *Experiments, Models, Paper Tools*; Bigg, "Diagrams"; and Kaiser, *Drawing Theories Apart*.

62. Giardino, "Space and Action," 41. For the origin of the concept of "extended mind," see Clark and Chalmers, "Extended Mind," who cite diagrams as an example of the phenomenon: "In all these cases the individual brain performs some operations, while others are delegated to manipulations of external media" (8).

63. For Cusanus's use of diagrams, in particular, his *figura paradigmatica*, see Miller, *Reading Cusanus*, 78–80, and Schneider, "Logik und Sinnspiel." For another outstanding figure in this context, who helped shaped Cusanus's fusion of geometry and theology, see Hamann, *Das Siegel der Ewigkeit*, and Geos, "Das 'Siegel der Ewigkeit.'" See also Albertson, "Beauty of the Trinity." For the early modern period, see Berger, *Art of Philosophy*.

64. Joachim of Fiore, *Tractatus*, 18: "ut intelligamus esse quemdam viventem ordinem in operibus divinis, per quem possint multa comprehendi in temporibus suis."

65. See Müller, "Gott ist (k)eine Sphäre," 353.

66. Kemp, "Substanz wird Form," 219: "Spezifisch ist der christlichen Kunst ein Beziehungssinn, nicht ein Hintersinn." Kemp, *Christliche Kunst*, identifies three modes in medieval art (one narrative, another non-narrative or, in his words, thematic, and a third involving the systematic, figurative ordering of the image-system), characterizes medieval images as "Kosmogramms" (73), and, using loaded language, speaks of "der Wille zur Struktur" in medieval art. See also Caviness, "Images of Divine Order." Messerer, "Einige Darstellungsprinzipien," represents an early, if often overlooked, contribution to the discussion.

67. See von Euw, "Die künstlerische Gestaltung"; and Eastwood and Graßhoff, "Planetary Diagrams."

68. Kühnel, "Carolingian Diagrams," 375. See more generally Meier, "Malerei des Unsichtbaren," and Garipzanov, "Rise of Graphicacy."

69. See, e.g., Kessler, "Medietas / Mediator," 39–55.

70. See Kessler, "Images of Christ." See also Kemp, "Visual Narratives," and Kemp, "Substanz wird Form."

71. In his review of Baltrušaitis, *La stylistique ornementale*, which originally appeared as "Über den Schematismus in der romanischen Kunst," *Kritische Berichte zur kunstgeschichtlichen Literatur* 1 (1932–33): 1–21, later published in English as "On Geometrical Schematicism in Romanesque Art," in *Romanesque Art* (New York: Braziller, 1977), 265–84. See also Baltrušaitis, "La géométrie."

72. A number of Baltrušaitis's early publications evince a strong interest in diagrams; see Baltrušaitis, "L'image du monde céleste," and Baltrušaitis, "Roses des vents."

73. See Schapiro, "On the Aesthetic Attitude." See also Berliner, "Freedom of Medieval Art."

74. Schapiro, "On Some Problems," 11–12. For this debate, see Hearn, *Romanesque Sculpture*, 14–15; Camille, "'New York'"; Cahn, "Focillon's Jongleur"; Cahn, "Schapiro and Focillon"; and Linda Seidel's introduction to Schapiro, *Romanesque Architectural Sculpture*, esp. xxx–xxxi.

75. For a similar understanding of frames in medieval art, see Pächt, *Rise of Pictorial Narrative*.

76. For a different view, which sees in such images expression of a "syntax, or underlying structure, for images of heavenly beings, of those that are spiritually enlightened, and of man's position in an ordered universe," see Caviness, "Images of Divine Order," 99, the abstract of which continues: "Schemata were adapted, by the addition of representational elements, to pictographs and figured diagrams, and they provided the hidden structure for fuller renderings of visionary subjects." Caviness, who associates the opposite phenomenon, disharmony, with representations of temporal imperfection, usefully points to these opposing tendencies as quasi-permanent characteristics of medieval art from the ninth to the fourteenth century, transcending the categories of style history within which its development is normally conceptualized.

77. Hrabanus Maurus, *De institution clericorum*, 234 (bk. 3, chap. 23): "Nunc ad geometricam veniamus, quae est descriptio contemplativa formarum, documentum etian visuale philosophorum."

78. Cassiodorus, *Institutiones*, 2:432 (2.6.1, lines 12–13): "provacti studiosi ad illa invisibilia cognoscenda *coeperunt.*"

79. Cassiodorus, *Institutiones*, 2:434 (2.6.1, line 16).

80. Hrabanus Maurus, *De institution clericorum*, 235 (bk. 3, chap. 23): "Haec igitur disciplina in tabernaculi templique aedificatione servata est, ubi linealis mensurae usus et circuli ac sphaerae atque

hemispherion, quadrangulae quoque formae et ceteram figuram dispositio habita est; quorum omnium notitia ad spiritualem intellectum non parum adiuvat tractatorem." On tabernacle, ark, and temple as physical manifestations of the divine, see Naredi-Rainer, *Salomos Tempel*; Kessler, "Through the Temple Veil"; Kessler, "*Arca arcanum*"; Kessler, "Sacred Light"; Eco, "Jerusalem", and Hamburger, "Body vs. Book."

81. Appleby, "Rudolf, Abbot Hrabanus, and the Ark," 432–42; Hahn, *Strange Beauty*, 241; and Raaijmakers, *Making of the Monastic Community*, 217–19.

82. Mathon, "Claudien Mamert."

83. Quoted in translation by Schanzer, "Augustine's Disciples," 82.

84. Hugh of St. Victor, *Commentatorium in Hierarchiam coelestem S. Dionisii Areopagitae secundum intepretationem Johannis Scoti*, 2.1 (*PL* 175:941).

85. Brittain, "No Place for a Platonist Soul," 251, who paraphrases Mamertus as follows: "The ability to cognize abstract geometrical figures presupposes that the mind itself is unextended."

86. McNamee, "Picturing as a Practice," 203.

87. Hamburger et al., *Beyond Words*, cat. no. 18, 34 (Lisa Fagin Davis). For a late Carolingian copy with a comparable, if less elaborate, apparatus, see Paris, BnF, ms. lat. 2279, ff. 41v–43r.

88. McNamee, "Picturing as a Practice," includes illustrations taken from commentaries on Macrobius.

89. Mamertus, *Opera*; translation from Cain, "Standing of the Soul," 245.

90. Mamertus's sequence closely matches Cassiodorus's "Principia geometriae disciplinae" given in *De artibus ac disciplinis liberalium litterarum*, *PL* 70:1105–1220, esp. 1214B, an expanded version of Cassiodorus, *Institutiones*, 2.6.

91. Cain, "Standing of the Soul," 249.

92. Thiofried of Echternach, *Flores Epytaphii*. See also Ferrari, "'Lemmata sanctorum'"; Ferrari, "Gold und Asche"; Roch, "L'odeur de la sainteté." For Guibert's tract, *PL* 156:607–80, see Guibert of Nogent, *Le reliquie dei santi*, and Platelle, "Guibert de Nogent."

93. Thiofried of Echternach, *Flores Epytaphii*, xix.

94. *In Hierarchiam celestem*, bk.7 (*PL* 175, col. 1054A): "Omnes sacras figurationes et sensibilia signa que vel in Veteri vel in novo Testamento, utpote tabernaculum federis, et arcam testamenti, et cetera huiusmodi que ad demonstrationem invisibilium Scriptura proponit . . . omnia scilicet sacra symbola contemplantur."

95. This despite having declared a preference in *Flores Epytaphii Sanctorum* for a literal over an allegorical reading: "Nam ut intellectum pretereamus allegoricum quare secundum litteram . . ."; see Thiofried of Echternach, *Flores Epytaphii*, 1.1, lines 26–27.

96. Thiofried of Echternach, *Flores Epytaphii*, 49, lines 606–66: "Et re uera omnes geometricae formae siue trigonae, siue tetragonae seu circulares que ob circumductionem unius lineae sunt diuinitati aptissimae ac omnium excellentissimae quibus decusantur sanctorum reliquiae testimonium perhibent eorum sanctimoniae ac magnificentiae, et ad uirtutum ornamenta et delectationes alliciunt pulchritudinem cuiusque felicis animae."

97. Obrist, "Image et prohétie," and Meier, "Malerei des Unsichtbaren," 40–56. Rudolph, *The Mystic Ark*, attempts an elaborate reconstruction of the supposed original, as does Sicard, *Diagrammes médiévaux*.

98. Carruthers and Ziolkowski, *Medieval Craft of Memory*, 45. For further discussion, consult Rudolph, *The Mystic Ark*, 16–18, and, for context, Meier, "Die Quadratur des Kreises." For the view that Hugh's diagram was intended to remain a mental construct, see Evans, "Fictive Painting," and Poirel, "*Machina universitatis*," 50–52.

99. For the metaphorics of sealing, especially as it relates to diplomatic practice, see Bedos-Rezak, *When Ego Was Imago*, 191–95.

100. Rudolph, "*First, I Find the Center Point*," 71–78, contends that such an image existed, although some of the arguments presented in favor of this conclusion are circular.

101. Berschin, "Uodalscalc-Studien IV," and Augustyn, "Die Klostergebäude," 675–79. See also Finckh, *Minor Mundus Homo*.

102. Wittwer's recording of a lost mural with a didactic program is not an isolated instance; cf. Hamburger, "Writing on the Wall," and, regarding a mnemonic diagram accompanying the treatise known after its incipit as *Nota hanc figuram*, Kiss, "Performing from Memory," 430.

103. Schoenen, "Aedificatio"; Ohly, "Haus als Metaphor"; Schulmeister, *Aedificatio und Imitatio*, 14–46; Bauer, *Claustrum animae*; and Waters, "Labor of *Aedificatio*."

104. Carruthers and Ziolkowski, *Medieval Craft of Memory*, 49.

105. Carruthers and Ziolkowski, *Medieval Craft of Memory*, 57.

106. Rudolph, *The Mystic Ark*, 77–85, includes discussion of the iconographic tradition, but strangely omits any mention of this critical feature.

107. Ross, "Illustrated Manuscripts," and von Borries-Schulten, *Die Romanischen*, 1:116–18 (cat. no. 68), vol. 2, pls. 279–87, where it is noted that analogous illustrations are not found in other copies of the text, which makes no mention of the story of the Flood.

108. Sicard, *Diagrammes médiévaux*, 168.

109. Carruthers and Ziolkowski, *Medieval Craft of Memory*, 58.

110. *PL* 175:954A-B (*In Hierarchiam Coelestem*): "Non enim sola haec, quae posita sunt, visibilia, id est formae suavitates, lumina disciplinae, ordines, eucharistia sacra, invisibilium habent, etsi multitudinem, et demonstrationem; sed et alia omnia visibilia quaecunque nobis, visibiliter erudiendis symbolice, id est figurative tradita, sunt proposita ad invisibilium significationem et declarationem. Et non sola haec visibilia, quae nobis symbolice tradita sunt, invisibilium demonstrationem habent; sed illa quoque, quae coelestibus essentiis, id est angelicis spiritibus, supermundane, id est invisibiliter et spiritualiter, et non secundum hujus mundi species tradita sunt, signa sunt invisibilium, et imagines eorum, quae in excellenti et incomprehensibili Divinitatis natura supra omnem intelligentiam subsistunt, et sensum."

111. Obrist, "Image et prohétie."

112. The best point of comparison is provided by Adam of Dryburgh; see De Fraja, "*Figurae* tra *littera*," and Meier, "Monastisches Gesellschaftsmodell."

113. See Hamburger, "Use of Images"; Hamburger, "Medieval Self-Fashioning"; and Hamburger, "Heinrich Seuse," the latter with additional bibliography.

114. In addition to the bibliography cited in note 113, see McGinn, "Theologians as Trinitarian Iconographers," 195–202, and Rozenski, *Von aller bilden bildlosekeit*.

115. Translation from Seuse, *Exemplar*, 201. For the Middle High German original, see Seuse, *Deutsche Schriften*, 191, lines 6–12 (chap. 53).

116. From the vast literature, I cite only Bancel, "Das Bild bei Heinrich Seuse," and Wilde, *Das neue Bild vom Gottesbild*.

117. See the essays gathered in Achtner, *Sprachbilder und Bildersprache*.

118. Wirth, "Von mittelalterlichen Bildern."

119. See, in addition to Stolz, *Artes-liberales-Zyklen*; Wirth, "Die kolorierten Federzeichnungen"; and Wirth, "Lateinische und deutsche Texte."

120. For this manuscript, see Gibson and Smith, *Codices Boethiani*, vol. 1, *Great Britain and the Republic of Ireland*, no. 137, 155–56. For the text, see Heath, *Mathematics in Aristotle*, 94–97, and for context within the history of Greek philosophy, see Mueller, "Greek Arithmetic." For depictions of students in the Middle Ages, see Willemsen, *Back to the Schoolyard*, and Cleaver, *Education in Twelfth-Century*.

121. For the text, see Chiaradonna, "What Is Porphyry's Isagoge?," and for the diagram, Verboon, "Medieval Tree." Olga Weijers has published a series of studies on the practice of *disputatio* in the medieval university: *La "disputatio"*; *In Search of Truth*; and *A Scholar's Paradise*, esp. chap. 12 ("Images of Knoweldge"), 175–93.

122. See Verboon, "Medieval Tree."

123. Eco, "From the Tree," 3. See also Eco, "La ligne et le labyrinthe."

124. As outlined by Eco, "From the Tree," 5.

125. Eco, "From the Tree," 16.

126. For didactic images more generally, see Schmitt, "Les images classificatrices."

127. Muratova, "Adam donne leur noms."

128. Diagrams of such divisions go back to Cassiodorus; see Gorman, "Diagrams in Cassiodorus' *Institutiones*." See also Bischoff, "Eine verschollene Einteilung"; Wirth, "Von mittelalterlichen Bildern"; Meirinhos, "Dessiner le savoir"; and Arfé, "Un autografo di Silvestro II."

129. For a digitization of the manuscript, see http://www.e-codices.unifr.ch/en/list/one/csg/0831; for bibliography: http://aleph.sg.ch/F/?func=find-b&find_code=WSU&request=Codex+!1+831 (both accessed October 23, 2016).

130. For a recent consideration of diagrammatic imagery in historical chronicles, see Cleaver, *Illuminated History Books*, chap. 4 ("Charting History"), 156–96.

131. Klapisch-Zuber, *L'ombre des ancêtres*; and Klapisch-Zuber, "De la nature végétale."

132. See Hinnebusch, "Extant Manuscripts," 159.

133. *Gesta pontificum*, ed. Pertz (1846), 172 (20, lines 39–40): "Cuius quidem ortum et proapiam, licet quidam ferant ex domini Salvatoris cognatorum descendisse famila . . ." See also Lejeune, *De legendarische stamboom*, and Lepape, "Le végétal," 459–63.

134. Châtelet, *Figuring Space*, 10. Châtelet also speaks diagrams abolishing "the rigid division between algebra, which clarified the determination operations of variables, and geometry, whose figures ensured the protection of the contemplative" (11).

135. See the essays gathered in Gattis, *Spatial Schemas*. For an argument in favor of diagrams, see Larkin and Simon, "Why a Diagram." See also Hull, "Iconic Peirce."

136. Harris, *Signs of Writing*, 46: "It is the availability of space for the deployment of written forms which gives the syntagmatics of writing far greater variety and complexity than the syntagmatics of speech could ever have." In contrasting the orality of the ancient world and the typography of the Renaissance, which he associates in turn with the predominance of hearing in what he calls Hebrew cultures and seeing in Greek culture, Ong, "From Allegory to Diagram," tackles some of the same issues, but from an outdated, essentialist perspective. His analysis of early modern allegorical tableaux as combining

naturalism "with organization in space which is not naturalistic but artificial, schematic, or diagrammatic" (425) anticipates that of Bender and Marrinan, *Culture of Diagram*, without its being mentioned there.

137. Goodman, *Languages of Art*, 170–73. For further discussion of these terms as they relate to diagrams, see Blackwell, "Diagrams about Thoughts." Cf. Blackwell, *Thinking with Diagrams*.

138. Galison, *Image and Logic*, 19.

139. Daston and Gallison, *Objectivity*, 48.

140. Cf. Krämer, "Schrift, Diagramm, Programm," who speaks of diagrams as occupying a middle ground between perception and abstraction, senses and sense, material and immaterial, rule and realization.

141. Storkerson, "Explicit and Implicit Graphs," 407.

142. Daston and Gallison, *Objectivity*, 48.

143. Ensmenger, "Multiple Meanings," 324.

144. Ensmenger, "Multiple Meanings," 324. The author borrows the concept of satisfying institutional requirements from Starr and Griesemer, "Institutional Ecology."

145. I would not go as far as Marrinan, "On the 'Thing-ness' of Diagrams," 56, who states that, "On my account, diagrams construct circumscribed environments conducive to thought-experiments by coupling users to a specific bandwidth of information without stipulating the rules of engagement," adding "My reading stands diametrically opposed to that of Peirce, who requires in the first instance that a diagram 'is an Icon of a set of rationally related objects.' The distance between us closes somewhat when Peirce invokes that 'state of activity in the Interpreter, mingled with curiosity' that leads to experimentation. . . . Perhaps the way forward is . . . to celebrate those moments when contemplating pictures leads us not to reason but to dream."

146. Peirce, *Collected Writings*, 2:282.

147. Peirce, *Collected Writings*, 2:279.

148. Quoted after MS Am 1632 (619), Peirce Papers, Houghton Library, Harvard University, 8, of which a digitization can be found at https://www.fromthepage.com/display/display_page?page_id=15813 (accessed December 26, 2018). Roberts, *Existential Graphs*, 126 inaccurately gives the source as MS 620, 8.

149. De Freitas, "Diagram as Story."

150. Rotman, "Making Marks on Paper," 70. See also Rotman, "Thinking Dia-Grams." Rotman's semiotic approach to mathematics has not always been appreciated; see Brian Hayes's review of Rotman's book, "In Postmodernist Territory": "he veers off into a long polemic against mathematical Platonism (the doctrine that mathematical objects are discovered rather than invented). This is a very old and tired controversy, not much enlivened by being recast in the vocabulary of semiotics." For an argument in favor of a certain form of mathematical Platonism linked to intuitions inspired by diagrams, see Brown, "Naturalism, Pictures, and Platonic Intuitions."

151. Cf. Ong, *Ramus*, 82–83, where he adds: "The fad for a diagrammatic logic and the groping towards an algebraic logic which followed on medieval logical quantification are epiphenomena of Western man's gradual revision of his attitude toward space." While Ong's emphasis on issues of spatiality was visionary for its time, his historical characterization of early modern developments vis à vis those of the Middle Ages is marred by an overestimation of the novelties of the typographical arrangement of elements on the printed page.

152. See Maierù, "Logic and Trinitarian Theology," and Uckelman, "Reasoning about the Trinity."

153. Ong, *Ramus*. Cf. Greaves, *Philosophical Status of Diagrams*: "today the teaching of geometry relegates diagrams to a completely subsidiary, logically derivative rold as a mere cognitive aid to the proof" (15), and "The sort of inference (subimplication) shown in the square of opposition, however, is so limited as to not be very useful" (121).

154. Macbeth, "Diagrammatic Reasoning," 292.

155. Quoted by Mancosu, "Visualization," 14, after the lectures, Niedersächsische Staats- und Universitätsbibliothck, Cod. Ms. Hilbert, 594, now published in translation as *David Hilbert's Lectures on the Foundations of Geometry, 1891–1902*, eds. Hallett and Majer, 75 (p. 11, lines 6–15), where the passage in full reads: "Der Beweis kann auch an der Hand einer geeigneten Figur geführt werden, doch ist die Zuziehung derselben durchaus nichts *nothwendiges*, sie erleichtert die *Auffassung* und ist ein *fruchtbares Mittel* zur Entdeckung neuer Sätze. Doch *Vorsicht* da sie leicht irreleitet. Der Lehrsatz ist erst dann bewiesen, wenn der *Beweis von der Figur vollkomen unabhängig ist*. Der Beweis muss sich Schritt für Schritt auf die *vorangegangnen Axiome* berufen." For an English translation of Hilbert's work as published, which, however, does not contain the passage in question, see Hilbert, *Foundations of Geometry*.

156. See Schlimm, "Pasch's Philosophy," 106–7. For a defense of diagrams with specific reference to Euclid, see Norman, *After Euclid*.

157. For the arithmetization of logic and philosophy—what she aptly calls "19th century 'Picture Shock'"—and the "suspicion of 'visual expectations,'" see Legg, "What Is a Logical Diagram?," 1–4.

158. Smadja, "Local Axioms in Disguise," 316.

159. Reid, *Hilbert*, 92.

160. Mancosu, "Visualization," speaks of a "renaissance of interest . . . in several different areas, including computer science, mathematics, mathematics education, cognitive psychology, and philosophy" (13) and of "the return of the visual as a change in mathematical style" (7–21). For a useful summary, with additional bibliography, focused on logic rather than on mathematics, see also Englebretsen, *Line Drawings for Logic*, 7–11.

161. Boehm, *Wie Bilder Sinn erzeugen*, 211: "Bildsinn is nicht prädikativ, deshalb auch nicht auf die Ja/Nein-Logik von Aussagesätzen zurückzuführen. 'Wahr' oder 'falsch' sind Bilder nicht, wohl aber deutlich bzw. dunkel. Ihre Evidenz ist nicht die des Satzes." For further discussion of Beohm's position, see Depner, *Zur Gestaltung von Philosophie*, 159–64.

162. For further discussion, see Mancosu, "Visualization," esp. 17–21, citing the work of Davis, "Visual Theorems"; Nelsen, *Proofs without Words*; and Nelsen, *Proofs without Words II*.

163. Kulpa, "Diagrammatic Representation," 77–78.

164. Campe, "Shapes and Figures," 285.

165. See Philippopoulos-Mihalopoulos, *Niklas Luhmann*, 69, and Amstutz, "Genesis of Law," 234–37.

166. See, e.g., the remarks of Shin, *Iconic Logic of Peirce's Graphs*, 1–10, on heterogenous or multimodal reasoning; also Weber, "Figures, Formulae, and Functors," 154: "There are two senses of representation to consider. One can talk about representing one mathematical object or structure with another. . . . One can also talk about using physical artifacts, like diagrams or expression, to represent mathematical objects and assertions. Although these are prima facie two very different senses of the word 'representation,' we will see how the two blur together, to the point of becoming indistinct." Kaiser, *Drawing Theories Apart*, 379, draws a useful distinction along similar lines: "In place of the logical positivists' deductive-nomological view of theories (often called the 'syntactic view'), which cast scientific theories as axiomatic systems made up of governing laws and deduced consequences, many of these authors describe scientific theories as collections of models (the 'semantic view'), focusing on the ways in which scientists fashion models and use them to mediate between concepts and the world." See also Wöpking, "Raum und Begriff."

167. For examples, see Kulpa, "Diagrammatic Representation," and Larkin and Simon, "Why a Diagram."

168. Manders, "Diagram-Based Geometric Practice."

169. Manders, "Euclidean Diagram," 80–81.

170. Cf. Knoespel, "Diagrammatic Writing," xii–xiii: "For Châtalet, in particular, diagrams work as prosthetic devices that become vehicles of intuition and thought."

171. Kühnel, *End of Time*, 25–64. See also Esmeijer, *Divina Quaternitas*.

172. *Glanz alter Buchkunst*, 124–25 (cat. no. 56). For further discussion, see Hamburger, "Idol Curiosity."

173. See Marrow, "*Circumdederunt me canes multi*."

174. For the origins of the square of opposition, see Londey and Johanson, *Logic of Apuleius*. For its uses in the Middle Ages, Gersch, *Concord in Discourse*, esp. 68–73, on John Scotus Eriugena's use of the square, and Correia, "Boethius on the Square of Opposition." See also the *Square of Opposition Handbook*, accessed June 11, 2017, http://www.square-of-opposition.org/images-vatican/HSquare-05042014.pdf, and Parsons, "Traditional Square."

175. By the fourteenth century, the square gave way in some quarters to a more complex diagram, the octagon of opposition, developed by the theologian, John Buridan. See Read, "John Buridan"; Benítez, "Medieval Octagon of Opposition"; and Lagerlund, *Modal Syllogistics*, 142, 162–63, 246.

176. See Londey and Johanson, *Logic of Apuleius*, 108–12.

177. Correia, "Boethius on the Square of Opposition."

178. All topics touched on and illustrated with examples in Murdoch, *Album of Science*, 62–71.

179. See, e.g., the composite manuscript miscellany containing texts by Aquinas and Aristotle, dated ca. 1300–1350, described and reproduced in Hirsch, *Valuable Manuscripts*, 35–36 (cat. no. 24), pl. 16, which includes several diagrams, among them an elaborated square of opposition, illustrating Aquinas's *De ente et essentia*, comparable to that reproduced in Murdoch, *Album of Science*, 63 (no. 60 = London, BL, Burney MS. 275, f. 193r).

180. Kienzler, review of *Around and Beyond the Square of Opposition*, who calls the square "a very simple device of traditional logic that seemingly has lost its very point after the rise of modern logic did away with most of its inferences. Even before that, the more sophisticated of traditional logicians had despised it as a trivial classroom tool used mainly for the visualization of what was evident already." See, however, Beziau and Read, "Square of Opposition."

181. Krauss, "Sculpture," 37–38, and Krauss, *Optical Unconscious*, 13–16, 189–92. Bogen and Thürlemann, "Jenseits der Opposition," 17–21, employ the square of opposition as part of their analysis

of medieval diagrams. Schmidt-Burkhart, *Kunst der Diagrammatik*, 38–53, includes some discussion of Krauss's contributions as well as those of Bogen and Thürlemann, but takes too narrow a view of the place of diagrams in art history by focusing, with few exceptions, on their analysis within German *Bildwissenschaft*. The same criticism can be made of Bucher, "Das Diagramm."

182. See Greimas, *Sémantique structurale*. Following Krauss, other art historians applied the diagram to the analysis of art of other periods; see, e.g., Carrier, "Towards a Structuralist Analysis." For a recent discussion, Corso, "Greimas's Semiotic Square." In his review of Alessandra Ponte, "Architecture AND Landscape: Beyond the Magic Diagram," accessed June 9, 2017, http://forty-five.com/papers/140#en1, David L. Hays offers a genealogy of Krauss's diagram, tracing it back to Burnham, *Structure of Art*, 56, in which Burnham states: "So far it has been hypothesized that all art is based on a quaternary structure where two terms are analogously equal to two other terms . . . there are a number of variations within this four-part structure. We might call this the matrix of logic modes controlling the making of art." Postulating Burnham as Krauss's point of departure, Hays writes: "As sources for his diagram, Burnham offers the algebra sets theorems developed by the Bourbaki mathematicians, the Klein Group concepts employed by semiology, and the analogous approach used by Lévi-Strauss for defining kinship relations and mythic forms. These sources are precisely the same quoted by Krauss in her essay to explain her own diagram, down to the same bibliographical references. In her text, Krauss (who does not mention Burnham's work) managed in a masterly way to conceal one of the most blatant limits of the structuralist approach, i. e., its synchronic character and the contradictions inherent in its application to a diachronic dimension. This particular inconsistency of structuralism is, instead, artlessly underlined by Burnham, who promises in his preface to *The Structure of Art* to write a future book about 'the perceptual laws defining the "historical" sequential discernment of art.'" Gamwell, *Mathematics + Art*, 446, extends the genealogy still further by tracing the somewhat tenuous connection between the German mathematician Felix Klein (1849–1925) and Greimas. In his *Vergleichende Betrachtungen über neuere geometrische Forschungen* (1872), otherwise known as the Erlangen Program, Klein sought to unify Euclidian and non-Euclidean geometries through sets of transformations which leave geometric figures unchanged. Krauss' diagram bears only the most tangential relationship to the profound complexities of the theorem.

183. Krauss, "Sculpture," 13.

184. Cf. Bois, "Not [on] Diagrams," 48: "I recognized that Rosalind's diagrammatization could be subjected to the same criticism as any structuralist operation: its reliance on binary opposition; its necessity of closure of the field it constructs in order to articulate it; its apoptropaic frenzy of arrows that seeks to mask its nondialectical status. Just as with Lévi-Strauss' work, I was more attentive to what this diagrammatization was producing, and to what it allowed Rosalind to perform."

185. Peter of Spain, *Tractatus*, 6 (1.11); translation from Peter of Spain, *Summaries*, 111.

186. Oresme, *Livre du ciel*, 220–21: "semblable a une que l'en fait pour la premiere introducion des enfans en logique."

187. For the condemnations, see Uckelman, "Logic and the Condemnations of 1277." For Oresme's *Livre du ciel*, see Quillet, "Les quatre éléments"; Quillet, "Nicole Oresme"; Sherman, *Imaging Aristotle*, esp. 190–92; Grant, "Nicole Oresme"; and Grant, *God and Reason*, 200–202.

188. Oresme, *Livre du ciel*, 228–29.

189. Riché, "Les traités."

190. For the library, see Morard, "La bibliothèque évaporée," and Stones, "Les dominicains."

191. "Feci etiam quasdam ymagines hic depingi ut in eis consolationem inveniant novitii desolato et ut in ferventibus novitiis et devotis amplius devotionis igniculus accendatur, ex celestis significationis materia sensibiliter ministrata." For the text, see "L'instruction," ed. Creytens (1952), 201–25, discussed at length by Mulchahey, *"First the Bow,"* 113–26. For the genre to which this unedited text belongs, see further Riché, "Les traités."

192. Toulouse, Bmun, ms. 418, f. 144v: "quedam demontarcio geumetrice per quam probatur quod illi qui [*added in margin*: abutuntur deliciis huius mundi sunt ad inferni supplicium descensuri]." For the text, see "L'instruction," ed. Creytens (1952), which, however, includes only excerpts, not including the chapter discussed here. A comprehensive study of the manuscript remains a desideratum. For discussion, see Mulchahey, *"First the Bow,"* 113–26; Dencry, "The Preacher and His Audience," 23–27; Brousset and Bourgerie, *Le parement d'autel*, cat. no. 5, 98–99 (Christian Heck); and Stones, *Gothic Manuscripts*, vol. 2, bk. 2, cat. no. VII-21, 197–98. Because Stones does not recognize the miniature on f. 144v as the square of opposition, she also fails to recognize the subject of the following miniature on f. 146r, which she describes as "Four roundels illustrating *dexter* and *sinister* in relation to the parable of Dives and Lazarus."

193. Toulouse, Bmun, ms. 418, f. 144v: "Ad hoc etiam ars geometrice te iuuabit ut probes et uideas

quasi per necessitatem argumentum quod illi qui abusii [*sic*] deliciarum mundi fuerunt dies suos sunt ad inferni supplicum decensuri et illi qui in afflicione penitencie moriuntur ueniunt ad requiem beatorum. et hoc geometrica ratione probare poteris per hunc modum, si facias duo puncta alternatim in parte dextra; in sinistra deinde facias alia duo puncta. alterum similiter in parte dextra, alterum in sinistra, ita quod illa quatro puncta quasi puncta sint in quadro, et in medio illorum punctorum, id est in illius medio quadrature, facias unum. Potest tamen deinde si a punctis superioribus, dextro uidelicet et sinstro, due recte linee protrahantur usque ad punctum medio loco situm, in quo necessario coniungatur si illas duas rectas ulterius protrahas usque ad inferiora alia duo, puncta dextrum uidelicet et sinistrum, in quibus finaliter terminentur. De necessitate linea illa que in puncto dextro superiori fuerat inchoacta terminabitur finaliter in sinistro puncto inferius collocato, et similiter e contrario linea illa in dextro puncto inferius finaliter terminabitur que in puncto sinitro superiori fuerat inchoata, ut manifestum est in sequenti figura."

194. Toulouse, Bmun, ms. 418, f. 145v: "et hec que dicta sunt satis patent in sequenti figura, quoniam docet facere geometrica sinens [*sic:* serviens] in hoc sapiencie salutari."

195. Paired miniatures at the beginning and end of a section of text occur only infrequently in Gothic illumination; see Camille, "Visualising in the Vernacular."

196. Toulouse, Bmun., ms. 418, ff. 144v–145r: "Hoc facto pone in puncto dextro superiori mundi prosperitatem et in ea uoluptuosum aliquem eius deliciis abutentem ut diuitem epulonem. in sinistro uno puncto superiori pone penitencie penalitatem et in ea aliquem penitentem miserum et afflictum ut Lazarum plenum ulceribus et mendicum. In punto uno medio pone mortem, et in duobus aliis punctus inferioribus describere in dextro puncto requiem beatorum, in sinistro uno puncto pone infernum et suplicia [*sic*] dampnatorum. Necesse est autem quod tam ille qui uiuens est in puncto dextro, id est in mundi prosperitate ut diues epulo, quam ille qui uiuens est in pecto sinistro, id est in penitencie afflictione ut miseri Lazazarus [*sic*] et mendicus, ad punctum medium ueniant, scilicet ad mortem, quia scriptum est de utroque: Mortuus est diues et iteum et iterum [*sic*] factum est ut morietur mendicus. lu. xvi. in puncto autem mortis nec diues nec Lazarus poterit remanere, quoniam anima non moritur quando a corpore separatur. Ideo necesse est quod hii duo, diues scilicet et pauper, transeat ad alia duo puncta, uidelicet dextrum et sinistrum. Si igitur ille due linee per quas diues et mendicum ad punctum medium

peruenerunt, uidelicet ad mortem, recto dyametro alterius protrahatur, ille cuius linea, id est vita presens, fuit in dextro puncto, uidelicet in deliciis huius mundi per quas ad medium uenit punctum, id est ad mortem, necesse est ut transacto puncto medio, id est morte, in sinistro puncto, id est inferni supplicio, finaliter transietur. Hoc est sic in perpetuum sine fine. Et similiter e contrario ille cuius linea, id est uita presens, fuit in puncto sinistro, id est in penitencie penalitate per quam ad medium uenit punctum, id est ad mortem, necesse est ut transacto puncto medio in morte in dextro puncto finaliter transietur, id est in requiem beatorum. sic in perpetuum sine fine."

197. The inscriptions read as follows: upper left, vertical label: "Alia est uita penitencium." In roundel: "Pars sinistra mundi aduersitas agens penitenciam Lazarus mendicus." Below figure: "Alie sunt pene." Upper right, vertical label: "Alia est uita peccatorum." In roundel: "Pars dextra mundi prosperitas abutens deliciis diues epulo." Below roundel: "Alie sunt deliciarum huius mundi."

198. Lower right, vertical label: "Alia est requies paradisi." Above roundel: "Alie sunt deliciarum paradisi." In roundel: "Pars dextra ciues sanctorum patrum lazarus mendicus." Lower left, vertical label: "Alia est pena inferni." Above roundel: "Alie sunt pene inferni." In roundel: "Pars sinistra supplicium inferni diues epulo."

199. Toulouse, Bmun., ms. 418, ff. 145r–145v: "Et similiter e contrario ille cuius linea, id est uita presens, fuit in puncto sinistro, id est in penitencie penalitate per quam ad medium uenit punctum, id est ad mortem, necesse est ut transacto puncto medio in morte in dextro puncto finaliter transietur, id est in requiem beatorum. Sic in perpetuum sine fine. et ideo secundum rectitudinem diuine iusticie diues ille epulo in peccato mortis de mundi deliciis transiuit ad penas inferni, ut pote de illorum merito qui ducunt in bonis dies suos et in puncto ad inferna descendunt, .Iob xxi; et ille mendicus de penalitatibus penitencie merito transiuit ad sinum Abrahe, id est ad requiem beatorum patrum, ut pote de illorum merito de quibus spiritus scilicet dei: beati mortui qui in domino moriuntur a modo. Enim iam dicit spiritus ut requiescat a laboribus suis .Apo .xiiii. quia secundum philosophum omnis motus est a contrario in contrarium. Non est ergo motus /145va/ huius mundi in deliciis ad delicias paradysi, ut de penis paradisi [*sic*] ad penas inferni, set pocius e contrario de deliciis mundi motus est ad penas inferni, et de penis penitencie motus est ad delicias paradisi. et ideo scriptum est de utroque: factum est ut moreretur mendicus, et portaretur ab ab [*sic*] angelis in sinum Abrahe. Mortuus est autem et diues, et sepultus est in inferno. Ideo dixit Abraham diuiti existenti in

tormentis: fili recordare quia <r>ecepisti bona in uita <tu>a et Lazarus similiter mal<a>. Nunc autem hic consolatur, tu uero cruciaris. Quasi dicat, tu uiuens fuisti in parte dextra quia recepisti bona in uita tua, et Lazarus uiuens fuit in parte sinistra, quia similiter ille recepit mala sua; et ideo Lazarus mortuus est in dextera parte modo quia nunc hic consolatur; tu uero mortuus modo es in parte sinistra tu modo cruciaris."

200. Toulouse, Bmun., ms. 418, f. 145v: "De ista parte dextera et sinistra dicitur in Genesi in figura. Dixit Abraham ad Loth: ne queso sit iurgium inter me et te fratres enim sumus. si tu ad sinistra ieris, ego dextram tenebo, si tu dextram elegeris, ego ad sinistram pergam. Gen. xiii."

201. Toulouse, Bmun., ms. 418, f. 145v: "i hec uerba et misteria eorum sig<nificant> iurgium enim est inter carnem et spiritum, quia caro concupiscit aduersus spiritum et spiritus aduersus carnem. Gal. v. dicit ergo aliquando carni spiritus a concupiscencia eius uictus: ne queso sit iurgium inter me et te fratres enim sumus. Si tu ad sinistram geris, scilicet in hoc mundo te per penitenciam affligendo, ego dextram tenebo in futuro.... <tu> ... s. Si tu de<xtram> <elegeris> in hoc mundo.... eius deliciis et peccatis, ego ad sinistram pergam in futuro, uidelicet cum dampnatis."

202. See Stolz, *Artes-liberales-Zyklen*, 1:160–88.

203. A comparison of the motif in all the extant manuscripts can be found at the website "Welscher Gast digital," accessed June 10, 2011, http://www.wgd.materiale-textkulturen.de/illustrationen/motiv.php?m=102.

204. Thomasin von Zirclaria, *Der Welsche Gast*, eds. Gibbs and McConnell,160.

205. O'Meadhra, "Medieval Logic Diagrams."

206. Lodi, "Serafino de' Serafini"; Hansen, *Das Bild des Ordenlehrers*; and Götze, *Der öffentliche Kosmos*, 105–6.

207. For the miniature and related images, see Stolz, *Artes-liberales-Zyklen*, 76–77n26.

208. For diagrammatic images of the Credo, see Lacroix and Renon, *Pensée, image & communication*, esp. Simor, "Le Credo dans son contexte," 216n43, with a long list of examples of this particular iconography.

209. For the emergence of monumental programs of didactic and political imagery in Trecento Italy, see Belting and Blume, *Malerei und Stadtkultur*; Götze, *Der öffentliche Kosmos*; and Krüger, *Politik der Evidenz*. For a spectacular if only partially preserved example of a monumental diagram in a church interior, kindly brought to my attention by Krisztina Ilko, see what is now a fragment of the former wall decoration, dating to the early fifteenth century, punctured by the construction in 1486 of

the chapel dedicated to San Sebastiano e San Rocco on the north side of the church of Sant'Agostino in Bergamo, which depicts, to the left, a tree diagram of the arts and, to the extent the inscriptions can be deciphered, on the right, a tree diagram of the vices or of their exemplars among various orders of society (with individual roundels labeled, in part, *canonicii, monachus, presbyter, diabolus, meratrix*, etc.). See Fumagalli, *S. Agostino di Bergamo*, 96, where, however, the relevant part of the chapel's decoration is unfortunately neither reproduced nor discussed, and Redaelli, "L'Osservanza Agostiniana a Bergamo," 227, who makes passing mention of the "Arbor scientiae," which she dates to the beginning of the fifteenth century. An image is available at http://rettorato.unibg.it/santagostino/web/it/collocazioni/22/cappella-di-san-sebastiano (accessed December 26, 2018).

210. Iacobus Nicholai de Dacia, *Liber*, 148–49 (*metrum* 23); Kabell, "Nachträgliches"; and Ernst, *Visuelle Poesie*, 349.

211. Carruthers, *Experience of Beauty*, 27.

212. See pp. 83 and 93.

213. For stained glass, see Kemp, *Sermo corporeus*. See also Morgan, "Iconography of Mosan Enamels."

214. For the *Biblia pauperum*, see Schmidt, *Armenbiblen*, and Wirth, *Die Biblia pauperum*. For the *Speculum humanae salvationis*, see most recently Palmer, "'Turning Many to Righteousness.'"

215. In addition to Herrad of Hohenbourg, *Hortus deliciarum*, 1:111–12 (ff. 67r–67v), 2:131–32 (no. 98–99), see Krüger and Runge, "Lifting the Veil."

216. Kemp, *Christliche Kunst*.

217. See Reudenbach, "Heilsgeschichtliche Sukzession," 28, and Wimmer, "Ein neuer Blick," 44–49. The same point is made briefly by Suckale, *Klosterreform und Buchkunst*, 84.

218. For the manuscript reproduced here, Munich, BSB, Clm 23426, see Schmidt, *Armenbiblen*, 34–35, and Hérnad, with Weiner, *Die gotischen Handschriften*, 195–99 (cat. no. 274).

219. Pippal, "Von der gewußten."

220. Kogman-Appel, "Christian Pictorial Sources."

221. See Melville, "Geschichte in graphischer Gestalt"; Panayotova, "Peter of Poitiers's *Compendium*"; Worm, "'Ista est Jerusalem'"; and Worm, "Visualizing the Order of History."

222. For various atempts to solve this knotty problem, including those by modern scholars, some of whom identify Matthew as the legal and Luke as the biological account, see Johnson, *Purpose of the Biblical Genealogies*, 140–45.

223. Rufinus of Aquileia, *History*, 44–45 (1.7.7–9).

224. To the best of my knowledge, only Macfarlane, "Biblical Genealogies," 139–44, has previously pointed this out.

225. Bretscher-Gisiger and Gamper, *Katalog*, 107–10.

226. See Sandler, *Psalter of Robert de Lisle*. A more complete list can be found in the appendix to the second edition, published in 1999, 114–15.

227. See Sandler, *Psalter of Robert de Lisle*, and Sandler, "John of Metz."

228. Häfele, *Franz von Retz*, 359–92.

229. Vetter, "Mariologische Tafelbilder"; Huber, "Franz von Retz"; Ziegler, "Ein unbekanntes Werk"; Slencza, *Lehrhafte Bildtafeln*, 165–73; Schmitz-Esser, "Inschriften als Bildungsvermittler?"; and König, *Von wundersamen Begebenheiten*.

230. Pfister, *Defensorium immaculatae virginitatis*, a facsimile of the imprint of 1471 (Johannes Eysenhut, Regensburg), with blocks carved by a cutter who signs himself as "f w," most likely Friedrich Walthern of Dinkelsbühl. For a list of the printed editions, with further bibliography, see *RDK*, vol. 3, cols. 1206–1218, accessed September 9, 2013, http://linux2.fbi.fh-koeln.de/rdk-smw/Defensorium.

231. See Wagner, "Das 'Defensorium inviolate.'"

232. See Wagner, "Das *Defensorium*"; Manuwald, "Der nichtverbrennende"; and Suckale, *Schöne Madonnen am Rhein*, cat. no. 9, 185–87, where it is suggested (without, however, there being any possibility of proof, given the lack of comparative material), that the painter may have come from Holland. The softness of the figural imagery combined with the archaic gold background is consistent with production in Cologne in the early fifteenth century.

233. Vetter, "Mariologische Tafelbilder," 65–87, postulates a first version in which the text greatly outweighed the illustrations.

234. Munich, BSB, Cgm 3976, written between 1446–1466, has 43 illustrations; Clm 18077, written by Anton Pelchinger in 1459, has 46. The unillustrated copy in Vienna, Österreichische Nationalbibliothek, Cod. lat. 4973, dated 1460, contains 53 captions without images.

235. For this expansion, see the essays by Ohly, "Außerbiblisch Typologisches"; Ohly, "Halbbiblische und außerbiblische Typologie"; also Ohly, "Typologische Figuren."

236. Douteil, *Die Concordantiae*, with previous bibliography; Röhrig, "Rota in medio rotae"; Wirth, *Pictor in carmine*; and Henry, *Eton Roundels*.

237. As recognized by Vetter, "Mariologische Tafelbilder," 127–37.

238. See p. 72.

239. See Wilks, "Peter Abelard," 110, and Martin, "Development of Logic," 1:134–35. In some respects Abelard's invention anticipated Buridan's octagon

of opposition, for which see chap. 5, n. 175. For a modern view of logic diagrams that sees them as more than "pictures on a page," see Legg, "What Is a Logical Diagram?"

240. See Sandler, *Psalter of Robert de Lisle*, and Sandler, "John of Metz."

241. Ransom, "Bernardian Roots," and Ransom, "Innovation and Identity."

242. Laske-Fix, *Der Bildzyklus*; and Garcia-Tejedor, "Los manuscritos."

243. From the large and growing literature on early modern scientific diagrams, I cite only the following: Hall, "The Didactic and the Elegant"; Lüthy and Smets, "Words, Lines, Diagrams, Images"; and Jardine and Fay, *Observing the World*.

Drawing Conclusions

1. Urfels-Capot, *Le sanctoral*, 97.1 (Vigil of Assumption).

2. For the full text, see the appendix. For the related genre of prayers by scribes, see Viallet, "Le salaire."

3. See Morgan, "Texts and Images in Thirteenth-Century"; Smith, "Bodies of Unsurpassed Beauty"; Russakoff, "Role of the Image"; Hamburger, "Rahmenbedingen"; and Sansterre, "La Vierge Marie."

4. Ladner, "Gestures of Prayer"; and Schmitt, *La raison des gestes*.

5. Boyle and Schmitt, *Modi orandi sancti Dominici*.

6. See Trexler, "Legitimating Prayer Gestures," and Trexler, *The Christian at Prayer*.

7. Boyle and Schmitt, *Modi orandi sancti Dominici*, f. 8v: "Stabat aliquin erectus sanctus pater dominicus ante altare cum esset in conuentu toto corpore directus super pedes suos, . . . habens aliquando ante pectus suum manus expansas, ad modum libri aperti."

8. For developments in German sculpture, especially in the Rhineland, see Suckale, "Schöne Madonnen am Rhein," 40–49.

9. *500 Jahre Rosenkranz*; Winston-Allen, *Stories of the Rose*; *Der heilige Rosenkranz*; and Keller, "Rosen-Metamorphosen."

10. Wilkins, *Rose-Garden Game*, 55, notes that the six-decade chaplet was common in southern Germany.

11. See p. 52.

12. Ernst, *Carmen figuratum*, 691, notes the symmetry of the two books taken together, but posits a relationship between the thirty figures of part 1 and the sixty of part 2 by not including the thirty-first figure (the second in the series) which Berthold added to part 1.

13. Keller, "Künstlerstoltz"; and Schwietering, "Origins of the Medieval Humility."

14. The reader should note that the explanation I proffer in what follows differs somewhat from that provided in my previous publication, "Hrabanus redivivus."

15. For images of this kind, in monumental painting as well as in manuscripts, see Oakes, *Ora pro nobis*, 37–64. See also the very useful surveys of material in Morgan, "Texts and Images in Thirteenth-Century," and Morgan, "Texts and Images in Fourteenth-Century."

16. Volfing, *John the Evangelist*.

17. For his advice on matters paleographical, I am indebted to Christoph Mackert.

18. Fulton, *From Judgment to Passion*, 264.

19. From the large literature, I cite only the following: Macy, *Theologies of the Eucharist*; Chazelle, "Figure, Character, and the Glorified Body"; and Surmann and Schröer, *Trotz Natur*.

20. See also Schmitt, "Rituels de l'image," 1:422–31.

21. *PL* 152:1306A, quoted by Bedos-Rezak, *When Ego Was Imago*, 169, as part of her incisive analysis of the *Acta*.

22. Bedos-Rezak, *When Ego Was Imago*, 170–71.

23. See Bynum, "Seeing and Seeing Beyond."

24. See Meier, "Die Quadratur des Kreises," 53.

25. Meier, "Malerei des Unsichtbaren," and Meier, "*Per invisibilia ad invisibilia*?"

26. See Dünninger, "Das himmlische Jerusalem," and Frontzek, "Während der Blick."

Appendix: Description and Partial Edition

1. See Tentzel, *Monatliche Unterredungen*, 209.

2. *Speculum uirginum*, bk. 8, lines 6–25; 221; Hartl, *Text und Miniaturen*, appendix B.2.

3. The last three inscriptions are in fact one continuous quotation from the Office of the Feast of the Nativity of the Virgin, for which see Fassler, "Mary's Nativity."

4. The inscriptions were written by a hand different from that found in the other figures. Distinguished by cursive elements, the hand is perhaps identifiable with that of one of the scribes who made marginal corrections.

5. A corrector has linked the two separate parts of the inscription, which were erroneously placed in separate lines.

6. For discussion of this miniature, see pp. 58–61.

7. John of Damascus, *De fide orthodoxa*, 318–19 (section 1156, chap. 87, lines 4–18).

8. Bernard of Clairvaux, *Opera*, vol. 4, 22, line 20–23, line 10. Richard of Saint-Laurent, chap. 1, incorporates precisely the same passage.

9. Urfels-Capot, *Le sanctoral*, *16.1 (10th Sunday after "Deus omnium"); cf. *PL* 96:279–80.

10. Anselm of Canterbury, *Orationes*, 18, line 4–19, line 28.

11. Anselm of Canterbury, *Orationes*, 20, line 59–21, line 74; Urfels-Capot, *Le sanctoral*, *25.2 (19th Sunday after "Deus omnium"). The passage selected by Berthold extends that chosen for the lesson by one sentence, suggesting that Anselm's prayer, rather than the lectionary, served as the immediate source.

12. *PL* 95:1163.

13. *PL* 39:2110; cf. Urfels-Capot, *Sanctoral*, *1.2 (1st Sunday after octave of Epiphany). The lectionary cannot have served as the immediate source, as the passage quoted is both longer and adheres to the wording of the original source.

14. *PL* 39:2197–98.

15. Bernard of Clairvaux, *Opera*, vol. 4, 25, line 17–26, line 8.

16. Anselm of Canterbury, *Orationes*, 19, line 32, 20, line 58.

17. *PL* 144:737–39.

18. Bede, *Opera homiletica*, bk.1, homily 4, lines 72–86.

19. Hrabanus Maurus, *In honorem*, I C, lines 16.1–26.

20. Bernard of Clairvaux, *Opera*, vol. 4, 26, line 10–27, line 17.

21. Urfels-Capot, *Le sanctoral*, 35.1–2 (Annunciation Sunday); cf. *PL* 39:2107–8. The match between the reading provided by Berthold and the lesson's reworking of the pseudo-Augustinian sermon indicates that the lectionary served as his source. For further discussion of applications of this sermon, see Clayton, *Cult of the Virgin Mary*, 199–201.

22. Ambrosius Autpertus, *Opera*, *Sermo in purificatione Sanctae Mariae*, chap. 3, lines 30–39. The same sermon serves as a source for three lessons for the feast in the Dominican lectionary; see Urfels-Capot, *Le sanctoral*, 27.1–3 (Purification of the Virgin).

23. Bernard of Clairvaux, *Opera*, vol. 7, 390, lines 15–20.

24. John of Damascus, *De fide orthodoxa*, 320–21 (section 1157, chap. 87, lines 36–64); cf. Urfels-Capot, *Le sanctoral*, 116.3b (Nativity of the Virgin). Berthold's commentary draws on the same source as two of the lessons for the feast in the Dominican lectionary.

25. *PL* 144:740.

26. Bernard of Clairvaux, *Opera*, vol. 4, 34, line 15–35, line 13.

27. Anselm of Canterbury, *Orationes*, 21, lines 82–91; Urfels-Capot, *Le sanctoral*, 25.3 (19th Sunday after "Deus omnium"). The fact that the reading here

is longer than the lesson indicates that Berthold drew directly on Anselm rather than relying on the lesson as an intermediary source.

28. The figure is incorrectly numbered; it should be XXI.

29. Ambrose, *De virginibus*, bk. 2, chap. 2, part 6; cf. Urfels-Capot, *Le sanctoral*, 119.1–3 (Nativity of the Virgin). In this case also, Berthold consulted the source of the lectionary, not the lectionary itself.

30. Bernard of Clairvaux, *Opera*, vol. 4, 29, line 12–33, line 22.

31. Urfels-Capot, *Le sanctoral*, 35.8–9 (Annunciation Sunday); cf. Bede, *Opera homiletica*, bk. 1, homily 3, lines 10–26.

32. Bernard of Clairvaux, *Opera*, vol. 5, 260, line 12–261, line 11.

33. Paschasius Radbertus, *De partu Virginis*, lines 213–64; cf. Urfels-Capot, *Le sanctoral*, 116.6 (Nativity of the Virgin). Berthold draws directly on the lectionary's source rather than on the lectionary itself.

34. John of Damascus, *De fide orthodoxa*, 170–73 (sections 984–85, chap. 46, lines 4–46).

35. Ambrose, *Expositio*, lines 311–40. Ambrosius's commentary on Luke served as a source for lessons in the Dominican lectionary; see Urfels-Capot, *Le sanctoral*, 68.7–9 (Peter and Paul); 137.8 (Luke).

36. Bede, *Opera homiletica*, lines 145–61. Bede's homilies on Luke also served as a source for the Dominican lectionary; see Urfels-Capot, *Le sanctoral*, 35.7b–9 (Annunciation of the Virgin).

37. *PL* 175:416–18.

38. *PL* 175:424.

39. *PL* 191:208–9.

40. *PL* 79:506–7.

41. Urfels-Capot, *Le sanctoral*, *16.2 (10th Sunday after "Deus omnium"); cf. *PL* 96:280.

42. Urfels-Capot, *Le sanctoral*, *2.3b (2nd Sunday after the Octave of Epiphany); cf. *PL* 39:1655–66.

43. The phrase "quo mortalibus oculis videri posset, et augmento lucis annue lucem se venisse mentium ostendet," which is appended at the end of the third lesson for the second Sunday after the octave of Epiphany, comes not from the Office, but rather from its source in Augustine (*PL* 39:1655), indicating that Berthold collated the lessons on which he was drawing with the sources for the Office.

44. Urfels-Capot, *Le sanctoral*, *32.2 (26th Sunday after "Deus omnium"); cf. *PL* 101:1307.

45. Urfels-Capot, *Le sanctoral*, 27.2–3 (Purification of the Virgin); cf. Ambrosius Autpertus, *Opera*, chap. 3, lines 43–57.

46. Urfels-Capot, *Le sanctoral*, *17.2–3 (11th Sunday after "Deus omnium"); cf. *PL* 57:866.

47. Bernard of Clairvaux, *Opera*, vol. 4, 277, line 11–278, line 22.

48. Augustine of Hippo, *Opera Omnia*, 24:404–5. The ps.-Augustinian corpus of sermons is among the sources most heavily drawn upon by the Dominican lectionary.

49. Bernard of Clairvaux, *Opera*, vol. 4, 342, line 15.

50. The Dominican lectionary draws on Ps. Chrysostomos, *Opus imperfectum in Matheum*, the text which Berthold identifies as his source; see Urfels-Capot, *Le sanctoral*, 14.1 (John), 16.1–3 (Holy Innocents), 128.1, 6a (Matthew), yet that work does not include the passage provided here. The source, rather, is another authentic work (in translation), Chrysostomus, *In Matthaeum homiliae Aniano interprete: Homilae I–XXV*, accessed September 5, 2018, http://web.wlu.ca/history/cnighman/ ChrysostomHomiliaeInMattheumAnianoInterprete1503.pdf. Berthold's commentary consists of two passages, quoted in reverse sequence, suggesting that there probably was an intermediary source, most likely a set of lessons. For the passages in question, see also Paris, BnF, ms. lat. 1776, ff. 52r–52v, accessed March 29, 2016, http://gallica.bnf.fr/ark:/12148/bt-v1b90764860/f1.item.

51. *Biblia latina cum glossa ordinaria*, 4:148–49. The Dominican lectionary draws on the *Glossa ordinaria*, without, however, employing the passage used here; see Urfels-Capot, *Le sanctoral*, 137.9 (Luke).

52. Bede, *Opera homiletica*, *In Lucae euangelium expositio*, bk. 1, chap. 2, lines 21–28.

53. Cf. Ambrose, *Expositio*, bk. 2, line 841.

54. Urfels-Capot, *Le sanctoral*, *14.3 (8th Sunday after "Deus omnium"); cf. Bernard of Clairvaux, *Opera*, vol. 4, 315, lines 10–16.

55. Urfels-Capot, *Le sanctoral*, *32.1 (26th Sunday after "Deus omnium"); cf. *PL* 101:1306.

56. Urfels-Capot, *Le sanctoral*, *11.1–3 (5th Sunday after "Deus omnium"); cf. Bernard of Clairvaux, *Opera*, vol. 5, 262, lines 12–263, line 21.

57. Urfels-Capot, *Le sanctoral*, 13.1–2 (7th Sunday after "Deus omnium"); cf. Bernard of Clairvaux, *Opera*, vol. 5, 249, line 17–250, line 4.

58. Paschasius Radbertus, *De partu Virginis*, lines 880–88, 872–74 (the second part of the passage precedes the first). The Dominican lectionary draws on this text, but not the passage employed here; see Urfels-Capot, *Le sanctoral*, 99.1–3 (Assumption), 100.1–3 (2nd feast within the octave of the Assumption), 101.1–3 (3rd feast within the octave of the Assumption), etc.

59. Bernard of Clairvaux, *Opera*, vol. 4, 49, lines 7–20. The Dominican lectionary makes use of this widely disseminated set of sermons by Bernard; see

Urfels-Capot, *Le sanctoral*, 118.1 (Nativity of the Virgin).

60. Bernard of Clairvaux, *Opera*, vol. 4, 36, lines 4–24.

61. Bernard of Clairvaux, *Opera*, vol. 4, 20, line 16–23, line 23; cf. Urfels-Capot, *Le sanctoral*, *15.1–2 (9th Sunday after "Deus omnium"). Berthold draws on Bernard directly, not the abbreviated version in the lectionary.

62. Bernard of Clairvaux, *Opera*, vol. 4, 23, line 25–24, line 12.

63. Bernard of Clairvaux, *Opera*, vol. 5, 236, lines 23–37.

64. Anselm of Canterbury, *Orationes*, 7-8, lines 40-45.

65. John of Damascus, *De fide orthodoxa*, 325, lines 124–31.

66. Urfels-Capot, *Le sanctoral*, 99.2–3 (Assumption); cf. Paschasius Radbertus, *De partu Virginis*, 83, lines 691–95; 82, lines 689–90; 83–84, lines 696–709; and 85, lines 715–17.

67. *PL* 144:717–18.

68. Urfels-Capot, *Le sanctoral*, 98.5–6 (Assumption, lessons 4–6); cf. Paschasius Radbertus, *De partu Virginis*, 118–25, lines 182–89, 308–16, 340–45, and 352–53.

69. Bernard of Clairvaux, *Opera*, vol. 5, 266, line 9–274, line 11; cf. Urfels-Capot, *Le sanctoral*, 102.2–3 (Assumption). Although Berthold's excerpts are closely related to those found in the lectionary, the wording indicates that he must have consulted the original.

70. *PL* 96:272; Urfels-Capot, *Le sanctoral*, *18:2–3 (12th Sunday after "Deus omnium").

71. Urfels-Capot, *Le sanctoral*, *14.1 (8th Sunday after "Deus omnium"); cf. Bernard of Clairvaux, *Opera*, vol. 5, 167, line 22–168, line 8.

72. For this miniature, see pp. 265–68.

73. Urfels-Capot, *Le sanctoral*, 97.8 (Vigil of Assumption, lessons 8–9).

74. Correction: *intemerate* for *intemate*.

75. Over erasure.

76. Over erasure.

77. "O noli delere . . . in libro vite" added.

Bibliography

Abbreviations

BAV: Biblioteca Apostolica Vaticana

BL: British Library

Bmun: Bibliothèque municipale

BnF: Bibliothèque nationale de France

BPL: Boston Public Library

BSB: Bayerische Staatsbibliothek

Can: Cantus Manuscript Database, cantus.uwaterloo.ca

CCCM: Corpus Christianorum Continuatio Mediaevalis

CCSL: Corpus Christianorum Series Latina

FBG: Forschungsbibliothek Gotha der Universität Erfurt

LcI: *Lexikon der christlichen Ikonographie*, ed. Engelbert Kirschbaum and Günter Bandmann, 8 vols. Rome: Herder, 1968–78.

LM: *Lexikon des Mittelalters*, ed. Robert Auty et al., 10 vols. Munich: Artemis Verlag, 1977–99.

PL: *Patrologia Latina*, ed. Jacques Paul Migne, 221 vols. Paris: Garnier, 1844–64.

RDK: *Reallexikon zur deutschen Kunstgeschichte*, ed. Otto Schmitt et al., 9 vols. Stuttgart: Metzler/Druckenmüller-Beck, 1937–.

SB: Stadtbibliothek

UB: Universitätsbibliothek

ULB: Universitäts- und Landesbibliothek

²VL: *Die deutsche Literatur des Mittelalters: Verfasserlexikon*, 2nd ed, ed. Kurt Ruh et al., 14 vols. Berlin: De Gruyter, 1978–2008.

Primary Sources

Acta Capitulorum Generalium Ordinis Praedicatorum, vol. 1, *Ab anno 1220 usque ad annum 1303*. Edited by Benedictus Maria Reichert. Monumenta Ordinis Fratrum Praedicatorum Historica 3. Rome: Typographia Polyglotta S.C. de Propaganda Fide, 1898.

Adams, Henry. *The Education of Henry Adams: An Autobiography*. Boston: Houghton Mifflin, 1918.

Aelred of Rievaulx (Aelredus Rieuallensis). *The Liturgical Sermons: The Second Clairvaux Collection; Christmas—All Saints*. Translated by Marie Anne Mayeski, with an introduction by Domenico Pezzini. Cistercian Fathers Series 77. Collegeville, MN: Liturgical Press, 2016.

——. *Sermones I–XLVI: Collectiones Claraeuallensis prima, et secunda*. Edited by Gaetano Raciti. CCCM 2A. Turnhout, Belgium: Brepols, 1989.

Albertus Magnus (Alberti Magni). [. . .] *Opera omnia*. 38 vols. Edited by Auguste Borgnet and Émile Borgnet. Paris: Apud Ludovicum Vivès, 1890–99.

Ambrose (Ambrosius Mediolanensis). *De virginibus*. Edited by Franco Gori. Sancti Ambrosii episcopi Mediolanensis Opera 14. Milan: Biblioteca Ambrosiana; Rome: Città nuova, 1989.

——. *Expositio euangelii secundum Lucam*. Edited by M. Adriaen. Sancti Ambrosii Mediolanensis Opera, CC SL 14. Turnhout: Brepols, 1957.

Ambrosius Autpertus. *Ambrosii Autperti Opera*. Edited by Robert Weber. CCCM 27A–B. Turnhout: Brepols, 1975–79.

Analecta Hymnica Medii Aevi. Edited by Guido Dreves and Clemens Blume. 55 vols. Leipzig: Fues's Verlag (R. Reisland), 1886–1922.

Anselm of Canterbury. *Orationes siue meditationes*. Vol. 3 of *Opera omnia*, edited by Franciscus Salesius Schmitt. Stuttgart: F. Frommann, 1984.

——. *St. Anselm's Book of Meditations and Prayers*. Translated by M. R. London: Burns and Oates, 1872.

Anthony of Padua. *Sancti Francisci Assisiatis et S. Antonii Paduani Opera Omnia*. Edited by Jean de la Haye. Stadt am Hof bei Regensburg: Johannes Gastl, 1739.

Aristotle. *Aristotle on Memory*. Edited and translated by Richard Sorabji, 2nd edition. London: Duckworth, 2004.

Augustine of Hippo (Augustinus Hipponensis; Sancti Aurelii Augustinei, Hipponensis Episcopi). *De ordine*. Translated and with an introduction by Silvano Borruso. South Bend, IN: St. Augustine's Press, 2007.

——. *De sermone Domini in monte*. Edited by Almut Muntzenbecher. CCSL 35; Aurelli Augustini Opera, VII/2. Turnhout: Brepols, 1967.

——. *Opera Omnia: Multis sermonibus ineditis aucta et locupletata extracta e Collectione SS. Ecclesiae Pa-*

trum. Edited by Armand B. Caillau. Collectio selecta SS. Ecclesiae Patrum 143. Paris: Parent-Desbarres, 1836.

Bede (Beda Venerabilis, Venerable Bede). *De temporum ratione liber*. Edited by Charles W. Jones. CCSL 123B. Turnhout: Brepols, 1977.

——. *Opera homiletica: Opera rhythmica*. Edited by David Hurst. CCSL 122. Turnholt: Brepols, 1955.

——. *The Reckoning of Time*. Translated by Faith Wallis. Liverpool: Liverpool University Press, 1999.

Benedict of Nursia. *The Order of St. Benedict, The Rule of St. Benedict*. Accessed May 30, 2017. http://www.osb.org/rb/text/toc.html.

Benjamin, Walter. *The Arcades Project*. Translated by Howard Eiland and Kevin McLaughlin based on the German volume edited by Rolf Tiedemann. Cambridge, MA: Belknap Press of Harvard University Press, 1999.

Bernard of Clairvaux. *Bernardi opera*. Edited by Jean Leclercq and Henri M. Rochais. 4 vols. Rome: Editiones Cistercienses, 1966–72.

Biblia latina cum glossa ordinaria: Facsimile Reprint of the Editio Princeps, Adolph Rusch of Strassburg 1480/81. 4 vols. Turnhout: Brepols, 1992.

Blake, William. *The Complete Poetry and Prose of William Blake*. Edited by David E. Erdman, with a new forward and commentary by Harold Bloom. Berkeley: University of California Press, 2008.

Boethius. *Boethian Number Theory: A Translation of the "De Institutione Arithmetica."* Edited, translated, and with an introduction by Michael Masi. Studies in Classical Antiquity 6. Amsterdam: Rodopi, 1983.

Boëthius (Anicius Manlius Severinus Boethius). *The Consolation of Philosophy: Authoritative Text, Contexts, Criticism*. Edited by Douglas C. Langston. New York: W. W. Norton, 2010.

Brower, Christoph. *Fuldensium Antiquitatum Libri IIII*. Antwerp: Plantin, 1612.

Cassiodorus (Flavius Magnus Aurelius Cassiodorus). *Institutiones divinarum et saecularium litterarum / Einführnug in die geistlichen und weltlichen Wissenschaften*. Translated and with an introduction by Wolfgang Bürsgens. 2 vols. Fontes Christiani 39/1–2. Freiburg i. Br.: Herder, 2003.

Chrysostom, John. *The Homilies of S. John Chrysostom, Archbishop of Constantinople on the Epistle of S. Paul the Apostle to the Hebrews*. Translated by Frederick Field. Oxford: James Parker, 1877.

Cicerco (Marcus Tullius Cicero). *De senectute, De amicitia, De divinatione*. Translated by William Armistead Falconer. Loeb Classical Library 20. Cambridge, MA: Harvard University Press, 1923.

Concilia Aevi Karolini I/2. Edited by Albert Werminghoff. Monumenta Germaniae Historica, section 3, vol. 2/2. Hannover: Hahn, 1908.

Constitutiones et Acta Capitulorum Ordinis Fratrum Praedicatorum 1232-2001. Edited by Istituto Sotrico Domenicano, Roma. Berlin: Directmedia, 2002.

Constitutiones Fratrum S. Ordinis Praedicatorum. Paris: Pousielgue, 1886.

Deutsche Mystiker des vierzehnten Jahrhunderts. Edited by Franz Pfeiffer. 2 vols. Leipzig: G. J. Göschen'sche Verlagshandlung, 1845–57.

Dreves, Guido Maria. *Ein Jahrtausend lateinischer Hymnendichtung: Eine Blütenlese aus den Analecta hymnica mit literarhistorischen Erläuterungen.* 2 vols. Leipzig: O. R. Reisland, 1909.

Elmer of Canterbury. "Écrits spirituels d'Elmer de Cantorbéry." Edited by Jean Leclercq. *Analecta Monastica,* 2 Ser. 31. Rome: Libreria vaticana, 1953, 45–117.

Galileo Galilei. *The Essential Galileo.* Edited and translated by Maurice A. Finocchiaro. Indianapolis: Hackett, 2008.

Gerard of Frachet. *Fratris Gerardi de Fracheto O.P., Vitae fratrum Ordinis Praedicatorum.* Monumenta Ordinis Fratrum Praedicatorum historica 1. Louvain: Typis E. Charpentier & J. Schoonjans, 1896.

——. *Lives of the Brethren of the Order of Preachers 1206-1259.* Translated by Placid Conway. Edited and with an introduction by Bede Jarrett. London: Burns, Oates and Washbourne, 1924.

Gerbert of Aurillac (Gerbert d'Aurillac). *Correspondance: Lettres 1 à 220 (avec 5 annexes).* Edited by Pierre Riché and Jean-Pierre Callu. Paris: Les Belles Lettres, 2008.

Gesta pontificum tungrensium sive Leodicensium. Edited by Georg Heinrich Pertz. Monumenta Germaniae Historica 9, Scriptorum 7. Hannover: Hahn, 1846.

Guibert of Nogent (Guiberto di Nogent). *Le reliquie dei santi.* Translated and with an introduction by Matteo Salaroli. CCCM 127, Corpus Christianorum in Translation 24. Turnhout: Belgium, 2015.

Heinrich von Herford. *Liber de rebus memorabilibus sive Chronicon Heinrici de Hervordia.* Edited by August Potthast. 2 vols. Göttingen: Dieterich, 1859.

Herrad of Hohenbourg. *Hortus deliciarum.* Edited by Rosalie Green et al. 2 vols. London: Warburg Institute, 1979.

Hilbert, David, and Stefan Cohn-Vossen. *Geometry and the Imagination.* Translated by Paul Nemenyi. New York: Chelsea Publishing Co., 1952., Originally published as *Anschauliche Geometrie.* Grundlehren der mathematischen Wissenschaften 37. Berlin: J. Springer, 1932.

——. *David Hilbert's Lectures on the Foundations of Geometry, 1891-1902.* Edited by Michael Hallett and Ulrich Majer. Vol. 1 of *David Hilbert's Lectures on the Foundations of Mathematics and Physics, 1891–1933.* Berlin: Springer, 2004.

——. *The Foundations of Geometry.* Translated by E. J. Townsend. Chicago: Open Court, 1902. Originally published as "Grundlagen der Geometrie," in *Festschrift zur Feier der Enthüllung des Gauss-Weber Denkmals in Göttingen: 1. Theil* (Leipzig: B. G. Teubner, 1899).

Hrabanus Maurus. *De Universo.* Edited by Schippers. Accessed December 26, 2018. http://www.hs-augsburg.de/~harsch/Chronologia/Lspost09/Hrabanus/hra_rn00.html.

——. *Epistolae.* Edited by Ernst Dümmler. Monumenta Germaniae historica: Epistolarum 5. Berlin: Weidmann, 1898–99.

——. *Hrabani Mauri Carmina* 38. Monumenta Germaniae Historica, PLAC 2. Edited by Ernst Dümmler. Berlin: Weidmann, 1884.

——. *In honorem sanctae crucis.* Edited by Michel Perrin. 2 vols. CCCN 100–100A. Turnhout: Brepols, 1997.

——. *Rabani Mauri, De Institutione Clericorum Libri Tres.* Edited by Aloisius Knoepfler. Veröffentlichungen aus dem Kirchenhistorischen Seminar München 5. Munich: E. Stahl, 1900.

——. *Raban Maur: Louanges de la Sainte Croix.* Edited and translated by Michel Perrin. Paris: Berg International-Trois Cailloux, 1998.

Hugh of Saint-Cher. *Hugonis Cardinalis Opera Omnia in Universum Vetus & Novum Testamentum.* 8 vols. Venice: N. Pezzana, 1703.

Hugh of St. Victor. "De tribus maximis circumstantiis gestorum." *Speculum* 18 (1943): 484–93.

——. *Hugonis de Sancto Victore Didascalicon de studio legendi.* Edited by Charles Henry Buttimer. Washington, D.C.: Catholic University of America Press, 1939.

Humbert of Romans. *B. Humberti de Romanis opera de vita regulari.* Edited by Joachim Joseph Berthier. 2 vols. Rome: Befani, 1888–89.

Iacobus Nicholai de Dacia. *Liber de distinccione metrorum. Mit Einleitung und Glossar.* Edited by Aage Kabell. Monografier utgivna av. K. humanistiska vetenskpas-samfundet i Uppsala 2. Uppsala, Almqvist & Wiksell, 1967.

Iacopo da Varazze. *Legenda Aurea con le miniature dal codice Ambrosiano C 240 inf.: Testo critico riveduto e commento.* Edited by Giovanni Paolo Mazzioni. Translated by Francesco Stella. 2 vols. Edizione Nazionale dei Testi Mediolatini 20; 2 Ser. 9. Milan: Biblioteca Ambrosiana; Florence: SISMEL, Edizioni del Galluzo, 2007.

"L'instruction des novices dominicains à la fin du XV^e siècle." Edited by Raymond Creytens. *Archivum Fratrum Praedicatorum* 22 (1952): 201–25.

Interpretation of Scripture: Theory. A Selection of Works of Hugh, Andrew, Richard and Godfrey of St Victor and of Robert of Melun. Edited by Franklin T. Harkins and Frans von Liere. Victorine Tests in Translation 3. Turnhout: Brepols, 2012.

Isidore of Seville. *The Etymologies of Isidore of Seville.* Translated by Stephen A. Barney et al. Cambridge: Cambridge University Press, 2006.

———. *Isidorus Hispalensis: Etymologiarum siue Originum libri XX.* Edited by Wallace Martin Lindsay. CPL 1186. Oxford: Claredon Press, 1971.

Joachim of Fiore. *Liber de Concordia Noui ac Veteris Testamenti.* Edited by E. Randolph Daniel. Transactions of the American Philosophical Society 73/8. Philadelphia: American Philosophical Society, 1983.

———. *Tractatus super quatuor evangelia*, I, 2. Edited by Francesco Santi. Fonti per la storia dell'Italia medievale. Antiquitates/Istituto storico italiano per il Medio Evo 17; Opera omnia 5; Fonti per la storia dell'Italia medievale. Antiquitates 17. Rome: Istituto storico italiano per il Medio Evo, 2002.

John of Damascus (Joannes Damascenus). *De fide orthodoxa.* Translated by Burgondio. Edited by Eligius M. Buytaert. New York: Franciscan Institute S. Bonaventure, 1955.

Josephus, Titus Flavius. *Jewish Antiquities, Books I–III.* Translated by H. St. J. Thackeray. Loeb Classical Library 242. 1930. Reprint, Cambridge, MA: Harvard University Press, 1998.

Klee, Paul. *Das bildnerische Denken: Schriften zur Form- und Gestaltungslehre.* Edited by Jürg Spiller. Basel: Benn Schwabe & Co., 1956.

———. *Kunst-Lehre.* Edited by Günther Regel. Leipzig: Reklam, 1987.

———. *The Thinking Eye: The Notebooks of Paul Klee.* Edited by Jörg Spiller. Translated by Ralph Manheim. New York: Wittenborn, 1961.

Lateinische Sequenzen des Mittelalters aus Handschriften und Drucken. Edited by Joseph Kehrein. Hildesheim: Georg Olms, 1969. Reprint, Mainz: Florian Kupferberg, 1873.

Lucas of Tuy (Lucas Tudensis). *De altera vita.* Edited by Emma Falque Rey. CCCM 74A. Turnhout: Brepols, 2009.

Macrobius (Ambrosius Aurelius Theodosius Macrobius). *Commentarii in Somnium Scipionis.* Edited by Jakob Willis. 2nd edition. Stuttgart: Teubner, 1994.

———. *Macrobius: Commentary on the Dream of Scipio.* Translated and with an introduction and notes by William Harris Stahl. New York: Columbia University Press, 1952.

Mamertus, Claudianus. *Claudiani Mamerti Opera.* Edited by Augustus Engelbrecht. Corpus Scriptorum Ecclesiasticorum Latinorum 11. Vienna: C. Geroldi Filium Bibliopolam Academiae, 1885.

Martianus Capella. *Martianus Capella and the Seven Liberal Arts*, vol. 2, *The Marriage of Philology and Mercury.* Translated by William Harris Stahl and Richard Johson, with E. L. Burge. New York: Columbia University Press, 1971.

Mechthild von Magdeburg. ‚*Lux divinitatis*'—‚*Das Liecht der Gotheit*'. *Synoptische Ausgabe.* Edited by Ernst Hellgardt et al. Berlin: De Gruyter, 2019.

More, Thomas. *Utopia: A Revised Translation, Backgrounds, Criticism.* Edited with a revised translation by George M. Logan. 3rd ed. New York: Norton, 2011.

Fra Nicola da Milano. *Collationes de beata virgine: A Cycle of Preaching in the Dominican Congregation of the Blessed Virgin Mary at Imola, 1286–1287, edited from Firenze, Biblioteca Nazionale Centrale, MS. Conv. soppr. G.7.1464.* Edited by M. Michèle Mulchahey. Toronto Medieval Latin Texts 24. Toronto: Pontifical Institute of Mediaeval Studies, 1997.

Nicholas of Cusa. *De docta ignorantia.* Edited by Ernest Hoffmann and Ramund Klibansky. Opera omnia 1. Leipzig: Felix Meiner, 1932.

———. *De ludo globi.* Edited by Hans G. Senger. Opera Omnia 9. Hamburg: Meiner Verlag, 1998. Translated by Jasper Hopkins as *The Bowling-Game* (Minneapolis, MN: Arthur J. Banning Press, 2000).

Oresme, Nicole. *Le Livre du ciel et du monde.* Edited by Albert D. Menut and Alexander J. Denomy. Translated and with an introduction by Albert D. Menut. Madison: University of Wisconsin Press, 1968.

Paschasius Radbertus. *De partu Virginis, De assumptione sanctae Mariae uirginis.* Edited by E. Ann Matter and Albert Ripberger. CCCM 56C. Turnhout: Brepols, 1985.

Passion de Perpétue et de Félicité suivi des Actes. Edited by Jacqueline Amat. Sources Chrétiennes 417. Paris: Éditions du Cerf, 1996.

Peirce, Charles Sanders. *Collected Writings.* Edited by Charles Hartshorne, Paul Weiss, and Arthur W. Burks. 8 vols. Cambridge, MA: Harvard University Press, 1931–58.

———. "An Essay toward Improving Our Reasoning in Security and Liberty." 1913, MS 682. Peirce Papers. Houghton Library, Harvard University.

———. "Logic as Semiotic: The Theory of Signs." MS [R] 798, 2.227–229. Peirce Papers. Houghton Library. Harvard University. Printed in *Philosophical Writings of Peirce*, edited by Justus Buchler (New York: Dover Publications, 1955), 98.

———. *Writings of Charles S. Peirce: A Chronological Edition.* Edited by Max H. Fisch. 5 vols. Bloomington: Indiana University Press, 1982–2010.

Peter Lombard. *Magistri Petri Lombardi Parisiensis episcopi Sententiae in IV libris distinctae.* Edited by Ignatius Brady. Spicilegium Bonaventurianum 4. Grottaferrata: Editiones Collegii S. Bonaventurae ad Claras Aquas, 1971.

Peter of Poitiers. *Petri Pictaviensis: Allegoriae super Tabernaculum Moysi.* Edited by Philip S. Moore and James A. Corbett. Publications in Mediaeval

Studies 3. Notre Dame, IN: University of Notre Dame Press, 1938.

Peter of Spain (Petrus Hispanus Portugalensis). *Summaries of Logic. Text, Translation, Introduction, and Notes*. Edited and translated by Brian P. Copenhaver, with Calbin Nomore and Terence Parsons. Oxford: Oxford University Press, 2014.

———. *Tractatus, called afterwards, Summule logicales, First Critical Edition from the Manuscripts*. With an introduction by Lambertus Marie de Rijk. Assen: Van Gorcum, 1972.

Philippe de Beaumanoir. *Coutumes de Beavaisis*. Edited by Amédés Salmon. 3 vols. Paris: A. Picard, 1899–1900. Reprinted with the addition of a commentary by Georges Hubrecht as *Coutumes de Beauvaisis: Texte critique publié avec une introduction, un glossaire, et une table analytique*, 3 vols. (Paris: A. and J. Picard, 1970–74).

Plato. *Complete Works*. Edited by John M. Cooper, with D. S. Hutchinson. Indianapolis: Hackett, 1997.

———. *Meno, interprete Henrico Aristippo*. Edited by Victor Kordeuter, with Carlotta Labowsky. Plato Latinus 1. London: Warburg Institute, 1940.

Poetae latini aevi Carolini 1. Edited by Ernst Dümmler. Monumenta Germaniae Historica, Poetarum latinarum medii aevi 1. Berlin: Weidmann, 1881.

Publilius Optatianus Porphryius. *Publilii Optatiani Porfyrii Carmina*. Edited by Johannes Polara. Turin: G. B. Paravia, 1973.

Quintilian. *The Instituto Oratoria of Quintilian, with an English Translation*. Translated by Harold Edgeworth Butler. Cambridge, MA: Harvard University Press; London: William Heinemann, Ltd., 1922.

Richalm von Schöntal. *Liber revelationum*. Edited by Paul Gerhardt Schmidt. Monumenta Germaniae Historica: Quellen zur Geistesgeschichte des Mittelalters 24. Hannover: Hahnsche Buchhandlung, 2009.

Rufinus of Aquileia. *History of the Church*. Translated by Philip R. Amidon S.J. Washington, D.C.: Catholic University of America Press, 2016.

A Scholastic Miscellany: Anselm to Ockham. Edited and translated by Eugene R. Fairweather. Philadelphia: Westminster Press, 1956.

Seuse, Heinrich (Henry Suso). *Deutsche Schriften*. Edited by Karl Bihlmeyer. Stuttgart: W. Kohlhammer, 1907. Reprint, Frankfurt a. M.: Minerva, 1961.

———. *The Exemplar, with Two German Sermons*. Translated, edited, and with an introduction by Frank Tobin. New York: Paulist Press, 1989.

Sicardus of Cremona. *Sicardus Cremonensis Chronica*. Edited by O. Holder-Egger. Monumenta Germaniae Historica, SS, vol. 31. Hannover: 1903.

Speculum uirginum. Edited by Jutta Seyfarth. CCCM 5. Turnhout: Brepols, 1990.

Texte aus der Zeit Meister Eckharts. Edited by Alessandra Beccarisi. 2 vols. Corpus Philosophorum Teutonicorum Medii Aevi 7/1–2. Hamburg: Felix Meiner Verlag, 2004.

Thiofried of Echternach (Thiofridi Abbatis Epternacensis). *Flores Epytaphii Sanctorum*. Edited by Michele Camillo Ferrari. CCCM 133. Turnhout: Berpols, 1996.

Thomas Aquinas. *In duodecim libros Metaphysicorum Aristotelis exposito*. Edited by M. R. Cathala and Raimondo M. Spiazzi. Turin: Marietti, 1964.

Thomasin von Zirclaria. *Der wälsche Gast des Thomasin von Zirclaria*. Edited by Heinrich Rückert. Bibliothek der gesammten deutschen National-Literatur, 1. Abth. 30. Quedlinburg: G. Basse, 1852.

———. *Der Welsche Gast (The Italian Guest)*. Translated and edited by Marion Gibbs and Winder McConnell. Medieval German Texts in Bilingual Editions 4. Kalamazoo, MI: Medieval Institute Publications, 2009.

Urkundenbuch des Hochstifts Halberstadt und seine Bischöfe. Edited by Gustav Schmidt, *Vierter Teil 1362-1425*. Leipzig: S. Hirzel, 1889.

Venantius Fortunatus. *Poems*. Edited and translated by Michael Roberts. Dumbarton Oaks Medieval Library 46. Cambridge, MA: Harvard University Press, 2017.

William of Conches. *A Dialogue on Natural Philosophy* (Dragmaticon Philosophiae*): Translation of the New Latin Critical Text with a Short Introduction and Explanatory Notes*. Translated by Italo Ronca and Matthew Curr. Notre Dame Texts in Medieval Culture 2. Notre Dame, IN: University of Notre Dame Press, 1997.

———. *Dragmaticon philosophiae*. Edited by Italo Ronca. Guillelmi de Conchis Opera omnia 1, CCCM 152. Turnhout: Brepols, 1997.

Secondary Sources

500 Jahre Rosenkranz 1475 Köln 1975: Kunst und Frömmigkeit im Spätmittlelater und ihr Weiterleben. Munich: Strube, 1975.

Achtner, Wolfgang, ed. *Sprachbilder und Bildersprache bei Meister Eckhart und in seiner Zeit*: Meister-Eckhart-Jahrbuch 9 (2015).

Adler, Jeremy, and Ulrich Ernst. *Text als Figur: Visuelle Poesie von der Antike bis zur Moderne*: Ausstellung im Zeughaus der Herzog August Bibliothek vom 1. September 1987-17. April 1988. Ausstellungskataloge der Herzog August Bibliothek 56. Weinheim: VCH, 1987.

Albertson, David. "The Beauty of the Trinity: Achard of St. Victor as a Forgotten Precursor of Nicholas of Cusa." *Mitteilungen und Forschungsbeiträge der Cusanus-Gesellschaft* 34 (2016): 3-20.

———. "Mapping the Space of God: Mystical Weltbilder in Nicholas of Cusa and the Structure of *De ludo globi* (1463)." In *Weltbilder im Mittelalter: Perceptions of the World in the Middle Ages*, 61–82. Bonn: Bernstein Verlag, 2009.

Amstutz, Marc. "The Genesis of Law: On the Paradox of Law's Origin and Its *supplément*." In *Law, Economics and Evolutionary Theory*, edited by Peer Zumbansen and Gralf-Peter Calliess, 226–47. Celtenham: Edward Elgar Publishing, 2011.

Anderson, Benjamin. *Cosmos and Community in Early Medieval Art*. New Haven: Yale University Press, 2017.

Anderson, Michael, and Robert McCartney. "Diagram Processing: Computing with Diagrams." *Artificial Intelligence* 145 (2003): 181–226.

Andersson-Schmidtt, Margarete, and Monica Hedlund. *Mittelalterliche Handschriften der Universitätsbibliothek Uppsala: Katalog über die C- Sammlung*, vol. 2, *C 51–200*. Acta Bibliothecae R. Universitatis Upsaliensis 26/2. Stockholm: Almqvist & Wiksell International, 1989.

Andrä, Christine, et al., eds. *750 Jahre Dominikanerinnenkloster Heilig Kreuz Regensburg: Ausstellung im Diözesanmuseum Regensburg, 22. Juli bis 18. September 1983*. Munich: Schnell + Steiner, 1983.

Angotti, Claire. "Formes et formules brèves: Enjeux de la mise en page. L'exemple des manuscrits des théologiens (XIIᵉ–XIVᵉ siècle)." In *Qu'est-ce que nommer? L'image légendée entre monde monastique et pensée scolastique*, edited by Christian Heck, Les Études du RILMA 1, 59–85. Turnhout: Brepols, 2010.

Appleby, David. "Instruction and Inspiration through Images in the Carolingian Period." In *Word, Image, Number: Communication in the Middle Ages*, edited by John J. Contreni and Santa Casciani, 85–111. Florence: SISMEL, Edizionzi del Galluzzo, 2002.

———. "Rudolf, Abbot Hrabanus, and the Ark of the Covenant Reliquary." *American Benedictine Review* 46 (1995): 419–43.

Arfé, Pasquale. "Un autografo di Silvestro II in un codice di Cusano: *Divisio philosophiae, arbor Porphiriana, remedium epilentiae*." In *Adorare caelestia, gubernare terrena: Atti del Colloquio Internazionale in onore di Paolo Lucentini (Napoli, 6-7 Novembre 2007)*, edited by Antonello Sannino et al., Instrumenta Patristica et Mediaevalia 58, 147–82. Turnhout: Brepols, 2011.

Aris, Marc-Aeilko, and Susana Bullido del Barrio, eds. *Hrabanus Maurus in Fulda: Mit einer Hrabanus Maurus-Bibliographie (1979–2009)*. Frankfurt a. M.: Verlag Josef Knecht, 2010.

Arnulf, Arwed. *Versus ad picturas: Studien zur Titulusdichtung als Quellengattung der Kunstgeschichte von der Antike bis zum Hochmittelalter*. Munich: Deutscher Kunstverlag, 1997.

Auerbach, Erich. "Figura." *Archivum Romanicum* 22 (1939): 436–89. Reprinted in *Neue Dantestudien*, Istanbuler Schriften 5 (Istanbul: A. Francke Verlag Bern, 1944), 11–71, translated as *Scenes from the Drama of European Literature*, trans. Ralph Manheim, Theory and History of Literature 9 (Minneapolis: University of Minnesota Press, 1984), 11–76, 229–37.

———. *Mimesis: The Representation of Reality in Western Literature*. Translated by Willard R. Trask, with an introduction by Edward W. Said. Princeton: Princeton University Press, 2013.

Augustyn, Wolfgang. "Die Klostergebäude von St. Ulrich und Afra vom Frühmittelalter bis zu ihrer Zerstörung." In *Benediktinerabtei St. Ulrich und Afra in Augsburg (1012-2012): Geschichte, Kunst, Wirtschaft und Kultur einer ehemaligen Reichsabtei. Festschrift zum tausendjährigen Jubiläum*, edited by Manfred Weitlauff with Walter Ansbacher and Thomas Groll, 1:657–816. 2 vols. Jahrbuch des Vereins für Augsburger Bistumsgeschichte. 45,1–2. Augsburg: Verlag des Vereins für Augsburger Bistumsgeschichte, 2010.

Baert, Barbara, ed. *Aan de vruchten kent men de boom: De boom in tekst en beeld in de middeleeuwse Nederlanden*. Symbolae 25. Leuven: Universitaire Pers, 2001.

Bagnoli, Martina. "Le fonti e I documenti per l'indagine iconografica." In *Un universo di simboli: Gli affreschi della cripta nella cattedrale di Agnani*, edited by Gioacchino Giammaria, 71–86. Rome: Viella, 2001.

———. "The Syzygy at Anagni. Measuring the Gap between Concept and Execution in Medieval Wall Painting." *Zeitschrift für Kunstgeschichte* 72 (2009): 313–28.

Bailey, Elizabeth. "Judith, Jael, and Humilitas in the *Speculum Virginum*." In *The Sword of Judith: Judith Studies across the Disciplines*, edited by Kevin R. Brine et al., 275–90. Cambridge: OpenBook Publishers, 2010.

Baker, Peter Stuart. "More Diagrams by Byrhtferth of Ramsey." In *Latin Learning and English Lore: Studies in Anglo-Saxon Literature for Michael Lapidge*, edited by Katherine O'Brian O'Keefe and Andy Orchard, 2:53–73. Toronto: University of Toronto Press, 2005.

Balace, Sophie, et al., eds. *Une renaissance. L'art entre Flandre et Champagne, 1150-1250*. Paris: Réunion des Musées nationaux, 2013.

Baladier, Charles. "Intensio de la charité et géométrie de l'infini chez Guillaume d'Auxerre." *Revue de l'histoire des religions* 225 (2008): 347–92.

Balke, Friedrich, and Hanna Engelmeier, eds. *Mimesis und Figura: Mit einer Neuausgabe des "Figura"-Aufsatzes von Erich Auerbach*. Medien und Mimesis 1. Munich: Wilhelm Fink, 2016.

Baltrušaitis, Jurgis. "La géométrie et les monstres: d'après quelques chapiteaux romans du Midi de la France." *Gazette des beaux-arts* 5 Pér. 18 (1928): 25–57.

———. *La stylistique ornementale dans la sculpture romane*. Paris: Leroux, 1931.

———. "L'image du monde céleste du II^e au XII^e siècle." *Gazette des beaux-arts* 6 Pér. 20 (1938): 137–48.

———. "Roses des vents et roses de personages à l'époque romane." *Gazette des beaux-arts* 6 Pér. 20 (1938): 265–76.

Bancel, Silvia Bara. "Das Bild bei Heinrich Seuse." In *Der Bildbegriff bei Meister Eckhart und Nikolaus von Kues*, edited by Johanna Hück et al., Texte und Studien zur europäischen Geistesgeschichte B/9, 65–80. Münster: Aschendorff, 2015.

Barré, Henri. *Prières anciennes de l'Occident a la mère du sauveur: Des origines à saint Anselme*. Paris: Lethielleux, 1963.

Bartl-Fliedl, Ilsebill, and Christoph Geissmar, eds. *Die Beredsamkeit des Leibes: Zur Körpersprache in der Kunst*. Salzburg: Residenz Verlag, 1992.

Baschet, Jérôme. "Jugment dernier: contradictions, complémentarité, chevauchement?" *Révue Mabillon*, n.s., 6 (1995): 159–203.

———. "Une image à deux temps: Jugement dernier et jugement des âmes dans l'Occident médiéval." In *Traditions et temporalités des images*, edited by Giovanni Careri et al., L'histoire et ses représentations 7, 103–24. Paris: École des hautes études en sciences sociales, 2009.

Bataillon, Louis-Jacques. "Intermédiares entre les traités de morale pratique et les sermons: les distinctiones bibliques alphabétique." In *Les Genres littéraires dans les sources théologiques et philosophiques médiévales: Définition, critique et exploitation. Actes du Colloque international de Louvain-la-Neuve, 25–27 mai 1981*, 213–26. Louvain-la-Neuve: Institut d'Études Médiévales de l'Université Catholique de Louvain, 1982.

———. "The Tradition of Nicolas of Biard's Distinctiones." *Viator* 25 (1994): 245–88.

Bataillon, Louis-Jacques, et al., eds. *Hugues de Saint-Cher († 1263): bibliste et théologien*. Bibliothèque d'histoire culturelle du Moyen Age 1. Turnhout: Brepols, 2004.

Batiffol, Pierre. *History of the Roman Breviary*. 3rd edition. Translated by Atwell M. Y. Baylay. London: Longmans, 1912.

Bauer, Gerhard. *Claustrum animae: Untersuchungen zur Geschichte der Metapher vom Herzen als Kloster*. Munich: Fink, 1973.

———. "'Deus est sphaera intellectualis infinita': Eckhart interprete del Liber XXIV philosophorum." In *Sphaera: Forma immagine e metafora tra medioevo ed età moderna*, 167–92. Florence: Olschki, 2012.

Bauer, Matthias, and Christoph Ernst. *Diagrammatik: Einführung in ein kultur- und medienwissenschaftliches Forschungsfeld*. Bielefeld: transkript Verlag, 2010.

Beccarisi, Alessandra. "'Deus est sphaera intellectualis infinita': Eckhart interprete del Liber XXIV philosophorum." In *Sphaera: Forma immagine e metafora tra medioeva ed età moderna*, 167–92. Florence: Olschki, 2012.

Becht-Jördens, Gereon. "*Litterae illuminatae*: Zur Geschichte eines literarischen Formtyps in Fulda." In *Kloster Fulda in der Welt der Karolinger und Ottonen*, Fuldaer Studien 7, 325–64. Frankfurt a. M.: J. Knecht, 1996.

Bedos-Rezak, Brigitte Miriam. *When Ego Was Imago: Signs of Identity in the Middle Ages*. Visualizing the Middle Ages 3. Leiden: Brill, 2011.

Beer, Ellen J. *Beiträge zur oberrheinischen Buchmalerei in der ersten Hälfte des 14. Jahrhunderts unter besonderer Berücksichtigung der Initialornamentik*. Basel: Birkhäuser, 1959.

———. "Die Buchkunst des Gradulae von St. Katharinenthal." In *Das Graduale von Sankt Katharinenthal: Kommentarband zur Faksimile-Ausgabe des Graduale von Sankt Katharinenthal*, edited by Alfred A. Schmidt, 103–224. Luzern: Faksimile Verlag, 1980–83.

Belting, Hans. "Zwischen Gotik und Byzanz: Gedanken zur Geschichte der sächsischen Buchmalerei im 13. Jahrhundert." *Zeitschrift für Kunstgeschichte* 41 (1978): 217–57.

Belting, Hans, and Dieter Blume, eds. *Malerei und Stadtkultur in der Dantezeit: Die Argumentation der Bilder*. Munich: Hirmer, 1989.

Belting-Ihm, Christa. "Zum Verhältnis von Bildprogrammen und Tituli in der Apsisdekoration früher westlicher Kirchenbauten." In *Testo e immagine nell'alto medioevo*, Settimane di studio del Centro italiano di studi sull'alto medioevo 41, 2:839–86. Spoleto: Il Centro italiano di studi sull'alto medioevo, 1994.

Bender, John, and Michael Marrinan. *The Culture of Diagram*. Stanford: Stanford University Press, 2010.

Bénédictins du Bouveret, ed. *Colophons de manuscrits occidentaux des origines au XVI^e siècle*. 6 vols. Spigilegii Friburgensis subsidia 2–7. Fribourg: Éditions universitaires, 1965–82.

Benesch, Evelyn. "Dedikations- und Präsentationsminiaturen in der Pariser Buchmalerei vom späten dreizehnten bis zum frühen fünfzehnten Jahrhundert." PhD. diss., University of Vienna, 1987.

Benítez, Juan Manuel Campos. "The Medieval Octagon of Opposition for Sentences with Quantified Predicates." *History and Philosophy of Logic* 35 (2014): 354–68.

Berg, Dieter. *Armut und Wissenschaft: Beiträge zur Geschichte des Studienwesens der Bettelorden im 13. Jahrhundert.* Düsseldorf: Schwann, 1977.

Berger, Susanna. *The Art of Philosophy: Visual Thinking in Europe from the Late Renaissance to the Early Enlightenment.* Princeton: Princeton University Press, 2017.

Bergmann, Ulrike. "PRIOR OMNIBUS AUTOR—An höchster Stelle aber steht der Stifter." In *Ornamenta Ecclesiae: Kunst und Künstler in der Romanik in Köln*, Katalog zur Ausstellung des Schnütgen-Museums in der Josef-Haubrich-Kunsthalle, Köln, 1985, 1:117–70. Cologne: Schnütgen-Museum, 1985.

Berliner, Rudolf. "The Freedom of Medieval Art." *Gazette des beaux-arts* 6 Pér. 28 (1945): 263–88. Reprinted in *Rudolf Berliner (1886–1967): "The Freedom of Medieval Art" und andere Studien zum christlichen Bild*, edited by Robert Suckale (Berlin: Lukas Verlag, 2003), 60–75.

Berns, Jörg Jochen. "Baumsprache und Sprachbaum. Baumikonographie als topologischer Komplex zwischen 13. und 17. Jahrhundert." In *Genealogie als Denkform in Mittelalter und Früher Neuzeit*, edited by Kilian Heck and Bernhard Jahn, 155–76, 230–46. Tübingen: Niemeyer, 2000.

Berschin, Walter. "Uodalscalc-Studien IV: Mikrokosmos und Makrokosmos bei Uodalsclalc von St. Ulrich und Afra (1124–um 1150) (Augsburg, Archiv des Bistums 78, fol. 72r)." In *Poetry and Philosophy in the Middle Ages: A Festschrift for Peter Dronke*, edited by John Marenbon, 19–27. Boston: Brill, 2001.

Beys, Béatrice. "La valeur des gestes dans les miniatures de dédicace (fin du XIVe siècle—début du XVe siècle." In *Le geste et les gestes au Moyen Âge*, Senefiance 41, 69–89. Aix-en-Provence: CUER MA, Université de Provence, Centre d'Aix, 1998. Accessed May 28, 2017. http://books.openedition.org/pup/3496?lang=fr.

Beziau, Jean-Yves, and Stephen Read. "Square of Opposition: A Diagram and a Theory in Historical Perspective." *History and Philosophy of Logic* 35 (2014): 315–16.

Bezner, Frank. *Vela veritatis: Hermaneutik, Wissen und Sprache in der "Intellectual History" des 12. Jahrhunderts.* Studien und Texte zur Geistesgeschichted des Mittelalters. Leiden: Brill, 2005.

Bidon, Danièle Alexandre, ed. *Le pressoir mystique: Actes du colloque de Récloses, 27 mai 1989.* Paris: Le Cerf, 1990.

Bigg, Charlotte. "Diagrams." In *A Companion to the History of Science*, edited by Bernard Lightman, 557–71. Oxford: Wiley Blackwell, 2016.

Binski, Paul. "The Crucifixion and the Censorship of Art around 1300." In *The Medieval World*, edited by Peter A. Linehan et al., 342–60. London: Routledge, 2003.

Bischoff, Bernhard. "Eine verschollene Einteilung der Wissenschaften." *Archives d'histoire doctrinale et littéraire du moyen âge* 25 (1958): 5–20. Reprinted in *Mittelalterliche Studien: Ausgewuahlte Aufsätze zur Schriftkunde und Literaturgeschichte* (Stuttgart: Hiersemann, 1966), 1:273–88.

———. *Katalog der festländischen Handschriften des neunten Jahrhunderts, mit Ausnahme der wisigotischen.* 3 vols. Wiesbaden: Harrassowitz, 1998–2014.

———. "Kreuz und Buch im Fruhmittelalter und in den ersten Jahrhunderten der spanischen Reconquista." In *Mittelalterliche Studien: Ausgewählte Aufsätze zur Schriftkunde und Literaturgeschichte*, 2:284–303. Stuttgart: Hiersemann, 1967–81.

———. *Manuscripts and Libraries in the Age of Charlemagne.* Translated by Michael M. Gorman. 2nd rev. ed. Cambridge: Cambridge University Press, 2007.

Blackwell, Alan F. "Diagrams about Thoughts about Thoughts about Diagrams." In *Reasoning with Diagrammatic Representations II: Papers from the AAAI 1997 Fall Symposium. Technical Report FS-97-03*, edited by Michael Anderson, 77–84. Menlo Park, CA: AAAI Press, 1997.

———, ed. *Thinking with Diagrams.* Dordrecht: Kluwer Academic Publishers, 2001. Reprinted from *Artificial Intelligence Review* 15, nos. 1–2 (2001).

Bloch, Peter. *Das Hornbacher Sakramentar und seine Stellung innerhalb der frühen Reichenauer Buchmalerei.* Basel: Birkhäuser, 1956.

———. "Dedikationsbild." *LcI* 1 (1968), cols. 491–94.

———. "Siebernarmige Leuchter in christlichen Kirchen." *Wallraf-Richartz-Jahrbuch* 23 (1961): 55–190.

Block, Ned, ed. *Imagery.* Cambridge, MA: MIT Press, 1981.

Blume, Dieter. "Körper und Kosmos im Mittelalter." In *Bild und Körper im Mittelalter*, edited by Kristin Marek et al., 225–41. Munich: Fink, 2006.

Boehm, Gottfried. *Wie Bilder Sinn erzeugen: Die Macht des Zeichens.* Berlin: Berlin University Press, 2007.

Bogen, Steffen. "Das Diagramm als Spiel: Semiotische Entdeckungen im Spielebuch von Alfons dem Weisen (1283 n. Chr.) mit einigen Beobachtungen zu Gudea als Architekt (2000 v. Chr.)." In *Diagramm und Text: Diagrammatische Strukturen und die Dynamisierung von Wissen und Erfahrung, Überstorfer Colloquium 2012*, edited by Eckhart Conrad Lutz et al., 385–412. Wiesbaden: Ludwig Reichert Verlag, 2014. Translated into English as "The Diagram as Board Game: Semiotic Discoveries in Alfonso the Wise's Book of Games (1283 CE)—with some Observations as to Gudea as Architect (2000 BCE)," in *Thinking with Diagrams: The Semiotic Basis of Human Cognition*, Semiotics, Communication and Cognition 17, edited by Sybille Krämer and Christina Ljungberg, 179–207. Berlin: De Gruyter, 2016.

———. "Verbundene Materie, geordnete Bilder: Reflexionen diagrammatischen Schauens in den Fenstern von Chartres." *Bildwelten des Wissens: Kunsthistorisches Jahrbuch für Bildkritik* 3: 72–84.

Bogen, Steffen, and Felix Thürlemann. "Jenseits der Opposition von Text und Bild: Überlegungen zu eine Theorie des Diagramms und des Diagrammatischen." In *Die Bildwelt der Diagramme Joachims von Fiore: Zur Medialität religiös-politischer Programme im Mittelalter*, edited by Alexander Patschovsky, 1–22. Ostfildern: Thorbecke, 2003.

Bois, Yve-Alain. "Not [on] Diagrams." In *Retracing the Expanded Field: Encounters between Art and Architecture*, edited by Spyros Papapetros and Julian Rose, 48–51. Cambridge, MA: MIT Press, 2014.

Bolzoni, Lina. *The Web of Images: Vernacular Preaching from its Origins to St. Bernardino da Siena*. Translated by Carole Preston and Lisa Chien. Aldershot: Ashgate, 2004. Originally published as *La rete dele immagini: Predicazione in volgare dalle origini a Bernardino da Siena* (Turin: Einaudi, 2001).

Bonne, Jean-Claude. "L'image de soi au Moyen Age (IXᵉ–XIIᵉ siècles): Raban Maur et Godefroy de Saint-Victor." In *Il ritratto e la memoria: Materiali* 2, edited by Augusto Gentili et al., 37–60. Rome: Bulzoni, 1993.

Bonniwell, William R. *A History of the Dominican Liturgy*. New York: J. F. Wagner, 1944.

Borst, Arno. *Das mittelalterliche Zahlenkampfspiel*. Supplemente zu den Sitzungsberichten der Heidelberger Akademie der Wissenschaften. Philosophisch-Historische Klasse 5. Jg. 1986. Heideberg: C. Winter, 1986.

Boskoboynikov, Oleg, ed. *Ideas of Harmony in Medieval Culture and Society*. Micrologus 25. Florence: SISMEL, Edizioni del Galluzzo, 2017.

Bosteels, Bruno. "Text to Diagram: Towards a Semiotics of Cultural Cartography." In *Semiotics 1994*, edited by C. W. Spinks and John Deely, 347–59. New York: Peter Lang, 1995.

Bouché-Leclercq, Auguste. *L'Astrologie greque*. Paris: Lerous, 1899. Reprint, Aalen: Scientia Verlag, 1979.

Boureau, Alain. "'Vitae fratrum,' 'Vitae patrum': L'ordre dominicain et le modèle des pères du desert au XIIIᵉ siècle." *Mélanges de l'Ecole française de Rome* 99 (1987): 79–100.

Boutilier, Craig. "The Influence of Influence Diagrams on Artificial Intelligence." *Decision Analysis* 2 (2005): 229–231.

Boyle, Leonard E., and Jean-Claude Schmitt, eds. *Modi orandi sancti Dominici: die Gebets- und Andachtsgesten des heiligen Dominikus. Eine Bilderhandschrift, Cod. Ross. 3(1)*. Zürich: Belser, 1995.

Boynton, Susan. "Rewriting the Early Sequence: 'Aureo flore' and 'Aurea virga.'" *Comitatus: A Journal of Medieval and Renaissance Studies* 25 (1994): 21–42.

Brady, Ignatius. "The Rubrics of Peter Lombard's Sentences." *Pier Lombardo* 6 (1962): 5–25.

Bredekamp, Horst. "The Picture Act: Tradition, Horizon, Philosophy." In *Bildakt at the Warburg Institute*, edited by Sabine Marienberg and Jürgen Trabant, Actus et Imago 12, 3–32. Berlin: De Gruyter, 2014.

Bremmer, Jan N., and Marco Formisano, eds. *Perpetua's Passions: Multidisciplinary Approaches to the Passio Perpetuae et Felicitatis*. Oxford: Oxford University Press, 2012.

Bretscher-Gisiger, Charlotte, and Rudolf Gamper. *Katalog der mittelalterlichen Handschriften des Klosters Wettingen*. Dictikon: Urs Graf Verlag, 2009.

Bright, David F. "Carolingian Hypertext: Visual and Textual Structures in Hrabanus Maurus, *In honorem Sanctae Crucis*." In *Classics Renewed: Reception and Innovation in the Latin Poetry of Late Antiquity*, edited by Scott McGill and Joseph Pucci, 355–83. Heidelberg: Winter, 2016.

Brilliant, Virginia. "Envisaging the Particular Judgment in Late-Medieval Italy." *Speculum* 84 (2009): 314–46.

Brittain, Charles. "No Place for a Platonist Soul in Fifth-Century Gaul? The Case of Mamertus Claudianus." In *Society and Culture in Late Antique Gaul: Revisiting the Sources*, edited by Ralph W. Mathisen and Danuta Schanzer, 239–62. Aldershot: Ashgate, 2001.

Brockett, Clyde. "The Frontispiece of Paris, Bibliothèque nationale, ms. lat. 776: Gerbert's Acrostic Pattern Poems." *Manuscripta* 29–40 (1995): 3–25.

Bromberg, Sarah Emily. "The Context and Reception History of the Illuminations in Nicholas of Lyra's *Postilla litteralis super totam bibliam*: Fifteenth-Century Case Studies." PhD diss., University of Pittsburgh, 2012.

Brousset, Michel, and Béatrice Bourgerie, eds. *Le parement d'autel: Anatomie d'un chef-d'oeuvre du XIVᵉ siècle des Cordeliers de Toulouse*. Paris: Somogy; Toulouse: Musée Paul-Dupuy, 2012.

Brown, James Robert. "Naturalism, Pictures, and Platonic Intuitions." In *Visualization, Explanation and Reasoning Styles in Mathematics*, edited by Paolo Mancosu, 57–73. Basel: Springer, 2005.

Bruhat, Marie-Odile. "Les Carmina figurata de Pvblivs Optatianvs Porfyrivs. La métamorphose d'un genre et l'invention d'une poésie liturgique impériale sous Constantin." PhD diss., Paris IV, 1999.

———. "Les poèmes figurées d'Optatianus Porfyrius: une écriture à contraintes, une éla contrainte." In *Formes de l'écriture, figures de la pensée dans la culture gréco-romaine*, edited by Françoise Toulze-Morisset, 101–25. Villeneuve d'Ascq: Université Charles-de-Gaulle-Lille 3, 2009.

Bucher, Sebastian. "Das Diagramm in den Bildwissen-schaften: Begriffsananalytische, gattungstheoretische und anwendungsorientierte Ansätze in der diagrammtheoretischen Forschung." In *Verwandte Bilder: Die Fragen der Bildwissenschaft*, edited by Ingeborg Reichle et al., 113–29. Berlin: Kunstverlag Kadmos, 2007.

Buchmann, Sabeth, and Rike Frank, eds. *Textile Theorien der Moderne: Alois Riegl in der Kunstkritik*. Berlin: B_books, 2015.

Buettner, Brigitte. "Images, diagramme et savoirs encyclopédiques." In *Les images dans l'occident médiéval*, edited by Jérôme Baschet and Pierre-Olivier Dittmar, L'atelier du médiéviste 14, 389–96. Turnhout: Brepols, 2015.

Bultot, Robert. "Konrad von Hirsau." In *²VL* 5 (1985), cols. 204–8.

Bunge, Matthias. *Zwischen Intuition und Ratio: Pole des bildnerischen Denkens bei Kandisnsky, Klee und Beuys*. Stuttgart: Franz Steiner, 1996.

Burger, Lilli. *"Mulier Amicta Sole" in der Kunst des Mittelalters*, Inaugural-Dissertation zur Erlangung der Doktorwürde einer Hohen Philosophischen Fakultät der Ruprecht-Karls-Universität zu Heidelberg. Speyer a. Rh.: Pilger-Drückerei, 1937.

Burnham, Jack. *The Structure of Art*. Revised edition. 1971; repr., New York: George Braziller, 1973.

Bynum, Caroline Walker. "Seeing and Seeing Beyond: The Mass of St. Gregory in the Fifteenth Century." In *The Mind's Eye: Art and Theological Argument in the Middle Ages*, edited by Jeffrey F. Hamburger and Anne-Marie Bouché, 208–40. Princeton: Department of Art and Archaeology, 2006.

Byrne, Donal. "Manuscript Ruling and Pictorial Design in the Work of the Limbourgs, the Bedford Master, and the Boucicaut Master." *Art Bulletin* 66 (1984): 118–36.

Cahn, Walter. "Architectural Draftsmanship in Twelfth-Century Paris: The Illustrations of Richard of Saint-Victor's commentary on Ezekiel's Temple Vision." In *Essays in Honor of Sumner McKnight Crosby*, edited by Pamela Z. Blum, Gesta 15, 247–56. New York: International Center of Medieval Art, 1976.

———. "Architecture and Exegesis: Richard of St.-Victor's Ezekiel Commentary and its Illustrations." *Art Bulletin* 76 (1994): 33–68. Reprinted in *Studies in Medieval Art and Interpretation* (London: Pindar, 2000), 369–406.

———. "Ascending to and Descending from Heaven: Ladder Themes in Early Medieval Art." *Santi e demoni nell'Alto Medioevo occidentale (Secoli V–XI)*, Settimane di studio del Centro italiano di studi sull'alto medioevo (Spoleto: Il Centro italiano di studi sull'alto medioevo, 1989), 697–724.

———. "Focillon's Jongleur." *Art History* 18 (1995): 345–62.

———. "Notes on the Illustrations of Ezekiel's Temple Vision in the 'Postilla litteralis' of Nicholas of Lyra." In *Between Judaism and Christianity: Art Historical Essays in Honor of Elisheva (Elisabeth) Revel-Neher*, edited by Katrin Kogman-Appel, 155–70. Leiden: Brill, 2009,

———. "Schapiro and Focillon." *Gesta* 41 (2002): 129–36.

Caiazzo, Irene. "Harmonie et mathématique dans le cosmos du XIIᵉ siècle." *Micrologus* 25 (2017): 121–47.

Cain, Steven Robert. "The Standing of the Soul: The Search for a Middle Being between God and Matter in the *De Statu Animae* of Claudianus Mamertus." PhD diss., Boston College Electronic Dissertation, 2016. Accessed October 31, 2016. http://hdl.handle.net/2345/bc-ir:105066.

Calabuig, Ignazio. "*Stella maris* da Girolamo a Bernardo: Schede per un repertorio." *Marianum* 54 (1992): 411–28.

Camille, Michael. "The Discourse of Images in Philosophical Manuscripts of the Middle Ages." In *Album: I luoghi dove si accumulano i segni. Dal manoscritto alle reti telematiche. Atti del convegno di studio della Fondazione Ezio Franceschini e della Fondazione IBM Italia, Certosa del Galluzzo, 20-21 ottobre 1995*, edited by Claudio Leonardi et al., 93–110. Spoleto: Il Centro italiano di studi sull'alto medioevo, 1996.

———. "The Dissenting Image: A Postcard from Matthew Paris." In *Criticism and Dissent in the Middle Ages*, edited by, Rita Copeland, 115–50. Cambridge: Cambridge University Press, 1996.

———. "'How New York stole the Idea of Romanesque Art': Medieval, Modern and Postmodern in Meyer Schapiro." *Oxford Art Journal* 17 (1994): 65–75.

———. "Illuminating Thought: The Trivial Arts in British Library, Burney Ms. 275." In *New Offerings, Ancient Treasures: Studies in Medieval Art for George Henderson*, 343–66. Thrup, Stroud, Gloucester: Sutton, 2001.

———. *Image on the Edge: The Margins of Medieval Art*. Cambridge, MA: Harvard University Press, 1992.

———. "Visualising in the Vernacular: A New Cycle of Early Fourteenth-Century Bible Illustrations." *Burlington Magazine* 13 (1988). 97 106.

Campe, Rüdiger. "Shapes and Figures—Geometry and Rhetoric in the Age of Evidence." *Monatshefte* 102, no. 3 (2010): 285–99.

Canal, José Maria. *Salve regina misericordiae: Historia y legendas en torno a esta antifona "Salve Regina."* Rome: Edizioni di storia e letteratura, 1963.

Carmassi, Patrizia. "Purpurismum in martyrio. Die Farbe des Blutes in mittelalterlichen Handschriften." In *Farbe im Mittelalter: Materialität–Medialität–Semantik*, edited by Ingrid Bennewitz and Andrea Schindler, Akten des 13. Symposiums des Mediävis-

tenverbandes vom 1. bis 5. März in Bamberg, 1:251–74. Berlin: Akademie Verlag, 2011.

———. "Übergänge: Ornamente und Diagramme zwischen Text, Buchstabe und Bild in Handschriften des frühen Mittelalters." In *Diagramme im Gebrauch (Das Mittelalter: Perspektiven mediävistischer Forschung* 22/2), edited by Henrike Haug et al., 408–30. Berlin: De Gruyter, 2017.

Carrier, David. "Towards a Structuralist Analysis of Baroque Art." *Source: Notes in the History of Art* 27 (2008): 32–36.

Carruthers, Mary J. *The Book of Memory: A Study of Memory in Medieval Culture.* Cambridge: Cambridge University Press, 1990.

———. *The Craft of Thought: Meditation, Rhetoric, and the Making of Images 400–1200.* Cambridge Studies in Medieval Literature 34. Cambridge: Cambridge University Press, 1998.

———. *The Experience of Beauty in the Middle Ages.* Oxford: Oxford University Press, 2013.

———. "Moving Images in the Mind's Eye." In *The Mind's Eye: Art and Theological Argument in the Middle Ages*, edited by Jeffrey F. Hamburger and Anne-Marie Bouché, 287–305. Princeton: Department of Art and Archaeology, 2006.

Carruthers, Mary, and Jan M. Ziolkowski, eds. *The Medieval Craft of Memory: An Anthology of Texts and Pictures.* Philadelphia: University of Pennsylvania Press, 2002.

Cavicchi, Elizabeth. "Reflections on the Teaching of Gerbert of Aurillac." In *Orbe Novus: Astronomia e Studi Gerbertiani* 1, edited by Costantino Sigismondi, 7–21. Rome: Universitalia, 2010.

Caviness, Madeline H. "Images of Divine Order and the Third Mode of Seeing." *Gesta* 22 (1983): 99–120.

Châtelet, Gilles. *Figuring Space: Philosophy, Mathematics and Physics.* Translated by Robert Shore and Muriel Zagha, with an introduction by Kenneth J. Knoespel. Science and Philosophy 8. Dordrecht: Kluwer Academic Publishers, 2000. Originally published as *Les enjeux du mobile: Mathématique, physique, philosophie* (Paris: Editions du Seuil, 1993).

Châtillon, François. "L'héritage littéraire de Richard de Saint-Laurent." *Revue du Moyen Âge latin* 2 (1946): 149–166.

Chazelle, Celia. *The Crucified God in the Carolingian Era: Theology and Art of Christ's Passion.* Cambridge: Cambridge University Press, 2001.

———. "Figure, Character, and the Glorified Body in the Carolingian Eucharistic Controversy." *Traditio* 47 (1992): 1–35.

———. "Memory, Instruction, Worship: 'Gregory's Influence' on Early Medieval Doctrines of the Artistic Image." In *Gregory the Great: A Symposium*, edited by John J. Cavadini, 181–215. Notre Dame, IN: University of Notre Dame Press, 1995.

Chiaradonna, Riccardo. "What Is Porphyry's Isagoge?" In *Documenti e studi sulla tradizione filosofica medievale* 19 (2008): 1–30.

Chiodo, Sonia, ed. *Ad usum fratris . . . : Miniature nei manoscritti laurenziani di Santa Croce (secoli XI–XIII).* With an introduction by Ida Giovanna Rao. Florence: Mandragora, 2016.

Ciggaar, Krynie. "The Dedication Miniatures in the Egmond Gospels: A Byzantinizing Iconography?" *Quaerendo* 16 (1986): 30–62.

Clark, Andy, and David Chalmers. "The Extended Mind." *Analysis* 58 (1998): 7–19.

Clark, Willene B. "Three Manuscripts for Clairmarais: A Cistercian Contribution to Early Gothic Figure Style." In *Studies in Cistercian Art and Architecture* 3, edited by Meredith Parsons Lillich, 97–110. Kalamazoo, MI: Cistercian Publications, 1987.

Classen, Theo. "Bemerkungen zum Kollektar der Straßburger Dominikanerin Margareta Widmann von 1495 in der Universitätsbibliothek Bonn." *Wahrheit und Wert in Bildung und Erziehung* 1 (1955): 126–34.

Clayton, Mary. *The Cult of the Virgin Mary in Anglo-Saxon England.* Cambridge Studies in Anglo-Saxon England 2. Cambridge: Cambridge University Press, 1990.

Cleaver, Laura. *Education in Twelfth-Century Art and Architecture: Images of Learning in Europe, c.1100–1220.* Woodbridge, UK: Boydell Press, 2016.

———. *Illuminated History Books in the Anglo-Norman World, 1066–1272.* Oxford: Oxford University Press, 2018.

———. "On the Nature of Things: The Content and Purpose of Walters W.73 and Decorated Treatises on Natural Philosophy in the Twelfth Century." *Journal of the Walters Art Museum* 68/69 (2010–11): 21–30.

Cochrane, Laura E. "Secular Learning and Sacred Purpose in a Carolingian Copy of Boethius's De institutione arithmetica (Bamberg, Staatsbibliothek, Msc. Class. 5)." *Peregrinations: Journal of Medieval Art and Architecture* 5 (2015): 1–36. Available online at urn:nbn:de:bvb:22-dtl-0000025360 (accessed December 26, 2018).

Cohen, Adam. *The Uta Codex: Art, Philosophy, and Reform in Eleventh-Century Germany.* University Park: Pennsylvania State University Press, 2000.

Cohen, Simona. *Transformations of Time and Temporality in Medieval and Renaissance Art.* Brills' Studies in Intellectual History 228/6. Leiden: Brill, 2014.

Constable, Giles. "The Popularity of Twelfth-Century Spiritual Writers in the Late Middle Ages." In *Renaissance: Studies in honor of Hans Baron*, edited by Anthony Molho and John A. Tedeschi, 3–28. Florence: G. C. Sansoni, 1971.

Copeland, Rita, and Ineke Sluiter, eds. *Medieval Grammar and Rhetoric: Language Arts and Literary Theory, AD 300–1475*. Oxford: Oxford University Press, 2009.

Correia, Manuel. "Boethius on the Square of Opposition." In *Around and Beyond the Square of Opposition*, edited by Jean-Yves Béziau and Dale Jacquette, 41–52. Basel: Springer, 2012.

Corso, John J. "What Does Greimas's Semiotic Square Really Do?" *Mosaic: A Journal for the Interdisciplinary Study of Literature* 47 (2014): 69–89.

Cotter-Lynch, Margaret. *Saint Perpetua across the Middle Ages*. London: Palgrave Macmillan, 2016.

Courcelle, Pierre. "Étude critique sur les commentaires de la Consolation de Boèce (IXᵉ–XVᵉ siècle)." *Archives d'histoire doctrinale et littéraire du moyen âge* 14 (1939): 5–140.

———. *La Consolation de Philosophie dans la tradition littéraire: Antécédents et postérité de Boèce*. Paris: Études Augustiniennes, 1967.

Curschmann, Michael. "Epistemological Perspectives at the Juncture of Word and Image in Medieval Books before 1300." In *Multi-Media Compositions from the Middle Ages to the Early Modern Period*, edited by Margriet Hoogvliet, Groningen Studies in Cultural Exchange 9, 1–14. Leuven: Peeters, 2004.

———. *Wort–Bild–Text: Studien zur Medialität des Literarischen in Hochmittelalter und früher Neuzeit*. 2 vols. Saecula Spiritalia 43. Baden-Baden: Valentin Koerner, 2007.

Dahan, Gilbert. "Genres, Forms and Various Methods in Christian Exegesis of the Middle Ages." In *Hebrew Bible, Old Testament: The History of its Interpretation*, edited by Magne Sæbø. Göttingen: Vandenhoeck & Ruprecht, 1996.

dalli Regoli, Gigetta. "Testimonianze relative al Volto Santo e alla Croce nei manoscritti lucchesi." In *Lucca, il Volto Santo e la civiltà medievale: Atti del convegno internazionale di studi, Lucca, Palazzo Pubblico 21–23 ottobre 1982, Accademia lucchese di scienze, lettere ed arti*, 95–108. Lucca: M. Pacini Fazzi, 1984.

d'Alverny, Marie-Thérèse. "Le cosmos symbolique du XIIᵉ siècle." *Archives d'histoire doctrinale et littéraire du moyen âge* 28 (1953): 31–81.

Daly, Peter M., ed. *Companion to Emblem Studies*. New York: AMS Press, 2008.

D'Amato, Alfonso. *La devozione a Maria nell'Ordine domenicano*. Bologna: Edizioni Studi Domenicano, 1984.

Damrosch, David. "Auerbach in Exile." *Comparative Literature* 47 (1995): 97–117.

Dane, Joseph A. "The Red and the Black." In *Blind Impressions: Methods and Mythologies in Book History*, 149–55, 204–205. Philadelphia: University of Pennsylvania Press, 2013.

———. "Two-Color Printing in the Fifteenth Century as Evidenced by Incunables at the Huntington Library." *Gutenberg Jahrbuch* (1999): 131–45.

Darlington, Oscar G. "Gerbert, the Teacher." *American Historical Review* 52 (1947): 456–76.

Daston, Lorraine, and Peter Gallison. *Objectivity*. New York: Zone Books, 2007.

Davis, Philip. "Visual Theorems." *Educational Studies in Mathematics* 24 (1993): 333–44.

Debiais, Vincent Aurélien. "Carolingian Verse Inscriptions and Images: From Aesthetics to Efficiency." *Convivium: Exchanges and Interactions* 1, no. 2 (2014): 89–101.

De Fraja, Valeria. "*Figurae tra littera e spiritus*: Il *tabernaculum* di Mosè e le sue rappresentazioni medievali (da Cosmas Indicopleustes ad Adam di Dryburgh)." In *Pensare per figure: Diagrammi e simboli in Gioacchino da Fiore*, edited by Alessandro Ghisalberti, Opera di Gioacchino da Fiore: testi e strumenti 23, 47–65. Rome: Viella, 2010.

de Freitas, Elizabeth. "The Diagram as Story: Unfolding the Event-Structure of the Mathematical Diagram." *For the Learning of Mathematics* 32, no. 2 (2012): 27–33.

de Hamel, Christopher. *Liberna Foundation: Catalogue of Miniatures and Manuscripts*. Hilversum: Liberna Foundation, 1982.

Deleuze, Gilles, and Félix Guattari. *Thousand Plateaus: Capitalism and Schizophrenia*, trans. Brian Massumi. New York: Continuum, 1987. Originally published as *Capitalisme et Schizophrénie*, vol. 2, *Mille Plateaux* (Paris: Les Éditions de Minuit, 1980).

———. *Rhizome: Introduction*. Paris: Les Éditions de Minuit, 1977.

Deloignon, Olivier. "Un modèle de virtuosité typographique humaniste: Raban Maur, *Louanges de la sainte croix*, Pforzheim, Thomas Anshelm, 1503." In *Strasbourg, ville de l'imprimerie: L'édition princeps aux XVᵉ et XVIᵉ siècles (textes et images)*, edited by Edith Karagiannis-Mazeaud, Bibliologia 44, 69–80. Turnhout: Brepols, 2017.

de Lubac, Henri. *Medieval Exegesis*. Translated by Edward M. Macierowski and Mark Debanc. 3 vols. Grand Rapids, MI: Eerdmans, 1998–2009.

Denery, Dallas G., II. "The Preacher and His Audience: Dominican Conceptions of the Self in the Thirteenth Century." In *Acts and Texts: Performance and Ritual in the Middle Ages and the Renaissance*, edited by Laurie Postlewate and Wim N. W. Hüsken, 17–34. Amsterdam: Rodopi, 2007.

Denis, Michel. "Arrows in Diagrammatic and Navigational Spaces." In *Representations in Mind and World: Essays Inspired by Barbara Tversky*, edited by Jeffrey M. Zacks and Holly A. Taylor, 63–84. New York: Routledge, 2018.

Depner, Hanno. *Zur Gestaltung von Philosophie: Eine diagrammatische Kritik*. Bielefeld: transcript, 2016.

Derolez, Albert. "Observations on the Aesthetics of the Gothic Manuscript." *Scriptorium* 50 (1996): 3–12.

Deshman, Robert. "Another Look at the Disappearing Christ: Corporeal and Spiritual Vision in Early Medieval Images." *Art Bulletin* 79 (1997): 518–46.

Devriendt, Jean. "Du triangle au Psaltérion: l'apport de Joachime de Flore à l'une des representations majeures de la Trinité." In *Pensare per figure: Diagrammi e simboli in Gioacchino da Fiore*, edited by Alessandro Ghisalberti, Opera di Gioacchino da Fiore: testi e strumenti 23, 187–202. Rome: Viella, 2010.

De Waal, Cornelis. *Peirce: A Guide for the Perplexed*. London: Bloomsbury Academic, 2013.

Dieter, Otto. "*Arbor picta*: The Medieval Tree of Preaching." *Quarterly Journal of Speech* 51 (1965): 123–44.

Dietmaring, Ursula. "Die Bedeutung von Rechts und Links in theologischen und literarischen Texten bis um 1200." *Zeitschrift für Deutsches Altertum und deutsche Literatur* 98 (1969): 265–92.

Dölger, Franz Joseph. *Sphragis: Eine altchristliche Taufbezeichnung in ihren Beziehungen zur profanen und religiösen Kultur des Altertums*. Studien zur Geschichte und Kultur des Altertums 5/3–4. Paderborn: Ferdinand Schöningh, 1911.

Donadieu-Rigaut, Dominique. *Penser en images les ordres religieux (XIIe–XVe siècles)*. Paris: Arguments, 2005.

Douteil, Herbert. *Die Concordantiae caritatis des Ulrich von Lilienfeld: Edition des Codex Campililiensis 151 (um 1355)*. Edited by Rudolf Suntrup et al. 2 vols. Münster: Aschendorff, 2010.

Dronke, Peter. "Tradition and Innovation in Medieval Western Colour-Imagery." In *The Realm of Colour/ Die Welt der Farben/Le monde des couleurs*, edited by Adolf Portmann and Rudolf Ritsema, Eranos Yearbook 41, 51–108. Leiden: Brill, 1972.

Drucker, Johanna. *Diagrammatic Writing*. Banff: Visual Writing/ubu editions, 2013.

Dufour, Jean. "La composition de la bibliothèque de Moissac à la lumière d'un inventaire du XVIIᵉ siècle nouvellement découvert." *Scriptorium* 35 (1981): 175–226.

Dünninger, Josef. "Das himmlische Jerusalem." *Württembergisch-Franken* 56 (1972): 61–72.

Dupuis, Joachim Daniel. *Gilles Deleuze, Félix Guattari et Gilles Châtelet: De l'expérience diagrammatique*. Paris: L'Harmattan, 2012.

Dürrig, Walter. *Imago: Ein Beitrag zur Terminologie und Theologie der Römischen Liturgie*. Münchener Theologische Studien: Systematische Abteilung 5. Munich: Karl Zink, 1952.

Duval, André. "La dévotion mariale dans l'Ordre des Frères Prècheurs." In *Maria: Études sur la sainte Vierge*, edited by Hubert du Manoir, 2:737–82.

Paris: Beauschesne et Fils, 1949–64.

Duys, Kathryn A. "Reading Royal Allegories in Gautier de Coinci's Miracles de Nostre Dame: The Soissons Manuscript (Paris, BnF, n.a. fr. 24541)." In *Collections in Context: The Organization of Knowledge and Community in Europe*, edited by Karen Fresco and Anne D. Hedeman, 208–36. Columbus: Ohio State University Press, 2011.

Eastwood, Bruce S. *Ordering the Heavens: Roman Astronomy and Cosmology in the Carolingian Renaissance*. History of Science and Medicine Library 4; Medieval and Early Modern Science 8. Leiden: Brill, 2007.

Eastwood, Bruce S., and Gerd Graßhoff. "Planetary Diagrams—Descriptions, Models, Theories. From Carolingian Deployments to Copernican Debates." In *The Power of Images in Early Modern Science*, edited by Wolfgang Lefèvre et al., 197–226. Basel: Birkhäuser, 2003.

———. *Planetary Diagrams for Roman Astronomy in Medieval Europe, ca. 800–1500*. Transactions of the American Philosophical Society 94/3. Philadelphia: American Philosophical Society, 2004.

Ebbesen, Sten. "What Counted as Logic in the Thirteenth Century." In *Methods and Methodologies: Aristotelian Logic East and West, 500–1500*, edited by Margaret Cameron and John Marenbon, Investigating Medieval Philosophy 2, 93–107. Leiden: Brill, 2011.

Eco, Umberto. "From Metaphor to *Analogia Entis*." In *From the Tree to the Labyrinth: Historical Studies on the Sign and Interpretation*, translated by Anthony Oldcorn, 116–70. Cambridge, MA: Harvard University Press, 2014.

———. "From the Tree to the Labyrinth." In *From the Tree to the Labyrinth: Historical Studies on the Sign and Interpretation*, translated by Anthony Oldcorn, 3–94. Cambridge, MA: Harvard University Press, 2014. Originally published as "Dall'albero al labirinto: Studi storici sul segno e l'interpretazione," in *Luoghi del silenzio imparziale: labirinto contemporaneo*, edited by Achille Bonito Oliva (Milan: Bompiani, 2008).

———. "Jerusalem and the Temple as Signs in Medieval Culture." In *Knowledge through Signs: Ancient Semiotic Theories and Practices*, edited by Giovanni Manetti, 329–44. Turnhout: Brepols, 1996.

———. "La ligne et le labyrinthe: les structures de la pensée latine." In *Civilisation latine*: *Des temps anciens au monde moderne*, edited by Georges Duby, 27–58. Paris: Orban, 1986.

Eggenberger, Christoph. "Psalterium eines Cistercienser-Klosters der Baseler Diözese um 1260: Besançon, Bibliothèque municipale, Ms. 54." *Baseler Zeitschrift für Geschichte und Altertumskunde* 110 (2010): 37–53.

Ehlen, Oliver. "Venantius Fortunatus und das Heilige Kreuz: Das Figurengedicht Carmen II 4." *Studia patristica* 48 (2010): 315–20.

Elkins, James. *The Domain of Images.* Ithaca, NY: Cornell University Press, 1999.

———. "Logic and Images in Art History." *Perspectives on Science* 7 (1999): 151–80.

Embach, Michael. *Die Kreuzesschrift des Hrabanus Maurus "De laudibus sanctae crucis."* Mitteilungen und Verzeichnisse aus der Bibliothek des Bischöflichen Priesterseminars zu Trier 23. Trier: Paulinus, 2007.

Engel, Franz. "*Epistêmy* und andere Grotesken." In *Das bildnerische Denken: Charles S. Peirce*, edited by Franz Engel et al., Actus et Imago 5, 149–85. Berlin: Akademie Verlag, 2012.

———. "The Peircean Labyrinth." In *My Brain Is in My Inkstand: Drawing as Thinking and Process*, curated by Nina Samuel, 26–31. Bloomfield Hills: Cranbrook Art Museum, 2014.

Engel, Franz, et al., eds. *Das bildnerische Denken: Charles S. Peirce.* Actus et Imago 5. Berlin: Akademie Verlag, 2012.

Engels, David. "Geometrie und Philosophie—zur Visualisierung metaphysischer Konzepte durch räumliche Darstellungen in der pythagoreischen Philosophie." In *Vom Bild zur Erkenntnis? Visualisierungskonzepte in den Wissenschaften*, edited by Dominik Groß and Stefanie Westermann, 113–29. Kassel: Kassel University Press, 2007.

Englebretsen, George. *Line Drawings for Logic: Drawing Conclusions.* Problems in Contemporary Philosophy 40. Lewiston: Edwin Mellen Press, 1998.

Ensmenger, Nathan. "The Multiple Meanings of a Flowchart." *Information & Culture* 51, no. 3 (2016): 321–51.

Ernst, Ulrich. *Carmen figuratum: Geschichte des Figurengedichtrs von den antiken Ursprüngen bis zum Ausgang des Mittelalters.* Picture & poësis 1. Cologne: Böhlau, 1991.

———. "Das Diagramm als visueller Text bei Joachim von Fiore: Zur Medialität und Mnemonik des Liber figurarum." In *Pensare per figure: Diagrammi e simboli in Gioacchino da Fiore*, edited by Alessandro Ghisalberti, Opera di Gioacchino da Fiore: testi e strumenti 23, 159–85. Rome: Viella, 2010.

———. "Die Kreuzgedichte des Hrabanus Maurus als multimediales Kunstwerk: Textualität, Ikonizität, Numeralität." In *Wissen und neue Medien: Bilder und Zeichen von 800 bis 2000*, edited by Ulrich Schmitz, Philologische Studien und Quellen 177, 13–37. Berlin: Erich Schmidt, 2003.

———. "Text und Intext: Textile Metaphorik und Poetik der Intextualität am Beispiel visueller Dichtungen der Spätantike und des Frühmittelalters." In ›Textus‹ im Mittelalter: Komponenten und Situationen des

Wortgebrauchs im schriftsemantischen Feld, edited by Ludolf Kuchenbuch and Uta Kleine, Veröffentlichungen des Max-Planck-Instituts für Geschichte 216, 43–73. Göttingen: Vandenhoeck & Rupprecht, 2006.

———, ed. *Visuelle Poesie: Historische Dokumentation, theoretischer Zeugnisse* 1: *Von der Antike bis zum Barock.* With Oliver Ehlen and Susanne Gramatzki. Berlin: De Gruyter, 2012.

———. "Zahl und Maß in den Figurengedichten der Antike und des Frühmittelalters: Beobachtungen zur Entwicklung tektonischer Bauformen." In *Intermedialität im europäischen Kulturzusammenhang: Beiträge zur Theorie und Geschichte der visuellen Lyrik*, edited by Ulrich Ernst, Allgemeine Literaturwissenschaft: Wuppertaler Schriften 4, 23–43. Berlin: Erich Schmidt, 2002.

Esmeijer, Anna C. *Divina Quaternitas: A Preliminary Study in the Method and Application of Visual Exegesis.* Amsterdam: Van Gorcum Assen, 1978.

Evans, Gillian. "The Rithmomachia: A Mediaeval Mathematical Teaching Aid?" *Janus* 63 (1976): 257–73.

———. "The 'Sub-Euclidean' Geometry of the Earlier Middle Ages, up to the Mid-Twelfth Century." *Archive for History of Exact Sciences* 16 (1976): 105–18.

Evans, Michael. "Fictive Painting in Twelfth-Century Paris." In *Sight and Insight: Essays on Art and Culture in Honour of E.H. Gombrich at 85*, edited by John Onians, 73–87. London: Phaidon, 1994.

———. "The Geometry of the Mind." *Architectural Association Quarterly* 12 (1980): 32–55.

———. "An Illustrated Fragment of Peraldus's *Summa* of Vice: Harleian MS 3244." *Journal of the Warburg and Courtauld Institutes* 45 (1982): 14–68.

Even-Ezra, Ayelet. "Schemata as Maps and Editing Tools in Thirteenth-Century Scholasticism." *Manuscripta* 61 (2017): 21–71.

———. "Visualizing Narrative Structure in the Medieval University: *Divisio textus* Revisited." *Traditio* 72 (2017): 341–76.

Falk, Birgitta. "Bildnisreliquiare: Zur Entstehung und Entwicklung der metallenen Kopf-, Büsten- und Halbfigurenreliquiare im Mittelalter." *Aachener Kunstblätter* 59 (1991–93): 99–238.

Fassler, Margot E. *Gothic Song: Victorine Sequences and Augustinian Reform in Twelfth-Century Paris.* 2nd ed. Notre Dame: University of Notre Dame Press, 2011.

———. "Mary's Nativity, Fulbert of Chartres, and the *Stirps Jesse*: Liturgical Innovation circa 1000 and Its Afterlife." *Speculum* 75 (2000): 389–434.

———. "Music and the Miraculous: Mary in the Mid-Thirteenth-Century Dominican Sequence Repertory." In *Aux origines de la liturgie dominicaine: Le manuscrit Santa Sabina XIV L 1*, edited by Leonard E. Boyle and Pierre-Marie Gy, Collection de

l'École Française de Rome 327; Document, Études et Répertoires 67, 229–78. Rome: CNRS/École Française de Rome, 2004.

Fer, Briony. *The Infinite Line: Re-Making Art after Modernism*. New Haven: Yale University Press, 2004.

Ferrari, Michele Camillo. "Gold und Asche: Reliquie und Reliquiare als Medien in Thiofrid von Echternachs Flores epytaphii sanctorum." In *Reliquiare im Mittelalter*, edited by Bruno Reudenbach and Gia Toussaint, 2nd ed., 61–74. Berlin: Akademie Verlag, 2011.

———. *Il "Liber sanctae crucis" di Rabano Mauro: Testo—immagine—contesto*. Lateinische Sprache und Literatur des Mittelalters 30. Bern: Peter Lang, 1999.

———. "'Lemmata sanctorum': Thiofrid d'Echternach et le discours sur les reliques au XIIᵉ siècle." *Cahiers de civilisation médiévale* 38 (1995): 215–25.

Finckh, Ruth. *Minor Mundus Homo: Studien zur Mikrokosmos-Idee in der mittelalterlichen Literatur*. Paelestra: Untersuchungen aus der deutschen und skandanavischen Philologie 306. Göttingen: Vandenhoeck & Rupprecht, 1999.

Fingernagel, Andreas. "'De fructibus carnis et spiritus': Der Baum der Tugenden und der Laster im Ausstattungsprogramm einer Handschrift des 'Compendiums' des Petrus Pictaviensis (Wien, Österreichische Nationalbibliothek, Cod. 12538)." *Wiener Jahrbuch für Kusntgeschichte* 46–47 (1993–94): 173–87.

Flint, Valerie I. J. "The 'Elucidarius' of Honorius Augustodunensis and Reform in Late Eleventh Century England." In *Ideas in the Medieval West: Texts and Contexts*, Variorum Collected Studies Series 268, 178–98. London: Variorum Reprints, 1988.

———. "Honorius Augustodunensis (d. c.1140)." *Oxford Dictionary of National Biography*. Oxford: Oxford University Press, 2004. Accessed November 5, 2017. http://www.oxforddnb.com.ezp-prod1.hul.harvard.edu/view/article/53485.

Folkerts, Menso. "Hermanns Schrift über das Zahlenkampfspiel (Rithmomachie)." In *Hermann der Lahme: Reichenauer Mönch und Universalgelehrter des 11. Jahrhunderts*, edited by Felix Heinzer and Thomas Zotz, Veröffentlichungen der Kommission für geschichtliche Landeskunde in Baden-Württemberg. Reihe B 208, 243–58. Stuttgart: W. Kohlhammer, 2016.

———. "'Rithmomachia,' a Mathematical Game from the Middle Ages." In *Essays on Early Medieval Mathematics. The Latin Tradition*. Aldershot: Ashgate; Burlington, VT: Variorum, 2003.

———. "La rithmomachie et le manuscrit Avranches 235." In *Science antique, Science médiévale (autour d'Avranches 235)*, edited by Louis Callebat and Olivier Desbordes, Actes du Colloque International, Mont-Saint-Michel, 4–7 septembre 1998, 347–57. Hildesheim: Olms/Weidmann, 2000.

Fontaine, Jacques. "Le genre littéraire du dialogue monastique dans l'Occident latin des Ve et VIᵉ siècles." In *The Spirituality of Ancient Monasticism: Acta of the International Colloquium held in Cracow-Tyniec, 16–19th November 1994*, edited by Marekp Starowieyski, Pontificia Academia Theologica Cracoviensis, Facultas Theologica: Studia 4, 227–50. Tyniec: Wydawnictwo Benedyktynów, 1995.

Förster, Hans. "Die ältesten marianische Antiphon—eine Fehldatierung? Überlegungen zum 'Ältesten Beleg' des 'Sub tuum praesidium.'" *Journal of Coptic Studies* 7 (2005): 99–109.

Forsyth, Ilene. *The Throne of Wisdom: Wood Sculptures of the Madonna in Romanesque France*. Princeton: Princeton University Press, 1972.

Franklin, James. "Diagrammatic Reasoning and Modelling in the Imagination: The Secret Weapons of the Scientific Revolution." In *1543 and All That: Image and Word, Change and Continuity in the Proto-Scientific Revolution*, edited by Guy Freeland and Anthony Corones, Australasian Studies in History and Philosophy of Science 13, 53–115. Dordrecht: Kluwer Academic Publishers, 2000.

Franklin-Brown, Mary. *Reading the World: Encyclopedic Writing in the Scholastic Ages*. Chicago: University of Chicago Press, 2012.

Franzen-Blumer, Ann Barbara. "Zisterziensermystik im 'Bonmont-Psalter': Ms. 54 der Bibliothèque Municipale von Besançon." *Kunst + Architektur in der Schweiz = Art + architecture en Suisse = Arte + architettura in Svizzera* 51 (2000): 21–28.

Freed, John B. *The Friars and German Society in the Thirteenth Century*. Cambridge, MA: Medieval Academy of America, 1977.

Freedberg, David. *The Power of Images: Studies in the History and Theory of Response*. Chicago: University of Chicago Press, 1989.

Frontzek, Ines. "'Während der Blick sich weidet an der Kunst dieser Metalle [. . .]': der Hertwig-Radleuchter der Comburg heute und seine Restaurierungsgeschichte." *Württembergisch-Franken* 97 (2013): 277–97.

Fulton, Rachel. *From Judgment to Passion: Devotion to Christ and the Virgin Mary, 800–1200*. New York: Columbia University Press, 2002.

———. *Mary and the Art of Prayer: The Hours of the Virgin in Medieval Christian Life and Thought*. New York: Columbia University Press, 2018.

———. "Mimetic Devotion, Marian Exegesis, and the Historical Sense of the Song of Songs." *Viator* 27 (1996): 85–116.

———. "The Virgin in the Garden, or Why Flowers Make Better Prayers." *Spiritus: A Journal of Christian Spirituality* 4 (2004): 1–23.

Fumagalli, Carrado. *S. Agostino di Bergamo: La storia e l'arte delle chiese e dei conventi agostiniani di Bergamo, Nembro, Almenno, Romano.* Villa di Serio, Bergamo: Villadiseriane, 1990.

Gábor, Ambrus. "Diagrammatic Design and the Doctrine of the Trinity in Joachim of Fiore." *Ephemerides theologicae Lovanienses* 90, no. 4 (2014): 617–64.

Gaffuri, Laura. "La predicazione domenicana su Maria (il secolo XIII)." In *Gli studi di mariologia medievale: Bilancio storiografico*, edited by Clelia Maria Piastra, Millennio Medievale 19; Atti di convegni 6, 193–215. Florence: SISMEL, Edizioni del Galluzzo, 2001.

Gajewski, Alexandra. Review of *Une renaissance*, by Sophie Balace et al. *Burlington Magazine* 155 (2013): 503–4.

Galison, Peter. *Image and Logic: A Material Culture of Microphysics.* Chicago: University of Chicago Press, 1997.

———. "Reflections on *Image and Logic: A Material Culture of Microphysics*." *Perspectives on Science* 7 (1999): 255–84.

Gameson, Richard. "A Scribe's Confession and the Making of the Anchin Hrabanus (Douai, Bibliothèque municipale, MS. 340)." In *Manuscripts in Transition: Recycling Manuscripts, Texts and Images. Proceedings of the International Congres* [sic] *held in Brussels (5–9 November 2002)*, Corpus of Illuminated Manuscripts 15; Low Countries Series 10, 65–79. Leuven: Peeters, 2005.

———. "'Signed' Manuscripts from Early Romanesque Flanders: Saint-Bertin and Saint-Vaast." In *Pen in Hand: Medieval Scribal Portraits, Colophons and Tools*, edited by Michael Gullick, 31–73. Walkern, Herts: Red Gull Press, 2006.

Gamwell, Lynn. *Mathematics + Art: A Cultural History.* Princeton: Princeton University Press, 2016.

Gandillac, Maurice de. "Symbolismes ludiques chez Nicolas de Cues: De la toupie et du jeu de boules au jeu de la sagesse." In *Les jeux à la Renaissance: Actes du XXIIIe colloque internationale d'études humanistes, Tours, juillet 1980*, edited by Philippe Ariès and Jean-Claude Margolin, De Pétrarch à Descartes 43, 345–65. Paris: Vrin, 1982.

Gangle, Rocco. *Diagrammatic Immanence: Category Theory and Philosophy.* Edinburgh: Edinburgh University Press, 2016.

Ganz, David. "Individual and Universal Salvation in the 'In honorem sanctae crucis.'" *Florilegium* 30 (2013): 167–89.

———. "*Pando quod ignoro*: In Search of Carolingian Artistic Experience." In *Intellectual Life in the Middle Ages: Essays Presented to Margaret Gibson*, edited by Lesley Smith and Benedicta Wards, 25–32. London: Hambledon Press, 1992.

Garcia-Tejedor, Carlos Miranda. "Los manuscritos con pinturas del 'Breviari d'Amor' de Matfre Ermengaud de Béziers: un estado de la cuestión." In *La miniatura medieval en la península Ibérica*, edited by Luaces Yarza and Joaquin José, 313–73. Murcia: Nausicaa, 2007.

Garipzanov, Ildar. "The Rise of Graphicacy in Late Antiquity and the Early Middle Ages." *Viator* 46 (2015): 1–22.

Gattis, Meredith, ed. *Spatial Schemas and Abstract Thought.* Cambridge, MA: MIT Press, 2001.

Gay-Canton, Réjane. *Entre dévotion et théologie scholastique: Réceptions de la controverse médiévales autour de l'Immaculée Conception en pays germaniques.* Bibliothéques d'histoire culturelle du Moyen Age 11. Turnhout: Brepols, 2011.

Gearhart, Heidi C. *Theophilus and the Theory and Practice of Medieval Art.* University Park: Pennsylvania State University Press, 2017.

Gellrich, Jesse M. "*Figura*, Allegory, and the Question of History." In *Literary History and the Challenge of Philology: The Legacy of Erich Auerbach*, edited by Seth Lerer, 107–23. Stanford: Stanford University Press, 1996.

Geos, Lioba. "Das 'Siegel der Ewigkeit' als Universalsymbol: Diagrammatik bei Heymericus de Campo (1395–1460)." In *Vom Bild zur Erkenntnis? Visualisierungskonzepte in den Wissenschaften*, edited by Dominik Groß and Stefanie Westermann, 131–48. Kassel: Kassel University Press, 2007.

Gerchow, Jan, ed. *Ebenbilder: Kopien von Körpern, Modelle des Menschen.* Ostfildern-Ruit: Hatje Cantz, 2002.

Gerhardt, Christoph. "Die *tumba gygantis* auf dem Wormelner Tafelbild 'Maria als Thron Salomons.'" *Westfälische Zeitschrift* 142 (1992): 247–75.

Gersch, Stephen. *Concord in Discourse: Harmonics and Semiotics in Late Classical and Early Medieval Platonism.* Approaches to Semiotics 125. Berlin: Mouton; New York: De Gruyter, 1996.

Gertsman, Elina. "The Pilgrim's Progress: Devotional Journey through the Holy Womb." In *Push Me, Pull You*, edited by Sarah Blick and Laura D. Gelfand, Studies in Medieval and Reformation Traditions 156, 2:231–59. Leiden: Brill, 2011.

———. *Worlds Within: Opening the Medieval Shrine Madonna.* University Park: Pennsylvania State University Press, 2015.

Giardino, Valeria. "Space and Action to Reason: From Gesture to Mathematics." In *In the Beginning Was the Image: The Omnipresence of Pictures*, edited by András Benedek and Ágnes Vezelski, 41–50. Bern: Peter Lang, 2016.

Gibson, Margaret T., and Lesley Smith, eds. *Codices Boethiani: A Conspectus of Manuscripts of the*

Works of Boethius. Warburg Institute Surveys and Texts 25. London: Warburg Institute, 1995.

Gilbert, Creighton. "A Statement of the Aesthetic Attitude around 1230." *Hebrew University Studies in Literature and the Arts* 13 (1985): 125–52.

Gill, Miriam. "The Role of Images in Monastic Education: The Evidence from Wall Painting in Late Medieval England." In *Medieval Monastic Education*, edited by George Ferzoco and Carolyn Muessig, 117–35. London: Leicester University Press, 2000.

Giraud, Eleanor. "The Dominican Scriptorium at Saint-Jacques, and its Production of Liturgical Exemplars." In *Scriptorium: Wesen, Funktion, Eigenheiten*, edited by Andreas Nievergelt et al., Comité international de paléographie latine, XVIII. Internationaler Kongress, St. Gallen, 11.–14. September 2013, 247–58. Munich: Bayerische Akademie der Wissenschaften, 2015.

Glanz alter Buchkunst: Mittelalterliche Handschriften der Staatsbibliothek Preußischer Kulturbesitz. Wiesbaden: Reichert Verlag, 1988.

Gombrich, Ernst H. *Art and Illusion: A Study in the Psychology of Pictorial Representation*. The Andrew W. Mellon Lectures in the Fine Arts 5. New York: Pantheon Books, 1960.

Goodman, Nelson. *Languages of Art*. Indianapolis: Hackett Publishing, 1976.

———. *Ways of Worldmaking*. Indianapolis: Hackett Publishing, 1978.

Górecka, Marzena. *Das Bild Mariens in der Deutschen Mystik des Mittelalters*. Deutsche Literatur von den Anfängen bis 1700, 29. Bern: Peter Lang, 1999.

Gorman, Michael M. "The Commentary on Genesis of Claudius of Turin and Bible Studies under Louis the Pious." *Speculum* 72 (1997): 279–329.

———. "The Diagrams in the Oldest Manuscripts of Cassiodorus' *Institutiones*." *Revue Bénédictine* 110 (2000): 27–41.

———. "The Diagrams in the Oldest Manuscripts of Isidore's 'De natura rerum,' with a Note on the Manuscript Traditions of Isidore's Works." *Studi medievali* 42 (2001): 529–45.

Gormans, Andreas. "Imaginationen des Unsichtbarens: Zur Gattungstheorie des wissenschaftlichen Diagramms." In *Erkenntnis, Erfindung, Konstruktion. Studien zur Bildgeschichte von Naturwissenschaften und Technik vom 16. bis zum 19. Jahrhundert*, 51–71. Berlin: Gebr. Mann, 2000.

Gotenburg, Erwin. "Die Handschriften der Kölner Kreuzbrüder." Inaugural-Dissertation, University of Cologne, 1957.

Götze, Oliver. *Der öffentliche Kosmos: Kunst und wissenschaftliches Ambiente in italienischen Städten des Mittelalters und der Renaissance*. Geschichtswissenschaften 24. Munich: Utz, 2010.

Graf, Klaus. "Zu Marco Raininis Buch über Konrad von Hirsau/Peregrinus Hirsaugiensis." Accessed December 25, 2018. https://archivalia.hypotheses.org/839.

Grant, Edward. *God and Reason in the Middle Ages*. Cambridge: Cambridge University Press, 2001.

———. "Nicole Oresme, Aristotle's *On the Heavens*, and the Court of Charles V." In *Texts and Contexts in Ancient and Medieval Science: Studies on the Occasion of John E. Murdoch's Seventieth Birthday*, edited by Edith Sylla and Michael McVaugh, 187–207. Leiden: Brill, 1997.

Graver, Margaret. "*Quaelibet Audendi*: Fortunatus and the Acrostic." *Transactions of the American Philological Association (1974–2014)* 123 (1993): 219–45.

Greaves, Mark. *The Philosophical Status of Diagrams*. Stanford, CA: CSLI Publications, 2002.

Green, Rosalie. "Reading the Portable Altar of Stavelot." *Revue belge d'archéologie et d'histoire de l'art* 72 (2003): 3–10.

Greimas, Algirdas Julien. *Sémantique structurale: Recherche de méthode*. Paris: Larousse, 1966. Translated by Daniele McDowell, Ronald Schleifer, and Alan Velie as *Structural Semantics: An Attempt at a Method*, with an introduction by Ronald Schleifer (Lincoln: University of Nebraska Press, 1983).

Grosfillier, Jean. *Les séquences d'Adam de Saint-Victor: Étude littéraire (poétique et rhétorique), textes et traductions, commentaires*. Turnhout: Brepols, 2008.

Gudera, Alice. *Der Tragaltar aus Stavelot: Ikonographue und Stil*. Bremen: WMIT-Dr. Verlag, 2003.

Guerrini, Paola. *Giocchino da Fiore e la conservazione del sapere nel medioevo: Diagrammi e figure da Boezio a Raimondo Lullo*. Uomini e Mondi Medievali 48. Spoleto: Il Centro italiano di studi sull'alto medioevo, 2016.

Guillaumin, Jean-Yves. "Boethius's *De institutione arithmetica* and Its Influence on Posterity." In *A Companion to Boethius in the Middle Ages*, edited by Noel Harold Kaylor Jr. and Dario Brancato, Brill's Companions to the Christian Tradition 30, 135–62. Leiden: Brill, 2012.

Guldan, Ernst. *Eva und Maria: Eine Antithese als Bildmotiv*. Graz: Böhlau, 1966.

Günzel, Stephan, and Lars Nowak, eds. *KartenWissen: territorial Räume zwischen Bild und Diagramm*. Wiesbaden: Reichert, 2012.

Gurtner, Daniel M. "The Veil of the Temple in History and Legend." *Journal of the Evangelical Theological Society* 49 (2006): 97–114.

Habinek, Thomas. "Optatian and His Ouevre: Explorations in Ontology." In *Morphogrammata / The Lettered Art of Optatian: Figuring Cultural Transformations in the Age of Constantine*, edited by Michael Squire and Johannes Wienand, Morphomata 33, 391–425. Paderborn: Wilhelm Fink, 2017.

Haefele, Hans. "Decerpsi police flores: Aus Hrabans Vermischten Gedichten." In *Tradition und Wertung: Festschrift Franz Brunhölzl zum 65. Geburtstag*, edited by Gunter Berndt et al., 49–74. Sigmaringen: J. Thorbecke, 1989.

Häfele, Gallus M. *Franz von Retz: Ein Beitrag zur Gelehrtengeschichte des Dominikanerordens und der Wiener Universität am Ausgange des Mittelalters*. Innsbruck: Tyrolia, 1918.

Hahn, Cynthia J. "The Graphic Cross as Salvific Mark and Organizing Principle: Making, Marking, Shaping." In *Graphic Devices and the Early Decorated Book*, edited by Michelle P. Brown et al., 100–123. Woodbridge: Boydell Press, 2017.

———. *The Reliquary Effect: Enshrining the Sacred Object*. London: Reaktion Books, 2017.

———. *Strange Beauty: Issues in the Making and Meaning of Reliquaries, 400–circa 1204*. University Park: Pennsylvania State University Press, 2012.

Halimi, Brice. "Diagrams as Sketches." *Synthese* 186 (2012): 387–409.

Hall, Bert S. "The Didactic and the Elegant: Some Thoughts on Scientific and Technological Illustrations in the Middle Ages and Renaissance." In *Picturing Knowledge: Historical and Philosophical Problems Concerning the Use of Art in Science*, edited by Brian S. Baigre, 3–39. Toronto: University of Toronto Pres, 1996.

Hamann, Florian. *Das Siegel der Ewigkeit: Universalwissenschaft und Konziliarismus bei Heymericus de Campo*. Buchreihe der Cusanus-Gesellschaft 16. Münster: Aschendorff, 2006.

Hamburger, Jeffrey F. "Body vs. Book. The Trope of Visibility in Images of Christian-Jewish Polemic." In *Ästhetik des Unsichtbaren: Bildtheorie und Bildgebrauch in der Vormoderne*, edited by David Ganz and Thomas Lentes, Kultbild. Visualität und Religion in der Vormoderne 1, 113–47. Berlin: Reimer, 2004.

———. *'Haec figura demonstrat': Diagramme in einem Pariser Exemplar von Lothars von Segni 'De missarum mysteriis' aus dem frühen 13. Jahrhundert*. Wolfgang Stammler Gastprofessur für Germanische Philologie: Vorträge 19. Berlin: De Gruyter, 2013.

———. *"Haec Figura demonstrat*: Diagrams in an Early-Thirteenth Century Copy of Lothar de Segni's *De missarum mysteriis*." *Wiener Jahrbuch für Kunstgeschichte* (2009): 7–78.

———. "The Hand of God and the Hand of the Scribe: Craft and Collaboration at Arnstein." In *Bibliothek des Mittelalters als dynamischer Prozess*, edited by Michael Embach, Trierer Beiträge zu den historischen Kulturwissenschaften 3, 55–80, pls. 4–20. Wiesbaden: Reichert, 2012.

———. "Heinrich Seuse, ›Das Exemplar‹." In *Katalog der deutschsprachigen illustrierten Handschriften des Mittelalters*, edited by Norbert Ott, 156–92. Munich: Bayerische Akademie der Wissenschaften, 2008.

———. "Hrabanus redivivus: Berthold of Nuremberg's Marian Supplement to *De laudibus sanctae crucis*." In *Diagramm und Text: Diagrammatische Strukturen und die Dynamisierung von Wissen und Erfahrung*, edited by Eckart Conrad Lutz et al., 175–204. Wiesbaden: Reichert, 2014.

———. "The Iconicity of Script." *Word & Image* 27 (2011): 249–61.

———. "Idol Curiosity." In *Curiositas: Welterfahrung und ästhetische Neugierde in Mittelalter und früher Neuzeit*, edited by Klaus Krüger, Göttinger Gespräche zur Geschichtswissenschaft 15, 19–58. Göttingen: Max-Planck-Institut für Geschichte, 2002.

———. "Magdalena Kremer, Scribe and Painter of the Dominican Convent of St. Johannes-Baptista in Kirchheim unter Teck." In *The Medieval Book: Glosses from Friends & Colleagues of Christopher de Hamel*, edited by James H. Marrow et al., 158–83. 't Goy-Houten: Hes & De Graaf, 2010.

———. "Magdalena Kremerin, Schreiberin und Malerin im Dominikanerinnenkloster St. Johannes des Täufers in Kirchheim unter Teck." In *Die Chronik der Magdalena Kremerin im interdisziplinären Dialog*, edited by Sigrid Hirbodian and Petra Kurz, Schriften zur südwestdeutschen Landeskunde 76, 62–82. Ostfildern: Thorbecke, 2016.

———. "Medieval Self-Fashioning: Authorship, Authority, and Autobiography in Suso's *Exemplar*." In *Christ among the Medieval Dominicans*, edited by Kent Emery Jr. and Joseph Wawrykow, 430–61. Notre Dame, IN: Notre Dame University Press, 1998. Reprinted in *The Visual and the Visionary: Art and Female Spirituality in Late Medieval Germany* (New York: Zone Books, 1998), 233–78, 534–46.

———. "The Place of Theology in Medieval Art History: Positions, Problems, Possibilities." In *The Mind's Eye: Art and Theological Argument in the Middle Ages*, edited by Jeffrey Hamburger and Anne-Marie Bouché, 11–31. Princeton: Princeton University Press, 2005.

———. "Rahmenbedingen der Marienfrommigkeit im Mittlelalter." In *Schöne Madonnen am Rhein: Rheinische Marienstatuen des schönen Stils*, edited by Robert Suckale, 121–37. Bonn: Rheinisches Landesmuseum, 2009.

———. "Revelation and Concealment: Apophatic Imagery in the Trinitarian Miniatures of the Rothschild Canticles." In "Beinecke Studies in Early Manuscripts." Supplement, *Yale University Library Gazette* 66 (1991): 134–58.

———. *The Rothschild Canticles: Art and Mysticism in Flanders and the Rhineland circa 1300*. New Haven: Yale University Press, 1990.

———. *Script as Image.* Corpus of Illuminated Manuscripts 21. Leuven: Peeters, 2014.

———. "Seeing and Believing: The Suspicion of Sight and the Authentication of Vision in Late Medieval Art." In *Imagination und Wirklichkeit: Zum Verhältnis von mentalen und realen Bilder in der Kunst der frühen Neuzeit*, edited by Alessandro Nova and Klaus Krüger, 47–70. Mainz: Philipp von Zabern, 2000.

———. "A Seminar on Diagrams as Conversation and Consolation." *Common Knowledge* 24 (2018): 356–65.

———. "Speculations on Speculation: Vision and Perception in the Theory and Practice of Mystical Devotions." In *Deutsche Mystik im abendländischen Zusammenhang: Neu erschlossene Texte, neue methodische Ansätze, neue theoretische Konzepte*, Kolloquium Kloster Fischingen, edited by Walter Haug and Wolfram Schneider-Lastin, 353–408. Tübingen: Niemeyer, 2000.

———. *St. John the Divine: The Deified Evangelist in Medieval Art and Theology.* Berkeley: University of California Press, 2002.

———. "The Use of Images in the Pastoral Care of Nuns: The Case of Heinrich Suso and the Dominicans." *Art Bulletin* 71 (1989): 20–46. Reprinted in *The Visual and the Visionary: Art and Female Spirituality in Late Medieval Germany* (New York: Zone Books, 1998), 197–232, 522–34.

———. "Visible, yet Secret: Images as Signs of Friendship in Seuse." In "Amicitia—weltlich und geistlich: Festschrift for Nigel Palmer on the Occasion of His 60th Birthday," edited by Annette Volfing and Hans-Jochen Schiewer, *Oxford German Studies* 36 (2007): 141–62.

———. "The Writing on the Wall: Inscriptions and Descriptions of Carthusian Crucifixions in a Fifteenth-Century Passion Miscellany." In *Tributes in Honor of James H. Marrow: Studies in Late Medieval and Renaissance Painting and Manuscript Illumination*, edited by Jeffrey F. Hamburger and Anne S. Korteweg, 231–52. Turnhout: Brepols, 2006.

Hamburger, Jeffrey F., and Nigel F. Palmer. *The Prayer Book of Ursula Begerin.* With a Conservation Report by Ulrike Bürger. 2 vols. Dietikon: Urs Graf Verlag, 2015.

Hamburger, Jeffrey F., and Eva Schlotheuber. "Books in Women's Hands: Liturgy, Learning, and the Libraries of Dominican Nuns in Westphalia." In *Entre stabilité et itinerance: Livres et culture des ordres mendiants, 13ᵉ–15ᵉ siècle*, Bibliologia 37, edited by Nicole Bériou et al., 127–55. Turnhout: Brepols, 2014.

Hamburger, Jeffrey F., Eva Schlotheuber, Susan Marti, and Margot Fassler. *Liturgical Life and Latin Learning at Paradies bei Soest, 1300-1425.* 2 vols. Münster: Aschendorff Verlag, 2017.

Hamburger, Jeffrey F., et al., eds. *Beyond Words: Illuminated Manuscripts in Boston Collections.* Chesnut Hill, MA: McMullen Museum of Art, Boston College, 2016.

Hansbauer, Severin. "Christus in der Kelter: Zu Herkunft, Umfeld und Verwandlung eines Bildmotivs." In *Von Rebstock und Riesenfaß: Ein Buch über Kellerwirtschaft in aller Zeit*, edited by Karl Holubar and Wolfgang Christian Huber, 174–84. Klosterneuburg: Mayer, 1994.

Hansen, Dorothee. *Das Bild des Ordenlehrers und die Allegorie des Wissens: Ein gemaltes Programm der Augustiner.* Berlin: Akademie Verlag, 1995.

Harnish, Jennifer Dyer. *Serial Images: The Modern Art of Iteration.* International Studies in Hermeneutics and Phenomenology 4. Berlin: Lit, 2011.

Harries, Karsten. "The Infinite Sphere: Comments on the History of a Metaphor." *Journal of the History of Philosophy* 13 (1975): 5–15.

Harris, Roy. *Signs of Writing.* London: Routledge, 1995.

Hartl, Wolfgang. *Text und Miniaturen der Handschrift "Dialogus de laudibus sanctae crucis" (München, Bayerische Staatsbibliothek Clm 14159): Ein monastischer Dialog und sein Bilderzyklus.* Hamburg: Verlag Dr. Kova , 2007.

Has, David L. Review of Alessandra Ponte, "Architecture AND Landscape: Beyond the Magic Diagram." Accessed June 9, 2017. http://forty-five.com/papers/140#en1.

Hathaway, Neil. "Compilatio: From Plagiarism to Compiling." *Viator* 20 (1989): 19–44.

Hayes, Brian. "In Postmodernist Territory." *American Scientist* 89, no. 3 (2001): 280–81.

Hearn, Millard F. *Romanesque Sculpture: The Revival of Monumental Stone Sculpture in the Eleventh and Twelfth Centuries.* Ithaca, NY: Cornell University Press, 1981.

Heath, Thomas. *Mathematics in Aristotle.* New York: Garland Publishing, 1980.

Heck, Christian. *L'Échelle celeste dans l'art du moyen âge: Une image de la quête du ciel.* Paris: Le Cerf, 1997.

———. "Raban Maur, Bernard de Clairvaux, Bonaventure: Expression de l'espace et topographie spirituelle dans les images médiévales." In *The Mind's Eye: Art and Theological Argument in the Middle Ages*, edited by Jeffrey F. Hamburger and Anne-Marie Bouché, 113–32. Princeton: Department of Art & Archaeology, 2006.

Der heilige Rosenkranz. Libelli Rhenani 5. Cologne: Erzbischöfliche Diözesan- und Dombibliothek, 2003.

Hempfer, Klaus W., and Anita Traninger, eds. *Der Dialog im Diskursfeld seiner Zeit: Von der Antike bis zur Aufklärung.* Text und Kontext 26. Stuttgart: Franz Steiner Verlag, 2010.

Hennig, Ursula. "Vorauer Bücher Mosis." In ²*VL* 10 (1999), cols. 513–16.

Henry, Avril. *The Eton Roundels: Eton College MS 177 ('Figurae bibliorum'): A Colour Facsimile with Transcription, Translation and Commentary.* Aldershot: Scholar Press, 1990.

Hérnad, Béatrice, with Andreas Weiner. *Die gotischen Handschriften deutscher Herkunft in der Bayerischen Staatsbibliothek* 1/1–2, Teil 1: Vom späten 13. bis zur Mitte des 14. Jahrhunderts, Katalog der illuminierten Handschriften der Bayerischen Staatsbibliothek in München 5. Wiesbaden: Reichert, 2000.

Hidrio, Guylène. *L'iconographie du "Speculum Virginum."* Le Corpus du RILMA 5. Turnhout: Brepols, 2017.

Higgins, Dick, ed. "Pattern Poetry: A Symposium." Special issue, *Visible Language* 20 (1986).

———. *Pattern Poetry: Guide to an Unknown Literature.* Albany: SUNY Press, 1987.

Hinkle, William M. "The Cosmic and Terrestrial Cycles on the Virgin Portal of Notre-Dame." *Art Bulletin* 49 (1967): 287–96.

Hinnebusch, John Frederick. "Extant Manuscripts of the Writings of Jacques de Vitry." *Scriptorium* 51 (1997): 156–64.

Hirsch, Emil, Antiquariat. *Valuable Manuscripts of the Middle-Ages, Mostly Illuminated, with XVI Plates,* catalogue 24. Munich: Hirsch, n.d.

Hofmann, Heinz. *Das Satorquadrat: Zur Geschichte und Deutung eines antiken Wortquadrats.* Bielefelder Papiere zur Linguistik und Literaturwissenschaft 6. Bielefeld: Fakultät für Linguistik und Literaturwisssschaft, 1977.

———. "Satorquadrat." In *Paulys Realencyclopädie der classischen Altertumswissenschaft,* Supplementband 15, cols. 478–565. Stuttgart: Metzler, 1978.

Holder, Arthur G. "New Treasures and Old in Bede's 'De Tabernaculo' and 'De Templo.'" *Revue Bénédictine* 99 (1989): 237–49.

Holtgen, Karl J. "Arbor, Scala und Fons vitae: Vorformen devotionaler Embleme in einer mittelenglischen Handschrift (B.M. Add. MS. 37049)." In *Chaucer und seine Zeit: Symposion für Walter F. Schirmer,* edited by Arno Esch, Buchreihe der Anglia: Zeitschrift für Englische Philologie 14, 355–91. Tübingen: Niemeyer, 1968.

Homburger, Otto. *Die illustrierten Handschriften der Burgerbibliothek Bern: die vorkarolingischen und karolingischen Handschriften.* Bern: Selbstverlag der Burgerbibliothek Bern, 1962.

Howe, Susan. *Pierce-Arrow.* New York: New Directions, 1997.

Huber, Alfons. "Franz von Retz und sein Defensorium im Brixner Kreuzgang und auf der Stamser Tafel." *Der Schlern* 42 (1968): 64–70.

Hübner, Wolfgang. *Zodiacus Christianus: Jüdisch-christliche Adaptionen des Tierkreises von der Antike bis zur Gegenwart.* Beiträge zur Klassischen Philologie 144. Königstein im Taunus: Anton Hain, 1983.

Hughes, Christopher G. "Art and Exegesis." In *A Companion to Medieval Art: Romanesque and Gothic in Northern Europe,* edited by Conrad Rudolph, 173–92. Oxford: Blackwell, 2006.

Huglo, Michel. "L'étude des diagrammes d'harmonique de Calcidius au Moyen Âge." *Revue de Musicologie* 91 (2005): 305–19.

———. "L'Office du Prime au Chapitre." In *L'Église et la mémoire des morts dans la France médiévale: Communications présentées à la table ronde du C.N.R.S., le 14 juin 1982,* edited by Jean-Loup Lemaître, 11–18. Paris: Études Augustiniennes, 1986.

Hull, Kathleen A. "The Iconic Peirce: Geometry, Spatial Intuition, and Visual Imagination." In *Peirce on Perception and Reasoning: From Icons to Logic,* edited by Kathleen A. Hull and Richard Kenneth Atkins, Routledge Studies in American Philosophy 10, 147–73. New York: Routledge, 2017.

Hurtado, Larry W. "Earliest Christian Graphic Symbols: Examples and References from the Second/Third Centuries." In *Graphic Signs of Identity, Faith, and Power in Late Antiquity and the Early Middle Ages,* edited by Ildar Garipzanov et al., 25–44. Turnhout: Brepols, 2017.

———. "The Staurogram in Early Christian Manuscripts: The Earliest Visual Reference to the Crucified Jesus?" In *New Testament Manuscripts: Their Texts and Their World,* edited by Thomas J. Kraus and Tobias Nicklas, Texts and Editions for New Testament Study 2, 207–26. Leiden: Brill, 2006.

Huygens, Robert B. C. "Mittelalterliche Kommentare zum *O qui perpetua . . .*" *Sacris erudiri* 6 (1954): 373–427.

Illich, Ivan. *In the Vineyard of the Text: A Commentary to Hugh's Didascalicon.* Chicago: University of Chicago Press, 1993.

Imbach, Reudi. "Le Néo-Platonisme médiéval: Proclus latin et l'École dominicaine allemande." *Revue de théologie et de philosophie* 110 (1978): 427–48.

Ingold, Tim. *Lines: A Brief History.* London: Routledge, 2007.

Jackson, Deirdre. "The Influence of the Theophilus Legend: An Overlooked Miniature in Alfonso X's 'Cantigas de Santa Maria' and Its Wider Context." In *Under the Influence: The Concept of Influence and the Study of Illuminated Manuscripts,* edited by John Lowden and Alixe Bovey, 75–87, 208–10. Turnhout: Brepols, 2005.

Jacobs, Friedrich, and Friedrich A. Ukert. *Beiträge zur älteren Litteratur oder Merkwürdigkeiten der*

Herzogl. öffentlichen Bibliothek zu Gotha. 3 vols. Leipzig: Dyk, 1835–38.

Jacoby, Michael. "Der Kampf gegen die Übermacht: Leviathan-Satan." *Amsterdamer Beiträge zur älteren Germanistik* 23 (1985): 97–130.

Jardine, Nicholas, and Isla Fay, eds. *Observing the World through Images: Diagrams and Figures in the Early-Modern Arts and Sciences*. Leiden: Brill, 2014.

Javelet, Robert. *Image et ressemblance au 12ᵉ siècle, de Saint Anselme à Alain de Lille*. 2 vols. Paris: Letouzey et Ané, 1967.

Jöcher, Christian Gottlieb. *Allgemeines Gelehrten-Lexicon: Darinne die Gelehrten aller Stände sowohl männ- als weiblichen Geschlechts, welche vom Anfange der Welt bis auf ietzige Zeit gelebt, und sich der gelehrten Welt bekannt gemacht; Nach ihrer Geburt, Leben, merckwürdigen Geschichten, Absterben und Schrifften aus den glaubwürdigsten Scribenten in alphabetischer Ordnung beschrieben werden*. Leipzig: Johann Friedrich Gleditschens Buchhandlung, 1750–51.

Johanek, Peter. "Bruder Berthold (von Freiburg)." In *²VL* 1 (1978), cols. 807–13.

Johnson, Christopher D. *Memory, Metaphor, and Aby Warburg's Atlas of Images*. Ithaca, NY: Cornell University Press, 2012.

Johnson, Marshall D. *The Purpose of the Biblical Genealogies with Special Reference to the Geneaologies of Jesus*. Cambridge: Cambridge University Press, 1969.

Joselit, David. "Dada's Diagrams." In *The Dada Seminars*, edited by Leah Dickerman, with Matthew S. Witkovsky, 221–39. Washington, D.C.: The National Gallery of Art; New York, D.A.P., 2005.

Joyner, Danielle Beth. *Painting the Hortus Deliciarum: Medieval Women, Wisdom, and Time*. University Park: Pennsylvania State University Press, 2016.

Jun, Soojin, Miso Kim, and Joonhwan Lee. "The System Diagrams: Shifting Perspectives." *Design Issues* 27 (2011): 72–89.

Kabell, Aage. "Nachträgliches zum *Liber de distinccione metrorum* des Iacobus Nicholai de Dacia." *Classica et Mediaevalia* 32 (1971–80): 297–332.

Kaczynski, Bernice M. "Illustrations of Tabernacle and Temple Implements in the 'Postilla in Testamentum Vetus' of Nicolaus de Lyra." *Yale University Library Gazette* 48 (1973): 1–11.

Kaeppeli, Thomas. *Scriptores Ordinis Praedicatorum Medii Aevi*. 4 vols. Rome: Ad S. Sabinae, 1970–93.

Kaiser, David. *Drawing Theories Apart: The Dispersion of Feynman Diagrams in Postwar Physics*. Chicago: University of Chicago Press, 2005.

Katz, Melissa R. "Behind Closed Doors: Distributed Bodies, Hidden Interiors, and Corporeal Erasure in *Vierge ouvrante* Sculpture." *Res: Journal of Anthropology and Aesthetics* 55–56 (2009): 194–221.

———. "Mary in Motion: Opening the Body of the 'Vierge Ouvrante.'" In *Meaning in Motion: The Semantics of Meaning in Medieval Art*, 63–91. Princeton: Department of Art & Archaeology, 2011.

Katz, Melissa R., and Robert A. Orsi, eds. *Divine Mirrors: The Virgin Mary in the Visual Arts*. Oxford: Oxford University Press, 2001.

Katzoff, Nancy M. "The Alton Towers Triptych: Time, Place, and Context." *Rugers Art Review* 3 (1982): 11–28.

Kaufmann, Eva-Maria. *Jakobs Traum und der Aufstieg des Menschen zu Gott: das Thema der Himmelsleiter in der bildenden Kunst des Mittelalters*. Tübingen: Wasmuth, 2006.

Keen, Elizabeth. "Shifting Horizons: The Medieval Compilation of Knowledge as Mirror of a Changing World." In *Encyclopaedism from Antiquity to the Renaissance*, edited by Jason König and Greg Woolf, 277–300. Cambridge: Cambridge University Press, 2013.

Keller, Harald. "Künstlerstoltz und Künstlerdemut im Mittelalter." In *Festschrift der Wissenschaftlichen Gesellschaft an der Johann Wolfgang Goethe-Universität Frankfurt*, 191–220. Wiesbaden: Steiner, 1981.

Keller, Hildegard E. "Rosen-Metamorphosen: Von unfesten Zeichen in spätmittelalterlichen Texten. Heinrich Seuses 'Exemplar' und das Mirakel 'Marien Rosenkranz.'" In *Der Rosenkranz: Andacht, Geschichte, Kunst*, edited by Urs-Beat Frei and Freddy Bühler, 49–68. Bern: Benteli; Sachseln: Museum Bruder Klaus, 2003.

Kemp, Wolfgang. *Christliche Kunst: Ihre Anfänge, ihre Strukturen*. Munich: Schirmer-Mosel, 1994.

———. "Mittelalterliche Bildsysteme." *Marburger Jahrbuch für Kunstwissenschaft* 22 (1989): 121–42.

———. *Sermo corporeus: Die Erzahlung der Mittelalterlichen Glasfenster*. Munich: Schirmer/Mosel, 1987. Translated by Caroline Dobson Saltzwedel as *The Narratives of Gothic Stained Glass* (Cambridge: Cambridge University Press, 1997).

———. "Substanz wird Form—Form ist Beziehung." In *Kunst und Sozialgeschichte*, edited by Martin Papenbrock, 219–34. Pfaffenweiler: Centaurus-Verlagsgesellschaft, 1995.

———. "Visual Narratives, Memory, and the Medieval *Esprit du System*." In *Images of Memory: On Remembering and Representation*, edited by Susanne Küchler and Walter Melion, 87–108, 226–29. Washington D.C.: Smithsonian Institution Press, 1991.

Kessler, Cordula. *Gotische Buchkultur: Dominikanische Handschriften aus dem Bistum Konstanz*. Berlin: Akademie Verlag, 2010.

Kessler, Herbert L. "*Arca arcanum*: Nested Boxes and the Dynamics of Sacred Experience." *Codex Aquilarensis* 30 (2014): 83–108.

———. "'Hoc visibile imaginatum figurat illud invisibile verum': Imagining God in Pictures of Christ." In *Seeing the Invisible in Late Antiquity and the Early Middle Ages: Papers from "Verbal and Pictorial Representations of the Invisible 400 to 1000" (Utrecht, 11–13 December 2003)*, edited by G. De Nie et al., 293–328. Turnhout: Brepols, 2005.

———. *The Illustrated Bibles from Tours*. Princeton: Princeton University Press, 1977.

———. "Images of Christ and Communication with God." In *Communicare e significare nell'Alto Medioevo, 15–20 aprile 2004*, Settimane di Studio della Fondazione Centro Italiano di Studi sull'Alto Medioevo 52, 1099–1136. Spoleto: Il Centro italiano di studi sull'alto medioevo, 2005.

———. "Medietas / Mediator and the Geometry of the Incarnation." In *Image and Incarnation: The Early Modern Doctrine of the Pictorial Image*, edited by Walter S. Melion and Lee Palmer Wandel, 17–75. Leiden: Brill, 2015.

———. "Pictorial Narrative and Church Mission in Sixth-Century Gaul." In *Pictorial Narrative in Antiquity and the Middle Ages*, edited by Herbert L. Kessler and Marianna Shreve Simpson, Studies in the History of Art / 16, 75–91. Washington, D.C.: National Gallery of Art, 1985.

———. "Sacred Light from Shadowy Things." *Codex Aquilarensis* 32 (2016): 237–70.

———. "A Sanctifying Serpent: Crucifix as Cure." In *Studies on Medieval Empathies*, edited by Karl. F. Morrison and Rudolph M. Bell, Disputatio 25, 161–85. Turnhout: Brepols, 2013.

———. *Spiritual Seeing: Picturing God's Invisibility: Picturing God's Invisibility in Medieval Art*. Philadelphia: University of Pennsylvania Press, 2000.

———. "Through the Temple Veil: The Holy Image in Judaism and Christianity." *Kairos* 32–33 (1990–91): 53–77.

Kesting, Peter. "Maria als Buch." In *Würzburger Prosastudien I.: Wort-, Begriffs- und Textkundliche Untersuchungen*, Medium Aevum 13, 122–47. Munich: Fink, 1968.

Keussen, Hermann, ed. *Die Matrikel der Universität Köln*. 3 vols. Publikationen der Gesellschaft für rheinische Geschichtskunde 8, Bonn: Hanstein, 1928.

Kienzler, Wolfgang. Review of *Around and Beyond the Square of Opposition*, edited by Jean-Yves Béziau and Dale Jacquette. *History and Philosophy of Logic* 35 (2014): 410–11.

Kingsley, Jennifer P. *The Bernward Gospels: Art, Memory, and the Episcopate in Medieval Germany*. University Park: Pennsylvania State University Press, 2014.

Kiss, Farkas Gábor. "Performing from Memory and Experiencing the Senses in Late Medieval Meditative Practice: The Treatises *Memoria fecunda, Nota hanc figuram*, and *Alphabetum Trinitatis*." *Daphnis* 41 (2012): 419–52.

Kitzinger, Beatrice. "The Instrumental Cross and the Use of the Gospel Book Troyes, Bibliothèque Municipale MS 960." *Different Visions: A Journal of New Perspectives on Medieval Art* 4 (2014): 1–33.

———. "Recasting Hrabanus: Romanesque Praise for the Holy Cross." In *Romanesque and the Past: Retrospection in the Art and Architecture of Romanesque Europe*, edited by John McNeill and Richard Plant, British Archaeology Assocation: Romanesque 1, 221–41. Leeds: British Archaeological Association, 2013.

Kitzler, Petr. *From "Passio Perpetuae" to "Acta Perpetuae": Recontextualizing a Martyr Story in the Literature of the Early Church*. Arbeiten zur Kirchengeschichte 127. Berlin: De Gruyter, 2015.

Klapisch-Zuber, Christiane. "De la nature végétale de l'arbre généalogique." In *Le monde végétal: Médecine, botanique, symbolique*, edited by Agostino Paravicini Bagliani, Micrologus' Library 30, 447–68. Florence: SISMEL, Edizioni del Galuzzo, 2009.

———. *L'ombre des ancêtres: Essai sur l'imaginaire médiéval de la parenté*. Paris: Fayard, 2000.

Klein, Holger A. *Byzanz, der Westen und das "wahre" Kreuz: Die Geschichte einer Reliquie und ihrer künstlerischen Fassung in Byzanz und im Abendland*. Spätantike, Frühes Christentum, Byzanz: Reihe B, Studien und Perspektiven 17. Wiesbaden: Reichert, 2004.

Klein, Ursula. *Experiments, Models, Paper Tools: Cultures of Organic Chemistry in the Nineteenth Century*. Stanford: Stanford University Press, 2003.

Klemm, Elisabeth. *Die illuminierten Handschriften des 13. Jahrhunderts deutscher Herkunft in der Bayerischen Staatsbibliothek*. 2 vols. Katalog der illuminierten Handschriften der Bayerischen Staatsbibliothek in München 4. Wiesbaden: Reichert, 1998.

Klepper, Deeana Copeland. *The Insight of Unbelievers: Nicholas of Lyra and Christian Reading of Jewish Text in the later Middle Ages*. Philadelphia: University of Pennsylvania Press, 2007.

Klingenberg, Heinz. "Hrabanus Maurus: In honorem sanctae crucis." In *Festschrift für Otto Höfler um 65. Geburtstag*, 273–300. Vienna: Verlag Notring, 1968.

Kloft, Matthias Th. "Hrabanus Maurus, die 'Tituli' und die Altarweihen." In *Raban Maur et son temps*, edited by Philippe Depreux et al., Collection Haut Moyen Âge 9, 367–87. Turnhout: Brepols, 2010.

Knepper, Joseph. *Jakob Wimpfeling (1450–1528): Sein Leben und seine Werke, nach den Quellen dargestellt*. Freiburg i. Br.: Herder, 1902.

Knibbs, Eric. "The Manuscript Evidence for the 'De octo quaestionibus' ascribed to Bede." *Traditio* 63 (2008): 129–83.

Knoespel, Kenneth J. "Diagrammatic Writing and the Configuration of Space." In *Figuring Space: Philosophy, Mathematics and Physics*, by Gilles Châtelet, translated by Robert Shore and Muriel Zagha, Science and Philosophy 8, ix–xxiii. Dordrecht: Kluwer Academic Publishers, 2000.

Koetsier, Teun, and Luc Bergmans, eds. *Mathematics and the Divine: A Historical Study*. Amsterdam: Elsevier, 2005.

Kogman-Appel, Katrin. "Coping with Christian Pictorial Sources: What did Jewish Miniaturists *Not* Paint?" *Speculum* 75 (2000): 816–58.

König, Eberhard. *Von wundersamen Begebenheiten: Franz von Retz*. Simbach am Inn: Müller & Schindler, 2006.

Körfer, Anna-Lena. "*Lector ludens*: Spiel und Rätsel in Optatians Panegyrik." In *Morphogrammata / The Lettered Art of Optatian: Figuring Cultural Transformations in the Age of Constantine*, edited by Michael Squire and Johannes Wienand, Morphomata 33, 191–225. Paderborn: Wilhelm Fink, 2017.

Kornrumpf, Gisela. "Zweiundziebzig Namen Marias (lat. und dt.)." In *²VL* 1, cols. 1698–1709.

Kottje, Raymund. *Verzeichnis der Handschriften mit den Werken des Hrabanus Maurus*. Assisted by Thomas A. Ziegler. Monumenta Germaniae Historica: Hilfsmittel 27. Hannover: Hahnsche Buchhandlung, 2012.

Krämer, Sigrid. *Handschriftenerbe des deutschen Mittelalters*. 3 vols. Mittelalterliche Bibliothekskataloge Deutschlands und der Schweiz: Ergänzungsband 1. Munich: C. H. Beck'sche Verlagsbuchhandlung, 1989–90.

Krämer, Sybille. *Figuration, Anschauung, Erkenntnis: Grundlinien einer Diamgrammatologie*. Suhrkamp Taschenbuch: Wissenschaft 2176. Berlin: Suhrkamp, 2016.

———. "Gedanken sichtbar machen: Platon, eine diagrammatologische Rekonstruktion. Ein Essay." In *Paradoxalität des Medialen*, edited by Jan-Henrik Möller et al., 175–89. Munich: Wilhelm Fink, 2013.

———. "Is There a Diagrammatic Impulse with Plato? 'Quasi-Diagrammatic-Scenes' in Plato's Philosophy." In *Thinking with Diagrams: The Semiotic Basis of Human Cognition*, edited by Sybille Krämer and Christina Ljungberg, Semiotics, Communication and Cognition 17, 163–77. Berlin: De Gruyter, 2016.

———. "'Operationsraum Schrift': Über einen Perspektivenwechsel in der Betrachtung der Schrift." In *Schrift: Kulturtechnik zwischen Auge, Hand und Maschine*, edited by Gernot Grube et al., 23–57. Munich: Fink, 2005.

———. "Operative Bildlichkeit: Von der 'Grammatologie' zu einer 'Diagrammatologie'? Reflexionen über erkennendes 'Sehen.'" In *Logik des Bildlichen: Zur Kritik der ikonischen Vernunft*, edited by Martina Hessler and Dieter Mersch, 94–122. Bielefeld: transcript, 2009.

———. "Punkt, Strich, Fläche. Von der Schriftbildlichkeit zur Diagrammatik." In *Schriftbildlichkeit: Wahrnehmbarkeit, Materialität und Operativität von Notationen*, edited by Sybille Krämer et al., Schriftbildlichkeit 1, 79–101. Berlin: Akademie Verlag, 2012.

———. "Schrift, Diagramm, Programm–Kulturtechniken der Inskription." In *Programm(e)*, edited by Dieter Mersch and Joachim Paech, 159–74. Zürich: Diaphanes, 2014.

———. "Trace, Writing, Diagram: Reflections on Spaciality, Intuition, Graphical Practices and Thinking." In *The Power of the Image: Emotion, Expression, Explanation*, edited by András Benedek and Kristóf Nyíri, Visual Learning 4, 3–22. Frankfurt a. M.: Lang, 2014.

———. "Zur Grammatik der Diagrammatik: Eine Annäherung an die Grundlagen des Diagrammgebrauches." *Zeitschrift für Literaturwissenschaft und Linguistik* 44 (2014): 11–30.

Krämer, Sybille, and Christina Ljungberg, eds. *Thinking with Diagrams—The Semiotic Basis of Human Cognition*. Semiotics, Communication and Cognition 17. Berlin: Mouton; Boston: De Gruyter, 2017.

Krämer, Sybille, et al., eds. *Schriftbildlichkeit: Wahrnehmbarkeit, Materialität und Operativität von Notationen*. Berlin: Akademie Verlag, 2012.

Krause, Kathy M., and Alison Stones, eds. *Gautier de Coinci: Miracles, Music, and Manuscripts*. Medieval Texts and Cultures of Northern Europe 13. Turnhout: Brepols, 2006.

Krauss, Rosalind E. *The Optical Unconscious*. Cambridge, MA: MIT Press, 1993.

———. "Sculpture in the Expanded Field." *October* 8 (1979): 30–44.

Krings, Bruno. *Das Prämonstratenserstift Arnstein a. d. Lahn im Mittelalter (1139–1527)*. Veröffentlichungen der Historischen Kommission für Nassau 48. Wiesbaden: Selbstverlag der Historischen Kommission für Nassau, 1990.

Krone und Schleier: Kunst aus mittelalterlichen Frauenklöstern. Edited by Kunst- und Ausstellungshalle der Bundesrepublik Deutschland, Bonn, and Ruhrlandmuseum, Essen. Munich: Hirmer Verlag, 2005.

Krüger, Annette, and Gabriele Runge. "Lifting the Veil: Two Typological Diagrams in the Hortus deliciarum." *Journal of the Warburg and Courtauld Institutes* 60 (1997): 1–22.

Krüger, Klaus. *Politik der Evidenz: Öffentliche Bilder als Bilder der Öffentlichkeit im Trecento.* Historische Geisteswissenschaften: Frankfürter Vorträge 8. Güttingen: Wallstein, 2015.

Kuchenbuch, Ludolf, and Uta Kleine, eds. *"Textus" im Mittelalter: Komponenten und Situationen des Wortgebrauchs im schriftsemantischen Feld.* Veröffentlichungen des Max-Planck-Instituts für Geschichte 216. Göttingen: Vandenhoeck & Rupprecht, 2006.

Kühnel, Bianca. "Carolingian Diagrams, Images of the Invisible." In *Seeing the Invisible in Late Antiquity and the Early Middle Ages*, edited by Giselle de Nie et al., 359–89. Turnhout: Brepols, 2005.

———. *The End of Time in the Order of Things: Science and Eschatology in Early Medieval Art.* Regensburg: Schnell + Steiner, 2003.

Kulpa, Zenon. "Diagrammatic Representation and Reasoning." *Machine Graphics and Vision: International Journal* 3, nos. 1–2 (1994): 77–103.

Kumler, Aden. "Handling the Letter." In *St. Albans and the Markyate Psalter: Seeing and Reading in Twelfth-Century England*, edited by Kristen Collins and Matthew Fisher, 69–100. Kalamazoo, MI: Medieval Institute Publications, 2017.

Kunz, Tobias. *Bildwerke nördlich der Alpen: 1050 bis 1380. Kritischer Bestandskatalog der Berliner Skulpturensammlung.* Petersberg: Michael Imhof Verlag, 2014.

Lacher, Eva. "Devotionsbild." *RDK* (1954), cols. 1189–97.

Lacroix, Pierre, and Andée Renon, eds. *Pensée, image & communication en Europe médiévale: À propos des stalles de Saint-Claude.* Besançon: Apsprodic, 1993.

Ladner, Gerhard. "Der Bilderstreit und die Kunst-Lehren der byzantinischen und abendländischen Theologie." *Zeitschrift für Kirchengeschichte* 50 (1931): 1–23. Reprinted in *Images and Ideas in the Middle Ages: Selected Studies in History and Art*, Storia e Letteratura: Raccolta di Studi e Testi 155 (Rome: Edizioni di Storia e Letteratura, 1983), 1:13–33.

———. "The Gestures of Prayer in Papal Iconography of the Thirteenth and Fourteenth Century." In *Didascaliae: Studies in Honor of Anselm M. Albareda*, 245–75. New York: B, M. Rosenthal, 1961. Reprinted in *Images and Ideas in the Middle Ages: Selected Studies in History and Art*, Storie e letteratura 155–56 (Rome: Edizioni di storia e letteratura, 1983), 1:209–37.

———. "St. Gregory of Nyssa and St. Augustine on the Symbolism of the Cross." In *Late Classical and Mediaeval Studies in Honor of Albert Mathias Friend, Jr.*, 88–95. Princeton: Princeton University Press, 1955. Reprinted in *Images and Ideas in the Middle Ages: Selected Studies in History and Art*, Storia e Letteratura: Raccolta di Studi e Testi 155 (Rome: Edizioni di Storia e Letteratura, 1983), 1:196–208.

———. "The Symbolism of the Biblical Corner Stone in the Medieval West." *Medieval Studies* 4 (1942): 43–60. Reprinted in *Images and Ideas in the Middle Ages: Selected Studies in History and Art*, Storia e Letteratura: Raccolta di Studi e Testi 155 (Rome: Edizioni di Storia e Letteratura), 1:171–96.

Lagerlund, Henrik. *Modal Syllogistics in the Middle Ages.* Studien und Texte zur Geistesgeschichte des Mittelalters 70. Leiden: Brill, 2000.

Laistner, Max L. W. "Source-Marks in Bede Manuscripts." *Journal of Theological Studies* 34 (1933): 350–54.

Landauer, Carl. "Mimesis and Erich Auerbach's Self-Mythologizing." *German Studies Review* 11 (1988): 83–96.

Lapidge, Michael. "Byrhtferth of Ramsey and the *Glossae Bridferti in Bedam*." *Journal of Medieval Latin* 17 (2007): 384–400.

Larkin, Jill H., and Herbert A. Simon. "Why a Diagram Is (Sometimes) Worth Ten Thousand Words." *Cognitive Science* 11 (1987): 65–99.

Laske-Fix, Katja. *Der Bildzyklus des Breviari d'amor.* Münchner kunsthistorische Abhandlungen 5. Munich: Schnell + Steiner, 1973.

Latour, Bruno. "Visualisation and Cognition: Drawing Things Together." In *Knowledge and Society: Studies in the Sociology of Culture Past and Present* 6, edited by Henrika Kuklick, 1–40. Greenwich, CT: Jai Press, 1986. Revised and reprinted in *Representation in Scientific Activity*, edited by Michael Lynch and Steve Woolgar (Cambridge, MA: MIT Press, 1990), 19–68.

———. "The Netz-Works of Greek Deductions." *Social Studies of Science* 38 (2008): 441–59.

Lausberg, Heinrich. *Der Hymnus "Ave maris stella."* Abhandlungen der Rheinisch-Westfälischen Akademie der Wissenschaften 61. Opladen: Westdeutscher Verlag, 1976.

Leclercq, Jean. "Saint Bernard et la dévotion médiévale envers Marie." *Revue d'Ascétique et de Mystique* 30 (1954): 361–75.

Ledegang, Freddy. "The Ophites and the 'Ophite' Diagram in Celsus and Origen." In *Heretics and Heresies in the Ancient Church and in Eastern Christianity: Studies in Honour of Adelbert Davids*, edited by Jozef Verheyden, Eastern Christian Studies 10, 51–83. Leuven: Peeters, 2008.

Legg, Catherine. "What Is a Logical Diagram?" In *Visual Reasoning with Diagrams*, edited by Amirouche Moktefi and Sun-Joo Shin, 1–18. Basel: Springer-Birkhauser, 2013.

Lehmann, Paul. *Mitteilungen aus Handschriften.* Vol. 2. Sitzungsberichte der Bayerischen Akademie der

Wissenschaften, Phil.-Hist. Abteilung 2. Munich: Akademie der Wissenschaften, 1930.

———. *Skadinaviens Anteil an der lateinischen Literatur und Wissenschaft des Mittelalters. 1. Stuck.* Sitzungsberichte der Bayerischen Akademie der Wissenschaften: Philosophisch-historische Abteilung (1936), 2. Munich: Verlag der Bayerischen Akademie der Wissenschaften, 1936.

Leja, Michael. "Peirce, Visuality, and Art." *Representations* 72 (2000): 97–122.

Lejeune, Serv. M. *De legendarische stamboom van St. Servaas in de Middeleeuwsche Kunst en Literatuur.* Publications de la Société historique et archéologique dans le Limburg à Maestricht 77. Maastricht: van Aelst, 1941.

Lemon, Oliver, and Ian Pratt. "On the Insufficiency of Linear Diagrams for Syllogisms." *Notre Dame Journal of Formal Logic* 39 (1998): 573–80.

———. "Spatial Logic and the Complexity of Diagrammatic Reasoning." *Machine Graphics and Vision* 6 (1997): 89–108.

Lentes, Thomas. "Die Auffaltung der 'mysteria involuta': Ritual und Allegorese in Diagrammen zum Liturgiekommentar Lothars von Segni." In *Allegorie: DFG-Symposion 2014,* edited by Ulla Haselstein, 67–87, 733–44. Berlin: De Gruyter, 2016.

Lepape, Séverine. "Le végétal et la parenté: Les arbres de la famille du Christ." In *Le monde végétal: médicine, botanique, symbolique,* edited by Agostono Paravicini Bagliani, Micrologus' Library 30. Florence: SISMEL, Edizioni del Galluzzo, 2009.

Levine, Robert. "The Pearl-child: Topos and Archetype in the Middle English *Pearl.*" *Mediaevalia et Humanistica* 8 (1977): 243–51.

———. "Squaring the Circle: Dante's Solution." *Neuphilologische Mitteilungen* 86 (1985): 280–84.

Levitan, William. "Dancing at the End of the Rope: Optatian Porfyry and the Field of Roman Verse." *Transactions of the American Philological Association (1974–)* 115 (1985): 245–69.

Liess, Hans-Christoph. *Astronomie mit Diagrammen: Geschichte und epistemische Funktion der Planetendiagramme des frühen Mittelalter.* Bern: Bern Studies in the History and Philosophy of Science, 2012.

Lima, Manuel. *The Book of Circles: Visualizing Spheres of Knowledge.* New York: Princeton Architectural Press, 2017.

———. *The Book of Trees: Visualizing Branches of Knowledge.* New York: Princeton Architectural Press, 2014.

Lipton, Sara. "'The Sweet Lean of His Head': Writing about Looking at the Crucifix in the High Middle Ages." *Speculum* 80 (2005): 1172–208.

Ljungberg, Christina. *Creative Dynamics: Diagrammatic Structures in Narrative.* Iconicity in Language

and Literature 11. Amsterdam: John Benjamins Publishing, 2012.

———. "The Diagrammatic Nature of Maps." In *Thinking with Diagrams: The Semiotic Basis of Human Cognition,* edited by Sybille Krämer and Christina Ljungberg, 139–59. Berlin: De Gruyter; Boston: Mouton, 2016.

Lodi, Letizia. "Serafino de' Serafini, attr., Trionfo di Sant'Agostino." In *La Pinacoteca nazionale di Ferrara: Catalogo generale,* edited by Jadranka Bentini, 24–27. Bologna: Nuova alfa editoriale, 1992.

Löer, Ulrich, ed. *Gotische Buchmalerei aus Westfalen: Choralbücher der Frauenklöster Paradies und Welver bei Soest.* Soester Beiträge 57. Soest: Westfälische Verlagsbuchhandlung Mocker & Jahn, 1997.

———. "Walburgiskloster und Walburgis-Antependium zu Soest: Ein Beitrag zu ihrer Entehungsgeschichte im Rahmen der kölnischen Territorialpolitik in Westfalen im 12. Jahrhundert." *Westfälische Zeitschrift* 143 (1993): 9–29.

Lohrum, M. "Dominikaner." In *Marienlexikon,* edited by Remigius Bäumer and Leo Scheffczyk, 2:207–9. St. Ottilien: EOS Verlag, 1989.

Londey, David, and Carmen Johanson. *The Logic of Apuleius, including a Complete Latin Text and English Translation of the Peri Hermeneias of Apuleius of Madaura.* Philosophia Antiqua 47. Leiden: Brill, 1987.

Löser, Freimut. "Meister Eckhart und seine Schüler: Lebemeister oder Lesemeister?" In *Schüler und Meister,* edited by Andreas Speer and Thomas Jeschke, Miscellanea mediaevalia 39, 255–76. Berlin: De Gruyter, 2016.

Lurker, Manfred. "Die Symbolbedeutung von Rechts und Links und ihr Niederschlag in der abendländischen christlichen Kunst." *Symbolon,* n.s., 5 (1980): 95–128.

Lüthy, Christoph, and Alexis Smets. "Words, Lines, Diagrams, Images: Towards a History of Scientific Imagery." In *Evidence and Interpretation in Studies on Early Science and Medicine: Essays in Honor of John E. Murdoch,* 398–439. Leiden: Brill, 2009.

Lutterbach, Hubertus. "Der Christus medicus und die Sancti medici. Das wechselvolle Verhältnis zweier Grundmotive christlicher Frömmigkeit zwischen Spätantike und Früher Neuzeit." *Saeculum* 47 (1996): 239–81.

Lutz, Gerhard. "The Drop of Blood: Image and Piety in the Twelfth and Thirteenth Centuries." *Preternature: Critical and Historical Studies on the Preternatural* 4 (2015): 37–51.

Lutz, Jules, and Paul Perdrizet. *Speculum humanae salvationis: Text critique, traduction inédite de Jean Miélot (1448). Les sources et l'influence iconographique principalement sur l'art alsacien du XIVe*

siècle; avec la reproduction en 140 planches du manuscrit de Sélestat, de la série complète des vitraux de Mulhouse, des vitraux de Colmar, de Wissembourg, etc. 2 vols. Mulhouse: E. Meininger, 1907–8.

Maas, Jörg F. "Zur Rationalität des vermeintlich Irrationalen: Einige Überlegungen zu Funktion und Geschichte des Diagramms in der Philosophie." In *Diagrammatik und Philosophie: Akten des 1. Interdisziplinären Kolloquium der Forschungsgruppe Philosophische Diagrammtik, an der FernUniversität/Gesamthochschule Hagen 15./16.12.1998*, edited by Petra Gehring et al., 51–73. Amsterdam: Rodopi, 1992.

Macbeth, Danielle. "Diagrammatic Reasoning in Frege's *Begriffsschrift*." *Synthese* 186 (2012): 289–314.

Macfarlane, Kirsten. "The Biblical Genealogies of the King James Bible (1611): Their Purpose, Sources, and Significance." *The Library* 19, no. 2 (2018): 131–58.

Machilek, Franz. "Zu einem Profeßzettel aus dem Augustiner-Chorherrenstift Langenzenn vom Jahre 1424." In *Bewahren und Umgestalten: Walter Jaroschka zum 60. Geburtstag*, edited by Hermann Rumschöttel and Erich Stahleder, Mitteilungen für die Archivpflege in Bayern: Sonderheft 6, 324–31. Munich: Generaldirektion der Staatlichen Archive Bayerns, 1992.

Macy, Gary. *The Theologies of the Eucharist in the Early Scholastic Period*. Oxford: Oxford University Press, 1984.

Maguire, Henry. "Magic and Geometry in Early Christian Floor Mosaics and Textiles." *Jahrbuch der österreichischen Byzantinistik* 44 (1994): 265–74.

——. "Validation and Disruption: The Binding and Severing of Text and Image in Byzantium." In *Bild und Text im Mittelalter*, edited by Karin Krause and Barbara Schellewald, 267–82. Cologne: Böhlau, 2010.

Mahnke, Dietrich. *Unendliche Sphäre und Allmittelpunkt*. Deutsche Vierteljahrsschrift für Literaturwissenschaft und Geistesgeschichte: Buchreihe 32. Halle: Niemeyer, 1937.

Maierù, Alfonso. "Logic and Trinitarian Theology: *De Modo Predicandi ac Sylogizandi in Divinis*." In *Meaning and Inference in Medieval Philosophy: Studies in Memory of Han Pinborg*, edited by Norman Kretzmann, 247–96. Dordrecht: Kluwer Academic Publishers, 1988.

Maler, Johannes. "Studien zur Geschichte der Marienantiphon 'Salve regina.'" PhD diss., Albert Ludwig Universität, Freiburg i. Br., 1939.

Mancosu, Paolo. "Visualization in Logic and Mathematics." In *Visualization, Explanation and Reasoning Styles in Mathematics*, edited by Paolo Mancosu, 13–30. Basel: Springer, 2005.

Manders, Kenneth. "Diagram-Based Geometric Practice." In *The Philosophy of Mathematical Practice*, edited by Paolo Mancosu, 65–79. Oxford: Oxford University Press, 2008.

——. "The Euclidean Diagram (1995)." In *The Philosophy of Mathematical Practice*, edited by Paolo Mancosu, 80–133. Oxford: Oxford University Press, 2008.

Mann, William E. "The Best of All Possible Worlds." In *Being and Goodness: The Concept of the Good in Metaphysics and Philosophical Theology*, edited by Scott MacDonald, 250–77. Ithaca: Cornell University Press, 1991.

Manuwald, Henrike. "Der nichtverbrennende Dornbusch und die Jungfrau Maria: Überlegungen zur Diagrammatizität typologischer Sinnbilder." In *Übertragung—Bedeutungspraxis und "Bildlichkeit" in Literatur und Kunst des Mittelalters*, edited by Franziska Wenzel and Pia Selmayr, 47–64, pls. 10–15. Wiesbaden: Reichert Verlag, 2017.

Marchand, James W. "Leviathan and the Mousetrap in the Niðrstigningarsaga." *Scandinavian Studies* 47 (1975): 328–38.

Marci, Giovanni. "La Legenda di Teofilo: La testimonianza delle verate del XIII secolo." *Arte Cristiana* 96 (2008): 191–210.

Marcovich, Miroslav. "Sator Arepo—Georgos Harpon." In *Studies in Graeco-Roman Religions and Gnosticism*, Studies in Greek and Roman Religion 4, 28–46. Leiden: Brill, 1988.

——. "Sator Arepo—Georgos Harpon (Knoyphi) Harpos." *Zeitschrift für Papyrologie und Epigraphik* 50 (1983): 155–71.

Marrinan, Michael. "On the 'Thing-ness' of Diagrams." In *Thinking with Diagrams: The Semiotic Basis of Human Cognition*, edited by Sybille Krämer and Christina Ljungberg, Semiotics, Communication and Cognition 17, 23–56. Berlin: De Gruyter, 2016.

Marrow, James H. "*Circumdederunt me canes multi*: Christ's Tormentors in Northern European Art of the Late Middle Ages and Early Renaissance." *Art Bulletin* 59 (1977): 167–81.

Martin, Christopher J. "The Development of Logic." In *The Cambridge History of Medieval Philosophy*, edited by Robert Pasnau, with Christina van Dyke, 1:129–46. Cambridge: Cambridge University Press, 2014.

Marx, Bernhard. *Balancieren im Zwischen: Zwischenreiche bei Paul Klee*. Würzburg: Königshausen & Neumann, 2007.

Masai, François, and Martin Wittek. *Manuscrits datés conservés en Belgique* 4 (1461–1480). Brussels: Éditions Scientifiques E. Story-Scientia, 1982.

Mathon, Gérard. "Claudien Mamert et la christianisation de la psychologie néoplatonicienne." *Mélanges de science religieuse* 19 (1962): 110–18.

Matter, E. Ann. *The Voice of My Beloved: The Song of Songs in Western Medieval Christianity*. Philadelphia: University of Pennsylvania Press, 1990.

Mayr-Harting, Henry. *Church and Cosmos in Early Ottonian Germany: The View from Cologne*. Oxford: Oxford University Press, 2007.

McGinn, Bernard. "Image as Insight in Joachim of Fiore's *Figurae*." In *Envisioning Experience in Late Antiquity and the Middle Ages: Dynamic Patterns in Texts and Images*, edited by Giselle de Nie and Thomas F. X. Noble, 93–118. Farnham: Ashgate, 2012.

——. "Theologians as Trinitarian Iconographers." In *The Mind's Eye: Art and Theological Argument in the Middle Ages*, edited by Jeffrey F. Hamburger and Anne-Marie Bouché, 186–207. Princeton: Princeton University Press, 2006.

——. "'Trinity higher than any Being!' Imaging the Invisible Trinity," In *Ästhetik des Unsichtbaren: Bildtheorie und Bildgebrauch in der Vormoderne*, edited by David Ganz and Thomas Lentes, with Georg Henkel, 76–93. Berlin: Reimer, 2004.

McKenzie, Allan Dean. "The Virgin Mary as the Throne of Solomon in Medieval Art." PhD diss., New York University, 1965.

McNamee, Megan. "Picturing as a Practice: Placing a Square above a Square in the Central Middle Ages." In *Canonical Texts and Scholarly Practices: A Global Comparative Approach*, edited by Anthony Grafton and Glenn Most, 200–203. Cambridge: Cambridge University Press, 2016.

Meersseman, Gilles G. *Der Hymnos Akathistos im Abendland*. 2 vols. Spicilegium Friburgense 2–3. Fribourg: Universitätsverlag, 1958–60.

Meier, Christel. "Die Quadratur des Kreises: die Diagrammatik des 12. Jahrhunderts als symbolische Denk- und Darstellungsform." In *Die Bildwelt der Diagramme Joachims von Fiore: Zur Medialität religiös-politischer Programme im Mittelalter*, edited by Alexander Patschovsky, 23–53. Ostfildern: Thorbecke, 2003.

——. "Malerei des Unsichtbaren: Über den Zusammenhang von Erkenntnistheorie und Bildstruktur im Mittelalter." In *Text und Bild, Bild und Text: DFG Symposion 1988*, edited by Wolfgang Harms, 35–65. Stuttgart: Metzler, 1990.

——. "Monastisches Gesellschaftsmodell und Zahl im Hochmittelalter: Adams von Dryburgh Stifthüttentraktat *De triplici tabernaculo una cum pictura*. Mit einer Rekonstruktion des allegorischen Tabernaculum von Ulrich Engelen." In *Was zählt: Ordnungsangebote, Gebrauchsformen und Erfahrungsmodalitäten des "numerus" im Mittelalter*, edited by Moritz Wedell, Pictura et Poësis 31, 387–418. Cologne: Böhlau, 2012.

——. "*Per invisibilia ad invisibilia*? Mittelalterliche Visionsikonographie zwischen analoger, negativer und 'analytischer' Ästhetik." In *Nova de veteribus: Mittel- und neulateinische Studien für Paul Gerhard Schmidt*, edited by Andreas Bihrer and Elisabeth Stein, 476–503. Munich: K.G. Sauer, 2004.

Meirinhos, José Francisco Preto. "Dessiner le savoir: un schéma des sciences du XIIᵉ siècles dans un manuscrit de Santa Cruz de Coimbra." In *Itinéraires de la raison: Études de philosophie médiévale offertes a Maria Cândida Pacheco*, Texts et Études du Moyen Âge 32, 186–204. Louvain-la-Neuve: Fédération Internationale des Instituts d'Études Médiévales, 2005.

Meiss, Millard. "Light as Form and Symbol in Some Fifteenth-Century Paintings." *Art Bulletin* 27 (1945): 175–81.

Mellinkoff, Ruth. "Judas's Red Hair and the Jews." *Journal of Jewish Art* 9 (1982): 31–46.

Mellon, Elizabeth A. "Inscribing Sound: Medieval Remakings of Boethius's *De institutione musica*." PhD diss., University of Pennsylvania, 2011.

Melnikas, Anthony. *The Corpus of Miniatures in the Manuscripts of the Decretum Gratiani*. 2 vols. Studia Gratiana 16–18. Rome: Index of Juridical and Civic Iconography, 1975.

Melville, Gert. "Geschichte in graphischer Gestalt: Beobachtungen zu einer spätmittelalterlichen Darstellungsweis." In *Geschichtsschreibung und Geschichtsbewusstsein im späten Mittelalter* 31, edited by Hans Patze, Vorträge und Forschungen Konstanzer Arbeitskreis für Mittelalterliche Geschichte, 57–154. Sigmaringen: Jan Thorbeke, 1987.

Mertens, Dieter. "Jakob Wimpfeling (1450–1528): Pädagogischer Humanismus." In *Humanismus im deutschen Südwesten: Biographische Profile*, edited by Paul Gerhard Schmidt, 35–57. Sigmaringen: Thorbecke, 1993.

——. "Wimpfeling (Wimphelng, -ius, Sletstattinus), Jakob." In *Deutscher Humanismus 1480–1520: Verfasserlexikon*, edited by Franz Josef Worstbrock, vol. 2, cols. 1289–1375. Berlin: De Gruyter, 2008–15.

Messerer, Wilhelm. "Einige Darstellungsprinzipien der Kunst im Mittelalter." *Deutsche Vierteljahrschrift für Literaturwissenschaft und Geistesgeschichte* 2 (1962): 157–78.

Mews, Constant J., ed. *Listen, Daughter: The "Speculum Virginum" and the Formation of Religious Women in the Middle Ages*. Basingstoke: Palgrave, 2001.

Meyer, Hans Bernard. "Crux, decus es mundi: Alkuins Kreuz- und Osterfrömmigkeit." In *Paschatis Sollemnia: Studien zu Osterfeier und Osterfrömmigkeit. Festschrift für Josef Andreas Jungmann von Schülern und Freunden dargeboten*, edited by Balthasar Fischer and Johannes Wagner, 96–107. Freiburg i. Br.: Herder, 1959.

Meyer, Heinz, and Rudolf Suntrup. *Lexikon der mittelalterlichen Zahlenbedeutungen*. Münstersche Mittelalter-Schriften 56. Munich: Fink, 1987.

Meyer-Krahmer, Benjamin. "Écriture et dessin dans la pratique graphique de C. S. Peirce." In "verbal non verbal." Special issue, *Genesis—Manuscrits, Recherche, Invention. Revue internationale de critique génétique ITEM* 37 (2013): 101–23.

———. "My Brain Is Localized in My Inkstand: Zur graphischen Praxis von Charles Sanders Peirce." In *Schriftbildlichkeit: Wahrnehmbarkeit, Materialität und Operativität von Notationen*, edited by Sybille Krämer et al., Schriftbildlichkeit 1, 401–14. Berlin: Akademie-Verlag, 2012.

Miller, Clyde Lee. *Reading Cusanus: Metaphor and Dialectic in a Conjectural Universe*. Studies in Philosophy and the History of Philosophy 37. Washington, D.C.: Catholic University of America Press, 2003.

Minkenberg, Georg. "Die Karlsbüste im Aachener Domschatz." In *Aachen und Prag—Krönungsstädte Europas: Beiträge des Kulturvereins Aachen-Prag e.V. 1. 1998–2003*, edited by Vera Blažek and Werner Gugat, 89–98. Prague: Libri Aquenses, 2004.

Minnis, Alistair J. "Late-Medieval Discussions of *Compilatio* and the Rôle of the *Compilator*." *Beiträge zur Geschichte der deutschen Sprache und Literatur* 101 (1979): 385–421.

Mitchell, Thomas W. J. "Diagrammatology." *Critical Inquiry* 7 (1981): 622–33.

———. *Iconology: Image, Text, Ideology*. Chicago: University of Chicago Press, 1986.

———. *Picture Theory: Essays on Verbal and Visual Representation*. Chicago: University of Chicago Press, 1994.

Mittelalter. Kunst und Kultur von der Spätantike bis zum 15. Jahrhundert. Die Schausammlungen des Germanischen Nationalmuseums 2. Nuremberg: Germanischen Nationalmuseum, 2007.

Mohnhaupt, Bernd. *Beziehungsgeflechte: Typologische Kunst des Mittelalters*. Vestigia Bibliae 22. Bern: Peter Lang, 2000.

Molland, Andrew G. "Mathematics in the Thought of Albertus Magnus." In *Albertus Magnus and the Sciences: Commemorative Essays, 1980*, edited by James A. Weisheipl, Studies and Texts 49, 463–78. Toronto: PIMS, 1980.

Molsdorf, Wilhelm. *Christliche Symbolik der mittelalterlichen Kunst*. Leipzig: Karl W. Hiersemann, 1926. Reprint, Graz: ADEVA, 1984.

Moore, Philip S. *The Works of Peter of Poitiers: Master in Theology and Chancellor of Paris (1193–1205)*. Washington, D.C.: Catholic University of America, 1936.

Morard, Martin. "La bibliothèque évaporée: Livres et manuscrits des dominicains de Toulouse (1215–1840)." In *Entre stabilité et itinérance: Livres et culture des ordres mendiants, XIII*ᵉ*—XV*ᵉ *siècle*, edited by Nicole Bériou and Donatella Nebbiai-Dalla Guarda, Bibliologia. Elementa ad librorum studia pertinentia 37, 73–128. Turnhout: Brepols, 2014.

Morello, Giovanni, and Gerhard Wolf, eds. *Il volto di Cristo*. Milan: Electa, 2000.

Morgan, Nigel. "The Iconography of Twelfth-Century Mosan Enamels." In *Rhein und Maas: Kunst und Kultur 800–1400*, 2:263–75. Cologne: Schnütgen Museum, 1972–73.

———. "Texts and Images of Marian Devotion in Fourteenth-Century England." In *England in the Fourteenth Century*, edited by Nicholas Rogers, Harlaxton Medieval Studies 3, 34–57. Stanford: Paul Watkins, 1993.

———. "Texts and Images of Marian Devotion in Thirteenth-Century England." In *England in the Thirteenth Century: Proceedings of the 1989 Harlaxton Symposium*, edited by William M. Ormrod, Harlaxton Medieval Studies 1, 69–103. Stamford: Paul Watkins, 1991.

Morrison, Tessa. "Bede's *de tabernaculo* and *de templo*." *Journal of the Australian Early Medieval Association* 3 (2007): 243–57.

Moyer, Ann E. *The Philosophers' Game: Rithmomachia in Medieval and Renaissance Europe, with an Edition of Ralph Lever and William Fulke, The Most Noble, Auncient, and Learned Playe (1563)*. Ann Arbor: University of Michigan Press, 2001.

Mueller, Ian. "Greek Arithmetic, Geometry and Harmonics: Thales to Plato." In *From the Beginning to Plato*, edited by Christopher Charles Wilson Taylor, Routledge History of Philosophy 1, 271–322. London: Routledge, 1997.

Mulchahey, Michèle. *"First the Bow is Bent in Study": Dominican Education before 1350*. Studies and Texts 132. Toronto: Pontifical Institute of Mediaeval Studies, 1998.

Mullarkey, John. *Post-Contintental Philosophy: An Outline*. London: Continuum, 2006.

Müller, Hans-Georg. *Hrabanus Maurus: De laudibus sancta [sic] crucis; Studien zur Überlieferung und Geistesgeschichte mit dem Faksimile-Textabdruck aus Codex Reg. Lat. 124 der Vatikanischen Bibliothek*. Beihefte zum *Mittellateinischen Jahrbuch* 11. Ratingen: A. Henn, 1979.

Müller, Kathrin. "'Admirabilis forma numeri': Diagramm und Ornament in mittelalterlichen Abschriften von Boethius' 'De arithmetica.'" In *Ornament: Motive—Modus—Bild*, edited by Vera Beyer and Christian Spies, 181–210. Paderborn: Fink, 2012.

———. "Gott ist (k)eine Sphäre: Visualisierungen des Göttlichen in geometrisch-abstrakten Diagrammen des Mittelalters." In *Handbuch der Bildtheologie*,

vol. 3, *Zwischen Zeichen und Präsenz*, edited by Reinhard Hoeps, 311–55. Paderborn: Ferdinand Schöningh, 2014.

———. "Irritierende Variabilität: Die mittelalterliche Reproduktion von Wissen im Diagramm." In *Übertragungen: Formen und Konzepte von Reproduktion in Mittelalter und Früher Neuzeit*, edited by Britta Bußmann et al., Trends in Medieval Philology 5, 415–36. Berlin: De Gruyter, 2005.

———. *Visuelle Weltaneignung: Astronomische und kosmologische Diagramme in Handschriften des Mittelalters*. Historische Semantik 11. Göttingen: Vandenhoeck & Rupprecht, 2008.

Münkner, Jörn. *Eingreifen und Begreifen: Handhabungen und Visualisierungen in Flugblättern der Frühen Neuzeit*. Philologische Studien und Quellen 214. Berlin: Erich Schmidt, 2008.

Muratova, Xénia. "Adam donne leur noms aux animaux: L'iconographie de la scène dans l'art du Moyen Âge. Les manuscrits des bestiaires enluminés du XIIe et XIIIe siècles." *Studi medievali* 3 Ser. 18 (1977): 367–94.

Murdoch, John E. *Album of Science: Antiquity and the Middle Ages*. New York: Scribner, 1984.

———. "From Social into Intellectual Factors: An Aspect of the Unitary Character of Late Medieval Learning." In *The Cultural Context of Medieval Learning: Proceedings of the First International Colloquium on Philosophy, Science, and Theology in the Middle Ages—September 1973*, Synthese Library 76; Boston Studies in the Philosophy of Science 26, 271–48. Dordrecht: D. Reidel, 1975.

———. "*Mathesis in philosophiam scholasticam introducta*: The Rise and Development of the Application of Mathematics in Fourteenth-Century Philosophy and Theology." In *Arts libéraux et philosophie au moyen âge: Actes du 4e congrès international de philosophie médiévale, 1967*, 215–54. Montréal, Institut d'études médiévales; Paris: Librairie philosophique J. Vrin, 1969.

Nagel, Alexander. *Medieval Modern: Art out of Time*. New York: Thames & Hudson, 2012.

Naredi-Rainer, Paul von. *Salomos Tempel und das Abendland: monumentale Folgen historischer Irrtümer*. Cologne: Dumont, 1994.

Nelsen, Roger B. *Proofs without Words*. Classroom Resource Materials 1. Washington, D.C.: The Mathematical Association of America, 1993.

———. *Proofs without Words II*. Classroom Resource Materials 2. Washington, D.C.: The Mathematical Association of America, 2000.

Netz, Reviel. "Greek Mathematical Diagrams: Their Use and Their Meaning." *For the Learning of Mathematics* 18 (1998): 33–39.

———. *The Shaping of Deduction in Greek Mathematics: A Study in Cognitive History*. Ideas in Context 51. Cambridge: Cambridge University Press, 1999.

Noble, Thomas F. X. *Images, Iconoclasm, and the Carolingians*. Philadelphia: University of Pennsylvania Press, 2009.

Nordenfalk, Carl, et al. *Medieval and Renaissance Miniatures from the National Gallery of Art*. Washington D.C.: National Gallery of Art, 1975.

Norman, Jesse. *After Euclid: Visual Reasoning & the Epistemology of Diagrams*. CSLI Lecture Notes 175. Stanford: CSLI Publications, 2006.

North, John. "Diagram and Thought in Medieval Science." In *Villard's Legacy: Studies in Medieval Technology, Science and Art in Memory of Jean Gimpel*, edited by Marie-Thérèse Zenner, AVISTA Studies in the History of Medieval Technology 2, 265–87. Aldershot: Ashgate, 2004.

Oakes, Catherine. *Ora pro nobis: The Virgin as Intercessor in Medieval Art and Devotion*. London: Harvey Miller; Turnhout: Brepols, 2008.

Oberweis, Michael. "Die mittelalterlichen T-O Karten." *Periplus* 23 (2013): 121–34.

Obrist, Barbara. "Image et prophétie au XIIe siècle: Hugues de Saint-Victor et Joachim de Flore." *Mélanges de l'École française de Rome: Moyen Âge-Temps Modernes* 98 (1986): 35–63.

———. *La cosmologie médiévale: textes et images*, I. *Les fondements antiques*, Micrologus' Library 11. Florence: SISMEL, Edizioni del Galluzzo, 2004.

———. "La figure géometrique dans l'oeuvre de Joachim de Flore." *Cahiers de civilization médiévale, Xe–XIIe siècles* 31 (1988): 297–321.

———. "Le système pictural de Joachim de Flore dans son context historique." In *Pensare per figure: Diagrammi e simboli in Gioacchino da Fiore*, edited by Alessandro Ghisalberti, Opera di Gioacchino da Fiore: testi e strumenti 23, 217–28. Rome: Viella, 2010.

Obrist, Barbara, and Irene Caiazzo, eds. *Guillaume de Conches: Philosophie et science au XIIe siècle*. Florence: SISMEL, Edizioni del Galluzzo, 2011.

Ohly, Friedrich. "Außerbiblisch Typologisches zwischen Cicero, Ambrosius und Aelred von Rievaulx." In *"Sagen mit Sinne": Festschrift für Marie-Luise Dittrich zum 65. Geburtstag*, edited by Helmut Rücker, 19–37. Göppingen: Kümmerle, 1976. Reprinted in *Schriften zur mittelalterlichen Bedeutungsforschung* (Darmstadt: Wissenschaftliche Buchgesellschaft, 1977), 360–88.

———. "Halbbiblische und außerbiblische Typologie." In *Simboli e simbologia nell'alto medioevo, 3–9 aprile 1975*, Settimane di studio del Centro italiano di studi sull'alto Medioevo 23, 2:429–79. Spoleto: Il Centro italiano di studi sull'alto medioevo, 1976. Reprinted

in *Schriften zur mittelalterlichen Bedeutungsfor-schung* (Darmstadt: Wissenschaftliche Buchge-sellschaft, 1977), 340–61.

———. "Haus als Metapher." *Reallexikon für Antike und Christentum* 13 (1986): cols. 905–1063.

———. *Hohelied-Studien: Grundzüge einer Geschichte der Hohliedauslegung des Abendlandes bis um 1200.* Schriften der Wissenschaftlichen Gesellschaft an der Johann Wolfgang Goethe-Universität Frankfurt am Main: Geisteswissenschaftliche Reihe 1. Wies-baden: Franz Steiner Verlag, 1958.

———. *Süsse Nägel der Passion: Ein Beitrag zur theolo-gischen Semantik.* Baden-Baden: V. Koerner, 1989.

———. "Typologische Figuren aus Natur und Mythus." In *Formen und Funktionen der Allegorie: Symposion Wolfenbüttel 1978*, edited by Walter Haug, Ger-manistische Symposien. Berichtsbände 3, 126–66. Stuttgart: Metzler, 1979. Reprinted in *Ausgewählte und neue Schriften zur Literaturgeschichte und zur Bedeutungsforschung*, edited by Uwe Ruberg und Dietmar Peil (Stuttgart: S. Hirzel, 1995), 437–508.

Oliver, Patrick. "Diagrammatic Reasoning: An Artifi-cial Intelligence Perspective." *Artificial Intelligence Review* 15 (2001): 63–78.

Olson, Glending. "Measuring the Immeasurable: Fart-ing, Geometry, and Theology in the *Summoner's Tale*." *Chaucer Review* 43 (2009): 414–27.

O'Meadhra, Uaininn. "Medieval Logic Diagrams in Bro Church, Gotland, Sweden." *Acta Archaeologica* 83 (2012): 287–316.

Omont, Henri. "Richard de St-Laurent et le Liber de laudibus beatae Mariae." *Bibliothèque de l'École de Chartres* 41 (1881): 503–4.

Ong, Walter J. "From Allegory to Diagram in the Re-naissance Mind: A Study in the Significance of the Allegorical Tableau." *Journal of Aesthetics and Art Criticism* 17 (1959): 423–40.

———. *Ramus: Method, and the Decay of Dialogue.* With a new foreword by Andrian Johns. Chicago: Univer-sity of Chicago Press, 2004.

O'Reilley, Jennifer. "Patristic and Insular Traditions of the Evangelists: Exegesis and Iconography of the Four-Symbol Page." In *Le isole britanniche e Roma in età romanobarbarica*, edited by Anna Maria Lu-iselli Fadda and Éamonn Ó'Carragain, Biblioteca di cultura romanobarbarica 1, 49–94. Rome: Herder, 1998.

———. *Studies in the Iconography of the Virtues and Vices in the Middle Ages.* New York: Garland Press, 1988.

Osbourne, John. "The 'Particular Judgment': An Early-Medieval Wall Painting in the Lower Church of San Clemente, Rome." *Burlington Magazine* 123 (1981): 335–41.

Otto, August. *Die Sprichwörter und sprichwörtlichen Re-densarten der Römer.* Reprint edition. Hildesheim: Olms, 1988.

Otto, Stephan. *Die Funktion des Bildbegriffes in der The-ologie des 12. Jahrhunderts.* Beiträge zur Geschichte der Philosophie und Theologie des Mittelalter: Text und Untersuchungen 40/1. Münster: Aschendorff, 1963.

Paccagnella, Ivano, and Elisa Gregori, eds. *Mimesis: l'eredità di Auerbach. Atti del XXXV Convegno in-teruniversitario (Bressanone-Innsbruck, 5–8 luglio 2007).* Quaderni del Circolo filologico linguistico padovano 23. Padua: Esedra, 2009.

Pächt, Otto. *Buchmalerei des Mittelalters.* Munich: Prestel, 1984. Translated by Kay Davenport as *Book Illumination in the Middle Ages* (London: Harvey Miller, 1986).

———. "The Practice of Art History." In *The Practice of Art History: Reflections on Method*, translated by David. Britt, with an introduction by Christopher S. Wood, 19–52. London: Harvey Miller, 1999.

———. *The Rise of Pictorial Narrative in the Twelfth Century.* Oxford: Clarendon Press, 1962.

Palazzo, Alessandro. "Philosophy and Theology in the German Dominican Scholae in the Late Middle Ages: The Cases of Ulrich of Strasbourg and Ber-thold of Wimpfen." In *Philosophy and Theology in the Studia of the Religious Orders and at Papal and Royal Courts: Acts of the XVth Annual Colloqui-um of the Société Internationale pour l'Étude de la Philosophie Médiévale, University of Notre Dame, 8–10 October 2008*, edited by Kent Emery Jr. et al., 75–105. Turnhout: Brepols, 2012.

Palazzo, Éric, ed. *Portraits d'écrivains: La representa-tion de l'auteur dans les manuscrits et les imprimés du Moyen Âge et de la première Renaissance*, Médiathèque François-Mitterand, Poitiers, 23 juillet–26 octobre. Collection "(Re)découvertes" 72. Poitiers: Médiathèque François-Mitterand, 2002.

Palmer, Nigel F. "Die lateinisch-deutsche 'Berliner Na-tivitätsprognostik.'" In *Licht der Natur: Medizin in Fachliteratur und Dichtung. Festschrift für Gundolf Keil zum 60. Geburtstag*, edited by Josef Domes et al., Göppinger Arbeiton zur Germanistik 585, 252–91. Göppingen: Kümmerle, 1994.

———. "Kapitel und Buch: Zu den Gliederungsprinzip-ien mittelalterlichen Bücher." *Frühmittelalterliche Studien* 23 (1989): 43–88.

———. "'Turning many to righteousness': Religious Didacticism in the 'Speculum humanae salvationis' and the Similitude of the Oak Tree." In *Dichtung und Didaxe: Lehrhaftes Sprechen in der deutschen Literatur*, edited by Henrike Lähnemann and San-dra Linden, 345–66. Berlin: De Gruyter, 2009.

——. *Zisterzienser und ihre Bücher: Die mittelalterliche Bibliotheksgeschichte von Kloster Eberbach im Rheingau unter besonderer Berücksichtigung der in Oxford und London aufbewahrten Handschriften.* Regensburg: Schnell + Steiner, 1998.

Panayotova, Stella D. "Peter of Poitiers's *Compendium in genealogia Christi*: The Early English Copies." In *Belief and Culture in the Middle Ages: Studies presented to Henry Mayr-Harting*, edited by Richard Gameson and Henrietta Leyser, 327–41. Oxford: Oxford University Press, 2001.

Paolucci, Claudio. "Semiotics, Schemata, Diagrams, and Graphs: A New Form of Diagrammatic Kantism by Peirce." In *Peirce on Perception and Reasoning: From Icons to Logic*, edited by Kathleen A. Hull and Richard Kenneth Atkins, Routledge Studies in American Philosophy 10, 74–85. New York: Routledge, 2017.

Pápay, Gyula. "Kartenwissen—Bildwissen—Diagrammwissen—Raumwissen: Theoretische und historische Reflexionen über die Beziehungen der Karte zu Bild und Diagramm." In *Kartenwissen: Territoriale Räume zwischen Bild und Diagramm*, edited by Stephan Günzel and Lars Nowak, 45–61. Wiesbaden: Reichert, 2012.

Parkes, Malcolm B. "The Influence of the Concepts of 'Ordinatio' and 'Compilatio' on the Development of the Book." In *Medieval Learning and Literature: Essays presented to Richard William Hunt*, edited by Jonathan J. G. Alexander and Margaret T. Gibson, 115–41. Oxford: Oxford University Press, 1976. Reprinted in *Scribes, Scripts and Readers: Studies in the Communication, Presentation and Dissemination of Medieval Texts* (London: Hambledon Press, 1991), 35–70.

——. *Pause and Effect: An Introduction to the History of Punctuation in the West.* Berkeley: University of Caliornia Press, 1993.

Parsons, Terence. "The Traditional Square of Opposition." In *The Stanford Encyclopedia of Philosophy* (Summer 2017 Edition), edited by Edward N. Zalta. Accessed December 28, 2018. https://plato.stanford.edu/archives/sum2017/entries/square/.

Patterson, Richard. "Diagrams, Dialectic, and Mathematical Foundations in Plato." *Apeiron: A Journal for Ancient Philosophy and Science* 40 (2007): 1–33.

Pavlíček, Ota. "*Scutum fidei christianae*: The Depiction and Explanation of the Shield of Faith in the Realist Teaching of Jerome of Prague in the Context of His Interpretation of the Trinity," *Filosofický časopis*, special issue 1 (2014). *The Bohemian Reformation and Religious Practice* 9, edited by D. V. Zdenek and D. R. Holeton, 72–97.

Peignot, Jérôme. *Du Calligramme.* Dossiers graphiques du Chêne. Paris: Chêne, 1978.

Perrin, Michel Jean-Louis. "Dans les marges de l'editio princeps du 'De laudibus sanctae crucis' de Hraban Maur (Pforzheim 1503): Un aperçu de l'humanisme rhénan vers 1500." In *Antiquité tardive et humanism: de Tertullien à Beatus Rhenanus: Mélanges offerts à François Heim à l'occasion de son 70e anniversaire*, edited by Yves Lehmann et al., 337–75. Turnhout: Brepols, 2005.

——. "La représentation figurée de César-Louis le Pieux chez Raban Maur en 835: Religion et idéologie." *Francia* 24, no. 1 (1997): 39–64.

——. *L'iconographie de la "Glore à la sainte croix" de Raban Maur.* Le Corpus de RILMA 1. Turnhout: Brepols, 2009.

——. "Un nouveau regard jété par Jakob Wimpfeling (1450–1528) sur la culture antique et chétienne: Quelques réflexions en large du *De laudibus sanctae crucis* de Raban Maur (Pforzheim 1503)." *Bulletin de l'Association Guillaume Budé* (March 1992): 73–86.

Peters, Ursula. *Das Ich im Bild: Die Figur des Autors in volkssprachigen Bilderhandschriften des 13. bis 16. Jahrhunderts.* Pictura et Poësis 22. Cologne: Böhlau, 2008.

——. "Werkauftrag und Buchübergabe: Textentstehungsgeschichten in Autorbildern volkssprachiger Handschriften des 12. bis 15. Jahrhunderts." In *Autorbilder: Zur Medialität literarischer Kommunikation in Mittelalter und Früher Neuzeit*, edited by Gerald Kapfhammer et al., Tholos: Kunsthistorische Studien 2, 25–62. Münster: Rhema Verlag, 2007.

Petzold, Andreas. "'His Face Like Lightning': Color as Signifier in Representations of the Holy Women at the Tomb." *Arte medievale* 6 (1992): 149–55.

Pfister, Kurt. *Defensorium immaculatae virginitatis: Faksimiliedruck des Blockbuches von 1470.* Leipzig: Insel Verlag, 1925.

Philippopoulos-Mihalopoulos, Andreas. *Niklas Luhmann: Law, Justice, Society.* Abingdon: Routledge, 2010.

Pietarinen, Ahti-Veikko. "Diagrams or Rubbish." In *Charles Sanders Peirce in His Own Words: 100 Years of Semiotics, Communication and Cognition*, edited by Torkild Thellefsen and Bent Sørensen, Semiotics, Communication and Cognition 14, 115–20. Boston: De Gruyter, 2014.

Pinkus, Assaf. "The Eye and the Womb: Viewing the Schreinmadonna." *Arte medievale* 4 Ser. 2 (2012): 201–20.

Pippal, Martina. "Von der gewußten zur geschauten Similitudo: Ein Beitrag zur Entwicklung der typologischen Darstellung bis 1181." *Der Kunsthistoriker* 4 (1987): 53–61.

Platelle, Henri. "Guibert de Nogent et le 'De pignoribus sanctorum': richesses et limites d'une critique

médiévale des reliques." In *Les reliques: Objets, cultes, symboles. Actes du colloque international de l'Université du Littoral-Côte d'Opale (Boulogne-sur-Mer) 4–6 septembre 1997*, edited by Edina Bozóky and Anne-Marie Helvétius, Hagiologia 1, 109–21. Turnhout: Brepols, 1999.

Poeschke, Joachim, ed. *Das Soester Antependium und die frühe mittelalterliche Tafelmalerei: Kunsttechnische und kunsthistorische Beiträge. Akten des Wissenschaftlichen Kolloquiums vom 5.–7. Dezember 2002 veranstaltet vom Institut für Kunstgeschichte der Universität Münster, vom Westfälischen Landesmuseum für Kunst und Kulturgeschichte in Münster und der Fachhochschule Köln*. Münster: Aschendorff, 2005.

Poggenpohl, Sharon Helmer, and Dietmar R. Winkler. "Diagrams as Tools for Worldmaking." *Visible Language* 26, nos. 3–4 (1992): 253–71.

Poilpré, Anne-Orange. *Maiestas Domini: Une image de l'Église en Occident Ve–IXe siècle*. Paris: Éditions du Cerf, 2005.

Poirel, Dominique. "*Machina universitatis*: les mutations du text aux XIIe–XIIIe siècles." In *Qu'est-ce que nommer? L'image légendée entre monde monastique et pensée scolastique*, edited by Christian Heck, Les Études du RILMA 1, 41–57. Turnhout: Brepols, 2010.

Polara, Giovanni. "I carmina figurata di Venanzio Fortunato." In *Venanzio Fortunato e il suo tempo: convegno internazionale di studio, Valdobbiadene, Chiesa di S. Gregorio Magno, 29 novembre 2001-Treviso, Casa dei Carraresi 30 novembre–1 dicembre 2001*, 211–30. Treviso: Fondazione Cassamarca, 2003.

———. "La poesia figurata tardoantica e medievale." In *Alfabeto in sogno: Dal carme figurato all a poesia concreta. Reggio Emilia, Chiostro do San Domenico, 20 gennaio–3 marzio, 2002*, edited by Claudio Parmiggiani, 67–86. Milan: Edizioni Gabriele Mazzota, 2002.

Porter, James I. "Erich Auerbach and the Judaizing of Philology." *Critical Inquiry* 35 (2008): 115–47.

Preisinger, Raphaèle. *Lignum vitae: Zum Verhältnis materieller Bilder und mentaler Bildpraxis im Mittelalter*. Munich: Fink, 2014.

Prica, Aleksandra. "Figuram inveniro': Auslegung, Zeit und Wahrheit im Archentraktat Hugos von St. Viktor." In *Figura: Dynamiken der Zeiten und Zeichen im Mittelalter*, edited by Christian Kiening and Katharina Mertens Fleury, 113–26. Würzburg: Königshausen & Neumann, 2013.

Prochno, Joachim. *Das Schreiber- und Dedikationsbild in der deutschen Buchmalerei*. Veröffentlichungen der Forschungsinstitute an der Universität Leipzig, Institut für Kultur- und Universalgeschichte. Die Entwicklung des menschlichen Bildnisses 2. Leipzig: B. G. Teubner, 1929.

Psalterium Egberti: Facsimile del ms. CXXXVI del Museo archeologico nazionale di cividale del Friuli. With commentary by Claudio Barberi. 2 vols. Relazioni della Soprintendenza per i beni ambientali, architettonici, archeologici, artistici e storici del Friuli–Venezia Giulia 13. Cividale: Ministero per i beni e le attività culturali, Soprintendenza per i beni ambientali, architettonici, archeologici, artistici e storici del Friuli–Venezia Giulia, 2000.

Quillet, Jeannine. "Les quatre éléments dans Le Livre du Ciel et du Monde de Nicole Oresme." In *Les Quatres éléments dans la culture médiévale: actes du colloque des 15, 26 et 27 mars 1982, Université de Picardie, Centre d'études médiévales*, edited by Danille Buschinger and André Crépin, Göppinger Arbeiten zur Germanistik 386, 63–75. Göppingen: Kümmerle Verlag, 1983.

———. "Nicole Oresme et la science nouvelle dans le *Livre du Ciel et du Monde*." In *Knowledge and the Sciences in Medieval Philosophy: Proceedings of the Eighth International Congress of Medieval Philosophy (S.I.E. P.M.), Helsinki 24–29 August 1987*, edited by Simo Knuuttila et al., Publications of the Luther-Agricola Society Series B 19, 2:314–21. Helsinki: Luther-Agricola Society, 1990.

Raaijmakers, Janneke. *The Making of the Monastic Community of Fulda, c. 744–c. 900*. Cambridge: Cambridge University Press, 2012.

———. "Word, Image and Relics: Hrabanus Maurus and the Cult of Saints (820s–840s)." In *Raban Maur et son temps*, edited by Philippe Depreux et al., Collection Haut Moyen Âge 9, 389–405. Turnhout: Brepols, 2010.

Rademacher-Chorus, Hildegard. "Maria mit den Sieben Gaben des Heiligen Geistes: eine Bildschöpfung der zisterziensischen Mystik." *Zeitschrift des Deutschen Vereins für Kunstwissenschaft*, n.f., 32 (1978): 30–45.

Radler, Gudrun. *Die Schreinmadonna "vierge ouvrante": Von den bernhardinischen Anfängen bis zur Frauenmystik im Deutschordensland; mit beschreibendem Katalog*. Frankfurter Fundamente der Kunstgeschichte 6. Frankfurt a.M.: Kunstgeschichtliches Institut, 1990.

Ragusa, Isa. "*Terror Demonum* and *Terror Inimicorum*: The Two Lions of the Throne of Solomon and the Open Door of Paradise." *Zeitschrift für Kunstgeschichte* 40 (1977): 93–114.

Rainer, Thomas. *Das Buch und die vier Ecken der Welt: von der Hülle der Thorarolle zum Deckel des Evangeliencodex*. Wiesbaden: Reichert, 2011.

Rainini, Marco. "From Regensburg to Hirsau and Back: Paths in 11th–12th Century German Theology." *Archa verbi* 13 (2016): 9–29.

———. *Corrado di Hirsau e il "Dialogus de cruce": Per la ricostruzione del profilo di un autore monastico del XII secolo*. Florence: SISMEL, Edizioni del Galluzzo, 2014.

Ramírez-Weaver, Eric M. *A Saving Science: Capturing the Heavens in Carolingian Manuscripts*. University Park: Pennyslvania State University Press, 2017.

Randall, Lilian C. *Images in the Margins of Gothic Manuscripts*. Berkeley: University of California Press, 1966.

Ransom, Lynn. "The Bernardian Roots of Bonaventure's *Lignum vitae*: Visual Evidence from the Verger de Soulas (Paris, Bibliothèque nationale de France, MS fr. 9220)." *IKON: Journal of Iconographic Studies* 1 (2008): 133–42.

———. "Innovation and Identity: A Franciscan Program of Illumination in the 'Verger de Soulas' (Paris, Bibliothèque nationale de France, Ms. fr. 9220." In *Insights and Interpretations*, edited by Colum Hourihane, Occasional Papers 5, 85–105. Princeton: Index of Christian Art, 2002.

Rasimus, Tuomas. *Paradise Reconsidered in Gnostic Mythmaking: Rethinking Sethianism in Light of the Ophite Evidence*. Nag Hammadi & Manichaean Studies 68. Leiden: Brill, 2009.

Read, Stephen. "John Buridan's Theory of Consequence and his Octagons of Opposition." In *Around and Beyond the Square of Opposition*, edited by Jean-Yves Beziau and Dale Jacquette, 93–110. Basel: Springer, 2012.

Redaelli, Luana. "L'Osservanza Agostiniana a Bergamo: Prime Considerazioni sul programma iconograpfico." In *Società, cultura, luoghi al tempo di Ambrogio da Calepio*, edited by Maria Mencaroni Zoppetti and Erminio Gennaro, 225–45. Bergamo: Edizioni dell'Ateneo, 2005.

Redlich, Virgil. *Tegernsee und die deutsche Geistesgeschichte im 15. Jahrhundert*. Schriftenreihe zur bayerischen Landesgeschichte 9. Munich: Verlag der Kommission, 1931.

Reeves, Marjorie, and Beatrice Hirsch-Reich. *The "Figurae" of Joachim of Fiore*. Oxford: Clarendon Press, 1972.

Reid, Constance. *Hilbert*. 2nd edition. New York: Springer, 1996.

Reidlinger, Helmut. *Die Makellosigkeit der Kirche in den Lateinischen Hoheliedkommentaren des Mittelalters*. Beiträge zur Geschichte der Philosophie und Theologie des Mittelalters: Texte und Untersuchungen 38/3. Münster: Aschendorff, 1958.

Reisner, Sonja. "Sub tuum praesidium confugimus: Zur Instrumentalisierung von Visionen und Wunderberichten in der dominikanischen Ordenshistoriographie am Beispiel der Schutzmantelmadonna." *Acta Antiqua Academiae Scientarum Hungaricae* 43 (2003): 393–406.

Resnick, Irven M. "The Priestly Raising of the Hands and Other Trinitarian Images in Petrus Alfonsi's Dialogue against the Jews." *Medieval Encounters* 12 (2007): 452–69.

Reudenbach, Bruno. "Das Verhältnis von Text und Bild in 'De laudibus sanctae crucis' des Hrabanus Maurus." In *Geistliche Denkformen in der Literatur des Mittelalters*, edited by Klaus Grubmüller et al., Münstersche Mittelalter-Schriften 51, 282–320. Munich: Fink, 1984.

———. "Heilsgeschichtliche Sukzession und typologische Synopse in Manuskripten der *Biblia pauperum*." In *Studien zur "Biblia pauperum*," edited by Hanna Wimmer et al., Vestigia Bibliae 34, 9–30. Bern: Peter Lang, 2016.

———. "Imago—Figura: Zum Bildverständnis in den Figurengedichten von Hrabanus Maurus." *Frühmittelalterlichen Studien* 20 (1986): 25–35.

———. "Salvation History, Typology and the End of Time in the *Biblia pauperum*." In *Between Jerusalem and Europe: Essays in Honour of Bianca Kühnel*, edited by Renana Bartal and Hanna Vorholt, 217–32. Leiden: Brill, 2015.

Reynhout, Lucien. *Formules latines de colophons*. 2 vols. Bibliologia 25. Turnhout: Brepols, 2006.

Richards, Earl Jeffrey. "Marian Devotion in Thirteenth-Century France and Spain and Interfaces between Latin and Vernacular Culture." In *Communities of Learning: Networks and the Shaping of Intellectual Identity in Europe, 1100–1500*, edited by Constant J. Mews and John N. Crossley, Europa Sacra 9, 177–212. Turnhout: Brepols, 2011.

Riché, Pierre. "Les traités pour la formation des novices, XIᵉ–XIIIᵉ siècles." In *Papauté, monachisme et théories politiques: I. Le pouvoir et l'institution ecclésiale. Études d'histoire médiévale offertes à Marcel Pacaut, Professeur émerite à l'Université Lumière-Lyon 2*, edited by Pierre Guichard et al., Collection d'histoire et d'archéologie médiévales 1, 371–77. Lyon: Presses universitaires de Lyon, 1994.

Richter, Dieter. "Die Allegorie der Pergamentbearbeitung: Beziehungen zwischen handwerklichen Vorgängen und der geistlichen Bildersprache des Mittelalters." In *Fachliteratur des Mittelalters: Festschrift für Gerhard Eis*, edited by Gundolf Keil et al., 83–92. Stuttgart: J. B. Metzler, 1968.

Rimmele, Marius. "Die Schreinmadonna: Bild—Körper—Matrix." In *Bild und Körper im Mittelalter*, edited by Kristen Marek et al., 41–59. Munich: Fink, 2006.

Roberts, Don D. *The Existential Graphs of Charles S. Peirce*. The Hague: Mouton, 1973.

Roch, Martin. "L'odeur de la sainteté dans le traité *Flores epytaphii sanctorum* (v. 1000) de Thiofrid d'Echternach." In *Parfums et odeurs au Moyen*

Âge: Science, usage, symboles, edited by Agostino Paravicini Bagliani, Micrologus' Library 67, 221–40. Rome: SISMEL, Edizioni del Galluzzo, 2015.

Rockar, Hans-Joachim. *Abendländische Bilderhandschriften der Forschungsbibliothek Gotha: Ein kurzes Verzeichnis*. Veröffentlichungen der Forschungsbibliothek Gotha 14. Gotha: Forschungsbibliothek, 1970.

Röhrig, Floridus. "Rota in medio rotae: Ein typologischer Zyklus aus Österreich." *Jahrbuch des Stiftes Klosterneuburg*, n.f., 5 (1965): 7–113.

Root, Jerry. *The Theophilus Legend in Medieval Text & Image*. Cambridge: D.S. Brewer, 2017.

Rosenau, Helen. "The Architecture of Nicolaus de Lyra's Temple Illustrations and the Jewish Tradition." *Journal of Jewish Studies* 25 (1974): 294–304.

Ross, D. John A. "Illustrated Manuscripts of Orosius." *Scriptorium* 9 (1955): 35–56.

Roten, J. "Richardus von St. Laurentius." In *Marienlexikon*, edited by Remigius Bäumer and Leo Sheffczyck, vol. 5, cols. 486–87.

Rotman, Brian. "Making Marks on Paper." In *Mathematics as Sign: Writing—Imagining—Counting*, 44–70. Stanford: Stanford University Press, 2000.

———. *Mathematics as Sign: Writing, Imagining, Counting*. Stanford: Stanford University Press, 2000.

———. "Thinking Dia-grams: Mathematics, Writing, and Virtual Reality." In *Mathematics, Science and Postclassical Theory*, edited by Barbara Herrnstein Smith and Arkady Plotnitsky, 17–39. Durham, NC: Duke University Press, 1997.

Rouse, Richard H. "La diffusion en Occident des outils de travail facilitant l'accés aus textes autoritatifs." *Revue des études islamiques* 44 (1976): 115–47.

Rouse, Richard H., and Mary A. Rouse. "Biblical *distinctiones* in the XIIIth Century." *Archives d'histoire doctrinale et littéraire du moyen âge* 41 (1974): 27–37.

———. "Ordinatio and Compilatio Revisited." In *Ad litteram. Authoritative Texts and their Medieval Readers*, edited by Mark D. Jordan and Kent Emery Jr., 113–34. Notre Dame, IN: University of Notre Dame Press, 1992.

———. *Preachers, Florilegia and Sermons: Studies on the Manipulus florum of Thomas of Ireland*. Studies and Texts 47. Toronto: Pontifical Institute of Mediaeval Studies, 1979.

———. "*Statim invenire*: Schools, Preachers, and New Attitudes towards the Page." In *The Renaissance of the Twelfth Century*, edited by Robert L. Benson and Giles Constable, with Carol D. Lanham, 201–25. Cambridge, MA: Harvard University Press, 1982. Reprinted in *Authentic Witnesses: Approaches to Medieval Texts and Manuscripts*, Publications in Medieval Studies 17 (Notre Dame, IN: University of Notre Dame Press, 1991), 191–219.

Roux, Guy. *Opicinus de Canistris, 1296-1352: Dieu fait homme et homme-dieu*. Paris: Léopard d'or, 2009.

Roux, Guy, and Muriel Laharie. *Art et folie au Moyen Age: Aventures et énigmes d'Opicinus de Canistris (1296–vers 1351)*. Paris: Léopard d'or, 1997.

Rozenski, Steven, Jr. "*Von aller bilden bildlosekeit*: The Trouble with Images of Heaven in the Works of Henry Suso." In *Envisaging Heaven in the Middle Ages*, edited by Carolyn Muessig and Ad Putter, Routledge Studies in Medieval Religion and Culture 6, 108–19. London: Routledge, 2007.

Rubin, Miri. *Mother of God: A History of the Virgin Mary*. New Haven: Yale University Press, 2009.

Rudolph, Conrad. *"First, I Find the Center Point": Reading the Text of Hugh of St. Victor's "The Mystic Ark."* Transactions of the American Philosophical Society 94/4. Philadelphia: American Philosophical Society, 2006.

———. *The Mystic Ark: Hugh of Saint Victor, Art, and Thought in the Twelfth Century*. New York: Cambridge University Press, 2014.

Russakoff, Anna. "The Role of the Image in Illustrated Manuscripts of 'Les Miracles de Notre Dame' by Gautier de Coinci. Besançon, Bibliothèque municipale 551." *Manuscripta* 47/48 (2003–4): 135–44.

Rüther, Andreas. "Profeß." In *LM* 7, cols. 240–41. Munich: Deutscher Taschenbuch Verlag, 2002.

Saffrey, Henri Dominique. "AGEÔMETRÊTOS MÊDEIS EISITÔ, une inscription légendaire." *Revue des études grecques* 81 (1968): 67–87.

Salisbury, Joyce E. *Perpetua's Passion: The Death and Memory of a Young Roman Woman*. New York: Routlege, 1997.

Salonius, Pippa, and Andrea Worm, eds. *The Tree: Symbol, Allegory, and Mnemonic Device in Medieval Art and Thought*. International Medieval Research 20. Turnhout: Brepols, 2014.

Salzer, Anselm. *Die Sinnbilder und Beiworte Mariens in der deutschen Literatur und lateinischen Hymnenpoesie des Mittelalters*. Linz: K.u.K. Hofbuchdruckerei J. Feichtingers Erben, im Selbstverlag des K.K. Ober-Gymnasiums, 1893.

Samuel, Nina. "My Brain Is in My Inkstand: A Curatorial Sketch." In *My Brain Is in My Inkstand: Drawing as Thinking and Process*, curated by Nina Samuel, 12–25. Bloomfield Hills: Cranbrook Art Museum, 2014.

———, curator. *My Brain Is in My Inkstand: Drawing as Thinking and Process*. Bloomfield Hills: Cranbrook Art Museum, 2014.

Sandler, Lucy Freeman. "John of Metz, The Tower of Wisdom." In *The Medieval Craft of Memory: An Anthology of Texts and Pictures*, edited by Mary Carruthers and Jan M. Ziolkowski, 215–25. Philadelphia: University of Pennsylvania Press, 2002.

———. "*Omne bonum*: *Compilatio* and *ordinatio* in an English Illustrated Encyclopedia of the Fourteenth Century." In *Medieval Book Production: Assessing the Evidence: Proceedings of the Second Conference of the Seminar in the History of the Book to 1500, Oxford, July 1988*, edited by Linda L. Brownrigg, 183–200. Los Altos Hills: Anderson-Lovelace, 1990.

———. *The Psalter of Robert de Lisle in the British Library*. Oxford: Harvey Miller, 1983.

Sansterre, Jean-Marie. "La Vierge Marie et ses images chez Gautier de Coinci et Césaire de Heisterbach." *Viator* 41 (2010): 147–78.

Sauerländer, Willibald. "Die Naumburger Stifterfiguren, Rückblick und Fragen." In *Die Zeit der Staufer*: *Geschichte, Kunst, Kultur. Katalog der Ausstellung Stuttgart, Altes Schloss und Kunstgebäude, 26. März–5. Juni 1977*, vol. 5, *Supplement: Vorträge und Forschungen*, edited by Reiner Haussherr, 169–245. Stuttgart: Württembergisches Landesmuseum, 1977–79.

Saurma-Jeltsch, Lieselotte E. "Der Zackenstil als ornatus difficilis." *Aachener Kunstblätter* 60 (1994): 257–66.

Sauser, Ekkart. "Christus Medicus: Christus als Arzt und seine Nachfolger im frühen Christentum." *Trierer Theologische Zeitschrift* 101 (1992): 101–23.

Schadt, Herman. *Die Darstellungen der Arbores Consanguinitatis und der Arbor Affinitatis*. Tübingen: Wasmuth, 1982.

Schaller, Dieter. "Die karolingischen Figurengedichte des Cod. Bern 212." In *Medium aevum vivum: Festschrift für Walther Bulst*, edited by Hans Robert Jauß and Dieter Schaller, 22–47. Heidelberg: C. Winter, 1961.

Schanzer, Danuta R. "Augustine's Disciples: *Silent diutius Musae Varronis*?" In *Augustine and the Disciples: From Cassiciacum to "Confessions*," edited by Karla Pollmann and Mark Vessey, 69–112. Oxford: Oxford University Press, 2005.

Schapiro, Meyer. "On Some Problems in the Semiotics of Visual Art: Field and Vehicle in Image-Signs." *Simiolus* 6 (1972–73): 9–19.

———. "On the Aesthetic Attitude in Romanesque Art." In *Art and Thought, issued in Honour of Dr. Ananda K. Coomaraswamy on the Occasion of his 70th Birthday*, edited by K. Bharatha Iyer, 130–50. London: Luzac, 1947. Reprinted in *Romanesque Art: Selected Papers* (New York: Braziller, 1977), 1–27.

———. *Romanesque Architectural Sculpture: The Charles Eliot Norton Lectures*. Edited and with an introduction by Linda Seidel. Chicago: University of Chicago Press, 2006.

———. "Über den Schematismus in der romanischen Kunst." *Kritische Berichte zur kunstgeschichtlichen Literatur* 1 (1932–33): 1–21. Published in English as "On Geometrical Schematicism in Romanesque Art," in *Romanesque Art* (New York: Braziller, 1977), 265–84.

Schedl, Claus. "'FEMINA CIRCUMDABIT VIRUM' oder 'VIA SALUTIS'? Textkritische Untersuchungen zu Jer 31, 22." *Zeitschrift für katholische Theologie* 83 (1961): 431–42.

Schiller, Gertrud. *The Passion of Jesus Christ*. Iconography of Christian Art 2. London: Lund Humphries, 1972.

Schipper, William. "Rabanus Maurus and his Sources." In *Schooling and Society: The Ordering and Reordering of Knowledge in the Western Middle Ages*, edited by Alasdair A. MacDonald and Michael W. Twomey, Groningen Studies in Cultural Change 6, 1–21. Leuven: Peeters, 2004.

———. "Secretive Bodies and Passionate Souls: Transgressive Sexuality Among the Carolingians." In *Conjunctions of Mind, Soul and Body from Plato to the Enlightenment*, edited by Danijela Kambaskovic, Studies in the History of Philosophy of Mind 15, 173–99. Springer: Dordrecht, 2014.

Schlimm, Dirk. "Pasch's Philosophy of Mathematics." *Review of Symbolic Logic* 3 (2010): 93–118.

Schmidt, Alfred A., ed. *Das Graduale von Sankt Katharinenthal: Kommentarband zur Faksimile-Ausgabe des Graduale von Sankt Katharinenthal*. Luzern: Faksimile Verlag, 1980–83.

Schmidt, Gerhard. *Die Armenbiblen des XIV. Jahrhunderts*. Veröffentlichungen des Instituts für Österreichische Geschichtsforschung 19. Graz: Böhlau, 1959.

Schmidt, Philipp. "Die Bibliothek des ehemaligen Dominikanerklosters Basel." *Basler Zeitschrift für Geschichte und Altertumskunde* 18 (1919): 160–254.

Schmidt, Suzanne Karr. *Interactive and Sculptural Printmaking in the Renaissance*. Brill's Studies in Intellectual History 270; Brill's Studies on Art, Art History, and Intellectual History 21. Leiden: Brill, 2018.

Schmidt-Burkhardt, Astritt. *Die Kunst der Diagrammatik: Perspektiven eines neuen bildwissenschaftlichen Paradigmas*. 2nd revised edition. Bielefeld: transcript, 2016.

Schmitt, Jean-Claude. "La culture de l'*imago*." *Annales: Économies, Sociétés, Civilisations* 51 (1996): 3–36.

———. *La raison des gestes dans l'occident médiévale*. Paris: Gallimard, 1990.

———. "Les images classificatrices." *Bibliothèque de l'École de Chartres* 147 (1989): 311–41.

———. *L'histoire en lignes et en rondelles: Les figures du temps chretien au Moyen Âge*. Wolfgang Stammler Gastprofessur für germanische Philologie: Vorträge 21. Wiesbaden: Reichert, 2015.

———. "Rituels de l'image et récits de vision." In *Testo e immagine nell'alto medioevo, 15–21 aprile 1993*,

Settimane de Studio del Centro Italiano di Studi sull'Alto Medioevo 41, 1:419–62. Spoleto: Il Centro italiano di studi sull'alto medioevo, 1994.

Schmitz, Wolfgang. "*O praeclarum et omni veneratione dignum opus. . .* : Zur Drucklegen von Hrabans 'Liber de laudibus sanctae crucis' im Jahre 1503." In *Architectura tectonica: Festschrift für Johannes Tathofer zum 65. Geburtstag*, edited by Ulrich Ernst and Bernhard Sowinski, Kölner Germanistische Studien 30, 399–402. Cologne: Böhlau, 1990.

Schmitz-Clivier-Lepie, Herte. *Die Domschatzkammer zu Aachen*. Aachen: Domkapitel Aachen, 1980.

Schmitz-Esser, Romedio. "Inschriften als Bildungsvermittler? Das *Defensorium* des Franz von Retz und die Überlieferung des Traktates als Altar in Stift Stams." *Mitteilungen des Instituts für österreichische Geschichtsforschung* 118 (2010): 344–76.

Schneider, Birgit, et al., eds. *Diagrammatik-Reader: Grundlegende Texte aus Theorie und Geschichte*. Berlin: De Gruyter, 2016.

Schneider, Karin. *Die lateinischen mittelalterlichen Handschriften* 1: *Theologische Handschriften*. Die Handschriften der Stadtbibliothek Nürnberg 2. Wiesbaden: Harrassowitz, 1967.

Schneider, Wolfgang C. "Logik und Sinnspiel: Spekulative anagogische Schemata des Mittelalters bis zum Ludus Globi und zur Figura Paradigmatica des Cusanus." In *Können—Spielen—Loben: Cusanus 2014*, edited by Iñigo Bocken et al., Texte und Studien zur Europäischen Geistesgeschichte, Reihe B/14, 271–300. Münster: Aschendorff, 2016.

——. "Semantische Symmetrien in mittelalterlichen Handschriften und Beinschnitzwerken." In *Symmetrie in Kunst, Natur und Wissenschaft: Mathildenhöhe Darmstadt, 1. Juni bis 24. August 1986*, edited by Bernd Krimmel, 197–230. Darmstadt: Mathildenhöhe, 1986.

Schoenen, Anno. "Aedificatio: zum Verständnis eines Glaubenswortes in Kult und Schrift." In *Enkainia: Gesammelte Aufsätze zum 800. Weihegedächnis der Abteikirche Maria Laach am 24. Aug. 1956*, edited by Hilarius Emonds, 14–29. Maria Laach: Patmos Verlag, 1956.

Schofield, Malcolm. "Aristotle on the Imagination." In *Essays on Aristotle's "De Anima,"* edited by Martha C. Nussbaum and Amélie Oksenberg Rorty, 249–77. Oxford: Clarendon, 1992.

Schonhardt, Michael. *Kloster und Wissen—Die Arnsteinbibel und ihr Kontext im frühen 13. Jahrhundert*. Reihe Septem 2. Freiburg i. Br.: Rombach Verlag, 2014.

Schottenloher, Karl. "Buchwidmungsbilder in Handschriften und Frühdrucken." *Zeitschrift für Bücherfreunde*, n.f., 12 (1920): 152–83.

Schreiner, Klaus. *Maria: Leben, Legenden, Symbole*. Munich: Beck, 2003.

Schröder, Jochen. "Die Rekonstruktion des Salomonischen Tempels bei den Victorinern und das Problem der Tempelnachfolge im 12. und 13. Jahrhundert." In *Form und Stil: Festschrift für Günther Binding zum 65. Geburtstag*, edited by Stefanie Lieb, 157–65. Darmstadt: Wissenschaftliche Buchgesellschaft, 2001.

Schulmeister, Rolf. *Aedificatio und Imitatio: Studien zur intentionalen Poetik der Legende und Kunstlegende*. Hamburg: Hartmut Lüdke Verlag, 1971.

Schwarz, Josef. *St. Peter: Petersberg bei Fulda. Werden, Wandel, Wirken*. Petersberg: Michael Imhoff, 1996.

Schwietering, Julius. "The Origins of the Medieval Humility Formula." *PLMA* 69 (1954): 1279–91.

Sears, Elizabeth. "Louis the Pious as 'miles Christi.' The Dedicatory Image in Hrabanus Maurus's *De laudibus sanctae crucis*." In *Charlemagne's Heir: New Perspectives on the Reign of Louis the Pious (814–840)*, edited by Peter Godman and Roger Collins, 605–28. Oxford: Clarendon Press, 1990.

——. "Word and Image in Carolingian *Carmina figurata*." In *World Art: Themes of Unity in Diversity: Acts of the XXVIth International Congress of the History of Art*, edited by Irving Lavin, 2:341–48. University Park: State University of Pennsylvania Press, 1989.

Séguy, Marie-Rose, et al., eds. *Le Livre*. Paris: Bibliotheque nationale de France, 1972.

Semper, Gottfried. *The Four Elements of Architecture and Other Writings*. Translated by Harry Francis Mallgrave and Wolfgang Herrmann. Cambridge: Cambridge University Press, 1989.

Senger, Hans Gerhard. *Ludus sapientiae: Studien zum Werk und zur Wirkungsgeschichte des Nikolaus von Kues*. Studien und Texte zur Geistesgeschichte des Mittelalters 78. Leiden: Brill, 2002.

Senner, Walter. "Meister Eckhart und Heinrich Seuse: Lese- oder Lebemeister—Student oder geistlicher Jünger." In *Schüler und Meister*, edited by Andreas Speer and Thomas Jeschke, Miscellanea mediaevalia 39, 277–312. Berlin: De Gruyter, 2016.

Sepière, Christine. *L'image d'un Dieu souffrant (IXe-Xe siècle): Aux origins du crucifix*. Paris: Les Éditions du Cerf, 1994.

Shahar, Galili. "Auerbach's Scars: Judaism and the Question of Literature." *Jewish Quarterly Review* 101 (2011): 604–30.

Shailor, Barbara. "A New Manuscript of Nicolaus de Lyra, 1270–1349." *Yale University Library Gazette* 58 (1983): 9–16.

Shaw, Brent D. "The Passion of Perpetua." *Past & Present* 139 (1993): 3–45.

Sherman, Claire Richter. *Imaging Aristotle: Verbal and Visual Representation in Fourteenth-Century France*. Berkeley: University of California Press, 1995.

———. *Writing on Hands: Memory and Knowledge in Early Modern Europe.* Trout Gallery, Dickinson College, and Folger Shakespeare Library. Seattle: University of Washington Press, 2001.

Shimojima, Atushi. "Operational Constraints in Diagrammatic Reasoning." In *Logical Reasoning with Diagrams*, edited by Gerard Allwein and Jon Barwise, 27–48. New York: Oxford University Press, 1996.

———. *Semantic Properties of Diagrams and Their Cognitive Potentials.* Stanford: Center for the Study of Language and Information, 2015.

Shin, Sun-Joo. "How Do Existential Graphs Show What They Show?" In *Das bildnerische Denken: Charles S. Peirce*, edited by Franz Engel et al., Actus et Imago 5, 219–33. Berlin: Akademie Verlag, 2012.

———. *The Iconic Logic of Peirce's Graphs.* Cambridge, MA: MIT Press, 2002.

Shin, Sun-Joo, Oliver Lemon, and John Mumma. "Diagrams." In *Stanford Encyclopedia of Philosophy*, Winter 2016 Edition. Standford, CA: Metaphysics Research Lab, Center for the Study of Languages and Information, Stanford University, 2016. Accessed December 26, 2018. https://plato.stanford.edu/entries/diagrams/.

Sicard, Patrice. *Diagrammes médiévaux et exégèse visuelle: Le "Libellus de formatione arche" de Hughes de Saint-Victor.* Bibliotheca Victorina 4. Turnhout: Brepols, 1993.

Silk, Edmund T. "Pseudo-Johannes Scottus, Adalbold of Utrecht, and the Early Commentaries on Boethius." *Mediaeval and Renaissance Studies* 3 (1954): 1–40.

Simor, Suzanna. "Le Credo dans son contexte: Un appui pour d'autres thèmes." In *Pensée, image & communication en Europe médiévale: À propos des stalles de Saint-Claude*, edited by Pierre Lacroix and Andée Renon, 207–16. Besançon: Apsprodic, 1993.

Sisko, John E. "Material Alteration and Cognitive Activity in Aristotle's 'De Anima.'" *Phronesis* 41 (1996): 138–57.

Skubiszewski, Piotr. "Fortunat et Baudonivie du ms. 250 de la médiathèque François-Mitterand de Poitiers et la tradition du 'portrait' d'auteur dans l'enluminure." *Cahiers de civilization médiévale Xe–XIIe siècle* 57 (2014): 267–312.

Slencza, Ruth. *Lehrhafte Bildtafeln in spätmittelalterlichen Kirchen.* Pictura et Poësis 10. Cologne: Böhlau, 1998.

Smadja, Ivahn. "Local Axioms in Disguise: Hilbert on Minkowski Diagrams." *Synthese* 186 (2012): 315–70.

Šmahel, František. "Das 'Scutum fidei christianae magistri Hieronymi Pragensis' in der Entwicklung der mittelalterlichen trinitarischen Diagramme." In *Die Bildwelt der Diagramme Joachims von Fiore: Zur Medialität religiös-politischer Programme im Mittelalter*, edited by Alexander Patschovsky, 186–214. Ostfildern: Thorbecke, 2003.

Smith, David Eugene, and Clara C. Eaton. "Rithmomachia, the Great Medieval Number Game." *Mathematical Association of American Monthly* 18 (1911): 73–80.

Smith, Kathryn A. "Bodies of Unsurpassed Beauty: 'Living' Images of the Virgin in the High Middle Ages." *Viator* 37 (2006): 167–87.

Solignac, Aimé. "Richard de Saint-Laurent." *Dictionnaire de spiritualité* 13 (1988): 590–93.

Somfai, Anna. "Calcidius' 'Commentary' on Plato's 'Timaeus' and Its Place in the Commentary Tradition: The Concept of 'Analogia' in Text and Diagrams." In "Philosophy, Science, and Exegesis in Greek, Arabic, and Latin Commentaries," vol. 1, edited by Peter Adamson, Han Baltussen, and M. W. F. Stone. Supplement, *Bulletin of the Institute of Classical Studies*, no. 83 (2004): 203–20.

———. "The Eleventh-Century Shift in the Reception of Plato's 'Timaeus' and Calcidius's 'Commentary.'" *Journal of the Warburg and Courtauld Institutes* 65 (2002): 1–21.

Sorrer, Angelika, and Eva Lia Wyss. "Pfeilzeichen: Formen und Funktinen in alten und neuen Medien." In *Wissen und neue Medien: Bilde und Zeichen von 800 bis 2000*, edited by Ulrich Schmitz and Horst Wenzel, Philologische Studien und Quellen 177, 159–95. Berlin: Erich Schmidt Verlag, 2003.

Sowa, John F. *Knowledge Representation: Logical, Philosophical, and Computational Foundations.* Pacific Grove, CA: Brooks/Cole Thomson Learning, 2000.

Spalding, Mary Caroline. "The Middle English Charters of Christ." PhD diss., Bryn Mawr College, 1914.

Spilling, Herrad. *Opus Magnentii Hrabani Mauri in honorem sanctae crucis conditum: Hrabans Beziehung zu seinem Werk.* Fuldaer Hochschulschriften 18. Frankfurt a. M.: Josef Knecht, 1992.

Spinks, C. W. *Peirce and Triadomania: A Walk in the Semiotic Wilderness.* Berlin: Mouton; New York: De Gruyter, 1991.

Spitz, Lewis William. *The Religious Renaissance of the German Humanists.* Cambridge, MA: Harvard University Press, 1963.

Square of Opposition Handbook. Accessed December 26, 2018. http://www.square-of-opposition.org/images-vatican/HSquare-05042014.pdf.

Squire, Michael. "Optatian and His Lettered Art: A Kaleidescopic Lens on Late Antiquity." In *Morphogrammata / The Lettered Art of Optatian: Figuring Cultural Transformations in the Age of Constantine*, edited by Michael Squire and Johannes Wienand, Morphomata 33, 55–120. Paderborn: Wilhelm Fink, 2017.

———. "Patterns of Significance: Publilius Optatianus Porfyrius and the Figurations of Meaning." In *Images and Texts: Papers in Honour of Professor E. W. Handley, CBE, FBA*, edited by Richard Green and Mike Edwards, 87–121. London: Institute of Classical Studies, 2015.

———. "POP Art: The Optical Poetics of Publilius Optatianus Porfyrius." In *The Poetics of Late Antique Literature*, edited by Ja Elsner and Jesús Herdández Lobato, 25–100. Oxford: Oxford University Press, 2017.

Squire, Michael, and Johannes Wienand, eds. *Morphogrammata / The Lettered Art of Optatian: Figuring Cultural Transformations in the Age of Constantine*. Morphomata 33. Paderborn: Wilhelm Fink, 2017.

Squire, Michael, and Christopher Witten. "*Machina sacra*: Optatian and the Lettered Art of the Christogram." In *Graphic Signs of Identity, Faith, and Power in Late Antiquity and the Early Middle Ages*, edited by Ildar Garipzanov et al., 45–108. Turnhout: Brepols, 2017.

Starkey, Kathryn. *A Courtier's Mirror. Cultivating Elite Identity in Thomasin Von Zerclaere's Welscher Gast*. Notre Dame, IN: University of Notre Dame Press, 2013.

Starr, Susan Leigh, and James R. Griesemer. "Institutional Ecology, 'Translations' and Boundary Objects: Amateurs and Professionals in Berkeley's Museum of Vertebrate Zoology, 1907–39." *Social Studies of Science* 19 (1989): 387–420.

Staub, Kurt Hans. *Geschichte der Dominikanerbibliothek in Wimpfen am Neckar (ca. 1460–1803): Untersuchungen an Hand der in der Hessischen Landes- und Hochschulbibliothek Darmstadt erhaltenen Bestände*. Studien zur Bibliotheksgeschichte 3. Graz: Akademische Druck- und Verlaganstalt, 1980.

Staub, Kurt Hans, and Hermann Knaus. *Die Handschriften der Hessischen Landes- und Hochschulbibliothek Darmstadt 4: Bibelhandschriften / Ältere theologische Texte*. Wiesbaden: Harrasowitz, 1979.

Stein, Gerhard, ed. *Das Kloster Bredelar und seine Bibel*. Marsberg: Druckerei Boxberger, 1990.

Steiner, Emily. *Documentary Culture and the Making of Medieval English Literature*. New York: Cambridge University Press, 2003.

Stein-Kecks, Heidrun. *Der Kapitelsaal in der mittelalterlichen Klosterbaukunst: Studien zu den Bildprogrammen*. Munich: Deutscher Kunstverlag, 2004.

———. "Quellen zum capitulum." In *Wohn- und Wirtschaftsbauten frümittelalterlichen Klöster: Internationales Symposium, 26.9–1.10.1995 in Zurzach und Müstair im Zusammenhang mit den Untersuchungen im Kloster St. Johann zu Müstair*, edited by Hans Rudolph Sennhauser. ID: Veröffentlichungen des Instituts für Denkmalplege an der ETH Zürich 17, 219–33. Zürich: VDF, 1996.

Steinova, Evina. "*Psalmos, notas, cantus*: On the Meanings of *nota* in the Carolingian Period." *Speculum* 90 (2015): 424–57.

Stevens, Welsey M. "Euclidean Geometry in the Early Middle Ages: A Preliminary Reassessment." In *Villard's Legacy: Studies in Medieval Technology, Science and Art in Memory of Jean Gimpel*, edited by Marie-Thérèse Zenner, AVISTA Studies in the History of Medieval Technology 2, 229–62. Aldershot: Ashgate; Burlington, VT: Variorum, 2004.

———. "Fields and Streams: Language and the Practice of Arithmetic and Geometry in Early Medieval Schools." In *Word, Image, Number: Communication in the Middle Ages*, edited by John J. Contreni and Santa Casciani, 113–204. Florence: SISMEL, Edizionzi del Galluzzo, 2002.

Stigter, Jurgen. "Rithmomachia, the Philosophers' Game: An Introduction to its History and its Rules." With a postscript by Peter Mebben and Jurgen Stigter. In *Ancient Board Games in Perspective: Papers from the 1990 British Museum Colloquium, with Additional Contributions*, edited by Irving L. Finkel, 263–69. London: British Museum Press, 2007.

Stjernfelt, Frederik. *Diagrammatology: An Investigation on the Borderlines of Phenomenology, Ontology, and Semiotics*. Synthese Library 336. Dordrecht: Springer, 2007.

———. "Diagrams as Centerpiece of a Peircean Epistemology." *Transactions of the Charles S. Peirce Society* 36 (2000): 357–84.

Stock, Brian. *Myth and Science in the Twelfth Century: A Study of Bernard Silvester*. Princeton: Princeton University Press, 1972.

Stolz, Michael. *Artes-liberales-Zyklen: Formationen des Wissens im Mittelalter*. 2 vols. Bibliotheca Germanica 47/1–2. Tübingen: A. Francke Verlag, 2004.

Stones, Alison. *Gothic Manuscripts 1260–1320*. 2 vols. in 4. London: Harvey Miller, 2013–14.

———. "Les dominicains et la production manuscrite à Toulouse aux environs de 1300." In *Le parement d'autel des Cordeliers de Toulouse: Anatomie d'un chef-d'oeuvre du XIVᵉ siècle [. . .] réalisé à l'occasion de l'exposition organisée au Musée Paul-Dupuy du 16 mars au 18 juin 2012*, edited by Christine Aribaud, 50–57. Paris: Somogy, 2012.

Storkerson, Peter. "Explicit and Implicit Graphs: Changing the Frame." *Visible Language* 26, nos. 3–4 (1992): 389–434.

Sturlese, Loris. "Philosophische Florilegien im mittelalterlichen Deutschland." In *Homo divinus: philosophische Projekte in Deutschland zwischen*

Meister Eckhart und Heinrich Seuse. Stuttgart: Kohlhammer, 2007.

———. "Tauler im Kontext: Die philosophischen Voraussetzungen des 'Seelengrundes' in der Lehre des deutschen Neuplatonikers Berthold von Moosberg." *Beiträge zur Geschichte der deutschen Sprache und Literatur* 109 (1987): 390–426.

Suckale, Robert. "Die Glatzer Madonnentafel des Prager Erzbischofs Ernst von Pardubitz als gemalter Marienhymnus: Zur Frühzeit der böhmischen Tafelmalerei, mit einem Beitrag zur Einordnung der Kaufmannschen Kreuzigung." In *Stil und Funktion*, edited by Peter Schmidt and Gregor Wedekind, 119–50. Munich: Deutscher Kunstverlag, 2003.

———. *Klosterreform und Buchkunst: Die Handschriften des Mettener Abtes Peter I. München, Bayerische Staatsbibliothek, Clm 8201 und Clm 8201d.* Petersberg: Michael Imhof, 2012.

———. "Schöne Madonnen am Rhein." In *Schöne Madonnen am Rhein: Rheinische Marienstatuen des schönen Stils*, edited by Robert Suckale, 39–119. Bonn: Rheinisches Landesmuseum, 2009.

———, ed. *Schöne Madonnen am Rhein: Rheinische Marienstatuen des schönen Stils.* Bonn: Rheinisches Landesmuseum, 2009.

Suckale-Redlefsen, Gude. *Die Handschriften des 8. bis 11. Jahrhunderts, 1. Teil: Texte, Katalog der illuminierten Handschriften der Staatsbibliothek Bamberg 1/1*, 2 vols. Wiesbaden: Harrasowitz, 2004.

Surmann, Ulrike, and Johannes Schröer, eds. *Trotz Natur und Augenschein: Eucharistie—Wandlung und Weltsicht.* Cologne: Kolumba, 2013.

Swarzenski, Hanns. *Die lateinischen illuminierten Handschriften des XIII. Jahrhunderts in den Ländern an Rheim, Main und Donau.* 2 vols. Berlin: Deutscher Verein für Kunstwissenschaft, 1936.

Swearingen, Jan C. *Rhetoric and Irony: Western Literacy and Western Lies.* New York: Oxford University Press, 1991.

Szövérffy, Joseph. *Marianische Motivik der Hymnen: Ein Beitrag zur Geschichte der marianischen Lyrik im Mittelalter.* Leiden: Classical Folia Editions, 1985.

Taeger, Burkhard. *Zahlensymbolik bei Hraban, bei Hincmar—und im "Heiland"? Studien zur Zahlensymbolik im Frühmittelalter.* Münchner Texte und Untersuchungen zur deutschen Literatur des Mittelalters 30. Munich: Beck, 1970.

Taub, Liba. *Science Writing in Greco-Roman Antiquity.* Cambridge: Cambridge University Press, 2017.

Tentzel, Wilhelm Ernst. *Monatliche Unterredungen einiger guten Freunden von allerhand Bücher.* Leipzig: J. T. Fritsch et al., 1689–98.

Tesori dell'arte mosana (950–1250): Roma, Palazzo Venezia, 8 novembre 1973–2 gennaio 1974. Rome: De Luca, 1973.

Testo e immagine nell'alto medioevo. 2 vols. Settimane di studio del Centro italiano di studi sull'alto medioevo 41. Spoleto: Il Centro italiano di studi sull'alto medioevo, 1994.

Thomas, Alois. *Die Darstellung Christi in der Kelter: Eine theologische und kulturhistorische Studie, zugleich ein Beitrag zur Geschichte und Volkskunde des Weinbaus.* Edited by Matthias Zender and Franz-Josef Heyen. Forschungen zur Volkskunde 20–21. Düsseldorf: Schwann, 1981.

Thunø, Erik. *Image and Relic: Mediating the Sacred in Early Medieval Rome.* Analecta Romana Instituti Danici: Supplementum 32. Rome: "L'Erma" di Bretschneider, 2002.

Tolan, John. *Petrus Alfonsi and His Medieval Readers.* Gainesville: University Press of Florida, 1993.

Tomaschek, Johann. "*Vivet in Admundo sacra concio mortua mundo*: Ein spirituell-monastisches 'Program' und seine eigenwillige graphische Umsetzung." In *Funktionsräume, Wahrnehmungsräume, Gefühlsräume: Mittelalterliche Lebensformen zwischen Kloster und Hof*, edited by Christina Lutter, Veröffentlichungen des Instituts für Österreichische Geschichtsforschung 59, 109–19. Vienna: Böhlau; Oldenbourg: Oldenbourg Verlag, 2011.

Topa, Alessandro. "'A Circle of Categories of which Kant's form an Arc': Zur diagrammatischen Form des topischen Zusammenhangs in der frühen Peirce'schen Kategorienspekulation." In *Das bildnerische Denken: Charles S. Peirce*, edited by Franz Engel et al., Actus et Imago 5, 189–218. Berlin: Akademie Verlag, 2012.

———. *Die Genese der Peirc'schen Semiotik*, vol. 1, *Das Kategorienproblem (1857–1865).* Würzburg: Könighausen & Neumann, 2007.

Trexler, Richard C. *The Christian at Prayer: An Illustrated Prayer Manual attributed to Peter the Chanter (d. 1197).* Medieval & Renaissance Studies 44. Binghamton: Medieval & Renaissance Texts and Studies, 1987.

———. "Legitimating Prayer Gestures in the Twelfth Century: The *De Penitentia* of Peter the Chanter." *History and Anthropology* 1 (1984): 97–126.

Troncarelli, Fabio. *Vivarium, i libri, il destino.* Turnhout: Brepols, 1998.

Tufte, Edward R. *The Visual Display of Quantitative Information.* Cheshire, CT: Graphics Press, 1983.

Tugwell, Simon. "L'évolution des 'Vitae fratrum': Résumé des conclusions provisoires." In *L'ordre des Prêcheurs et son histoire en France méridionale*, Cahiers de Fanjeaux 36, 415–18. Toulouse: Privat, 2001.

Tummers, Paul M. J. E. "Geometry and Theology in the XIIIth century: An Example of their Interrelation as found in the Ms Admont 442. The Influence of William of Auxerre?" *Vivarium* 18 (1980): 111–42.

Tversky, Barbara. "Spatial Schemas in Depictions." In *Spatial Schemas and Abstract Thought*, edited by Merideth Gattis, 79–112. Cambridge, MA: MIT Press, 2001.

Uckelman, Sara L. "Logic and the Condemnations of 1277." *Journal of Philosophical Logic* 39 (2010): 201–27.

———. "Reasoning about the Trinity: A Modern Formalization of a Medieval System of Trinitarian Logic." In *Logic in Religious Discourse*, edited by Andrew Shumann, 216–38. Heusenstamm: ontos verlag, 2010.

Uhlemann, Silvia. "Zwei Bibelhandschriften aus der Hessischen Landes- und Hochschulbibliothek Darmstadt." In *Vom Kurkölnischen Krummstab über den Hessischen Löwen zum Preußischen Adler: Die Säkularisation und ihre Folgen im Herzogtum Westfalen 1803–2003*, Ausstellung vom 21.9.2003–4.1.2004 in Arnsberg, Sauerland-Museum des Hochsauerlandkreises, 117–19. Arnsberg: F. W. Becker, 2003.

Ungruh, Christine. "Paradies und *vera icon*: Kriterien für die Bildkomposition der Ebstorfer Weltkarte." In *Kloster und Bildung im Mittelalter*, edited by Nathalie Kruppa and Jürgen Wilke, Veröffentlichungen des Max-Planck-Instituts für Geschichte 218; Studien zur Germania Sacra 28, 301–29. Göttingen: Vandenhoeck & Rupprecht, 2006.

Unterkircher, Franz, ed. *Die Wiener Biblia Pauperum Codex Vindobonensis 1198*. With an introduction by Gerhard Schmidt, and a foreword by Josef Stummvoll. 3 vols. Graz: Verlag Styria, 1962.

Urfels-Capot, Anne-Elisabeth. *Le sanctoral du lectionnaire de l'office dominicain (1254–1256): Édition et étude d'après le ms. Rome, Sainte-Sabine XIV L1. "Ecclesiasticum officium secundum ordinem fratrum praedicatorum."* Mémoires et documents de l'École des Chartes 84. Paris: École des Chartes, 2007.

van Eck, Caroline. *Art, Agency and Living Presence: From the Animated Image to the Excessive Object*. Studien aus dem Warburg-Haus 16. Berlin: De Gruyter; Leiden: Leiden University Press, 2015.

Van Engen, John. "Theophilus Presbyter and Rupert of Deutz: The Manual Arts and Benedictine Theology in the Early Twelfth Century." *Viator* 11 (1980): 147–63.

van Run, Anton J. "'Quia facilior ad intellectum per oculos via est': Over 'uitleg' op school en in de kunst." In *Scholing in de Middeleeuwen*, edited by René Ernst Victor Stuip and Cornelius Vellekoop, 127–58. Hilversum: Verloren, 1995.

Väth, Paula. *Die illuminierten lateinischen Handschriften deutscher Provenienz der Staatsbibliothek zu Berlin–Preussischer Kulturbesitz 1200–1350. Teil 1: Text, Staatsbibliothek Preussischer Kulturbesitz. Kataloge der Handschriftenabteilung: Reihe 3. Illuminierte Handschriften 3*. Wiesbaden: Harrassowitz, 2001.

Vauchez, André. "Les stigmates de saint François et leurs détracteurs dans les derniers siècles du moyen âge." *Mélanges d'archéologie et d'histoire* 80 (1968): 595–625.

Vennebusch, Joachim. *Die theologischen Handschriften des Stadtarchivs Köln*. 4 vols. Mitteilungen aus dem Stadtarchiv von Köln; Die Handschriften des Archivs. Cologne: Historisches Archiv der Stadt Köln, 1976–86.

Verboon, Annemieke R. "The Medieval Tree of Porphory: An Organic Structure of Logic." In *The Tree: Symbol, Allegory, and Mnemonic Device in Medieval Art and Thought*, edited by Pippa Salonius and Andrea Worm, IMR 20, 95–116. Turnhout: Brepols, 2014.

Vetter, Ewald Maria. "Mariologische Tafelbilder des 15. Jahrhunderts und das Defensorium des Fraz von Retz: Ein Beitrag zur Geschichte der Bildtypen im Mittelalter." Inaugural-Dissertation, University of Heidelberg, 1954. Accessed May 15, 2017. http://digi.ub.uni-heidelberg.de/diglit/vetter1954bd1/0009.

———. "Mulier amicta sole und mater salvatoris." *Münchner Jahrbuch der bildenden Kunst* 3. Folge 9–10 (1958–59): 32–71.

———. "Programm und Deutung des Triumphkreuzes im Dom zu Lübeck." In *Triumphkreuz im Dom zu Lübeck: Ein Meisterwerk Bernt Notkes*, edited by Karlheinz Stoll et al., 17–54. Wiesbaden: Reichert, 1979.

———. "Virgo in sole." In *Homenaje a Johannes Vincke para el 11 de mayo, 1962*, edited by Consejo Superior de Investigaciones Científicas and the Goerres-Gesellschaft zur Pflege der Wissenschaft, 1:367–417. Madrid: Consejo Superior de Investigaciones Cientificas; Görres-Gesellschaft zur Pflege der Wissenschaft, 1962–63.

———. "Zum 500. Todestag Bischof Krummedicks 1489–1989." *Zeitschrift des Vereins für Lübeckische Geschichte und Altertumskunde* 70 (1990): 103–28.

Viallet, Ludovic. "Le salaire de la plume: Prières de notaires et de copistes à la fin du moyen âge (XIVᵉ–XVIᵉ siècles)." In *La Prière en latin de l'antiquité au XVIᵉ siècle: Formes, évolutions, significations*, edited by Jean-François Cottier, Collection d'études médiévales de Nice 6, 291–314. Turnhout: Brepols, 2006.

Vidler, Anthony. "Diagrams of Diagrams: Architectural Abstraction and Modern Representation." *Representations* 72 (2000): 1–20.

———. "What Is a Diagram Anyway?" In *Peter Eisemann: Feints*, edited by Silvio Cassara et al., 19–27. Milan: Skira, 2006.

Virchow, Corinna. "Basel." In *Schreiborte des deutschen Mittelalters: Skriptorien—Werke—Mäzene*, edited by Martin Schubert, 57–82. Berlin: De Gruyter, 2013.

Voigts, Linda Ehrsam. "Scientific and Medical Books." In *Book Production and Publishing in Britain 1375–1475*, edited by Jeremy Griffiths and Derek Pearsall, Cambridge Studies in Publishing and Printing History, 345–402. Cambridge: Cambridge University Press, 1989.

Volfing, Annette. *John the Evangelist and Medieval German Writing: Imitating the Inimitable*. Oxford: Oxford University Press, 2001.

Volkert, Klaus Thomas. *Die Krise der Anschauung: Eine Studie zu formalen und heuristischen Verfahren in der Mathematik seit 1850*. Studien zur Wissenschafts- Sozial- und Bildungsgeschichte der Mathematik 3. Göttingen: Vandenhoeck & Rupprecht, 1986.

von Borries-Schulten, Sigrid. *Die Romanischen Handschriften* 1: *Provenienz Zwiefalten*. Katalog der illuminierten Handschriften der Württembergischen Landesbibliothek Stuttgart 2. 2 vols. Wiesbaden: Harrassowitz, 1978.

von Euw, Anton. "Die künstlerische Gestaltung der astronomischen und komputistischen Handschriften des Westens." In *Science in Western and Eastern Civilization in Carolingian Times*, edited by Paul Leo Butzer and Dietrich Lohrmann, 251–69. Basel: Birkhäuser, 1993.

von Moos, Peter. "Gespräch, Dialogform und Dialog nach älterer Theorie." In *Gattungen mittelalterlicher Schriftlichkeit*, edited by Barbara Frank et al., ScriptOralia 99, 235–59. Tübingen: Narr, 1997.

Vossen, Paul. "Über die Elementen-Syzygien." In *Liber floridus: Mittellateinische Studien. Paul Lehmann zum 65. Geburtstag am 13. Juli 1949 gewidmet von Freunden, Kollegen und Schülern*, edited by Bernhard Bischoff and Suso Brechter, 33–46. St. Ottilien: EOS Verlag, 1950.

Wagner, Kathrin. "Das *Defensorium* des Franz von Retz in Tafelmalerei und Schnitzkunt." In *Von wundersamen Begebenheiten: Franz von Retz*, edited by Eberhard König, 33–46. Simbach am Inn: Müller & Schindler, 2006.

———. "Das 'Defensorium inviolate virginitatis beatae Mariae' des Franz von Retz und seine bildliche Umsetzung am Pelpliner Chorgestühl." In *Terra sanctae Mariae: Mittelalterliche Bildwerke der Marienverehrung im Deutschordensland Preußen*, edited by Gerhard Eimer et al., 173–83. Bonn: Kulturstiftung der Vertriebenen, 2009.

Waldhoff, Stephan. *Alcuins Gebetbuch für Karl den Großen: Seine Rekonstruktion und seine Stellung in der frühmittelalterlichen Geschichte der "libelli precum."* Liturgiewissenschaftliche Quellen und Forschungen 89. Münster: Aschendorff, 2003.

Wallis, Faith. "What a Medieval Diagram Shows: A Case Study of *Computus*." *Studies in Iconography* 36 (2015): 1–40.

Walz, Dorothea. "Text im Text: Das Figurengedicht V,6 des Venantius Fortunatus." In *Text und Text in lateinischer und volkssprachiger Überlieferung des Mittelalters*, edited by Eckart Conrad Lutz, Wolfram-Studien 19, 59–93. Berlin: Erich Schmidt, 2006.

Waters, Claire M. "The Labor of *Aedificatio* and the Business of Preaching in the Thirteenth Century." *Viator* 38 (2007): 167–89.

Watson, Arthur. *The Early Iconography of the Tree of Jesse*. London: Milford, 1934.

Weber, Zach. "Figures, Formulae, and Functors." In *Visual Reasoning with Diagrams*, edited by Amirouche Moktefi and Sun-Joo Shin, 153–70. Basel: Springer-Birkhauser, 2013.

Wedell, Mortiz. "Zachäus auf dem Palmbaum. Enumerativ-ikonische Schemata zwischen Predigtkunst und Verlegergeschick (Geilers von Kaysersberg Predigten Teütsch, 1508, 1510)." In *Die Predigt im Mittelalter zwischen Mündlichkeit, Bildlichkeit und Schriftlichkeit / La predication au Moyen Age entre oralité, visualité et écriture*, edited by René Wetzel and Fabrice Flückiger, with Robert Schulz, Medienwandel—Medienwechsel—Medienwissen 13, 261–304. Zürich: Chronos, 2010.

Weijers, Olga. *In Search of Truth: A History of Disputation Techniques from Antiquity to Early Modern Times*. Turnhout: Brepols, 2014.

———. *La "disputatio" dans les facultés des arts au Moyen Âge*. Turnhout, Brepols, 2002.

———. *A Scholar's Paradise: Teaching and Debating in Medieval Paris*. Studies on the Faculty of Arts: History and Influence 2. Turnhout: Brepols, 2015.

———. *Terminologie des universités au XIIIᵉ siècle*. Rome: Edizioni dell'Ateneo, 1987.

Wells, David A. "Die Allegorie als Interpretationsmittel mittelalterliche Texte." In *Bildhafte Rede in Mittelalter und früher Neuzeit: Probleme ihrer Legitimation und ihrer Funktion*, edited by Wolfgang Harms and Klaus Speckenbach, in collaboration with Herfried Vögel, 1–24. Tübingen: Max Niemeyer Verlag, 1992.

———. *The Vorau Moses and Balaam: A Study of their Relationship to Exegetical Tradition*. Cambridge: Modern Humanities Resezrch Association, 1970.

Wenzel, Horst. "Bilder für den Hof: Zeitlichkeit und Visualisierung in den illustrierten Handschriften

des Welschen Gates von Thomasin von Zerclaere." In *Gesichtsdarstellung. Medien—Methoden— Strategien*, edited by Vittoria Borsò and Christoph Kann, 193–213. Cologne: Böhlau, 2004.

Wenzel, Horst, and Christina Lechterman, eds. *Beweglichkeit der Bilder: Text und Imagination in den illustrierten Handschriften des "Welschen Gastes" von Thomasin von Zerclaere*. Pictura et Poësis 15. Cologne: Böhlau, 2002.

Wenzel, Siegfried. *The Art of Preaching. Five Medieval Texts & Translations*. Washington, D.C.: Catholic University of America Press, 2013.

Westermann-Angerhausen, Hiltrud, et al., eds. *Joseph Beuys und das Mittelalter*. Ostfildern: Cantz, 1997.

Whittington, Karl. *Body-Worlds: Opicinus de Canistris and the Medieval Cartographic Imagination*. Toronto: Pontifical Institute of Mediaeval Studies, 2013.

Wilde, Mauritius. *Das neue Bild vom Gottesbild: Bild und Theologie bei Meister Eckhart*, Dokimion 24. Freiburg i. Üe.: Universitätsverlag Freiburg/Schweiz, 2000.

Wilhelmy, Winfried. "Rabans 'De laudibus sanctae crucis' in seiner schönsten Fassung: Der Codex Vaticanus Reginensis latinus 124." In *Rabanus Maurus: Auf den Spuren eines karolingischen Gelehrten. Katalog zur Ausstellung der Handschrift Vat. Reg. lat. 124*, edited by Hans-Jürgen Kotzur, 33–42. Mainz: Philipp von Zabern, 2006.

Wilkins, Eithne. *The Rose-Garden Game: The Symbolic Background to the European Prayer-Beads*. London: Gollancz, 1969.

Wilks, Ian. "Peter Abelard and His Contemporaries." In *Mediaeval and Renaissance Logic*, edited by Dov M. Gabbay and John Woods, Handbook of The History of Logic 2, 83–156. Amsterdam: Elsevier, 2008.

Willemsen, Annemarieke. *Back to the Schoolyard: The Daily Practice of Medieval and Renaissance Education*. Studies in European Urban History 1100–1800, vol. 15. Turnhout: Brepols, 2008.

Williamson, Paul. *The Medieval Treasury*. London: V&A Publications, 1986.

Wilmart, André. "Les méditations réunies sous le nom de saint Anselme." In *Auteurs spirituels et textes dévots du moyen âge*, 158–98. Paris: Bloud et Gay, 1932.

———. "Un répertoire d'exégèse composé en Angleterre vers le début du XIIIᵉ siècle." In *Memorial Lagrange*, 307–46. Paris: Gabalda, 1940.

Wimmer, Hanna. "Ein neuer Blick auf die Seitendisposition in *Biblia pauperum*-Handschriften." In *Studien zur "Biblia pauperum*," edited by Hanna Wimmer et al., Vestigia Bibliae 34, 31–100. Bern: Peter Lang, 2016.

———. *Illustrierte Aristotelescodices: die medialen Konsequenzen universitärer Lehr- und Lernpraxis in Oxford und Paris*. Sensus 7. Vienna: Böhlau Verlag, 2018.

———. "Schnittstellen: Illustration und Seitendisposition zwischen Text und Lehrdiskurs." *Das Mittelalter* 17 (2012): 87–97.

Winston-Allen, Anne. *Stories of the Rose: The Making of the Rosary in the Middle Ages*. University Park: Pennsylvania State University Press, 1997.

Wirth, Jean, ed. *Les marges à drolleries des manuscrits gothiques, 1250–1350*. Geneva: Droz, 2008.

Wirth, Karl-August. *Die Biblia pauperum im Codex Palatinus 871 der Biblioteca Apostolica Vaticana sowie ihre bebilderten Zusätze*. Zürich: Belser, 1982.

———. "Die Entstehung des Drei-Nagel-Crucifixus: Seine typengeschichtliche Entwicklung bis zur Mitte des 13. Jahrhunderts in Frankreich und Deutschland." PhD diss., Universität Frankfurt, 1954.

———. "Die kolorierten Federzeichnungen im cod. 2975 der Österreichischen Nationalbibliothek: Ein Beitrag zur Ikonographie der Artes Liberales im 15. Jahrhundert." *Anzeiger des Germanischen Nationalmuseums* (1979): 67–110.

———. "Lateinische und deutsche Texte in einer Bilderhandschrift aus der Frühzeit des 15. Jahrhunderts." In *Latein und Volkssprache im deutschen Mittelalter 1100–1500: Regensburger Colloquium 1988*, edited by Nikolaus Henkel und Nigel F. Palmer, 256–95. Tübingen: Niemeyer, 1992.

———, ed. *Pictor in carmine: Ein Handbuch der Typologie aus der Zeit um 1200. Nach MS 300 des Corpus Christi College in Cambridge*. Veröffentlichungen des Zentralinstitutes für Kunstgeschichte 17. Berlin: Gebr. Mann, 2006.

———. "Von mittelalterlichen Bildern und Lehrfiguren im Dienste der Schule und des Unterrichts." In *Studien zum städtischen Bildungswesen: Bericht über Kolloquien der Kommission zur Erforschung der Kultur des Spätmittelalters 1978 bis 1981*, edited by Bernd Moeller et al., Abhandlungen der Akademie der Wissenschaften in Göttingen, Philologisch-Historische Klasse 3. Folge, 137, 256–370. Göttingen: Vandenhoeck und Rupprecht, 1983.

Wirth, Uwe. "Logik der Streichung." In *Schreiben und Streichen: Zu einem Moment produktiver Negativität*, edited by Lucas Marco Gisi. Beide Seiten: Autoren und Wissenschaftler im Gespräch 2, 23–45. Zürich: Wallstein; Göttingen: Chronos, 2011.

Wittekind, Susanne. *Altar, Reliquar, Retable: Kunst und Liturgie bei Wibald von Stablo*. Pictura et Poësis 17. Cologne: Böhlau, 2004.

Wood, Christopher S. "Art History Reviewed VI: E.H. Gombrich's 'Art and Illusion: A Study in the Psychology of Pictorial Representation,' 1960." *Burlington Magazine* 151, no. 1281 (2009): 836–39. Reprinted in *The Books that Shaped Art History from Gombrich and Greenberg to Alpers and Krauss*, edited by Richard Shone and John-Paul Stonard (London: Thames & Hudson, 2013), 116–27.

Wöpking, Jan. "Raum und Begriff. Zur Wiederentdeckung der epistemischen Bedeutung von Diagrammen in der Geometrie." In *Konstruktion und Geltung: Beiträge zu einer postkonstruktivistischen Sozial- und Medientheorie*, edited by Joachim Renn et al., 233–58. Wiesbaden: Springer, 2012.

———. *Raum und Wissen: Elemente einer Theorie epistemischen Diagrammgebrauches.* Berlin Studies in Knowledge Research 8. Berlin: De Gruyter, 2016.

———. "Space, Structure, and Similarity: On Representational Theories of Diagrams." In *Studies in Diagrammatology and Diagram Praxis*, edited by Olga Pombo and Alexander Gerner, 39–55. London: College Publications, 2010.

Worm, Andrea. "'Ista est Jerusalem': Intertextuality and Visual Exegesis in Peter of Poitiers' *Compendium historiae in genealogia Christi* and Werner Rolevink's *Fasciculus temporum*." In *Imagining Jerusalem in the Medieval West*, edited by Lucy Donkin and Hanna Vorholt, Proceedings of the British Academy 175, 123–61. Oxford: Oxford University Press, 2012.

———. "Mittelalterliche Buchmalerei im Spiegel neuzeitlicher Publikationen." In *Visualisierung und Imagination: Materielle Relikte des Mittelalters in bildlichen Darstellungen der Neuzeit und Moderne*, edited by Bernd Carqué et al., Göttinger Gespräche zur Geschichtswissenschaft 25, 1:153–214. Göttingen: Vandenhoeck & Rupprecht, 2006.

———. "Visualizing the Order of History: Hugh of Saint Victor's *Chronicon* and Peter of Poitiers' *Compendium historiae*." In *Romanesque and the Past: Retrospection in the Art and Architecture of Romanesque Europe*, edited by John McNeil and Richard Plant, 243–64. Leeds: British Archaeological Association, 2013.

Zaitsev, Evgeny A. "The Meaning of Early Medieval Geometry: From Euclid and Surveyors' Manuals to Christian Philosophy." *Isis* 90 (1999): 522–53.

Zakai, Avihu, and David Weinstein. "Erich Auerbach and His 'Figura': An Apology for the Old Testament in an Age of Aryan Philology." *Religions* 3 (2012): 320–38.

Zchomelidse, Nino. "Das Bild im Busch: Zu Theorie und Ikonographie der alttestamentlichen Gottesvision im Mittelalter." In *Die Sichtbarkeit des Unsichtbaren: Zur Korrelation von Text und Bild im Wirkungskreis der Bibel*, edited by Bernd Janowski and Nino Zchomelidse, 165–89; 273–85. Stuttgart: Deutsche Bibelgesellschaft, 2003.

Zdebik, Jakub. *Deleuze and the Diagram: Aesthetic Threads in Visual Organization.* London: Continuum Books, 2012.

Zellinger, Johannes. "Der geköderte Leviathan im Hortus deliciarum de Herrad von Landsperg." *Historisches Jahrbuch* 45 (1925): 161–77.

Ziegler, Charlotte. "Ein unbekanntes Werk des 'Lehrbuchmeisters.'" *Österreichische Zeitschrift für Kunst und Denkmalplege* 34 (1980): 1–8.

Zinn, Grover A. "Hugh of St. Victor and the Art of Memory." *Viator* 5 (1974): 211–34.

Zlatar, Zdenko. *The Epic Circle: Allegoresis and the Western Epic Tradition from Homer to Tasso.* Sydney Studies in Society and Culture 10. Sydney: Sydney Association for Studies in Society and Culture, 1993.

Zorach, Rebecca. *The Passionate Triangle.* Chicago: University of Chicago Press, 2011.

Manuscripts Cited

Einsiedeln, Stiftsbibliothek
 Cod. 301(469), p. 98: 242, *242*

Florence, Biblioteca Medicea Laurenziana
 MS Pluteo 31 sin. 9: 315n74

Gotha, Universitäts- und Forschungsbibliothek
 Memb. I 120: 92, *92*, 253, *253*
 Memb. I 80: 2, 4–5, 28, 45, 51, 52, 54–55, *55–57*,
 57–59, 92, *92*, 94, 95–97, *97*, 100–102, *100*,
 102, 104–5, *104–5*, 107, *107*, 109, *109–11*,
 110–11, 115–17, *115–17*, 119–20, 122, *122*,
 124–26, *124*, *126*, *131*, 133, *133*, 135–37,
 135–36, 139–42, *139–41*, *145*, 147, 150–60,
 151–60, 163, *163*, 165–207, *165–66*, *168–70*,
 172–207, 253, *253*, 265–67, *266*, 329n18
Göttingen, Niedersächsische Staats- und Universitäts-
 bibliothek
 Cod. Ms. Hilbert: 340n155

Karlsruhe, Badische Landesbibliothek
 Ms. Aug. perg. 106: 214–15, *215*

London, British Library
 Add. MS. 11695: 317n8
 Add. MS. 22797: 13–14, *14*
 Burney MS. 351: 240, *240*
 Cotton MS. Claudius A.XIV: 216, *216*, 255–56, *256*
 Cotton MS. Faustina B VII: 224–25, *225*
 Harley MS. 2893: 34, 36, *36*
 Harley MS. 3405: 47–49, *48*, *49*
 Harley MS. 3667: 102–3, *103*, 105
 Royal MS. 12 D II: 234–36, *236*
Lucca, Biblioteca Statale
 Ms. 370: 126–27, *127*

Madrid, Biblioteca Nacional
 Mss/197, vol. 2: 253–55, *254*
Mettingen, Draiflessen Collection (Liberna)
 M. 2 Hilversum, 57–58, *58*, 320n67
Munich, Bayerische Staatsbibliothek
 Cgm 3976: 345n234
 Clm 210: 66, 69, *69*
 Clm 3050: 53, 94
 Clm 7384: 62–63, *62*
 Clm 8201: 46–47, *46*
 Clm 8826: 53, 94, 319n54
 Clm 13004: 138, 139
 Clm 14159: 93, 94, 146–47, *147*
 Clm 18077: 345n234
 Clm 18188: 53, 71, 94, 319n52
 Clm 21624: 53, 94, 319n52
 Clm 23426: 258–59, *258*, 344n218

Nancy, Cathedral Treasury
 102, *103*, 328n118
New York, Metropolitan Museum of Art, The Cloisters
 Collection
 acq. no. 2011.20.1: 166–67, *167*
Nuremberg, Germanisches Nationalmuseum
 Hs. 21897: 57, *57*
Nuremberg, Stadtbibliothek
 Cod. Cent. II, 56: 94

Oxford, Bodleian Library
 MS. Auct. F.5.28: 334–35n23
 MS. Laud. misc. 377: 94

Paris, Bibliothèque nationale de France
 ms. fr. 1082: 205, *205*
 ms. fr. 9220: 120, *121*, 263
 ms. lat. 1: 102
 ms. lat. 2279: 338n87
 ms. lat. 7361: 220–21, *220*
 ms. lat. 8916: 54–55, *54*, *55*, 86–87, 94–95, 325n26,
 325n38
 ms. lat. 10630: 94
 ms. lat. 11685: 325n44
 ms. nouv. acq. fr. 24541, f. Av.: 163–65, *164*
Paris, Bibliothèque nationale de France, Arsenal
 ms. 472: *44*, 45–47
 ms. 3517: 201–2, *201*, 238

Rome, Basilica di Santa Sabina all'Aventino
 Ms. XIV.L.I: 75

St. Gallen, Stiftsbibliothek
 Cod. Sang. 831, p. 362: 237–38, *238*
Strasbourg, Bibliothèque nationale et universitaire
 ms. 2929: 232–33, *233*
Stuttgart, Württembergische Landesbibliothek
 Cod. hist. 2° 410: 231–32, *232*
 Cod. hist. 2° 415: 89–91, *90*

Toulouse, Bibliothèque municipal
 ms. 418: 248–53, *249–50*, 342nn192–93, 343n194,
 343n196, 343n199, 344nn200–201

Uppsala, University Library
 Hs. C.78: 75–76, *76*

Vatican City, Biblioteca Apostolica Vaticana
 Cod. Reg. lat. 124: 34–35, *35*, 38, *39*, 41–43, *42*, 64,
 64, 65, *65*, 87–89, *87*, *88*, 96–98, *98*, *99*,
 100, *106*, 107, *108*, 118, 122–23, *123*, 125,
 132–33, *132*, 134–35, *134*, 138–39, *138*
Victoria & Albert Museum

Inv. no. 265&A-1886: 139–40, *140*
Vienna, Österreichische Nationalbibliothek
 Cod. lat. 4973: 345n234

Washington, DC, National Gallery of Art, Rosenwald
 Collection
 B-15, 391: 320n67
Wellesley, Wellesley College, Special Collections
 MS 19: 209, *209–11*
Windsor, UK, Eton College Library
 Ms. 177: 171

Zürich, Schweizerisches Landesmuseum
 Inv. no. LM 26117, f. 188r: 58–59, *59*

Index

Note: Berthold's *figurae* are listed along with serial figure numbers in the following way: "fig. 139 (book 2, *figura* 18),", where the serial figure number is followed by the corresponding *figura* number of Berthold's commentary, whether in book 1 (*In honorem sancti crucis*) or book 2 (*Liber de misteriis et laudibus intemerate Virginis genitricis Dei et Domini nostri Ihesu*). In addition, references to passages in the Bible are listed separately from relevant eponymous protagonists, as, e.g., in the entry headings "Daniel (OT)" and "Daniel: in lions' den."

arithmetic
among liberal arts, 214
Boethius on, 36 fig. 17, 217, 219 fig. 189
in games, 217 fig. 189
part of *quadrivium*, 217
See also geometry; liberal arts, seven
Ark of the Covenant
contains Old Law as Mary did New (Jesus), 157
David's joy at arrival of, 203
first of Berthold's combined diagram/figures, 156–57
fig. 122 (book 2, *figura* 6)
importance of theme for Berthold, 110
removed from Sion, 204 (*see also* Holy of Holies)
Artaxerxes, 206–7 fig. 179 (book 2, *figura* 58)
"Asilo"
probably Adelbero, bishop of Würzburg, 270
Assumption, of Virgin Mary, 203–4, 205 fig. 177 (book
2, *figura* 56)
Bede's homily on, 265
Bernard of Clairvaux on, 193–95, 193–94 fig. 166
(book 2, *figura* 45), 194–95 fig. 167 (book
2, *figura* 46), 199 fig. 173 (book 2, *figura*
52)
Paschasius Radbertus on, 56, 179–80 fig. 146 (book
2, *figura* 25), 202–3 fig. 176 (book 2, *figura*
55)
exaltation of, above choirs of angels, 204 fig. 178
(book 2, *figura* 57)
surrounded by Gospel quotations, 161 fig. 127
See also Marian Supplement to Berthold's Commentaries (*Liber de misteriis et laudibus intemerate Virginis genitricis Dei et Domini nostri Ihesu Christi*); Virgin Mary
astrology, 209
and biblical exegesis, 173–74 fig. 139 (book 2, *figura*
18)
See also zodiac
Auerbach, Erich
on word *figura*, 82. See also *figura*
Augustine of Hippo, Saint, 156–57, 214
defines Beatitudes, 122 fig. 90 (book 1, *figura* 20)
on geometry as liberal art, 214
on Incarnation, 157–58
on origins of geometry, 214–15 (*see also* geometry)
on Trinity, 28
authorial subscription
Berthold's, 62 fig. 42, 63, 268 fig. 216 (book 2, authorial subscription)
Hrabanus's, 64–65 figs. 44–45
Aymer de Valences (duke of Pembroke), 217

Babylonian Captivity, 110–11 fig. 79 (book 1, *figura* 14)
Balaam, 175 fig. 140
Baltrušaitis, Jurgis, 227
Bartolus de Sassoferrato
Lectura super digesto novo, 254–55 fig. 209

Bathsheba, 207
Beatitudes, eight, 91, 122 fig. 90 (book 1, *figura* 20)
Hrabanus's figure of compared to Berthold's, 122
Bede, Venerable, 136, 178–79 fig. 144 (book 2, *figura* 23),
182 fig. 149 (book 2, *figura* 28)
homily on Annunciation, 178–79 fig. 144 (book 2,
figura 23)
homily on Assumption, 265
invented source marks for mss., 74
quoted by Berthold, 61, 265
Bedos-Rezak, Brigitte, 270
Benjamin, Walter
on compilation, 72
Beresford Hope reliquary cross, 139–40 fig. 109
Bernard of Clairvaux, 176–78 fig. 143 (book 2, *figura* 22)
on circumcision of Jesus, 189–90 fig. 159 (book 2,
figura 38)
on Eve and the serpent, 174–75 fig. 140 (book 2, *figura* 19), 198–99 fig. 172 (book 2, *figura* 51)
frequent use of rhetorical questions, 75
on *Hortus spiritalis*, 76
on Virgin Mary, 151–52 fig. 117 (book 2, *figura* 1),
169–70 fig. 135 (book 2, *figura* 14), 171–72
fig. 137 (book 2, *figura* 16), 190–91 fig. 161
(book 2, *figura* 40), 195–97 fig. 169 (book
2, *figura* 48), 197 fig. 170 (book 2, *figura*
49), 205 fig. 179 (book 2, *figura* 58), 207–8
fig. 181 (book 2, *figura* 60), 209
Assumption of, 193–95, 193–94 fig. 166 (book 2,
figura 45), 194–95 fig. 167 (book 2, *figura*
46), 199 fig. 173 (book 2, *figura* 52)
miracle of pregnancy of, 169, 174 fig. 140 (book 2,
figura 19)
Berthold of Nuremberg
association with Revelation, 268–69
commentaries as exegetical meditation (Fulton), 269
commentary by (*De laudibus sanctae crucis*)
aids meditation, 210–11
based on Dominican liturgy, 77–78
comprises all of biblical history, 150
dating of, 55–57
diagrams evolve like mathematical proof, 30
eschatology in, 268–69
figures correlated with Hrabanus's *carmina*, 83–
84, 84–85t
homilies (*sermones*) excerpted within, 210
Hrabanus only definite source of, 92–94
image of, in Gradual, 58
images of in Gotha ms., 58, 61–63
ordering of, 142
as outline of sacred history, 237
as pastoral/devotional, 116–17
pilcrow marks in, 73
prologue to, 86–87
excised from Gotha ms., 86

Dada
 diagrammatic aspects of, 29
Daniel, 102 fig. 69
 stone of, 170–71 fig. 136 (book 2, *figura* 15), 212
 symbolizes virgins in Ezekiel (14:13–14), 18
Daniel (OT), 170
Daniel de Geertuidenberg (canon), 54–55 figs. 31–32
 (book 1), 94, 319n58
David, King, 164 fig. 131 (book 2, *figura* 11)
 Abisag brought to, 187
 joy of at arrival of Ark of the Covenant, 203 fig. 177
 (book 2, *figura* 56)
 Mary's lineage goes back to, 187–88
 as prophet, 165–66 fig. 131 (book 2, *figura* 11)
 Ruth ancestor of, 187
 See also Psalms
death
 board game and, 217
 of Christ, 126 fig. 94 (book 2, *figura* 22), 129, 135,
 162 fig. 128, 200
 commissioned *carmen figuratum* and, 216–17 fig. 187
 cross as victory over (Hrabanus), 88 fig. 54 (book 1,
 figura 2), 93 fig. 58, 95, 96, 110
 Levirate marriage and, 259–60
 love as strong as (Song of Songs), 188 fig. 157 (book
 2, *figura* 36)
 as midpoint between heaven and hell, 250–51
 passage from, to eternity, 202, 233 fig. 197
 reproach against (Nicholai de Dacia), 255
Deborah (prophetess), 182 fig. 149 (book 2, *figura* 28),
 193–94 fig. 166 (book 2, *figura* 45)
 See also Virgin Mary
declarationes figurae, 33, 86
 sole prayer among reiterated by Berthold, 86 fig. 53
 (book 1, *figura* 1)
*Defensorium inviolatae perpetuaeque virginitatis castis-
 simae genetricis Mariae*, 260, 262, 263
 See also Franz von Retz, *Defensorium inviolatae
 perpetuaeque virginitatis castissimae
 genetricis Mariae*
De laudibus beatae Mariae virginis, 161
De laudibus sanctae crucis. See under Hrabanus Maurus
De modo orandi corporaliter sancti Dominici, 265, 267
Derrida, Jacques, 244
Deuteronomy (OT), 259
Diagrammatik, 10, 312n17
"diagrammatology," 72–73, 227, 312n17
diagrams, 263
 abstraction of, 21
 algorithms as, 10
 Augustine on, 214
 Berthold's, 78
 combine analog and digital realms, 241
 concern cleric/theology and teacher/logic, 241
 cumulative effects of, 270–72

descent of rules of, 218, 234–63
describe a Christian cosmos, 214, and *passim*
figural though abstract, 270–71
logical basis of method of, 234–63
order and substance of components important,
 240–41
"playing with," 214–18, 271
three basic categories of, 235, 237
as tools of creativity, 246–47
as "working objects," 241
Boethius's, 228
as church graffiti, 253
compared with metaphor, 28 (*see also* metaphor)
concretize forms (Augustine), 214
cosmological (Cassiodorus), 214
as craving for order in world, 9
cyberspace as, 10
defining, 10–11, 16–21, 27, 32, 53, 313n15
as demonstrations, 21–28, 218–26
and desire, 13–16
didactic texts lack, 54
exclusion of (hypothetical) (Rotman), 242
fields encompassed, 10
"free ride"
 and medieval theology, 243–44
 supply supplementary (AI researchers), 221
as geometric
 inferior to dialectic, 213–14
 as means, not ends (Socrates), 213
 simulate the divine (Aquinas), 226
 and Trinity (Joachim), 224
as heuristic, 243
history of, 6, 54
as iconic, 32, 316–17n105
ideation of, in mind of God, 30
as imagetexts, 31, 53–54
justifications for, 10, 218–24 fig. 190
 vision can access the invisible, 220 (*see also*
 visible)
late thirteenth century as "mad for," 263–64
limits of (Joachim of Fiore), 224
and logic, 7, 234–64
"look-see" phenomenon, 221, 224
manipulation of parts of, 215
as material and abstract storytellers, 241–42
and meaning in medieval art, 54, and *passim*
and metaphors, 18, 240
as models, not descriptions (Zenon Kulpa), 244
modern vs. medieval, 9–11, 17, 29–31, 215, 241, 244
as necessary, 24, 244
as necessary (Berthold), 241
our world and selves as, 10
postmodernists on, 21
practicality of, 220, 224–26
proceed from third to fourth dimension, 17

provide insights into world, time, history, etc., 264

religiosity of, 7–9, 54, and *passim*

rooted in antique cosmology, 21, 54

as scientific, 25, 29

and signs, 25, 30, 31–32 figs. 12–13

as subdivision of hypoicon, 25

symbiotic with medieval curriculum, 234–35

terminology of and computer graphics, 30

as three-dimensional, 17

as tools with which to think, 246

trees as, 31 (*see also* Tree of Consanguinity; Tree of Jesse; Tree of Life [*Arbor vitae*])

use quincunx pattern, 237, 245–46, 257 fig. 211

uses of, past and present, 32, 219, 226, 264

See also Berthold of Nuremberg; geometry

dialectic, 213, 253 fig. 208

as highest human science (Plato), 213–14

personified as "lady," 235 fig. 199

Dialogus de laudibus sanctae crucis

contains history of salvation, 93–94

diagram of cross in, 34, 116, 142 figs. 113–14, 146

Homo constat treatise in, 92–93 fig. 58

one ms. of survives, 93

Dialogus Peregrini et Theodore. See *Speculum virginum*

didacticism, diagrammatic, 70–78, 248–53

See also diagrams; education; Rithmomachy (*De pugna numerorum, Ludus philosophorum*)

directionality

left vs. right allegorized in *Libellus* (Dives and Lazarus, and Abraham and Lot), 251–53

divinity, 184, 228

See also God; Holy Spirit (Holy Ghost); Jesus Christ

Dominic, Saint, 63, 266–67

Dominican Library at Toulouse, 248

Dominican order, 265, 267 fig. 216

Berthold's profile within, 77–78

education of, 248, 253

eschews Immaculate Conception, 171–72

uses Bede's homily on Assumption, 265

and Virgin Mary, 149–50, 263

dove(s)

and baptism of Jesus Christ, 166–67 fig. 132 (book 2, *figura* 12)

Elizabeth Zacharie compares to fruit of Mary's womb, 181 fig. 148 (book 2, *figura* 27)

gift of olive branch to Noah, 181–82 fig. 148 (book 2, *figura* 27)

as offerings for rituals, 190–91 fig. 161 (book 2, *figura* 40)

and purification of Virgin Mary, 190–91 fig. 161 (book 2, *figura* 40)

in Song of Songs simile, 202–3 fig. 176 (book 2, *figura* 55)

See also Holy Spirit (Holy Ghost); Noah's ark

Earth

diagrammed by child, 6, 13 fig. 4

Ecclesiasticus (OT), 198, 208. *See also* Sirach (Ecclesiasticus)

Ecclesiasticus (Sirach)

and Berthold's book 2, exegesis, 208

eclipse

on cross from Regensburg, 130–31 fig. 98

when Umberto Christ crucified, 8

Eco, Umberto

on metaphor, 28

on semantics, 235

education, 70–78, 93

diagrams as, 224, 226, 234–35, 243

of Dominican novices, 253

games promote, 217

elements (four), 97 fig. 64 (book 1, *figura* 6), 214 fig. 186

Elias (prophet), 200, 201

Eliseus (2 Kings), 201

Elizabeth Zacharie (mother of John the Baptist)

compares dove that came to Noah with fruit of Mary's womb, 181 fig. 148 (book 2, *figura* 27)

Leah as "type of," 183–84 fig. 151 (book 2, *figura* 30)

Elkins, James, 53

Elmer of Canterbury, 127

Emmanuel. *See* Jesus Christ

Ephesians (Epistle to the), 100, 184, 228

Epiphany

diagram for, 190 fig. 160 (book 2, *figura* 39)

Ernst, Ulrich, 34

Esdras (2) (OT), 206–7

Esmeria (mother of Elizabeth), 240

Esther

beauty of, 175

in diagram with Mary, 173 fig. 139 (book 2, *figura* 18), 175–76 fig. 141 (book 2, *figura* 20), 193 fig. 165 (book 2, *figura* 44)

prefigures Virgin Mary, 173, 193, 205 fig. 179 (book 2, *figura* 58), 212

See also Deborah (prophetess); Judith; Miriam ("Maria," prophetess); Ruth; Susanna; Virgin Mary

Esther (OT), 173, 193, 205

etymology, 237

Euclid, 21, 243

in theology, 225

Eusebius

studied Christ's ancestry, 259

Evangelists

surround Lamb of God in quincunx structure, 106, 136–37 fig. 105 (book 1, *figura* 27)

Eve

identified with pride, 153

Virgin Mary as new, 152, 159 fig. 125 (book 2, *figura*

imagetexts
 Berthold separates Hrabanus's, 81–82
 diagrams as, 31
Immaculate Conception, 169–70, 174
 compared to star's pure radiation (Bernard), 174–75
 fig. 140 (book 2, *figura* 19)
 Dominicans deny, 171–72
 See also Marian Supplement to Berthold's Commen-
 taries (*Liber de misteriis et laudibus inte-*
 merate Virginis genitricis Dei et Domini
 nostri Ihesu Christi); Virgin Mary
Incarnation, 157
 attempts to understand in diagram, 181
 Berthold evolves figuration to depict graphically, 29
 and diagrams, 31, 120–21 (*see also* diagrams)
 Hrabanus only touches on, 50
 importance of, 120
 miracle of, 158–59 fig. 125 (book 2, *figura* 9), 168–69
 fig. 134 (book 2, *figura* 13), 170, 180–81 fig.
 147 (book 2, *figura* 26), 184 fig. 152 (book
 2, *figura* 31), 186–87 fig. 155 (book 2, *figura*
 34), 187–88 fig. 156 (book 2, *figura* 35), 212
indices
 subdivision of sign/diagram (Peirce), 25
infertility
 of Rebekah and Elizabeth, 183–84
Ingold, Tim
 on *textus* and weaving, 73
In honorem sanctae crucis (Hrabanus Maurus). *See*
 under Hrabanus Maurus
inscriptions
 on framing elements, 7
 medieval, predisposed to diagram, 73 (*see also*
 diagrams)
 soteriological, 7, 105
intexts (*versus intexti*), 33–34, 37–38, 41 fig. 20, 122
invisible. *See under* visible
Isaac
 sacrifice of, 7, 186 fig. 154 (book 2, *figura* 33)
Isaiah
 among prophets juxtaposed with Evangelists, 101–5
 fig. 68 (book 2, *figura* 8)
 prophesies birth of Christ, 117–22 fig. 86 (book 1,
 figura 19), 147, 166–68 fig. 132 (book 2,
 figura 12), 169
 vision of seraphim, 110 fig. 78 (book 1, *figura* 13)
Isaiah (OT), 89, 100, 119, 120, 147, 162, 165, 166–68, 169,
 181, 187, 202
Isidore of Seville, 14 fig. 5, 75, 100–101, 231
 diagram of four seasons and directions, 100–101 fig.
 67
 indicts paintings, 80
 on origins of geometry, 228
 See also geometry

Jacob
 blessed by Isaac, 169
 dream of
 as scriptural model for ladder imagery, 89
 Leah bore children to, 183–84 fig. 151 (book 2, *figura*
 30), 195
 vision and humility of, 89
Jacobus de Fusignano
 on *thema* as branching of tree, 210
Jacobus de Voragine
 Legenda aurea, 149
Jean Pucelle, 163 fig. 130
Jeremiah
 God's words to, applied to Virgin Mary, 172–73 fig.
 137 (book 2, *figura* 16)
 prophesies about Virgin Mary, 168–69 fig. 134 (book
 2, *figura* 13)
Jeremiah (OT), 102, 109, 110–11, 115, 168–69, 172–73
Jerusalem, 116
 allegorized, 151–52 fig. 117 (book 2, *figura* 1)
 image of, 161, 218, 271–72 fig. 217
 as type of the Church, 185
Jesse. *See* Jesus Christ: ancestry of; Tree of Jesse
Jesus Christ
 absence/presence of in Berthold's images, 270 (*see*
 also diagrams: Berthold's)
 ancestry of, 111 fig. 29 (*see also* Tree of Jesse)
 as anthropomorphic, 29, 41–45 figs. 21–23, 82, 270
 Ascension of, 202–3 fig. 176 (book 2, *figura* 55), 203–
 4 fig. 177 (book 2, *figura* 56)
 ascent to, 120
 baptism of, 167
 birth from Virgin Mary's womb, 184 fig. 152 (book 2,
 figura 31), 187–88 fig. 156 (book 2, *figura*
 35)
 chastity of (Berthold, Hrabanus), 167
 compared with pyramid (Thiofrid), 230
 crucifix in center "ignored," 8
 depicted as cross, 200
 depicted in Hrabanus's *In honorem sanctae crucis*,
 45–47 figs. 21–23, 142
 Descent into Hell of
 as salvation, 7
 as divine vs. historic, 142
 as fulfillment of Old and creator of New Covenants,
 189–90 fig. 159 (book 2, *figura* 9)
 genealogy of, 259–60 fig. 213
 and Isaac, as sacrificial sons, 185–86
 joy of, at Mary's coronation, 185 fig. 153 (book 2,
 figura 32)
 King David as, 203 fig. 178
 loved by Virgin Mary
 prefigured in Song of Songs, 202–3 fig. 176 (book
 2, *figura* 55)
 love for Virgin Mary, 188–89 fig. 158 (book 2, *figura*
 37)